KANDINSKY IN MUNICH

THE FORMATIVE JUGENDSTIL YEARS

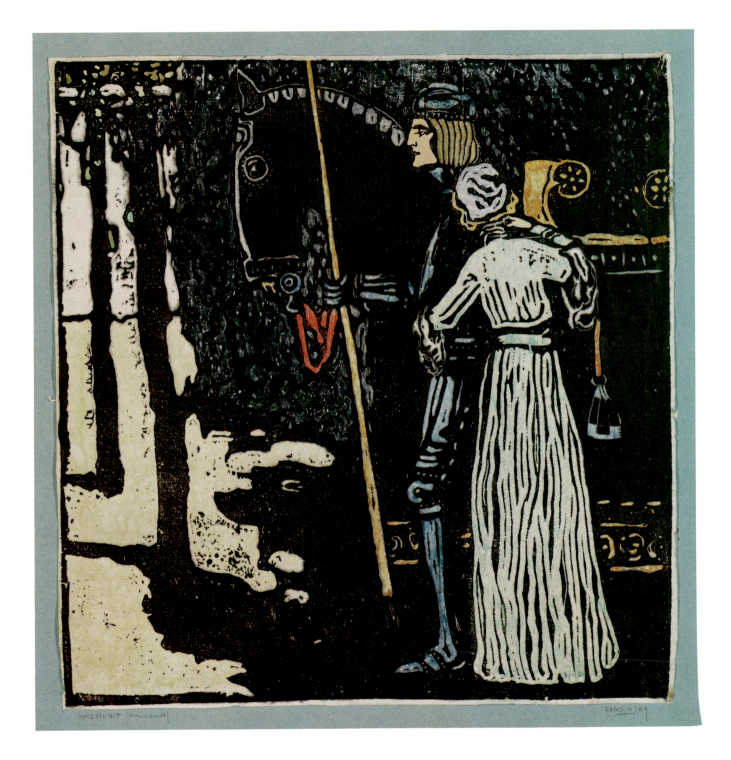

HOLZSCHNITT (Handdruck) KANDINSKY

KANDINSKY IN MUNICH

THE FORMATIVE JUGENDSTIL YEARS

By Peg Weiss

PRINCETON UNIVERSITY PRESS

PRINCETON, NEW JERSEY

Copyright © 1979 by Princeton University Press
Published by Princeton University Press, Princeton, New Jersey
In the United Kingdom: Princeton University Press, Guildford, Surrey
First Princeton Paperback printing, 1985
All Rights Reserved
Library of Congress Cataloging in Publication Data

Weiss, Peg.

Kandinsky in Munich.

1. Kandinsky, Wassily, 1866-1944.
2. Art nouveau—Germany, West—Munich. I. Title.
ND699.K3W43 759.7 78-51203
ISBN 0-691-03934-8
ISBN 0-691-00374-2 (pbk.)

Inclusion of color plates in this volume has been made possible by a grant from

MM

The Millard Meiss Publication Fund
of the College Art Association of America

Publication of this book has been aided
by a grant from the Andrew W. Mellon Foundation

This book has been composed in Linotype Caledonia

Clothbound editions of Princeton University Press books are printed on
acid-free paper, and binding materials are chosen for strength and durability.

Designed by Frank Mahood

Printed in the United States of America
by Princeton University Press, Princeton, New Jersey

Color Plate I (frontispiece)
KANDINSKY. Abschied (Farewell), 1903

Color plates by The Village Craftsmen, Rosemont, New Jersey

Black and white illustrations by the Meriden Gravure
Company, Meriden, Connecticut

Contents

CONTENTS

vii

APPENDICES

List of Illustrations

In Color

I. KANDINSKY. *Abschied* (*Farewell*), 1903. Color woodcut, 30.7 x 29.8 cm., GMS 207. Städtische Galerie im Lenbachhaus, Munich (*frontispiece*).

II. GABRIELE MÜNTER. *Portrait of Kandinsky*, 1906. Color linocut, 24.4 x 17.7 cm. The Solomon R. Guggenheim Museum, New York (*facing p. xviii*).

III. KANDINSKY. *Vor der Stadt* (*Before the City*), 1908. Oil on cardboard, 49.8 x 69.6 cm., GMS 35. Städtische Galerie im Lenbachhaus, Munich (*facing p. 12*).

IV. ADOLF HÖLZEL. *Komposition in Rot I* (*Composition in Red I*), 1905. Oil on canvas, 68 x 85 cm. Pelikan Kunstsammlung, Hannover (*facing p. 28*).

V. KANDINSKY. *Improvisation 6* (*Afrikanisches*) (*Improvisation 6* [*African*]), 1909. Oil on canvas, 107.5 x 95.5 cm., GMS 56. Städtische Galerie im Lenbachhaus, Munich (*facing p. 44*).

VI. KANDINSKY. *Dämmerung* (*Dusk*), ca. 1901. Tempera, crayon, gold and silver paint on cardboard, 15.7 x 47.7 cm., GMS 99. Städtische Galerie im Lenbachhaus, Munich (*facing p. 60*).

VII. KANDINSKY. *Einige Kreise* (*Several Circles*), 1926. Oil on canvas, 140.3 x 140.7 cm. The Solomon R. Guggenheim Museum, New York (*facing p. 124*).

VIII. KANDINSKY. *Im Sommer* (*In Summer*), 1904. Color woodcut, 30.6 x 16.5 cm., GMS 265. Städtische Galerie im Lenbachhaus, Munich (*facing p. 140*).

In Black and White

1. ERNST STERN. *Caricature of Anton Ažbè*, ca. 1900. Narodna Galerija, Ljubljana, Yugoslavia.

2. KANDINSKY. *Page from a sketchbook*, ca. 1897-99, GMS 344, p. 3. Städtische Galerie im Lenbachhaus, Munich.[1]

3. ANTON AŽBÈ. *Seated male nude*, 1886. Charcoal on paper, 138 x 154 cm. Narodna Galerija, Ljubljana, Yugoslavia.

4. ANTON AŽBÈ. *Portrait of a Negress*, 1895. Oil on wood panel, 55.2 x 39.5 cm. Narodna Galerija, Ljubljana, Yugoslavia.

5. ANTON AŽBÈ. *Half-nude woman*, 1888. Oil on canvas, 100 x 81 cm. Narodna Galerija, Ljubljana, Yugoslavia.

6. ANTON AŽBÈ. *Self-portrait*, 1889. Oil on canvas, 65 x 51 cm. Narodna Galerija, Ljubljana, Yugoslavia.

7. ANTON AŽBÈ. *In the Harem*, ca. 1905. Oil on canvas 44.3 x 51.3 cm. Narodna Galerija, Ljubljana, Yugoslavia.

8. HERMANN OBRIST. *Embroidered rug exhibited at the Munich Secession*, 1897. Wool on wool. *Pan*, I, 5 (1896).

[1] Works in the Gabriele Münter Stiftung of the Städtische Galerie im Lenbachhaus are referred to by the appropriate GMS numbers.

[2] According to E. Hanfstaengl (*Wassily Kandinsky, Zeichnungen und Aquarelle . . .*), the wood relief belongs to the Gabriele Münter- und Johannes Eichner-Stiftung, cf. no. 132, p. 56.

Acknowledgments

This book really began with Ezra Pound. Early in my graduate studies, I came upon Pound's 1914 essay on Vorticism, in which the poet expressed his appreciation of Kandinsky's book, *Über das Geistige in der Kunst*. "The image is the poet's pigment," he wrote, "with that in mind you can go ahead and apply Kandinsky, you can transpose his chapter on the language of form and color and apply it to the writing of verse." He recalled that after reading Kandinsky's words on form and color ". . . I only felt that someone else understood what I understood and had written it out very clearly."[1]

Pound's enthusiasm led me to Kandinsky and to a comparative study of the poet and the artist. A consideration of the origins of Kandinsky's thought and his momentous breakthrough to abstraction was a natural consequence, which in turn led me to Munich, the site of the artist's formative period, and to the research which culminated in the present study. In the transformation from dissertation to book, corrections have been made where errors typographical or otherwise have been discovered; relevant new material has been added, since research on this project has never really come to a halt; and the introduction has been entirely rewritten. Since completion of the dissertation at Syracuse University in 1973, two articles drawn from the fundamental research have been published, one in *The Burlington Magazine* (May 1975) and another in *Pantheon* (Summer 1977). However,

in both of these cases the material was of necessity greatly condensed. Thus the reader will find here much that is new accompanied by photographic documentation that was not available to me at the time the dissertation was completed.

In over a decade of involvement in Kandinsky studies the accumulation of debts of gratitude to friends and colleagues here and abroad is overwhelming. But I should like to take this opportunity to express my thanks to all who have so generously offered their knowledge, advice, encouragement, support and criticism over the years. And, although many have helped, I must emphasize that the final responsibility for interpretation of facts as well as for translations from the German is entirely my own.

First and foremost I wish to express my gratitude to Professor Kenneth C. Lindsay of the State University of New York at Binghamton whose landmark dissertation had long since introduced me to Kandinsky scholarship when we first met in Binghamton in December of 1970. My research was already well advanced and I had already spent a year foraging in Munich, but from the time of that first meeting, the project took on new immediacy and significance. Professor Lindsay generously opened his own extensive collection of research materials and shared with me his vast knowledge of Kandinsky accumulated over a period of some twenty years. The rich documentation he placed at my disposal provided not only corroboration of my findings, but many of the missing links in the story of Kandinsky's Munich experience

[1] Ezra Pound, "Vorticism," *The Fortnightly Review*, xcvi (September 1, 1914), 465.

as well. His sensitive guidance, enthusiastic encouragement and insightful criticism became a continuing source of inspiration, and eventually he served as a member of my dissertation defense committee. His careful readings of the manuscript through many drafts have been of invaluable assistance. It is perhaps rare when such a meeting in the academic arena leads to a deep and rewarding friendship between families, but such has been most happily the case in this instance. To Christine Lindsay whose refreshing wit and generous hospitality seem never ending, I am also enormously grateful.

It has been my good fortune to visit with Mme. Nina Kandinsky at her home in Neuilly-sur-Seine on several occasions. I am most grateful for her continuing interest in my work and for generously giving permission to reproduce Kandinsky's works and to quote from his writings and letters in my publications. But even more, I am grateful for the opportunity she has provided of establishing a sense of immediate contact with Kandinsky—for she has kept their apartment much as it was during his lifetime: his atelier lined with books, his brushes and bottles of pigments, his vintage typewriter, his memorabilia, all remain very much as they were then. The treasured paintings by Henri Rousseau still grace the walls; furniture designed by Marcel Breuer at the Bauhaus adorns the dining room. And Mme. Kandinsky still receives her guests in the gracious tradition of Russian hospitality to which she has long been accustomed. In these many touching ways she has shown her devotion to Kandinsky and provided for visiting scholars like myself a link with the past we might otherwise never have known.

Without the assistance of many individuals at the Städtische Galerie im Lenbachhaus, Munich, which houses the most significant collection in the world of material related to Kandinsky's early Munich period, the research for this book could not have been completed. I am especially grateful to Dr. Michael Petzet who, while director in 1972, permitted me full access to all of the Kandinsky sketchbooks, notebooks and drawings in the museum's collection, a fund of material which proved to be absolutely crucial in the final stages of my documentation of the artist's relationship to Munich's cultural and artistic life at the turn of the century. I am also grateful to Dr. Armin Zweite, present director of the Städtische Galerie, for his continuing cooperation and genuine interest. But I wish particularly to thank Dr. Rosel Gollek, curator of the Städtische Galerie, who so patiently answered my many queries and arranged for the extensive photography necessary for this book. Her precise documentation of the paintings of Kandinsky and his colleagues in the collection of the Städtische Galerie has also been of invaluable assistance. I am also indebted to Dr. Erika Hanfstängl for her responses to many of my inquiries and for her equally invaluable catalog of the Kandinsky drawings and watercolors (published, however, only after completion of this manuscript).

The staff of the Solomon R. Guggenheim Museum, New York, has been extremely helpful over the years as well. I am especially indebted to research curator Angelica Rudenstine who has assisted in innumerable ways, always generously sharing with me her insights and findings. But her energetic example and tremendous enthusiasm have been a special source of delight and inspiration to me. I am also grateful to Director Thomas M. Messer, to Curator Louise Averill Svendsen, and to librarian Mary Joan Hall for their generous cooperation.

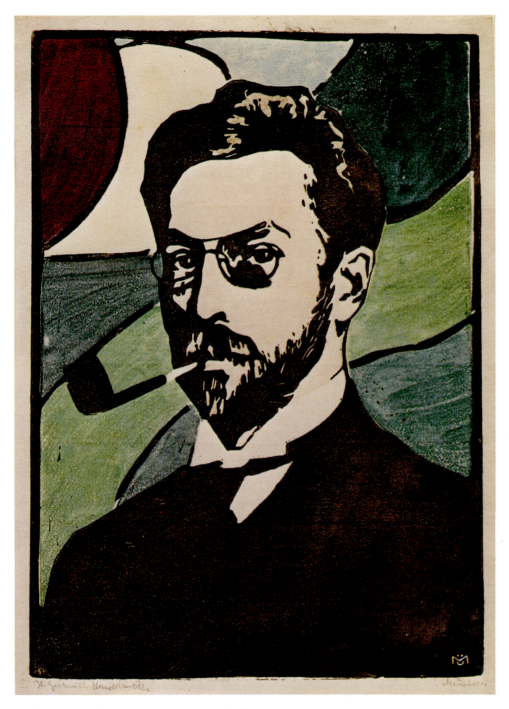

II. Gabriele Münter. *Portrait of Kandinsky*, 1906.

It is a special pleasure to express my gratitude to Dr. Wolfgang Venzmer of the Mittelrheinisches Landesmuseum, Mainz, who is preparing the first major monograph on the German abstract artist Adolf Hölzel. Dr. Venzmer graciously shared his personal collection of research materials with me including rare documentation of a personal meeting between Kandinsky and Hölzel in the early 1920s. He also kindly introduced me to private collectors of Hölzel works and to Frau Doris Dieckmann-Hölzel, the artist's granddaughter. Dr. Venzmer's steadfast kindness and generosity, and the hospitality of his whole family, especially of Gerda Venzmer, can never be adequately acknowledged. I am most grateful to Frau Dieckmann-Hölzel who graciously received me at her home in Stuttgart and allowed me to photograph many of her grandfather's paintings. I am indebted as well to Herr Helmut Beck of Stuttgart and Herr Kurt Deschler of Ulm for their generous help with photographic documentation. Also through the good offices of Dr. Venzmer, I met Herr Walter Buhre, formerly of the Pelikan Sammlung at the Gunther Wagner Pelikan-Werke, Hannover, who kindly arranged for me to visit and study the extensive collection of Hölzel works owned by the company. He also generously provided archival and photographic documentation.

Unforgettable was the assistance rendered me by Dr. Anica Cevc, director, and Dr. Ksenija Rozman, assistant director, of the Narodna Galerija of Ljubljana, Yugoslavia, which houses the only significant collection extant of works by Kandinsky's first teacher, Anton Ažbè. Appprised of my impending visit only weeks before my arrival, they undertook to recall paintings by Ažbè then out on loan and to borrow other works from local collectors. On my arrival, I found a whole gallery had been set aside for me and filled with paintings and drawings by Ažbè and his Yugoslavian students, as well as with every publication in the museum archives relevant to Ažbè, including the personal file of former director Karel Dobida. Sustained by repeated servings of Yugoslavian espresso and sweets, I spent several days pleasurably immersed in Ažbè lore, emerging with the basis for the first extensive discussion in English of this hitherto little known but brilliant and influential artist and teacher. I am especially grateful to Dr. Rozman for her continuing interest in my work.

In Munich I am also indebted to Klaus-Jürgen Sembach, formerly of the Neue Sammlung, who was very helpful to me, as well as to Dr. Martha Dreesbach, former director of the Münchner Stadtmuseum and to Dr. Helga Schmoll gen. Eisenwerth, who graciously arranged for me to see objects in that collection. Also at the Stadtmuseum, Dr. Johanna Müller-Meiningen patiently arranged for the photography of a number of objects for this book.

To Dr. Werner Haftmann, former director of the National Gallery, Berlin, and to Dr. Werner Hofmann, director of the Kunsthalle, Hamburg, I offer special thanks for the kind and helpful replies to my many queries over a period of several years. I am also grateful to Dr. Heinrich Voss of Munich, author of the catalogue raisonné of the work of Franz von Stuck, and to Dr. Gerhard Woeckel of the Kunsthistorisches Institut, Munich, for generously supplying information and photographs of many paintings and objects included in this book. A special note of thanks is due Dr. Isobel Spencer of the Scottish Arts Council, Edinburgh, for kindly sharing useful information on Walter Crane.

It is a special pleasure to thank sculptor Ruth Vollmer of New York for introducing me to her childhood friend Judith Köllhofer-Wolfskehl, the daughter of poet Karl Wolfskehl. And I am deeply grateful to Frau Köllhofer-Wolfskehl for her lengthy and detailed correspondence in reply to my inquiries concerning Wolfskehl's relationship to Kandinsky and other figures on the Munich scene at the turn of the century, as well as for her kind permission to quote from her father's work and correspondence. I am also deeply indebted to her friend and contemporary Mea Nijland-Verwey, the daughter of Dutch poet Albert Verwey, for her generous permission to quote from her father's poetry and correspondence with the Wolfskehl family. For permission to quote from the poetry of Stefan George, I am very grateful to Ursula Küpper of the Verlag Helmut Küpper (formerly Georg Bondi), of Düsseldorf and Munich.

Among fellow scholars in Kandinsky research whom I would like to thank are Dr. Klaus Brisch, now director of the Museum for Islamic Culture, Berlin, who wrote one of the first dissertations on Kandinsky; Dr. Rose-Carol Washton-Long, who has kindly shared many of her insights with me; and Peter Vergo, of Essex, England, whose wide-ranging knowledge of Austrian and German art at the turn of the century he has generously shared.

A special thanks is due Professor John E. Bowlt of the University of Texas at Austin for his generous help in providing translations from the Russian, particularly in relation to the Ažbè school and its students. I am also indebted to Professor Robert Stacy of Syracuse University and to Mrs. Olga Stacy for their kind help with many questions of translation from the Russian, particularly relative to Kandinsky's reviews for Apollon. I would like to thank as well Mr. Metod Milac, assistant director of Bird Library, Syracuse University, for his kind help in providing translations from the Slovenian relevant to Ažbè. The hospitality of the Milac family during my visit to Ljubljana in 1972 was also overwhelming.

Professor Alessandra Comini of Southern Methodist University, Dallas, deserves a very special place in these acknowledgments. It was her initial seemingly boundless enthusiasm which originally helped to bring this manuscript to the attention of interested publishers, and I am indeed grateful.

Among the many friends and colleagues at Syracuse University who found the time and the patience to read, advise, encourage, suggest and exhort over a period of many years, I would like especially to thank Professor Emeritus Dr. William Fleming, who introduced me to the study of the humanities; Professor Louis Krasner, whose personal acquaintance with Arnold Schönberg and Alban Berg provided another indirect link with Kandinsky; Professor Antje Bultmann Lemke, whose encyclopedic first-hand knowledge of Germany's cultural resources provided many invaluable insights for me; Professor Catherine Lord, who introduced me to the proper study of aesthetics; Professor Walter Sutton, in whose course on modern criticism I first met the critical writings of Ezra Pound; Professor William P. Hotchkiss, with whom I undertook my first historical study of the Munich milieu; Professor Ellen Oppler, who guided the original dissertation; Professor Gerd Schneider, who kindly discussed a number of fine points in translations from the German; Professor Donald E. Kibbey, formerly Vice President for Graduate Affairs; Professor David Tatham and Professor Sidney Thomas, both former

chairmen of the Fine Arts Department at Syracuse University, who helped in innumerable ways.

Financial assistance has come from several sources. I am most grateful to the Fulbright Foundation for providing a study and travel grant to Munich in 1967-68 which enabled me to initiate the fundamental research on which this book is based. I also wish to express my deep appreciation to Syracuse University which provided travel grants in 1972, 1975, and again in 1976, providing me with the opportunity of pursuing further details of my research in Yugoslavia, Germany, Great Britain, and France. I am also extremely grateful to the Millard Meiss Publication Fund for its generous grant to aid in the production of color plates for this book.

I would also like to thank members of the Board of Trustees of the Everson Museum of Art, where I served as Curator from 1974 to 1980, for generously allowing leaves of absence whenever necessary, and colleagues who graciously accepted an extra burden at such times, especially Marina Walker, Ami Belsky, Sara Gregg, and Leslie Gorman.

Thanks are also extended to all those institutions and private collectors indicated in the list of illustrations for generously providing photographs and for their permission to publish. I also wish to thank those photographers who undertook special commissions, including Jörg P. Anders (Berlin), Walter Dräyer (Zurich), Chris Focht (Binghamton), Fotosiegel (Neu Ulm), Foto Studio van Santvoort (Wuppertal), Sophie-Renate Gnamm (Munich), Photo Lill (Hannover), André Morain (Paris), and Gerhard Weiss (Munich).

To the untiring patience, devotion and skill of Margot Cutter, at Princeton University Press, I owe the final consistencies and editorial form of this long manuscript. Her firm and sensitive guidance especially in the final stages of preparation made the publication process a pleasure rather than a trial. And I also wish to offer a special note of gratitude to Mary Laing who introduced the manuscript to Princeton University Press and sent it on its way. Frank Mahood's intelligent and sensitive response to the special design problems presented by the content of this book has also been greatly appreciated.

To my typist Jane Frost, I owe an enormous debt of thanks. Her skill and attention to detail, combined with patience and cheerful fortitude helped immeasurably in the production of the final draft. For technical assistance with difficult photographic problems I am especially grateful to Nicco Büdinger of Munich, Robert Lorenz of Syracuse, and Cynthia L. Clark of Princeton University.

I should like to offer special thanks to my parents, Amy and Robb Hake, who provided not only constant moral support but, especially in the early stages of this project, frequently and cheerfully added grandchildren and family pets to their own responsibilities, providing me the necessary free time for research and writing. In Munich, Leni and Kurt Radtke became surrogate parents, offering friendship and encouragement at the most trying times; for their generosity and hospitality over many years I am extremely grateful.

But my deepest debt of gratitude and one that can never be adequately expressed in words is to my husband, Volker, and to our two sons, Erick and Christopher. To these three who sustained me with their unswerving faith and devotion all these years, I dedicate this book.

List of Abbreviations

DBR *Der Blaue Reiter.* Almanach edited by Wassily Kandinsky and Franz Marc (originally published in 1912). New documentary edition by Klaus Lankheit. Munich: R. Piper & Co., 1965.

DK *Dekorative Kunst.* Illustrated monthly periodical for applied art, published by Bruckmann, Munich, from 1897. (After 1900 bound together with *Kunst für Alle* as *Die Kunst Monatshefte für freie und angewandte Kunst*; however, since the two magazines continued to retain their separate titles and separate characteristics, being bound as two separate volumes of *Die Kunst* for each year, they are referred to throughout this book by their own titles, i.e. *DK* and *KfA*, even when the reference is after 1900.)

DKuD *Deutsche Kunst und Dekoration.* Illustrated monthly periodical for applied art, published by Alexander Koch, Darmstadt, from 1897.

EuKuK Kandinsky: *Essays über Kunst und Künstler.* Edited, with commentaries, by Max Bill. 2nd ed. Bern: Benteli Verlag, 1963.

GMS Gabriele Münter Stiftung. Works in the collection of the Städtische Galerie im Lenbach-haus, Munich, which were given through the estate of Gabriele Münter.

KfA *Die Kunst für Alle.* Bimonthly periodical for fine and applied art, published by Bruckmann, Munich, from 1886. (After 1899, bound together with *Dekorative Kunst, Monatshefte für freie und angewandte Kunst,* see *DK,* above.)

KgW *Kandinsky—Das graphische Werk.* Catalogue raisonné of Kandinsky's graphic oeuvre by Hans K. Röthel. Cologne: DuMont Schauberg, 1970.

KuK *Kunst und Künstler.* Monthly art periodical, published in Berlin from 1902.

PLF *Punkt und Linie zu Fläche, Beitrag zur Analyse der malerischen Elemente.* By Wassily Kandinsky. (Originally published for the Bauhaus by Albert Langen, Munich, 1926.) Introduction by Max Bill, ed. Bern: Benteli Verlag, 1964.

UGK *Über das Geistige in der Kunst.* By Wassily Kandinsky. (Originally published by R. Piper & Co., Munich, 1912.) 8th ed. [*sic*]. Bern: Benteli Verlag, 1965.

KANDINSKY IN MUNICH

THE FORMATIVE JUGENDSTIL YEARS

Introduction

"MUNICH was radiant." So begins a short story by Thomas Mann describing a glorious June morning around 1900 in the city sometimes known as the "Athens on the Isar." The throngs of tourists from all nations are observed; the university area teeming with students; every fifth house with its "atelier windows blinking in the sun"; the occasional aesthetic facade, its "bizarre ornament full of wit and style," the design of an imaginative young architect. "What fantastic comfort, what linear humor" in the forms of things displayed in the luxury shops, exclaims the narrator. The reader is invited to peruse the titles in a bookshop window: *The Art of Interior Design since the Renaissance, The Education of the Color Sense, The Renaissance in Modern Arts and Crafts, The Book as a Work of Art, The Decorative Arts, The Hunger for Art . . .* "Art blossoms, art reigns, art stretches her rose-wound scepter over the city and smiles . . . a guileless cult of line, of decoration, of form, of sensuousness, of beauty reigns—Munich was radiant."[1]

In 1930 Kandinsky remembered Munich at the turn of the century in much the same terms: "Everyone painted—or wrote poems, or made music, or took up dancing. In every house one found at least two ateliers under the roof. . . ." Schwabing, he wrote, referring to the Bohemian sector of Munich, was not so much a geographic location as a "spiritual situation . . . a spiritual island in the great world, in Germany, mostly in Munich itself."[2]

This Munich experience, which the artist himself recalled he had entered with a feeling of "being re-born," these Munich years have been curiously neglected in the recorded history of modern art.[3] Indeed, the fact that Kandinsky spent nearly eighteen years of his life—more than a third of his artistic career—in Munich has made little impact on a literature which has emphasized his international, particularly his French associations. With the *Blaue Reiter* exhibitions of 1911-12, the *Blaue Reiter* almanach (which he edited together with his friend Franz Marc), and the publication of his own book, *Über das Geistige in der Kunst* in the same year, Kandinsky became a figure of international renown. Even prior to that, with the second exhibition of the Neue Künstlervereinigung in 1910, his international significance had been established. The years from 1910 to 1914 and after have thus attracted the most public and scholarly interest. Since he was scorned as an outsider by those *Münchener* who were shocked by his radical abstractions and celebrated only amongst a small coterie of disciples and the international avant-garde of his time, it was perhaps inevitable that historians came to view him as an almost mythical figure above and beyond time and place. He was taken out of context as it were.

At the same time little has been written about the origins of his revolutionary move to abstraction. Yet clearly, without some knowledge of the context of that Munich experience, it hardly seems possible to trace those origins. It seemed to me that there must be a logical if complex connection between Kandinsky's development toward abstraction and his immersion in the Munich milieu of the turn of the century. Thus it

has been my goal to delve into that context in the hope of illuminating Kandinsky's actual experience there. What I have found forms the subject of this book.

In 1896 Kandinsky had left his native Russia and settled in Munich to become a painter. Fifteen years later, in the winter of 1911-12, he became an international celebrity as the artist who wanted to paint pictures without objects. His book *Über das Geistige in der Kunst*, published that year in Munich, proclaimed the emergence of the revolutionary art form in no uncertain terms.[4] But what was it that had drawn Kandinsky to the Bavarian capital in the first place? What formed the substance of his earliest associations? What was it there that precipitated his breakthrough to abstraction? And why, in looking back, did he think so fondly of Munich as a "spiritual island"? In fact, Munich had long held a position of importance in the cultural life of Europe.

Munich: The Isar Athens

By the 1890's Munich offered a constellation of intellectual and artistic currents truly representative of a "golden age." Second only to Paris as a marketplace for European art, Munich had for over a century enjoyed a reputation as a *Kunststadt*, a city of art. Since the days of Karl Theodor in the eighteenth century, the house of Wittelsbach had devoted itself with consummate passion and skill to the creation in Munich of a cultural center equal to any in the world. Under Ludwig I in the nineteenth century, Leo von Klenze and Friedrich von Gärtner had undertaken the construction of the Athenian Königsplatz, the university, and the dignified Ludwigstrasse. The eloquent collections of the major museums, the Pinakothek and Glyptothek, had been enlarged and housed in suitable buildings also by von Klenze. Ludwig's successor, Maximilian II, had called famous scholars to the university and had himself taken part in weekly symposia. A growing reputation for liberalism and intellectual freedom enhanced Munich's attraction for intellectuals in search of patronage, stimulation, and *Gemütlichkeit*.[5] The flamboyant Ludwig II, with his passion for Wagner and the *Gesamtkunstwerk* had added an exotic, even fantastic note. By the turn of the century, one authority estimated that artists and students in Munich numbered over twenty thousand.[6] Munich offered theaters, concert halls, cafés, salons, unparalleled museums, a relatively liberal press, an academy and countless private ateliers, a university studded with scholars of international repute—and infinite possibilities.

The same year that Kandinsky arrived in Munich from Moscow, 1896, Rainer Maria Rilke also arrived to try his fortunes. Thomas and Heinrich Mann, momentarily on a trip to Italy, had already discovered in Munich a haven for their literary talents. Frank Wedekind returned to Munich from Paris in 1896, already stigmatized as a *Bürgerschreck*: he still had years to wait for the first production of his shocking play *Frühlings Erwachen*.[7] He was to join Albert Langen, also returned from Paris that year, in founding the radical and rascally periodical *Simplicissimus* aimed at bourgeois complacency. In the same year, Georg Hirth founded the Munich periodical *Jugend*, which was soon to give its name to a style and an era. Both magazines were to publish the work of such able Munich caricaturists as Thomas Theodor Heine, Bruno Paul, Ernst Neumann, and Ernst Stern, as well as the

poems of Rilke, Hugo von Hofmannsthal, Max Dauthendey, Ricarda Huch, Richard Dehmel, Arno Holz, and many others. Richard Strauss was Munich's official *Kappelmeister* then. The archeologist Adolf Furtwängler taught at the university, as did the psychologist-philosopher Theodor Lipps. A young student of Lipps, the architect August Endell, had just completed the Elvira Atelier, with its fanciful facade and "bizarre ornament" described later by Thomas Mann in the story "Gladius Dei." Karl Wolfskehl, who was called the "Zeus of Schwabing," regularly opened his home to a roster of literati that included at one time or another most of Germany's intellectual elite. And his was only one of many cultural salons in the city. Germany's first Secession was in full sway in Munich. Adolf von Hildebrand, Franz von Lenbach, and Franz Stuck shared the laurel as Munich's artistic aristocracy. The city offered immense resources and opportunities. In fact, Kandinsky had chosen well the arena for his personal struggle with the muses.[8]

MUNICH AND THE ORIGINS OF ABSTRACTION

The irony of history is of course its very complexity. Clearly a myriad of subtly interwoven factors contributed in one way or another to the development of nonrepresentational forms of expression in the visual arts during the early years of the twentieth century. One might cite the growing schism between the artist in his "ivory tower" and the general public; or the increasing tendency to view the artist as seer, invested with unusual powers capable of revealing "mysteries" to the initiated; or the spread of the symbolist movement throughout Europe in the nineteenth century; or the rise of Impressionism with its emphasis on technique and color theory; or the invention of photography, which for a time seemed to threaten the mandate of representation in painting; or any one of a number of other developments, including economic, social and political factors. The truth must lie somewhere within a discreet acknowledgment of the whole historical vortex or milieu.[9]

Nonetheless, each separate analysis contributes toward our general understanding of Kandinsky and his work. As far back as 1913, Wilhelm Hausenstein was more inclined to attribute Kandinsky's abstraction to his "Russianness" than to anything else.[10] And Hans Hildebrandt also tended to see Kandinsky's abstraction as a characteristic result of his Slavic mentality.[11] The fact is that even today the real significance of the Russian background for Kandinsky's growth as an artist has yet to be thoroughly analyzed.[12]

One of the first scholarly studies of Kandinsky's work suggested that the Russian and German fairy tale motifs of many of the early works represented one stage in his stylistic move away from representational reality.[13] The artist's interest in naive art, with its "unrealistic" stylizations, has also been documented in an exhibition of his paintings on glass, a Bavarian folk genre Kandinsky and his friends "discovered" during the Murnau period.[14] More recently, the indisputable influence of French symbolist thought on the artist has been demonstrated, and his technique of obscuring or "veiling" painterly references to representational reality has been described as a further step toward total abstraction.[15]

Some scholars have argued that at the roots of Kandinsky's move to abstraction lay his personal interest in the occult teachings of Madame Blavatsky and Rudolf Steiner. The most avid proponent of this view-

point has been Sixten Ringbom, whose persuasive arguments tend in their very narrowness to obscure the breadth and eclecticism of Kandinsky's actual experience and background.[16] The widespread general interest in theosophy and the occult at the turn of the century represented a quite natural reaction to the rationalism and scientism of the eighteenth and nineteenth centuries, and a continuation of tendencies inherited from the Romantic movement. All over Europe throughout the nineteenth century, small cliques of artists banded together in societies characterized by distinctly religious overtones: the Nazarenes, the Pre-Raphaelite Brotherhood, the Rose+Croix, and the Nabis come to mind.[17] Catholicism drew many converts. In Russia many symbolist writers subscribed to Merezhkovsky's view of a "Third Testament" and a messianic vision of a future Utopian society in which paganism and Christianity would be fused.[18] Blavatsky and Steiner offered the mysteries of religious experience in the guise of a pseudo-scientific, pseudo-philosophical aesthetic vision that was acceptable to many disenchanted with the confines of traditional religious beliefs. A reading of a popular *roman à clef* like Franziska von Reventlow's *Herrn Dames Aufzeichnungen* reveals the broad appeal of the occult to turn-of-the-century society.[19]

By all accounts, Kandinsky's actual exposure to theosophical teachings was limited and probably due more to the promptings of his friend Gabriele Münter than to anything else.[20] Specific references to theosophy in Kandinsky's writings were fleeting and in fact appear in only one major published work.[21] It is apparent in his own statements not only that he was openly skeptical of the theosophists, but that he welcomed the movement chiefly because its apparent appeal

seemed to suggest a general trend toward a less materialistic orientation, and such a less materialistically oriented public might be better disposed to accept, perhaps even comprehend, his efforts to reveal a significant and profound content through nonrepresentational painting. However, it is clear that he saw it as only one of many overt signs of an eventual triumph of man's spiritual-intellectual qualities over his materialistic nature. In a letter of 1911 to Franz Marc, as preparations were being made for the *Blaue Reiter* almanach, Kandinsky particularly emphasized that it might be well to mention the theosophists "*statistically.*" In the same letter, he also urged the inclusion of something on the "Russian religious movement."[22] Thus clearly the theosophical movement represented for him merely one confirmation among many of the possibility of that "spiritual revolution" for which he, and Marc, and the Munich symbolists still hoped. Furthermore, it is apparent from an analysis of the critical literature of the period that words such as *Klang* and *geistig*—words often used by Kandinsky—were not the special province of the theosophists, as Ringbom seems to imply, but were in common usage among critics, poets, artists, and other literati of the time.[23]

The fact remains that the origins of Kandinsky's abstraction have not yet been satisfactorily explained. At the same time, his earliest experiences as an artist in Munich at the turn of the century have remained obscure. While some few influences have been recognized and analyzed with acumen and perspicacity, that broad historical context has been virtually ignored.[24] The present study attempts to rectify that situation at least in part by focusing on a number of hitherto little-known aspects of Kandinsky's Munich

experience. Inescapably a degree of selectivity must obtain.[25] However, the attempt here has been to "set the stage" for a much more complete view of those Munich years than has previously been available to the scholar of modern art.

ARTS AND CRAFTS—JUGENDSTIL—ABSTRACTION

Pervading all aspects of Munich's artistic milieu at the turn of the century was the powerful arts and crafts movement. Indeed, within the radiantly effervescent cultural milieu of Munich in the nineties, that one movement in particular was to exert an enormous effect not only on Kandinsky but upon the whole art of the twentieth century. It was the art proclaimed in the titles of the books described in Mann's story: *The Renaissance in Modern Arts and Crafts . . . The Decorative Arts . . . The Education of the Color Sense. . . .* The aesthetic mannerisms so aptly and ironically observed by Mann were symptomatic of a movement that had come into its own throughout Europe in the nineties, and was soon known internationally as Art Nouveau. In Munich, the movement took the name of its spiritual godfather, the periodical *Jugend*: the style of youth, *Jugendstil*, it was soon called. When Mann spoke of a "guileless cult of line, of decoration, of form, of sensuousness," he was describing very nearly the essential characteristics of a style which, though dedicated to youth, and everywhere a prescient vehicle of the avant-garde, was yet nourished by roots deep in the nineteenth century.

Kandinsky arrived in Munich in 1896. The same year, across the continent in Hammersmith, England, William Morris died at the age of sixty-two, and three months after the publication of his masterwork, the Kelmscott Chaucer. Thus it may be suggested that the year 1896 marks a kind of watershed in the history of modern art. Indeed, the arts and crafts movement initiated by the genius of William Morris was to serve as a powerful catalyst for quite a different genius.

It was to William Morris that the international revolution in arts and crafts (with its concommitant repercussions in the fine arts) owed its inspiration and its strength. Prompted by the awesome eclecticism of London's great Crystal Palace Exhibition of 1851, Rossetti, Morris, their friends and other concerned artists and artisans had embarked upon a reform movement that reverberated throughout Europe from Red House on Bexley Heath in 1860 all the way to the Bauhaus at Weimar in 1919. Following Pugin and Ruskin, the reformers urged a new humanistic relation between art and life. The rigid sanction of precedent was to be overturned in favor of a sanction of the present, the immediate and particular experience. Like the ideal of the *Gesamtkunstwerk*—the total work of art— that informed it, the arts and crafts movement touched all the arts in one way or another, ushering in a period of unusual vitality and unity.

Everywhere the new aesthetic demanded a total reform of life: a new architecture, a new decoration, a new music, a new poetry, a new painting—all at the service of the *Gesamtkunstwerk*. Traditional forms were discarded and new ones invented. Morris and Company's medievalizing eccentricities gradually gave way to the simplifications demanded by function; Horta and Van de Velde derived startlingly abstract formal patterns based on a new-found regard for modern technology. But underlying all these transformations lay the same motivations, the same focus: namely, the ultimate creation of a socially viable total

aesthetic environment, informed by a fresh awareness of and respect for the psychological and symbolic potential of such fundamental aesthetic elements as color, line and form.

Everywhere periodicals sprang up to propagandize the new aesthetic: *The Studio* in London (1893), *Van Nu en Straks* in Brussels (1892), *La Revue blanche* in Paris (1891) and later *L'Art décoratif* (1898), *Jugend* in Munich (1896) and its imitator *Joventut* in Barcelona (1900), *Pan* in Berlin (1895) and *Mir Iskusstva* in St. Petersburg (1899), were only a few.[26] In general they followed faithfully the principles of good book design developed by Morris and his followers—each page a work of art, the whole a total work of art. The best talents in Europe submitted their work—poets, critics, and artists alike. The cohesiveness and scope of the movement was demonstrated not only in the strength of its propaganda but by the surprising swiftness with which it spread to cities as diverse as London, Glasgow, Brussels, Barcelona, Paris, Munich, Berlin, and Vienna in the last decade of the century.

If the aesthete London world of *The Yellow Book* and the circle of Oscar Wilde and Aubrey Beardsley seemed almost to iridesce in the peculiar twilight of a decaying civilization, the jaunty, even strident, opening of Samuel Bing's "L'Art Nouveau" shop in Paris in the winter of 1895 celebrated a growing cult of youth and Utopian optimism soon to be reflected as well in the giddy convolutions of Hector Guimard's Parisian subway stations and in the flamboyant élan of the 1900 world exhibition.

In fact, nothing could more aptly symbolize the paradoxical contradictions of the period than the convoluted wavy line so characteristic of the new style.

Undulating, coiling, turning endlessly back upon itself, the wavy line leapt from wallpaper to architecture, from jewelry to ceramics, from the posters of Toulouse-Lautrec and Alphonse Mucha to the swirling veils of Loïe Fuller, in effect unifying old and new. Liberated from its role as delineator of observed reality, line emerged as a free agent charged with astonishing energy. "The line is a force," Van de Velde was to write, ". . . it derives its power from the energy of him who drew it."[27]

The hitherto unsuspected power of line-in-itself and color-in-itself had been revealed with special clarity as a by-product of the arts and crafts movement, with its intense concern for the essential nature of the fundamental artistic elements. In Paris, Charles Henry's parallel investigations of the psychology of line and form inspired Seurat's studied compositions, which also in their pointillist technique recalled the handcrafts of mosaic or of tapestry.[28] In Munich, Theodor Lipps lectured on the psychological implications of lines and forms to an enthralled university audience. In his class sat more than one young prophet of artistic abstraction.[29] And in England Walter Crane's book *Line and Form* was soon to emphasize the power of "that rhythmic, silent music which the more formalized and abstract decorative design may contain, *quite apart from the forms it actually represents.*"[30]

Thus inextricably interwoven with the rise of the arts and crafts movement was a growing tendency to conceive of line, form and color as independent entities capable of previously unsuspected energy. At the same time, the symbolist dream of a poetry and an art capable of suggesting an intensity of emotions beyond the everyday world of mere appearance and beyond

the range of ordinary description complemented this new respect for the basic elements of the various arts. As words chosen not for their descriptive but for their emotional power became the vehicle of the symbolist poem, so too color, line and form, freed from any absolute necessity to imitate nature, might yield the full range of aesthetic emotion. Whistler had long since defined painting as an arrangement of line and color when, in 1890, Maurice Denis published his famous statement that a painting "before it is a battlehorse, a nude woman, or some anecdote—is essentially a flat surface covered with colors assembled in a certain order."[31] Both artists were close to the symbolist movement; both were involved in one way or another in the arts and crafts movement.

But beyond this theoretical predisposition to abstraction, the arts and crafts movement carried with it an unusual intensity of conviction and hope, an almost fanatic, even religious utopianism. The artist as seer had become involved in a crusade to reform the whole social and cultural fabric of life. The arts and crafts movement offered a bridge between the "ivory tower" and the people, and a vehicle for a vast spiritual revolution. Thus Walter Crane depicted the artist as St. George battling the dragon-guardian of an industrialized city, with its smokestacks spewing the pollution of a materialistic society into the heavens (Fig. 153). Less than two decades later Kandinsky was to represent St. George in a similar symbolic role, overcoming the dragon of materialism, on the cover of the *Blaue Reiter* almanach (Fig. 157). The zeal of the religious crusade still sparked beneath the words of Gropius's Bauhaus manifesto when he wrote in 1919 of a future architecture, founded on the concept of the crafts-

man's guild, which he likened to the "crystal symbol" of a "new faith."[32] The idea then of a spiritual renewal through art also spanned the century's turn, from Morris and his followers to Kandinsky and beyond.

The connection between the rise in significance of the decorative arts and the rise of abstraction in painting is an issue that long escaped serious scholarly attention.[33] Although some tenuous correlation had been previously perceived between Art Nouveau and abstraction, it was only with the beginnings of scholarly research into the Art Nouveau-Jugendstil epoch that serious consideration was given to the possibility, for example, of a profound relationship between Kandinsky and the Jugendstil movement centered in Munich. Fritz Schmalenbach was the first to suggest that Kandinsky might be seen as a "continuation" of Munich's Jugendstil architect August Endell, and that there might be a relationship between Kandinsky's theories and those of Jugendstil *Flächenkunst*.[34] Yet even with the burgeoning of Art Noveau literature since the 1950s, little more than lip service has been paid to this idea by most scholars.[35]

This book then is the result of an intensive investigation of Munich's Jugendstil milieu and Kandinsky's relationship to it. It was in Munich that Kandinsky made his breakthrough to abstraction. What sort of artistic atmosphere did he actually encounter on his arrival in 1896? Was it as barren as some writers have suggested?[36] Or was there indeed some special agent in that radiant Isar-Athens powerful enough to revolutionize the history of art? Who was this Anton Ažbè to whom Kandinsky turned for his first lessons in art? And what could possibly have appealed to him in the work of his second teacher, Franz von Stuck, whose

Jugendstil mannerisms may seem at first glance so appallingly out of tune with twentieth-century art? Was there in fact any indication at all that other artists or critics in Munich might be preparing the way for the movement toward abstraction? And what of Kandinsky's actual contacts there with other artists, with poets and critics? Clearly Kandinsky did not live in isolation during the Munich years. Diaries, letters, exhibition catalogs and reviews all attest to his direct personal involvement in a rich and rewarding milieu.

My own conviction that the history of art must be viewed from a broad cultural point of view led to this study of Kandinsky's Munich experience in many, if not all, of its cultural manifestations. The result of my investigation suggests that Kandinsky's move toward abstraction was, perhaps more than anything else, the result of a convergence of strong Jugendstil tendencies toward abstract ornamentation with a symbolist striving for inner significance and *geistige* revolution.

Munich Jugendstil offered line-in-itself and color-in-itself, and the prophecy of an art with forms that "represent nothing." Munich's symbolist poetics offered the principle of "inner necessity," the prophecy of a new "spiritual realm," and densely woven images imbued with inner significance.

Early in his Munich career, Kandinsky found himself driven to the conclusion that recognizable objects damaged his paintings.[37] He was faced with the question of what should replace the object. It was obvious to him that mere ornament in itself could not offer a solution. He recalled later that only years of patient work and intensive thought, a total immersion in painterly forms, prepared him to experience such forms purely and abstractly.[38] This time of total immersion was also a time for Kandinsky of immediate involvement in the Jugendstil decorative arts movement and close contacts with Munich's symbolist milieu. These were indeed the formative years.

PART ONE

ARTISTIC MILIEU:
THE TRAINING OF
THE ARTIST

III. KANDINSKY. *Vor der Stadt* (*Before the City*), 1908.

CHAPTER

·|·

The First Teacher: Anton Ažbè

KANDINSKY'S decision to exchange the possibility of a promising career as a university professor for the uncertainty of the artist's life was announced by a dramatic plunge away from Moscow and into the Bavarian heart of *la vie bohémienne*.[1] Not only did he settle immediately in Munich's bohemian sector, Schwabing, but he enrolled for his first formal lessons in the private academy of Schwabing's most bohemian of artists —Anton Ažbè, actually a Slovenian, whose atelier was one of the most popular in Munich outside the Academy.[2]

A number of factors may have contributed to Kandinsky's decision to enter the Ažbè school. He may well have heard about Ažbè before he left Russia, since the master had an international reputation and many Russian students. Two of these were to become close associates of Kandinsky in later years: Alexei Jawlensky and Marianne von Werefkin, both of whom had arrived in Munich from Russia the same year as Kandinsky. At least two other artists who were later to become well known in Russia, Igor Grabar and Mstislav Dobuzhinsky, were also Ažbè students and have left memoirs concerning their experiences at the school.[3]

Ažbè's studio was located at Georgenstrasse 16, in the heart of Schwabing. It was just around the corner from Kandinsky's first address,[4] and must have seemed attractive to the new exiles, since Dobuzhinsky reported it was in a "big wooden house built in quasi-Russian style."[5]

"As a human being, he was one of the most original and best-known artistic personalities of Munich." Such was the final tribute to Kandinsky's first teacher, at his premature death in 1905. Anton Ažbè was then only forty-three years old, yet already he had become an almost mythical figure in Munich's bohemia. The same obituary recalls that Ažbè was the teacher of many artists who had received recognition. Though he himself, in his "almost proverbial modesty," never achieved fame as an artist, the effect on his students and friends "of his selfless dedication" was a "rich blessing." Despite its brevity, this nine-line obituary in the *Kunstchronik* suggests a warmly emotional farewell.[6] A review of Ažbè memorabilia reveals that the tribute was genuine and shared by many who knew him.

Kandinsky, for instance, recalled particularly Ažbè's generous nature in a special note about his teacher in "Rückblicke." "He was a talented artist and an unusually good man," wrote Kandinsky, who recalled that "many of his numerous students studied with him free of charge. His answer to the excuses offered for not being able to pay was invariably, 'Just work hard!'"[7]

With characteristic sensitivity, Kandinsky wrote that Ažbè had apparently led a most unhappy life. "One could hear him laugh—but not see it: the corners of his mouth scarcely turned up and his eyes were always sad. I don't know whether anyone knew the

riddle to his lonely life. And his death was as lonely as his life: he died alone in his studio."[8]

Accounts of Ažbè's generosity abound, and Kandinsky noted that despite his large income (presumably from students who could pay—and everyone recalled that his studio was always overflowing), he left only a few thousand marks. "Only after his death did it become known, to what extent his generosity attained."[9]

That Ažbè was well loved is recorded even by the caricatures of him done by prominent Munich artists like Eduard Thöny, Olaf Gulbransson, and Ernst Stern. They show him very small, wrapped in a gigantic coat or cape.[10] Thöny drew a gentle, bespectacled face peering out from under a jauntily set soft cap, with a label from a wine bottle completing the composition. Gulbransson, less kindly, drew a bewhiskered face dominated by a gigantic artist's plush-velvet hat and large bow tie. One of his students, Beta Vukanovic, portrayed him with a palette half his size, a colossal brush and the eternal cigarillo.[11] But Stern's portrayal is the most sympathetic (Fig. 1). The little man is seen from the back jauntily walking along with the aid of a walking stick of shoulder height, clothed in the legendary coat and booted, a cigarillo elongated by a holder aloft—a figure at once flamboyant, bohemian, and pathetic.[12]

Perhaps the most touching of the stories about Ažbè is related to the nickname by which he was known throughout Schwabing, Professor Nämlich (Professor Namely). For, it seems, after every correction, made always with lightning speed and astonishing accuracy, he would say simply, "So, nämlich," and pass on to the next easel.[13] So, as Professor Nämlich he was known in the cafés around Schwabing, most especially at the famous Café Simplicissimus, where he enjoyed a wide

circle of acquaintances, including the artists Ludwig Herterich, Heinrich Zügel, Fritz von Uhde, Albert Weisgerber, and such literary men as Frank Wedekind, Max Halbe, Eduard von Keyserling, and Max Dauthendey.[14]

Marianne von Werefkin, also a student at Ažbè's and a colleague of Jawlensky and Kandinsky, described the little master as something of a clown, with his "medal in his buttonhole, dirty pants on his legs and wine in his head. He feels himself a cavalier. An unusual figure, the personality of a great comic. It is not his place in society, but a combination of great merits, that makes him 'sympathisch' [appealing] and at the same time makes of him an indescribable buffoon."[15]

But it was more than his endearing personal qualities that built Ažbè's reputation as a teacher. He did have a distinct pedagogical talent and, while perhaps not a definite program, a theoretical approach that combined contemporary artistic theories with individual insights sometimes strikingly advanced for his time. According to one source, his students claimed that "a single correction by Ažbè was more valuable than a year at the academy."[16]

Ažbè had arrived in Munich in 1884, having studied for two years at the Academy of Fine Arts in Vienna.[17] He then entered the Munich Academy where he studied for some six years.[18] During his later years at the Academy, he exhibited his work at Munich's great exhibition hall, the Glaspalast. He also received commissions for portraits and copies of classical works. But in 1891, at the urging of his young Yugoslavian colleagues,[19] he opened a private school. His "exceptional aptitude" as a teacher soon attracted many students and the fame of the school spread far and wide. Soon students from all over Europe and even the

United States were in attendance. His dedication to teaching resulted in the neglect of his own work, so that very few paintings by his hand survive.[20]

AŽBÈ'S METHOD

There were four major aspects of Ažbè's "method" which are particularly relevant both to an understanding of Kandinsky's development and to the history of modern art in general. These were: his emphasis on the use of pure colors applied directly to the canvas without mixing; his widely known *principe de la sphère* or *Kugel-system* as it was also called; his advice to work with broad, sweeping lines, and with a very wide brush; and finally, his commitment to encouraging the individual development of his students.[21]

Ažbè's promotion of what was for the time an avant-garde theory of color and color application was perhaps a major factor in attracting the large numbers of students, reported at times to have been over a hundred.[22] Since the Munich Academy with all its large staff and its reputation only enrolled between three and four hundred students a semester at that time, some idea of Ažbè's popularity may be deduced.[23] And the Academy was yet to come to terms with the basic theories of French impressionism.

According to Stelè, Ažbè taught that knowledge of the laws of color was indispensable to the definition of objects on the canvas. In Ažbè's teaching, color alone was the fundamental instrument of modeling forms in space. It is in this respect that Stelè compares Ažbè's method to that of Cézanne.[24] Ažbè stood then in the mainstream of avant-garde artistic development, teaching painting as an art of color. He believed that the basis for the painting of the future would be a strong sense of color and that the purpose of school-

ing must be to develop this color sense. Thus he advocated the transference of pure colors directly from the palette to the canvas, next to one another. The result, he taught, would be especially clean and vibrating. He called this effect "crystallization of color." Another expression he used to indicate the scintillation thus achieved was "diamond effect."[25]

Indeed, Ažbè's faith in color was such that if he recognized a well-developed sense of color in a student, he "believed in his talent as a painter."[26] This would partially explain Kandinsky's presence in Ažbè's atelier, which he continued to visit over a period of two years. In "Rückblicke," Kandinsky convincingly relates that color was for him an experience of such fundamental significance that it influenced his whole development. The memoir begins with a recollection of his first sensations of color, and its pages are filled with references to vividly remembered color experiences.[27] It is significant that of Ažbè's students, both Jawlensky and Kandinsky were to develop into colorists par excellence. Indeed, Kandinsky's first major publication, *Über das Geistige in der Kunst*, was largely devoted to a discussion of "color language."[28] Later, at the Bauhaus, Kandinsky was to direct the seminar on color.

Apparently relying on Grabar's testimony, Stelè has related Ažbè's method to neo-impressionist color theory. Grabar wrote that Ažbè believed in not mixing the colors on the palette, but in placing them separately on the canvas "so that they would mingle of their own accord in the eye of the spectator."[29] Stelè's commentary then suggests that Ažbè actually advocated theories of "optical mixture."[30]

While it cannot be determined for certain perhaps,[31] this interpretation may be, to a certain extent, a misinterpretation after the fact. As J. Carson Webster

pointed out in his reappraisal of impressionist and neo-impressionist color theory, "optical mixture" is "rarely if ever" the actual result achieved by neo-impressionist technique.[32] On the other hand, as Webster suggested, the juxtaposition of separate dots of pure color does indeed often result in an effect of scintillation.[33] The terms "diamond effect" and "crystallization of light" attributed to Ažbè by several sources would indicate his awareness of this effect, but do not necessarily imply the notion of "optical mixture."[34]

Stelè emphasized that Ažbè, while making use of a number of current ideas, did not really belong to any one of the dominant schools of thought. In his opinion, Ažbè was closer to various post-impressionist positions, especially to Cézanne: "what he sought were new possibilities in the sense of the truth of color."[35] Kandinsky, perhaps inspired by Ažbè's independence, was always wary of cut and dried theories. In "Rückblicke," he stated that impressionist theories had never really interested him. Neo-impressionist theory seemed "more important" since it addressed itself fundamentally "to color effect" and "left the air in peace." But, characteristically, he emphasized that any "external" (such as a theory) must "grow out of the inner or be still-born."[36]

Thus, in regard to color theory, Ažbè was, at least as far as Germany was concerned, ahead of his time. Kandinsky had chosen to work outside the academy and in a studio where avant-garde theories were current. However, Ažbè was not a theoretician. While advocating certain technical approaches as regards color and paint application, he left his students free in matters of composition. This freely experimental attitude undoubtedly appealed to Kandinsky, who later recalled that he even felt restricted by the discipline of drawing from the model, though he recognized the necessity of such training.[37] But Ažbè's color enthusiasm found a responsive chord in Kandinsky's natural inclination. He noted in "Rückblicke" that his colleagues soon labeled him a colorist.[38]

Ažbè's emphasis on problems of color and techniques of painting almost to the exclusion of problems of composition tended naturally, as Stelè has suggested, toward a separation of color and form.[39] Thus, as he also pointed out, it is scarcely surprising that one of his most gifted students, Kandinsky, was to become the "founder of the abstract school," nor that others, such as Werefkin, developed toward expressionism.[40]

Despite the fact that Kandinsky was at first impatient with Ažbè's *Prinzip der Kugel*,[41] this was, as Stelè points out, where Ažbè's genius was prophetic of formal developments that were not to become widespread until after the turn of the century, and which Stelè compared to the ideas of Cézanne.[42] Ažbè taught that the student who can paint a sphere can also paint a head, a model, or a tree, or indeed any three-dimensional object effectively. He also worked with his students on problems of surfaces of solids and their appearance as altered by direction.[43] Dobuzhinsky stated in his memoirs that Ažbè's "geometrical heads already anticipated Cubism."[44]

KANDINSKY AS STUDENT

At the time, apparently, Kandinsky was more taken with Ažbè's emphasis on free linear development. Although painting from a model did not appeal to him, he recalled that he was often fascinated by the *Linienspiel* (play of lines) while observing the model.[45] Do-

buzhinsky recalled that the master used to say, "Work only with broad lines."[46] At the same time, he advocated the use of a wide brush, with which in a few strokes he could capture the characteristics of the model. Grabar reported that Kandinsky was already using a palette knife rather than a brush at that time.[47] Perhaps the freedom of the Ažbè atelier encouraged Kandinsky's experimentation. It certainly remained a basis of his consistent defense of the freedom of the artist to use any means in any way.

Indeed, Kandinsky related that he sought freedom from the discipline of the studio by frequently skipping school. He could breathe more freely, he wrote, out in Schwabing, in the English Garden, or along the Isar with his paint box. Or, he admitted, he stayed at home and tried to make a picture from memory, from a study, or freely out of his fantasy. And he noted candidly that his colleagues thought him lazy or even not very talented, which bothered him considerably since he felt within himself both talent and a dedication to hard work. Thus he felt isolated and devoted himself more intensively to his private wishes.[48]

Despite some reservations,[49] Kandinsky was a conscientious student, as is attested by the numerous drawings and sketches preserved in the archives of the Städtische Galerie in Munich.[50] In fact, he enrolled twice in anatomy courses offered by the Academy.[51] However, he also recalled later that Ažbè had advised him, "You must know anatomy, but before the easel you must forget it."[52]

Figure 2 is typical of the work of this early period.[53] The head of the old woman and the seated half-nude are particularly characteristic of the Ažbè school.[54] The conscientious schematic drawings and notes similar to those in several other early sketchbooks suggest the thoroughness that was to become characteristic of Kandinsky's attention to any artistic problem.

There was, however, another aspect of Ažbè's method which apparently made a positive impression on Kandinsky, since he adopted it some years later in his own school. And that was the painting excursion by bicycle. Grabar related that when he and Kardowski first arrived in Ažbè's school in 1896, the master's first question was "Have you a bicycle?" For, as Grabar put it, he "believed in" painting excursions.[55] Later, after Kandinsky had founded his own school, he spent whole summers with his students out in the country. One of his students recalled that he would send them out to their motifs on bicycle and then round them up again, riding about blowing on a small whistle.[56]

AŽBÈ AS ARTIST

Although Ažbè did not achieve fame as a painter in his lifetime, even a cursory examination of his work reveals an excellent technical capacity, a bravura disregard for naturalistic detail, and an exquisite fineness of sensibility. His drawings show that Grabar's tribute to him as a "fine graphic artist" is well deserved.[57] The large charcoal drawing of a seated man recently discovered in the National Gallery at Ljubljana offers a good demonstration of this talent (Fig. 3).[58] Dated 1886, it displays the technical excellence surprising in the work of a twenty-four-year-old, which won the admiration of his colleagues, who subsequently urged him to open his own studio.

The superb *Portrait of a Negress*, which is dated 1895 (Fig. 4), demonstrates an interesting combination of naturalistic representation and sophisticated formal analysis. The white triangle at lower left re-

flects in the highlights of the face, and the rectangular shape at the upper left neatly emphasizes the forward thrust of the features, while balancing the movement of the shoulder toward the lower right. These formal compositional elements contrasted with a seemingly casual, painterly technique lend the portrait a quality both of tenderness and strength.

The color of the original is astonishingly rich and luminous. Ažbè illuminated the background with a delicate, yet at the same time bold, scumbling of vermilion and yellow, intensifying the strength of the gaze, and suggesting perhaps his subject's southern origin. A transparent bluish cloak serves as a necessary contrast to the warm background, while the feathery white blouse creates an incredibly soft foil for the strong face.[59] According to Stelè, this portrait held a place of honor in Ažbè's studio, where it served as a demonstration of his *principe de la sphère*.[60]

An earlier portrait of a seated girl (1888) reveals the same sensitive tenderness combined with compositional eloquence (Fig. 5). The figure is typically academic, yet the wistful expression, the delicate treatment of the colors and the sly insertion of one blue fragment into the overall golden hue of the composition, demonstrates a sophistication reminiscent of Whistler or Carrière. The same qualities characterize the *Self-Portrait* of 1889 (Fig. 6). Indeed, a sensitive and gentle regard for his models as human beings is apparent in two other portraits at the National Gallery: *Portrait of a Bavarian* and *Portrait of a Man in a Black Tie*.

The only later work in the collection is *In the Harem*, of 1905 (Fig. 7). In its perhaps incomplete state, this painting is indeed very free, yet also reveals strong formal controls. Despite its small format, its boldness lends a quality of monumentality. It also reveals a dramatic flair suggested previously in the *Portrait of a Negress*.

It is clear, then, that from the very beginnings of his formal artistic career, Kandinsky was exposed to advanced ideas about color and to the enthusiasm for the use of pure colors that was to become a consistent characteristic of his own work throughout his lifetime. From the first, he was exposed to specifically formal ideas which were to concern him intensely later on.[61] Ažbè's emphasis on the use of a very broad brush may well have influenced Kandinsky to work with a palette knife, as in nearly all of his early oil sketches, and later to make use of broad, bold strokes of color, as in the works of the Murnau period.[62] The attitudes absorbed in Ažbè's studio contributed to Kandinsky's life-long skepticism regarding the imposition of rules in art, and underscored his sense of estrangement from the demands of traditional naturalist schooling.

In fact, as has been noted, Ažbè's emphasis on color and certain technical devices (the broad brush, the principle of the sphere) combined with his disdain for academic compositional rules tended toward a freedom of attitude with regard to the artistic media which undoubtedly had a critical influence on Kandinsky's development. Furthermore, his dedicated support of individual tendencies encouraged the evolution of the most diverse styles among his students.[63] Kandinsky's initiation into the formal processes of art could scarcely have been more propitious for his later development to abstraction.

CHAPTER

·II·

Munich's Secession Movement

KANDINSKY'S decision to study in Munich may have been at least partially determined by the presence there of the famous Munich Secession, the first in the series of Secession movements that were to clear the way for even more radical apostasies in the future. The Munich Secession had been founded in the spring of 1892 in protest against the increasing and suffocating provincialism of the Munich Artists' Society (Münchener Künstlergenossenschaft), which for a number of years had been promoting and holding gigantic annual exhibitions with the result of a steady decline in quality.[1]

The artists who seceded from the Künstlergenossenschaft did so with the promise that they would bring elite, highly selective exhibitions to Munich not only of their own work but of the best in foreign achievement as well. They disclaimed the intention of representing any one direction and made but one demand: that only the "absolutely artistic" would be allowed.[2] On April 4, 1892, seventy-eight artists left the fold and founded the "Verein bildender Künstler—Secession."

Among the founding fathers and early corresponding members were Peter Behrens, Ludwig Dill, Lovis Corinth, Otto Eckmann, Adolf Hölzel, Max Liebermann, Giovanni Segantini, Franz Stuck, Paul Besnard, Jacques-Emile Blanche, Eugène Carrière, and many others. Of these, several were to achieve international fame, and to have directly or indirectly some

influence on the development of the young Kandinsky.

The Secession kept its word. Its exhibitions, at least for a time, became show windows for the best of all the various tendencies in European art of the day. Hugo von Hofmannsthal counted off some seven or eight different directions when the Munich Secession exhibited in Vienna in 1894: the neo-romantic (Böcklin), the naturalistic (Uhde), Besnard and the luminists, Whistler, the Scots, and the Japanese influence, as well as what he termed the new "latin" romantic of Puvis de Chavannes, Moreau, and Khnopff.[3]

Besides its synthesizing and selective function, however, the Munich Secession also served as a catalyst: within the next eight years two more major Secession groups were to be founded (in Vienna, 1897, and Berlin, 1898), as well as at least four splinter groups within Munich itself.[4] The Munich groups were "Neu-Dachau," 1894; "Luitpoldgruppe," 1896; "Vereinigte Werkstätten für Kunst im Handwerk," 1897; and "Scholle," 1899. Yet these new groups did not have the effect of detracting from each other; on the contrary, the activity seemed to create an effervescent contagion of excitement. As Hevesi wrote at the founding of the Viennese Secession, "The young foreigners cry out their greetings joyfully. New-Munich, New-Berlin stand as a man together with New-Vienna. . . ."[5]

In 1896, too, the year of Kandinsky's arrival in Munich, the Secession included a cross-section of late

nineteenth-century art. There were colorists after Whistler's manner, naturalists who were moving beyond impressionism and beginning to experiment tentatively with neo-impressionism, mannerists who chose to work in stiffly neo-rococo or neo-Biedermeier styles, and flamboyant symbolists of the Böcklin strain, the best known of whom was Franz Stuck, soon to become Kandinsky's second teacher. It included sculpture and graphic arts, making no secret of its pride in the achievements of the *Jugend* and *Simplicissmus* designers and caricaturists. There was also a group of "naturalists" whose reaction against traditional naturalism, that is, the French stream of impressionism, took the form of obsession with formal and psychological qualities of composition. This was the Neu-Dachau school (consisting of Adolf Hölzel, Ludwig Dill, and Arthur Langhammer), which was to have a subtle but definite influence on Kandinsky's search for his own style.

If Kandinsky arrived in Munich in time to see the 1896 Secession exhibition, he would certainly have been drawn to it if only because, for the first time, several Russians were included in the selection.[6] The artist Paul Schultze-Naumburg, reviewing the show for *Kunst für Alle*, wrote that the Russian contribution was a "fresh and honest art," which must have seemed a gratifying accolade to the new exiles.[7]

Whether or not Kandinsky actually visited the exhibition, he certainly must have informed himself about the latest news in Munich art upon his arrival. He may well have read the review by Schultze-Naumburg in *Kunst für Alle*. A brief perusal of this review provides us with some startling insights into Kandinsky's later thought, the direction of his development and even his use of language as found in his earliest known writings.

For example, Schultze-Naumburg found one of the major characteristics of the newest German art represented at the Secession to be that the effect of each picture had been achieved by "purely artistic means." At the same time he noted an increase in the "most uninhibited *Farbenfreudigkeit*" (figuratively, abandonment to color), as well as a strong tendency on the part of each artist to follow "the laws of his own talent." He identified Böcklin as a major influence with his "intellectualized manner of viewing nature" (vergeistigten Art der Naturanschauung).[8]

The exploitation of "purely artistic means," the "uninhibited" use of color, and the individual nature of artistic development were to become almost leitmotifs for Kandinsky, as it were, building blocks of his own development as well as basic assumptions of his major writings.

The belated recognition of Böcklin, whose fantasies had driven naturalists to distraction only a few years earlier, is reflected in Naumburg's enthusiastic approval of the idea that nature may be interpreted by the artist in a *vergeistigte* manner. Perceptive as he was, he doubtless could not imagine to what extent Kandinsky would carry the *Geistige* in art in another few years.[9]

Another word that was to take on a spectrum of special meanings for Kandinsky was used by Schultze-Naumburg in his comments on Ludwig Herterich's painting *Sommer-Abend*. He wrote of the "magic of the colors" ("Zauber der Farben") and described the painting as "modern lyric in colors" ("moderne Lyrik in Farben"). He wrote that it was of a tonal beauty such that anything similar to its *Klang* was not to be found in the room. *Klang* and *Lyrik* (musical resonance and poetic lyricism) were to become warp and woof of the texture of Kandinsky's expressed thoughts on art in the future, and were to appear in the titles of some

of his most successful as well as revolutionary artistic achievements.[10]

The Munich Secession exhibitions provided Kandinsky with a complete résumé of European art in the waning years of the nineteenth century. In 1897, for example, the selection ranged all the way from Hodler's fantastic *The Night* (*Die Nacht*) and his *Eurythmie*, with its mysterious repetitions, to two Monets and a Turner. There was a series of seven paintings by Burne-Jones, *The Legend of St. George and the Dragon.* There were numerous works by Böcklin (including the *Isle of the Dead* [*Toteninsel*] and the more recent *The Surf* [*Meeresbrandung*]), as well as five works by the English "colorist" Brangwyn, who was later to be recognized by Kandinsky in *Über das Geistige in der Kunst* as one of the first modern artists to use "primitive" color combinations.[11] In the graphics section there were drawings by Walter Crane and by Goya, as well as a woodcut by Lucien Pissarro.

In 1898 the Secession show included a special collection of works by illustrators for the popular Munich weekly *Jugend*, as well as the usual European cross-section, which always included a large number of painters representing the "Glasgow school."[12] In 1899, the Neu-Dachau group was especially well-represented, including three landscapes by Ludwig Dill and three by Adolf Hölzel who, as will be shown, was soon to prefigure Kandinsky's later writings in his own theoretical investigations.[13]

But even in 1896 there were some signs that the strength of the Secession movement in Munich was on the wane. For one thing, that year the Secession was invited back into the fold, namely, to cooperate with the Munich Artists' Society by exhibiting with them at the Glaspalast every four years. Despite the fact that it was about to move into an elegant gallery of its own on the Königsplatz, the Secession agreed to the arrangement, retaining however, its own independent jury and "hanging commission."

More subtle, perhaps, but pervasive, were the signs that some of its early boosters, like the critic Karl Voll, were incapable of keeping up with each new wave. Although in 1897, he was still bravely lauding the fact that the Secession did not show anything that was not *reinmalerisch* (purely painterly), he nevertheless waxed most enthusiastic about paintings the dramatic content of which could be described literally.[14] And already by 1898, he was scolding those "decorative" painters who would completely "abandon" the "content." What differentiates such painters from great art, he wrote, is that they do not intend to say anything, and this "denial of content goes much too far" (Verzicht auf Inhalt geht wohl gar zu weit).[15]

He also expressed reservations about the work of Walter Leistikow (a founder of the Berlin Secession that year): "It is no longer a question of truth to nature, but rather has to do with the charm of a highly personal 'artistic handwriting.' The object as such that is chosen for representation, no longer matters, only that which the artist's mood has made out of it (and that without any depth of knowledge). I do not deny Leistikow's power to make forms, but I have strong reservations about this direction."[16] Two years later, he was still objecting to Leistikow's "intellectual games" (*geistreiche Spielerei*).[17] Actually, Leistikow's increasingly simplified, highly stylized, flat landscapes were in the mainstream of *Stilkunst* (literally "style-art") at the turn of the century, an example of the *Flächenkunst* (or planar art), that Kandinsky was later to identify as one of the first steps into the "realm of the abstract" ("*Reich des Abstrakten*").[18] This new movement was Jugendstil.

CHAPTER

·III·

Jugendstil: The Arts and Crafts Movement

ALMOST at the same time as the Secession was gathering strength, a second and more powerful artistic current burst upon the Isar Athens. Radiating from Munich outward across Germany, it brought the first tremors of a radical departure from representational art. A kind of second "Secession,"[1] it was at first only identified as the "modern style" or the "decorative movement."[2] However, it soon received the name of its spiritual godfather, the Munich periodical *Jugend*, and eventually became commonly known as "Jugendstil."[3]

This new movement had certain aesthetic convictions at its core which were, in effect, to seed the artistic clouds of the twentieth century. These mainly involved the artist's sovereignty over his materials and a reappraisal of them in their own terms. There was a certain social conscience involved as well, for a renewal of aesthetic appreciation in such basic terms would require a total restructuring of man's environment: his tools, his home, his whole life style; a new education and new attitudes; expanded perceptual capacities and new sensitivities. It was foreseen that the result would be a general raising of the quality of everyone's life.[4] The dreams of the idealists were never to be realized, but for a time their hopes indeed raised the quality of art and moved it into the twentieth century.

As a matter of fact, it was in 1896, the year of Kan-

dinsky's arrival, that the Munich Secession unwittingly provoked the herald of that entirely new and powerful movement that was, almost in a moment, to change the course of art in Munich and to become for a time the actual vehicle of avant-garde art in Germany.[5] That herald was August Endell, who came to instant acclaim in 1896 with his critical pamphlet *Um die Schönheit, eine Paraphrase über die Münchener Kunstausstellungen 1896*. With a sensuous orchid as its motif and a poem by Baudelaire as its slogan, the sixty-pfennig sheet ripped into the Zola mystique of art as a bit of nature to proclaim the sensuous immediacy of art, its utter independence from nature, and its essential quality as form and color to be seen and felt, not "understood." "There is no greater error than the belief that the painstaking imitation of nature is art," he proclaimed.[6]

Although Endell's criticism was aimed at the exhibitions of the Secession and the Glaspalast, he was in fact spokesman for that other movement, namely, the arts and crafts movement, at that moment little known by the public at large. He had shrewdly chosen the established artistic scene as a vehicle by which to reach a wider audience. When he called for a new education, an education to the enjoyment of art, for an awakening of the capacity to see and enjoy form and color, he was in effect calling for a total environmental change, a secession from old ways of thinking

and living. He was giving expression to ideas introduced by William Morris and transmitted by the arts and crafts movement in England, carried to the continent by the Belgian Van de Velde, and already spreading rapidly across Europe.[7] The new art, *l'art nouveau,* had already come to Munich with Endell's colleague and teacher, Hermann Obrist, who was in fact already a prime mover amongst a growing phalanx of young artists planning an organized assault on the fortress of tradition.

In the spring of 1896, Obrist had focused international attention on the renaissance of arts and crafts in Munich with an exhibition devoted entirely to his embroideries at one of the city's most prestigious salons. Embroidery had scarcely been considered a "fine art" before, yet now an artist appeared who did not hesitate to exhibit his creations in this genre as fine art. Obrist had settled in Munich little more than a year and a half previously and had soon been "discovered" by the young writer Georg Fuchs.[8] Enchanted with what he had seen at Obrist's studio, Fuchs wrote an ecstatic essay for the new elitist art periodical *Pan,* which appeared in the winter of 1895-96.[9] In April of 1896, Littauer's Salon on the Odeonsplatz in central Munich exhibited some thirty-five embroideries designed by Obrist and carried out by his devoted assistant, Berthe Ruchet.[10]

The embroideries caused a sensation. Newspapers announced the "hour of birth of a new applied art."[11] Periodicals carried the news far and wide. Even the English periodical *Studio* reported on the exhibition in its May issue, and by November carried a major article on Obrist. That autumn Obrist gave a public lecture in which he sketched for the layman the idea of a self-determined aesthetic environment, and suggested an arts and crafts society or union that would act as liaison between the public and the artist-craftsman.[12]

During the same spring of 1896, the Munich Secession was exhibiting a special retrospective collection of the work of the great English craftsman and apostle of William Morris, Walter Crane. Although *Kunst für Alle* ignored the Obrist exhibit, it published a major article on Crane by Hans Eduard von Berlepsch, who was soon to join forces with Endell and Obrist and to become the organizing energy which drew together the elements of the new movement. The article was accompanied by illustrations of Crane works including one of St. George slaying a dragon, the protector of an industrial city, with its smokestacks billowing away in the background (Fig. 153).[13]

The June issue of *Kunst für Alle* carried a review of the German translation of Crane's book, *The Claims of Decorative Art.*[14] It had been recommended by von Berlepsch in his Crane article.

In his review of the spring exhibition of the Secession,[15] von Berlepsch reported as well on a group of French graphic artists included in the show: Toulouse-Lautrec, Beardsley, Steinlen, Gandara, Grasset and others. He commented particularly that the work of many Munich artists who illustrated for *Jugend* and *Simplicissimus* compared favorably to these, and suggested they be shown together.[16] He also pointed out that Stuck's poster for the Secession would stand up to any such comparison (Fig. 44).[17]

Thus, even as Kandinsky arrived in Munich and began to look around, a revolution of unsuspected force was in preparation and was already clearing the underbrush for his pathfinding mission. Within months the revolutionaries had organized for action. The Jan-

uary 1897 issue of *Kunst für Alle* announced that the next international art exhibition at the Glaspalast (with cooperation of the Secession), would include the arts and crafts (*Kunstgewerbe*). The reason given for this unusual innovation (since craft work had never before been considered a category of the fine, or higher, arts) was that the central committee "*recognizes the fact that a part of the arts and crafts movement has begun to pioneer new paths,*" to reveal new tasks and new forms.[18] Among the committee members appointed to make the arrangements were von Berlepsch and Obrist. Others soon to become involved included August Endell, Richard Riemerschmid, Bernhard Pankok, Bruno Paul, the young Peter Behrens, and Otto Eckmann, who had already given up his career as a painter to devote himself to *Kunstgewerbe*. Behrens, of course, was to play an enormous role in the innovative developments of twentieth-century architecture leading ultimately to the creation of the Bauhaus.[19]

By the time the international exhibition opened early that summer of 1897, these vigorous proponents of the new movement were ready to move into the two small rooms opened to them by the Secession (at the furthest corner of the immense Glaspalast) with a startling but certainly tradition-smashing collection ranging from Tiffany glass to rugs, from delicately embroidered wall hangings to furniture, from a ceramic tile oven to a display of designs for book bindings.

Small as it was, the exhibition demonstrated that the arts and crafts movement had become the champion of the avant-garde in Munich. The cultural barrier between the "higher" and "lower" arts had been broken.[20] A precedent of incalculable significance had been set: the full arsenal of artistic media was open to the artist for the first time. "*In these two rooms,*" wrote Schultze-Naumburg, "*lie the seeds of the future.*"[21]

Among the Munich exhibitors, Obrist showed seven embroideries which were praised for the "musical language" communicated by their "pure, delicate curves" and their "moody harmony" (*Stimmungsvoller Einklang*),[22] and a small wooden trunk decorated with strange seaweedlike metal ornaments. Perhaps his most startling embroidery was a wool rug with a motif that had been described by Fuchs as a "whirling, flaming track of circling spirals (Fig. 8)."[23] Unlike most of Obrist's work at that time, it had no immediately recognizable organic or naturalistic motif.

Otto Eckmann showed his woven wall hangings with their typical Art Nouveau motifs: swans gliding along a winding brook, gulls wing-spread over stylized waves, a wood pond reflecting bending grasses, stars, and the moon. These were startling in their own way, adapting as they did naturalistic motifs to the flat woven surface, abstracted however from illusionistic modes of representation and thus often as enigmatic as the paintings of Toorop or Khnopff.

Carl Ule of Munich displayed several stained glass windows with modern motifs (lawn tennis, for example) designed by Riemerschmid and Erler, some exploiting the new opalescent glass recently introduced from America.[24] Endell showed three wall-hangings (Fig. 9); Behrens, color woodcuts; and Bernhard Pankok, furniture. Carl Strathmann showed a decorative painting in which frame and picture were woven into one complex motif (Fig. 10).

Included in this exhibition were some twenty-nine works of Emile Gallé, twenty-five from the Tiffany Glass and Decorating Co., N.Y., three rugs by the Bel-

gian Georges Lemmen, as well as work by other German artists such as Karl Köpping and Walter Leistikow.[25]

It is perhaps interesting also to note that the Secession exhibition that year included (under another category) three designs for stained glass windows by Walter Crane, as well as five of his drawings for Spenser's *Faerie Queene*. There was also a section devoted to architecture which included designs by Voysey, Ashbee, and Walton.

If the "seeds of the future" were sown in pastures opened to them by a Secession already on the wane, so too were they to be nourished by the establishment in a way that met with perhaps unforeseen success. In September 1897, Schultze-Naumburg reported in the columns of *Kunst für Alle* the imminent birth of a new periodical, to be published by the same firm (Bruckmann), and to be called *Dekorative Kunst*. Its purpose would be to give general expression to those reform ideas represented by the recent arts and crafts exhibition. Anyone can see, he wrote, that "all the fresh energies, all the positive men of action . . . are storming with a real hunger toward the new tasks as toward a redemption . . . [and demonstrating] that our total artistic production stands before a powerful, incisive crisis."[26]

In fact, *Dekorative Kunst* did become the spokesman for the avant-garde in Munich, reflecting in its pages all the nuances of aesthetic change that were to usher in the increasingly abstract art of the twentieth century. The lead article of the first issue (October 1897) was by Samuel Bing, the enterprising founder of the Art Nouveau shop in Paris, and long a pioneer in the cause of avant-garde art. "Wohin Treiben Wir?" was its title—where are we going? And he began with the proclamation that "A new wind is blowing . . . we must learn to see anew."[27]

PREMONITIONS OF ABSTRACTION

Thus, even as the arts and crafts movement gained in strength and numbers (within months a centralized workshop and business office had been formed: the Vereinigten Werkstätten für Kunst im Handwerk), the ideas engendered by the movement and through it were as rapidly being brought to public attention. A fresh wind was blowing indeed, and with it the first murmurs of an art abstracted not only from nature but from the mind, the psyche, whispers even of an art without object—before the turn of the century.

Fullest expression was given these "whispers" within six months of the magazine's inception by the young architect and Secession critic, August Endell. This prophetic statement appeared on the last page of the March 1898 issue, under the rubric "Thoughts":

Formkunst: There is an art that no one seems to know about: Formart, which bubbles up out of the human soul only through forms, which are like nothing known, that represent nothing and symbolize nothing, that work through freely found forms, as music does through free tones. But men as yet want to know nothing about it, they can't enjoy what their understanding doesn't take in, and so they invented program music, that means something, and program decoration, that reminds them of something, in order to prove their justification for existence. And the time comes, nevertheless, when in parks and on public places monuments will be raised that represent neither men nor animals, fantasy forms, which will carry the human heart away to intoxicating enthusiasm and unimaginable delight.[28]

Already in the November 1897 issue of the periodical, Endell had begun a major article on the beauty of forms and decorative art by suggesting that every aware person is conscious not only of standing at the beginning of a new style period, but at the same time "at the beginning of a totally new art, an art with forms, that mean nothing and represent nothing and remind one of nothing, yet that will be able to move our souls so deeply, so strongly, as before only music has been able to do with tones."[29]

Endell was not the only correspondent to suggest the winds of change. There was talk of "abstract works of art" for example, in a report from Paris on some wood reliefs by Georges Lacombe which, by the way, reminded the reviewer of Van Gogh and Gauguin.[30] The psychology of line received the attention of a reporter reviewing Otto Eckmann's book, *Neue Formen*, the same year: "To borrow from the angry swan the rhythmic line and not the swan—that is the problem in ornamental usage."[31] And it was noted that these new forms are so removed from nature, that one "forgets" the original botanical or biological image (Fig. 11).[32]

In May 1898, a special article on Peter Behrens had high praise for his technical ability to exploit the linear effects "for which the woodcut is born." In discussing his series of five large woodcuts, which had already been shown in Berlin as well as in Munich, the reviewer stated that though they all have some "subject," "this subject" (*dieses Sachliche*) entirely loses its representational meaning in Behrens' designs. For example, in *Triumph* (Fig. 12), the striding male figure is "not motivated by logic but by purely linear considerations. The eye seeks here the striding lines. The triumphant power lies not in the psychic expression of the man, but rather in the power of the linear composition; it would be just as strong, just as beautiful, *even if instead of the man, a purely ornamental figure were there to bring the same linear power to expression*—yes, this might even be more powerful yet, because it would appear stripped of any confusing side effect."[33]

In the practical sphere, the strength of the movement was shown in its increasing significance in exhibitions. From two small rooms in 1897, applied arts expanded the next year into eight rooms at the Glaspalast. And in 1899, both the Secession in its own building on Königsplatz and the Glaspalast held extensive exhibitions of arts and crafts. Munich craftsmen were participating in similar exhibitions in other cities, and even being called away from Munich altogether to begin arts and crafts schools in other places or to teach in already established institutions.[34]

Despite the fact that there were continuing complaints that the applied arts were not receiving enough state support in Munich, that the craft exhibitions lacked organization, and so on, still, the Secession catalog of 1899 documents a collection of international scope that must have been a veritable feast for any artist's eye. And in the catalog, the craft section is now called *Kunst im Handwerk* instead of the more condescending term *Kleinkunst*, of 1897. For the first time Henry Van de Velde exhibited in Munich and with no less than sixty items.[35] But there were also works by Lalique, Majorelle, Fabergé, Charles Mackintosh, and Margaret and Frances Macdonald of Glasgow. There were glasses and vases by Tiffany (twenty-one items in the catalog),[36] and fans by Aubert. The type of items shown ranged from electric, gas and petroleum lamps to lace, from iridescent glass and

jewelry to furniture of all types. Among the Munich artists represented were Endell, Obrist, Bruno Paul, Fritz Erler, Bernhard Pankok (some twenty-four items in a room designed or arranged by him), and Riemerschmid.[37]

An allegorical painting by the anglicized German artist George Sauter, in the fine arts section of the same exhibition, proclaimed a theme that was indeed to have significant repercussions in twentieth-century art; it was called *Inspiration (Kunsthandwerk)*.[38] The implications of the new movement were not lost on Kandinsky, who was soon to become actively involved in it himself. In fact, he was already a student of Franz Stuck, who had proven himself as both painter and craftsman. Soon Kandinsky was to design craftwork himself, to become active in a Munich applied arts society, and to exhibit Jugendstil applied art at his Phalanx society. As will be seen, the decorative movement and problems of ornament were to exert a very crucial influence on Kandinsky's development toward abstraction. In the meantime, he was in a position to absorb the work and teachings of three great Jugendstil artists at first hand: Hermann Obrist, August Endell, and Adolf Hölzel—three Munich prophets of abstraction.

CHAPTER

·IV·

Prophets of Abstraction

HERMANN OBRIST

OF all the artists involved in the arts and crafts movement in Munich, the most admired, appreciated, and respected yet the least credited, and today perhaps the least known, was Hermann Obrist. Yet Obrist was for many years at the very heart of the movement and was its most vigorous spokesman. The direct line of development out of the craft movement of certain elements of modern abstraction can be clearly glimpsed in the ideas and work of this man. Indeed, it was he who wrote in 1901:

> If only the citizens of Munich would come to the realization of what is actually going on here: that here the first act in the drama of the art of the future is being played out—of that art which will lead from applied arts to architecture and from there to sculpture and then to monumental painting . . . it is on this art that the future of Munich as an art city depends.[1]

This remarkable prediction was characteristic of him, and it is little wonder then that he soon counted Kandinsky among his intimate friends.[2] He exercised a decisive influence on August Endell and Peter Behrens,[3] as well as on the many students who flocked to the school he opened together with Wilhelm von Debschitz in 1901. Among those students were Hans Schmithals, one of the first artists to attempt paintings without "objects," and Ernst Ludwig Kirchner who was later to become the leader of the Dresden group of expressionists known as "Die Brücke."[4] His ideas were certainly known by most of Munich's artists and may well have influenced Anton Ažbè and Franz Stuck, as well as Adolf Hölzel, whose writings on art are in many instances prophetic of Kandinsky's later writings.[5]

From the time his embroideries enchanted all Europe in 1896, Obrist had been a fount of inspiration for a whole generation of artists. Yet, though he lectured and taught widely, he seldom found commissions for his own work, which seemed always to strive beyond the possibilities of public taste. He founded a school on principles prophetic of the Bauhaus, which drew hundreds and hundreds of students. Yet he remained obscure as far as the general public was concerned. In 1910, Karl Scheffler, then editor of *Kunst und Künstler*, published an article on Obrist in an effort to rekindle public enthusiasm for the artist he described as a German Van de Velde, a "prophet unsung in his own land."[6] In this article, some idea of Obrist's significance for the development in Munich of abstract painting can be glimpsed, though it can scarcely be inferred that Scheffler himself fully realized the implications at the time.

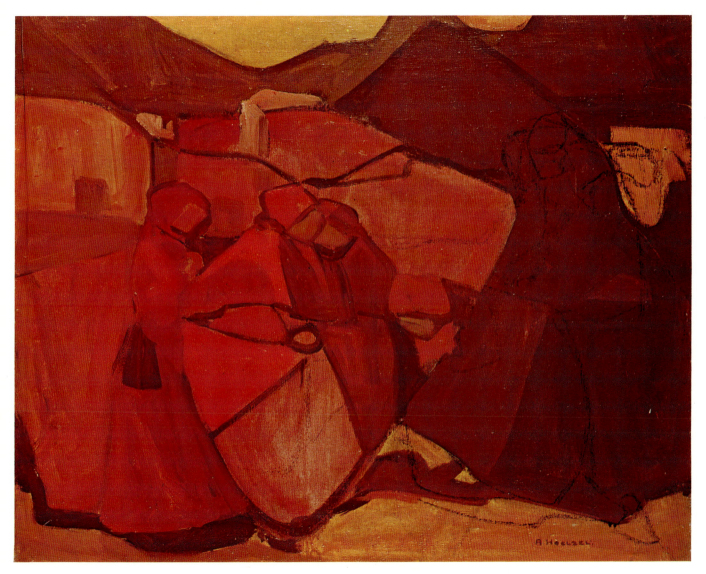

IV. Adolf Hölzel. *Komposition in Rot I (Composition in Red I)*, 1905.

What is unique about Obrist, Scheffler wrote, is his "original, free feeling for form." This "form-instinct" appears "abstract [*Abstrakt*], although it is full of natural sensuousness." Scheffler called Obrist an "ecstatic of form." "His abstractions are filled to bursting with sensuousness; [yet] in the chaos of his form, there is in embryonic state a higher architectural order."[7] Scheffler reported further:

> One hears that [Obrist] is at the point of drawing the last consequences of this tendency. In his atelier there is supposed to be a gigantic Something, that has neither purpose nor aim, and that has in it neither anything naturalistic nor figurative . . . probably such works will be problematic yet, strange as it may sound, in just such problematic does Obrist's special genius express itself most purely.[8]

The monument to which Scheffler referred was the *Arch Pillar* (Fig. 13), that surprising, stark pillar which, in the time of Rodin and von Hildebrand, could scarcely have drawn a comprehending response. Scheffler's vain attempt to make Obrist understandable by emphasizing his "architectural" genius fell wide of the mark. However, in 1915, when plans for what was to become the Bauhaus were underway, Van de Velde proposed Obrist, along with August Endell and Walter Gropius, as a possible director.[9] Of course, it was Gropius who was ultimately selected, not Obrist.

In actual fact, Obrist's genius lay in his attitudes and visions rather than in the architectonics of his oddly dated symbolist gravestones, funerary urns, and fountains, "abstract" as these were in their day. It was when he proclaimed that art must be an "intensification of life," or that what is needed is not "rash impression" but "deepened expression"; it was then that

he struck a responsive chord in such admirers as Kandinsky, who, however, was to realize his vision not in architectural form but in painting.

A *Jugendstil* "Renaissance Man"

After a precocious childhood, Obrist began formal studies at the university in Heidelberg in medicine and the natural sciences, in the spring of 1885.[10] Restlessly moving on the following year to study in Berlin, he then traveled to Scotland and England in 1887. There he must have been deeply impressed by the burgeoning arts and crafts movement, for on his return, he decided to devote himself to the study of applied arts and, accordingly, entered the school of applied arts at Karlsruhe in the fall of that year. But, desperately disappointed by a curriculum that demanded rote copying of historical models, he soon departed in order to apprentice himself to a potter out in the country. Within a year, he was producing pottery and successfully marketing it. Although this brought him into a clash with his socially minded mother, he persevered and in 1889 his pottery and furniture won a gold medal in Paris.[11]

He then moved to Paris, where he worked at the Académie Julian and studied sculpture. In 1892, with money earned from the sale of his first fountain, he transferred his activities to Florence, where he set up a studio to make embroideries. His assistant in this venture was a family friend, Berthe Ruchet, who devoted her energies to carrying out his intricate designs. At the same time, he was still experimenting in marble sculpture, but decided that, since he could say nothing more with the human figure, it would be necessary to invent a new "canon of form."[12]

With the inheritance from his mother, who died that year, Obrist was able to move to Munich in 1894. There, he built a large house with studios for an embroidery workshop and for sculpture.[13] Soon he came to public attention with his exhibition of thirty-five embroideries at Littauer's and the double article on him in the prestigious *Pan* magazine.[14]

Almost immediately, Obrist began to give public lectures on the urgency of reform in the arts and crafts, on the drastic changes he foresaw in art and in art education, introducing revolutionary ideas and at the same time urging a rapprochement between art and the public.[15] As has been indicated, he was instrumental in organizing the various crafts-oriented artists in Munich into a cohesive movement and in founding the United Workshops in 1897.

His lecturing activity soon extended to cities throughout Germany (including Berlin, Dresden, and Hamburg), sponsored by various arts and crafts societies.[16] Indeed he was already an international figure, his embroideries having been described with great enthusiasm and illustrated in the widely read English journal *Studio*, in the November 1896 issue.[17]

It is difficult to characterize briefly the work and ideas of this remarkable man. Though many were touched by his ideas, few gave him credit. Though he fairly erupted continuously with ideas and models for fantastic projects, few were ever realized. And though he touched fire, one might say, with two of the major creators of twentieth-century art—Behrens and Kandinsky—his significance has been little recognized. Yet as a man, he seems to have inspired affection and enthusiasm universally in those he met, and the originality of his work was spontaneously acclaimed by colleagues and critics alike. Perhaps his lack of recog-

nition is due to the fact that he had an inspired gift for teaching, and, like many born teachers, the full power of his genius became apparent only much later in the work of his students or even farther afield.

As early as July 1898, his gifts as a teacher received recognition in an article on him in *Dekorative Kunst*.[18] He was characterized not merely as a teacher, but as an educator, which is "infinitely more than to teach. . . . He seeks to encourage and develop talent," not merely to judge. And at the same time he seeks to "awaken a seriousness" and the "energy to persevere." It was suggested that this gift of his was due to a rare combination of "character and talent, of artist and man."[19]

In a revealing memoir, the art critic and editor Karl Scheffler described Obrist's gift to express himself in a "romantic speech rich in imagery . . . everything he said was educational in a fantastic way."[20] At the turn of the century, Scheffler later recalled: ". . . in Munich, he was the agitator of the movement, enthusiastic and engendering enthusiasm, a stimulator, a workshop founder, teacher, writer, artist and craftsman, a man excited by great possibilities, an almost fanatic believer, uncompromising, interested in everything and aristocratically educated."[21]

In fact, Obrist's ideas on education and educational methods prefigure ideas that are found later strikingly expressed in Kandinsky's *Blaue Reiter* exhibitions, and still later and most completely in the program of the Bauhaus. As early as 1899, he had developed a program of art education by means of seminars illustrated by *projected slides* with which comparisons could be made between works of different historical periods, different genres, and of varying aesthetic significance.

These ideas were fully described in his article

"Wozu über Kunst schreiben?" which was published in the February 1900 issue of *Dekorative Kunst*. In this typically intelligent, witty, ironical essay, Obrist ranged from the aesthetic education of craftsmen to the artistic education of the general public.[22] He advanced the concept that value in aesthetic matters knows no historical boundaries, a concept that was within a few years to become a central concern of both Wilhelm Worringer and Kandinsky. A true artist, he wrote, can recognize the strength of a genuine work of art whether it represents "Plein-air or symbolism, or impressionism or Empire style . . . whether it be from the Stone Age or from the 1860's. . . ." How does he develop this ability? There is only one "artistically-psychologically right way—and that is by means of comparative looking."[23]

For an understanding of aesthetic quality, it is necessary to engage the senses, he suggested. But it was not until a decade later that his program for stylistic and historical comparison as an educational device was tranferred into an actual demonstration: at the exhibition of the editorial board of the *Blaue Reiter*. And, of course, years elapsed before the use of projected slides became a common educational device.[24]

An Artist of Intensified Life

In extraordinary measure, Obrist was able to "see anew," by creating images of "intensified life."[25] Revolutionary as were his ideas on art education, his art itself was far more so. In fact, it scarcely touched the consciousness of his era. Even his most earnest supporters admitted that his work had a certain "exclusivity" and was rather for the few than for the many.[26] It is revealing that of his immense productivity, only his designs for tombs and funeral urns ever achieved

much "popularity." The very abstractness of death itself apparently made his "abstract" monuments to the dead seem appropriate and therefore "functional" (*zweckmässig*). Several were commissioned, while his other work was largely overlooked (Fig. 14).[27]

Yet it was in his designs for monuments and fountains that Obrist achieved the greatest degree of originality and abstraction.[28] He himself suggested that his capacity to "see anew" stemmed from the fact that he had come from outside the "official" tradition of arts and crafts training.[29] Unfortunately his work has survived only fragmentarily in a few plaster and plasticine models, and in sketches among his manuscripts. Yet these reveal a unique image-making capacity and a truly remarkable fantasy.

A comparison of his fountains with those of even the best of his contemporaries gives some indication of the genius of his invention. Fountains designed for public plazas in his day were tired recastings of Renaissance designs. For all his theorizing, even the great Adolf von Hildebrand had failed to create new forms, least of all in his famous Wittelsbach fountain in Munich (Fig. 15). In comparison, Obrist's fountains appear to be of another world.

For Obrist, water and stone together created the image "fountain" and that was all that he needed. He had a mind that could address itself directly, and unhindered by preconceived notions, to the material and task at hand. It was not necessary for him to begin with a thematic idea or some ready-made form. First came the material and its use; with these elements he fantasized. Infinite combinations of water and rock and space were available to such a mind: water spurting, running, dripping, splashing, gurgling onto round rocks, flat rocks, jagged rocks, convex and concave

surfaces. As the abstract painter was able only much later to manipulate the basic elements of paint, color, line, plane on canvas without reference to some observed object or to a preconceived thematic device, so Obrist worked with the elements of fountain design.

In an effort to explain Obrist's fountains to the public, the critic Bredt suggested that his capacity to create "new sculptural and tectonic form values" was based on his observations of, and sensitivity to, the essential nature of stone and water, as well as to his creative fantasy. "The power, the strength, the rigidity of the rock, the washing, eroding, polishing effect of the water, that is what this sculptor makes visible to us. . . ."[30] There is an "ancient music" in these works, wrote Bredt, but it is only heard by those to whom the "rushing of water" in a mountain stream is a "melody of the soul."[31]

In fact, the *Model for a fountain with wide, flat water basin* (Fig. 16) is so constructed that the water spraying out from the center is intended to flow over a variety of convex and concave surfaces before it splashes into the wide flat bowl below, in order that different tonal variations will be audible.[32] Another fountain was compared by the artist himself to Beethoven sonatas, or a symphony that is "lucid only in optical space."[33]

The startlingly simple and "modern" *Model for a fountain with three egg-shaped bowls* is a delightful combination of geometric (or stereometric) and free forms (Fig. 17).[34] The sprays of water were to be adjusted to splash against one another—to "hide playing children."[35] The various levels of the foundation formation were obviously conceived also with the needs of children in mind.

Today, a plain spray of water splashing into a pool fulfills the concept "fountain" in the public mind. So commonplace has this "form language" become that it may even be difficult for us to see the novelty in Obrist's creations. It is necessary to recall the gigantic composites of seahorses, bulls, sea gods, and water nymphs surrounding perhaps a realistic likeness of Bismarck or the Kaiser that passed for "fountain" in late nineteenth-century Germany; water was the least consideration in such monstrosities. Obrist's fountains were genuine innovations.

But Obrist did not necessarily limit himself by disregarding completely images provided by nature. On the contrary, he reveled in a vast "arsenal" of images from every conceivable corner of human experience. Indeed, he actively objected to strict schematizations, such as the "Belgian abstract linear ornament," as too logical, too strictly rational.[36] He constantly urged a combination of fantasy and function, of uninhibited joy in free forms and solid construction. In his "arsenal" (a word borrowed here from Kandinsky),[37] he kept clippings of such things as microscope photographs of a drop of milk splashing, photographs of a cresting wave or a bird in flight.[38] He hoarded shells and stones and pods, bits and pieces of the world to stoke his imagination.[39] But always his imagination catapulted him beyond the limits of traditional or contemporary conceptions of art (Fig. 18). As Bredt wrote in 1902, Obrist "embodies a great dynamic rule (or presence), even in small things—and *without the figurative as no one else.*"[40]

Two other examples may be cited of works in which Obrist expressed his ideal combination of fantasy and construction. The first is a very early fountain which consisted only of a smooth, round bowl nestled into a rocklike formation. The contrast between the rough-

hewn rock and the smooth side of the bowl, between the "free" form and the geometric form, provides a theme in itself, as natural as a bowl held under a waterfall (Fig. 19).

The other is far more startling. It is the so-called *Gewölbepfeiler* (*Arch Pillar*).[41] It is a perfectly smooth cylindrical column with a remarkable cluster of rectangular stereometric forms at the top. It seems to push up like a piston out of a rough-hewn rock formation. The image was utterly new. It combined a constructivist delight in pure geometric forms with a romantic nostalgia for nature, an image of intellect arising out of mother earth (Fig. 13).[42]

Even his earliest embroideries had demonstrated both fantasy based in nature and a remarkable ability to exploit the constructive elements of the artistic media. Georg Fuchs (in the *Pan* essay as early as 1895) had recognized the significance of this transforming genius and described the process as an "aesthetic transubstantiation."[43] These works have, wrote Fuchs, "fulfilled our yearning for a more spiritual, purer, more creative art."[44] His embroideries are not simple imitations of motifs in nature, but have been "transliterated into an expressive, free ornament-motif."[45]

"These embroideries," wrote Fuchs, "do not intend to 'mean' anything, to say anything. . . ." They are "companions." They involve themselves in our feelings. In describing a wall hanging called *Cyclamen* (*Alpenveilchen*), Fuchs bestowed a new name upon it which became famous: "This racing movement seems to us like the abrupt, powerful convolution of the lash at the crack of a whip. Now it appears like the image of sudden, powerful elements: a lightning bolt, and then again like the defiant signature of a great man, a conqueror, an intellect who commands

new laws through new instruments."[46] Thereafter, the work was known everywhere as the *Whiplash* (Fig. 21). Today it is justly considered a paradigm of Jugendstil art. The floral motif convoluted into a powerful image of lashing energy was no longer a "bit of nature," but a subjective expression, an abstract representation of feeling. Kandinsky, was to write, "The true work of art . . . is a *Being*."[47] He might have been describing Obrist's *Whiplash*.[48]

At another place Fuchs exclaimed, "O this teller of fairy tales—what all are we not expected to believe of him?"[49] Indeed, in his time Obrist was a teller of fairy tales, but there were some who believed. August Endell was among the first; Wassily Kandinsky was another.

By 1904, Kandinsky had become a close friend of Obrist who, he told Münter, understood him and appreciated his ideas about art.[50] Obrist's confidence in him seems to have strengthened Kandinsky's confidence in himself. The influence Obrist exerted on Kandinsky was, moreover, that of an inspirational teacher rather than that of a model. That they were often together is confirmed not only by Münter's memoir of their frequent meetings,[51] but in the letters Kandinsky wrote to Münter. Apparently their friendship lasted from the days of the Phalanx exhibitions in the early 1900's throughout Kandinsky's Munich experience.[52]

In one of his "Letters from Munich" in the Russian journal *Apollon* in 1910, Kandinsky spoke of an acquaintance "not a native but [one who] had lived here many years, a known sculptor and a very 'restless' person." This sculptor had commented to Kandinsky, in regard to the mixed public reception of the first exhibition of the Neue Künstlervereinigung: "Just look! So many outsiders have become residents—the entire

face of the city is changing, even though slowly. And all of a sudden, one day, Munich will have awakened!"[53] One certainly suspects the voice of Hermann Obrist, for it was typical of his optimism and faith in a future that always eluded him. Though his vision soared beyond temporal bounds, his initial fame as a Jugendstil decorative artist par excellence had trapped him into obsolescence. At his death in 1927, few recognized the significance of his contribution to twentieth-century art.[54] Yet he was one of the pioneers whose genius had prepared in Munich a fertile ground for the development of abstraction.

AUGUST ENDELL

Obrist's closest associate in those years was August Endell, the prophet of an art "with forms that signify nothing, represent nothing and recall nothing, but that will be able to excite our souls as deeply as only music has been able to do with tones."[55] Endell is as important as Obrist in an understanding of Kandinsky's early development, not only because everything he wrote and did was sensational and cannot have escaped the attention of the young Russian, nor just because he seems to have pointed the way to Kandinsky's ultimate abstraction, but because his earliest writings express a great many ideas we find later clearly reflected in Kandinsky's own writings.

Endell, who was nearly a decade younger than Obrist, had come from Berlin to study philosophy in Munich.[56] As the son of an architect, it was perhaps only natural that he was drawn to the arts. It was undoubtedly under the influence of the lectures of Theodor Lipps at the University of Munich, during the nineties, that he first became enthusiastic about ap-

plying the then unexplored possibilities of the psychology of perception to the aesthetic experience in practical terms.[57] At any rate, it was Endell's clarion call to the senses in the pamphlet *Um die Schönheit* that first brought him to public attention, and from that moment on he became Munich's most vociferous and ubiquitous herald of the twentieth century.[58]

For even as he exhorted the public to stop thinking and start feeling, Endell was preparing a feast for the senses that was to demonstrate not only that new forms were possible, but that they could both engage and enrage those senses. This was what has since become his most famous creation, the so-called Hofatelier Elvira, or Elvira Studio. Endell undertook this commission, which actually involved the renovation of an existing building, between 1896 and 1897, during Kandinsky's first months in Munich. Since the house was to be used as a photography studio, which would be located in the front of the upper story, a major problem was presented by a large expanse of windowless facade. The idea of false windows being contrary to his principles,[59] Endell let fancy reign in best Obristian fashion, and invented a gigantic "free form" in plaster to fill the void.

Swirling across the upper story like some bizarre abstract rococo Venus on a Japanese wave, in grating tones of turquoise and crimson, Endell's stucco relief caused a sensation that detracted considerably from his genuine architectural accomplishments (Fig. 23). In an article published later in *Dekorative Kunst*, Endell sought to vindicate himself.[60] Staunchly defending his facade ornament, he stated that its original effect had been spoiled by the introduction of a window over the doorway and changes in his designs for the stucco ornament in that area, as well as by a one

meter change in the height of the facade itself.[61] The facade had, he felt, become "senseless, disharmonious, agonizing" and he also disclaimed responsibility for its harsh color.[62]

However, Endell pointed with justifiable pride to a number of strikingly successful aspects of the building. He was particularly proud of the fantastic wrought iron gate, the interior doorways with their variety of unusual and finely wrought forms in hardware, and the windows on the garden side, which had been designed to pivot on a horizontal axis to permit better air flow. He felt that the stair railing was too weak, though in fact it is today considered a prime example of Art Nouveau design, and as fine as any by Horta or Guimard (Fig. 24).

Indeed the importance of the building lay in the total freedom with which the young architect had handled his materials. The wrought iron gate at the entrance vibrated with nervous excitement (Fig. 25). Inside, the light fixtures appeared to grow on wrought-iron stems out of free plaster wall ornaments that were vaguely reminiscent of some exotic seaweed (Fig. 26). The carved doors seemed invitations to important places. The metal hardware of the doors seemed to have been splashed in a molten state onto the polished wood rather than nailed there (Fig. 27). The stair railing swirled upward in sinuous undulations illuminated by the tendrils of a light-bulb-spouting sea anemone (Fig. 24).

The best the critics could do was to call it "rococo," or "oriental." Karl Scheffler, who was one of the first to appreciate Endell, made a comparison between the new style and an amalgam of rococo and late Gothic, or "rococo-flamboyant." He suggested that only this might explain "for example, the remarkable works of

August Endell, the artistic value of which one may decide for oneself, but whose symptomatic significance for the spirit of the new ornament-art is above question."[63] In his memoirs, Scheffler recalled Endell's forms as having also something "Moorish, East Asiatic, and hieroglyphic" about them.

Endell himself insisted on the independent nature of his *Formkunst*: "No ornament was created on the basis of nature studies, although of course some resonance of natural images in the face of nature's sheer wealth may be unavoidable; but never was the imitation of nature a goal, rather [the goal was] a unique characteristic effect achieved by means of freely invented forms aimed specifically at that effect. . . .[64] The purpose is in fact not anecdote or some teaching about plants and animals, but aesthetic effect."[65]

Other critics took Endell as an extreme example of the "individualizing" tendencies of modern art. "He goes uniquely along his own special way," wrote one critic in *Dekorative Kunst*, ". . . always thinking and translating his thought into fine nuances of line; the analytic psychologist of this line-and-form-world creates in his own way."[66]

Though to the man in the street, Endell's Elvira facade may have seemed a ridiculous and extravagant joke or *Spielerei*, it was in fact a concomitant of serious perceptual psychological theories Endell had begun to publish in November of 1897.[67] The first part of his article on "The Beauty of Forms and Decorative Art," in which he predicted the coming not only of a new stylistic period but of a new art with forms that represent nothing, was devoted to convincing the reader of the sheer power forms can have, once perception is permitted to function fully. "We must discover our eyes," he urged.

The Power of Forms: Endell and Kandinsky

In explaining the nature of the power forms can exercise, Endell wrote that it was not the result of any sort of anthropomorphism. When we talk about a "weeping willow," we don't really mean to say that we believe the tree might have feelings of sadness, rather that it arouses a feeling of sadness in us. Nor is this immediate effect of forms related to memory or associations. Though a circle may recall a ring and thereby elicit an association with faithfulness and eternity, this has nothing to do with the immediate power of the form itself. Nor is the effectiveness of *Formkunst* the result of some subconscious or imagined notion about the being (or essence) of an object. "At most there is a certain parallelism between essence and appearance." But, it is the appearance of the thing that strikes us first. We then transfer (impute) the impression (feeling) we have to the inner being of the object, and because of that parallelism already mentioned, we are most often correct.[68]

Visual forms are as immediately effective as the forms of music. And just as one can enjoy the feelings aroused by certain musical chords and series of chords without understanding why they affect us so deeply, so it is possible to enjoy visual forms without knowing why. But, Endell suggested, there are psychological explanations for such phenomena.

Endell's promised explanation was not published, however, until some six months later, and then it was so novel and "abstract" that the editors felt compelled to print an editorial disclaimer at the end of the article.[69]

The second and third parts of the article were titled "The Straight Line" and "Straight-Line Images."

These titles alone suggest passages in Kandinsky's much later book *Punkt und Linie zu Fläche*, in which he attempted an analysis of the components of the artistic media in an effort to create the canon of form Endell aimed at. Chronologically closer to Endell, of course, was Kandinsky's chapter on the language of forms and colors in *Über das Geistige in der Kunst*.[70] There, he used a psychological approach to analyze color[71] similar to the method used by Endell in discussing line. What Kandinsky poetically called a "thorough bass" (*Generalbass*) for painting was in effect a further development of Endell's "aesthetic training" (*aesthetische Schulung*).[72]

Endell's thesis in this article was that straight lines of different types—thick, thin, long, short—always exercise certain kinds of effects on the observer. In perceiving a line successively, he suggested, the observer experiences a feeling similar to that experienced when the eye follows a moving object. Hence the use of the term "movement" in reference to lines or to forms in series.[73]

Length or shortness of a line are functions of time, while thickness or thinness are functions of tension in Endell's system. Thus lines or line complexes and, ultimately forms, which are only modifications of line complexes, can express all the nuances of feeling experienced in movement, which always exhibits both time, or "tempo," and tension. The feelings associated with such qualities as warmth or coldness, heaviness or lightness, the terrifying or the energetic, can then be expressed in terms of nuances of tempo and tension, and thus translated into lines and line complexes, just as in music such feelings are expressed in tonal complexes. Endell points out that it is not the quality itself that is represented by the line, but the *feeling* that ac-

companies it. Certainly, he says, mildness contains more "in human and actual terms" than a linear complex expressive "of slowness and light tension," but the latter does in effect express the feeling that *accompanies* "mildness."[74]

Almost thirty years later, in his Bauhaus publication *Punkt und Linie zu Fläche*, Kandinsky was to express strikingly similar ideas, in respect to both the quantitative and qualitative characteristics of lines and linear complexes. For Kandinsky, also, linear expansion was a durational concept. Endell had explained that the straight line appears both "faster" and "easier" than the crooked line.[75] Length combined with straightness and thinness gives the feeling of speed, since such a line provides the eye with an ever increasing quantity of known information. Width, on the other hand, exercises a retarding influence, since it takes more time to comprehend than a thin line. Kandinsky wrote:

> . . . length is a durational concept. On the other hand, the time required to follow a straight line is different from the time required to follow a curved line even if the lengths are the same, and the more animated the curved line is, the more it stretches itself out in time. In line therefore, the possibilities of using up time are very manifold. The use of time in the horizontal and in the vertical has also a different inner coloration in lines even of the same length. . . .[76]

In discussing the relative lightness or heaviness of vertical lines, Endell explained that the "falling" straight line has the character of something light and effortless, while the upward surging line has a feeling of heightened tension. Kandinsky, in his discussion of a similar problem (the upward-springing curved line),

demonstrated that such a line thicker at the bottom and diminishing toward the top achieves a "heightened tension of the upward movement."[77]

In the section of *Punkt und Linie* on linear complexes (*Linienkomplexe*), Kandinsky also discussed their effects from the quantitative and the qualitative point of view. Such complexes, he wrote, as soon as they involve something more than simple repetition, achieve a *qualitative* intensification.[78] Endell had concluded Part II of his article with an attempt at a "qualitative" demonstration by means of a table of "feeling nuances" purporting to indicate by approximation how degrees of feeling are related to time and tension, and hence to linear complexes.[79]

Endell concluded his article[80] with a series of his own architectural drawings demonstrating that the manipulation of simple elements (horizontals and verticals within a rectangle) can produce certain effects (Fig. 28).[81] The tall thin house with the unevenly upward-surging narrow windows is "not sympathetic," as it is too "hard and busy." The low horizontal house with horizontally designed windows appears "almost too comfortable," while the facade with a balanced combination of forms has a "mild energy" and a "peaceful security" not without "liveliness."[82]

As an architect, Endell was suggesting, of course, that elementary forms in endless variety can be effective without the traditonal reliance on historical forms. The dignity of a bank can be expressed otherwise than by forcing it into some neoclassical or Renaissance form hitherto considered mandatory. He wanted to demonstrate that forms are effective independently of historical, biological, anecdotal, or other traditional associations.

However, Endell's revolutionary ideas were never

confined to the realm of architecture alone. His first publication had been a response to the painter's world. The revolution he called for was not to be confined to any particular art. He wanted a revolution in seeing and feeling. Already in *Um die Schönheit*, he had written:

> He who has once learned to give himself over completely to his visual impressions, without associations and without afterthoughts, who has once truly felt the effect of forms and colors, he will discover there a never failing source of extraordinary and unimagined pleasure. In fact, a new world reveals itself. And it should be the experience of a lifetime when for the first time an understanding for these things is awakened. It is like an intoxication, like a madness that comes over us. Joy threatens to destroy us, the flood of beauty to suffocate us. He who has not gone through such an experience will never understand art.
>
> He who has never been delighted by the exquisite bendings of the blade of grass, by the wonderful inexorability of the thistle, the austere youthfulness of the sprouting leaf buds—who has never been gripped by the powerful form of a tree root, the stolid power of the cracked bark . . . and stirred to the depths of his soul, he still knows nothing about the beauty of forms.[83]

In order to fully appreciate such an experience, to arrive at true art, Endell points out, it is necessary to realize that *"nature and art are two totally different things."*[84]

To demonstrate the depth of the impact this text must have exercised on Kandinsky, it is only necessary to compare a strikingly similar passage in his own memoir, "Rückblicke." He recalled that he had finally come to the realization that the *"goals (therefore also the means) of nature and art are essentially different. . . ."* This solution, he continued,

freed me and opened new worlds to me. Everything "dead" trembled. Not only the oft-sung stars, moon, woods, flowers, but also a cigarette butt lying in the ash tray, a patient white trouser button peeking up out of a puddle in the street, a docile bit of bark being pulled through the high grass in the strong jaws of an ant to uncertain and important purposes, a calendar page after it is torn from the warm society of its fellows on the block by the outstretched, conscious hand—everything showed me its face, its innermost being, its secret soul that more often keeps silence than speaks. Thus every resting point and every moving point ($=$ line) became just as alive and revealed to me its soul. That was enough for me, enough to understand with my whole being, with my total senses, the possibility and the existence [being] of art, which today in contrast to "objective"[85] is called "abstract."[86]

Kandinsky's poetic evocation of his personal revelation has just that "intoxication" that Endell described, and even some of the same imagery. New worlds have been opened. For Kandinsky it was the experience ("of a lifetime") by which he was able to comprehend art with his whole being and with all his senses. The imputing of feelings to objects is also comparable: the "patience" of the button, the "docile" bark, the "purposeful" ant, on the one hand, and Endell's "austere youthfulness" of leaf buds, and "stolid" bark, on the other.

In the article "Möglichkeit und Ziele einer neuen Architektur,"[87] Endell reiterated his basic ideas and enlarged upon them. Once again, he exhorted both layman and artist alike to "see with the whole power of your soul." "Form-feeling" is the basic prerequisite for both pleasure and creation. The artist's fantasy must be "so full of forms that these stream effortlessly from him for a specific purpose—and from these he makes formal images. For *formal images* are the goal

of all decorative art, not stylized plants and animals." This notion of a fantasy full of forms was later to be taken up by Kandinsky, who referred to it as the artist's *Vorratskammer*, his storage room or "arsenal."[88] For both Endell and Kandinsky, this arsenal of forms was a source of the artist's freedom.

Yet another striking prefiguration of *Punkt und Linie* is to be found in this article. Endell suggested that images may be formed from one point, or from a line, or from forms that arise out of several points, for example a door frame that rises out of two points and then melts into one.[89] In *Punkt und Linie*, Kandinsky used a similar image in discussing how a point may be the origin of surfaces, and ". . . in Gothic buildings the points are often especially emphasized by sharp archings and often sculpturally underlined. . . ."[90]

In this article, Endell also directly challenged Kandinsky and other artists of his generation: "We have now as yet very few works of pure form-art [*Formkunst*], i.e., formal images that are nothing and mean nothing, that affect us directly without the mediation of the intellect, like the tones of music."[91] This call for an art of formal images that would affect the viewer directly without the mediation of thought, as music moves the soul, was to recur like a refrain throughout the writings of Kandinsky.[92]

The role of the intellect, wrote Endell, is to aid the fantasy in developing freely, by recognizing and weeding out the dross imposed by traditional limitations. Then follows another striking prefiguration of Kandinsky:

All our striving is to this end: to give the fantasy free reign, to aim clearly at the goal and at the same time to set aside all dogmas—the goal is free forms, without any tradition, forms that rise up out of the soul of the individual and thus are his forms, his creatures.[93]

This article, too, was considered incendiary enough to necessitate an editorial comment. In this case, however, the editors, while admitting that the article might well cause controversy, containing as it did, both harsh judgments and contradictions, recommended it as useful in the fields of both architecture and the applied arts.[94]

Within a few years Endell had jolted the public again, this time with his "Buntes Theater" in Berlin. On that occasion once again, Endell was called upon to defend himself and did so with an essay in *Deutsche Kunst und Dekoration* called "Originalität und Tradition."[95] He called for the kind of courage that is required to carry out an idea to its logical extreme as he had done, and again sounded the call for freedom: "There is only one tradition for the artist and that is the tradition of artistic creativity."

He did not have to stand alone, however, as a companion article was published along with his by the same writer who had "discovered" Hermann Obrist. Georg Fuchs now leapt into the fray for Obrist's follower. The wild cacophony of scintillating visual motifs in this variety theater would be a challenge to any op-art enthusiast today (Fig. 29). Yet Fuchs bravely defended its "bizarre but spirited liveliness." He suggested that any truly sensitive observer would find an intense pleasure almost dramatic in itself in the "necessary affective unity" arising out of this apparent chaos of "unheard-of things, of colors never seen before, of lines never before so convoluted."[96]

Certainly in his years in Munich, August Endell was much in the public eye. He exhibited in the 1897 and 1899 arts and crafts shows already discussed, and already by 1898 another exhibitor was designated as an

"Endell student." He designed furniture, wall hangings, jewelry and carpets, and wrote poetry.[97] According to Karl Scheffler, Endell's personality was as difficult as his designs, but certainly his ideas had an immense impact on his young colleagues.[98]

When, in 1908, he wrote poetically about the *Schönheit der grossen Stadt*, his description of the insensitive observer who cannot understand something that does not reflect the material values of his life again prefigured Kandinsky: "The object as such has been eliminated. . . . Art comes forth for the first time absolute and unconditioned."[99] But the ordinary observer fails to appreciate it, missing *"das Geistige . . .* the spiritual, the ideal . . . and doesn't suspect that the visible as spiritual experience [*das Sichtbare als seelisches Erlebnis*] is just as spiritual [*geistig*], just as ideal, just as valuable as any other great stirring of the soul."[100]

Kandinsky was also concerned to reveal the *Geistige* in art. His way toward that goal was illuminated by the Jugendstil genius of Obrist and Endell, whose idea of *Formkunst* was prophetic of abstraction.

ADOLF HÖLZEL

There was yet another artist in the Munich area who, by the turn of the century, had already embarked upon a course that would lead him eventually to an art without objects. Still largely unknown, like Obrist and Endell, Adolf Hölzel (1853-1934) in fact made substantial contributions to the development of abstract painting in this century.[101] While his name has entered the history books as the teacher of such illustrious twentieth-century artists as Emil Nolde, Oskar Schlemmer, Johannes Itten, and Willi Baumeister, little attention has been directed to his own personal

achievements which, for a painter of his generation—and he was thirteen years older than Kandinsky—were indeed astonishing. Nor has the significance of his relationship to Kandinsky and the Munich art scene been fully explored.

Adolf Hölzel was already an established painter of some note by the time Kandinsky arrived in Munich. As a founding member of the Munich Secession, Hölzel was exhibiting regularly at the Secession, as well as in shows elsewhere in Germany and Austria.[102] By the mid-nineties, he was also running a very successful painting school at Dachau.[103] By 1891 he had already won a gold medal at Munich's Glaspalast, and by 1893 another painting of his, *Home Prayers* (Fig. 31), had been acquired by the Neue Pinakothek.[104] Yet even as his initial fame was made by these solidly naturalistic paintings, Hölzel had already begun to move in another direction and into the mainstream of Jugendstil art.

Trained in Vienna and Munich, Hölzel eventually achieved an expertise that led critics to compare his work to that of Munich's master naturalist Wilhelm Leibl.[105] Following an eye-opening trip to Paris in 1887,[106] Hölzel withdrew from Munich to the peaceful surroundings of Dachau in order to develop his skills independently. His work of that early period reveals the influence of the German naturalist Fritz von Uhde. But gradually he turned more and more to problems of form and color.

He was soon joined in Dachau by his close associates of those years, Ludwig Dill (1848-1940), then president of the Munich Secession, and Arthur Langhammer (1854-1901). Together they formed what became known as the "Neu-Dachau Group."[107] Hölzel now turned altogether away from impressionist tech-

nique and subject matter, devoting himself to landscape as a vehicle for the expression of problems of form. As a group, the work of the Neu-Dachau painters was characterized by an obsession with dark masses in deep greenish tones against a lighter ground, often bound by the sinuous Jugendstil curves of a river or path. The obsession with form in itself overcame any interest in the subject matter per se. Of his work at this time, Hölzel wrote that the essential aim was to achieve the "image as a harmonic whole. Large and simplified object-form. Color-harmonic view of nature, preference and exploitation of that bit of nature which contains these elements."[108]

Typical of his work at this period is the painting *Birches on the Moor* of 1900-02 (Fig. 30).[109] Representative of his work from about 1894,[110] it forms a startling contrast to the gold medal winner *The Carpenter's Wife* or the even earlier *Home Prayers* (Fig. 31). The impressionist attempt to recreate an illusion of naturalistic space and light has been abandoned, along with sentimental, anecdotal subject matter. Instead, the painting has become a densely organized construction of highly stylized elements. Tree foliage has been massed into monumental forms. The planar integrity of the canvas has been strongly confirmed by the clarity with which horizontal and vertical elements echo and support one another. The round "key hole" effect in the upper right area adds an almost surreal touch. The strict, flat horizontal line of the tree tops at the left nearly destroys the possibility of "reading" the content as "forest." Only the dark masses steeped in deep moss green and the birch bark verticals suggest nature as a source. It represents no specific place or time, but is instead a rather somber meditation on the theme of nature's eternal beauty and perfection.

The painting is more "abstract" than naturalistic, and typically Jugendstil in its ambiguity.

At about the same time, Hölzel had begun a systematic study of art history in an attempt to confirm his hypothesis that great art has always been more concerned wih the primary elements of painting than with mere subject matter. He had also begun work on a theory of color as a teaching device.[111] He had embarked on what was to become a life-long search for a set of theories in art that would be comparable to those theories of harmony on which music is based. Kandinsky was to set for himself a similar goal.[112]

Already by the turn of the century, Hölzel was lecturing[113] and publishing on the subject of the eternal inherent lawfulness (*Gesetzmässigkeit*) of art. A born teacher, he felt compelled to demonstrate that art is primarily the result of the artist's personal struggle with basic problems of construction (form, line, color, and contrasts of dark and light) rather than of a concern for subject matter.

A *Prefiguration of Kandinsky*

As early as 1901, Hölzel published an article concerned with the primacy of the artistic means in the influential Jugendstil periodical *Ver Sacrum*, the official journal of the Vienna Secession. It was called "On Forms and the Distribution of Masses in the Painting."[114] In typographical style as well as in content, the article offers a startling parallel to Kandinsky's much later and much more fully developed *Punkt und Linie zu Fläche*.[115]

The article began with a proclamation worthy of a manifesto: "In the struggle between nations as between masters, those win the battle who strive for and accomplish the highest and simplest exploitation of

the means available to them in order to bring their inspiration to expression."[116] Hölzel suggested that great art has always been based on practical experience with the artistic means which has in turn resulted in rational laws serving to "clarify the spiritual and manual part of our labor."[117] While these rules change and must be changed with the needs of different times, it is necessary to know them and to study the causes of certain effects in art and nature.

Hölzel then turned to the basic considerations of painterly construction with which the artist is faced; the plane or surface and the relationship to it of forms placed upon it: "It dawns on us at once that the essential thing is not the imitation or rendering of any particular bit of nature, but rather that the study of nature must first take fully into consideration the artistic means available. . . ."[118]

He demonstrated how the eye glides across an empty surface without resting, by providing an illustration of a plain empty rectangle next to the text. The following illustration introduced a single spot onto the plane to demonstrate how the eye is attracted in such a case. Another illustration added a second dot to show how then tension and movement might be introduced by such simple means in contrast. He then enunciated a few basic guidelines from these simple visual experiences. For example, that the more strongly a contrast is concentrated in one spot, the more the eye is drawn to it. Or otherwise expressed, that such a spot surrounded by a large contrasting area will draw attention to itself.[119] Again, that evenly distributed masses in a painting tend to set up irresolvable tensions and should be avoided. Or that many small dots will cause a feeling of uneasiness, whereas if these are drawn together into a mass, the result will be a feeling of rest.[120] Hence, he pointed out, a few forms influence all the others, and "certain given or *invented* basic forms in formal relationship can be determining factors" in the final result.[121] Every form is significant he wrote, including the necessarily created *Zwischenräume*, or negative spaces, and in their manifold use offer important means for the enrichment of painting.[122] While he did not consider regular geometric figures (such as the square, triangle, circle) suitable for use in painting, he suggested that with slight irregularities they offer a "great kingdom" of formal variation available to all artists.[123] He proceeded to demonstrate this point by including illustrations of works by van der Goes, Botticelli, and Rubens, in which he pointed out the basic geometric concepts underlying the composition.

Kandinsky, too, it will be recalled, used illustrations of past masters to demonstrate that geometric concepts in composition have been characteristic of art in all ages.[124] Indeed, the article prefigures Kandinsky's later writings in other ways. The illustrations of the effectiveness of the spot or dot on the picture plane are also comparable to illustrations in Kandinsky's *Punkt und Linie zu Fläche*. The reciprocal effect of elementary compositional elements on one another was also pointed out by Kandinsky.[125] The significance of *every* form was also of primary concern to Kandinsky, who wrote that "There is no form . . . that says nothing."[126] And the idea of a "great kingdom" or "treasure" of forms available to the artist is also to be found in Kandinsky's writings.[127] Kandinsky, too, spoke of the use of pure geometric forms and "countless others" ever more complicated, but warned that "Today the

artist cannot get by exclusively with pure abstract forms." In this reservation he echoed Hölzel's hesitation before the use of regular geometric figures.[128]

Compared to Kandinsky's highly developed aesthetic in *Punkt und Linie*, Hölzel's article appears as a first step in that direction. Hölzel may also have been inspired by the efforts of August Endell. In any case, the declaration of the primacy of the artistic means pointed the way to abstraction.

The autonomy and primacy of the artistic means was also the theme of a major three-part article by Hölzel which appeared in *Kunst für Alle* in 1904.[129] Here Hölzel expanded on his hypothesis, tracing the history of art in terms of the primary artistic elements (line, color, and form) from Giotto to his own contemporaries, concluding that an understanding of the artist's means is as necessary to the proper appreciation of past art as it is to the proper evaluation of modern art. The ways in which the basic elements have been used has varied and must continue to vary with new discoveries and rediscoveries, and with the customs of the times. But the art of each era must be judged on its own terms with due consideration of the ways in which the artist has consciously exploited the means at his own disposal. Throughout the article, the object in art takes a secondary position. For example, in discussing Titian, Hölzel wrote, "Titian's composition is then no longer a purely objective [*rein gegenständliche*] presentation of the imagination, but rather much more a unification of the most simple contrasts and harmonic combinations of object-form, spatial distribution, chiaroscuro and color movement. . . . The great harmony is here more important than the purely representational [*das rein Gegenständliche*]."[130]

Echoes of the sentiments expressed in this article are to be found in Kandinsky's writings. The plea for an understanding and judgment of contemporary works based on a genuine appreciation of the artistic means is expressed again most forcefully in Kandinsky's essay on the question of form, and was a basic tenet of the whole *Blaue Reiter* almanach and exhibitions.[131] But of course Kandinsky was in a position to carry each argument a step further. Thus, whereas Hölzel wrote, in typical Jugendstil fashion, that the first artistic act consists in the ability to perceive plastic form as planar form,[132] Kandinsky was able to see that ability as a "first step into the realm of the abstract."[133] Indeed, Hölzel was one of those who took the first step.

Hölzel's Early Abstractions

In fact, before the turn of the century, Hölzel had begun to experiment with an abstract or nonrepresentational form of expression. He had begun to produce line drawings without reference to real objects which he called "abstract ornaments." Although they were never exhibited, they were known to friends and students.[134] In 1905, two of these drawings were published in a popular monograph series, so that they were then known to the public at large.[135]

Titled "Abstract Ornaments" in the monograph, these drawings provide perhaps the most startling evidence available of the predisposition to abstraction inherent in Jugendstil art (Figs. 32a-c). But of particular interest is the fact that they were not just appended to the monograph as an afterthought. On the contrary, the author devoted several pages of text to a discussion of them.[136] It is apparent that he considered them

highly significant. Indeed, he suggested that they represented a preliminary stage in the development of a future art.

Arthur Roessler reported that he had seen "a number" of such drawings during a visit to Hölzel at Dachau. They were pages, he said, "on which the artist's emotional and intellectual movements had been recorded at various times in his life."[137] Some of the drawings were "extraordinarily beautiful and strongly decorative, without in the least recalling any known animal, botanical or technically organic form."[138]

Roessler on the Psychology of Line

When Roessler asked how he had come to produce such drawings, Hölzel replied that he had developed a habit over the years of accompanying the "rhythmic movement" of deep thought or meditation with lines drawn on paper. Something that had begun as intuitive and unconscious eventually became purposeful creation. But always, according to Roessler, the result formed an image or expression of the "inner rhythm of the soul or the intellect."[139]

Since the drawings were the result of conscious effort, Roessler suggested they might even be called "scientific," were they not at the same time creations of fantasy. "In any case, such drawings form abstract ornaments; *abstract in the sense of nonobjective.*"[140]

Explaining that just as all new art at first seems "hieroglyphic" and strange, he suggested that with study one could learn to interpret the linear and formal elements of art.[141] He further suggested that the newly developing scientific interest in graphology might provide a key to the interpretation of the new art. Art historians and artists alike should undertake a systematic study of line, following the lead of Chevreul, Helmholtz, and Bezold in their studies of color. "Perhaps we can expect that psychology will turn to the study of artistic linear expressive movement . . . ," he wrote, noting that some studies of "pathologically significant expressive movement" had already been undertaken.[142]

Recognizing that a veritable drive to form and line was characteristic of the art of the time, he quoted the art critic Karl Scheffler on the idea that this drive to form, line, and ornament lay at the very heart of the modern movement.[143] He also quoted Van de Velde on the line as a form of energy.

Line in itself, he wrote, may very well be significant not only as ornament or as a necessary constructive element, but "as the expression, as graphic sign, as gesture of a thought or feeling."[144] Since both thoughts and feelings are *Bewegungen* (movements) and every movement, spiritual or bodily, results in *Schwingungen* (vibrations) which can be rendered graphically, so, too, can thoughts and feelings be rendered graphically. "Just as emotional processes (*seelische Vorgänge*) can be expressed in certain bodily gestures, so too can artistic feelings as inner movement be made visible through line."[145] Lines have the capacity to awaken in us the mood of their creator, wrote Roessler, echoing Endell. "Just as certain sequences of tones, *without being music,* can exercise an effect on us— and a similar effect of color on our souls has been recognized, so too the line . . . exercises a strong effect."[146] Forms then, Roessler wrote, are not only important as aesthetic means, but are "significant as symbolic veils, sensuously perceptible expressions of movements of the spirit or the soul."[147]

Thus clearly, Roessler was transmitting ideas in-

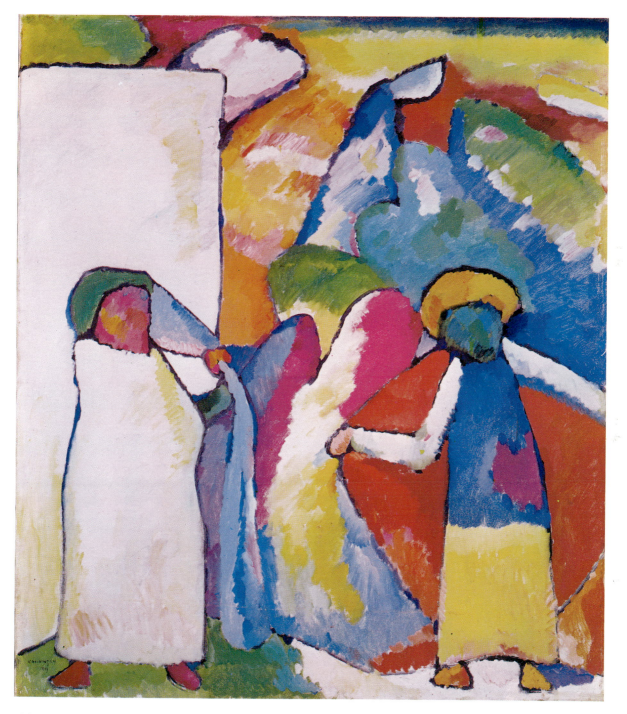

V. KANDINSKY. *Improvisation 6 (Afrikanisches)* (*Improvisation 6 [African]*), 1909.

spired by Hölzel and already expressed by Obrist, Endell, Van de Velde, Scheffler, and others; ideas which served as a kind of springboard to the conscious exploitation of the artistic means as autonomous expressive elements in abstract art. It was to be many years before Hölzel made his personal "breakthrough" to abstraction, but obviously the stage had been set.

Hölzel's Later Development

Meanwhile in his painting, Hölzel turned briefly again to the figure, attempting to incorporate it as an integral rhythmical element into his landscapes. The results were not particularly successful. Indeed, Hölzel's entire career was to be characterized by continual experimentation, sometimes leaping forward into new forms, but often leaning backward toward the old. Around 1903-04, Hölzel also produced some paintings in which he adopted a "mosaic" brush technique, which might be characterized as "neo-impressionist," although the subdued coloration typical of the early period persisted.[148]

However, in 1905 he once again made a startling leap forward, both in his landscape and in his figural composition. It was then that he produced the remarkable series known as *Dachau Moor I-IV*, in which a great tree formation is gradually transformed from a compositional study into a strong expressive statement. Breaking away for the first time from the subtle gray-blue-brown color mode of the earlier Dachau period, he gave to color the autonomy of the other elements and produced a nearly "expressionistic" landscape (Fig. 33). The strong broad brush stroke that was characteristic of his work at this time was now enhanced by intense, bright blues, yellows, oranges.[149]

In the same year Hölzel produced *Composition in Red*, an astonishing painting for the time in Germany (Fig. 34, Pl. IV). In this work, color has been almost entirely emancipated from naturalistic associations and the figures have been stylized and drastically simplified. However, once again as in the case of the "abstract ornaments," it was to be some years before this painting came to the public eye, in a 1916 exhibition in Freiburg called "Hölzel and His Circle."[150] Nevertheless, the painting stands as an important though isolated monument in the development of abstract painting. It was not until around 1909 that Kandinsky reached a similar degree of flat stylization in his figural oil paintings. *Improvisation 6*, of 1909, for example, might be compared to it (Fig. 35, Pl. v). In both cases the faces and hands are simplified to rounded areas without features, compositional elements have been strongly outlined, and the color laid on in large flat areas.

In the autumn of 1905 Hölzel, then aged fifty-three, left Dachau to accept a teaching post at the Stuttgart Academy. There he continued his gradual development toward abstraction despite the surprise and jealousy of his colleagues, who had previously failed to recognize the latent avant-garde tendencies in his work.[151] He attracted more students than they and kept up a continual interest in the important artistic movements of the time.[152]

During these years, he worked on developing his theory of color and became obsessed with the idea of creating an "absolute painting." But he remained a "loner" and led a rather isolated existence in Stuttgart surrounded only by a close circle of devoted students. These included Willi Baumeister (by 1910), Oskar Schlemmer (by 1912), and Johannes Itten (by 1913).[153]

Between 1908 and 1914, Hölzel's work moved further toward abstraction, as can be seen in Figure 36. References to figurative elements became more and more ambiguous, as did compositional relationships. Color assumed an ever stronger role, so that by 1914 *Biblical Motif* appeared as an almost collagelike assemblage of richly colored accents circling about the central motif. This motif, an "adoration" theme, had become an important leitmotif for Hölzel, a "significant form," or, as Venzmer has said, "an expressive vehicle of art's highest symbolic content."[154]

Free as were these compositions, Hölzel's first major work that can be considered fully abstract did not come until 1915-17, when he fulfilled a commission to design stained glass windows for the conference hall of the Hermann Bahlsen Company in Hannover.[155] Employing collage technique with transparent colored papers to create his designs, Hölzel was for the first time able to achieve his goal of a "musical" composition based solely on an "orchestration" of colors (Fig. 37).[156] Thus did the prophet only belatedly fulfill the promise of the "abstract ornaments"—but then in monumental style.

In his old age, Hölzel turned to the medium of pastel, in which he managed to achieve a radiance of color matched only by his stained glass windows. Decorative and closely related to its Jugendstil origins, his pastel work, however, never attained the monumentality of the windows. And his abstraction remained ambiguous to the end. Yet it was a magical ambiguity in which figures seem to disappear into autonomous color areas, which in turn revert to figurative groups, so that a continual transformation seems to take place.[157]

Kandinsky and Hölzel

The nature of the reciprocal influences between these two artists remains unclear. Yet there were parallels not only in their careers and work, but in their whole approach to art.[158] Hölzel's many aphorisms, as well as his color theory, contain much that is reminiscent of Kandinsky's writing and theory.[159] But what is of primary importance for consideration here is the Munich milieu and Kandinsky's artistic growth within it. Inasmuch as Hölzel was an important stimulus on the Munich scene, he can be said to have contributed much to the atmosphere in which Kandinsky's own development toward abstraction took place. Hölzel's early strong emphasis, both in his published writing and in his work, on composition and on the primacy and power of the autonomous artistic means were an integral part of the Munich legacy inherited by Kandinsky.

Consciously or unconsciously Kandinsky assimilated echoes of Hölzel's art into his own. In two works representing the beginning and the end of Kandinsky's career, the Hölzel stimulus can be detected. *Trüber Tag (Cloudy Day)* of 1901 bears a strikingly close resemblance to Hölzel's painting *Winter, Tauschnee (Winter, Thawing Snow)* of 1900 (cf. Figs. 38-39).[160] From Kandinsky's correspondence it is known that he sometimes rode his bicycle out to Dachau to paint.[161] Thus he may accidentally have hit upon the same motif. On the other hand, it is possible that *Winter, Tauschnee* was one of the four Hölzel paintings exhibited at the 1901 Munich Secession, and that Kandinsky was impressed by it there.[162] It is an impressive painting. Though coloristically subdued and full of subtle

harmonies, its composition and broad brush stroke are very strong. Kandinsky had only been painting seriously for about five years at the time and his painting lacks both the compositional control and the strength of the Hölzel work.[163]

In a letter to Hans Hildebrandt of 1937, Kandinsky expressed surprise that Hölzel might have worked abstractly before 1910.[164] Yet, near the end of his career, in 1942, Kandinsky produced a woodcut that reflects at the very least a *Klang* of Hölzel's early "abstract ornaments." The print, produced for inclusion in a portfolio entitled *10 Origin*, bears an almost eerie resemblance to one of the Hölzel ornaments reproduced in the Roessler monograph (cf. Figs. 32b and 40).[165] Yet in this case, Kandinsky's print is the finished, eloquent work of the master in full control of an established artistic vocabulary, whereas the Hölzel drawing remains the tentative and strangely unsatisfying work of the novice. Nevertheless, Kandinsky's *Origin* print, seen from this perspective, is a direct descendant of Jugendstil and of that other pioneer in abstraction—Adolf Hölzel.

CHAPTER

·V·

The Second Teacher: Franz Stuck

GIVEN the vigor of the *Kunstgewerbliche* movement in Munich, it is hardly surprising that Kandinsky chose as his next formal teacher an artist who, as a founder of the Munich Secession and as architect of his own house, had a foot firmly planted in both the "higher" arts and in the arts and crafts movement. Franz Stuck, then at the zenith of his fame and fortune, had in fact, begun his meteoric rise to prominence as a student in the old Munich Arts and Crafts School.

"At that time," wrote Kandinsky in "Rückblicke," "Franz Stuck was 'the first draftsman of Germany.' "[1] Indeed, it was Stuck's natural drawing ability that had started him on his illustrious way. The impecunious son of a miller in lower Bavaria, Stuck had come to Munich in the early eighties to study at the Kunstgewerbeschule, earning his way by drawing vignettes and cartoons for the *Fliegende Blätter*, a popular Munich periodical. Soon his facility with pen and ink attracted the attention of a well-known publishing firm which commissioned a series of "Allegories and Emblems" followed by a series of "Cards and Vignettes." These were published in two volumes as copybooks. Before long, Stuck's designs were appearing everywhere on menus, greeting cards, invitations, and anniversary announcements.[2]

Stuck was born in 1863, just three years before Kandinsky, and his unqualified commercial success at so young an age created a considerable stir among his colleagues. His copybook designs were considered genuine examples of craftsmanship, in contrast to his cartoons; he had become a *Kunstgewerbler*, and was no longer a mere *Karikaturist*. However, while his vignette designs exhibited the international arts and crafts style of an earlier period, overladen with baroque ornament and allegories usually involving Cupid and sin, his cartoons for the *Fliegende Blätter* were often timely and fresh. His ability to metamorphose an ordinary event into a humorous situation with a few well-chosen forms and deft strokes was considered astonishing in one so young. But it was more than mere artistic dexterity that made his cartoons so successful. In fact, he had a rare "image-making" ability, one that was uniquely in tune with his time. Soon, Hugo von Hofmannsthal was to call Stuck a "myth maker."[3]

In the meantime, Stuck was considered widely to be *the* man of the future in the area of arts and crafts.[4] Though he had enrolled at the Academy as a student of Lindenschmit in 1881, he rarely attended classes, and, while influenced by Arnold Böcklin, was largely self-taught as a painter.[5] Thus, it must have come as a considerable surprise to Munich's art world and public alike when he entered two large, light-blazing paintings in the Glaspalast exhibition of 1889, and walked away with a gold medal and a prize of 60,000 marks for one of them—*Guardian of Paradise*.[6]

Overnight Stuck was famous. At the age of twenty-five he had challenged the great names of Munich's artistic establishment, at whose head stood the mighty Lenbach, and had conquered. His *Guardian* caused a sensation, as well it might. The painting was the first in a series of images that synthesized the ambiguities of the age in a way no other Munich painter had dared to do. In it he combined the most extreme, dissolved "light-painting" (or impressionism) with the most splendidly solid form, the most extreme naturalism with the most extreme fantasy, an illusion of atmospheric depth with an illusion of tapestrylike flatness, modern man in all his most sensuous presence with the man of a pure and mythic past (Fig. 41).

In a blinding flash of sunlight stood a handsome muscular youth, but in his hand he braced a fiery sword, and on his back grew mighty wings. The space his solid body appeared to require seemed at once infinite and unreal. To a contemporary, the color seemed "secret, strange," and "magic flowers seemingly woven out of sunbeams blossomed" behind him. Some critics complained that the "real" was not yet raised completely to the level of the ideal.[7] But, as Hofstätter writes, "The integration of the real and the ideal is not even possible for this type of art; its reality consists in the representation of a discrepancy, which cannot be overcome even in an existential sense, and which is itself much more a unique characteristic of a time and a society wavering between positivism and idealism."[8]

Stuck's unerring capacity to make out of ambiguity and discrepancy striking images that could be grasped by the public assured him popularity and success. Hofmannsthal laid this special ability to Stuck's talent in caricature. "From caricature he possesses the gift for the striking, more-than-striking characteristic." And again, Stuck has learned from caricature "to utilize the living ornamentally and to enliven the ornamental."[9]

In rapid succession followed a series of such images, each more striking, more dramatic, more "characteristic" than the last: *Lucifer, The Lost Paradise,* a *Pietà, Sphinx, Sin, War,* the *Dancers,* and multiple variations on the sex life of the faun. The public was entranced. Stuck's technical virtuosity was beyond question, and every theme he chose seemed transformed and cast into a language the *fin-de-siècle* man could understand.[10] Indeed, Stuck felt free to manipulate the images of traditional symbolism at his own whim and fancy. He blithely lifted centaurs and fauns from the Greek vases in the Glyptothek and set them loose to roam in naturalistic woods and fields after Eros—then as blithely turned them back again into silhouettes in painted friezes and plaster reliefs. He constantly played erotic games in the face of "middle-class morality." As Julius Meier-Graefe was to note, Stuck "made Sphinxes out of waitresses and waitresses out of Sphinxes."[11] But Eros looked harmless and "healthy" decked out as a prancing faun, and the dark side of Stuck's more harrowing "dream" paintings (like *The Guilty Conscience* and *The Wild Hunt* [Figs. 42, 43]) was passed over by a public looking for titillation not terror.

In 1893, the year he designed the Secession poster with the wise and rational head of Pallas Athena, which was to become its hallmark (Fig. 44), Stuck created the painting that was to become *his* hallmark —the darkly irrational *Sin.* This became perhaps his most famous and most popular painting (Fig. 45). He painted it at least eight times.[12] Eventually, he en-

shrined it in an altar in his atelier. On the surface, *Sin* seemed a harmless enough didactic allegory with a certain biblical respectability. Yet the serpent was no longer a mere tempter, but a dreadful, threatening bailiff and his prisoner no innocent Eve, but an Ophelia maddened by a secret knowledge.[13] A more appropriate symbol of *fin-de-siècle* decadence can scarcely be imagined. Nor could the discrepancy be greater between the Secession's Athena formally inscribed in the octagon and circle, rational symbol of regeneration, and the darkly irrational, backward-looking *Sin*.[14]

In 1895, only ten years after he had registered for his first brief academic training, Stuck was appointed professor of painting at the Academy. Now, at the height of his career, he turned again to the craftsman's role and began designs for his own villa, which was then built on the low bluffs above the east side of the Isar River between 1897 and 1898. Reminiscent of Böcklin's *Villa by the Sea*, Stuck's villa was again a synthetic image of *fin-de-siècle* ambiguity. It combined the romantic German yearning for an idyllic classical past with a rampant modern eclecticism;[15] pomp and splendor with consideration for practical necessity; a strict programmatic symbolism with a bravura disregard for consequence. Stuck designed not only the architectural plans for the building itself, but all of its ornament, including furniture and lighting fixtures, as well.[16]

Thus, even as the arts and crafts movement found official sanction, and equality with the fine arts in the exhibition rooms of the Secession, Munich's *Malerfürst* (painter-prince) brilliantly demonstrated his versatility in both areas. For sheer vigor and freedom of invention few could match him.

STUCK'S ATTRACTION AS A TEACHER

This freedom, this technical virtuosity, this subtle anarchy—these were not lost on his colleagues, nor on a younger generation struggling to free itself of the past.[17] His very eclecticism was the key to the immense admiration he engendered. "Who else," exclaimed Hans Purrmann in his memoir, could have produced "such demonic, sinful images, who else could act baroque and appear Hellenic. . . ?"[18]

Yet, looking back, it has been difficult for many to understand Stuck's attraction. In retrospect, the fauns and centaurs, once thought symbols of a "healthy," robust nature[19] or the expression of "fanciful lyricism";[20] the serpent-entangled nudes, once symbols of "metaphysical sensuality";[21] and the neoclassicism once considered a genuinely "Germanic" expression[22]—all now seemed florid, decadent, and sickly.[23]

It is instructive, therefore, to analyze in greater detail the attraction Stuck had at the time, and not only in retrospect. It will then be seen that, in fact, those attributes of technical virtuosity, freedom, and anarchy were indeed the forces that drew the students who were to make the breakthrough at which Stuck himself only hinted.

Besides Kandinsky, other Stuck students included Paul Klee, Hans Purrmann, Eugen Kahler, Ernst Stern, Albert Weisgerber, Alexander von Salzmann, Hermann Haller, Willi Geiger, and later (1919-20), Josef Albers. All moved from their experience with Stuck on into the isms of the twentieth century. Most played important roles in the development of abstract art. Stuck was like some magnetic alchemist both attracting and stimulating energies that streamed out far

afield, in another form and in all the arts—painting, sculpture, applied and graphic arts. Klee and Kahler, of course, were later associated with Kandinsky in the *Blaue Reiter*. Purrmann and Weisgerber were both later to be associated with the Café du Dôme group and Matisse in Paris. Albers went on to the Bauhaus and remains even today a hero of the avant-garde. Ernst Stern attained fame as a designer for the stage productions of Max Reinhardt. Alexander von Salzmann, like Kandinsky a Russian (and an early associate of his in the Phalanx society), later also became a theatrical designer, at one time with the Théâtre des Champs Elysées in Paris.[24]

Purrmann later recalled that ". . . to be accepted in [Stuck's] class was a proof and recognition of a talent of which one could be proud."[25] Indeed, acceptance in Stuck's class meant so much that Kandinsky, having been turned down once, worked for a whole year to gain that acceptance. On his first approach to Stuck, he had been advised to work on his drawing in the appropriate class at the Academy for a year. Upon attempting to follow this advice, however, Kandinsky failed the entrance examination. Not discouraged even by this blow (for, as he said, he saw drawings accepted that he considered utterly without talent), the then thirty-three-year-old student resolved to work for a year at home.[26] The second time he presented himself to Stuck (with some unfinished paintings, including landscape studies), he was admitted to the master's class.[27]

In every way, the strictly formal aspects of Stuck's work aimed directly at the future: composition as a problem of psychologically effective construction, the appreciation of form in itself disassociated from mean-ing, the emphasis and play with surface and line, anaturalistic color and willful distribution of motifs. All these were to become special characteristics of twentieth-century art. At the same time they were typical of Jugendstil,[28] and thus within the mainstream of the art of the nineties.

Stuck's paintings (and his villa as well) were "constructed" with strict attention to compositional effect.[29] He preferred to emphasize strong contrasts of horizontal against vertical, and of space at once flat and deep, as in the double self-portrait with his wife, in which the major forms are strongly silhouetted (Stuck in profile against an expanse of white canvas, Mary against a red rectangle), yet the Renaissance game of depth illusion is played with the tiles of the floor (Fig. 46). He played with abandon on formal linear rhythm as in *The Dance* and the *Dancers*, both examples par excellence of the Jugendstil "felt" image (Figs. 47, 48).[30] He paid great attention to achieving a unity of painting and frame which added to the decorative, craftsmanlike totality of his work.[31]

KANDINSKY AT STUCK'S ATELIER

Kandinsky was particularly struck by Stuck's genuine appreciation of form for its own sake. "He spoke with surprising tenderness about art, about the play of forms, about the flowing into one another of forms, and won my complete sympathy."[32] Hofmannsthal had already noticed Stuck's talent to grasp the "deep sense of forms"[33] and had commented that this was an important artistic conquest *"to see things as forms irrespective of their conventional significance."*[34] This perceptive critic also noted that Stuck had learned

to appreciate the symbolic value of such details as each little arabesque and spot (*Fleck*).[35]

Indeed, Kandinsky owed much to Stuck in respect to the recognition of form as a painterly element, since it was Stuck who first advised him to drop his "extravagances" in color, and to devote his attention to a study of form. Evidently he saw that Kandinsky was a born colorist, for he immediately advised his new student to work exclusively in black and white as a first step in the study of form.[36] Thus, Stuck effectively launched Kandinsky on his almost obsessive study of positive and negative space which was to be characteristic of most of his early work, and was eventually to lead to his first significant artistic achievement in the medium of the woodcut.[37]

Color and lighting effects were also subject to Stuck's fancy. He came to prefer the totally anaturalistic colors best achieved by means of tempera paint. With this medium he could produce the rich gemlike or "phosphorescent" gleams that added mystery to his dark imagery. He often achieved the garish and stagey lighting effects that the expressionists were later to appreciate and to exploit themselves.[38]

Stuck also mixed media with gay abandon, turning a painting into a relief or into a sculpture without a qualm (cf. Figs. 48, 49).[39] Dimensionality was a "fluid medium" one might say, as it was to become in abstract painting.

In all he did however, most characteristic was the freedom with which he manipulated the disparate elements of his craft. Though he was never able to free himself completely from some sort of object in painting, he disassociated the objects he used from traditional limitations and subjected them to multiple transformations both in meaning and in medium. Perhaps

this freedom was in part a result of the fact that he, too, like Endell and Obrist, had never had a strictly academic training.

Most significantly, as far as his students were concerned, this unusual degree of freedom was carried over into his teaching. Both Purrmann and Willi Geiger remarked in their memoirs on the great freedom of the Stuck atelier. Geiger recalled that although Stuck seemed "enmeshed" in his own program, he never attempted to impose it on his students, but on the contrary, was always open to anything new.[40] And Purrmann, whose father had run a strictly rule-book furniture workshop, was amazed at the experimental nature of Stuck's studio at the Academy.[41] With gratitude, Purrmann recalled that Stuck's class had no formal program. While other classes were subjected to numbing drills, Stuck students were free to try whatever they wished. Many worked at home most of the time and showed up for the weekly *Korrektur* or not as they wished.[42] Geiger wrote that Stuck saw the university as a "place for research and research meant for him, to make use of the natural gifts of a person, of his ability to seek the truth, to exploit every means— each according to his particular needs."[43]

This in itself goes a long way toward explaining the amazing diversity of talents that "graduated" from Stuck's classes. But there was more to it than that. Stuck apparently exercised a rare psychological insight in relations with his students. Although he maintained a very definite distance between himself and his students, and spoke seldom, when he did speak, it was with relevance and understanding. Geiger recalled that he had an unusual power to intensify and direct his students' energies toward their goals.[44]

This, too, helps explain the apparently incongruous

fact that Kandinsky could have been a Stuck student at all. Purrmann recalls that Kandinsky, who was a student at the same time as he in 1900, used to warn him against too much academic training, and that Kandinsky showed him his work, which consisted of "overly-colored paintings of Russian folk scenes."[45] Different as was Kandinsky's work from that of other students, Stuck was able to accept him, too, and to give him encouragement.

For Kandinsky also recalled that Stuck's psychological insight and ability to say the right thing at the right moment marked a turning point in his own career:

> He cured my terrible malady of being incapable of finishing a painting by means of a single remark. He said to me that I work too nervously, that I pluck out the interesting in the first instant and then spoil the interest in the too-long-delayed dry part of the work. [Stuck said] "I wake up with the thought, today I shall allow myself to do this or that." This "I shall allow myself" revealed to me not only Stuck's deep love and high respect for art, but also the secret of serious work. And at home I carried my first painting to completion.[46]

Purrmann's recollections about Stuck's recommendations concerning the use of color are also interesting in relation to Kandinsky's early painting. According to Purrmann, the use of tempera paint (which he found viscous and difficult to use) was the general rule in Stuck's studio. And the earliest works of Kandinsky available to us indicate that he frequently used tempera. Further, Purrmann recounts that in the use of oils, Stuck advised that dark places and shadows should be painted *lasierend durchsichtig* (transparently with a varnish medium), and that white should only be mixed with other colors in light areas, and then sparingly.[47] This advice was also taken by Kandinsky as can be seen in his earliest work. *The Sluice* of 1901 demonstrates the use of varnish mixed with the medium to produce the effect of slick, dark water (Fig. 50). The paintings done at Rapallo (such as *Fishing Boats*, 1906, at the Guggenheim Museum) demonstrate the use of white mixed almost conscientiously with the light colors in delicate graduations. In a letter to Münter in 1904, answering her request for advice on how to handle the representation of dark water, Kandinsky wrote that she must dissolve the area with varnish, otherwise the result would be muddy.[48]

Some have seen Franz Stuck as a "prisoner of stylization."[49] Yet, ironically, he was uniquely free. And it was in this respect that he was able to function as a remarkable catalyst. Perhaps no other teacher of his time so well deserved the gratitude Stuck's students, such as Geiger, Purrmann, and Kandinsky, addressed to him. Perhaps no other major figure of the turn of the century sank so quickly into disrepute and the historical exile of oblivion.[50] Yet Stuck was an active force in the evolution of twentieth-century art, and was of particular significance in Kandinsky's development. In his life and in his art, Stuck was indeed a "myth-maker," as Hofmannsthal had said, and as a teacher, he generated an energy of surprising force and consequence.

PART TWO

*THE IMPULSE TO
ARTISTIC ACTIVISM*

CHAPTER

·VI·

The Phalanx Society

Munich. A new artists' society, *Phalanx*, has just been formed here, which has set for itself the task of furthering common interests in close association. Above all, it intends to help overcome the difficulties that often stand in the way of young artists wishing to exhibit their work. To this end, it has been decided to arrange for a permanent exhibition of works by society members, as well as those of invited guests, in a building of their own.[1]

KANDINSKY's first step on leaving Stuck's studio in late 1900,[2] was to organize a new independent exhibition association, the Phalanx. With this announcement in the pages of *Kunst für Alle*, the first organization in which he was to serve as a prime mover and founder came before the public.[3] Out of this was born his own school of the same name. At the same time he became actively involved in the applied arts movement, forming associations with some of its leading exponents. Soon he began to publish his own criticism, to submit his work for exhibition throughout Europe, and to travel. A detailed review of the Phalanx exhibitions reveals that Kandinsky was not only aware of the Secession and Jugendstil movements, but was in close contact with several significant representatives of these currents. It also reveals his proximity to, indeed his direct involvement in, the Munich art scene itself, as well as his growing interest in certain stylistic forms and techniques, especially in the graphic arts.

The word *Phalanx*, of Greek derivation, means "a body of heavily armed infantry in ranks and files close and deep, with shields joined and long spears overlapping."[4] Just so is the Phalanx depicted in the poster designed by Kandinsky for the first exhibition of the group, which opened on 17 August 1901 (Fig. 51).[5] Heads bowed, two heavily helmeted Grecian warriors, shields joined and spears overlapping, advance to meet the foe, leaving behind a field strewn with bodies and monstrous threatening birds of carrion.

At the turn of the century, the word Phalanx had another connotation which was suggested in the published announcement: that of a group of men and women bound in "close association" to further "common interests." The idea of the "Phalanx" as a harmonious unit of society had been advanced by Charles Fourier in the early nineteenth century, and it is quite possible that this Utopian ideal of the Phalanx may have been an inspiration to Kandinsky.[6] Clearly, his two warriors appear to be male and female (to the left, with the finely chiseled nose and eye). The tented encampment on the left suggests motifs so often used by Walter Crane that they might be considered associative references to the Utopian social ideas of Crane and Morris.[7]

The Phalanx poster also betrays Kandinsky's recent association with Stuck, the motif clearly referring to

the Secession poster designed by Kandinsky's former teacher (Fig. 44). Not only are the crested helmets similar, not to mention the choice of a warrior figure, but also the mosaic-like border design was undoubtedly suggested by the Stuck poster, which depicts the helmeted Pallas Athena head (in profile also) on a gold mosaic ground. Both posters exhibit typical Jugendstil "free-form" lettering.[8]

A revolutionary feature of the Phalanx exhibitions was the attempt to have works of art chosen by an anonymous jury. The art work was also to be submitted anonymously, in order to insure a fair choice based only on aesthetic considerations.[9] This experiment received the approval of the *Kunst für Alle* reviewer, who, however, expressed some doubt that it would succeed. A further unusual effort was to be the institution of exhibitions during the winter months, when there were otherwise few art exhibitions in Munich.

The Phalanx exhibition rooms were located, during the first year at least, at Finkenstrasse 2.[10] Although one reviewer complained that the rooms were not well-suited for exhibitions,[11] the location itself could scarcely have been better. The address was close to the center of town, near Odeonsplatz with its art salons, and only a few blocks from the Secession exhibition gallery and the Kunstverein.

PHALANX I

The first exhibition, opening in mid-August of 1901, achieved the distinction of being immediately labeled "hyper-modern."[12] Contributing artists included Hans Hayek, Ernst Stern, Carl Piepho, and Franz Hoch, who were also associated with the "Luitpoldgruppe."

There were also works by Kandinsky, Alexander von Salzmann, and Leo Meeser. Sculpture was represented with "two of the original Scharfrichter masks by Wilhelm Hüsgen and with Waldemar Hecker's well-caricatured types for the political marionette theater."[13]

A number of interesting observations may be made concerning the participants in this first Phalanx exhibition. At least two of them were students of Stuck at the same time as Kandinsky: Ernst Stern (1876-1954) who, according to Purrmann's account, was *Obmann* (assistant to the professor) the year Kandinsky was there,[14] and Alexander von Salzmann (1870-?), who was also a Russian. Both Stern and Salzmann were to make significant careers as theatrical designers. As has been previously noted, Stern became the chief designer for Max Reinhardt's Deutsches Theater in Berlin. Salzmann later designed avant-garde light-theater arrangements at the Hellerau school of modern dance directed by Emil Jaques-Dalcroze. There can be scarcely a doubt that Kandinsky knew both of these men personally, and the possibility that they discussed drama and theater design is not to be discounted.[15]

Hans von Hayek (1869-1940) was already a rather well-known painter of the Neu-Dachau persuasion and a member of the Secession. His landscapes emphasized formal qualities at the expense of "clarity."[16] One of his paintings had already been purchased for the Bavarian Staatssammlung. The same honor had also been bestowed upon a painting by Franz Hoch (1869-1916).[17] Thus the Phalanx cannot be thought of as merely an exhibition opportunity for unknowns.

Perhaps the most interesting contributions were those by the sculptor Hüsgen (1877-1962), the two masks for the Elf Scharfrichter. Again, here is evidence of Kandinsky's interest in the theater and of his ap-

preciation for the avant-garde. The Elf Scharfrichter was in fact the most avant-garde cabaret group then performing in Munich. The name may be translated approximately as the Eleven Executioners. This morbid troupe featured social and political satire in song, mime, and dance. Perhaps best known of the eleven was the dramatist, Frank Wedekind, who sang there his dry satirical ballads in a gravelly voice, accompanying himself on the guitar. One of the eleven Scharfrichter was in fact a Phalanx exhibitor; Ernst Stern (Stuck's assistant in 1900), who did settings for the cabaret as well as caricatures and posters.[18] The masks designed by Hüsgen may possibly have looked like those depicted on the Scharfrichter poster designed by Thomas Theodor Heine in 1903.[19]

Apparently Hecker's marionettes were also used in performances of the Elf Scharfrichter, because Reinhard Piper recalled that his duties as *Henkersknecht* (hangman's knave) involved working marionettes in "satirical and burlesque" plays.[20]

Since there was apparently no catalog for the first Phalanx exhibition,[21] it is not known with certainty what Kandinsky exhibited of his own work. However, these probably included tempera paintings, or "colored drawings" as he also called them. *Rendezvous*, of which only a later version of 1902 is known, may also have been shown.[22]

Of the two remaining exhibitors, Carl Piepho (1869-1920) had also exhibited with the Secession (as had Hayek and Hoch),[23] and was already making a name for himself as a "poetic" landscapist.[24] His nostalgic *At the Edge of the Wood* (Fig. 52) of 1901, with its rider on a white horse passing through an idyllic wood of majestic cedars, has much of the romantic feeling of some early Kandinsky works, such as *The Blue Rider* of 1903 (Fig. 53), *In the Wood* and *Rider in a Landscape* of about the same date (Figs. 54a and 54b), as well as the later *Riding Couple* (Fig. 66).[25] *The River*, shown by Piepho at the spring exhibit of the Munich Secession in 1902, with its meandering stream, its soft haziness and flat perspective, may well have been shown also at the Phalanx exhibit. Leo Meeser, who had the distinction of having been born in Mexico, may have added a somewhat exotic note, though it is not known what he exhibited. He had studied at Karlsruhe, as had Piepho, and later became known as a portraitist.[26]

Soon after the first exhibition, a change took place in the leadership of the Phalanx organization. Rolf Niczky (1871-?), a co-founder of the group with Kandinsky, and its first president, withdrew from membership and Kandinsky took over the chairmanship, a position he held until 1904.[27] Vice-president of the group was the sculptor Waldemar Hecker, and secretary was Gustav Freytag (son of the writer).[28] The recording secretary was the sculptor and designer of the Scharfrichter masks, Wilhelm Hüsgen.[29]

PHALANX II
LUDWIG VON HOFMANN, ARTS AND CRAFTS

Thus it was that the "hyper-modern" Phalanx, with Kandinsky in command, set about making arrangements for its second exhibition, which was to be equally timely and avant-garde. In the summer of 1901 in Germany, the most provocative artistic event without doubt was the opening of the exhibition of the Darmstadt Künstler-Kolonie (Artists' Colony). It marked at once the culmination of Jugendstil and a watershed between the art of the nineteenth and the twentieth cen-

turies. In many respects it prefigured the Bauhaus. Within months of its closing, the Phalanx opened an exhibition which included a substantial representation of works by the leading artists of the Darmstadt Artists' Colony.

The second Phalanx exhibition, which opened in January of 1902, was in effect a direct demonstration of Kandinsky's involvement with the arts and crafts movement, with the decorative arts. A special guest of this exhibition (and not associated with the Darmstadt group, though a native of Darmstadt) was the dean of Germany's decorative painters, Ludwig von Hofmann (1861-1945). Then at the height of his fame as a Jugendstil painter par excellence, von Hofmann had been a founding member of the Berlin Secession and was also a member of the Munich Secession. It must have been a considerable coup for Kandinsky to have secured his participation. This in itself is indicative of Kandinsky's growing stature as leader and organizer.[30]

In retrospect, however, it is Kandinsky's appreciation of the achievement of the Darmstadt artists that appears most significant, along with the over-all emphasis of the exhibition on the applied arts. Indeed, nearly all of the exhibitors at this Phalanx show were intimately involved with the applied arts. From Darmstadt there were Peter Behrens, Rudolf Bosselt, Hans Christiansen, and Patriz Huber, all in their roles as architects, interior designers, and craftsmen. But also exhibiting were Erich Kleinhempel,[31] a well-known Dresden craftsman, and Natalia Davidov of Moscow, whose embroideries had created a stir at the world exposition of 1900 in Paris.[32]

Furthermore, there were even works from the Ver-

einigte Werkstätten (the United Workshops) of Munich, which included among other things, furniture designed by Richard Riemerschmid, Bernhard Pankok, and Paul Schultze-Naumburg, all of them then at the height of their fame as pioneers of the new style. Riemerschmid had participated in that very first precedent-setting craft exhibit at the Secession in 1897, in which Schultze-Naumburg had seen the "seeds of the future."[33] Pankok had been responsible for a whole room at the large 1899 Secession crafts exhibition. Both had participated in the German section of the 1900 Paris Exposition. Schultze-Naumburg, who was also a noted painter and architect as well as a writer, was then also a regular correspondent for the art periodical *Kunstwart*, which had one of its publishing offices in the same building where the Phalanx had its showrooms.[34] Another exhibitor was Moritz Baurnfeind (1870-?) who was, interestingly enough, the grandson of the famous nineteenth-century decorative painter Moritz von Schwind.[35] The younger Moritz had inherited his grandfather's skill at drawing and was known for his political caricatures and social satires. He was a frequent exhibitor in the Munich Glaspalast exhibitions from 1900 on.[36]

Hüsgen exhibited masks again, and Hecker exhibited portrait reliefs. Of course, the exhibition of the Scharfrichter masks and marionettes in the first Phalanx show had indicated an interest in the applied arts as fine art. Of particular interest and significance is the fact that four of the works submitted by Kandinsky at this second show were designated in the catalog as "decorative sketches." As such, they provide evidence of Kandinsky's interest in the Jugendstil arts and crafts movement.[37] Among them was the brilliant-

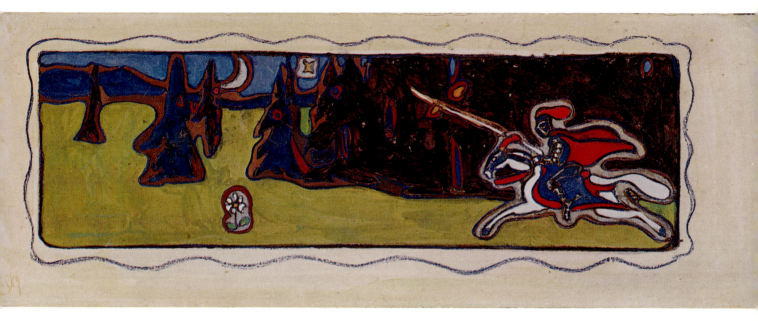

VI. Kandinsky. *Dämmerung* (*Dusk*), ca. 1901.

ly colorful *Dusk* (Fig. 122, Pl. vi), representing a charging horse and rider, perhaps the first instance of this motif in Kandinsky's oeuvre.[38]

It was at this exhibition that Kandinsky himself created something of a stir. The anonymous reviewer in *Kunst für Alle* described him as "the original Russian colorist, who paints purely for the sake of the color. . . ." Kandinsky, he wrote, "lets fly all kinds of coloristic fireworks and uses the most various techniques, oil, tempera and lacquer, the latter unfortunately reflecting so strongly, that one scarcely sees the picture." The reviewer praised Kandinsky's *Autumn Days* and *Bright Air* particularly as "belonging to the best works of Kandinsky."[39]

Among the remaining exhibitors were Alexander von Salzmann again (with two tempera friezes based on Russian folk scenes), and another Russian, Nikolai Kusnetsov of Odessa, already well known in Russia and a former professor at the St. Petersburg Academy of Art (1895-97).[40]

DARMSTADT ARTISTS' COLONY

Because of the vital significance of the Darmstadt experiment and of the Darmstadt artists, particularly Peter Behrens, for the development of twentieth-century art, a discussion of the Artists' Colony is absolutely essential for a complete understanding of Kandinsky's experience in these early Munich years.[41]

The Darmstadt Künstlerkolonie was, in the first instance, the brainchild of Georg Fuchs, that intrepid ally of the crafts movement, whose writings have been cited previously in regard to Obrist and Endell.[42] As early as 1892, Fuchs (a native of Darmstadt) had pub-

lished a proposal for an ideal cultural community which he addressed to the new Grand Duke of Hesse, Ernst Ludwig.[43] The young Duke soon acted upon it by calling to Darmstadt a dazzling cluster of Germany's leading artists for the purpose of establishing a community in which the arts and crafts would flourish. A reciprocal relationship was to be established between the community (including industry), the court, an arts and crafts school (administered by the artists), and the artists themselves as independent designers working on commission. Among the first to be called, in the summer of 1899, were Peter Behrens, Patriz Huber, Paul Bürck, and Ludwig Habich, all from Munich. To these were added Hans Christiansen (originally from Hamburg, but at one time a student at the Arts and Crafts School in Munich), Rudolph Bosselt of Darmstadt, and, at that moment best known (for his exhibition hall for the Viennese Secession), Joseph-Maria Olbrich of Vienna.[44]

The artists were offered land at extremely reduced cost on the beautiful green parkland on a hill above Darmstadt, known as the Mathildenhöhe. On this lovely site they were to be allowed to construct homes for themselves of their own design, all costs to be advanced generously, with complete freedom to design everything from sidewalks to furnishings. Until then, the only building gracing the park was the jewellike, Russian-style Orthodox chapel built for Czar Nicholas II and his wife Alexandra, sister to the Grand Duke of Darmstadt-Hesse.

The plan included the construction of a central artists' building (the Ernst-Ludwig House), which would contain studios and workshops, exhibition space and quarters for unmarried artists. There were also to be

separate buildings for theatrical productions, graphic arts workshops, and for special exhibitions.[45] Arrangements were to be made with industry for the reproduction of craftwork designed by the artists, who were to receive reasonable payment for reproduction rights as well as the first sample produced. Commissions were expected to follow on the opening of the artists' homes to the public in the great exhibition arranged for the summer of 1901.

With remarkable speed and energy the plan was brought to fruition, and the colony, which had already been hailed as harbinger of a "new Weimar"[46] was opened to the public with pomp and ceremony on 15 May 1901. The exhibition's sumptuous catalog, officially known as the *Dokument Deutscher Kunst* (Document of German Art) designed by Behrens, was published by Alexander Koch.[47] Fuchs wrote the opening festival play, for which Behrens designed the costumes and directed the movements of the chorus.[48]

The Colony created a sensation. In four short years in Germany, the applied arts had progressed from a showing in a few crowded rooms in Munich's Glaspalast to a demonstration of total environment and community planning. Peter Behrens, the father of twentieth-century functional architecture and future teacher of Gropius, had designed his own house from ground plan "to the last porcelain plate,"[49] controlling every detail of interior and exterior design. Other members of the community had done likewise. Bosselt, Huber, and Bürck had designed their own apartments in the central building. Olbrich had designed his own house as well as one for Ludwig Habich and one for Hans Christiansen, which the latter (who already enjoyed a reputation as a colorist and expert

designer of stained glass) decorated in "uninhibited colors." By August, lengthy articles accompanied by many photographs of the buildings and their interiors, were being published in periodicals everywhere, including *Dekorative Kunst* in Munich.[50] In a stirring speech reprinted in the August issue of the magazine, Rudolf Bosselt called for a "new spiritual art for new times, one that is commensurate with our time, with our inner and outer life and which guides and forms it anew."[51]

Thus Phalanx, in its second exhibition, paid tribute to the latest demonstration of the strength of the arts and crafts movement. Bosselt's commemorative medallion of the Darmstadt exhibition was on display, as well as jewelry, small bronzes, and posters designed by him.[52] Hans Christiansen's carpets (produced by the famous Scherrebek Weaving School) captured the attention of the *Kunst für Alle* critic by their "splendid color" and "striking stylization" in design.[53] Christiansen also exhibited several embroidered linens, as well as thirteen vases. Among the embroideries were six cushions, probably the same six illustrated a few months previously in *Deutsche Kunst und Dekoration* (Fig. 56).[54] The sensual exploitation of surface and the degree of abstraction are characteristic of much Jugendstil design. Other Jugendstil artists, however, often surpassed Christiansen in this respect; for example, Behrens, in a carpet illustrated as early as 1898 in *Dekorative Kunst* (Fig. 57). In the second Phalanx show, Behrens displayed a silver box, while Huber exhibited jewelry and a cigarette box, among other items.[55]

It is quite possible that Kandinsky had visited the Darmstadt exhibition himself. Indeed, an incentive

may have been the special exhibition of Russian art from the Mir Iskusstva group of Moscow, included in the document exhibition by the Grand Duke in honor of his illustrious brother-in-law, the Czar of Russia.[56]

From his student days in Russia, Kandinsky had dreamed of an art that could surround one and become a total experience. He recalled in "Rückblicke" how these ideas had been inspired by a field trip into the primitive Vologda region. On entering a peasant's home, he had experienced a feeling he never forgot: "As I finally stepped into the room, I felt myself surrounded on all sides by the painting, into which I had therefore moved."[57] These "magic houses," he wrote, taught him to "move within the *picture*, to live in the picture."[58] He recorded that he had experienced similar feelings in Russian and Bavarian rococo churches.

Certainly he would have experienced analogous feelings in visiting the Darmstadt colony. The whole exhibition was geared to achieve the effect of total environment. Behrens' house was even decked out for the occasion with gigantic banners at the gate, high as the house, which had been designed by the architect himself (Fig. 58). Moving in the breeze, setting off reflections in the gleaming dark green tiles and the rich bronze decoration of the doorway (like "the sound of an organ," an *Orgelklang*, one observer reported), they must have enhanced the feeling of being engulfed by the environment.[59]

Kandinsky must have been deeply impressed, for not only did he invite these artists to exhibit with the Phalanx, but his involvement with the applied arts movement continued and became even deeper with the passage of time. Bosselt's inspiring call for a *neugeistige neuzeitliche Kunst* that would reflect and

form both the inner and the outer life found its echo in Kandinsky's later writings. *Über das Geistige* begins: "Every work of art is a child of its time, often it is the mother of our feelings."[60]

THE PHALANX SCHOOL

At this crucial moment in his Munich experience, Kandinsky suddenly seemed driven to demonstrate his ability in many different areas. He plunged into a veritable whirlwind of activities.[61] Besides the Phalanx society, he now undertook to organize a Phalanx school, to accept students himself, to travel more extensively, to exhibit outside of Munich, and to write.

The Phalanx school was established sometime during the winter of 1901-02. Freytag recalled how, "with characteristic daring and little forethought," they had plunged into the plan to form a private school, by renting a large studio building at Hohenzollernstrasse in Schwabing.[62] According to Freytag, the building housed six large, light studios on the first, second, and third floors. Hüsgen and Hecker, who already had sculpture students of their own, moved into the first-floor studios. Kandinsky's studio was on the second floor. Freytag, the medical student, gave instruction in anatomy for a time.

According to Carl Palme, the school followed a routine similar to most art schools: four hours in the morning and three in the afternoon of working from a model, with a two-hour evening session of sketching. One feature that was unique, however, was the intermittent substitution of a modeling class in the afternoons. "Kandinsky found this was a good discipline in order to work away from and up out of the outline."[63] The

modeling class is a typical example of Kandinsky's pedagogical talent and invention. It also further demonstrates his typical turn-of-the-century fascination with forms. In "Rückblicke," he recalled how impressed he had been with Stuck's talk about "the flowing together of forms," and of course Stuck, too, tried his hand at modeling and sculpture.[64]

In fact, Kandinsky's pedagogical talent manifested itself almost immediately in the fact that he soon had attracted more students than his colleagues.[65] Among these, sometime in the late winter or early spring of 1902, came a strong-willed young lady of considerable talent who transferred out of Hüsgen's sculpture studio into Kandinsky's painting class at about that time. This was Gabriele Münter (1877-1962), then twenty-five years old, who was to become a good friend and confidant of Kandinsky during the Munich years. It is her recollection of events that would seem to indicate that the Phalanx school was in operation by mid-winter of 1901-02 at the latest.[66]

Another innovation, according to Palme, was the institution of a special class in still-life.[67] This is substantiated by Münter's recollection that her first meeting with Kandinsky was in his still-life class.[68] He had set up a still-life "of glowing gaiety, wonderful to look at," and although she had scarcely used brush and paint before, she attacked the problem with a characteristic uninhibited freshness that immediately attracted the master's attention.[69] The fact that work from still-life was offered was also announced on the official school flyer, which stated that every eight days a still-life would be set up.[70]

Freytag, Palme, and Münter all have testified to Kandinsky's unusual pedagogical gifts. "The great artistic seriousness, the pedagogical aptitude and the human maturity of the man drew ever more eager students of art, so that in his classes great vitality always held sway."[71] Palme recalled that Kandinsky usually spent all day on Saturday with his students at the school, and ranked Kandinsky with Matisse as one of the most significant influences on his own development.[72] According to Eichner, Münter was especially struck by the "encouraging, individual" correction given by Kandinsky, who did not attempt to tear the student's work down, but instead encouraged the direction his or her particular talents seemed to lie, drawing attention to this or that which might be brought out, or indicating some artistic relationship the student might not have noticed.[73]

Brisch raised the question of why Kandinsky founded the Phalanx school when in fact he was financially well off, and had no real need to earn money by means of teaching. Both Freytag[74] and Palme[75] recall that Kandinsky was well-to-do and, in fact, that he bore most of the costs of the exhibitions and of the school. According to Brisch, Kandinsky was generously supported by his father during these years.[76] "The reasons for a teaching activity, then, lie much more likely in a real pedagogical interest, in a desire to spare would-be artists the disadvantages of the academies and other private schools."[77] Brisch related this teaching drive to that desire for change and innovation which may be seen also in his extraordinary exhibition activity at this time. Brisch also drew attention to Kandinsky's later activity as a teacher in Russia after the revolution and later at the Bauhaus.

That Kandinsky's pedagogical aptitude was inspired by a genuine consciousness of mission and responsi-

bility is reinforced by comments in a letter he wrote to Münter in October of 1903.[78] There Kandinsky expressed concern about his involvement in so many "outside" activities. He seemed torn between a sense of duty or responsibility to participate in life through teaching (he referred specifically to the Phalanx society and school) and a strong desire for an egotistical withdrawal into peace. Perhaps an artist *"needs* to be *vielseitig* (many-sided)," he wrote, or perhaps again it is peace that he needs. Apparently Kandinsky felt that he should make a decision but was unable to do so at that time. Indeed, he was to continue to participate actively in the life of the artistic community as educator, exhibitor, and critic for many years to come, and his writings attest to a genuine consciousness of mission in this respect.

PHALANX III
LOVIS CORINTH, WILHELM TRÜBNER

In its third exhibition in the spring of 1902,[79] Phalanx returned to the "fine" arts with an exhibition of works by two very well-known German artists: Lovis Corinth (1858-1925) and Wilhelm Trübner (1851-1917). According to the review in *Kunst für Alle*,[80] Trübner exhibited only a few small works, studies of horses and nudes. Trübner, who had been the subject of a major article by Hans Rosenhagen in the May 15 issue of *Kunst für Alle*, was then enjoying considerable prominence as a "genuine" German impressionist.[81] The more flamboyant Corinth was represented with a collection dating back to 1893. Corinth, who had been a founding member of the Munich Secession and then moved on to become a mainstay of the Berlin Seces-

sion, was among the most controversial of the "younger" German painters, both because of his preference for erotic subjects (especially Rubenesque nudes) and because of his sometimes slashingly free translation of impressionism.

Once again, this exhibition was a demonstration of Kandinsky's far-reaching connections as well as of his ambition. Already in April 1902, Kandinsky had arranged for a Phalanx exhibition in Wiesbaden at Banger's Kunstsalon.[82] Since Trübner resided in Frankfurt, near Wiesbaden, it is possible that arrangements for Trübner's participation in the Munich Phalanx show were made through Banger. But a personal connection is also possible.[83] In 1901, Ernst Stern of the Phalanx group had exhibited in the Berlin Secession. And in the summer of 1902 Kandinsky was represented with three works at the Berlin Secession. Both Corinth (who was then an officer of the Berlin Secession) and Trübner also exhibited at the Berlin Secession that year. But none of the three were represented in the Munich Secession of 1902.

PHALANX IV
AXEL GALLEN, ALBERT WEISGERBER

By mid-summer of 1902, the applied arts had returned to the exhibition rooms of Phalanx. The stars of the fourth Phalanx exhibition were the Finn, Akseli Gallen-Kallela (1865-1931),[84] and the young Stuck student, Albert Weisgerber (1878-1915). There were also a few sculptural pieces by Wilhelm Hüsgen and Ernst Geiger. *Kunst für Alle* noted that Weisgerber had created a considerable stir at the spring exhibition of the Munich Secession that year, and remarked on the versa-

tility exhibited in his poster designs and illustrations.[85]

In fact, Georg Habich, reviewing the Secession's spring exhibition (traditionally a show for young artists), had accorded the twenty-four-year-old Weisgerber "top billing."[86] Habich found Weisgerber's work astonishingly "sure and firm." Even more surprising to him was the fact that a man whose "element" appeared to be "free air and strong sunlight" could be a student of Franz Stuck. But he suggested that this was an indication of a good teacher and to Stuck's credit.[87] Weisgerber's works "reflect as much honor on the master as on the student," Habich wrote.

In all likelihood, Kandinsky knew Weisgerber from Stuck's studio. Purrmann recalled that Weisgerber was very poor and had to work for a living so that he could not paint at the studio daily. Nevertheless, Purrmann wrote, Weisgerber soon overtook them all.[88] In fact, Weisgerber had been awarded a prize by the Munich Academy in the 1901 Christmas competition,[89] and he soon became a regular illustrator for the periodical *Jugend*.[90]

But by far the most interesting exhibitor at this Phalanx show was Axel Gallen. Nearly the same age as Kandinsky, Gallen was already widely known for his paintings based on the Finnish folk epic, the *Kalevala*. Like his musical counterpart and contemporary, Jean Sibelius,[91] Gallen gave artistic expression to the rising tide of Finnish nationalism. His murals at the Finnish pavilion of the 1900 Paris World Exposition brought him a gold medal and international attention. But his work had been exhibited in Munich as early as 1898 by the Secession.[92]

Possibly that is where Kandinsky first saw Gallen's work, since it was included, along with that of other Finnish artists, in a special exhibition of Russian art at the Secession building on Königsplatz in May and June of 1898. The archaic stylization and emphasis on folk idiom of the Finnish painters, especially Gallen, was enthusiastically received. Gallen's powerful *The Fight for Sampo* was among those exhibited (Fig. 59).[93]

The *Sampo* painting may well have been among those exhibited at the Phalanx, since the *Kunst für Alle* reviewer mentioned the "compositions" from the Finnish *Kalevala* saga, which he found extremely strange due to their extraordinary mixture of "stylized and realistic elements." He suggested that these works would be better suited to "textile art," that is, to weavings and wall hangings.[94]

In fact, for some years Gallen had been engaged in creating designs for craft work. In 1894 he had moved to an isolated village in northern Finland to devote himself to mastering various types of craft techniques. He experimented with stained glass design, etching, woodcut, lithography, and designs for weaving and embroidery. Gradually he developed an individual style characterized by large areas of flat color and boldly outlined stylized forms.

The Phalanx exhibition of Gallen works represented a comprehensive selection of his work in all areas, including the applied arts. The reviewer particularly noted the "sureness in coloristic and linear abstraction" in some woven wall hangings. Some idea of the degree of abstraction achieved in Gallen's decorative work may be obtained by studying the embroidery in Figure 60.[95] Like some of the designs of Obrist and Endell, this is biomorphic in feeling yet cannot be immediately associated with any real object in nature.

Also included in the Phalanx exhibition were portraits and winter landscapes which the critic found most impressive.[96]

Among the *Kalevala* paintings exhibited, it is likely that, besides the *Sampo* painting (1896), *The Mother of Lemminkainen* (1897-99) was shown. Both of these exhibit stylistic or thematic elements that were particularly significant for Kandinsky. The "Sampo" of the *Kalevala* legend was a miraculous treasure forged by one of the heroes of the saga. Its defense against the forces of evil by the people of the *Kalevala* may be taken as a symbol of the defense of man's cultural progress.[97] Thus it was analogous in symbolic value, at the turn of the century, to the St. George and the dragon theme used in a similar sense by Crane and other painters of the period, including Kandinsky. The scene of Lemminkainen's mother lamenting his death and praying for his resurrection, with its eerie linear motif, symbolic of mysterious and magical forces, demonstrates the discrepancy between abstract and realistic elements noted by the *Kunst für Alle* critic (Fig. 61).[98] As in the case of Franz Stuck, it was this very freedom to combine such elements at will, for painterly effect, that was to affect Kandinsky so strongly.

Purrmann recalled in his memoir that of all the artists who exhibited at the Phalanx, Kandinsky told him that he gave most weight to "a Finnish painter, whom I found more extraordinary in the applied arts sense than artistically free: Axel Galen [*sic*]."[99] But Purrmann was to go a different way into twentieth-century art than Kandinsky.

For Kandinsky, folk lore and applied arts became stepping stones toward abstraction. In the realm of folk lore, as in the applied arts, combinations of the abstract and the real (or functional), and the uninhibited use of color and form symbols for pictorial effect seemed justifiable.[100]

PHALANX V, VI, VII[101]
CLAUDE MONET AS GUEST

In May of 1903, Kandinsky brought to the Phalanx an exhibition which demonstrated without a doubt his ability as an entrepreneur, as well as the degree of influence to which he had by that time attained.[102] The seventh Phalanx exhibit, at a prestigious Theatinerstrasse address, featured as guest artist, Claude Monet, with sixteen paintings.[103] Earlier that spring, Cassirer's salon in Berlin had held a large Monet retrospective and it is possible that Kandinsky obtained the Monet paintings for the Phalanx show either through his connections with the Munich dealer Littauer or perhaps directly from Cassirer.[104] Indeed, at least some of the paintings shown at Cassirer's may have been the same as those shown at Phalanx. Identical titles included *The Water Iris, Park at Monceau*, and *The Thames at London*. There were also two views of Vétheuil and a portrait of Madame Monet.

That the work of Monet had been an inspiration to Kandinsky before he ever set out to become a painter is known from his recollections in "Rückblicke." He recalled how his first sight of a Monet painting of a haystack at an exhibition in Moscow, had been a shattering experience for him. He could not at first recognize the object in the painting as a haystack. He felt humiliated. But the longer he worried over the problem in his mind, the more impressed was he that, despite his failure to recognize the haystack as a hay-

stack, the *painting* itself, as a painting, remained fresh and vibrant in his memory. Although at the time, he wrote, he could not draw the "simple consequences" of the experience, what was clear to him was the power of the palette, which had been hidden from him before. "Painting attained a fabulous power and splendor." In the next sentence of the recollection, Kandinsky goes on to say: ". . . unconsciously the object as an inevitable element of the picture was discredited."[105]

Thus, at this crucial point in his Munich career, when for the first time he was beginning to feel confident as an artist himself, and to demonstrate his skills in international exhibitions, it is highly significant that he should have been moved to bring a large Monet exhibition to Munich under the aegis of his own Phalanx society. One may surmise that, by that time, he had drawn the "simple consequences"; that, surrounded on all sides by a theoretical acceptance of "abstraction" in the "decorative arts," he now clearly recognized the expendability of the object in painting.[106]

That this may well have been the case is further substantiated by another recollection in "Rückblicke." It was in Munich, he recalled, that, returning to his studio one evening just at dusk, he was startled by the sight of an "indescribably beautiful painting, saturated with an inner glow." He recognized in it nothing but forms and colors. On moving closer, he then realized it was one of his own paintings standing on its side, against the wall.[107] Although this recollection is undated, a most suggestive passage in a letter of this period, just months after the Monet exhibit, enhances the possibility that the incident took place early in his Munich experience and quite possibly in relationship

to his Monet exhibition. In that letter he wrote that, in thinking about various artistic problems, he found certain things that are "theoretically ready." But the problem remained of finding a "suitable form."[108] The recollection in "Rückblicke" continued with the description of his attempts then to find a suitable substitute for the dispensable object. The search was to take him through years of experimentation.

The exhibition was announced to the public once again with a poster designed by Kandinsky. Picking up another favorite theme of Jugendstil design, the decorative illustration at the top of the poster depicted a winding stream with a row of graceful Viking ships, perhaps symbolic of the search for discovery on which the Phalanx artists were embarked (Fig. 62). Freytag, in his memoirs, recalled that the greatest event precipitated by the show was the visit to it by the Prince Regent of Bavaria, Luitpold, himself.[109]

Monet was not the only participant in this show. Kandinsky was represented with six works.[110] Hecker and Hüsgen of the Phalanx exhibited, as well as Philip Klein (1871-1907), Hermann Schlittgen,[111] and John Jack Vrieslander, a graphic artist, with forty-four works.[112]

PHALANX VIII
CARL STRATHMANN

Another artist whose works were exhibited by the Phalanx was Carl Strathmann (1866-1939), at once humorist and colorist, an "original" of his time, as Corinth called him.[113] Thirty-one works by Strathmann were shown at the eighth Phalanx exhibition, November to December, 1903. In the same show were thirty-two works by the graphic artist Heinrich Wolff (1875-1940), who was already well known in Munich for his

school for graphic arts. A portfolio published by Julius Meier-Graefe at his "Maison Moderne" in Paris, titled *Germinal*, containing lithographs and color woodcuts by German and French artists, was also on display. The album included prints by Bonnard, Brangvyn [*sic*], Carrière, Degas, Denis, Van Gogh, Toulouse-Lantrei [*sic*, Lautrec], Liebermann, Renoir, Rodin, Van Rysselberghe, Stremel, Toross [*sic*, Toorop], Vuillard, Ganpuin [*sic*, Gauguin], Mueller, Zuloaga, Behrens, Minne, and Valloton [*sic*]. Max Arthur Stremel (1859-1928), Munich artist, also exhibited several other works.[114]

As noted by the Munich critic Georg J. Wolf, the Strathmann exhibition represented a retrospective collection, including oils, watercolors, and charcoal drawings.[115] With his mosaic, Byzantine luminescence, and his uninhibited, capricious imagination, Strathmann represented another step in the path toward abstraction. He, too, was more *Kunstgewerbler* (craftsman), than painter, illustrating for the *Fliegende Blätter* and *Jugend*, as well as turning out Jugendstil vases and tapestries.[116]

Strathmann had been working and exhibiting in Munich since the early nineties, and his work would have been well known to Kandinsky. In his pamphlet *Um die Schönheit*, of 1896, Endell had commented that Strathmann's "ornamental talent is nearly inexhaustible. He brings new forms unceasingly. . . . One laughs over him," wrote Endell, "one would do better to study him intensively."[117] It is indicative of Kandinsky's perceptiveness and sensitivity that he accorded Strathmann the appreciation he deserved at a time when other critics were complaining that Strathmann ought to channel his talents in a more "serious" direction.[118]

Strathmann was, in fact, a remarkable artist. He combined the humor of a caricaturist with the serious approach to media of a true craftsman. Yet, often as not, he sacrificed compositional clarity to a veritable orgy of Jugendstil grotesqueries. His paintings were densely woven tapestries of jewellike colors, sometimes indeed obtained by the use of actual "jewels," a "mixed media" technique unique at the time. His *Salambo*, of 1894, glittered all over with colored stones "glued or sewn" onto the canvas.[119] The painting was even banned from major painting exhibitions that year because it was, according to the juries, a work of craft, rather than of "fine art."[120] Another example of Strathmann's unusually decorative approach was the painting *The Cranes of Ibykus*[121] in which the cranes were painted in goldleaf.[122] In Strathmann's work, abstract decorative qualities always took precedence over subject matter (cf. Figs. 10, 63).

PHALANX IX

ALFRED KUBIN

The ninth Phalanx exhibition a few weeks later, in January and February of 1904, introduced an even more exotic artist to the Munich public: Alfred Kubin, whom Kandinsky was to call a "clairvoyant of decadence,"[123] and whose works forged links between the exhibitions of the Phalanx, the Neue Künstlervereinigung,[124] and the *Blaue Reiter*.

Kubin had been in Munich since 1898. Quite possibly it was his early acquaintance with Ernst Stern, Alexander von Salzmann, and Albert Weisgerber (all Stuck students and Phalanx exhibitors) which led to his association with Kandinsky and the Phalanx. In 1901-02 Kubin had been allied with them in a group

called the "Sturmfackel" (literally "Stormflare"), which met at a café in Schwabing.[125]

But Kubin's reputation had been growing, too. His first exhibition at Cassirer's in Berlin in the winter of 1902 had perhaps attracted only connoisseurs of the fantastic, though at least one reviewer compared his work to the *Caprichos* and the *Tauromaquia* of Goya.[126] But a young publisher, Hans von Weber, had been so struck by the "demonic something"[127] in Kubin's works that he determined to publish a portfolio of them. When the portfolio actually appeared a year later[128] it received an unusual illustrated review in *Kunst für Alle* by Arthur Holitscher.[129] Holitscher extolled Kubin as an artist beyond the petty limitations of any one era, whose suffering created convincing form "out of his innermost being."[130]

It is hardly surprising then to find Kubin described as the "main attraction" at the ninth Phalanx exhibition almost exactly a year after the appearance of the portfolio.[131] He was then only twenty-seven years old, yet as Holitscher had noted, his style was already "mature." Except for increasing density, neither his style nor his métier was to change much over the years. "The dream is a powerful magician," he once wrote[132] and, indeed, he was early described as a "dream artist."[133] But his dreams were nightmares. Kandinsky's appreciation in *Über das Geistige* was more to the point: "With invincible force we are drawn into the ghastly atmosphere of a hard void. . . ."[134] By that time Kubin's "clairvoyant" novel of decadence had appeared, *Die Andere Seite* (*The Other Side*), in which the hero dreamed of an art of "psycho-graphics": "a fragmentary style more calligraphic than drawn [which] expressed the slightest alterations of my mood like some sensitive meteorological instru-ment."[135] Kubin's work was another signpost along Kandinsky's way toward abstraction, and it was set by 1904.

While judging that Kubin's art "cannot be analyzed," the *Kunst für Alle* reviewer found Kandinsky's works the "freshest offerings of the collection" at the ninth Phalanx. Kandinsky himself showed a group of ten color drawings and three woodcuts. Perceptively enough, the reviewer noted the relationship between the tempera drawings on black cardboard and the woodcut medium when he remarked that the color drawings raised hopes that a series of color woodcuts would be forthcoming.[136] In fact, many of the color drawings were then transformed into woodcuts which were exhibited at a subsequent Phalanx show.[137]

Most of the other exhibitors at Phalanx IX seem to have been experimenting with neo-impressionism since the reviewer's response was that someone might also "invent a painting machine" to thus "draw the last consequences of impressionism" (a tired expression which was a commonplace of contemporary criticism).[138] Of these, H. J. Wagner (1871-?) was another Stuck student, who later did murals for the German embassy in Leningrad designed by Peter Behrens.[139] Another was Carl Palme, the Swedish painter and student of Kandinsky,[140] whose memoir of the Phalanx School has been previously cited.

PHALANX X
NEO-IMPRESSIONISTS

The tenth and eleventh Phalanx exhibitions appeared simultaneously in April and May of 1904. But it was the tenth that represented once and for all the international stature to which Kandinsky himself aspired:

Paul Signac, Theo van Rysselberghe, Vallotton, and Toulouse-Lautrec were among the artists whose works were shown under the Phalanx sign at Theatinerstrasse 15. The then very well-known Belgian craftsman Georges Lemmen also exhibited.[141]

But neo-impressionism was still "hyper-modern" and "experimental" in Munich.[142] Once again the *Kunst für Alle* critic found it an art "based on a mechanically reproductive activity." While noting that Signac's work approached the effects of mosaic, he yet found it too "barren." Vallotton he found more interesting.[143]

PHALANX XI
THE GRAPHIC ARTS

Not surprisingly, the critic found the twin Phalanx exhibition at Helbing's Salon in Wagmüllerstrasse "much more exciting." Phalanx XI was a rather large graphics exhibition which included collections representing various Munich graphics societies.[144] Among the artists represented were Franz Hoch of the Scholle, who had previously exhibited in the first Phalanx show, and Rudolph Schiestl (1878-1931), who had also been a Stuck student. Kandinsky himself exhibited seven romantic woodcuts to which the critic this time responded with the compliment that "many harmonies [of Kandinsky's] especially light-blooming colors in all gradations . . . recall Whistler in fineness of tone."[145] Among the prints were two of Kandinsky's best: *Strolling Lady* (also known as *Night*) and *Farewell* (Fig. 67, Pl. 1), both of 1903.

Perhaps most interesting from the point of view of Kandinsky's later development was the fact that a Frau M. Buschmann-Czazek [*sic*] exhibited. This was in fact Mechthild Buschmann-Czapek, whose husband, Rudolph Czapek (1871-1935), was to write a book that would have significant repercussions in Kandinsky's still later writings.[146] Kandinsky's friend Georg [*sic*] Treumann (to whom he was soon to turn over the leadership of the Phalanx) also exhibited.[147] The other exhibitors included J. Brockhoff (1871-?), with Ernst Neumann and Heinrich Wolff, among the best known of Munich's graphic artists;[148] August Braun (1876-?), a student of Ernst Neumann; and Paul Neuenborn (1866-1913), known as an animal painter.[149] Another woman graphic artist exhibited, Martha Wenzel (1859-?), as well as Hans Neumann (1873-?), and one Braunmüller (who was probably Georg Braumüller, another student of Ernst Neumann).[150]

KANDINSKY AT THE KUNSTVEREIN

Despite the fact that he was preparing to leave Munich in the fall of 1904, in order to travel, Kandinsky maintained a fever pitch of activity and in July exhibited with his friend Treumann at the Kunstverein, which had hitherto been closed to him.[151] Kandinsky showed some twenty works which once again met with some misunderstanding in the pages of *Kunst für Alle*, where they were called "impressionist studies."[152] On the other hand, the same reviewer followed with the perceptive remark that Kandinsky's method was to "work all the light areas up out of great darknesses—he sees things as in a black mirror."[153]

PHALANX XII AND FINIS

Although Kandinsky had written of plans for Phalanx exhibitions in Krefeld and Düsseldorf during the winter of 1904-05,[154] the last Phalanx show documented

in the pages of *Kunst für Alle* took place in Darmstadt in December of 1904.[155] Kandinsky showed together with the graphic artist Heinrich Wolff (who had exhibited in Phalanx VIII) and the Munich landscapist Karl Küstner (1861-?). Though not enthusiastic about Kandinsky's work, the Darmstadt reviewer admitted it demonstrated a "strong original talent."[156]

Thus ended the brief but vigorous life of the Phalanx. Though it scarcely caused an earthquake on the Munich artistic scene, it did create tremors and in many ways forecast the great *Blaue Reiter* exhibitions a decade later. The eclectic character of the Phalanx exhibitions; the interest in theater, with so many exhibitors also involved in the Elf Scharfrichter (the theatrical masks presaged the Egyptian shadow puppets in the *Blaue Reiter* almanach); the discovery of Kubin; the appreciation of graphics, and of the arts and crafts— all were crucial to Kandinsky's artistic development, and became as well facets of the *Blaue Reiter* exhibitions.

CHAPTER

·VII·

The Critic and Exhibitor

BEYOND his activity as entrepreneur, teacher, and practicing craftsman and artist, Kandinsky now added another role—that of critic. In the summer of 1902, while in the midst of arrangements for the fourth Phalanx exhibit, and while spending at least part of his time at the summer resort of Kochel am See with his students, Kandinsky wrote a review of Munich's major summer exhibitions for the elite Russian art periodical *Mir Iskusstva* (*World of Art*). This review set a precedent for Kandinsky's activity as a critic, which was resumed in 1909-10 with a series of five reviews for another Russian journal, *Apollon.*[1]

The review reveals a number of interesting facts about the writer, in particular his obviously keen awareness of the Munich art scene. It reveals plainly that he had followed the exhibitions of the Secession and Glaspalast regularly since his arrival in Munich, for he was able to evaluate the progress of various artists on the basis of past experience. We also learn that he was well aware of the competitive relationship between Munich and Berlin; 1902 was the year of the great debate over Munich's "decline" as a city of art. Further, it suggests again his deep seriousness regarding artistic matters, a clue to his own seemingly slow development, and affirms the inborn sensitivity to color described later in "Rückblicke."

Kandinsky began his review with the observation that the Secession had this year determined to do its "best": "perhaps mainly as a result of the competition with Berlin for the title of *Kunststadt.*"[2] The year 1902 was fateful for Munich. A storm of protest had arisen over a provocative statement by the Berlin art critic Hans Rosenhagen implying that the position of Munich as a great city of art was now being seriously threatened by upstart Berlin.[3] By February of 1902, the results of a questionnaire on the debate submitted to thirty-three artists and critics had been published in Munich.[4] Among others, Stuck, Lenbach, Obrist, Hermann Bahr, and Rosenhagen himself contributed their opinions on the subject. The new president of Munich's Artists' Society, Hans Petersen, even offered figures indicating a steady increase in income from the annual Glaspalast exhibitions; in 1901, it stood at 770,000 marks! Some pungently remarked that artists, not cities, make art (Lenbach). Others pointed proudly to the fact that artists who had studied in Munich had been called to teaching posts all over Germany. Some, such as Obrist, declared that Munich's casual attitude toward art had in fact acted as a positive force in spurring greater efforts. Georg Hirth, publisher of the powerful Munich paper (*Münchener Neueste Nachrichten*) and editor of *Jugend*, pointed to Munich's "Jugendstil" as not so much a style as the very "principle of freedom." The Müncheners had gained points from a speech delivered by the Kaiser the preceding December (at the opening of Berlin's

Siegesallee) in which he had attacked all modern art for having descended "into the gutter."[5] All in all, it was a passionate debate, and Kandinsky himself took sides, writing later to Münter that he much preferred "our old Munich" to militaristic Berlin.[6]

Yet Kandinsky remarked nevertheless that the former pioneers of the Secession seemed each year a little more faded. Only Ludwig Herterich, he felt, had continued to apply himself to new problems.[7] As an example of general stagnation, Kandinsky cited the fact that the popular Spanish painter Ignacio Zuloaga had not been seen at the Munich Secession until that year.

Zuloaga (1870-1945) was then enjoying an immense popularity throughout Europe with his exotic portraits of Spanish dancers, actresses, and bullfighters. His dramatic flair led to rather untenable comparisons with Goya and even Velazquez. But Kandinsky was not exaggerating when he referred to the *Portrait of the Actress Consuelo* in the 1902 Secession as "world-renowned."[8] Although Kandinsky did not indulge in further discussion of the painting, remarks by Pascent in *Kunst für Alle* give a clue to Zuloaga's attraction for Kandinsky and many other young artists. Pascent found the portrait "infinitely free and light," and expressed amazement that the composition worked so well despite its "revolting" color ("beyond beauty and ugliness," as he put it), and despite its apparently sloppy technique (one could observe the red of the dress through the body of the dog, he wrote).[9] He predicted, somewhat facetiously no doubt, that many artists who were not academically minded would find inspiration in Zuloaga's work.[10]

Kandinsky also singled out Antonio de la Gandara (1862-1917) as another outstanding "first" for Mu-

nich.[11] Gandara was another facile young artist who was then modish. It was perhaps possible to see a touch of Whistlerian economy and elegance in the *Portrait of M. Escudier*. But the same could scarcely be said for *The Sleeping Young Woman*, which Kandinsky also mentioned.[12] Nonetheless Gandara's piquant mannerism must have seemed refreshing compared to the heavily realistic nudes of such popular Munich painters as Hugo von Habermann.

Devoting his opening comments to the foreigners in the exhibition, Kandinsky characterized Ménard, Cottet, Blanche, Aman-Jean, and Besnard as "first-rate Frenchmen." He was particularly struck by Cottet's large *Procession*, which, he wrote, "was molded upon a contrast of a whole symphony of vivid color spots (figures in Bretagne costumes, gonfalons [banners] in the sunlight) against calmly generalized shadows in which the figure groups on the side and the entire rear landscape were submersed. . . ."

The colorful peasant costumes attracted Kandinsky, who was fascinated by the variety of forms, patterns, and colors of folk art and who was exploiting these elements in his own work at the time. Further, the reliance on spots of bright color and light-dark contrasts as formal structural elements to sustain the composition also attracted Kandinsky, since his own work of this period displayed a similar use of color and contrast.[13]

Kandinsky referred to Aman-Jean's *The Fan* as a "marvelous little canvas (a bright lady with a black fan)," again revealing his sensitivity to contrasts of light and dark. George Sauter, the anglicized German painter, also attracted with a Whistlerian composition in gray and black entitled *Morning Conversation*. Here Kandinsky's tone was faintly sarcastic as he

noted that Sauter had achieved an "absolute harmony" by not introducing a single color outside of grayish white and black. His appreciation of genuine traditional values in painting is apparent in his assessment of two works by the elderly Hans Thoma, *Herd of Goats* (which he noted had been reproduced in *Mir Iskusstva*, 1901, no. 8-9) and *Summer Landscape*. These, he wrote, were "aptly described by the German word *echt* [honest]."

Turning to the German artists, Kandinsky also took note of the strained relationship between the Berlin Secession and the Munich Secession, which within the year was to come to an open breach (precipitated by the argument over Munich's "decline").[14] He mentioned especially "two good things" by Leistikow and "not too bad a piece" by Ludwig von Hofmann, both Berlin "symbolist" painters. Leistikow was known for his highly stylized, enigmatic landscapes. Von Hofmann specialized in dreamy idylls inhabited by nymphs and shepherds.[15] Some of these idylls had been shown at Phalanx earlier in the year.[16]

Of the Munich artists, Kandinsky had most to say about the young painter Hans R. Lichtenberger (1876-1957). "His unusual love for 'painting,'" Kandinsky wrote, "fell upon the fertile soil of an amazingly fine feeling for proportion and a clear grasp of the meaning of a colorful spot. His *interieurs*, pure examples of intimate painting, are a source of gratification for a real gourmet of color." Again, it was the color itself and the "color spot" which attracted Kandinsky.[17]

As for his former teacher, Franz Stuck, Kandinsky noted that his portraits had gone "commercial" in recent years, but was favorably impressed with the great double portrait of Stuck and his wife which the "painter prince" had submitted that year (Fig. 46). (Indeed,

it had caused something of the sensation that Stuck in his heyday had customarily aroused. Pascent noted that Stuck had had the originality to paint "only good Stucks" this year.)[18]

In his review of the exhibition at the Glaspalast, Kandinsky provided a keen portrait of the gigantic annual show:

The huge building, which contains 75 halls of various sizes, is so carefully shaded inside from the light that, when on a grey day you wander about in this labyrinth, you ask yourself: why was it built out of glass from the foundation up to the roof? But in our times it is easier to shield oneself from the sun in a glass building than to escape from the "fresh air" in art.

He also described the numbing effect of the vast scale of the exhibition: "Sometimes you can't even tell at once whether something is beautiful, and you are like a person who, jumping into cold water on a hot day, is unable to determine how cold the water is."

But the room occupied by the Scholle group caused a shudder. One of a series of murals for a music room by Fritz Erler captured Kandinsky's attention by its "breath-taking contrast between the huge white spot . . . and the narrow strip of the dark indigo sea; between the grey sky over which stretch dark grey clouds in the form of huge wild ducks, and a bright yellow cage with a yellow canary which seems to be suspended from the sky."[19] But Kandinsky attacked the artist for his "deliberate" originality; the painting was too much of a *tour de force* for him. He also objected vigorously to the fact that Erler's fame seemed to rest on the rumor that he had painted this canvas in a week.

"I don't know why this should make anybody happy . . . ," Kandinsky wrote. "Böcklin said that a true picture 'should appear as a huge improvisation.' I would like to add that it absolutely doesn't make any difference whether this picture was created in eight days or eight years. . . ." Here we find the startling revelation that Kandinsky was wholly conscious of one of his major goals in painting at this early date. Years later, in *Über das Geistige*, in a crucial discussion of the relationship between form and content in the work of art, Kandinsky again cited the quotation from Böcklin.[20] In this critique of Erler, Kandinsky was also concerned with content, for the lack of it in such a major work disturbed him. Haste, he suggested, had caused Erler to "build his house upon sand." But, he wrote, "there is nothing more revolting and harmful than these technical and forced modes. A true temperament cannot be falsely created by tricks." In *Über das Geistige*, in the same section cited above, Kandinsky was to write, *"The artist must have something to say, for his task is not the mastery of form, but rather the suiting of this form to the content."*[21]

As an example of "true temperament," he cited a work of simple illustrative realism by Reinhold Max Eichler.[22] Kandinsky appreciated Eichler's simplicity and naïveté: "In his work, true poetry usually walks hand in hand with a subtle and good-natured humor; [these] are not invented but have risen naturally out of pure love for nature" (Fig. 64).[23]

Kandinsky was also attracted to the work of Walter Georgi (1871-1924), another Scholle member (and illustrator for *Jugend*, as were all the Scholle painters). His description of a decorative frieze by Georgi emphasized the way in which the artist had exploited color for effects of mood.

In the remainder of the exhibition, Kandinsky found little of interest, only giving Lenbach an appreciative comment in passing as "a venerable master." He ended with an attack on the vast numbers of "shameless imitations" of such "masters" as Dill, Zügel, and Böcklin.

This rather detailed analysis of Kandinsky's "Correspondence from Munich" of 1902 indicates quite clearly his thorough familiarity with Munich art and artists. It also reveals his sensitivity to formal problems of composition, color, and imagery, as well as to the element of "honesty" in art which was to be of such concern to him. The fact that he was in the habit of visiting the annual Secession and Glaspalast exhibitions can be read between the lines, and is a factor that becomes increasingly interesting in stylistic and thematic discussions of his early work.[24] But perhaps most interesting is the possibility of observing what Purrmann described in his memoirs as "the battle between talent and intellect, that played itself out [in Kandinsky]." It was a battle, Purrmann wrote, that was both "shattering and magnificent."[25]

KANDINSKY AS EXHIBITOR

The year 1902 was also the one in which Kandinsky began to exhibit independently outside of Munich. Three of his works were hung at the fifth exhibition of the Berlin Secession in the summer of that year.[26] Also exhibiting in the same show were various artists whose works had been shown, or were later to be exhibited, by the Phalanx. Among them were Paul Baum, Lovis Corinth, Wilhelm Trübner, Hermann Schlittgen, and Carl Strathmann. Corinth, whose work had been shown at the Phalanx the previous May and June, was then on the board of the Berlin Secession. Thus even

at this early date, it is apparent that Kandinsky had successfully established relations with important people in the art world.

The intrepid Berlin critic, Hans Rosenhagen, also reviewed this exhibition for *Kunst für Alle*.[27] Rosenhagen was not only intrepid, he was facile. It didn't seem to matter much to him what he said, so long as it was said with flair and a certain amount of "artistic" ambiguity. Thus his abbreviated comment on Kandinsky: "Wassily Kandinsky (Munich) imitates, not without success, the Spaniard Anglada."[28]

Though indeed, Anglada (1872-?), like Zuloaga, had recently come into fashion, it is very doubtful that Kandinsky had yet seen his work.[29] On the other hand, the comparison was not entirely without merit. Kandinsky's *Bright Air*, with its light-crinolined ladies in a sunny park had certain thematic and even structural affinities with Anglada's paintings of similar motifs. Indeed Anglada, too, was a "gourmet of color," and used it nonrealistically as a compositional device. Nevertheless, in such Anglada works as *The White Peacock* or *Evening Party*, the subject matter is always identifiable as contemporary, whereas Kandinsky at this period, in paintings such as *Bright Air*, chose nostalgic or "timeless" themes, often selecting motifs from bygone centuries; Biedermeier ladies or medieval knights.[30] Even his landscapes, such as *Old City*, shown at this exhibition, were removed from reference to daily life. *Old City* was in fact a view of the ancient town of Rothenburg-on-the-Tauber, noted for its picturesque medieval walls and turrets.[31] Sometimes Anglada, too, chose a nostalgic theme, as in his *Spanish Peasants from Valencia* (Fig. 65). Then a closer comparison might be made, for example, to Kandinsky's *Riding Couple*, of about 1906-07 (Fig. 66), where the

spotting of the color also results in a rich mosaic effect.[32] But a painting such as Anglada's impassioned, one might even say "expressionistic," *Gypsy Dance*[33] was far removed from any of Kandinsky's contemporary work.

Ironically, it may have been this exhibition at the Berlin Secession that prevented Kandinsky's works from being shown subsequently at the Munich Secession. For, as has already been mentioned, the quarrel over Munich's "decline" soon resulted in an open, and bitter, breach between the two groups. Members of one were urged to withdraw from the other and cooperation was virtually extinguished for some years.[34] Meanwhile, Kandinsky continued to exhibit at the Berlin Secession. He was thus possibly a victim of the great dispute.

However, by 1903, he was exhibiting independently in Odessa as well as in Berlin, and within the next few years had expanded his exhibition activity as far afield as St. Petersburg (1904), Rome (1904, 1905, 1907), Moscow (1904, 1905), Hamburg (1904, 1905), Dresden (1904, 1905, 1907), Paris (1904-1909), Prague (1906), Warsaw (1905), Vienna (1905), etc.[35]

In 1905, his work at the second Deutscher Künstlerbund exhibition was compared to that of Amandus Faure, who, it was said, painted in a "posterlike" fashion. Kandinsky's work was distinguished by an "oriental" flavor and a "rosy, at times also garish color."[36]

The same year, his work was selected for special consideration in a major article on graphics by Wilhelm Michel in *Deutsche Kunst und Dekoration*.[37] "Wassily Kandinsky reveals his Russian heritage in the stylization and adventurous, almost stained glass quality of color in his prints," wrote Michel. "Greater dexterity in the mastery of the material will doubtless

later add much to an intensification of vitality in his drawing."[38] Reproduced in the article were two of Kandinsky's earliest woodcuts: *The Songstress* and *Promenade* [*sic*] both of 1903.[39] Other artists mentioned in Michel's article included several who had exhibited at the Phalanx: August Braun, Hans Neumann, Martha Wenzel, and Georg Braumüller.[40]

Thus we have seen that already by the early years of the century, Kandinsky as critic and exhibitor was reaching a wide European audience. His immense activity in those years was remarkable, but it was accompanied by an equally immense inner turbulence. This "drive to activity" or *Tätigkeitsdrang*, as Brisch so aptly called it,[41] worried him and caused great inner suffering, which he expressed in letters to Münter. He felt torn between his responsibilities as a teacher and his responsibility to his own art. He even worried at the beginning that he might turn out a "dealer" rather than an artist.[42] Nevertheless all this activity bore fruit, for by the time he founded the Neue Künstlervereinigung München in 1909 and settled down in Murnau, his reputation and status as a leader of the avant-garde had been established, a measure of inner peace had returned; the manuscript of *Über das Geistige* was nearly complete, and the way to the breakthrough lay straight ahead.

PART THREE

THE SYMBOLIST MILIEU:
SEARCH FOR
INNER SIGNIFICANCE

The Stefan George Circle

JUST as the arts and crafts movement left its imprint on Kandinsky, so too did Munich's symbolist milieu. Indeed, without taking this vigorous and significant movement into consideration, a full evaluation of Kandinsky's early work can scarcely be made. Not only did he have direct and indirect contacts with symbolist writers and artists in Munich, but in his own works, literary and artistic, demonstrated clear stylistic and thematic associations with them. He also shared with them the enthusiasm for a *geistige Kunst*, a spiritual art, and a belief in an epochal renewal of life through art. Two aspects of Munich's symbolist movement were of particular significance for Kandinsky: the symbolist poetics of the Stefan George circle, and the movement for a symbolist revolution in the theater spurred by Peter Behrens and Georg Fuchs.[1]

When Kandinsky concluded *Über das Geistige* with a prophecy of a "new spiritual realm" and a dawning "epoch of the great spiritual,"[2] he reasserted thoughts expressed two decades before by the poet Stefan George. In 1892, George had introduced the first issue of his periodical *Blätter für die Kunst* with a call to a "spiritual art on the basis of a new manner of feeling and doing" and a confession to a belief in a "splendid rebirth" in art.[3] Though at first devoted to the slogan, "art for art," *Blätter für die Kunst* gradually transformed the idea of *geistige Kunst* from associations with flight from reality to the idea of "an active power,

which would regenerate and lead the world."[4] For Kandinsky, too, the *Geistige* in art had become an active force. The true work of art, he wrote, "lives, is effective, and is active in the creation of the . . . spiritual atmosphere."[5]

By the turn of the century, Stefan George (two years younger than Kandinsky) was already hailed as a savior of German poetry and "priest of the spirit."[6] Indeed, linguistic prodigy that he was (before the age of ten, he had invented his own language), George probably did more for the German language than any poet since Goethe or Heine.[7] George had already served his apprenticeship at the salons of Mallarmé by the time he founded the *Blätter für die Kunst*, modeled on such symbolist reviews as the French *Mercure de France* and the Belgian *Floréal.* During a stay in Paris in 1889, George had been introduced into Mallarmé's Tuesday evenings and to a circle of poets that included Verlaine, Henri de Régnier, Jean Moréas, and Villiers de l'Isle-Adam. He also met the Belgian and Dutch symbolist poets Emile Verhaeren and Albert Verwey. He absorbed the works of Rimbaud, Poe, and Baudelaire (whose *Fleurs du mal* he soon translated), and his travels took him as far as England where he learned of the English Pre-Raphaelite poets, Rossetti and Swinburne, and the symbolist Ernest Dowson. Profoundly affected by the symbolist movement then little known in Germany, he returned to

the Rhine with a messianic vision of single-handedly revivifying German poetry.[8] His early poetry was to meld elements of French symbolism, English Pre-Raphaelitism and German romanticism. It was, in effect, to become Jugendstil poetry par excellence.[9] By sheer force of personality and genius, he had soon gathered disciples and set about systematically to spread his gospel, spending a part of each year in Munich, Berlin, Heidelberg, and Bingen (his parental home). His faithful band soon became known as the *George-Kreis*, or circle.

In Munich, the center of this circle, and one of George's earliest and most faithful apostles, was Karl Wolfskehl (1869-1948), himself a dynamic personality of prodigious learning and talent.[10] It would be difficult to exaggerate the significance of Karl Wolfskehl for the life of Schwabing in those years. Known as the "Zeus of Schwabing,"[11] Wolfskehl exercised an almost "magic" attraction on Munich's Bohemia.[12] His home, first in the Leopoldstrasse and later in the Römerstrasse, became Munich's most famous salon, remaining at the center of Munich's intellectual and cultural life until well into the twenties.[13] Visitors included poets, artists, musicians, philosophers, scholars, in short, representatives of the whole cultural spectrum: Martin Buber, Heinrich Wölfflin, Rainer Maria Rilke, Peter Behrens, Hugo von Hofmannsthal, Albert Verwey, Stefan Zweig, Thomas Mann, Ricarda Huch, Adolf Hildebrand, and many others of equal renown.[14] There George came to confer with his disciples, and there for many years the Wolfskehls kept a room available for their peripatetic friend, who was soon known as *Meister* (Master) even to his intimates.

It should not surprise us then to discover that Wassily Kandinsky was among the Wolfskehls' visitors. In-deed, the relationship between Kandinsky and Wolfskehl became quite close and lasted over a number of years, from soon after the turn of the century until even after Kandinsky's departure from Munich. In a letter written long after, from the Bauhaus, to Hanna Wolfskehl in Munich, Kandinsky concluded with greetings to Karl, indicating that he still thought fondly of him. The letter read in part: "The old times—Ainmiller-Römerstrasse—I still have in good memory. Those were in general good, exciting, hopeful times that promised more than has been realized 'til now. . . ."[15]

Actually, however, the relationship to Wolfskehl extended further back, before Kandinsky had taken the apartment in the Ainmillerstrasse, which was around the corner from the Römerstrasse.[16] An early document indicates their acquaintance may have dated from 1907 and perhaps earlier. In an undated letter to the Dutch poet Albert Verwey, Hanna Wolfskehl described the guests at their recent *Fasching* festival: ". . . the dark Sacharow [sic], the light Alastair, the gray-headed Ricarda—then Kandinsky, whose face always seems to me anyway a countenance [full] of interesting Chinese acuteness and refinement, the great Wölfflin . . . Karl looked quite Assyrian!"[17]

The fact that Hanna Wolfskehl referred to Kandinsky in this letter so casually and familiarly, would indicate that this was not the first time she had seen him.[18] Another early documentation, firmly dated 31 December 1911, is a letter from Kandinsky to Wolfskehl in which, again, the whole tone is on a level of familiarity such that previous acquaintance must be inferred.

The likelihood of an earlier relationship between Kandinsky and the George circle increases as other circumstances are considered. Alfred Kubin, whose

works were exhibited by the Phalanx in January and February of 1904, was in fact a protégé of the George circle, having been "discovered" by the poet Max Dauthendey, who was intimately associated with the George circle in the early years.[19] Dauthendey introduced Kubin to his friends, including the publisher Hans von Weber, and Oskar A. H. Schmitz, then one of Munich's best-known writers and also an associate of George and Wolfskehl.[20] In the same year that his symbolist novel, *Die andere Seite*, was published (1909), Kubin undertook a trip into the Balkans accompanied by Karl Wolfskehl, who by that time had become a good friend.

Other artists who had ties with both the Phalanx (and hence, Kandinsky) and the George circle were Hermann Schlittgen and Peter Behrens. Schlittgen, who exhibited with Phalanx in May-July 1903, had provided art work for the *Blätter für die Kunst* and was a frequent guest at the Wolfskehls'.[21] Peter Behrens, whose association with Kandinsky dates from the second Phalanx exhibition in 1902, was acquainted with the Wolfskehls by 1900.[22] Wolfskehl was also a close friend of Hermann Obrist, whose association with Kandinsky began in the earliest days of the Phalanx School.[23]

Thus it can be seen that Kandinsky had social contacts with the Stefan George circle as early as 1903 or 1904. There can be little doubt that he knew of their well-publicized meetings and that he read their publications. That the relationship with Wolfskehl grew to a close personal association can be seen in later documents.

A memoir by a young friend of the Wolfskehls indicates that as early as 1910, Kandinsky's paintings were on view at the Wolfskehl residence. Marie Buchold, who arrived as a student in Munich in 1910, lived from time to time at the Wolfskehl's home, where she had the opportunity of observing the George circle at close range. She recalled that Kandinsky "was allowed to hang his paintings [there]" and that these were observed with some admiration and much "head-shaking."[24] The George biographer Edgar Salin also recalled that paintings by Kandinsky, Klee, and Marc were to be seen at the Wolfskehl residence.[25]

A letter from Kandinsky to Wolfskehl of December 1911, in the midst of the first *Blaue Reiter* exhibition, reveals not only his sympathetic concern for his friend Franz Marc, but also the intimacy of his relationship with Wolfskehl.[26] In an effort to arrange a sale of Marc paintings to the collector Thannhauser, Kandinsky asked Wolfskehl to intercede, suggesting that Wolfskehl's word would be taken more seriously than his own. He emphasized that the prices of Marc's paintings were sure to go up. Closing with greetings from Marc, who was at that time in Berlin, Kandinsky took pains to indicate that Marc knew nothing of this private plea to Wolfskehl.

In 1912, the Dutch symbolist poet Albert Verwey, having been "deeply impressed" by some Kandinsky paintings he had seen in Paris, wrote a poem in praise of them which Karl Wolfskehl immediately translated into German. This was the same Albert Verwey who had been an early member of the George circle, and who was an intimate friend of the Wolfskehls for many years; to him, Hanna Wolfskehl had written the description of Kandinsky at her *Fasching* party.

Kandinsky responded to the poem with a poignantly moving letter in which he emphasized a favorite theme of his—the interrelationship of the arts: ". . . A recognition by an artist (that is, in artistic form) is a very

great joy, such as one cannot often experience. It calls forth a spiritual relationship and in the name of *this* relationship I press your hand heartily."[27]

Also in 1912, Wolfskehl purchased the Kandinsky painting *Landscape with Red Spots*, which was then shown at Kandinsky's collective exhibition at the Sturm Gallery in Berlin the following year (with the catalog notation of ownership by Karl Wolfskehl). The poem, "An Kandinsky," appeared at the front of the Sturm catalog; a symbolist attempt at creating a poetic equivalent to the apparent chaos of Kandinsky's ever-increasing abstraction.[28]

Gabriele Münter also recalled the frequent meetings between Kandinsky and Wolfskehl. Their "debates" are mentioned in Eichner's account,[29] and in letters from Münter to Kenneth Lindsay.[30] Wolfskehl was also a good friend to Franz Marc and Paul Klee, with both of whom he corresponded.[31] Wolfskehl and other members of the George circle were frequently mentioned in Marc's letters written from the front during World War I.[32]

Thus there were indeed direct connections between Kandinsky and his circle of friends and the George circle with its symbolist poets. Karl Wolfskehl was the intermediary since he was acquainted not only with Kandinsky but with Kubin, Marc, and Klee, not to mention Sacharov, Schlittgen, Behrens and Obrist—and he was George's closest associate.[33]

Kandinsky himself experimented with poetry off and on over the years, publishing prose-poems as late as 1938 in *Transition* magazine.[34] In fact one of his most exquisite accomplishments was the volume of prose-poems and woodcuts entitled *Klänge* (*Resonances*), published in 1913.[35] He later referred to it as a "syn-

thetic work," thus revealing its significance to him as a type of *Gesamtkunstwerk*.[36] But, in fact, Kandinsky had demonstrated his interest in poetry much earlier.

In letters to Gabriele Münter dating from 1903, he sometimes expressed himself in poetry and recalled once, with a note of regret, that he had written fair poetry in Russian, but German was another matter. The longing was there. That he already associated the poetic process with the artistic is clear, for, when he composed a little folk song for Münter on the motif of a white cloud and a black wood, he suggested that it might be made into a color drawing on black cardboard. Indeed, the transformation was made the same year, resulting in the color drawing titled *White Cloud*.[37]

It was apparently this sense of frustration at his lack of poetic facility in German that led to the publication in 1904 of the portfolio of woodcuts *Poems without Words*, the title an obvious reference to the well-known *Songs without Words* of the French symbolist poet Paul Verlaine.[38] In fact, Kandinsky's graphic poems contain many images commonly associated with symbolist or Jugendstil poetry, including that of Stefan George, as will be seen.

One might even say that Kandinsky's Munich experience was in a sense "framed" by the poetic muse; the *Poems without Words* appearing near the beginning, and the *Klänge* near the end of the Munich period. In the same way, the poetry of George contributed to that frame. Parallels between Kandinsky's early oeuvre and that of George appear in imagery and in style. And in 1911, the *Blaue Reiter* almanach contained two references to Stefan George.[39] Among the three songs included in the almanach was a setting by

Anton Webern of the George poem "Ihr tratet zu dem herde" ("You reached the hearth") from the volume *Das Jahr der Seele* (*The Year of the Soul*, 1899).[40] Furthermore, in his essay, "Das Verhältnis zum Text" (The Relationship to the Text), also published in the almanach, Arnold Schönberg referred to the poems of Stefan George that *he* had set to music.[41] He wrote that he had composed the music to George's texts directly out of the *Klang* (resonance) of the poems, rather than out of any discursive textual understanding of them.[42]

KANDINSKY AND THE GEORGE PROFILE

There is yet another fascinating "clue" that seems to indicate an interest on Kandinsky's part in the work of George. Among Kandinsky's earliest woodcuts is one of 1903 called *Farewell* (Fig. 67, Pl. 1). It depicts a medieval knight in armor, lance in hand, standing beside his horse, about to bid farewell to the lady at his side. The knight, posed in profile, gazes stalwartly out of the picture, not at his lady, giving the appearance of utter dedication to some mission.[43]

The fact is that Kandinsky's knight bears a striking resemblance to the profile of Stefan George. By 1900 George's unusually strong profile was well known not only in literary, but in artistic circles as well. Jan Toorop had done a much-reproduced sketch in 1896 of the striking profile with its characteristic high forehead, prominent brow, long straight nose, and jutting chin (Fig. 68).

In 1900, Melchior Lechter's mural designs for the Pallenberg Hall in the Cologne Arts and Crafts Museum won a grand prize at the Paris world exposition. Central in the mural was the figure and profile of Stefan George as a knight at the "mystical source."[44] Photographs of George confirm the fact that nature had indeed provided him with the physical endowments to match his masterful personality (Fig. 69). Nearly every account of the poet includes a somewhat awed description of his appearance, emphasizing the unique profile.[45]

In 1902, the portraitist Karl Bauer[46] exhibited a drawing of Stefan George as a saint at the spring exhibition of the Munich Secession.[47] The following year, Bauer exhibited a similar motif at the regular Secession, entitled *Knight before the Battle*, again bearing the unmistakable features of George (Fig. 70). It is this portrait of George as a knight that bears the most striking resemblance to Kandinsky's *Farewell*. Not only is the Georgian profile unmistakable in both, but the knight clasps a lance upright before him, and gazes resolutely out of the picture to the left. On the other hand, the headband on Kandinsky's knight is reminiscent of the headband in Lechter's portrait of the poet as a knight.

The symbolic identification of George with a knight figure, undoubtedly St. George, whom (the reader may recall) Crane had depicted slaying the dragon of materialism,[48] was consistent with the aims of the *George-Kreis*. Doubtless this dual reference was appreciated by Bauer in rendering the poet as saint and knight.[49] And doubtless the symbolism was not lost on Kandinsky, who himself adopted the motif of St. George as symbolic of the *geistige Kunst* he prophesied. A St. George figure adorned the cover of the *Blaue Reiter* almanach and became a favorite motif of Kandinsky.[50]

Whether Kandinsky's reference to the George profile in his woodcut, *Farewell*, was conscious or unconscious, the resemblance is striking. And, significantly enough, a smaller version of *Farewell* appeared in *Poems without Words*.

PARALLELS: GEORGE AND KANDINSKY

But it is on the ground of Jugendstil imagery and style that the early work of Kandinsky and that of Stefan George actually meet. George's early poetry has been characterized as "Jugendstil"[51] and, indeed, even a brief glance through such a work as *Algabal* of 1892, or *Teppich des Lebens* (*Tapestry of Life*) of 1899, reveals numerous images associated with Jugendstil: waves, nymphs with long flowing hair, reedy ponds, winding streams, colors associated with jewels, the plucked flower motif, and so on.

George also shared the enthusiasm of Jugendstil artists for handcraft and for producing the *Gesamtkunstwerk*, involving himself in the typographical details of book design even to the extent of developing a special type face (known as the "Stefan George Type") in imitation of his own handwriting. The appearance of the poem on the page was of as great importance to him as its sound. He also eliminated capital letters and most traditional punctuation marks, so that the poems would be read with the intended flow and rhythm, according to the sound of the words rather than to a specific meaning.[52]

Kandinsky demonstrated his appreciation of the symbolic power of lettering in his essay "Über die Formfrage" (On the Question of Form) in the *Blaue Reiter* almanach. There he wrote that the letter is ef-fective as sign, as form, and as "inner *Klang*" of that form.[53] Kandinsky too, of course, exercised meticulous care in the design of his publications.[54]

Stylistically, George's poetry may be said to share certain characteristics of Jugendstil art that may also be observed in Kandinsky's early work. George's poems often displayed a static, mosaic quality, achieved by means of controlled rhythm and rhyme but also by means of short, abbreviated words and phrases.[55] The compression of images and the radical abbreviation of grammatical elements in George's verse leads also to the effect of "two-dimensionality," noted by David, as well as to a veiling of discursive meaning.[56] A certain psychic distance also typical of Jugendstil is achieved by the use of archaic forms and references, and the stylization of form, emphasizing harmony and tonal reflection above meaning.[57] The following comparisons demonstrate a few striking parallels between the work of two artists dedicated to the ultimate goal of a *geistige Kunst*.[58]

Among the Jugendstil images found in George's poetry, one of the most frequent is the garden or park.[59] This civilized and artificial arena provides a setting for meditation or a mood of nostalgia in Kandinsky's early work as well. In both cases the garden provides a sense of calm repose and a certain dispassionate distance. Kandinsky's early painting *Bright Air* (1902) is an example of this use of the park image. The compositional balance achieved by the equal division of light and shade, the balance of verticals and horizontals, and the repetitions of the full-skirted Biedermeier ladies all lend the sense of harmonic repose found also, for example, in Seurat's *A Sunday Afternoon on the Island of the Grand Jatte*. This sense of repose and

balance is best exemplified perhaps in the group of George poems *After the Harvest* in *Das Jahr der Seele* of 1899.

The famous poem "Komm in den totgesagten park und schau" (Come in the park they say is dead and see), also reveals similarities to a Kandinsky work, the woodcut *In the Palace Garden* (Fig. 71). The poem suggests the image of a couple strolling in a park, and, as in the Kandinsky print, picking flowers. Even the image of the wreath is present in both: "There take the yellow, take the gray/ from the birch and from the beech . . ./ The late roses have not wilted yet/ take them, kiss them, weave the wreath."[60] In Kandinsky's print, the couple is obviously engaged in plucking flowers: the suitor holds a flower in one hand and a wreath in the other.[61] The poem also refers to the *bunten pfade*, or gay, flower-bordered path, and the clouds reflected in the pond, both of which are to be observed in Kandinsky's garden as well. One is tempted to speculate that Kandinsky had the poem in mind when he made this image, so well does it suggest the tone and content of the poem.[62]

The quality of tension in repose in the George poem is the result of the regular repetition of the vowel sounds and the rhythmic balance of the lines, which may be compared to the compositional balance and thematic repetitions in the Kandinsky print (the repetitions of the flower motif, for example). As Kandinsky has compressed the figures into the same plane and used a highly stylized flower motif, so too George has compressed phrases and invented neologisms which have the effect of fusing image and meaning in a manner as characteristic of symbolist poetry as of Jugendstil art. The compressed word *totgesagten*, liter-

ally "dead-said," to describe the park at the edge of autumn is such a stylistic device.

Another George poem with a park motif is the third poem in the "Traurige Tänze" (Sad Dances) of the same volume, "Es lacht in dem steigenden jahr dir/ Der duft aus dem garten noch leis" (The garden's perfume, gently laughing, still surrounds you in the rising year. . .).[63] The tone of this poem is that mood of "sad happiness" that Kandinsky once wrote about in a letter to Münter.[64] The poet sings of the perfume that still rises from the garden, and the roses that, though faded, still nod greeting. There is a note of resignation in the idea of the contentment still to be found in a fading garden and a walk together, and still time to weave a flower in "your fluttering hair." Kandinsky's later woodcut *Ladies in the Wood* conveys a similar mood.[65] The motif consists of several figures walking in a wood or park. A certain gaiety is suggested by the central figure which is, however, tempered by the more somber figure at the left, holding her "fluttering hair" (Fig. 72).

Yet another poem from this collection bears a comparison to a Kandinsky woodcut on the same theme. It is "Flammende wälder am bergesgrat" (Flaming woods on the mountainside), in which once again the mood of autumn is evoked (the woods are yellow red) and the image of the wreath is employed. The theme is startlingly similar in Kandinsky's 1904 color woodcut *Autumn* (Fig. 73). The maiden, who may be taken as the "du" of the poem, clasps the harvest wreath, and its color echoes that of the "yellow red," flamelike tree in the background, at the mountain's edge.

George's poem "Mühle lass die arme still" (Windmill do your vanes arrest/ for the heather wants to

rest)⁶⁶ contains elements and effects that can also be found in two Kandinsky works. The motif of the windmill appears in the color-drawing *Windmill* of 1904, no doubt a result of Kandinsky's trip to Holland in the early summer of that year (Fig. 74).⁶⁷ And, as in the poem, the drawn windmill is at absolute rest. The static quality has been achieved by means of an almost perfect symmetry in the composition; the vanes of the mill meet at the vertical center, and the canals from the lower corners, being very nearly parallel to the vanes, appear as their continuation. The almost equal distribution of dark and light values adds to the effect of stillness. As Brisch also noted, the overall effect is of an embroidery.⁶⁸

In the poem, the mill is stilled because the heath is frozen and "wants to rest." The static quality here is also achieved by means of symmetry. Though the season is different, the effect is the same. The flowers in the color-drawing are as "frozen" as the little bushes on the heath that look like dipped cornflowers, and the grasses that look like "lances."

Despite the somewhat sinister effect of the black background, the drawing lacks the intense emotional undercurrent of the poem. The second and last stanzas tell of a group of young girls returning home from communion across the ice on the heath. The ice breaks and they are drowned. At home the lamps flicker; mysteriously, a sudden wind seems to whistle, a faint cry is heard. An image of "black knaves" from the deeps who "receive their brides" arouses an even more macabre note. Then the disaster bell rings out.

It is this last image, "Glocke läute glocke läute!" (Bell ring bell ring!), that calls to mind another Kandinsky painting of a later date. *Storm Bell* of 1907 has, once again, that same static "frozen" quality but, at the same time, the intense emotional undercurrent of the George poem.

The prominent "storm bell" exists in an utterly surrealistic space, disproportionately large and even of a different genre than the stiffly dotted figures around it. There is a nightmarish quality to the figures that gesticulate strangely in some unmotivated drama. A "magician" seems to cast a spell on the maiden in the foreground, while behind him a "black knave" gestures menacingly. Both poem and painting are strangely otherworldly and macabre. And, despite the image of the bell, or because of it, both are overwhelmingly silent.⁶⁹

Yet another color-drawing on black cardboard exhibits an image found in a George poem. *The Night* of 1906 may have been inspired by some Russian fairy tale (Fig. 75). Certainly it has a fairy tale atmosphere about it, heightened by the "witch" figure at the right, and its utterly unrealistic colors (the hair and face of the maiden as well as the face of the witch are shades of blue green). But the figure on the left is reminiscent of an image in a George poem from his *Der Teppich des Lebens* (*The Tapestry of Life*), published in 1901.

The poem, "Die Fremde" (The Stranger), tells of a strange woman who aroused the suspicions of the community because she lived alone, told fortunes, and lured the young men away from their families.⁷⁰ One day she sank into a peat bog, though some said she just disappeared, leaving behind only a small boy both "black as night" and "bleached as linen." But it is the last line of the first verse that seems closest to Kandinsky's image: "Sie sang im mond mit offenem haar" (She sang in the moonlight with loosened hair).

Kandinsky's maiden, too, sings in the moonlight,

"with loosened hair." The child with a face "bleached as linen" stands nearby. Again, both artist and poet have resorted to highly stylized forms to achieve their effects. George has imitated the sing-song rhythm of folk song, or even incantation, to set a tone of sorcery and suspicion. He has also made use of antiquated words from folk lore, such as *hornungschein,*[71] and such archaic forms as *ward* and *buk.* Again, the black background in the Kandinsky drawing already lends a sinister note. Together with the chalky, unrealistic colors and the stylized figures made of color dots, this creates an eerie mood similar to that of the poem.

George's poem "Vogelschau" (Augury) with which he ended the exotic series *Algabal* (1899), finds comparison with two Kandinsky prints of 1907—*The Ravens* and *The Birds* (Figs. 76, 77).[72] The poem contrasts two types of birds which the poet takes as omens of his own fortunes: the white swallows representing his ideals contrast with the exotic jungle birds and menacing black ravens and daws of the "bewitched wood" through which he has come. As C. M. Bowra has interpreted the poem, the exotic birds are symbols of the poet's experiences with the aberrational underworld of Algabal, from which he has emerged refreshed and ready to follow the "white swallows" into the cold, clear atmosphere of the future.[73]

Kandinsky's *Ravens* has a similar imagery: the great black ravens seem to augur the fleet passage of time as the young maidens gather flowers in the meadow below.[74] But the woodcut *The Birds* is even closer in theme to the George poem.

On the left, an eerie, dark figure stands "guard" before a tree heavily laden with foliage, the "magic tree" in the bewitched wood of Tusferi. Overhead flies a large black bird. The whole mood of the left-hand side

of the picture is sinister and menacing. The right, on the other hand, is light and *clear,* even *cold* and *windy*:

> Schwalben seh ich wieder fliegen
> Schnee- und silberweisse schar
> Wie sie sich im winde wiegen
> In dem winde kalt und klar.
>
> (Swallows I see once more flying
> Snowy- silver-white they veer
> Cradling in the wind aflying
> In the wind so cold and clear.)

While the bird aloft on the right-hand side is hardly a swallow, but a much more exotic "bird" (closer to the *Papagei* of the second verse), still the wind seems to be tossing the hair of the figure below, and the tree's limbs are barren of leaves, signifying a cold, wintry season. The print is a beautiful, almost musical study in contrasts and counterpoint, a good match for the harmonics of the George poem.

An unusually interesting comparison exists between the George poem "Weisser Gesang" (White Song), from *Das Jahr der Seele,* and the Kandinsky painting *White Sound* of 1908. The painting seems to "illustrate" the poem through and through (Fig. 78).

The poem begins: "Dass ich für sie den weissen traum ersänne. . ." (That I conjured for her the white dream. . .). In the painting, a reclining figure on the right may be the "dreamer," the figure on the left, the woman, and floating above them to the right is the "white dream," like a white cloud touching earth.[75]

The later color woodcut which appeared in *Klänge,* and which was based on this painting, makes the identifications more explicit; the female figure seems more feminine and regal, while the reclining figure seems

to have taken on once again the characteristic features of Stefan George (Fig. 79).

Other images in the poem also appear in the painting: the "quaking aspens" (which perhaps seem more like willows in the woodcut); the "two children" (here one might take the two figures on the right as the two children, on the other hand, Brisch suggested that one figure seems to carry a child,[76] which might refer then to the "soft burden" in the third verse); the "castle" or churchlike structure in the background; the "pond" (which is evident in the woodcut, directly in the foreground). Only the herons of the poem seem to be absent, and the "marble steps" (apparently leading down to the water's edge), although a "stair railing" may be discovered in the woodcut (lower right).

At the conclusion of the poem, in a cloud of sweet vapours, the dreamy forms rise and fade into the ether. The painting particularly, has the same amorphous quality; the forms seem to fade into one another while the "white sound," or dream, or song dominates the whole.

Many other parallel images may be found to exist in George poems and in Kandinsky paintings and woodcuts, but only a few more can be mentioned here: the motif of the minnesinger with his lyre, the Rhine River, the canoe or rowboat, the dragon, the medieval lady to whom the minnesinger or the knight pays court, the mirror, the veil, "ashen horses," and the child playing with a hoop in a park (George's poem with this motif is called "Hochsommer" [High Summer] and Kandinsky's color woodcut, *Sommer*).[77] Especially striking is the "black flower" motif of *Algabal*. "Dunkle grosse schwarze blume?" (Dark great black flower?) is the last line of the underworld poems of *Algabal*. It could be the precedent for a similar motif

in the drawing for the cover of Kandinsky's collective exhibition catalog of 1912, or the "black flower" in the 1911 painting *Romantic Landscape* (Fig. 80).

But the poem which perhaps best expressed Kandinsky's philosophy at that time is "Der Teppich" (The Tapestry), from *The Tapestry of Life*. As David has pointed out in his article on George and Jugendstil, the very idea of life as a tapestry is typical of Jugendstil art.[78] The two-dimensional, mosaiclike quality of much turn-of-the-century art, including that of the neo-impressionists, is as characteristic of the period as the idea of the *Gesamtkunstwerk*, of which the mosaic mural or tapestry decoration is an integral part. The poem describes a tapestry in which human figures and animals are interwoven and "frozen" in a chaotic tangle. Only at the magic hour of creative inspiration do they come alive and the riddle of their being is solved. But this "magic hour" is not for everyone, only for the chosen few, nor is the meaning available to discourse (any more than is the poetic symbol available to discursive analysis). The meaning will be revealed:

> . . . den vielen nie und nie durch rede
> Sie wird den seltnen selten im gebilde.
>
> (It will be revealed to many never
> and never then through speech/ It
> may be revealed to a few but then in
> image only.)[79]

In a letter to Münter in 1904, Kandinsky expressed to her what he called his "art philosophy." He wrote that the content of his work was not meant to be observed immediately, but only "felt" slowly, and not at all by those who are insensitive to finer things. The

work must have an inner *Klang* (resonance) which, however, is not immediately apparent. The more possibilities for interpretations and fantasy, he wrote, the better.[80]

In *Über das Geistige*, Kandinsky spoke also of the "veiled" which, when combined with the obvious, would provide a new motif in composition. ". . . veiling is an enormous power in art," he wrote.[81] In another section of the same work, in his discussion of the dance, Kandinsky wrote of the power of the "unmotivated" action: "In the simple movement that is externally unmotivated lies an incalculable treasure full of possibilities."[82]

Just as George created a dense weave of verbal symbols by compressing images, omitting prepositions, and fusing modifiers and nouns into new words, so, too, did Kandinsky create a dense tapestry of symbolic imagery by compressing figures into one plane, by fragmenting the picture surface, and by filling that surface with equally significant positive and negative values. Thus did both poet and artist veil old meanings while at the same time revealing new ones. Many examples could be cited: the 1907 woodcut *Fugue*, for example; or the *Archer* of 1908-09, or *Composition II* of 1910 (Fig. 81).[83] All are two-dimensional and filled with a chaotic tangle of apparently unmotivated (or "veiled") forms:

Und kahle linien ziehn in reich-gestickten
Und teil um teil ist wirr und gegenwendig
Und keiner ahnt das rätsel der verstrickten . . .
Da eines abends wird das werk lebendig.

(And bleak drawn lines are richly interwoven
And part on part confused or wild in strife
And no one knows the riddle of the woven ones
Until one night the weaving comes to life.)

CHAPTER

·IX·

The Munich Artists' Theater

WHEN, in the spring of 1914, Kandinsky's name was included in a list of artists proposed for association with the Munich Artists' Theater,[1] it can have caused little surprise among those who were familiar with his books. In both *Über das Geistige* and the *Blaue Reiter* almanach, Kandinsky had demonstrated a vital interest in theatrical matters. *Über das Geistige* contained numerous references to "stage composition," to a "monumental art of the future" which would be a great synthesis of the arts, and to a "theater of the future."[2] The almanach contained not only an essay by Kandinsky entitled "Über Bühnenkomposition" (On Stage Composition), but also an experimental color opera by the artist, called *Der gelbe Klang* (The Yellow Sound).[3]

In fact, Kandinsky composed four such "color-tone-dramas" in all between 1909 and 1914: *Schwarz und Weiss* (Black and White), *Grüner Klang* (Green Sound), *Der gelbe Klang*, and *Violett*. While the first two remain unpublished, a fragment of *Violett* was published in the Bauhaus quarterly in 1927, together with an excerpt from an earlier essay by Kandinsky, "Über die abstrakte Bühnensynthese" (On the Abstract Stage-synthesis).[4] During the postwar period in Russia, Kandinsky continued his interest in theater as a member of the management of the Theater and Film Department of Narkompros (The People's Commissariat for Education), of which he was also a director.

In 1918, he translated his essay "On Stage Composition" into Russian for publication the following year in the periodical *Izobraziteľnoje iskusstvo*.[5] Later, at the Bauhaus, Kandinsky designed a production of Mussorgsky's *Pictures at an Exhibition* which was performed at the Friedrich Theater in Dessau in 1928.[6]

Yet, despite these strong indications of Kandinsky's lifelong interest in the theater, little effort has been made to understand its origins, or its possible relationship to his ultimate breakthrough to abstraction. The cataclysm of World War I obscured the fact that *Der gelbe Klang* very nearly came to performance in Munich, on the stage of one of the most advanced theaters in Europe. The significance of the Munich Artists' Theater for the development of Kandinsky's thoughts on a great synthesis of the arts, indeed, its role in the very composition of his only fully published dramatic work, has been entirely overlooked.[7]

There is little doubt, however, that the original impetus and inspiration for Kandinsky's enduring interest in the theater is to be found in the vigorous theatrical reform movement in Munich at the turn of the century which culminated in the foundation of the Munich Artists' Theater in 1908—the theater with which the names of Kandinsky, Hugo Ball, Franz Marc, Paul Klee, Alexei Jawlensky, Arnold Schönberg, and Alexander Sacharov were to be briefly linked in 1914. There is even good reason to believe, as will be

seen, that Kandinsky had the stage of the Munich Artists' Theater in mind when he composed *Der gelbe Klang*.

In fact, Kandinsky's interest in the theatrical world can be traced back to the first Phalanx exhibition in 1901, which included masks designed for the Elf Scharfrichter cabaret, and to his early association with Ernst Stern, Alexander von Salzmann, and Peter Behrens, all Phalanx exhibitors and theater enthusiasts. Ernst Stern, whom Kandinsky had known at Stuck's atelier, was actively involved in the theater by 1901 as a member of the Elf Scharfrichter, an enterprise which had a strong impact on the movement for theatrical reform.[8] Stern eventually devoted his talents wholly to the theater, becoming the chief set designer for Max Reinhardt, an association which lasted many years.[9]

The Light Theater at Hellerau

Alexander von Salzmann, a compatriot of Kandinsky and another former Stuck student and Phalanx exhibitor, shared an atelier with Ernst Stern.[10] Salzmann, too, became fascinated with the theater and by 1910 was designing lighting and sets for the modern dance school of Jaques-Dalcroze (1865-1950) at Hellerau near Dresden.[11] The advanced "light theater" at Hellerau had been designed in collaboration with Adolphe Appia, whose ideas on lighting as a primary expressive element in set design had been known in Munich since the publication there in 1899 of his book, *Die Musik und die Inscenierung*.[12] It is well within the realm of possibility that Kandinsky and Salzmann discussed problems of design for the theater as early as the Phalanx era. When the Dalcroze school opened in 1910,

it aroused international attention and Kandinsky certainly took a lively interest in it.[13]

But it was Peter Behrens who, among Kandinsky's early acquaintances, was most directly involved in the original ideas that led to a realization of theater reform in Munich. Together with Georg Fuchs at the Darmstadt Artists' Colony just at the turn of the century, Behrens had formulated plans for a complete revision of traditional theater.[14] He called not only for a total theater, the *Gesamtkunstwerk* idea so close to the heart of the arts and crafts movement (especially in its manifestation at Darmstadt), but for an altogether new architectural form. Behrens and Fuchs collaborated on plans for the elaborate opening ceremonies of the Darmstadt Artists' Colony in 1901,[15] and their writings on theater reform were widely published.[16]

Their ideas gave expression both to the synthetic compulsion of the arts and crafts movement and to the symbolist search for significant expressive means. The hypernaturalism of the nineteenth-century stage was to be abandoned. Drama should be returned to its mystic-religious origins. It should be a celebration of life in which both audience and actors are creative participants. It should be a total aesthetic experience eliciting a total response. To do so, the drama of the future must achieve a monumental synthesis of all the arts: poetry, music, dance, painting, and architecture. Simplification, stylization, and symbolism were to characterize the new form, and to be realized in the Munich Artists' Theater.[17]

Georg Fuchs: Founder of the Artists' Theater

Georg Fuchs had been continually on the Munich scene since the 1890s.[18] Besides his books, he published

articles, essays, and reviews in a wide variety of periodicals, including such Munich publications as *Dekorative Kunst, Kunst für Alle,* and the *Münchener Neueste Nachrichten.* As a matter of fact, Fuchs' work was also known in Russia, and well before the publication of Kandinsky's first two books. *Apollon,* the same Russian journal that carried Kandinsky's series of reviews entitled "Letters from Munich," published two articles by Georg Fuchs. The first of these, "The Munich Artists' Theater," appeared in the November 1909 issue, one month after Kandinsky's first review.[19] The second, "The Aims of German Theater," was published in the October 1910 issue, the same one which carried Kandinsky's fifth and last review.[20] Furthermore, a quotation from Fuchs' book, *Revolution des Theaters,* had been cited and footnoted in an article on the theater by Meyerhold in the same issue of *Apollon* that had carried the first of Kandinsky's reviews, the previous year in October 1909.[21] Fuchs' major work, *Revolution des Theaters,* was available in Russian translation by 1911.[22]

A comparison between Kandinsky's expressed ideas on theater and those of Fuchs indicate that Kandinsky was not only aware of the general European symbolist movement in the theater but specifically of its manifestation in the Munich Artists' Theater, and further, that he was also aware of Fuchs' writings on the subject.[23]

MUNICH'S THEATER OF THE FUTURE

While it is within the realm of possibility that Kandinsky and Behrens discussed their ideas on theater during their contacts in 1902-03,[24] it was certainly the actual realization of a "theater of the future" in Mu-

nich that had the greatest impact on Kandinsky's thinking about the theater. And it was Georg Fuchs who provided the energy and bore the primary responsibility for bringing that theater into being. After Behrens' departure to direct the Arts and Crafts School at Düsseldorf, Fuchs continued to work on their theatrical vision and by 1905 published a book, *Die Schaubühne der Zukunft,* introducing plans by the architect Max Littmann. Within three years these plans, with some transformations, were realized in the construction of the Munich Artists' Theater under Fuchs' direction.[25]

When the Munich Artists' Theater (Münchener Künstlertheater) actually opened in May of 1908, it was the most modern theater in Germany, perhaps in Europe.[26] Its first season attracted international attention[27] and can scarcely be thought to have escaped the attention of Kandinsky, who returned to the Munich area from his travels in June of that year.[28] Its major innovations were: its relatively shallow stage (the so-called "relief stage");[29] its advanced lighting system; its broad inner proscenium, which was adjustable in height and width (by a system of movable screens) and which obviated the need for painted side walls to mask the backstage area; and an upstage area that could be raised or lowered. But it was also the first modern art theater to be constructed as an organic whole; its revolutionary innovations were not merely grafted onto an existent traditional shell, but were built into a functional new design (Figs. 82, 83).[30]

The new theater was in itself a Jugendstil *Gesamtkunstwerk.* Fuchs himself not only associated the development of the Artists' Theater with the arts and crafts movement, but also with that revolution which, as he said, freed the arts from the "yoke of litera-

ture";[31] the Artists' Theater was another "Secession." Indeed, most of the artists originally involved did come from the ranks of the Munich Secession and the arts and crafts movement.[32] Among the noted Munich artists who designed for it were Fritz Erler,[33] Thomas Theodor Heine, Julius Diez, and Adolf Hengeler, as well as Kandinsky's friend Ernst Stern. Margarete von Brauchitsch designed the embroidered curtain.[34] Franz von Stuck served as first vice-president of the Artists' Theater Society. Furthermore, dramas and music composed by local artists were encouraged. The Munich Philharmonic provided the music, a fact noted with appreciative enthusiasm by Edward Gordon Craig, who visited Munich in the summer of 1908 expressly to see the Artists' Theater.[35] Certainly the potential for "total theater" was present.

Because there are numerous parallels between the ideas expressed by Georg Fuchs and those of Kandinsky on the theater, and because Kandinsky's directions for *Der gelbe Klang* seem to have been determined to some degree by the provisions of the Artists' Theater stage, it is illuminating to consider both Kandinsky's ideas and the stage of the Artists' Theater in some detail here.

The whole thrust of the Munich Artists' Theater was toward a nonnaturalistic symbolic theater. Its "relief stage" was designed on the premise that symbolic movement (thought by Behrens and Fuchs to be the heart of the genuine dramatic experience) had been all but lost on the deep stage of the traditional "peepshow" theater.[36] Behrens, for example, had written, "The relief is the most characteristic, most concentrated expression of line, the moved as well as the moving line: movement that is everything in drama."[37] Fuchs believed that good drama naturally disposes it-

self in relieflike images which develop "of themselves from the dramatic necessities of the play."[38] In order to be effective, these images should be thrust forward on a narrow, shelflike stage, and set off by a simple background.[39] The relief stage was a natural theatrical concomitant of Jugendstil *Flächenkunst*.

The stage of the Artists' Theater was, in fact, narrower than those in conventional theaters of the time, and had the effect of forcing the desired simplifications in stage setting while compressing images into planes defined by the three distinct stage areas.[40] On the other hand, lighting arrangements were such that unusual spatial effects could be achieved without the use of crude painted perspectives and numerous props. The forestage and middle stage could be lighted independently from above, an innovation at the time. Even more revolutionary, the back stage area (which could be raised or lowered with respect to the middle stage) could be lighted from *below*, thus dispelling shadows on the backdrop or diorama. Thus, effects of "infinite space," or a space symbolic of psychic distance, could be achieved by means of light alone. Due to the flexibility of both stage and lighting therefore, effects both of friezelike compression and of indefinable spatial expansion could be attained. It was an eminently symbolist stage.[41]

The power of light was fully appreciated by Fuchs, who wrote that it was the most important vehicle of spatial definition in the drama.[42] By means of light, he wrote, it was possible to utterly dissolve, "to dematerialize," the physical presence.[43] And by means only of relations between light and mass, any physical or psychological environment could be created.[44]

Adding to the versatility of the stage was the fact that the orchestra, which swept out toward the seats

of the auditorium, could be covered when not in use. The middle stage area was terraced a step above the forestage, and contained between two stylized pylons or "towers" which formed the inner proscenium and effectively masked the backstage area (Fig. 84). These towers were connected above by a movable bridge (containing concealed lights) which could be raised or lowered. The *Hinterbühne*, or third stage section farthest back, which could also be raised or lowered as noted (as much as two yards below the middle stage), could be closed off partially or completely by means of movable screens sliding in from the wings. Thus, the playing area could be effectively expanded or diminished in accordance with the physical or psychological demands of the drama. The mobility and versatility of this design was astonishing to contemporary critics.[45]

DER GELBE KLANG AND THE ARTISTS' THEATER

Actually, *Der gelbe Klang* seems a miniature compendium of ideas and elements integral to the Artists' Theater. This becomes apparent in a comparison of Kandinsky's stage directions with the characteristics of the Artists' Theater stage.

The drama, Fuchs once wrote, should become like a fine object of art, a "beautiful object," and ought to strike that same "necessarily felt resonance" ("notwendig empfundenen Klang").[46] Kandinsky wrote that his stage composition represented an attempt to create out of the source of "inner necessity." *Der gelbe Klang* might be seen then as a fulfillment of that wish for the "necessarily felt *Klang*."

Der gelbe Klang consists of a series of six "images" with an introduction. The characters are designated as "co-workers," and include five "giants," "indefinite creatures," a child, a man, people in loose drapery, people in tights and, behind the stage, one tenor, and a chorus. There is no apparent plot or dialogue in the ordinary sense. The action consists solely of changes in color and light, and in the movement of objects and figures, singly and in groups. The chorus declaims symbolist verses here and there, but there is no recognizable narrative commentary. The "dialogue" consists largely of random sounds and phrases. At one point, for example, the tenor is directed to cry out indefinite words such as "Kalasimunafakola!" The scenes climax in an image of a cross formed by one of the yellow giants with outstretched arms, increasing in size until it reaches the full height of the stage.[47]

As will be seen, the freedom to dispense with "dialogue" altogether had already been achieved on the stage of the Artists' Theater with Max Reinhardt's 1910 production of the pantomime, *Sumurun*. The idea of puppetlike symbolic characters had also been prefigured at the Artists' Theater, in the three heroic "angels" of Fuchs' *Faust* production,[48] and in the outlandish puppetlike costumes of a modernized version of Aristophanes' *The Birds*, also performed in the first season (Fig. 85).[49] In fact, the "indefinite creatures" of scene one of *Der gelbe Klang* may well have been suggested by the costumes of the Aristophanes production. According to Kandinsky's directions, they "vaguely recall birds, have large heads and a distant resemblance to men."[50] Further, *Der gelbe Klang* seems to suit Fuchs' idea of a "chamber opera," or "nonliterary music drama," as appropriate for the relief stage.[51] The extraordinary emphasis on dance, obviously inspired by the type of "modern dance" exemplified by Jaques-Dalcroze or Isadora Duncan, had also its precedent in

the writings of Fuchs and in performances at the Artists' Theater.

According to many observers, one of the most innovative and striking characteristics of the Munich Artists' Theater was its effective use of colored light. Further, the Artists' Theater increased the conventional spectrum of colored lights to five, with the addition of blue.[52]

In this respect, *Der gelbe Klang* is a veritable color-light spectacle. Time and again, Kandinsky's directions call for color effects that may well have been inspired by the example of the Artists' Theater. Blue light is called for repeatedly. At "curtain," the stage is already bathed in "dark blue dusk," and various shades of blue recur throughout. The whole sequence in scene two, in which the symbolic flower glows yellow with an increasing intensity, while the general lighting of the stage changes from white to dull red, to "garish" blue, then to an all-obscuring gray, had a precedent in the Artists' Theater production of *Faust*. One of the chief effects noted by reviewers in regard to *Faust* was the symbolic use of colored light. At one point, the walls of Faust's study "take on a color as though blood ran from their pores"; the curtain changes to deep blue and Faust's silhouette "stands out against it in dark purple."[53] At another, a single red flower in the garden remained lighted while the rest of the stage faded into darkness.[54]

In scene three of *Der gelbe Klang*, directions call for garish beams of colored light (blue, red, violet, and green) to fall on the stage "in quick sequence," then all together, "whereby they are mixed." After a sudden darkness, a yellow light then suffuses the stage, increasing in intensity, a possibility specifically described by Fuchs in his book.[55] Furthermore, direc-

tions call for different colors on different areas of the stage at the same time, another possibility afforded by the arrangements of the Artists' Theater stage.

Yet another reference to the possibilities of the Artists' Theater may be the direction in scene five, which calls for "white light, without shadows." By means of lights concealed both above the separate stage areas and below the level of the middle stage (in the lowered rear area), it was possible at the Artists' Theater to create shadowless effects.[56] The Artists' Theater had also greatly reduced the number and intensity of footlights in order to do away with shadows, except where necessary for the creation of certain effects.

Kandinsky's stage directions also seem to assume a planar division of stage depth as on the relief stage of the Artists' Theater. The direction at the opening of scene one calls for the stage to be "as deep as possible." And in the second scene, figures are directed to move to the "forestage." Further, in scene one, an apparently odd direction calls for the background to "receive wide black borders," which could have been accomplished on the Artists' Theater stage by means of the movable proscenium and screens.[57]

The directions also call for various objects to increase in size, first the "green hill" in the background of scene one, and then the "five yellow giants" in scene three, and at the conclusion. This could easily have been accomplished on the Artists' Theater stage by arranging for the objects in question to move gradually up from the lowered rear stage, the area often referred to as the *mystischen Abgrund*, or mystical abyss. Since the lowered area was some six feet below the level of the middle stage, this "growth" could have been managed quite effectively.[58] Also, in scene two, directions call for very small figures to pass over the

hill "in continual sequence." This could have been accomplished by means of steps built up from the lowered stage so that figures could appear and disappear as if climbing up and over the hill continually. A similar effect had been created by Max Reinhardt in his production of *Midsummer Night's Dream* at the Artists' Theater in the summer of 1909, when elves continually appeared and disappeared into the "mystical abyss."[59] The effect might also have been achieved by means of projected shadow pictures.[60]

TOWARD GREATER ABSTRACTION IN THEATER

Symbolist Reduction

In the Artists' Theater, as in Kandinsky's proposed stage composition, the external means were to be reduced to the barest essentials. This approach was related to a new recognition of the potential for imaginative participation on the part of the spectator. Fuchs wrote that the emphasis in set design in the Artists' Theater was on providing no more than the eye of the beholder needed "in order to create for itself the spatiality which seemed appropriate to the particular psychic happenings."[61] This is what Kandinsky meant when he referred to the potential of the artistic means to excite the fantasy in such a way that it "continues creating." His reference to the "free space" which separates the work from the last degree of expression, the *Nicht-bis-zuletzt-Sagen* (or not-saying-every-last-thing), was an expression of the same idea.[62]

In their discussions of the simplification of stage scenery, Fuchs and Kandinsky referred to strikingly similar examples. Fuchs demonstrated the effectiveness of stage procedures reduced to the point of primi-

tivism in the description of a nativity play he had observed performed by peasants in the village of Dachau. There, he said, no attempt had been made to disguise the fact that the "walls" of the "stable" were plain linen sheets, yet the whole was immensely effective.[63] Similarly Kandinsky, in his discussion of Maeterlinck's symbolist reduction of "material means," related how Maeterlinck himself had once (during a rehearsal in St. Petersburg) directed that a missing tower be replaced by a piece of plain canvas. "This tendency to excite the fantasy of the viewer plays a large role in contemporary theater," he wrote, mentioning in particular the Russian stage, but perhaps thinking of the much closer Munich Artists' Theater. Significantly, Kandinsky ended this particular comment with a reference to Fuchs' slogan, "the theater of the future." The tendency, he wrote, "is a necessary transition from the material to the spiritual of the theater of the future."[64]

Fuchs' use of the nativity play as an example indicated that he shared the symbolist view that the hope of the future lay in a revival of the medieval mystery or miracle play, which of course was characterized by simplicity, symbolism, and high religious seriousness. Wolfskehl, in his major essay on the drama, pointed to the mystery play as the drama of the future. His own playlets were experiments in that direction.[65] It is interesting to note that Kandinsky's *Der gelbe Klang* has been described as a "mystery play."[66]

The reduced or simplified means of the Artists' Theater symbolist stage made it possible, Fuchs maintained, to demonstrate the "inner" continuity or integrity of even such an apparently "chaotic" work as *Faust* (which was, in fact, the opening production of the theater).[67] Kandinsky's essay attempted to demon-

strate that external chaos or disharmony was irrelevant if the emphasis be placed on the "inner *Klang*" of a few primary elements, that is, if only those response-eliciting elements are taken into consideration.[68]

Cabaret, Shadow-play, and Marionettes

It is interesting that in *Revolution des Theaters*, Fuchs emphasized the significance of the contemporary cabaret or variety show theater. He cited with special enthusiasm the Munich cabaret group, the Elf Scharf-richter, in which the various arts collaborated in a lively fashion: dance, song, mime, and painting, unencumbered by dull conventions.[69] He admired the acrobats, the jugglers, the mimes, and dancers of the cabaret, and suggested that there must the theater of the future seek its talent. Only there, he wrote, was the true art of gesture alive and for that reason it was no wonder that artistic people often preferred the cabaret to the theater.[70] In a strikingly similar passage in his later essay on the abstract stage-synthesis, Kandinsky noted that it was not in vain that, faced with the decadence of the conventional theater, people turned to the variety theater, the circus, and the cabaret for solutions.[71] Furthermore, in an article published in Russia in 1919, Kandinsky proposed an international conference of artists which would include representatives of all the various arts, including "variety entertainment and circus."[72]

But Fuchs also paid tribute to two other peculiarly unique manifestations of theater in Munich, which he considered significant for the development of modern theater. These were the Schwabinger Schattenspiel (Shadow-play) Theater and the Marionetten Theater Münchener Künstler. Both of these aroused considerable attention at the time, especially the shadow-play

theater in which the George circle took a lively interest. Indeed, Kandinsky's friend, Karl Wolfskehl, was actively involved in the Schwabing shadow theater, which was located on Ainmillerstrasse, the same street on which Kandinsky had an apartment from 1908.[73] The shadow-play theater was founded by Alexander von Bernus (also a friend of Kandinsky's associate Alfred Kubin) in 1907. It was so successful that it was included in the exposition "München 1908" with which the Artists' Theater was also associated.[74]

The shadow-play theater in fact represented for the symbolists a first step toward that theater of the future which could only be achieved by means of "a complete stepping-into-the-background of the actor."[75] In his essay on drama, Wolfskehl suggested that the best drama of the past had arisen when conditions were such that drama could rely entirely on artistic means and did not have to "borrow" from nature.[76] The shadow-play theater offered a miniature experiment in drama completely divorced from nature.

The magic quality of the shadow-play surface again provided that mysterious suggestion of a mystical or psychic space beyond the limits of conventional perspective, that must have held a special fascination for Kandinsky, for he included no less than eight illustrations of Egyptian shadow-play figures in the *Blaue Reiter* almanach.[77] As on the open stage, light afforded a means of dematerializing objects, so, too, did the reduction to two-dimensionality of the shadow-play screen.

Fuchs reported that another friend of Kandinsky, Alexander von Salzmann, designed puppets and sets for the marionette theater.[78] Nor is the interest in marionette theater to be dismissed lightly either, since it figured so importantly in theatrical ideas fostered by

Oskar Schlemmer at the Bauhaus some fifteen to twenty years later. It should also be recalled that the first Phalanx exhibition included designs by Waldemar Hecker for a "political" marionette theater. In fact, Kandinsky's descriptions of the "five giants" in *Der gelbe Klang* are indicative rather of marionettes than of human figures. They are "shoved out" onto the stage, in the first scene, "as if swaying over the floor." They have strange yellow faces that are "indefinite." They are directed to "turn their heads . . . very slowly and make simple movements with their arms."[79] For the most part, their bodies remain immobile, while their heads and arms make certain specified motions. At one point in the play, Kandinsky described the appearance of the "people in tights" as "like jointed dolls or mannequins" ("wie Gliederpuppen").[80]

Pantomime

The dematerialization of objects and the inclination to mask the actor or to do away with him altogether,[81] were accompanied by a suspicion of the word itself as dramatic vehicle.[82] Hence the great emphasis on mime and movement in theories about the drama of the future. This particular tendency perhaps reached its zenith at the Artists' Theater in 1910, when Max Reinhardt produced *Sumurun* by Friedrich Freksa, an entire play in pantomime.[83] A contemporary critic reported, "The actual author was once again Reinhardt. Together with Ernst Stern's painterly inspiration, he has conjured up wonderful images, lovely and sensuously beguiling."[84] The production exploited movement, color and mime: "utterly liberated from the word."[85]

But the most interesting thing about this phenomenon of the pantomime is its parallelism with Kandinsky's *Der gelbe Klang* in which, as Kandinsky specifi-

cally stated in the final sentence of his introductory essay, "The sound of the human voice has also been used in its pure state, that is to say without obscuring it by means of the word, by the sense of the word."[86]

Color and Movement

Both Fuchs and Kandinsky were enthusiastic about the "inexhaustible material" available in a full exploitation of the artistic elements in a drama, particularly of color and dance. The three primary elements in Kandinsky's stage composition were to be music, dance, and color.[87] He envisioned vast unexplored possibilities in the combination of these elements, and proposed that each be treated as an independent and equally important element in the dramatic production. Fuchs had already suggested that there were "inexhaustible possibilities" in the treatment of color, as well as in the "rhythmic play and counterplay" of line, and in the movement of groups and masses on the stage in relation to color and stage design.[88]

Both insisted on the primacy of dance and movement in the dramatic production. Fuchs believed that dramatic art is in essence dance: "rhythmic movement of the body in space."[89] Kandinsky's essay on stage composition also made movement a primary element. In fact, all three of the "external means" he proposed as essential elements were conceived in terms of movement: "musical tone and its movement," "bodily-spiritual *Klang* and its movement" (by which he meant dance), and "color tone and its movement."[90]

Response and "Vibration"

But for Fuchs, as for Kandinsky, the physical arrangements of the Artists' Theater, revolutionary as they were, were only secondary to the ultimate function of the dramatic stage. The primary function of

any stage and drama, Fuchs wrote, is to "grip the soul,"[91] to create excitement, to elicit a deep response. The goal of theater should be to recapture the child's response to it: ". . . that intoxication which transforms all our senses, our fantasy, our soul into that utterly changed, heightened tension."[92] Thus for Fuchs, the value of the dramatic work of art resides not in any particular physical invention (the relief stage, he wrote, is not a technical concept but a stylistic one),[93] but in experience and response: "The dramatic work of art is created neither on the stage nor in the script, but rather it is created anew in each moment in which it is experienced as a space-time-bound form of movement."[94] The drama takes place not on the stage but in a complex of inner responses elicited by the dramatic elements in movement.[95]

Kandinsky's 1912 essay on stage composition, published in *Der Blaue Reiter* as an introduction to *Der gelbe Klang*, began with the expression of similar sentiments. Indeed, it was on the basis of this assumption, namely that the goal of the dramatic work of art is to elicit a complex of inner responses, that Kandinsky developed his idea of the synthesis of psychologically effective artistic elements in the "stage composition." In metaphorical terms, Kandinsky described the effect of the arts on the spectator as that of causing a "vibration of the soul."[96] A single vibration may cause other "strings of the soul" to vibrate, as when the fantasy is stimulated to continue the creative act.[97] Any given artistic means elicits such a "soul process" (*Seelenvorgang*) or "vibration," and a "certain complex of vibrations" is the goal of a work.[98] The drama itself arises "out of the complex of inner experiences (soul vibrations) of the viewer."[99]

It is significant that both Kandinsky and Fuchs used the metaphor of "vibration" to describe the notion of psychological response. "The work of art," wrote Fuchs,

> . . . is not object and not subject, rather it is *movement*, a movement which springs out of the contact and saturation of the 'subject' with the 'object.' The movement is perceived, is raised to consciousness through certain organs we generally call 'sense' and 'soul' [*Sinne und Seele*]. It depends on the nature [or constitution—*Beschaffenheit*] of these organs how many such *vibrations* [*Schwingungen*] are received and with what intensity, how frequently and how vigorously by their obedience to rhythmic law they are felt by the individual as harmony, accord, as fulfillment, bringing joy to the individual.[100]

Elsewhere Fuchs wrote that the drama ". . . transforms itself . . . at the curtain line from a physical movement-rhythm [*Bewegungs-Rhythmik*] into a spiritual movement-rhythm [*geistige Bewegungs-Rhythmik*]."[101] But there are other indications that Kandinsky knew this text very well. Fuchs suggested that the degree of response depended on the constitution (or nature) of the viewer's perceptive "organs" (in which he included not merely the physical senses but the "soul"). Similarly Kandinsky suggested that the response may be weak or strong according to the "degree of development" of the spectator, as well as to "temporal influences," and that the depth of response (or number of vibrations) is in accordance with the "soul" of the viewer.[102]

For both Kandinsky and Fuchs, then, the essence of the dramatic experience lay not in the manipulation and movement of various elements in the dramatic production, but rather in the inner response elicited by these means.

If the response is primary, the means employed deserve particular attention. In the matter of set design,

Fuchs urged the use of painting as painting, in terms of the effects of line, color, and form, rather than as a mere tool to achieve naturalistic effects. He urged the use of light and color as well for symbolism and effect.[103] Time and again, however, he subordinated these elements to the "physical and poetic movement" of the drama.[104] Kandinsky here went much further than Fuchs, demanding that all the arts involved be treated equally; not subordinated to one another as in the Wagnerian synthesis, but alternated. The means were to be subordinate only to the "inner goal."[105]

Fuchs had also attacked the Wagnerian synthesis as a "mongrel species"; fundamentally he, too, envisioned a drama in which the arts would cooperate at the highest level, and in which the "inner principles" of the individual arts would be respected.

> The drama is possible without word or tone, without scenery or costume, purely as rhythmic movement of the human body; but the art of the stage can enrich its rhythms and its forms from the wealth of all other arts. . . . However, if the drama is to create additional strength of expression from the other arts, it is obvious that it must subordinate poetry, music, painting, and architecture to the rule of the drama, *without forcing the individual arts to repudiate their innate principles*.[106]

In fact, the cooperation of talented, well-trained artists in the scenic design was a fundamental concept of the Artists' Theater, which was, of course, in turn rooted in the Jugendstil or arts-and-crafts-movement ideal of the *Gesamtkunstwerk*. This was directly in line with Fuchs' involvement in the Darmstadt Artists' Colony, and in the applied arts movement as a whole.[107] Altogether, the Munich Artists' Theater, as originally envisioned by Fuchs—with its Jugendstil relief stage, its advanced lighting techniques, its emphasis on symbol and synthesis—offered most auspicious conditions for Kandinsky's experiment in theater. It offered possibilities that tended beyond its own limitations, toward greater abstraction and the realization of Kandinsky's dream of a grand synthesis of the arts in a "theater of the future."

FROM REVOLUTION TO ANARCHY

The many parallels between Kandinsky's ideas on theater and those expressed by Fuchs indicate that indeed, the Artists' Theater exercised a substantial influence on the development of Kandinsky's thought. And, if the comparisons between Kandinsky's stage directions for *Der gelbe Klang* and the possibilities offered by the Artists' Theater seem convincing, then it is hardly surprising to find that, in fact, Kandinsky's play was proposed for performance on the stage of the Artists' Theater in the spring of 1914.[108] Further, if the influence of the Artists' Theater on the artistic community and particularly on Kandinsky is seen in perspective, then the proclamation even earlier that year, which associated Kandinsky's name with the Artists' Theater, is not surprising either.[109]

The proclamation was published in the Munich press early in the spring of 1914 when the Artists' Theater was near financial collapse, and the suggestion had been made to turn it over for the approaching season to a troupe of players from Düsseldorf. Under the leadership of the young architect Erich Mendelsohn,[110] Munich's artistic community leapt into the ensuing controversy, publishing an appeal under the banner "The Munich Artists' Theater to Munich Art-

ists!" It was signed by Franz Marc, Reinhard Piper, Alfred Kubin, Hugo Ball, and Franz von Stuck, among others.[111] The proposal this group submitted to the exhibition park society (which controlled the theater), named Hugo Ball as director.[112] Artists suggested to collaborate on scenic design included Kandinsky, Klee, Marc, Jawlensky, Mendelsohn, Alexander von Salzmann, Vladimir von Bechteiev, Albert Weisgerber, the dancer Alexander Sacharov, and the composer Arnold Schönberg.[113]

By 1914, of course, Kandinsky, the *Blaue Reiter* artists, and their friends were notorious. To the Munich establishment which ultimately controlled the fortunes of the exhibition park (which, of course, held a large interest in Munich's tourist trade), these artists represented not merely reform, but anarchy. Quickly as they had arisen, the hopes of the "anarchists" were snuffed out. The Düsseldorf troupe was engaged, and Fuchs retained as director, taking over, however, at least one play from the repertoire submitted by the upstarts; it was Shakespeare's *The Tempest* (in German, *Der Sturm*, doubtless taken by them as a pun on the Berlin avant-garde group and periodical of the same name).

Had the war not interrupted the dreams of everyone, it is quite possible that the aims of the Mendelsohn-Ball group might nevertheless have come to fruition. In fact, a book, *Das neue Theater*, was planned for publication by Piper in October of 1914,[114] which was to bring the new program before the public, with the "ideas which we want to bring to the *Artists' Theater*."[115] Kandinsky was to have contributed a piece on the "total work of art" (*Gesamtkunstwerk*), and Marc, designs for *The Tempest*. Klee, Kokoschka, Kubin, Ball, and Mendelsohn were among other contributors suggested.[116]

Clearly, the ideas of the Mendelsohn-Ball committee were based on a thorough familiarity with the original aims of the Artists' Theater and observation of its gradual disintegration.[117] In an article published at the height of the controversy, Ball wrote that the committee of interested parties intended to retain the original ideal of the Artists' Theater as a *Festspiel* or festival theater, and as an experimental stage specifically for Munich artists. Beyond that, however, the new aims would represent not "merely a reform," but a complete "break with tradition." The Artists' Theater should become a "theater of the new art," he wrote, "if you will: of Expressionism."[118] It was no longer simply a question of decoration and stage setting, but rather one of "a new form of the total dramatic-scenic and theatrical expression."[119] Kandinsky's *Der gelbe Klang* was among the works suggested for performance on the stage of the Artists' Theater.

The whole plan was of course shattered by the outbreak of the war.[120] But, as has already been noted, Kandinsky continued to take a lively interest in problems of the theater during the years in Russia, and later at the Bauhaus. The *Klang* of the Munich Artists' Theater struck a long and resounding echo.

PART FOUR

EMERGENCE TO
ABSTRACTION

CHAPTER

·X·

Ornament and an Art Without Objects

THE CALL to abstraction through ornament was perfectly clear to Kandinsky. There is no doubt that from the beginning his most successful works were those that were "ornamental" or "decorative." Indeed, his first professional recognition was the result of his talent as a "decorative painter."[1] At the second Phalanx exhibition, which was almost entirely devoted to the decorative arts, Kandinsky had exhibited four "decorative sketches." Of these, *Dusk* was perhaps one of the most successful and significant of his early works. The silvery horse and rider charging across the moonlit landscape bore a symbolic significance far beyond the immediate aim of a design for appliqué (Fig. 122, Pl. vi).[2]

In "Rückblicke," Kandinsky recalled that his attempts to track down and capture "nature" in his wanderings around Munich during his student days had always ended in disappointment.[3] This activity, he felt even then, was not so responsible as the creation of paintings in which, consciously or unconsciously, he sought the "compositional" factor.[4] In fact, his work of this period displays a dichotomy between those rather uninspired oil studies from nature such as *The Sluice* (Fig. 50), and the strongly composed "mosaic" color drawings such as *White Cloud* or the decorative sketches such as *Dusk* or *Fairytale Town* (cf. Fig. 55), both of which were shown at Phalanx II.

But decorative art had its pitfalls, as Kandinsky also recognized. In a letter to Münter in 1904, he complained that people persisted in seeing the "decorative" in his drawings without seeming to notice anything of the "content."[5] On the other hand, he felt that this was an advantage: the more possibilities for fantasy and interpretation the better. The work should "resound" (*klingen*) with possibilities, he said, and the "inner" content should emerge only slowly.[6] Thus he suggested that the "decorative" work could indeed serve as a bridge to the end goal of "fine art" with a higher significance. He often felt himself almost plagued by decorative ideas,[7] yet he clearly recognized in them their great potential, as will be seen.

As early as 1899, in an article published in *Kunst für Alle*, the critic Schultze-Naumburg had linked the idea of the "composed" painting with the idea of the ornamental and the "abstract," in which indeed spiritual values predominate:[8]

> Because composition means literally a "setting together," so one is to understand here in the narrower sense an artistic work, which does not faithfully imitate a given piece of nature, but rather one in which the parts are drawn together to a new whole that was not given as a model in nature, so that one might speak of a *composed* and a *not-composed picture*.[9]

This compositional concept is particularly important in regard to ornament, wrote Schultze-Naumburg. For in ornament,

the decorative function has the say; the "what" [anecdotal element] steps completely into the background and wins at the most symbolic meaning. *With abstract [abstrakten] works of art, of course, purely spiritual [seelische] values take the lead*; and these values will be expressed in no limited degree by the form in which they appear, thus they are dependent on the manner of the composition in line and color.[10]

In *Über das Geistige*, Kandinsky was to write:

Thus in art the abstract element steps ever closer into the foreground. . . . And this growth and final predominance of the abstract is natural. It is natural because, the more the organic form [meaning "real" or "literary"] is driven back, the more this abstract [element] steps forward of itself and gains in resonance [*Klang*].[11]

Although Schultze-Naumburg did not go so far as to suggest that paintings be based on nonnaturalistic images, he employed a vocabulary with which to deal with such paintings, and which was later exploited by Kandinsky, among others. Already in 1904, Kandinsky described a painting to Münter as being an almost purely naturalistic piece of work, but nonetheless "composed."[12]

The very term "composition" took on a special significance for Kandinsky. In "Rückblicke," he wrote that the very word devastated him, and that it was his "life's goal" to paint a "composition." The word seemed to him like a prayer.[13] In fact, the "compositional" was to be the type of one of the two main branches of art in the future. This "compositional" would arise exclusively "out of the artist," as music arises from the composer. Works of this type stand closer, he wrote,

to the abstract idea of art itself and perhaps indeed are slated to embody that abstract idea in far distant times.[14]

At the conclusion of *Über das Geistige*, Kandinsky had also returned to the concept of the "compositional." There he predicted that the time of the "conscious, rational, compositional" grows ever closer, and soon the painter would be proud to declare his works "constructive," and that this direction would lead into the "epoch of the great spiritual."[15]

As in much Jugendstil criticism, the "abstract," the "compositional," and the "spiritual" were all linked in Kandinsky's aesthetic. The connection was described in even more explicit terms in the essay "Malerei als reine Kunst," in which Kandinsky suggested that "compositional painting," in which the object would be replaced by the "constructive," was the first step toward "pure art."[16]

THE DECORATIVE AND THE ABSTRACT

Already by the turn of the century, a body of criticism had been developed establishing a connection between the possibility of a future art independent of naturalist imagery and the new movement in the applied and decorative arts. Some examples of this prophetic criticism have already been cited.[17] Endell's revolutionary prophecy of an art of forms free of any imitative or associative characteristics, yet that would move the soul as deeply as music was wont to do, had been published in Munich's major periodical of the applied arts, *Dekorative Kunst*, in 1897.[18] At about the same time, Schultze-Naumburg had described the arts and crafts movement itself as a kind of "redemption."[19]

The primacy of ornament in the arts at the turn of

the century was stated most succinctly in the lead article of the April 1898 issue of *Dekorative Kunst*:

> Ornament . . . is the most telling expression for that which the modern movement has achieved until now in terms of tangible, purely artistic results. Its history belongs to the deepest, most complex and interesting problems of modern art criticism. It touches the essential being of the remarkable art epoch in which we live. . . .

The conclusion of the article (probably written by Julius Meier-Graefe) emphasized the "necessity" of the arts and crafts movement: ". . . today it is in fact more necessary to renew our arts and crafts than to paint pictures." The article ended with the claim that most contemporary painting stood

> under the sign of the purely decorative. . . . These paintings are no longer "pictures"; they want to be wallpaper, carpets and who knows what—in the last instance ornament. The transition [from painting to applied arts] can neither be hastened nor, still less, restrained. The consciousness that is necessary can only be expeditious.[20]

In 1899, Van de Velde's "abstract" woodcuts for *Van Nu en Straks* (Fig. 86) were published in *Dekorative Kunst* with an accompanying article about his writings and work.[21] In this article, the question of whether it might be possible to arouse certain significant "feeling complexes," with lines that have no objective associations ("keine sachlichen Vorstellungen") was discussed. The author pointed to Seurat and the theories of Charles Henry as precedent to Van de Velde's experiments. However, it was suggested that although Van de Velde's signs for *Van Nu en Straks* achieved a certain degree of expression, they were

"bad ornaments." These signs had failed as ornaments because they were merely abstracted from natural imagery. The signet for the magazine, it was explained, was based on the image of a sail filled by the wind, of which only the forward movement remained, symbolizing the "progressive character" of the periodical. Recognizing the "danger" in this, Van de Velde then turned away from symbolism in order to create a "unique, closed ornamental form." According to the article, this new "pure form" could then become the vehicle of expression and of a "free symbolism."

Thus the basic assumptions of abstract painting were current in German criticism related to the decorative arts movement by the turn of the century. Even the use of the term "abstract" had become quite common by that time in German art periodicals. For example, in discussing the Belgian artist Georges Lemmen in the pages of *Dekorative Kunst* in 1899, the author "Aries" wrote that

> Lemmen avoided the dangerous stumbling block of remaining ambiguously between picture and ornament. The step into the *abstract* [*Abstrakte*] was made without forcing the issue, and he had the tact, in regard to concrete things, to stop at the bounds of possible stylization.[22]

The same author had devoted a whole article to the problem of the abstract versus naturalism in the previous issue.[23] The problem was stated as a conflict between the "floralists" and the "linearists."[24] The term *abstrakt* was used throughout the article both in the sense of "abstracting from nature" and as descriptive of an art divorced from naturalist imagery. The ambiguity of the term was clearly recognized: "There is no floral and no abstract ornament. Every ornament is

abstract, abstract in the sense that it abstracts from nature, for nature itself doesn't give art. And what is true of ornament is valid also for other forms."[25]

THE DECORATIVE MOVEMENT AND SCHEFFLER'S "NOTES ON COLOR"

"Abstraction," wrote Karl Scheffler in 1901, "is the essential domain of the ornamentalist."[26] Little wonder then that in his chapter on the language of form and color in *Über das Geistige*, Kandinsky singled out for special mention an article by the same critic called "Notes on Color" ("Notizen über Farbe"), which had appeared in the Munich periodical *Dekorative Kunst* in February of 1901.[27] A scrutiny of this article reveals that it was written specifically within the context of the applied arts movement. Scheffler, himself trained as a craftsman, was at that time one of the most serious and dedicated of the writers then campaigning for the new movement.[28]

An analysis of "Notes on Color" reveals that it dealt with the need for the recognition of the essential autonomy of color. The article was in effect a plea for the use of color in art as an independent abstract entity. Its main thesis was that color, as an autonomous effective element, had yet to be discovered and exploited by the arts. Further, Scheffler suggested that the first step in that direction would have to be taken by the decorative arts. Thus, as early as 1901, Kandinsky was confronted with a basic tenet of abstraction, with an idea that was "prerequisite" to the development of his thought on the possibility of a nonobjective art; and it had been presented within the context of the decorative arts.

"The word ornament describes a real metaphysics of human creative power," wrote Scheffler, "it is one of the proudest syntheses."[29] Yet, even though the applied arts had to a certain extent liberated form and line from imitative literary requirements, color had remained dependent on some "architectonic-poetic" element. Color, he suggested, had yet to be freed and then subjected to the same "energetic stylizations" as line and form.

Color as Language

Even the so-called great colorists (he cited Titian, Rembrandt, and Böcklin) used color only as the "servant of an architectonic-poetic image-making capacity."[30] Yet, Scheffler pointed out, "everyone knows" that certain tones correspond to certain "feeling complexes." Indeed, "every sensitive man quietly develops his own color symbolism, which is much more than arbitrary play." Scheffler related that he himself was color-sensitive with respect to vowels (for example, he felt "u" as "dark blue"), ". . . and in this way even the languages of the various peoples differentiate themselves for me on the basis of color."[31] "Behind such instinctive stimuli," he wrote, "great secrets are hidden, a drive toward the development of an as yet incomplete organ [of perception] announces itself." He also suggested that all stylistic periods in history have had their characteristic color preferences. Nevertheless, color as an independent entity had never been fully exploited. Even the coloristic achievement of the impressionists had only limited significance in this respect, he thought.[32]

Scheffler then suggested that it was within the applied arts movement, if anywhere, that experiments in color as an independent element were being carried out. Van de Velde, he complained, lacked gaiety and

lightness in his use of color. The English were more daring, yet even they hesitated before the use of complementaries. He contrasted Morris, who "mixed with earth colors," with Eckmann (in his opinion the best colorist among German craftsmen), who "mixed with rank aniline colors."[33]

The only place where color was used with genuine naïveté and joyousness, said Scheffler, was in the homes of the farmers (in *alten Bauernstuben*). This is a striking example because it calls to mind Kandinsky's recollection in "Rückblicke" of the strong impact exercised on him by the brightly colored interiors of peasant homes he visited during his trip to the Vologda region of Russia.[34] Perhaps Scheffler's example in this article reinforced that memory and increased its significance for Kandinsky.

Since Kandinsky cited this article in *Über das Geistige*, we know that it did indeed affect him strongly. But its effect was perhaps more immediate than has been realized hitherto. For, as early as 1904, Kandinsky was working on what he called his "color language."[35] By that time already, he felt a deep sense of mission in this respect, and wrote to Münter that if he could solve the problem of color language, he could open up a new way in painting that others had only dreamed of.[36] Scheffler's article, then, appears to have been a catalyst in his thinking on color as a language of the artist.[37] Thus in Munich, by the turn of the century, he had found precedents for his thinking in regard to line, form, and color, in the writings and example of Endell, Obrist, Karl Scheffler, and others who were intimately associated with the applied arts movement.[38]

The connection between Karl Scheffler and Kandinsky seems all the more striking when we consider not only the context, but the whole tone of the following quotation from an article Scheffler published the same year called "Meditations on Ornament," in which he considered the "handwriting" of the artist in relation to his work:

Abstraction is therefore the essential domain of the ornamentalist. These remarkable artistic images [of ornament] are in truth tabular lines of the eternal world equilibrium, paraphrases of inborn instincts, attempts to capture the great causality of the world's architecture in a reduction mirror, a gay dance with the hand—all of that at once. The creative choice of the artist is infinite; yet in every case he is under the pressure of his visions, his lines are then either necessary or they count for nothing. . . . He who is able to draw the consequences of the relationships between graphology and ornamental art, who observes exactly how feelings discharge themselves in lines, how lawfulness manifests itself everywhere in artistic creation and how at a certain point the architectonic and the musical, the reflective and the fantastic-playful instincts meet and even become identified with one another—such a one will have made great progress toward a monistic world view. . . . We still hear the *Klänge*, the sounds [of a unified style] from olden times, a hundred harmonies sounding all at once; but a fanfare drowns them out and calls clearly to the future. He who has ears to hear, must listen![39]

He might have been speaking directly to Kandinsky who heard the *Klang der Ewigkeit-Kunst*, and urged the artist to turn an open eye to his "inner life," and his ear to the "mouth of inner necessity."[40] He was intimately familiar with the synaesthetic effects of art,[41] and later commented in a letter to Arthur J. Eddy that one must learn to view the painting as a "graphic representation of a mood."[42]

The Intellectual, the Spiritual, and the Decorative

The drive of Jugendstil painting in general toward the "decorative" was viewed with suspicion in some quarters, while in others it was welcomed as a reaction against the trivial anecdotal painting of naturalism. It will be recalled that the critic Karl Voll had scolded the decorative painters at the 1898 Secession for having "abandoned" content, and accused the painter Walter Leistikow of "playing intellectual games" with his stylized, flat, uninhabited landscapes.[43] *Geistreiche Spielerei*, was the term he used—"intellectual games."

But there were defenders of the *Geistreiche* in art. In January 1903, an article appeared in *Kunst für Alle* with the suggestive title, "Das Geistreiche im Kunstwerk." It was by Ludwig Volkmann, and immediately preceded an important article on Alfred Kubin.[44] The title can be only loosely translated as "On the Intellectual-Spiritual in the Work of Art."[45] The conclusion is almost inescapable that it had a very definite impact on Kandinsky, who was already collecting notes for his book on the *Geistige* in art.[46]

Volkmann felt that the term *geistreich* had been so overworked by critics that it had lost its essential meaning. All too often, he said, it was used to denote the merely "witty" or "brilliant" in the conventional sense of the term. All too often it was applied to the work of artists who could do little more than "recite" a few good ideas with brush or chisel.

The term *geistreich* (or, better, *geistvoll*), he felt, should be employed to refer only to the whole "spiritual substance" of the work of art, not merely to its material or contextual idea (". . . nicht nur der stoffliche oder inhaltliche Gedanke, sondern der gesamte geistige Gehalt des Kunstwerkes . . ."). Only in this

way, he suggested, would it be possible for the critic to approach the "innermost being" of the work of art.[47]

Neither the intellectual idea (or any thought that can be as well expressed in words), nor the technique itself, nor the mere imitation of nature have anything to do with the *geistreiche* in the artistic sense. For any of these may be employed without *Geist*, without spirit. Everything is *geistreich* which, in a clear and convincing way, serves the artistic intention, in either formalistic or coloristic sense; anything which, through a saturation of spirit (*Geist*) and conception, enriches and clarifies our imagination, thus giving us something that no one but the artist can give or even see. These thoughts were, of course, to be echoed even more strongly in Kandinsky's *Über das Geistige*: ". . . the artist is not only justified, but obligated to use forms in any way necessary for his purposes."[48]

In his use of space, his manipulation of color, his arrangement of forms, the artist speaks to us, wrote Volkmann. But his most personal "medium" is his capacity to "emphasize the essential and to exclude the nonessential" (". . . *das Betonen des Wesentlichen und das Ausscheiden des Nebensächlichen. . . .*").[49] This sentiment was also echoed later by Kandinsky in his introduction to the first catalog of the *Neue Künstlervereinigung*, in 1909. There Kandinsky spoke of the artist's need to bring to expression a "reciprocal saturation" of external and inner experience, of his search for forms "which must be liberated from all nonessentials. . . ." ("die von allem Nebensächlichen befreit sein müssen").[50]

All simplification is *geistreich*, wrote Volkmann, who ended by including ornamental art, architecture, and even the art of reproduction within the possible bounds of the *Geistreiche*. (Kandinsky, too, included

reproduction as a legitimate artistic expression, among the "virtuoso" or realistic arts.)[51]

In a concluding comment to his article, published subsequently, Volkmann urged once again that it is not the artist's ability to conjure illusion that is the decisive factor in art, but the fact "that he has something to say," something that is not available to other people.[52] And he contended that the fruitless argument as to the priority of art or nature be finally laid to rest since "it has long since been acknowledged that these two great forces are incommensurate."[53]

A NEW LANGUAGE OF FORMS

Thus while some warned against the increasing distance between art and life, others, such as Volkmann, urged altogether different standards. Endell had already dreamt of an art with forms that would "represent nothing," as early as 1897. Now some began to suggest that there might develop out of the ornamental arts a "new language" of forms which, imbued with significance, would lead to the prophesied art. Such an idea was urged by Ferdinand Avenarius in a surprising essay published in the magazine he edited, *Kunstwart*, in the summer of 1908.[54]

The essay was titled "Eine Neue Sprache?" (A New Language?), and dealt with a group of drawings by the Dresden artist Katharine Schäffner.[55] While most of the Schäffner drawings appear somewhat forced, even trite today, the essay by Avenarius appears fresh and startling, especially when considered in relation to the way in which Kandinsky moved toward abstraction over the bridge of the decorative arts.

Until now, Avenarius wrote, there has been no painting unrelated to applied art which has been able to transmit spiritual values (*seelische Werte*) exclusively by means of light, or color, or line, without imitating the forms of reality. Although we have already witnessed a few cases in which applied art has been able to accomplish this completely without figurative imitation, such a phenomenon "is just beginning to be prepared in the free arts."[56] At the most, he said (perhaps thinking of August Endell's Elvira atelier decoration), we have already experienced the "super-ornament" (*das "Über-Ornament"*). In this case, the decorative element is secondary, while the major function is not the presentation of a mere eye-pleasing object, but "nothing less than a free color-, light-, and linear-image for the transmission of a spiritual content."[57] One such example was offered, he suggested, by the drawings of Schäffner.

In discussing the relationship of the new art to the old, Avenarius employed an image that was later to be taken over by Kandinsky. He wrote that free art (he meant the fine arts) seemed in some remarkable manner to be growing a new branch on its trunk. "There is something new 'spooking' about in [the fine arts], that could present a most remarkable and more important problem, and which could become much more powerful than all the various 'directions' of the last decades. . . ."[58] The result might be, he thought, a "visual art, which would take a position essentially between visual art and music, something like a 'musical seeing.'"[59] In "Rückblicke," Kandinsky also described the new art as a new branch on the trunk of the old tree of art. Furthermore, in Kandinsky's scheme, the "new branch" represented the "compositional" art of the future, which he promptly associated with music.[60]

While conceding that Schäffner's drawings do not conclusively "prove" that profound emotions can be expressed purely by means of the artistic elements,

"that is, with the means of pure ornament," Avenarius wrote that he didn't know of any reason why that might not be possible.[61] Perhaps, he suggested, with greater practice in the "reading of the 'new language,' conventional signs might be developed, which could be understood by everyone, while differing individually."[62] He warned, however, of the danger that might result from developing an explicit sign language that would convey concepts rather than "moods." Such a result would, he noted, once again lead away from the "artistic."[63]

Avenarius concluded that the aesthetic merit of the new movement lay in the possibility of freely transforming elements of reality and exploiting them for the expression of one's own inner life, without being bound by the spatial relationships of reality, for the "freest expression of spiritual situations." And he prophesied that in the coming years many would attempt to make use of the "new language."

While most of Schäffner's drawings scarcely exceed the bounds of caricature (such as *Ghostly Silence* [Fig. 87]), one or two present rather convincing images of psychological or physiological states.[64] *Slumber* and *Passion* are perhaps the best (Figs. 88, 89). As Avenarius himself conceded, these scarcely demonstrated great profundity, but yet they suggested to him immense possibilities. It was his own essay which contributed most to the impetus of the new movement.

INNER NECESSITY AND THE DECORATIVE INSTINCT

When Wilhelm Worringer reviewed Rudolf Czapek's book *Grundprobleme der Malerei* for *Kunst und Künstler* in 1910 (two years after its publication), he took special note of the author's "feeling for the meta-physical substance of so-called technique, which conditions the symbolic value of all art."[65] It is not surprising then to find that Kandinsky was familiar with Czapek's book,[66] and indeed, in scope and style, it is in some ways comparable to Kandinsky's later publications.[67]

Czapek presented a theory of art as *Flächenkunst* conditioned by the interaction of spiritual conception and technical execution. "Inner necessity" was the artist's driving force and the decorative instinct was taken as his most valuable spiritual-intellectual tool in the composition of the painting. He wrote that a picture "can correspond to an observed cross section of nature completely, partially, or not at all; can be painted partially or wholly from memory, or can be entirely freely composed."[68]

But perhaps the most striking observation in Czapek's book was the conclusion to his chapter on historical development. There we find a statement almost as surprising as the Avenarius essay:

> This slow development or unfolding of painting raises the question whether perhaps an auspicious and ever progressing spiritual development may not bring forth a painting which may take an ever freer stance with regard to the world of things (which has become increasingly its domain); and if it may [in the future] offer the eye what by today's standards would seem pure ornamental decoration [but then] of inestimable inner significance. If perhaps it might be possible to read out of the direction of the decorative spirit a spiral of symbolically effective ornament. . . .[69]

Thus it can be seen that the development of the idea of a new formal language growing out of ornament and the decorative arts went hand in hand with the conviction that spiritual values could be retained and

expressed by these means. These few examples scarcely scratch the surface of the burgeoning literature that was rapidly developing to diagnose and interpret the radical changes foreseen in the arts. The quotations cited have been selected to demonstrate that the relationship between the applied arts movement and the possibility of an "abstract" art was recognized in Munich during the early years of the century, at least on a theoretical level. That it was to be years before the *Formkunst* prophesied by Endell could become an actuality is merely indicative of the deeply problematic nature of the phenomena involved. Though the seeds of an abstract art had been sown by the applied arts, it would be necessary for the offspring to discard certain characteristics of the ancestor; in fact, drastic metamorphoses had yet to take place. The "merely decorative" had to be disinherited, the psychology of color, line, and form to be fully explored, a new symbology created, before an independent abstract art could claim the status of a fine art, before Kandinsky could arrive at what he called, in close reminiscence of Endell, *Formenkomposition* (form-composition).[70]

Overcoming Ornament

Indeed, the importance accorded "Ornament" in the crucial "Theory" chapter of *Über das Geistige*[71] suggests that not only was Kandinsky concerned with ornament as a phenomenon with which the "fine arts" must come to terms, but that his theory itself was consciously founded on assumptions arising out of the decorative arts, out of ornament.

In that chapter, Kandinsky predicted the future development of art in two directions: "pure abstraction" and "pure realism." Step by step he had clearly de-

rived these from the two poles he detected in contemporary art. The first of these ("to the right" in his imaginary scheme) was the *"fully abstract, wholly emancipated use of color in 'geometric' form* (Ornament)." The second pole, to the left, consisted of the *"more real uses of color—too strongly crippled by external forms*—in 'bodily form' (the Fantastic)."[72] He described these poles as representing two "dangers" for the contemporary artist. But beyond them he glimpsed ("on the right" again) the way to *"pure abstraction* (that is, greater abstraction than that of geometric form)" and on the other side, *"pure realism* (i.e., higher fantasy—fantasy in hardest material)."[73] Between the poles he saw "boundless freedom. . . ."

The "danger" inherent in ornament was a major concern of Kandinsky. In fact, there is little doubt that his own progress beyond the pole of ornament to pure abstraction had long been impeded by this very concern.[74] It was characteristic of his integrity that he found it necessary to analyze this "danger" then, at the very beginning of the chapter on theory in *Über das Geistige*.

Whereas ornament (with which he had most intimate associations, as will be demonstrated) offered a direct route to the painting without an object, he recognized clearly that *"the beauty of color and form is* (despite the opinion of the pure aesthetes or even the naturalists, who aim primarily for [conventional] 'beauty') *no sufficient goal in art."* He also recognized that, due "to the elementary state" of contemporary painting, people are "scarcely capable of achieving inner experience from wholly emancipated color-, form-composition."[75]

However, he admitted that, in confronting *craft works* (*kunstgewerblichen Werke*) one might "of

course" experience "nerve vibrations." In other words, he took it for granted that works of applied art can inspire a relatively deep response. Yet, he considered these "vibrations" "too weak" to call forth the "devastations of the soul" that really great works of art do inspire.

Nevertheless, "even ornament," he wrote, "is no lifeless being." Ornament offered a world with its own "inner *Klang*" which was "in principle necessary" and offered possibilities, despite the fact that it often exhibited a kaleidoscopic confusion. (Even this, he said, was a precise kind of life, though of "another sphere.")[76] But the main point was that even the most illogical, planless, and arbitrary ornament is capable of exercising an *effect* on us.

We react instantly, for example, to differences between the ornaments of different peoples, he wrote (e.g., between Oriental, Swedish, Negro, or ancient Greek ornament). Yet most significant of all for Kandinsky was the approximation between the effects of ornament and the effects of music (for, as Endell had predicted, the future *Formkunst* would be able to move the soul as deeply as only music had been able to do before). Kandinsky noted that it was "not without reason that ornamental patterns for fabrics [were] customarily designated as gay, serious, sad, lively, etc., that is, with the same adjectives always used by musicians (Allegro, Serioso, Grave, Vivace, etc.). . . ."[77]

He also took note of the relationship of ornament to nature. Though possibly ornament may have developed largely from nature, he conceded, yet in "*good Ornament*," natural forms and colors were not handled in a "purely external" manner, "but rather much more as symbols which finally were used almost hieroglyphically."[78] But, like the hieroglyph, such ornament be-

came with time incomprehensible. Thus even something as "precisely anatomical" as a "Chinese dragon" ornament may have become so meaningless to us today that we pay as little heed to it in our homes as to a table-runner decorated with embroidered daisies.

Yet Kandinsky prophesied a "new ornament" that would develop toward the end of "*our presently dawning period, which however will scarcely consist of geometrical forms.*"[79] To force this development, he wrote, would be vain.

Indeed, to force the "pure abstraction" he foresaw in painting would be equally vain:

If we were to begin today to destroy completely the bond that ties us to nature, to steer off with force toward freedom and to content ourselves exclusively with the combination of pure color and independent form, we would create works that would look like a geometric ornament, which, grossly stated, would be like a tie, a carpet.[80]

Yet, as he also pointed out in this chapter, ornament has the power to affect us deeply, in a manner analogous to music; it can cause "nerve vibrations"; it has its own "inner *Klang*." In fact, the lessons learned from ornament were to become the basis (the *Generalbass* mentioned at the beginning of the chapter) of Kandinsky's theory in his later book, *Punkt und Linie zu Fläche*. Kandinsky was fully aware of living in the "midst of the decorative movement" and he did not hesitate to recognize its immense significance at the germinating core of the modern movement: "*To the right lies the fully abstract, wholly emancipated use of color in 'geometric' form* (Ornament). . . ."[81]

It is even possible to demonstrate the context of

Kandinsky's reference in the theory chapter to tie fabrics and carpets. In the May 1903 issue of *Dekorative Kunst*, Karl Scheffler introduced illustrations of tie materials then being exhibited at the elegant art salon of Keller and Reiner in Berlin (Figs. 90a, 90b). In the accompanying article, "Technik als Kunst" (Technology as Art), Scheffler compared the high quality of these fabrics, both in terms of design and technique, to that of works by Tiffany, in that the "craft and the art [have been] so intimately bonded and translated into textile."[82] Significantly enough, Scheffler noted at the close of the article that it was Friedrich Deneken of the Krefeld Museum who had been responsible for encouraging and supporting the firm which had produced the fabrics. This was the same Dr. Deneken who had arranged the two highly influential exhibitions: "Color-show" of 1902, and "Line and Form" of 1904, which Kandinsky very likely saw.[83]

From a present-day point of view, some of the patterns seem remarkably prophetic of the "drip" and "op" motifs common in art over the past quarter century. As for carpets, those designed by Behrens and Schmithals (Figs. 57, 91) had been widely exhibited and illustrated.[84] These, too, seem as "modern" today as they did nearly three-quarters of a century ago. In fact, the connection Kandinsky made between ornament and abstraction seems perhaps more relevant and penetrating now than it did at the time.[85]

CHAPTER

·XI·

The Craftsman

THAT Kandinsky was fully conscious of living in the midst of the decorative movement has been suggested in the previous chapter, as well as in the discussion of the rapid growth of the arts and crafts movement in Munich, and in the chapters on Obrist, Endell, Hölzel, and Stuck. But did Kandinsky himself actually participate in it? Or did he reject it out of hand, an impression one might receive from reading certain passages in *Über das Geistige* out of context?[1]

In fact, the evidence that he did indeed participate actively in the applied arts movement is at hand, and increases in significance as the whole context of his activity at this time is more thoroughly investigated. It was not characteristic of him to "reject out of hand." Rather, a drive to exhaust every possibility was far more typical, and accounts in large part for the deliberation with which he moved toward the goal of a nonobjective art. For example, his rejection of the fairy-tale mode as a means of achieving abstraction[2] came only after years of experiment with fairy tale and folk art motifs in his own work. This slow progression was symptomatic of his deep sense of responsibility and of his whole approach to abstraction.

Thus it is not surprising to find that his involvement with applied art extended also over a period of many years. Indeed, seen from a broad historical point of view, this involvement may be said to have extended from the decorative sketches exhibited at the second Phalanx show in 1902 to his departure from the Bauhaus in 1933.[3] The second Phalanx exhibition, as has been shown, was in fact a full-scale applied arts event.[4] It is then, within the context of the decorative movement, that the continuity of his development may best be understood.

But, in order to establish the significance of Kandinsky's ties to Jugendstil in the light of his later development to nonobjective painting, it is necessary to begin with the actual evidence of his personal involvement in the decorative movement.[5] The fact that the catalog of the Salon d'Automne of 1906 cited *seven* items of craft work designed by "Basile Kandinsky" will then no longer appear so startling.

The Salon d'Automne of 1906 was in fact distinguished by a large retrospective of works by Paul Gauguin. In the catalog, an article on Gauguin by Charles Morice began with a quotation of 1903 from Carrière: "Gauguin est une expression décoratif." Gauguin is a decorative expression. This must have seemed especially appropriate to Kandinsky, whose contribution to this exhibition included the crafted objects and woodcuts (then still considered "applied" rather than "fine" art), as well as twelve paintings and drawings. The craft works included two ex-libris (which were hand-printed woodcuts), four handbags (including two for children), a sewing kit, a "small panel," and a tobacco pouch. The tobacco pouch was

described as having "bead-work executed by G. Münter." The small panel may have been an embroidered wall hanging.[6] Of the works of "fine art" submitted by Kandinsky, three items were color woodcuts described as "printed by hand," thus emphasizing their essential nature as hand-crafted objects.

Nor was this exhibition an isolated instance. Already in the Salon d'Automne of 1905, Kandinsky had exhibited two *Kunstgewerbliche* items and four "lithographs" (as well as six paintings). Number 822, *Solitude*, was described in the catalog as a *Projet décoratif*, while number 823 was merely identified as a *Projet de Vitrail.*[7]

According to the recollections of Gabriele Münter as recorded by Eichner, some of these works originated during the trip to Tunis undertaken by Kandinsky and Münter in the winter of 1904-05. According to Eichner, Münter carried out at that time many of the decorative designs Kandinsky had prepared. These included handbags and wall hangings in appliqué and beaded embroidery which were "later exhibited in Paris."[8] "There were Viking ships and German winter landscapes with rabbits and a snowman intended for children, but also almost abstract images of ornamental fashion."[9] At another place, Eichner described a small wall hanging with Viking ships and "Jugendstil clouds" (Fig. 92).[10] According to Eichner, the handbags exhibited motifs in various degrees of "abstracting stylization." For example, a Pegasus motif became a puzzle in which one had to search for the given subject.[11] There was also a carpet with stylized crinolined Biedermeier ladies around the border.[12]

In tracing the evidence of Kandinsky's activity as a craftsman back in time from these two Salon d'Automne exhibitions, it becomes clear that the objects exhibited on those occasions were part of a continuous development that had begun by the turn of the century.

THE SOCIETY FOR APPLIED ART

During the summer of 1904 in Munich, Kandinsky had been actively involved with the Vereinigung für angewandte Kunst (Society for Applied Art). He attended meetings of this society which had grown out of the original United Workshops group begun by Obrist, Endell, and others before the turn of the century. In letters to Münter, he described these activities and also his enthusiasm for the applied arts. At one point he exclaimed as if bursting with excitement: "Pictures, decorative paintings, embroideries, whole rooms are suddenly in my head again and once more I'm thinking in color. Will it last long?"[13] A few weeks later, he wrote that besides all the other projects he was rushing to complete before leaving Munich for a trip to Russia (and subsequently the trip to Tunis with Münter), he wanted to make a few sketches for the Society for Applied Art.[14]

Kandinsky's involvement with the Society for Applied Art demonstrated not only his interest in the arts and crafts movement but again his sense of responsibility as an artist. For if the United Workshops had been a response to Obrist's Utopian messages on the necessity to raise the quality of life, the Society for Applied Art was dedicated to more practical goals, namely, the problem of extending the aesthetic ideals of applied arts to the whole spectrum of city planning. An anonymous article in *Dekorative Kunst* in July 1904, entitled "Wie steht es um München?" (How goes it with Munich?), ascribed to the new society the goal

of developing exhibitions which would include industrial design, interior design, architecture, and so on, with the idea that art should "encompass the whole life of the city."[15]

Among the seventy members of the society (which had been founded in 1903) were, besides Kandinsky, Hermann Obrist, Richard Riemerschmid, Carl Ule, Adalbert Niemeyer, Thomas Theodor Heine, and Margarete von Brauchitsch; all very well-known Munich craftsmen. Work by Peter Behrens and Ernst Stern, both former Phalanx exhibitors, was included in the 1905 exhibit. And from Kandinsky's letters, we know that he, too, aspired to submit designs.[16]

THE KREFELD LINE, FORM, AND COLOR EXHIBITIONS

Indeed, the summer of 1904 was rife with activity in the arts and crafts: Peter Behrens' Arts and Crafts School at Düsseldorf was featured in a lead article in *Dekorative Kunst*;[17] a widely hailed exhibition entitled "Linie und Form" (Line and Form) was on at Krefeld, under the aegis of Friedrich Deneken of the Kaiser-Wilhelm-Museum (who, two years previously, had broken precedent with an exhibition called "Farbenschau," or "Color-show"); and August Endell announced the opening in Berlin of a "School for Form-art" (*Formkunst*).[18]

It is very possible that in the spring of 1904 Kandinsky's travels included the exhibit at Krefeld, as well as a visit to Behrens and his school at Düsseldorf, and to the large international exhibition there. An announcement of the Krefeld exhibition opening had appeared in the same issue of *Kunstchronik* that carried the announcement of the important Phalanx neo-impressionist show.[19] Kandinsky, in fact, visited Krefeld, Düsseldorf, and Cologne between 11 May and 17 May 1904.[20]

The exhibition, "Line and Form," would surely have held great interest for Kandinsky, with its stated goal of "opening the eyes" to the effects of line and form. It juxtaposed engineering drawings of modern ships and iron bridges with drawings of old and new masters like Puvis de Chavannes, the German Nazarenes, Beardsley, Heine, and even Maurice Denis. A reviewer complained that not only was Dürer absent, but that designs for old sailing vessels ought to have been included as well.[21] It is interesting to note that twenty years later Kandinsky used designs for both types of ship in his book *Punkt und Linie zu Fläche*.[22] The reviewer was particularly taken with the display of linear designs from nature which included animal skulls, a bat, various sea animals, and insects. Again, in *Punkt und Linie*, Kandinsky also used photographs and drawings of animal and plant life to demonstrate certain characteristics of line.[23]

PROFESSIONAL RECOGNITION

A visit to Behrens at this time is very likely because in the previous summer of 1903, almost immediately following Behrens' appointment as director of the Düsseldorf Arts and Crafts School, he had approached Kandinsky with the offer of a position there. At the time, Kandinsky had written to Münter: "Yesterday Prof. P. Behrens came to me and asked me to take over the direction of the class for *decorative painting* at the Düsseldorf Arts and Crafts School."[24]

This early recognition of his talent by an established and already famous artist must have been most

gratifying to Kandinsky. It is then significant, for a contextual understanding of his development, that this first official acknowledgment as a professional artist was in the area of the *decorative arts*, the arts and crafts.

It was characteristic of Kandinsky that he did not rush to accept the offer. His letter to Münter went on to express doubts about the amount of time such a position would leave for his own work, though he admitted that the connections might be advantageous. He soon decided not to take the job at least for a year.[25] Undoubtedly Kandinsky visited Behrens in the spring of 1904 to discuss, if not the position itself, then common interests in the arts and crafts and perhaps methods of teaching as well.

KANDINSKY AND THE OBRIST-DEBSCHITZ SCHOOL

During the same winter in which Kandinsky's Phalanx School had opened its doors (1901-02), Hermann Obrist and his friend Wilhelm von Debschitz had also founded a school of their own. They rented their first teaching studios in a building at Hohenzollernstrasse 7a, on the same street as the Phalanx School, which was at Hohenzollernstrasse 6.[26] From only three students at the beginning, the school had grown to over one hundred students by 1904.

The "Lehr- und Versuch-Ateliers für angewandte und freie Kunst" translates as the "Teaching and Experimental Studios for Applied and Fine Art," somewhat awkwardly but effectively indicating the new and significant rapprochement sought between the "lower" and the "higher" arts, between craft and fine art. And in March of 1904, just before Kandinsky's trip to

Krefeld and Düsseldorf, almost the entire issue of *Dekorative Kunst* was devoted to three major articles on the Obrist-Debschitz School and its methods.

By that time, Obrist and Kandinsky were already on fairly intimate terms: visiting one another, going to the Nordbad (a municipal swimming pool) together, even enjoying overnight bicycle excursions together, and exchanging ideas on art.[27] Kandinsky wrote Münter that Obrist understood him, particularly his need to progress slowly.[28] No doubt Obrist's uncanny ability to encourage and inspire his students affected Kandinsky as well, for Kandinsky wrote appreciatively of Obrist's expressed regard for his work.[29] Undoubtedly it was Obrist's lead in raising embroidery to the status of a "fine art" that had inspired Kandinsky to try his hand at designing embroideries as well.[30]

The lead article in the issue of *Dekorative Kunst* devoted to the Obrist-Debschitz School revealed a stunningly progressive, modern, and permissive approach to teaching that must have seemed nothing short of revolutionary to most educators of the day.[31] The emphasis of the school (and its novelty) was first and foremost on formal artistic problems of a perceptual-psychological nature. In order to understand the origin of certain effects in nature, the student was taught to look for the sources of those effects in the formal structure of the image. Thus, the lightness of a wheat stalk, for example, was seen to reside in the abstract qualities of its linear structure. Debschitz developed this argument much as Endell had done in his series of articles on form and line in 1897.[32] Figure 93 was used to demonstrate how certain linear figures can produce the effects of lightness or heaviness, rising or falling, in much the same way Kandinsky was to

demonstrate such effects in his later book *Punkt und Linie*.[33]

Seeing with Eye and Soul

The process by which the artist is able so to "abstract" the essentials from nature was likened by Debschitz to the ability to extract and recall a melody, in which "not only the ear, but also the soul is involved in the hearing." So must the artist be able to see "with eye and soul."[34] Harmonic linear relationships, linear rhythm, rhythmic harmonies, and construction were to be observed and abstracted. The student was to be led through a series of exercises which included the problem of "peeling off" (the word *abzulösen* was used) the recognized structural law from appearance and rendering the effect *"without imitating the form in nature."*[35] Similar exercises in color, size, light, and shadow were also to be undertaken.

From just such exercises originated the remarkable studies published in this issue of *Dekorative Kunst* in stunning full-page color reproductions. One by B. Tölken was called *Hanging and Tension Study* (Fig. 94). The other, by Hans Schmithals, was simply entitled *Study* (Fig. 95). The Tölken study set a precedent for similar illustrations of energy and direction in Kandinsky's *Punkt und Linie*, and for still later paintings with titles such as *Tensed on Two Sides* of 1933, *Tensed in the Angle* of 1930, or *Fixed Points* of 1929, which also exploited a weblike motif (Fig. 96).[36]

The Schmithals work, with its abstract play of relationships between forms derived from nature and naturalistic (though decidedly distorted), dreamlike space also had repercussions in Kandinsky's later work. It seems to have provided a precedent for those transitional improvisations of the late Murnau period (ca.

1912-14), in which strange jellyfishlike forms float or war in dreamlike but still naturalistic spaces (Fig. 97).[37]

The article by Obrist in the same issue emphasized particularly the *geistige* (spiritual-intellectual) aspect of the instruction, which was designed to bring the student to an attitude of "thinking observation" which must accompany the mere "optical observation." This *geistige* aspect would inspire the quest after *Notwendigkeiten* (necessities) and *Gesetzmässigkeiten* (inherent laws) which must predominate, he said, in applied art. He likened Debschitz' method to a canon of harmony or counterpoint applied to the crafts and decorative art.[38]

Surprisingly enough, Obrist ended his article with a testimonial to the principle of coeducation, which he claimed worked all to the good in his school.[39] Kandinsky had consistently admitted women to his school and exhibitions. Apparently Behrens must have taken note, for within months it was announced that henceforth the Düsseldorf School of Arts and Crafts would open its doors to women. In an official academy, this was a revolutionary break with tradition.[40]

CERAMICS, JEWELRY, AND FURNITURE

In the meantime, other areas of craftsmanship had been opened to Kandinsky. During the summer of 1903 (the summer when Behrens offered him the position at Düsseldorf), Kandinsky had taken his Phalanx class out into the country, to Kallmünz, for a few weeks of landscape painting. Kallmünz was, according to one student's memory, a village so remote that there was no train connection and visitors had to arrive by an old-fashioned, horse-drawn coach. Carl Palme

wrote, "The coach announced its arrival by post horn, which echoed through the hills just as in Roman times. One could hardly believe it."[41] The students lived in local farmhouses. Palme found lodging with a potter, and so it was that Kandinsky joined Palme in his first experiments with pottery and glazing.[42]

Palme related that he and Kandinsky tried their hand at decorating the potter's jars and vases, and at adding the glazes. He recalled their surprise when they observed the "prank" which the kiln had played on them, but noted that they also understood the possibilities which accident had offered.[43] Eichner also reported that Kandinsky had experimented with pottery that summer, thus further substantiating Palme's recollection.[44]

A sketch in the collection of the Städtische Galerie in Munich (Fig. 98) indicates that Kandinsky did indeed make designs intended for a ceramic or possibly glass medium. The globe-shaped forms suggest the possibility that Kandinsky may have intended these as designs for glass lampshades, although they may also have been intended for vases. The motifs are typical of the Jugendstil period, particularly in the simplification and stylization of forms, the flattening of perspective, and the use of a winding or wavy line to bind the composition and to set up that characteristic surface rhythm.[45]

Several designs Kandinsky made for jewelry also survive in the notebooks and sketches at the Städtische Galerie. They reveal a sure, even bold, feeling for design and the distinct impress of Jugendstil. Figure 99, a composition of circles and wavy lines, is particularly typical of the period, with its juxtaposition of the characteristic Jugendstil wavy line and the repeated circles.[46] In fact, this particular design repre-

sents a striking example of Kandinsky's genius for abstraction and synthesis. Compared, for example, to a typically Jugendstil brooch by Ferdinand Hauser (Fig. 100),[47] Kandinsky's design emerges as a paradigm of Jugendstil design. Dispensing with Hauser's extravagance, Kandinsky has yet synthesized the characteristic elements of the style into an abstract Jugendstil composition par excellence.[48] Indeed, this early drawing is almost eerily prophetic of such a later painting as *Several Circles* of 1926, with its repeated circles and wavy swirls of color (cf. Fig. 99, Pl. VII).

Other jewelry designs from this period include an oval with circular inclusions and pendants, a griffin, a triangle within a circle (with triangular pendants), a Tunesian village, and a Biedermeier lady. These also reveal a typical Jugendstil interest in pattern and plane (Figs. 101-103).[49] The design of the triangle in a circle, of course, introduces a synthesis of two motifs that were to have a dominant role in Kandinsky's later oeuvre. All demonstrate a characteristic reduction or simplification in motif, combined with an intensification of surface interest by means of patterned inclusions or rhythmic repetitions of design elements.[50]

In a notebook of 1904, there are several rather detailed drawings for a ring based on the form of a fish turning back upon itself (Fig. 104).[51] Another ring, on the same page, has a double setting based on a floral motif. A third ring reveals a more abstract conception with odd-shaped inclusions. There are also sketches apparently intended for a silver box with blue enamel, decorated with a design of spirals and wavy lines.[52]

Other notebooks contain several pages of designs for furniture, including a sketch for a chair with a

design of Viking ships and a falling star or rocket on its back (Figs. 105-106).[53] There is also a whole page devoted to designs for keys and locks, typically Jugendstil in the adaptation of organic form to an inert material (Fig. 107).[54] They are strikingly reminiscent of Endell's designs for the Elvira Atelier (cf. Fig. 108).[55]

Several designs in the Städtische Galerie collection seem to have been intended for embroideries or for woven material, for example, Figure 109.[56] These reveal a typical Jugendstil simplification of form, particularly in the massing of the tree foliage, but also in the stylized floral motifs.

The furniture designs are especially relevant, for they presaged a much later activity. During the years when Kandinsky lived at Murnau (1909-14), he decorated a number of pieces of furniture in peasant style for his house there. They are crude, simple pine pieces, but the decorations sing with gaiety. Besides a red desk and chair decorated with floral motifs, and a bookcase decorated with a Biedermeier lady, there is also a small, white night-stand, which displays the beloved horse-and-rider motif, and the mountain topped with a citadel. At that time he also decorated the stairway of the house with a design of suns, flowers, and leaping horsemen in yellow, lavender, blue, and other pastel hues. He also carved a small watch-stand and made at least three wood reliefs (e.g., Fig. 110b).[57]

Kandinsky never entirely left handcraft behind. It was related to his fervent hope for a synthesis of the arts, which led ultimately to his association with the Bauhaus. In 1924, he wrote to his biographer Will Grohmann: "Work in space, that is, together with architecture, is my old dream. . . ." And he mentioned in this connection, his designs for murals for the 1922 Juryfrei Exhibition in Berlin.[58]

FREE SPIRITS, THE FAIR SEX, AND FASHION

Undoubtedly it was the experimental freedom of craft work that appealed to Kandinsky. Coming to craft design, as he did, without prior training, it was perhaps not difficult to set aside traditional or preconceived notions. It was possible to concentrate instead on the medium itself and its possibilities. It was even possible to restrict a study of the medium to very specific effects (as in the case of the potter's glazes), or to considerations of positive and negative space alone (as in the woodcut), or to concentrate on the effects of color masses, or the reduction of motif required by such media as embroidery or tapestry design. Indeed, most of the innovators in the applied arts at the turn of the century came originally from "outside" or were self taught.

One of the freest self-taught spirits in applied arts in Munich at that time was Margarethe von Brauchitsch (1867-1957), like Kandinsky a member of the Society for Applied Art. Von Brauchitsch was a talented craftswoman whose embroidery designs had already created interest at the 1900 World Exposition in Paris. She was among the first to follow Obrist in transforming embroidery into a fine art, and also one of the first to use the sewing machine to achieve the fine effects of hand embroidery. As versatile as she was inventive, von Brauchitsch had also designed wallpaper and carpets, and her work had been reproduced in *Pan* as early as 1896-97.[59]

Where von Brauchitsch relied on motifs from na-

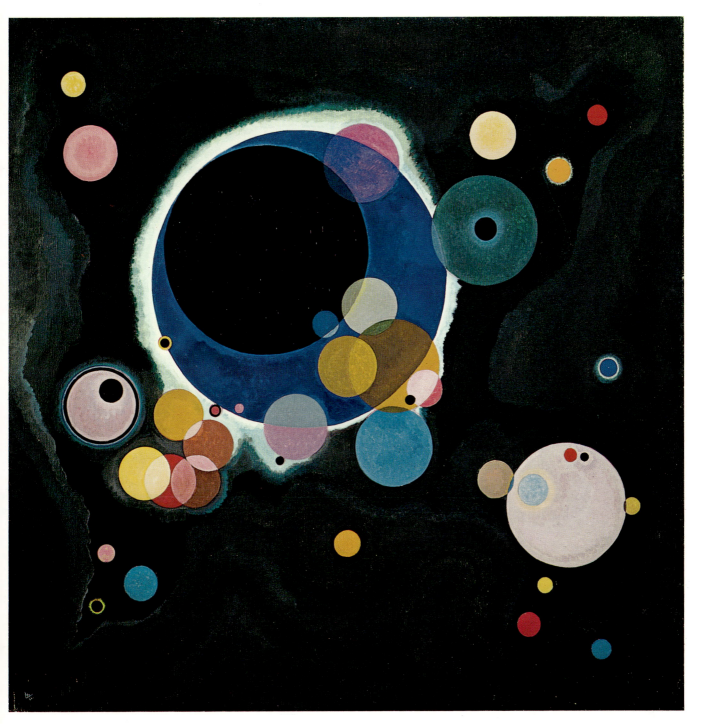

VII. KANDINSKY. *Einige Kreise (Several Circles)*, 1926.

ture, these were highly stylized, but more often than not she departed drastically from recognizable natural images to create quite fantastic, abstract "improvisations."[60] Sometimes these embroidered "improvisations" vaguely recalled some organic image as in Figure 111. But she was just as free and sure in designs with a more geometrical organization, as in Figure 112.

Von Brauchitsch also participated in the *Reformkleid* movement.[61] Indeed, at a time when women were beginning to compete openly with men in the arts and sciences (though still generally banned from the art academies, they had taken to riding bicycles), the reform movement in clothing came none too soon. It is hardly surprising then that a vivacious, independent personality like Margarethe von Brauchitsch should also try her hand at fashion design, and that an equally independent young woman like Gabriele Münter should model those designs.

If Kandinsky had not noticed the work of von Brauchitsch before, his attention must have been captured by photographs which appeared in *Dekorative Kunst* in the spring of 1902 depicting a young lady modeling a *Reformkleid* designed by von Brauchitsch. He would have recognized in the model that talented new student of his, Gabriele Münter (Figs. 113a and b).[62] Demure yet determined, Münter posed before a copy of Böcklin's moody *Villa by the Sea* in an elegant silvery gray dress decorated with silk appliqué in shimmering tones of mother-of-pearl. A reviewer described the appliqué work as having an "indescribable color magic."[63]

There is little doubt that the model was indeed Münter: the characteristic high forehead, the sloping nose, the small yet stubborn chin correspond to the photographs of Münter in Eichner's book (Figs. 114, 115).[64] Even the ring on the little finger of the left hand appears to be the same. The pose is also similar, with the right hand on a chair.

Thus another link is established between Kandinsky and the arts and crafts movement, a link that accounts for his own experiments in fashion design: for the dresses worn by Münter in the Eichner photographs were designed by Kandinsky himself.[65] It is apparent that the practical ideals of the reform movement had been taken into consideration in the design. The dark over-dress (or "jumper") appears to be the same in both Eichner photographs, with the same dark (possibly velvet) band around the shoulders and neckline, and the fringe around the armholes. But the blouse and tie have been varied. The design successfully achieved two different effects and purposes; the one an elegant evening dress, while the other, with a dark blouse, is suitable for less formal occasions.

An actual sketch by Kandinsky for another dress is preserved in the Städtische Galerie collection (Figs. 116a and b).[66] It is a more elaborate two-piece ensemble, with a jacket. The notations indicate that the dress was to have been dark green, with a pale green blouse. The skirt is decorated with stylized floral embroidery motifs, while a leafy pattern adorns the jacket, which is closed with a silver clasp and chain.

Thus it can be seen that Kandinsky's active participation in the decorative movement ran the gamut of Jungendstil possibilities: from membership in an applied arts society to the offer of a position as professor of decorative painting; from experiments in pottery and jewelry to embroidery and fashion design. He learned techniques and studied a great variety of

media, demonstrating a high degree of versatility and freedom, and a sense for synthesis; characteristics already indicative of his genius. But it was the craft of the woodcut that was to prove his greatest inspiration.

KANDINSKY'S DEFENSE OF THE WOODCUT CRAFT

Among other projects Kandinsky had been working on, in August of 1904, were woodcuts for the 1904 Salon d'Automne and for a new publishing firm in Munich, established by Reinhard Piper, which had requested work for a catalog.[67] Apparently Münter had complained that his involvement with the woodcut medium was not a really serious artistic occupation, that it was mere "play," because in the same month Kandinsky wrote to her a stunning defense of his activity as a craftsman:

> Now, about woodcuts . . . You needn't ask the purpose of this or that work: they all have only one purpose— I had to make them, because I can free myself in no other way from the thought (or dream). Nor do I think of any practical use. I simply *must* make the thing. Later you will understand me better. You say: Play! Of course! Everything the artist makes is after all play. He agonizes, tries to find an expression for his feelings and thoughts; he speaks with color, form, drawing, sound, word, etc. What for? Great question! About that later, in conversation. Superficially only

play. For him (the artist) the question "what for" has little sense. He only knows a "why." So arise works of art, so arise also things that are as yet not works of art, but rather only stations, ways to that end, but which already have within them also a little glimmer of light, a *Klang* [resonance]. The first ones and likewise the second (the first are all too seldom) *had* to be made because otherwise one has no peace. You saw in Kallmünz how I paint. So I do everything that I must: it is ready within me and it *must* find expression. If I play in this way every nerve in me vibrates, music rings in my whole body and God is in my heart. I don't care if it is hard or easy, takes much or little time, is useful or not. . . .[68]

The first major result of Kandinsky's enchantment with the craft of the woodcut was the publication sometime in the year 1903-04 of the small, handprinted album of woodcuts entitled *Poems without Words*.[69] This miniature *Gesamtkunstwerk* links Kandinsky stylistically and iconographically to both the arts and crafts movement, and to the German symbolist movement, as was demonstrated in the chapter on Stefan George.[70] Including the prints for *Poems without Words*, Kandinsky completed some forty-eight woodcuts in the period 1902 through 1904 alone, an auspicious introduction to an interest in the graphic arts that was to be of crucial significance in his development toward abstraction.[71]

CHAPTER

·XII·

Graphic Art: From Ornament to Abstraction

FOR KANDINSKY, the woodcut represented a *Klang*, a synthesis of poetic, musical, and artistic elements. In his moving defense of the woodcut medium, Kandinsky had described his woodcuts specifically as "artistic purposes [leading] toward a goal," "stations on the way" to works of art. They already bore a *Klang* of the end goal within them.[1] Woodcuts were at once "decorative" and significant. They were capable of suggesting profound meaning in much the same way as poetry, by means of a condensed image. As has been pointed out in the chapter on Kandinsky and the symbolist poetry of Stefan George, his first significant work, *Poems without Words*, was a supremely poetic effort. A second portfolio of woodcuts published in 1909 represented another such effort. It was called *Xylographies*, an obvious reference to the musical quality Kandinsky felt them to represent.[2] In 1913 Kandinsky published his graphic masterpiece, the volume of prose-poems and woodcuts entitled *Klänge*, which contained echoes of his work from his earlier to his later Munich period.[3]

It was the woodcut which was to serve as the bridge over which Kandinsky was able to advance from "decorative" art to abstraction. In an essay written for *XX^e Siècle* in 1938, Kandinsky in fact stated that in his woodcuts and poems were to be seen the traces of his development from the "figurative to the abstract. . . ."[4]

Whereas Kandinsky's early landscapes, until approx-

imately 1907-08, remained for the most part hesitant and awkward, his more decorative paintings and his woodcuts fairly sang with confidence and skill. While exhibiting a steady progress in clarity of color and ease of paint application, many of the landscape oil studies can only be assessed as minor works in the total oeuvre. The woodcuts, on the other hand, despite their size, are works of major significance. The *Xylographies*, made in 1906, demonstrate a superb technical finesse quite beyond many paintings of the same period (compare, for example, the 1906 oil study, *Near Paris*, and the woodcut from *Xylographies*, *The Birds* [Figs. 117, 77]).[5] The published portfolios do not by any means represent all of his graphic work at this period. Between 1906 and 1908, some thirty-three woodcuts by Kandinsky were published in the French periodical *Tendances nouvelles*, some dating from as early as 1902-04.[6]

One of the technical devices Kandinsky adapted from his earliest *decorative* paintings to the transitional landscapes of the Murnau period (after 1908), was the short, oblong, mosaiclike brush stroke. Already in those early paintings, such as *White Cloud* or *Riding Couple* (Fig. 66), the color *Fleck*, or spot, had an independent compositional significance.[7] In the later landscapes, enlarged in size, these color dots were used quite like independent building blocks, as for example in *Street in Murnau* of 1908 (Fig. 118).

It is also interesting to note that many of the Murnau landscapes bear a characteristic resemblance to woodcuts. *Church in Murnau,* for example, with its strong, flat areas of color and simplified forms has the crispness of a color woodcut (Fig. 119). The palette has been reduced to a few saturated colors, which are placed next to one another without transitional tones. The dark and light areas contrast strongly and are handled in much the same way as positive and negative space in a woodcut. If we compare the painting *Landscape near Murnau* of 1909 (Fig. 120) with a woodcut on a similar theme by Martha Cunz (Fig. 121), the resemblance is striking. While the Cunz work is somewhat more "naturalistic," both the smoke and the train are stylized and treated as independent compositional forms as in the Kandinsky painting. The trees and clouds in the painting are even more concentrated than in the print.

The woodcut by Cunz, called *Evening,* had been reproduced in the same 1905 article by Wilhelm Michel on Munich graphic artists that had included reproductions of two Kandinsky woodcuts, as well as a discussion of Kandinsky's work in that medium.[8] In fact, Kandinsky had corresponded with Michel, with whom he seems to have shared ideas on art,[9] for the article began:

> Graphic art is style, graphic art is aperçu, lyric, extremely personal epigram; graphic art is no striving after truth to nature, but rather yearning for subjective language. Graphic art is not world history, but rather, diary. Far off, life, large and incomprehensible, strikes the waves of its colors and lines, but on the modest, plain wood block are found only schematic abbreviations and personal sublimations of all that richness together. Graphic art is therefore romanti-

cism. . . . Graphic art is conscious subjectivism, it is critique of perception and transcendental idealism. . . . Graphic art is aphorism. . . .[10]

A little farther on, Michel added the very Kandinsky-like note: "Everywhere the material is the vehicle of the spiritual" ("Uberall ist die Materie das Vehikel des Geistigen").[11]

It had become clear to Kandinsky that the drastic simplifications required by woodcut resulted in an enhancement of his work. That he placed a high value on his work in this medium can be seen by the fact that he continued to produce woodcuts and to exhibit these works throughout the Munich period. He exhibited his woodcuts in Phalanx exhibitions and in all of the Neue Künstlervereinigung exhibitions in which he participated. They were also included in his retrospective exhibition at Der Sturm in 1913.[12] Kandinsky decorated his book *Über das Geistige* with his own woodcuts and included them in the *Blaue Reiter* almanach, the cover of which bore his woodcut variation on the theme of St. George and the dragon.

HORSE, RIDER, AND CIRCLE

The horse-and-rider motif in fact represents a theme that can be traced through Kandinsky's oeuvre almost from beginning to end. Its gradual transformation from a figurative symbol to a symbolic abstract image can be observed in his decorative work, and in the woodcuts, with more consistency than in the paintings. A brief survey of the theme in terms of these works reveals the gradual development of an abstract form-language somewhat in the way that Ferdinand Avenarius had predicted.[13]

Kandinsky himself provided a fascinating clue to

the development of this formal language in observations he made to Paul Plaut in 1929:

> If for example in recent years I have preferred to use the circle so often and passionately, the reason (or cause) for this was not the "geometric" form of the circle, or its geometrical characteristics, but rather my strong feeling of the inner force of the circle in its countless variations; I love the circle today as I previously loved the horse, for example—perhaps more, because I find in the circle more inner possibilities, for which reason it has taken the place of the horse.[14]

Kandinsky further associated the circle itself with his concepts of the romantic and the lyric, in a letter written to his biographer Will Grohmann, in 1925, just a year before completion of the major painting, *Several Circles*, now at the Guggenheim Museum (Pl. VII).[15] For him, the romantic represented a constant, timeless value: "The sense, the content of art is romantic, and it is our own fault if we take the historical phenomenon for the whole concept." He felt that his painting *Romantic Landscape* (with its three racing horses) expressed the timelessness of the concept. ". . . where are the boundaries between the lyric and the romantic?" he wrote. "The circle, that I have used so much recently, can often be characterized in no other way than as romantic." Thus the "inner power," the "romanticism" once embodied for him in the horse, was now symbolized by the circle with its "inexhaustible" variations and "countless tensions."[16]

The horse-and-rider motif in Kandinsky's early work was associated with the knight-crusader image, the image of St. George,[17] the riders of the Apocalypse, and had perhaps as well associations with the Russian fairy tale, and with fond memories of a favorite jockey game he played as a child and recalled in "Rück-blicke."[18] Thus, many myths were concentrated in one image, and later transferred to the circle conceived as a truly "cosmic" symbol as in the 1926 masterpiece *Several Circles*.[19]

Since this is such a powerful motif in Kandinsky's oeuvre, it is important to consider if indeed the horse and rider did actually evolve into a circle, and if so, how this was accomplished. By tracing the evolution of the motif in the woodcuts it may be possible to gain some insight into the method of transformation and into the question of whether or not this transformation was rooted in Kandinsky's decorative graphic art, as he himself suggested.

One of the earliest horse and riders in Kandinsky's oeuvre is to be found in the decorative painting *Dusk*, which was shown at the second Phalanx exhibition in the early spring of 1902 (Fig. 122, Pl. VI). In the catalog, *Dusk* was identified as a "decorative sketch." Due to the broad outline around each of the forms in the design, it can be safely assumed that the work was intended as a design for appliqué. It depicts a knight on horseback charging through a moonlit wood. Both horse and rider are romantically set off with silver paint. The moon, the backing of the flower in the foreground, and the star are also silver. The star itself and the lance are gold, while the petals of the flower, in true romantic fashion, are blue. The horse is also pale blue, while the rider's cape and plume, the reins, saddle blanket, and harness plume are all a brilliant, saturated red. The acid green of the turf contrasts sharply, while the mottled brownish tone of the wood balances the composition. It is a bold painting. The wavy line surrounding the rectangular area of the painting is an integral part of the design, as can be

seen by the fact that the work is signed in the lower left corner, well below the border. This wavy line has the effect of softening the rectangular contour of the composition and perhaps suggests a primitive hint of the circular motif to come.[20]

It is on the title page of *Poems without Words* that we find the horse-and-rider motif for the first time surrounded by a circular border (Fig. 123).[21] The circle contains four horses and riders in all, one of whom is a mounted trumpeter; a boy in medieval garb with hands pressed together in a prayerful attitude; an incongruous cat, and several Russian buildings, some topped by crosses. Clouds swirling across the sky seem to dissolve into the decorative border. This is indeed a circle with many "inner possibilities."

Some of the woodcuts published in *Les Tendances nouvelles* also associated the horse and rider with a circular motif. *The Dragon* (Fig. 124)[22] depicts a horse and rider leaping or flying over a deep chasm, threatened by the three-headed beast. While this knight is not surrounded by a circle, he carries a perfectly round shield and is enclosed overhead by a sweeping half-circle, perhaps alluding to a rainbow.

Knight on Horseback reverts to the more-or-less rectangular format of *Dusk* with a similar motif, the knight charging from right to left. But here the outline has definitely been softened, not by a wavy line, but by a strong decorative oval (Fig. 125).

While *Russian Knight* (Fig. 126) is not enclosed by a circle, it is on a perfectly square block and the points outlined by the horse's forelock, the tip of the rider's helmet, the top of the building in the background, and the horse's tail and raised foreleg, as well as the lines of the background hill, suggest an invisible circle.

This principle of the invisible compositional circle combined with the horse-and-rider motif can also be observed in the membership card for the Neue Künstlervereinigung of 1909. The theme is based on the earlier color drawing and painting *Riding Couple* (cf. Fig. 66 and Fig. 127). Here the circular movement is initiated by the curving black cliff on the left, carried on by the stepped roofs of the buildings on the higher cliff, then by the inward sweeping branches of the tree on the right. The hind legs of the horse touch the lower circumference of the circle.

Meanwhile the horse and rider began to undergo simplifications such that in a small woodcut for *Tendances nouvelles* in 1908, the horse is suggested by little more than the wood grain (Fig. 128). In *Über das Geistige*, the horse appears in a drastically reduced image again enclosed by a circular form. In the vignette preceding the chapter "Die Bewegung," the horse leaping from left to right seems to burst through the plane of the circle. The form that streaks upward above his head suggests an abbreviated lance (Fig. 129).

In several of the preliminary sketches for the cover of the *Blaue Reiter* almanach, the horse-and-rider motif appears as the central image, contained within a distinct circular form as, for example, in the watercolor sketch GMS 603 (Fig. 130).[23] In the woodcut design for the cover of a monograph on Kandinsky (which subsequently was not published), we find the image of the battling stick-figure horses of *Composition IV* (Fig. 131).[24] Here once again, the invisible compositional circle is apparent, its upper left circumference marked by the back of the left-hand horse and its lower right circumference by the bending forms of the couple.

In the 1913 publication *Klänge*, there are a number of horse-and-rider motifs in combination with circular or oval forms. In Figure 132, the central rider is enclosed by a domed cloud form suggesting a circle. Figure 133 depicts two riders surrounded by an oval. In the vignette for the poem "Fagott" the stick figure riders are framed by an oblong form. And the rider motif accompanying the poem "Blätter" is completely enclosed in a circle (Fig. 134). In this case, the circle is actually repeated and reinforced by a series of dots around the outer circumference.

But the real beginning of the dissolution and final transformation of horse and rider to circle is to be seen in Figure 135. Here the horses, reduced to the barest outlines, are partially masked by large floating color motifs in circular shapes. One small horse and rider is visible in the upper central portion of the composition, the other two move toward left and right foreground, seeming to burst out from the center. Again, the whole design has been contained by a circular movement, this time suggested by the rounded corners on the left. The riders have been reduced to hooked or double curved lines, suggesting the head and back only of each rider.

Another work in which the horses and riders are drastically reduced, and also in which the masking spots appear, is the vignette for the poem "Ausgang." The color spots are much more explicit in the watercolor on the same motif known as *With Three Riders* (Fig. 136). Here the three riders are clearly distinguished by large egg-shaped forms in yellow, blue, and red, and have been reduced to the double curved line.

The most famous horse and rider in the woodcut *Lyrical*, in *Klänge*, does not display an obvious circle.

However, once again the corners of the composition have been softened so that the whole contour is more like an oblong than a rectangle. Again the development of the rider to a simple double curve is apparent (Fig. 137).

Kandinsky wrote to Grohmann in 1932 that he had "transferred the line from its narrow confinement in graphics over into painting."[25] To determine whether or not these motifs were indeed transferred by Kandinsky to his paintings, we have only to study *Picture with White Edge* (Fig. 138). The central motif reveals the double curve associated with the rider motif in the woodcuts already analyzed. But further, he is surrounded by a large circular color spot associated, as has been indicated, with the horse-and-rider motif in several previous works. In fact, a drawing of 1912, closely related to this painting, displays the horse-and-rider motif clearly enclosed within a circle (Fig. 139). The painting, dated 1913, may have been begun as early as 1912.[26] However, the woodcut *Lyrical*, in which the double curved rider is apparent, can be dated to 1911.[27] It is also likely that the *Klänge* woodcut with the three riders and the color spots (Fig. 135) dates from this earlier period.

In 1913 Kandinsky created a drawing related to his painting of the same year *Small Pleasures*, which was, as Lindsay has said, "like a late bud on a tree . . . prophetic of future growth."[28] The drawing demonstrates in no uncertain terms the transition of the horse-and-rider motif to the circle. On the left side of *Small Pleasures* (Fig. 140) three riders gallop up a hillside. They are even more clearly to be seen in the glass painting of the same title in the collection of the Städtische Galerie (Fig. 141). In the remarkable drawing (which is signed and dated 1913), irregular

circular forms take the place of two of the horsemen, while a perfect circle appears to replace the third (Fig. 142). A transitional watercolor study of 1913 (Fig. 143) reveals the beginning of the angular horse motif (lower left) to which the perfect circle in the drawing is affixed. Slightly above this and to the right, a half-circle begins to encompass the next horse and rider, while near the upper center, an irregular, pale blue color spot envelops the third horse and rider, reduced now to linear schemata. In 1924, Kandinsky took up this theme once again to create the painting called *Backward Glance*, in which all of the horsemen have become circles (Fig. 144).

After World War I, the circle appeared repeatedly in Kandinsky's work, often accompanied by a "lance," by the double curved sign for the "rider," or by the serpent-shaped dragon of St. George. All of these signs appear in *Backward Glance*.[29] In a 1938 woodcut for the cover of *Transition* magazine, we find the horse-and-rider circle, the lance, and the serpent in constellation (Fig. 145).

Kandinsky himself had suggested that traces of his development from the "figurative" to the "abstract" might be found among the decorative woodcuts. Indeed, the evolution of a favored motif has been traced. Thus did the artist's formal language progress toward abstraction.[30] It may be recalled that one of Kandinsky's most successful and at the same time most Jugendstil decorative designs was composed of circles and wavy lines alone (Fig. 99). If he had begun to compose paintings at that time, as early as 1904, with circles alone, he would have violated his own principles. For the artist "*must have something to say.*"[31] He could only arrive at a concrete image by imbuing it with experience. The circle eventually contained the crusader, the mounted trumpeter, the leaping horse, the lyric couple, the battle, the contradictions, the "inner force," in short, the sum of the "romantic."

Kandinsky was in later years adamant that the public should not be content merely to observe his use of circles and triangles. He wanted people to see what lay *behind* his paintings, what he called the "inner."[32] The circle, he said later, comes the closest of the three primary forms to the fourth dimension.[33] And the past it contained for him extended back in time to his first horse and rider in *Dusk*. The circle had become for Kandinsky a nexus of experience and memory, a cosmic all-encompassing image through which his past sped ever toward the future. Graphic art had served him well as a bridge over which he passed from Jugendstil toward abstraction.

Conclusion

IT WAS STATED at the beginning that Munich at the turn of the century was radiant with possibilities. Certainly Kandinsky was profoundly affected by his Munich experience. Perhaps in no other place would he have found so fertile a ground for his progress toward abstraction. Munich was the birthplace of Jugendstil with its prophecy of an art devoid of naturalistic forms and based on a new formal language. It was there more than anywhere that art was seen as the vehicle for an approaching spiritual revolution.

Kandinsky was deeply involved from the beginning in Munich's vigorous artistic and cultural milieu. Not only did he participate actively in the Jugendstil arts and crafts movement, but his own development toward abstraction was conditioned to a large extent by Jugendstil criticism and aesthetics. Munich's symbolist poetics affected him significantly, as did the movement for a reform theater in the example of the Munich Artists' Theater. In fact, Jugendstil and the arts and crafts movement, particularly in its manifestation as graphic art, served as a bridge between the decorative arts and Kandinsky's ultimate breakthrough to abstraction.

Jugendstil provided not only a rich theoretical context but it also opened a vast arsenal of forms. It expanded the formal language permissible to the artist, encouraging the simultaneous exploitation of purely decorative motifs alongside abbreviated naturalistic motifs. It stimulated the imagination. Its emphasis on planar form was a result of its concern for inner neces-

sity and honesty in the use of the artistic media.[1] And the Jugendstil idea of the *objet d'art* found expression as a new reverence for the painting as a work of art complete in itself, without reference to the real world. Symbolist poetics suggested that condensed, even drastically abbreviated images could convey profound significance, as symbolist theater suggested that pure color, light, sound, movement, abstracted from naturalistic dialogue and plot, could convey dramatic effect.

Jugendstil was the primary force on the Munich scene from the time of Kandinsky's arrival there in 1896 until well after the turn of the century. During the earliest days of his apprenticeship, the works and writings of August Endell, Hermann Obrist, and Adolf Hölzel enunciated the rejection of naturalism and prophesied radical changes in the arts. Endell urged the artist to use forms freely, to invent, to fantasize. He proclaimed the advent of a new art with forms that represent nothing yet that would move the soul as deeply as music. Obrist urged a "spiritual seeing," a stripping away of the world of appearances to reveal the underlying vitality of all being. Hölzel emphasized the timeless significance of the artistic means above and beyond the limitations of traditional artistic aims. Kandinsky heard these voices and reflected them in his own work.

Although he rejected the inherent naturalism of his first teacher, Anton Ažbè, Kandinsky appreciated the little master's sensitivity to pure color and his sheer

virtuosity with the artistic means. In fact, Ažbě's skeptical attitude toward academic rules and his emphasis on the artistic means themselves as vehicles of expression made an indelible impression on Kandinsky.

His second teacher, Franz Stuck, stood in the mainstream of *Stilkunst* at the turn of the century. He exemplified the magical ambiguity of Jugendstil, by which sculpture could be transformed to relief, relief to frieze, frieze to easel painting, and back again; in which space was never either statically planar or illusionistic, but a vibrant continuum. He urged Kandinsky to study those magical effects in terms of black and white, positive and negative space, and thus paved the way to Kandinsky's success with graphic art.

At the Secession exhibitions around the turn of the century, before Secession became synonymous with conservatism itself, Kandinsky was in touch with the main currents of European art. But it was Jugendstil and the Munich scene that touched him most nearly, as can be seen in the associations formed through his organization, the Phalanx. It was through the Phalanx that he came in close contact with Peter Behrens, who accorded him his first significant professional recognition by inviting him to direct the course in decorative painting at the Düsseldorf School of Arts and Crafts. It was through Phalanx that Kandinsky became associated with most of the outstanding graphic artists in Munich. It was there that he paid his homage to Monet, revealing an early self-knowledge (for he recalled that Monet had demonstrated to him the possibility of art without objects before he had ever left Moscow). His awareness of the international currents of Jugendstil, or *Stilkunst*, was revealed in a Phalanx exhibition that included the work of Vallotton, van Rysselberghe, and Signac.

In Munich's symbolist milieu, he also found kindred spirits. The parallelism between the poetic imagery of Stefan George and some of Kandinsky's early works, suggests that Georgian poetics also exercised an important influence. Kandinsky's method of condensing images and veiling objects, as he moved toward abstraction, corresponds to a similar technique in George's verse. George had forecast the rebirth of a spiritual art long before the turn of the century, and the idea of art as the vehicle of a spiritual revolution struck a responsive chord in Kandinsky. While French symbolism influenced him as well, his personal contact with George's friend, Karl Wolfskehl, lends credence to the suggestion of a correspondence between the work of the Russian painter and that of the German poet.

The Munich Artists' Theater and the theories expounded by Georg Fuchs had also a direct effect on Kandinsky's development. The symbolist thrust toward a theater of pure color, sound, and movement paralleled Kandinsky's progress toward a similar goal in painting and in his dream of a monumental synthesis of the arts. His essay on stage composition directly reflected many of the ideas advocated by Fuchs; his color-opera, *Der gelbe Klang*, may well have been composed with the stage of the Munich Artists' Theater in mind. As his woodcut series, *Poems without Words*, reflected symbolist poetics, so too did *Der gelbe Klang* reflect the symbolist theater. And both moved away from naturalism, from the word, from discursive meaning, toward spiritual content and abstraction.

Jugendstil criticism repeatedly raised the possibility of a nonnaturalistic, abstract form-language that would yet retain the capacity to transmit spiritual-intellectual

values. The *Geistreiche* and the *Geistige* in the work of art were advanced as transcendent values, and the means the artist chose to communicate those values were recognized as the province of "inner necessity." Jugendstil criticism felt the tremors of the approaching revolution as something "spooking about" in contemporary art, and it regarded the decorative arts as the vehicle of that revolution. But genius was required to cut the Gordian knot of the "merely decorative" and that was Kandinsky's merit.

For Kandinsky had much more than a theoretical interest in the arts and crafts movement. His personal involvement encouraged a freedom with the artistic media that might never have been attained otherwise. Graphic art in particular, which required above all simplification, reduction, and compression of imagery, afforded the necessary bridge between ornamentation and abstraction. It was in graphic art that drastic transformations were first undertaken and here that Kandinsky found his way to abstraction.

In conclusion, it may be stated that Kandinsky's development to abstraction was above all the result of a convergence of strong Jugendstil tendencies toward abstract ornamentation with a symbolist thrust toward inner significance and spiritual revolution. It was Kandinsky's merit and his genius that he was able to overcome the "merely ornamental," to imbue a new formal language with significance, and ultimately to achieve the breakthrough to a new art form.

Kandinsky once wrote that "new principles never fall from heaven, but rather stand in causal relationship to the past and the future."[2] He also suggested that the work of art itself can only be understood within the context of its epoch and the artist's personality.[3]

This book represents one attempt to comprehend the progress of the artist by revealing the context within which his development took place. Hitherto little-known facets of Kandinsky's Munich experience have been illuminated, and in the process, insight has been achieved. As perspective is gained, and the rich endowments of place and time appreciated, Kandinsky's monumental contribution to the history of modern art can better be evaluated.

Munich was the site of Kandinsky's historic breakthrough to abstraction. As the circle had come to signify for Kandinsky a nexus of belief and experience, Munich had been for a time that radiant nexus itself.

APPENDICES

APPENDIX

·A·

*A Note on Translations in General and
of "das Geistige" in Particular*

THE COMPLEXITIES involved in dealing with the original texts of Kandinsky's writings, as well as their attendant translations, were first brought to light in Lindsay's dissertation of 1951 (pp. 1-41). The problems persist and will remain until a true variorum edition can be published. The French edition by Denoël is not a variorum edition. Consequently, scholars have been forced to use whatever texts are available and to make their own translations if they judge that previous translations have been inadequate. Since it would be impossible to cite all the variant editions and translations, and since it is not the intention here to solve these complex problems, I have selected the editions most readily available to me and made my own translations wherever necessary.[1]

In the case of Kandinsky's memoir, "Rückblicke," I have referred to the original version which appeared in *Kandinsky 1901-1913* (Berlin: Der Sturm, 1913). Three variant English translations of this work, none entirely satisfactory, are available: "Reminiscences" by Mrs. Robert L. Herbert (in R. L. Herbert, *Modern Artists on Art, Ten Unabridged Essays* [Englewood Cliffs, N. J.: Prentice-Hall, Inc., 1964], pp. 20-44); "Retrospects by Wassily Kandinsky," apparently trans-

lated by Hilla Rebay (in *Kandinsky* [New York: The Solomon R. Guggenheim Foundation, 1945]); and "Text Artista," a translation by Boris Berg of the 1918 version of the same memoir (with some alterations) which Kandinsky published in Russia (in *In Memory of Wassily Kandinsky* [The Solomon R. Guggenheim Foundation, Museum of Non-Objective Paintings, N. Y., March 15-May 15, 1945]).

Über das Geistige in der Kunst was first published by Reinhard Piper, Munich, in December of 1911, but dated 1912. Two further editions appeared during 1912. Although Kandinsky prepared a list of *kleine Änderungen* (little alterations) for a proposed fourth German edition, this edition was never published. In 1952, a reprint of the "original text" appeared as the "fourth German edition authorized by Frau Nina Kandinsky," prepared by Max Bill and published by the Benteli-Verlag, Bern. It is this version in its 1965 (or "eighth edition" [*sic*]) which I have chosen to use, because of its ready availability in paperback (hereafter cited as *UGK*). This version does not include the *kleine Änderungen*. The same publisher has also provided paperback editions of Kandinsky's *Punkt und Linie zu Fläche, Beitrag zur Analyse der malerischen Elemente* (with introduction by Max Bill [Bern: Benteli-Verlag, 1964]), hereafter cited as *PLF*; and an anthology of thirty-three essays by Kandinsky (1912-

[1] *Kandinsky, The Complete Writings*, edited by Kenneth Lindsay and Peter Vergo, is now in preparation by The Viking Press, New York.

1943) entitled *Essays über Kunst und Künstler*, edited by Max Bill (Bern: Benteli-Verlag, 1963), hereafter cited as *EuKuK*.

Über das Geistige has undergone three English translations, none of which is entirely satisfactory. The most readily available is the Wittenborn edition (*Concerning the Spiritual in Art*, Documents of Modern Art, vol. 5 [New York: George Wittenborn, Inc., 1947]), which, however, is based on the 1914 Sadler translation, and includes, without citations, the "little alterations" proposed for the nonexistent fourth edition. (For further details on the Wittenborn edition, and the changes, see Lindsay's dissertation, chap. I.) *Punkt und Linie* was originally published in 1926 by Albert Langen, Munich, as volume nine of the Bauhaus-Bücher. It was translated into English by Howard Dearstyne and Hilla Rebay as *Point and Line to Plane* (New York: The Solomon R. Guggenheim Foundation, 1947).

ON THE TRANSLATION OF "DAS GEISTIGE"

The German term *das Geistige* raises a difficult problem for translators. *Über das Geistige in der Kunst* was first translated into English as *The Art of Spiritual Harmony* (by Michael T. H. Sadler in 1914), and the word "spiritual" has appeared in the title of the two subsequent English translations, *On the Spiritual in Art* (translated by Hilla Rebay and published by the Museum of Non-Objective Painting, New York, 1946) and *Concerning the Spiritual in Art* ("a version of the Sadler translation, with considerable re-translation, by Francis Golffing, Michael Harrison and Ferdinand Ostertag," published by Wittenborn). Thus, there has

been general acceptance of the translation of *das Geistige* as "the spiritual." However, in German, the term *das Geistige* suggests rather a different spectrum of meaning than the English term "the spiritual." Both the term *Geist* and the term *geistig* suggest almost equally the notion of the incorporeal or immaterial *and* the notions of mind, intellect, or genius. (See Grimm's *Deutsches Wörterbuch* [the volume including *Geist* was published in 1897, by the way].) The substantive *das Geistige* is demonstrated in Grimm as having been used by Goethe and Schiller to indicate the whole man; that is, to define the intellectual-spiritual side of man as opposed to the physical-sensual side. The term *geistreich* (ingenious, witty, clever) has a similar status, although it may even at times be used to cast a somewhat negative implication, as something that is overly or superficially intellectual. (However the usual meaning of *geistreich* is close to the French *esprit* or *génie*.)

On the other hand, the word "spiritual" in English is almost exclusively concerned with the incorporeal, the notion of the soul, and the idea of the supernatural. Its religious connotations are overriding. The *Oxford English Dictionary* defines the word "spiritual" in religious terms only, in its first five definitions. Only in definitions six through eight (out of nine), is it related to the "intellect or higher faculties of the mind." As a substantive, the term "the spiritual" is defined by the OED in its religious aspects only.[2]

This significant distinction should be borne in mind, yet there seems no way out of this translation dilemma,

[2] Paul Overy also raised the question of the translation of the term *Geist* as used by Kandinsky (see his *Kandinsky—The Language of the Eye*. New York: Praeger Publishers, 1969, p. 51).

VIII. KANDINSKY. *Im Sommer*
(*In Summer*), 1904.

since to translate *das Geistige* as "the intellectual" would also result in a certain distortion of meaning.[3] Unfortunately, the translation "spiritual" tends to exaggerate the notion of the "supernatural" in Kandinsky's thought.[4] In this respect, it should also be noted that the usual German word for "spiritualism" is *Spiritismus* (and also *Geisterglaube*), words not used by Kandinsky, except in that particular context. On the other hand, the *geistige* qualities of art and literature were often the subject of German critical writing at the turn of the century, and we can be sure that such references were to those immaterial, intellectual qualities that particularly distinguish the arts rather than to varieties of supernaturalism.[5] As is demonstrated in this book, contemporary critics often spoke of *das Geistige* in art (one wrote an illuminating article on *das Geistreiche* in art [see Chapter x], and the symbolists called for a new *geistige Kunst* [see Chapter viii]). When Schultze-Naumburg spoke of Böcklin's *vergeistigte* manner, he was not referring to any "occult" suggestions in Böcklin's painting, but to its sophistication and intellectualism (see Chapter ii). When August Endell wrote that the ordinary person looks for the object depicted in a painting, completely missing *das Geistige*, he was not referring to the "supernatural," but to certain ineffable, inexpressible, intellectual qualities that only the artist can give (see Chapter iv). This is the way in which Kandinsky used the term *das Geistige*, and, in fact, a careful reading of *Über das Geistige* reveals that this was indeed his understanding of the term.

[3] This problem has of course been encountered by translators of other texts from the German. Thus R. J. Hollingdale in his 1968 translation of Nietzsche's *Twilight of the Idols* footnoted the word *Geist* as follows: "*Geist*. All the meanings contained in this word cannot be conveyed in a single English word: what is meant is spirit, mind, intellect, intelligence. I have translated it as 'spirit,' 'spiritual,' when the most inclusive sense seems indicated, as 'intellect,' 'intellectual' when this seems more appropriate." Clearly, Hollingdale did not find any possible "religious" connotations worthy of comment (Friedrich Nietzsche, *Twilight of the Idols and The Anti-Christ*, trans., with an introduction and commentary by R. J. Hollingdale [Harmondsworth, Middlesex, England: Penguin Books, Inc., 1968], p. 25).

[4] For example, see Ringbom, Washton (Long), and Fingesten (Peter Fingesten, "Spirituality, Mysticism and Nonobjective Art," *The Art Journal*, xxi [Fall 1961], pp. 2-6).

[5] It is worth noting too that the term "*Geisteswissenschaften*" is used to distinguish those studies which in English are called "the humanities." After completion of this manuscript, Professor Oswald Werner of Northwestern University undertook a preliminary semantic analysis of the term "*Geist*" at the author's request. His results, communicated in a letter of January 30, 1978, confirm the opinion expressed here. He further points out that the German word "*Geist*" has an "extended meaning range" as opposed to the more specific English word "spirit." Thus the German "*Geist*" is inherently more ambiguous. Werner too concludes that Kandinsky's intention was to emphasize the "mind and intellect" meaning range of "*das Geistige*."

APPENDIX

· B ·

Some Thematic Comparisons

In his memoir "Backward Glances" ("Rückblicke"), Kandinsky reported that he had experienced from his youth an exceptionally strong "visual memory."[1] This eidetic capacity was such that he had been able to recall a whole page of numbers during an examination at the university, and as a boy had been able to imitate from memory paintings he had observed in exhibitions. In fact, he even felt that he was often able to paint landscapes better from memory than from nature. Specifically, he recalled that he had painted *Die alte Stadt* and numerous Dutch and Arabic scenes from memory.[2] The phenomenon was so overwhelming that it even caused him suffering and he reported that he often felt exhausted from this enforced "continual seeing."[3]

Kandinsky's phenomenal visual memory undoubtedly accounts for a number of motifs in his Munich work which can be related to motifs and themes he experienced in local exhibitions or by means of reproductions in periodicals.[4] Although the artist felt that this capacity abated with the development of his ability to concentrate and to become more deeply absorbed in the "inner life of art (and therefore also of my soul)," he in fact sometimes reworked images many years later that are still recognizably related to the earlier period.[5] The images he assimilated from his environment were never taken over literally but were always transformed. Usually the image is intensified, either by means of a reduction in parts or by a more drastic reduction of the major form to a schema.

An early example of such a transformation is the figure of the youth in medieval dress that is the central motif of the title page of Kandinsky's *Poems without Words* (Fig. 123). The figure appears to be closely

be blind and deaf?" ("darf und kann ein Künstler blind und taub sein?"), suggesting even an *obligation* on the part of the artist to observe both nature *and* art. In the course of my research it became clear that much in Munich's artistic environment at the turn of the century had been assimilated by Kandinsky and "transliterated" into his own work, often in surprising transformations. The following comparisons in terms of imagery, thematic content, compositional devices, even attitudes, are not to be taken in any way as dogmatic or final solutions, but as suggestions that may illuminate not only the sources of the specific works discussed here, but which may even shed light on possible ways of looking at Kandinsky's later oeuvre in future.

[1] Kandinsky, "Rückblicke," p. xvi.

[2] *Ibid.*, p. xvii.

[3] *Ibid.*

[4] It may well also account for the "self-plunder" noted by Lindsay in Kandinsky's oeuvre ("The Genesis and Meaning," p. 51). It should also be recalled that in "Rückblicke" (pp. xxvii), Kandinsky had suggested that the ability to "experience" the work of others could only result in a refinement of the artist's own sensitivity. He compared this capacity to the artist's experience of nature, and added "may and can the artist

[5] Lindsay pointed out such an example in his discussion of the painting *Small Pleasures* of 1913 which Kandinsky recalled in another style more than ten years later (in *Backward Glance* of 1924). See "The Genesis and Meaning," p. 50.

related to the central figure in an embroidery by a Scotch artist that was reproduced in the August issue of *Dekorative Kunst* in 1902 (Fig. 146). In both cases, the central figure stands solemnly with hands pressed together as if in prayer. The costume is a robe and the hair style is a symmetrical long bob associated with medieval costume. The dotted border of the robe in the embroidery has been taken over by Kandinsky as a motif for the whole garment.[6]

It is known that Kandinsky devoted a great deal of time to the study of medieval costume. Many of the books he consulted in his researches are recorded in his early notebooks.[7] However, there is another factor to be taken into account: namely, that the bending, flower-plucking figure in the embroidery also appears

in another Kandinsky woodcut which, indeed, even suggests a similar thematic content. This other woodcut is *The Ravens* of 1907 (Fig. 76). In this case, the costume is quite different, but the pose and the sentiment is comparable. The title of the embroidery is "Gather ye Rosebuds While ye May" and, in both cases, the bending figure is plucking a flower. In the Kandinsky print, the flight of threatening black ravens overhead certainly represents "old time still aflying." In fact, all three figures in the print bear a relationship to the figures in the embroidery, with their stylized, ornamental costumes and caps.

An example of a more radical kind of transformation that could take place in the assimilation of an image may be observed in comparing a painting by Harrington Mann to a 1904 woodcut by Kandinsky. The Mann painting, *Hyde Park*, was reproduced in *Kunst für Alle* of July 1901 (one issue before the first Phalanx announcement appeared in that magazine) (Fig. 147). The painting may well have been on exhibition in Munich that summer, though this is not certain. However, it seems to have struck Kandinsky's fancy. His woodcut *In Summer* (Fig. 148, Pl. VIII) has adapted the central motif from the painting, distilling it into a fine Jugendstil study in rhythmic forms. Kandinsky's tall lady could be the twin of the central lady in the Mann painting, with the same costume, the same oval face under a very similar broad-brimmed, garlanded hat. Her parasol has been lowered and tilted sideways but the strong rhythmic shape has been retained. The little girl with the hoop and stick has been reversed entirely. She has become left-handed and her head turned toward the lady, so that the back of her head with its beribboned hat, rather than her face, is visible. The reversal can be partly explained by the

[6] A similar figure appears in Kandinsky's 1907 painting, *Das bunte Leben*, in the lower left portion. In fact, the figure in *Das bunte Leben* is even closer to the embroidered figure, with its hands folded rather than pressed together upright as in the print. This painting itself is related thematically to a work by the Munich painter Ludwig von Zumbusch, entitled *Vor der Stadt* which was reproduced in the 1 January 1903 issue of *Kunst für Alle* (p. 158), depicting a crowd of people engaged in various activities. It includes a mother and child, an old man with a stick, a figure (also in the lower right) eating, and figures in the background fighting, as well as a fat lady with arms akimbo. In both cases, foreground figures are cut off by the frame. While the von Zumbusch painting depicts a contemporary German peasant scene, Kandinsky's more romanticized painting contains more activity and the figures wear Russian peasant and medieval dress. While the style of the von Zumbusch is naturalistic, Kandinsky has employed his highly stylized manner of mosaic dots.

[7] Lists of such books are contained in the Notebook GMS 341 at the Städtische Galerie. These are accompanied by detailed sketches of knights in armor and ladies in medieval costume. In most cases, the book from which the sketch was copied is noted.

process of print-making in which the original drawing becomes reversed. (This does not, of course, explain the change in positions; the child's head turned away and the body of the lady slightly to the side.) Kandinsky seems to have abstracted an image from the busy, extroverted atmosphere of impressionism and transformed it into a nostalgic, introverted meditation typical of Jugendstil. From a trivial "snapshot" of Hyde Park, Kandinsky was able to distill the essence of summer.

Another case of transformation from triviality to monumentality, from naturalism toward abstraction, is represented by the painting *Bild mit Reifrockdamen*, now called *Crinolines*, of 1909, at the Guggenheim Museum (Fig. 149). The inspiration for the theme of this large work seems to have been one half of a double mural shown by the Munich painter Adolf Münzer at the annual Glaspalast exhibition in 1900.[8] The panels were entitled *Luxury and Work*. Kandinsky chose to concentrate on *Luxury* (Fig. 150).

The general arrangement of figures on the surface is almost exactly the same. Kandinsky has reduced the number of figures from ten to eight. But the horizon line, the open space at the right between the figures, revealing reflections in water, and even the line of the dresses along the foreground remain close to the original. In the Münzer painting, the figure of a woman on the far right is seen from the back, turning and twisting toward the center. This figure is matched in the Kandinsky painting by a male figure who, how-

ever, is engaged in the same kind of movement. In fact, Kandinsky has emphasized the turning motion by using dark spiraling lines on the man's coat. The next figure to the left in *Crinolines* is a female figure engaged in a graceful bending, turning movement. Once again, we find that Kandinsky has entirely reversed a figure in the process of transformation. The counterpart of this figure is to be seen in the Münzer panel in almost the same order, the second lady from the right. Kandinsky has reversed her direction and also turned her around so that she faces back into the painting, but the same dipping, turning motion is apparent. The middle three figures in the Kandinsky work assume nearly the same positions as the central three in the Münzer, except that there are two males and one female instead of the reverse. A simpering lady behind an incongruous table takes the place of the leering man in the Münzer (in each case, the third figure from the left). In both cases, the second figure from the left is a lady who turns slightly toward the left. But in *Crinolines*, this lady is seen in two positions. Her head is seen full face, tilted slightly toward the left of the painting and at the same time, it is seen from the back, twisted sideways toward the table. It is a double image such as might have been employed by a caricaturist, similar to the spiraling lines indicating a twisting motion in the figure at the far right. The figure on the far left in the Münzer painting is a woman, while that in the Kandinsky version is a man, but both complete the composition by moving toward the center.

Kandinsky has again removed the scene from the mundane world of contemporary dress to the nostalgic world of memory, almost of fairy tale, dressing his figures in Biedermeier costumes. The significance of the general theme of the world at one or two removes

[8] It is therefore of some interest that Kandinsky mentioned the name of Münzer in his first review for the Russian periodical *Apollon*, in a list of *Scholle* and *Jugend* artists being exhibited by Brakl at the Modern Gallery in Munich ("Letter from Munich," *Apollon*, 3 October 1909).

from reality, as in memory or fairy tale images, for Kandinsky's development toward abstraction has been pointed out by Klaus Brisch.[9] However, Brisch conveys a misleading impression in suggesting that Kandinsky turned away from such themes in 1908 to devote himself wholly to landscape.[10] On the contrary, these themes persist right up to the point of breakthrough, and recur once more in a series of light-hearted, often nostalgic, watercolors and paintings on glass between 1916 and 1918.[11] That this particular painting was considered of special significance by the artist himself may be surmised from the price listed for it in the catalog of the first exhibition of the Neue Künstlervereinigung in 1909. The price was 3,000 marks, compared to 1,500 marks for his next most expensive painting, *Picture with Boat*, also an imaginary scene.[12] The same year he produced another painting with a similar motif and title, called *Crinolines*, which was even larger in size.[13]

Kandinsky's choice of such themes as *Crinolines* may well have been inspired by comments on figure painting made by August Endell in his 1896 pamphlet *Um die Schönheit* (with which Kandinsky was un-doubtedly familiar, as was noted in the section on Endell). There Endell had written,

. . . The only possible task of figure painting is to present beautiful people in beautiful movements, a strong, characteristic basic tone toward which everything is directed. Everything else is totally irrelevant. If there exist such people and such a milieu, what they do and what they are, that is secondary. We have only to ask: "are these movements, these lines, this expression characteristic; how do they lead into one another; do they disturb one another or do they intensify one another; is the result a strong sensation of pleasure."

The artist can use only infinitely little of the scenes of life, and even that only as motif. Nowhere is the tranformation process more necessary than here, and nowhere are the technical difficulties more significant. Figural composition demands absolute control of lines, arrangements and movements of the human body, and the finest sense for the character of form.[14]

In 1911 Kandinsky painted another in this series of ladies with crinolines. This one, entitled *Pastoral*, sets

[9] Brisch, "Kandinsky," chap. II, pts. A-2, A-3.

[10] *Ibid.*, p. 164.

[11] An untitled watercolor of 1916 in the Guggenheim collection is such a one. Several of the paintings on glass of this type are reproduced in the catalog *Kandinsky, Painting on Glass.*

[12] The painting was listed under the title *Bild mit Reifrockdamen* in the catalog. Only one other painting in the show was listed at 3,000 marks, and that was Vladimir von Bechteiev's *Amazonen.* (Compare the catalog of the *Neue Künstlervereinigung* München, Turnus 1909-1910.)

[13] Illustrated in Grohmann, *Kandinsky*, p. 350, no. 18.

[14] Endell, *Um die Schönheit*, p. 23. ". . . Die einzig mögliche Aufgabe der Figurenmalerei ist: schöne Menschen in schönen Bewegungen zu geben, ein starker, charaktervoller Grundton, auf den alles hinzielt. Alles Uebrige ist total belanglos. Ob es solche Menschen und solches Milieu gibt, was sie thun, und was sie sind, das ist Nebensache. Wir haben nur zu fragen: sind diese Bewegungen, diese Linien, dieser Ausdruck charakteristisch, wie sind sie ineinander übergeführt, stören sie sich oder heben sie sich gegenseitig, resultiert ein starkes Lustgefühl.

"Der Künstler kann also von den Scenen des Lebens nur unendlich wenig brauchen, und auch das nur als Motiv. Nirgends ist der Umwandlungsprocess notwendiger als hier, und nirgends sind die technischen Schwierigkeiten bedeutender. Figurencomposition erfordert die absolute Beherrschung der Linien, Stellungen und Bewegungen des menschlichen Körpers, und den feinsten Sinn für Formcharakter."

the ladies out to pasture with a gay entourage of farm animals including a cow, a horse, a piping shepherdess (prudently with her boots on, since she seems to be sitting in a pond), and a couple of sheep. Here, the move toward abstraction has been more drastic (Fig. 151). Here Kandinsky has achieved the goal he had set for himself of creating a magic effect out of a combination of quite unrelated and apparently unmotivated figures and movements.[15] Nevertheless, the three female figures on the right, in their décolleté gowns, are reminiscent of the three ladies in a similar position in the painting *Phantasy* by Guillaume Roger of Paris (Fig. 152). The painting had been reproduced in the August issue of *Dekorative Kunst* in 1899. If the reader is skeptical, he would do well to study the way in which the three ladies recede toward the right background in both paintings, the repeated décolletage, and the way in which the circular floral motif is set off against the gown of the first lady in the row. And, although the left-hand side of the painting is entirely different in motif, the general scheme of diagonals leading from lower center up toward the left side and then turning toward the right to upper center has been retained in Kandinsky's version.

The time gap between the 1899 *Phantasy* and the 1911 *Pastoral* should come as no surprise once it has been realized that visual images had an astonishing persistence in Kandinsky's memory. This can be demonstrated by comparing, for example, the 1906 decorative painting *Song of the Volga* to the painting *Woven*, created some twenty years later in 1927.[16] The Viking ship, a commonplace motif of Jugendstil art, has undergone another transformation but is still recognizable as the one depicted in *Song of the Volga*. Particularly interesting is the title chosen for the later painting. Consciously or unconsciously, the title *Woven* recalls the very texture of the earlier painting, which seems more like a tapestry than a painting. It recalls, too, the Jugendstil penchant for such crafts as weaving. It has already been noted that the 1930 painting *Fluttering* seems to reflect the joyful motifs of a painting that had attracted Kandinsky's attention at the 1902 Secession exhibition. He had described Cottet's *Procession* in his *Mir Iskusstva* review. Nearly thirty years later, the pennants, the candle, the church, and the sunshine reappeared in abstract form.[17] One might venture to suggest that the transformation effected here is only different in degree from the transformation effected between Harrington Mann's girl with a hoop in *Hyde Park* and Kandinsky's *Summer*.

Although thematic references to paintings experienced in Munich could be discussed at far greater length, only one other will be discussed here: St. George and the Dragon. As was pointed out in the chapter on Stefan George, the St. George motif became very important for Kandinsky, symbolizing, of course, the conquest of materialistic values by man's spiritual nature or by the spiritual nature of art. The

[15] In his discussion of the fairy tale in painting, Kandinsky had explained that sheer illustrative use of the fairy tale merely created a distraction, similar to that caused by the inclusion of objects from nature. Therefore, he suggested that the artist must use form, movement, color, and the objects borrowed from "real or unreal" nature in such a way that they call forth no anecdotal effect. "And the less externally motivated the movement is . . . the purer, deeper and more profound will be its effect" (*UGK*, pp. 122-23).

[16] See Chapter VII. Both are reproduced in Grohmann: *Song of The Volga* on p. 404, no. 657; *Woven* on p. 370, no. 255.

[17] The Cottet painting was reproduced in *KfA*, 1 August 1902, p. 493. Kandinsky's *Fluttering* is reproduced in Grohmann, p. 378, no. 345.

Japanese scholar Hideho Nishida has already discussed the relationship of Kandinsky's St. Georges to the St. George motifs to be found in Murnau.[18] Certainly the altar painting in the ancient Ramsach church in Murnau, of St. George slaying the dragon, may have provided impetus to the proliferation of this motif in Kandinsky's work.[19] However, St. George had long been a popular motif in German art. Indeed, the fountain in the main square of Rothenburg (where Kandinsky went to paint in 1903, a trip he recalled with great nostalgia in "Rückblicke") boasts a bronze statue of St. George and the dragon atop a high column. And in fact, St. George was much in evidence at exhibitions in Munich and in art periodicals.

As has already been mentioned, Walter Crane's St. George slaying the dragon of materialism (represented by belching smokestacks in the background) had been reproduced in *Kunst für Alle* in 1896, when it was on tour around Europe with a Crane retrospective (Fig. 153). The well-known *St. George* of Hans von Marees was reproduced in the same periodical in 1902 (Fig. 154), in an article on the artist, which also included an illustration of his *St. Martin*.[20]

Any of these might have served as inspiration to Kandinsky in his transformations of St. George. The glass painting *St. George III* (reproduced in the catalog *Kandinsky, Painting on Glass*, no. 28) seems closest to the von Marees *St. George*, at least in terms of the direction of the action. However, what is perhaps most astonishing about Kandinsky's St. Georges is the broad humor with which the dragon is often portrayed. Sometimes he has a blissful expression on his face, as in the version just mentioned. Sometimes he fights back by attempting to push the lance from his mouth, as in the glass painting *St. George II* (Fig. 155). In one large oil painting, *St. George III*, at the Städtische Galerie, he is depicted as a silly spotted salamander, lolling on his back with a look of utter astonishment in his eyes (Fig. 156). In fact, the spotted hide is the distinguishing characteristic of the dragon on the cover of the almanach (Fig. 157).

But there was a precedent for silly spotted dragons. The Munich artist and caricaturist Thomas Theodor Heine exhibited a satirical *Battle with the Dragon* at Dresden in 1903, which was reproduced in an August issue of *Kunst für Alle* that year (Fig. 158). In it, St. George as a jester stands over a spotted dragon, clasping the hand of the Biedermeier lady he has rescued. The spotted monster has the rounded head of a salamander, large round eyes similar to Kandinsky's dragon (in *St. George III*), and lolls rather foolishly on his back.

The St. George motif persisted in Kandinsky's oeuvre throughout his career. He is the central motif in the *Picture with White Edge* of 1913, in which the humped line of the rider is apparent and the long white form is unmistakable as the lance. Again, the dragon seems to be indicated by an arrangement of

[18] Hideho Nishida, "Genèse du Cavalier bleu," *XX^e Siècle*, no. 27 (December 1966), pp. 18-24.

[19] The small, elevated statue of St. George depicted in the Nishida article (*ibid.*, p. 20) is attached to the Pfarrkirche in the center of Murnau, not to the little Ramsach church on the edge of Murnau, as stated in the article.

[20] A Bavarian mirror painting of a St. Martin appeared as the frontispiece of the *Blaue Reiter* almanach. As Nishida pointed out, this led Eichner to suggest that the figure on the cover of the almanach was a St. Martin, and E. Roters to suggest that the figure is a combination of St. Martin and St. George. Nishida disagreed with both these views, demonstrating quite conclusively that the figure in fact was based on the St. George motif (*ibid.*).

spots to the left of the tip of the lance (Fig. 138).[21] The drastic abstraction of the motif for the 1938 cover of *Transition* magazine (Fig. 145) has already been mentioned (in Chap. XII). But St. George appears in an even later work as well, the 1943 painting *Brown Elan* (Fig. 159). Here a tragicomic mood prevails. It is St. George (the "helmeted" figure leaning toward the upper right) who appears aghast, for his spear (the diagonal form from right center toward lower left) is broken off at the tip. Nevertheless, the dragon, here reduced to a snake, has been upended, and the "horse" rears bravely. A Viking ship with many oars (upper right) stands at the ready, perhaps to carry them off to further adventures.

The role of humor in Kandinsky's development to abstraction has been overlooked. But surely, in transformations as drastic as those Kandinsky undertook, humor had a role to play. Like the fairy tale and memory image, humor enabled the artist to view the world at one remove. The dissolution of the dragon of materialism into an abstract design of spots required even more than a sense of design, a keen sense of humor.[22]

[21] In his discussion of this painting in the 1913 *Sturm* album, Kandinsky did not identify this motif explicitly as "St. George," but referred instead to a *"Kampf in Weiss und Schwarz"* (battle in white and black) in the lower left part of the canvas (in "Das Bild mit weissem Rand," in *Kandinsky, 1901–1913*, p. xxxx). This motif has also been identified as St. George and the dragon in Washton "Kandinsky," pp. 219-21. For more on Kandinsky's use of the St. George and dragon motif, see Peg Weiss, "Kandinsky in Munich: Encounters and Transformations," in *Kandinsky in Munich 1896–1914* (New York: Solomon R. Guggenheim Museum, 1982), especially pp. 28-30, 67-82, and Edward J. Kimball and Peg Weiss, "A Pictorial Analysis of 'In the Black Square' " in *Art Journal* (Spring 1983),

pp. 36-40. Hitherto overlooked in the literature is the fact that St. George was the patron saint of the town of Murnau where Kandinsky and Münter spent their summers from 1909 to 1914.

[22] Kandinsky himself mentioned the role of humor in the development of one of his glass paintings. In his notes on *Composition VI*, he wrote that the starting point had been a glass painting of the Deluge: "Here were given various objective forms which were in part funny (I enjoyed mingling serious forms with comical external expressions): nudes, the ark, animals, palms, lightnings, rain, etc." ("Komposition 6," in *Kandinsky, 1901–1913*, p. xxxv). A photograph of this lost painting is reproduced in *Kandinsky, Painting on Glass*, p. 13.

APPENDIX

·C·

Endell and Kandinsky, Original Texts

IN CHAPTER IV, a comparison was made between texts by August Endell and Kandinsky concerning the awakening of thought and feeling to the essential experience of beauty, to the essence of art as distinct from nature. The original German texts of these two quotations are here set side by side so that the reader may observe for himself how much the two artists' statements have in common.

FROM AUGUST ENDELL
Um die Schönheit (1896)

Natur und Kunst sind zwei total verschiedene Dinge (p. 27).

Wer es aber gelernt hat, sich seinen visuellen Eindrücken völlig ohne Associationen, ohne irgend welche Nebengedanken hinzugeben, wer nur einmal die Gefühlswirkung der Formen und Farben verspürt hat, der wird darin eine nie versiegende Quelle ausserordentlichen und ungeahnten Genusses finden. Es ist in der That eine neue Welt, die sich da aufthut. Und es sollte ein Ereignis in jedes Menschen Leben sein, wo zum ersten Mal das Verständnis für diese Dinge erwacht. Es ist wie ein Rausch, wie ein Wahnsinn, der uns da überkommt. Die Freude droht uns zu vernichten, die Überfülle an Schönheit uns zu ersticken. Wer das nicht durchgemacht hat, wird niemals bildende Kunst begreifen.

Wen niemals die köstlichen Biegungen der Grashalme, die wunderbare Unerbittlichkeit des Distelblattes, die herbe Jugendlichkeit spriessender Blatt-

FROM WASSILY KANDINSKY
"Rückblicke," 1913

Es mussten viele Jahre vergehen, bis ich durch Fühlen und Denken zu der einfachen Lösung kam, dass die Ziele (also auch die Mittel) der Natur und der Kunst wesentlich, organisch und weltgesetzlich verschieden sind. . . .

Diese Lösung befreite mich und öffnete mir neue Welten. Alles 'Tote' erzitterte. Nicht nur die bedichteten Sterne, Mond, Wälder, Blumen, sondern auch ein im Aschenbecher liegender Stummel, ein auf der Strasse aus der Pfütze blickender, geduldiger weisser Hosenknopf, ein fügsames Stückchen Baumrinde, das eine Ameise im starken Gebiss zu unbestimmten und wichtigen Zwecken durch das hohe Gras zieht, ein Kalenderblatt, nach dem sich die bewusste Hand ausstreckt und aus der warmen Geselligkeit mit den noch im Block bleibenden Mitblättern gewaltsam herausreisst—alles zeigte mir sein Gesicht, sein innerstes Wesen, die geheime Seele, die öfter schweigt als spricht. So wurde für mich jeder ruhende und jeder

(from Endell continued)

knospen in Entzücken versetzt haben, wen nie die wuchtige Gestaltung einer Baumwurzel, die unerschütterliche Kraft geborstner Rinde, die schlanke Geschmeidigkeit eines Birkenstamms, die grosse Ruhe weiter Blättermassen gepackt und bis in die Tiefen seiner Seele erregt haben, der weiss noch nichts von der Schönheit der Formen (p. 11).

(from Kandinsky continued)

bewegte Punkt (= Linie) ebenso lebendig und offenbarte mir seine Seele. Das war für mich genug, um mit meinem ganzen Wesen, mit meinen sämtlichen Sinnen die Möglichkeit und das Dasein der Kunst zu 'begreifen,' die heute im Gegensatz zur 'Gegenständlichen' die 'Abstrakte' genannt wird (p. vi).

APPENDIX

·D·

"An Kandinsky" by Albert Verwey
Translated by Karl Wolfskehl

AN KANDINSKY

Seele nun sieh gleich dem leuchtenden Morgen
Offen um Gipfel erblühtes Bunt
Keinerlei Ding doch bezwungen verborgen
Ursinn von Feuchte und Dampf und Grund

Welch Gefüge das Flammen zerreissen
Welch ein Gepralle von Seufzern geduckt
Linien die schneidend den Abgrund zerreissen
Ringelndes Weben das Lüfte durchzuckt

Himmel und Erde Geheimes verheissen
Äther und Trübung quirlend in Eins
Dunkel Gedröhn aus den Tiefen die kreisen
Himmlische Weide voll zitternden Scheins

In mir empfangen die Pole einander
Knisternder Funke schweisst Gluten hinein
Nimmer für mich der antike Mäander
Mein von den Blitzen das Zick-zack Gebein

Was gilt es mir ob Formen sich klären
Ob Euer Kind-Herz Gewesenem anhangt
Wo sich in Farben dem Auge gebären
Wunder: das Seele zwieseelig vor-bangt

Wunder das All in Bewegung verflossen
Sichtbare: Drinnen ihr Spielgesell
Ewiger Wechsel enthüllt und verschlossen
Stürzet in uns ein endloser Quell

Quelle des Alls sein flutendes Leben
Wirbel und Wurl von Farb und Gezack
Mit ihm zerrinnen wir mit ihm verweben
Wir in ein strömendes Glimmer-Geflack

Dies unser Wesen, das Licht und die Glänze
Wo sich Fahren und Formen verlor
Wo inmitten der endlosen Tänze
Augenblicks Starre kein Nu sich erkor.

APPENDIX

· E ·

Chronology

1866 December 4, Kandinsky born in Moscow (according to the old Russian calendar, November 22).[1]

1869 Travels to Italy with his parents.

1871 Family moves to Odessa, where Kandinsky studies art and music, and later attends the humanistic Gymnasium.

1886 Enters the University of Moscow, where he studies law and economics.

1889 Expedition to the Vologda province sponsored by the Society of Natural Science and Anthropology, which later publishes the resultant study on peasant laws and customs. Kandinsky is much impressed by the vigorous folk art of the peasants.
Visits St. Petersburg and Paris.

1892 Completes studies, passes law examination.
Marries Ania Chimiakin, a cousin.
Second trip to Paris.

1893 Teaching assistant at the University of Moscow.

1895 At an exhibition of French painting in Moscow, Kandinsky is impressed by Monet's *Haystack*; observes that the object in the painting is not indispensable.
Works at an art printing firm in Moscow.

1896 Rejects offer of a teaching position at the University

of Dorpat in order to devote himself to the study of painting.
Moves to Munich, where he enters the Ažbè atelier.

1897 Studies with Ažbè for two years. Meets the painters Jawlensky and Werefkin. Visits the Munich Secession exhibitions, witnesses the heyday of Munich Jugendstil.

1900 Student of Franz Stuck at the Munich Academy. Meets Ernst Stern, Alexander von Salzmann, Albert Weisgerber, Hans Purrmann.

1901 May or June, founds the Phalanx exhibition society (with Rolf Niczky, Waldemar Hecker, Gustav Freytag, and Wilhelm Hüsgen).
First Phalanx exhibition in August, 1901.
Late summer or early autumn, Kandinsky becomes president of the Phalanx group.

1902 During the winter of 1901-02, Kandinsky and other members of the Phalanx form the Phalanx School. Meets Gabriele Münter, who joins his painting class.
January, Second Phalanx Exhibition, devoted to the arts and crafts movement, features artists associated with the Darmstadt Künstlerkolonie, including Peter Behrens.
Writes review of Munich art scene for the Russian periodical *Mir Iskusstva*.
Spends summer months with his school at Kochel.
Phalanx holds two other exhibitions.
Exhibits at the Berlin Secession.
Friendship with Hermann Obrist.

[1] This brief chronology has been compiled from the research for this book and from various other sources (e.g., Grohmann, Eichner, and exhibition catalogs of the Guggenheim Museum) for the convenience of the reader. It is not intended to be definitive.

1903 Travels to Vienna, Venice, Odessa, Moscow, Berlin, Cologne.
Spends summer months with school at Kallmünz.
Phalanx holds four exhibitions.
Peter Behrens offers him position teaching decorative painting at the Düsseldorf School of Arts and Crafts.

1904 January, Alfred Kubin exhibits at Phalanx; Kubin's and Behrens' association with various members of the circle around symbolist poet Stefan George, including Karl Wolfskehl, suggests that Kandinsky's own association with Wolfskehl may have begun by this time if not earlier.
In May, travels to Krefeld, Düsseldorf, Cologne.
Late May and June, travels in Holland.
Spends summer in Munich working on woodcuts.
Exhibits at the Munich Kunstverein.
Makes craft designs for the Society for Applied Art, Munich.
Phalanx holds four exhibitions (including its last, at Darmstadt in December).
Poems without Words, an album of woodcuts, published in Moscow.

1905 From December 1904 until April 1905, travels in Tunis. Returns to the Munich area in late spring; bicycle tour in Switzerland; visits Dresden.
Returns to Munich in late summer again. In late fall, to Odessa.
Exhibits at the Salon d'Automne (including craft designs).

1906 From December 1905 until April 1906, winters at Rappallo, Italy.
In June, moves to Sèvres near Paris, where he remains until June of 1907.
Exhibits at the Salon d'Automne (including seven designs for craftwork, as well as woodcuts and paintings).
Works on woodcuts for *Xylographies*, some of which are published in *Les Tendances nouvelles*.
Winter 1906-07, exhibits with Die Brücke in Dresden.

1907 Early June, leaves Paris, returns to Munich area.
In September, goes to Berlin.

1908 Remains in Berlin until the end of April; then returns once more to the Munich area.
May, opening of the Munich Artists' Theater.
In September, takes apartment in the Ainmillerstrasse in Schwabing.
Visits Murnau.

1909 Acquires house in Murnau, where he resides most of the time until the late summer of 1914.
Works on Murnau landscapes; begins the *Improvisations*. Founds the Neue Künstlervereinigung.
Writes reviews for Russian periodical *Apollon* (through 1910).
According to some sources, begins work on compositions for the stage, such as *Der gelbe Klang* (later published in the *Blaue Reiter* almanach).

1910 Completes manuscript of *Über das Geistige in der Kunst*.
Begins the *Compositions*.
"First abstract watercolor" is dated 1910.[2]
Meets Franz Marc.
Visits Moscow, Petersburg, Moscow in the autumn.

1911 Friendship with Marc, Klee, Macke, Arnold Schönberg, and Karl Wolfskehl documented in correspondence.
Begins plans with Marc for the *Blaue Reiter* almanach.
Break with the Neue Künstervereinigung.

[2] Lindsay has suggested that this particular watercolor, which is a sketch for *Composition VII* of 1913, may actually have been accidentally misdated 1910 at a later time (see Lindsay's review of the Grohmann monograph in *Art Bulletin* [1959], p. 350).

December 18, the first exhibition of the *Blaue Reiter* editorial board.

Über das Geistige in der Kunst is published by R. Piper of Munich in December, though dated 1912.

Divorces Ania Chimiakin.

1912 Second exhibition of the *Blaue Reiter*.
Blaue Reiter almanach is published; *Über das Geistige* comes out in two more editions.
Blaue Reiter exhibition at Der Sturm, Berlin.

1913 *Klänge*, a book of prose-poems and woodcuts, published.
Kandinsky's memoir "Rückblicke" published.
Retrospective exhibition at Der Sturm, Berlin.
Participates in the first German Autumn Salon in Berlin.
Participates in the Armory Show in New York.

1914 *Blaue Reiter* exhibition in Berlin.
Hugo Ball proposes Kandinsky's *Der gelbe Klang* for performance on the stage of the Munich Artists' Theater.
At the outbreak of the First World War, travels to Goldach on the Lake of Constance, where he be-
gins work on *Punkt und Linie zu Fläche*.
In late November returns to Russia.

1915 Last visit with Münter in Stockholm, in the winter of 1915-16.

1917 Marries Nina de Andreevskaya.

1918- Engages in various activities as a member of the
1921 Commissariat for Cultural Progress. Teaches at the Art Academy in Moscow. Founds Museum for Artistic Culture; instrumental in distributing paintings to twenty-two provincial museums.

1921 Leaves Russia for Berlin.

1922 Accepts post at the Bauhaus at Weimar.

1925 Moves with the Bauhaus to Dessau.

1926 Publication of *Punkt und Linie zu Fläche*.

1933 Moves to Paris when the Bauhaus is closed by the Nazis.
Settles at Neuilly-sur-Seine. During 1930s, exhibitions in Paris, San Francisco, New York, London.

1937 Kandinsky paintings confiscated by the Nazi government are sold.

1940 Despite invitations to go to America, chooses to remain in France.

1944 Becomes ill in spring. Dies December 13 in Neuilly.

Notes

INTRODUCTION

1. Thomas Mann, "Gladius Dei" (1902) in *Die Erzählungen*, I (Frankfurt: Fischer Bucherei, 1967), pp. 149-62. The opening section of this story both begins and ends with the words, "München leuchtete."

2. Wassily Kandinsky, "Der Blaue Reiter (Rückblick)" in *Das Kunstblatt*, XIV (1930), p. 57. Kandinsky's reference to Munich as a "spiritual situation" was a paraphrase of the famous definition by Franziska von Reventlow of Schwabing as a "spiritual movement, a niveau, a direction, a protest, a new cult or much more, the attempt to win once again out of ancient cults new religious possibilities. . . ." in her autobiographical *roman à clef*, *Herrn Dames Aufzeichnungen*, *Drei Romane* (Munich: Biederstein Verlag, 1958 [originally published in 1913]), p. 116. Since much of the material referenced in this book is not available in translation, nearly all of the translations in the text are my own (unless otherwise indicated). I have taken this course in the interests of consistency, realizing that translations are often as much a matter of taste as of accuracy. Furthermore, I have found that the few available translations of Kandinsky's writings contain certain inaccuracies which often tended to distort passages I felt were especially important in a particular context; which is not to say that I am convinced I have always found the nonexistent "perfect" translation myself. For a brief discussion of the problems involved in working with the variant editions and translations of Kandinsky's writings, as well as notes on the versions I have cited, see Appendix A, "A Note on Translations in General and of *das Geistige* in Particular."

3. Wassily Kandinsky, "Rückblicke," *Kandinsky, 1901-1913* (Berlin: Der Sturm, 1913), p. xx. In fact as late as 1959, Sir Herbert Read remarked that "The history of the first decade [of the twentieth century] in Munich has never been adequately written. . . ." (Read, *A Concise History of Modern Painting* [New York: Frederick A. Praeger, third printing 1964, originally published 1959], p. 33.) And as recently as 1975, in a review of an exhibition of work by Alexei von Jawlensky—one of Kandinsky's earliest Munich colleagues—Hilton Kramer suggested that only a fuller exploration of Munich's avant-garde at the

turn of the century might lead to a complete understanding of the artist's achievement (see Kramer, "Color-Drenched Paintings of Jawlensky," *The New York Times*, Sunday, 2 February 1975, p. 25).

4. Wassily Kandinsky, *Über das Geistige in der Kunst*, originally published by R. Piper, Munich, 1912. My references throughout are to the edition edited by Max Bill (Bern: Benteli-Verlag, 8th ed. [*sic*], 1965), hereafter cited as Kandinsky, *UGK* (see also Appendix A). My reasons for adhering to the German title throughout are also set forth in Appendix A. The artist himself will be referred to simply as Kandinsky, because in an early letter to his friend Gabriele Münter, he stated quite emphatically that he preferred to be referred to in this way (letter of 11.7.04, see Chapter IV, n. 50). Throughout his German period, official usage, for example in his own exhibition catalogs and published writings, dictated the German transliteration of his given name as "Wassily" (the English transliteration is "Vasily"). Since this book is specifically concerned with the artist's German period, I have elected to use the German transliteration throughout whenever such reference is necessary.

5. Henrik Ibsen, who lived in Munich for sixteen years (1875-91), often spoke of the intellectual and personal freedom he enjoyed there. See Hanns Arens, *Unsterbliches München: Streifzüge durch 200 Jahre literarischen Lebens der Stadt* (Munich: Bechtle Verlag, 1968), p. 199.

6. H. R. Wadleigh, *Munich: History, Monuments and Art* (London: T. Fischer Unwin, 1910), p. 92.

7. *Frühlings Erwachen* had been published in Munich in 1891, but dealt with what was then considered too explosive a theme (adolescent sexuality) to find immediate public performance. As a *Bürgerschreck*, or in today's parlance a rather "far-out hippie," Wedekind eventually became one of the folk heroes of Munich's bohemia. See Sol Gittleman, *Frank Wedekind* (New York: Twayne Publishers, 1969), pp. x-xi.

8. Naturally, a thumbnail sketch of this type is scarcely adequate to suggest the wealth and complexity of the historical scene. A good source for background information on Munich's intellectual life is Arens, *Unsterbliches München* (previously

cited). See also Hajo Holborn, *A History of Modern Germany 1840-1945* (New York: Alfred A. Knopf, 1969). Holborn's book provides insight into the political and economic factors that encouraged Munich's flowering as a *Kunststadt* at the turn of the century. Cf. *Apollo*, XCIV, 117 (November 1971), pp. 331-402, and the landmark catalog *Bayern—Kunst und Kultur*, ed. Michael Petzet (Munich: Prestel Verlag, 1972).

9. An interesting theoretical investigation of the historical evolution of "abstraction in art" is to be found in Otto Stelzer, *Die Vorgeschichte der abstrakten Kunst* (Munich: R. Piper and Co., 1964). The common interchangeability of the terms "abstract," "nonrepresentational," and "nonobjective" in contemporary references to this form of modern art is reflected in the 1967 edition of the *Random House Dictionary of the English Language*. Although there has been much debate on the subject of terminology in regard to the type of art having little or no reference to recognizable objects, such as that created by Kandinsky and other artists early in the century, the topic still awaits a thorough scholarly analysis. I have elected to use the terms interchangeably in this book. In translating from the German, I have generally translated *abstrakt* as "abstract," and *ungegenständlich* (and *gegenstandslos*) as "nonobjective" (or "nonrepresentational"), often indicating in the text the exact reference, for the sake of clarity (see also Chapter IV, n. 140).

10. W. Hausenstein, *Die bildende Kunst der Gegenwart* (Stuttgart/Berlin: Deutsche Verlags-Anstalt, 1914 [manuscript completed 1913]), pp. 298-300.

11. H. Hildebrandt, *Die Kunst des 19. und 20. Jahrhunderts* (Potsdam: Akademische Verlagsgesellschaft Atenaion, 1924), pp. 398-99.

12. A tentative beginning has been suggested by Rose-Carol Washton Long in "Kandinsky's Abstract Style: The Veiling of Apocalyptic Folk Imagery" (*Art Journal*, XXXIV, 3, Spring 1975, pp. 217-28), in which some iconographic details are traced to Russian folk illustrations (*lubki*). Although Grohmann hinted at the Russian influences, his standard monograph provided very little specific information (Will Grohmann, *Wassily Kandinsky, Life and Work* [New York: Harry N. Abrams, Inc., 1958]). Lindsay, in his review of the Grohmann book, noted this lack and suggested some specific iconographic sources in Russian folk tales (Kenneth C. Lindsay, "Will Grohmann, Kandinsky" [*Art Bulletin*, XLI, 4, December 1959, p. 349]). Lindsay's own dissertation was concerned with the relationship between Kandinsky's stated theories and his painting, and therefore did not touch specifically on the artist's relationship to the Munich milieu (K. C. Lindsay, "An Examination of the Fundamental Theories of Wassily Kandinsky" [unpublished Ph.D. dissertation, University of Wisconsin, 1951]).

13. Klaus Brisch, "Wassily Kandinsky, Untersuchung zur Entstehung der gegenstandslosen Malerei" (unpublished Ph.D. dissertation, University of Bonn, 1955), chap. II, pts. A-2, A-3.

14. *Kandinsky—Painting on Glass (Hinterglasmalerei)*, Anniversary Exhibition. The Solomon R. Guggenheim Museum, N. Y., 1966 (preface by Thomas M. Messer, introduction by Hans K. Roethel).

15. Rose-Carol Washton (Long), "Vasily Kandinsky, 1909-1913: Painting and Theory" (unpublished Ph.D. dissertation, Yale University, 1968). See also by the same author, "Kandinsky and Abstraction: The Role of the Hidden Image" (*Artforum*, June 1972, pp. 42-49); and also "Kandinsky's Abstract Style," cited above, n. 12.

16. Sixten Ringbom, *The Sounding Cosmos, A Study in the Spiritualism of Kandinsky and the Genesis of Abstract Painting* (Helsingfors: Abo Akademi, 1970). See also, by the same author, "Art in 'the Epoch of the Great Spiritual,' Occult Elements in the Early Theory of Abstract Painting," *Journal of the Warburg and Courtauld Institutes*, XXIX (1966), pp. 386-418. In the light of evidence offered in the present book, Ringbom's statement that "occult influences" affected Kandinsky's "basic outlook more profoundly than any of these other sources" must certainly be reevaluated. The "other sources" mentioned by Ringbom were Worringer, Fiedler, "and others"—a rather severe reduction of the broad range of influences available to Kandinsky in the Munich milieu, as will be seen (Ringbom, "Art in 'the Epoch' . . . ," cited above, p. 408). Washton Long has also emphasized the role of theosophy in Kandinsky's development (n. 15, above). Yet another dissertation suggesting sources for Kandinsky's thought in theosophy was Laxmi P. Sihare's "Oriental Influences on Wassily Kandinsky and Piet Mondrian, 1909-1917" (unpublished Ph.D. dissertation, New York University, The Institute of Fine Arts, 1967). Unfortunately all of these well-intentioned efforts have resulted in a regrettable distortion of fact. Kandinsky was never a "devoted follower" of theosophy, an assumption apparently accepted, for example, by Hilton Kramer, in commenting on the work of some of these scholars in the pages of *The Times* ("Theosophy and Abstraction," *The New York Times*, 23 July 1972). On the other hand, Mondrian was not only a follower but an official member of the Theosophical Society for some years. While there may be interesting parallels between the stylistic devel-

opments of these two pioneers of abstraction, it should not be thought that theosophy by any means provided Kandinsky with his sole (or even major) source of inspiration.

17. Kandinsky himself specifically singled out Rossetti and Burne-Jones as exemplary "seekers after the 'inner,' " in *UGK*, p. 50. He also mentioned in the same context Sâr Péladan of *Le Salon de la Rose + Croix*, whose quaint Wagnerian adaptation of Catholicism to the current fashion for the occult proved highly popular for a time: most of Europe's major symbolist artists exhibited at the Rose + Croix, including Hodler, Vallotton, Toorop, Khnopff and Georges Rouault (see John Milner, *Symbolists and Decadents* [London: Studio Vista Limited, 1971]).

18. See Oleg A. Maslenikov, *The Frenzied Poets—Andrey Biely and the Russian Symbolists* (New York: Greenwood Press, Publishers, 1968), pp. 128-29. (For a short time, 1914-16, Biely was to experiment with anthroposophy, residing at Steiner's community in Dornach, Switzerland.)

19. Reventlow, *Herrn Dames Aufzeichnungen*, pp. 104-06 and *passim*. Her description of the Fasching revels of Munich's symbolist poets satirized the popular confusion between Nietzschean dogma and a variety of occult beliefs and practices.

20. Kandinsky himself expressly denied any allegation that he was trying to paint "states of the soul" or *Seelenzustände* in the draft of a lecture dated 1914, which is published in Johannes Eichner's book *Kandinsky und Gabriele Münter—von Ursprüngen Moderner Kunst* (Munich: Verlag F. Bruckmann, n.d.), pp. 108-16. The lecture, to have been presented at the *Kreis der Kunst* in Cologne early in 1914, was in fact never given due to the fact that the leaders of the society felt it would have been too confusing to the uninitiated. Eichner's transcript was adapted from Kandinsky's handwritten notes and may, in itself, be faulty. But the isolated emphatic statements near the end of the notes can scarcely have been misinterpreted: "I do not want to paint music. I do not want to paint states of the soul. I do not want to paint colorfully or uncolorfully. I do not wish to change, fight or overthrow a single jot in the harmony of masterpieces of past times. I do not wish to show the future its proper ways" ("Ich will keine Musik malen. Ich will keine Seelenzustände malen. Ich will nicht farbig oder unfarbig malen. Ich will in der Harmonie der Meisterwerke der vergangenen Zeit keinen Punkt ändern, bekämpfen oder umwerfen. Ich will nicht der Zukunft ihre richtigen Wege zeigen.") He continued, saying that he wanted to paint "just good, necessary, lively pictures . . ." ("nur gute, notwendige, lebendige Bilder . . .") (Eichner, p. 116).

Mme. Nina Kandinsky has also emphatically denied that Kandinsky ever had any serious interest in theosophy, maintaining that he simply shared the normal interest of most intellectuals of the day in what was considered a passing fad. She has also stated that it "angered" Kandinsky in later years to be called a "theosophist" (interview with the author, May 1968).

According to Eichner, it was Münter who was interested in the occult (e.g., Eichner, p. 30). Ringbom states that the books and magazines reflecting theosophist thought, which he cites as part of the Münter estate, bear marginal notes in *Münter's* hand (although in some instances he attributes these notes—and even "underlinings"—to Kandinsky). (See Ringbom, *Sounding Cosmos*, pp. 53, 63, and *passim*.) While none of this material held by the Gabriele Münter-und Johannes Eichner-Stiftung was available to other scholars at the time of writing and thus could not be checked, it can now be stated that most of these books and pamphlets originally belonged to Münter's family. Significantly, this material remained with Münter in Munich when Kandinsky left for Russia in 1914. Apparently another Kandinsky friend, the composer Thomas de Hartmann (later a follower of Gurdjieff), was also interested in theosophy for a time.

21. Kandinsky, *UGK*, p. 43, where he expresses open skepticism about the ability of the theosophists to provide an answer to what he calls the "eternal, immense question mark" ("ewige immense Fragezeichen") of life. It is clear from the context of his remarks that theosophy was only one of many signs of the general *geistige* movement for which Kandinsky hoped.

22. Kandinsky, letter of 1 September 1911, quoted by Klaus Lankheit in "Wissenschaftlicher Anhang," *Der Blaue Reiter, dokumentarische Neuausgabe* (Munich: R. Piper and Co., 1965, originally published by Piper in 1912), p. 261 (italics mine). This work is generally referred to as the *Blaue Reiter* almanach. (Hereafter the new documentary edition will be cited as *DBR*.) In fact, no specific references were made to theosophy in the almanach.

23. On the translation of the word *geistig*, see Appendix A. In *The Sounding Cosmos*, Ringbom consistently refrained from any objective assessment of Jugendstil, leaving the impression that Kandinsky's abstraction was solely the result of theosophist thinking. This one-sided concentration led him to numerous dubious conclusions. For example, Ringbom suggests (pp. 132-33) that the passage in Kandinsky's memoir "Rückblicke," in which he described his realization of the separateness of art and nature, was directly derived from Steiner's theosophical

interpretation of empathy. In fact the passage was more likely derived from a similar statement by August Endell, who in turn was inspired by the theories on empathy of Theodor Lipps (see Chapter IV and Appendix C). In his discussion of "chromotherapy" (pp. 86-87), Ringbom does not even mention the article by the Jugendstil critic Karl Scheffler, "Notizen über Farbe," in which color language and chromotherapy are discussed within the context of the arts and crafts movement—although Kandinsky himself cited Scheffler's article in *Über das Geistige in der Kunst* (*UGK*, p. 66). Indeed, there are many references in Ringbom's book to statements by Kandinsky which are better understood within the context of Jugendstil aesthetics than within that of theosophy.

24. Munich itself has not fared well in Kandinsky scholarship. For example, according to Grohmann: "The artistic atmosphere in Munich at the time of Kandinsky's debut as an artist was anything but encouraging" (Grohmann, *Kandinsky* p. 34). Jacques Lassaigne followed Grohmann's lead: "When Kandinsky arrived in Munich in 1896, he found it scarcely more stimulating than Russia had been" (Lassaigne, *Kandinsky* [Geneva: Skira, 1964], p. 24). And as recently as 1970 Ringbom wrote ". . . he found the artistic climate of Munich stale and oppressive" (Ringbom, *The Sounding Cosmos*, p. 26).

Grohmann in fact devoted only some fourteen pages of text to Kandinsky's early Munich years until 1908, with little more than a paragraph or two of discussion on the artist's first exhibition society, the Phalanx. He touched only fleetingly on such major figures as Adolf Hölzel, Hermann Obrist, and August Endell, and although he mentioned the existence of Jugendstil, even admitting that it "produced something like a revolution" there, he found that "we have no documentary evidence as to how much Kandinsky was interested in such matters" (Grohmann, *Kandinsky*, pp. 34-35). Klaus Brisch did suggest the possible influence of Munich Jugendstil (especially its emphasis on *Flächenkunst*, or planar art), and of the aesthetic theories of Endell and Theodor Lipps. However, he did not attempt to find any specific relationship between Kandinsky's development and these phenomena (Brisch, "Wassily Kandinsky . . . ," pp. 29-31, 127, 168, 320).

Only Peter Selz in his 1957 book *German Expressionist Painting* (Berkeley and Los Angeles: University of California Press, 1957), indicated the importance of the role Munich played in offering Kandinsky a stimulating cultural milieu. In his discussion of Kandinsky, Selz mentioned not only Jugendstil, but also the influen-

tial presence in Munich of the symbolist poets Stefan George and Karl Wolfskehl (p. 180). He also included a brief chapter on Jugendstil as a major source of expressionist painting (pp. 48-64).

However, only in Munich itself, with the 1958 exhibition "München 1869-1958, Aufbruch zur Modernen Kunst" (organized by Siegfried Wichmann), was Kandinsky placed firmly within the context of Munich art at the turn of the century. (See "*München 1869-1958. . . .*" catalog of the exhibition at the Haus der Kunst, June 21-October 5, 1958, Munich, hereafter referred to as *Aufbruch* catalog.) The following year Sir Herbert Read put forward the thesis that "the continuity of Kandinsky's stylistic development is unbroken from his early Jugendstil phase until the end of his life" (Read, "Introduction," *Kandinsky* [London: Faber and Faber, 1959], p. 2). Eventually, it was possible for Werner Haftmann to state that Jugendstil aesthetics had openly raised the question of abstract art, and to link with this Kandinsky's presence in Munich, where "more than anywhere else the theoretical groundwork for abstract painting had been laid" (Haftmann, *Painting in the Twentieth Century* [New York/Washington: Frederick A. Praeger, 1965, first ed. 1961], pp. 135-38). More recently the monumental exhibition of 1972 with its excellent catalog, *Bayern—Kunst und Kultur* (previously cited), illustrated the full panorama of the Bavarian cultural scene.

25. For example, although my investigation generally covers the years from Kandinsky's arrival in Munich in 1896 to his departure at the outbreak of World War I, I have not dealt in depth with either the Neue Künstlervereinigung or the Blaue Reiter exhibitions and associations, since both of these phenomena have been thoroughly discussed elsewhere. (See e.g., P. Weiss, "Kandinsky in Munich: Encounters and Transformations," in *Kandinsky in Munich 1896–1914* (New York: Solomon R. Guggenheim Museum, 1982), pp. 57-82; Grohmann, *Kandinsky* pp. 62-80, and *passim*; K. Brisch, "Kandinsky," pp. 35-50; K. Lankheit [ed.], *DBR*, pp. 253-326; P. Selz, *German Expressionist Painting*, pp. 185-222.) Nor have I considered the many influences exerted on Kandinsky by the world beyond Munich: his Russian heritage; the year in Paris (1906-07), which was above all one of isolation and despair. He stated himself that he did not remember the Paris sojourn gladly and was relieved to return to Munich. (See Kandinsky, letter of 18.8.32, quoted in *Künstler schreiben an Will Grohmann*, ed. by Karl Gutbrod [Cologne: DuMont Schauberg 1968], pp. 59-60; also Eichner, p. 52. A recent study suggests that the Parisian interlude may have been more significant than has hitherto been realized [Jonathan D. Fineberg, "Kandinsky

in Paris 1906-7," unpublished Ph.D. dissertation, Harvard University, 1975].) Nor have I touched on Munich's vigorous musical milieu which undoubtedly held considerable interest for Kandinsky.

Wilhelm Worringer, the author of *Abstraktion und Einfühlung* (Munich: R. Piper and Co., 1908), appears only peripherally in this study, since his book appeared relatively late on the Munich scene and because his position as a whole remains somewhat problematic. A few compulsory copies of the book, which was Worringer's doctoral dissertation, were printed privately in 1907. It was one of these private copies which was read by the poet Paul Ernst, who then published his review of it in *Kunst und Künstler* in August, 1908 (p. 529). Only *after* Ernst's review appeared did Piper undertake publication of the book for the general public (late in 1908). Thus Kandinsky is not likely to have seen the book in any case much before 1909, when his own ideas, as will be seen, were already well formulated. (Only in the third edition, of 1911, did the appendix, "Von Transzendenz und Immanenz in der Kunst," appear.) But more important, Worringer actually based his argument on a *rejection* of the very theories (of Lipps) on which Jugendstil artists and critics (like Endell, Obrist, Scheffler, Arthur Roessler, Ferdinand Avenarius, and many others) based their concept of the possibility of an art without objects. (Lipps lectured publicly at the university in Munich from 1894 to 1913, and published widely as well.) Worringer insisted that Lipps' theory was applicable only to naturalistic art: "For the basic purpose of my essay is to show that this modern aesthetics [i.e. of Lipps], which proceeds from the concept of empathy, is inapplicable to wide tracts of art history [i.e., to forms of abstraction]" (Worringer, *Abstraction and Empathy*, trans. by Michael Bullock [Cleveland and New York: World Publishing Co., 1967], p. 4; subsequent quotations are from this translation). Worringer was perfectly aware of the propensity of Jugendstil for abstraction, yet he apparently failed to appreciate the contribution of Lipps' aesthetics to the development of that trend. For example, he cited the work of Adolf Hildebrand, whose insistence on relief in sculpture—a typically Jugendstil manifestation—Worringer associated with abstraction. In a footnote, Worringer even admitted the possibility of feeling empathy for abstract forms, but immediately discounted it (*ibid.*, p. 137, n.7). That Worringer was in fact intimately involved himself in the whole Jugendstil ambience is apparent from a reading of his striking essay on Frank Wedekind, published in the *Münchner Almanach, ein Sammelbuch neuer deutscher*

Dichtung, ed., Karl Schloss (Munich: R. Piper and Co., 1905), pp. 55-64.

Worringer's real merit in the eyes of the contemporary avantgarde was, as he himself later admitted, the "conjunction, quite unsuspected by myself, of my personal disposition for certain problems with the fact that a whole period was disposed for a radical reorientation of its standards of aesthetic value" (Worringer, *Abstraction and Empathy*, p. vii). For his theory did indeed insist upon the reordering of values and a new appreciation of the type of art he described as "abstract" (i.e., Archaic Greek, Byzantine, Egyptian, Oriental, etc.). His association of a tendency to abstraction with a state of existential loneliness also struck a responsive chord. As he himself said, "the times were ripe" (*ibid.*, p. vii). Even as Worringer's book reached the public, Munich was host to the great exhibitions of Mohammedan and East Asiatic art that attracted artists from all over Europe (including, for example, Matisse). Nonetheless, this study of the Munich milieu demonstrates that Kandinsky's development toward a degree of abstraction unimagined by Worringer (and later rejected by him) was, in fact, conditioned to a large extent by those very theories Worringer had rejected and which he associated with classical naturalism (*ibid.*, pp. 14, 45, 101f, and *passim*).

26. See Robert Schmutzler, *Art Nouveau* (New York: Harry N. Abrams, Inc., originally published 1962), p. 299, where a fairly complete list of periodicals is given. Schmutzler's book is one of the major scholarly works to assess the international scope of the Art Nouveau movement. (For further bibliographical notes on Art Nouveau and Jugendstil, see Chapter III, n. 7.)

27. Henri Van de Velde, *Zum Neuen Stil. Aus seinen Schriften ausgewählt und eingeleitet von Hans Curjel* (Munich: R. Piper and Co., 1955), pp. 130-31. (The passage is excerpted from the book *Kunstgewerbliche Laienpredigten*, originally published in 1902.)

28. The symbolist critic Félix Fénéon compared Seurat's *La Grande Jatte* to a tapestry in his review of the eighth impressionist exhibition (printed in *La Vogue*, June 1886; reprinted in translation in Linda Nochlin, *Impressonism and Post-Impressionism, 1874-1904, Sources and Documents* [Englewood Cliffs, N. J.: Prentice-Hall, Inc., 1966], p. 109).

29. August Endell is known to have heard Lipps lecture; Marianne von Werefkin also recalled that Lipps was highly regarded by her circle of friends (see Chapter IV, n. 57, and n. 73). In a lecture at the 1976 College Art Association meeting, Marianne L. Teuber emphasized the influence of Lipps

on a number of artists who evolved toward abstraction, including Kandinsky and Paul Klee (Teuber, "Visual Science and Bauhaus Teaching," College Art Association, Chicago, February 1976). Teuber's previous lecture should also be noted, "Paul Klee: Abstract Art and Visual Perception," CAA, New York, 1973; and *Paul Klee Paintings and Watercolors from the Bauhaus Years 1921-1931*, with introduction by Marianne L. Teuber (Des Moines Art Center, 1973).

30. Walter Crane, *Line and Form* (London: George Bell and Sons, 1904, first published 1900), p. 35 (italics in original). Crane's book appeared in German translation as *Linie und Form* (Leipzig: Hermann Seemann Nachfolger, 1901).

31. From Maurice Denis, "A Definition of Neo-Traditionism," translated and quoted in Linda Nochlin, *Impressionism and Post-Impressionism*, p. 187. (It was first published in *Art et critique*, August 1890.) Whistler's definition came out in the famous 1878 libel trial against Ruskin (for his attack on Whistler's painting *"Nocturne in Black and Gold: The Falling Rocket"*).

32. Walter Gropius, Bauhaus manifesto, quoted in *50 jahre bauhaus* [*sic*] (Stuttgart: Kunstgebäude am Schlossplatz, 1968), p. 13. Feininger's design for the cover of the manifesto represented the ideal *Gesamtkunstwerk*, the medieval cathedral, also idealized nearly a century earlier by Pugin, whose work was to become a source of inspiration for the arts and crafts movement.

33. Quite recently, however, new attempts to analyze this complex relationship have appeared. See Weiss, "Kandinsky and the 'Jugendstil' Arts and Crafts Movement" (*The Burlington Magazine*, cxvii, 866, May 1975, pp. 270-79); Klaus Hoffmann, *Neue Ornamentik, Die ornamentale Kunst im 20. Jahr-*

hundert (Cologne: M. DuMont Schauberg). Also recently a spate of articles on Matisse and decoration has appeared: John Hallmark Neff, "Matisse and Decoration—The Shchukin Panels" (*Art in America*, July-August 1975, pp. 39-48), and "Matisse and Decoration: an Introduction (*arts magazine*, May and June 1975); Amy Goldin, "Matisse and Decoration—The Late Cut-Outs" (*Art in America*, July-August 1975, pp. 49-59). Matisse's connection to Art Nouveau was explored earlier by Frank Anderson Trapp, "Matisse and the Spirit of Art Nouveau" (*Yale Literary Magazine*, 123, pp. 28-34).

34. F. Schmalenbach, *Jugendstil, Ein Beitrag zu Theorie und Geschichte der Flächenkunst* (Würzburg: Verlag Konrad Triltsch [Ph.D. dissertation], 1935), pp. 32, 154.

35. Despite the fact, as noted previously, that Peter Selz (in *German Expressionist Painting*) had devoted a chapter to Jugendstil as a source for expressionist art. Only a brief hint of the idea is to be found, for example, in S. Tschudi Madsen's important book, *Art Nouveau* (London: Weidenfeld and Nicolson, 1967), p. 238. In Helmut Seling's excellent anthology, *Jugendstil, der Weg ins 20. Jahrhundert* (Heidelberg/Munich: Keysersche Verlagsbuchhandlung, 1959), Kandinsky is mentioned in the essay on book decoration (pp. 246-47), and in the chapter on manifestoes, where it was suggested that Kandinsky may have been influenced by the writings of Endell (p. 423). Hans Hofstätter, in *Geschichte der europäischen Jugendstilmalerei* (Cologne: DuMont Schauberg, 1965, 2nd ed.), made no attempt to relate the artist's development to Munich's Jugendstil (pp. 240-41).

36. See note 24, above.

37. Kandinsky, "Rückblicke," p. xv.

38. *Ibid.*

CHAPTER I

1. Kandinsky, who had completed studies in law and economics at the University of Moscow and passed his law examinations in 1892, declined the offer of an appointment at the University of Dorpat in Estonia in 1896. (In his review of Paul Overy's *Kandinsky, the Language of the Eye*, Peter Vergo stated that the offer concerned a lectureship [*Burlington Magazine*, cxii (October 1970), p. 711].) Kandinsky had always been drawn to art and in 1895 was employed in an art printing firm in Moscow. However, his decision to break with traditional expectations at this point and to devote himself entirely to art

may well have been triggered by the political situation in Dorpat. The university at Dorpat had been forcibly "russified" in 1893, but liberal sentiments were with the Estonian nationalists. His own liberal political tendencies (documented in "Rückblicke," p. vii) would have ordained against acceptance of such a position.

2. By 1902, Arthur Roessler reported that Ažbè's school was the "most famous" and "largest" private academy in Munich. He also reported that personages of the highest social standing were among Ažbè's students, as for example, Prince Friedrich

Karl of Hesse (brother-in-law of the German emperor), Prince Ernst of Sachsen-Meiningen, a Baron Scerbatov, a Baroness Wrede, a Baron Kudasev, and one Graf Firmian. See "Meister Anton Ažbè, ein Lehrer der Schönheit," in *Anton Ažbè in Njegova Sola* (Ljubljana: Narodna Galerija), 1962, pp. 81-84. This publication is the catalog of the retrospective exhibition, "Anton Ažbè and his School," held in the city of Ljubljana (Laibach), Yugoslavia, at the National Gallery in 1962. Hereafter this catalog will be referred to as *Ažbè* catalog. Translations from the Slovenian were provided for me by Metod M. Milac, Assistant Director for Collections, Bird Library, Syracuse University. [*Note*: Since 1979, spelling revised to Ažbe.]

3. Igor Grabar, *Moya zhizn* (*My Life*) (Moscow-Leningrad) 1937, chap. vi, pp. 119-46. M. Dobuzhinsky, "Iz vospominanii" ("From my Memoirs") in *Novyi zhurnal* (*New Journal*), no. 52 (New York 1958), 109-39. Subsequent references are to the English synopses of these passages provided for me by Dr. John E. Bowlt, professor of Slavic languages, literature, and art at the University of Texas.

4. Eichner gives this as the Friedrichsstrasse. But Arens says the Russians (Kandinsky, Jawlensky, Werefkin) lived first in the Giselastrasse and then in the Georgenstrasse (*Unsterbliches München*, p. 309). Any of these addresses would have been within a few blocks of the studio.

5. Dobuzhinsky, "From my Memoirs" (Bowlt synopsis).

6. *Kunstchronik und Kunstmarkt*, xv, 31 (18 August 1905), p. 505. Similar sentiments were expressed in the obituary in *KfA*, 15 September 1905, p. 581.

7. Kandinsky, "Rückblicke," p. xx. The same phrase, "Nur recht fleissig arbeiten," slightly altered, was also reported by Karel Dobida. According to Dobida, Ažbè was known for the slogan "Nur fest!" (Just hard at it!) ("Biographie Sommaire," in *Ažbè* catalog, p. 136).

8. His death also passed into the bohemian mythology of Schwabing, acquiring in passage, as is the way with myths, various alterations. Leonhard Frank wrote in his autobiographical novel, *Links wo das Herz ist* (Munich: Nymphenburger Verlagshandlung, 1952), p. 28, "Years later, on a cold December night, he [Ažbè] fell in the snow on the way home, intoxicated with cognac, and died. He was not found until the next morning. Frozen. His origins remained unknown. The artists of Munich followed the coffin." Ažbè actually died on 5 August 1905. Death by debauchery has been a favorite in the history of art, e.g., the seventeenth-century Flemish painter Adriaen Brouwer, whose biographer cites several legendary accounts of

a dissolute end. See Gerard Knuttel, *Adriaen Brouwer, The Master and His Work* (The Hague: L. U. C. Boucher, 1962).

9. Kandinsky, Rückblicke," p. xx. Apparently Ažbè's example was an inspiration to Kandinsky. Lyonel and Julia Feininger reported that Kandinsky, during his career at the Bauhaus, gave "material help to those in need, quite secretively. . ." ("Wassily Kandinsky," *Magazine of Art*, xxxviii, 5 [May 1945], 174).

10. Frank described him dressed in a fur-lined coat so long that he had to hold it up to traverse the stairs, and a fur cap a quarter of a meter high (*Links wo das Herz*, pp. 26f).

11. Reproduced in *Ažbè* catalog, pp. 30, 45, 124, respectively.

12. As to his size, Frank related that the "Korrektur" invariably began with the lowering of the easel by forty centimeters to Ažbè's eye level, that he was the size of a ten-year-old (*Links wo das Herz*, p. 27).

13. Reported by Frank, Dobida, Grabar, and others.

14. Dobida, *Ažbè* catalog, p. 136.

15. Marianne Werefkin, *Briefe an einen Unbekannten, 1901-1905*, ed. Clemens Weiler (Cologne: Verlag M. DuMont, 1960), p. 38. Beta Vukanovic also recalled that Ažbè was very proud of this medal (*Ažbè* catalog, p. 125f). The original text of the letter recommending Ažbè for the "Ritterkreuz des Franz-Joseph Ordens" mentions particularly the fact that he had taught many young artists entirely without recompense and even supported them himself. The letter, in the archive of the National Gallery in Ljubljana, is dated 6 December 1903. The award was actually conferred on 20 December 1903. According to Vukanovic, Ažbè was awarded another medal by the Serbian government during his lifetime for his services as a teacher.

16. Ulf Seidl, "Feine Brüder," *Wiener Tagblatt* (Vienna) 4 October 1930. A manuscript copy of this article is in the archive of the National Gallery, Ljubljana.

17. I am indebted to Dr. Ksenija Rozman, assistant director of the National Gallery in Ljubljana, who opened the entire Ažbè archive of the National Gallery to my inspection during a research trip to Ljubljana in June 1972. Thanks to her enthusiastic cooperation, I was able to examine all of the Ažbè paintings and drawings known to the museum, as well as works by several of Ažbè's Yugoslavian students. To my knowledge, this is the most extensive collection of Ažbè material in existence. Dr. Rozman also made available to me the valuable biographical material collected by the late Dr. Karel Dobida, former director of the museum. The biographical material presented

here is based upon this source and upon Dobida's "Biographie Sommaire," *Ažbè* catalog, p. 136.

18. Under Gabriel Hackl, W. Müller, L. Löfftz, and A. Wagner (*ibid*).

19. Rihard Jakopic (1869-1943) and Ferdo Vesel (1861-1946). Jakopic worked with Ažbè for several years and later achieved considerable fame in his own country. He is today considered one of Yugoslavia's major modern artists. See *Rihard Jakopic, Retrospektivna Razstava, Moderna Galerija, 23 Maja-5 Julija 1970* (exhibition catalog of the Modern Gallery, Ljubljana, May-July 1970, introduction by Zoran Kržišnik [with French translation]).

20. Less than a dozen oils and fewer drawings could be assembled for the retrospective exhibition in 1962. Seven oils were made available for my inspection at the National Gallery, as well as six drawings, including one only recently discovered. Dobida suggested that a "serious illness" may also have prevented him from working on his own paintings in later years (*Ažbè* catalog, p. 136).

21. These points are stressed particularly by France Stelè, "Anton Ažbè—Ucitelj," *Ažbè* catalog, pp. 5-18; and also in his essay, "Anton Ažbè comme Pedagogue," *Ažbè* catalog, pp. 133-35.

22. Dobida, *Ažbè* catalog, p. 136.

23. *KfA*, 15 July 1898, p. 131 (304 students reported enrolled in the Academy); 1 July 1899, p. 317 (304 students); 15 January 1900, p. 188 (winter semester, 382 students).

24. Stelè points out that Ažbè himself was never able to make the leap into a new style. Furthermore, none of his Yugoslavian students seemed able to transfer his ideas to their own work, few progressing beyond a modified impressionism, even though Ažbè constantly promulgated the most modern tendencies of contemporary painting in his teaching (*Ažbè* catalog, pp. 133, 135).

25. *Ibid.*, pp. 10, 134.

26. *Ibid.*, p. 133.

27. Kandinsky, "Rückblicke," pp. I-XXIV, passim.

28. Kandinsky, *Über das Geistige in der Kunst* (Bern: Benteli-Verlag, 8th ed., 1965 [originally published by R. Piper, Munich, 1912]), pp. 66-112. (Kandinsky, *UGK*. See also Appendix A).

29. Grabar, *My Life* (Bowlt synopsis).

30. Stelè, *Ažbè* catalog, p. 134.

31. Due to the paucity of primary source information on Ažbè.

32. J. Carson Webster, "The Technique of Impressionism: A Reappraisal," *College Art Journal* (November 1944), p. 14.

33. *Ibid.*, pp. 20-21. Webster uses the terms "flickering or shimmering effect," "active luminosity," and "vibrating quality."

34. Furthermore, Signac's influential article explaining neo-impressionist theory was not to appear in Germany until 1898, when extracts from it were published in *Pan* at approximately the same time as its publication serially in *Revue blanche* as "D'Eugène Delacroix au neoimpressionisme" (1 and 15 May, and 1 July 1898). The version in *Pan*, IV, 1 (1898), pp. 55-62 was called "Französische Kunst. Neoimpressionismus."

35. Stelè, *Ažbè* catalog, p. 134.

36. Kandinsky, "Rückblicke," p. IX.

37. *Ibid.*, pp. XX-XXI.

38. *Ibid.*, p. XXII.

39. Stelè, *Ažbè* catalog, p. 134.

40. *Ibid.* Ažbè's de-emphasis of compositional rules has also been noted by the Russian Ažbè scholars, Moleva and Beljutin. According to their commentary, Ažbè utterly rejected composition as it was taught in the Munich Academy, freeing his students of all conventional rules. However, they criticize him for not substituting other guidelines, without apparently appreciating the influence this freedom was to have on Kandinsky's development. (In fact, Kandinsky is only fleetingly mentioned in their book.) See Nina M. Moleva and Elij M. Beljutin, "Metoda Antona Azbeta," *Ažbè* catalog, p. 55. This article is excerpted from their book: N. M. Moleva and M. Beljutin, *Skola Antona Ažbè* (Moscow: Gosvdarstvennoe izdatel'stvo "Iskusstvo," 1958).

41. Kandinsky recalled that he felt that the students in Ažbè's atelier were so wrapped up in representation according to specific methods and the *"Prinzip der Kugel,"* that they thought *"keinen Augenblick an die Kunst* (not a moment about art)" ("Rückblicke," p. XX).

42. Stelè, *Ažbè* catalog, p. 15.

43. *Ibid.*

44. Dobuzhinsky, "Memoirs" (Bowlt synopsis).

45. Kandinsky, "Rückblicke," p. XX.

46. "Nur mit grossen Linien arbeiten." Dobuzhinsky, "Memoirs" (Bowlt synopsis).

47. Grabar, *My Life* (Bowlt synopsis).

48. Kandinsky, "Rückblicke," pp. XX-XXI. Grabar's memoir of Kandinsky at Ažbè's corresponds rather closely with the account in "Rückblicke": "He was different from us other Russians. He was reserved, independent. He painted small land-

scapes not with a paintbrush, but with a palette knife; he put colors on separately on separate planes; he used bright colors. We used to joke about his 'purity of colors.' He was not very successful at Ažbè's school and didn't seem talented. He yielded to the general influence of T. T. Heine and Somov stylization and to the passion for the 1830's. His pictures were not accepted at the *World of Art*. By 1901, Kandinsky was already painting big canvases in fluid oils, intense colors, which were supposed to transmit complicated feelings, sensations and even ideas. They were chaotic canvases and I can't remember them now. They were unpleasant and contrived. Kandinsky's misfortune lay in the fact that all his 'inventions' came from his brain, not from his feeling" (Grabar, *My Life* [Bowlt synopsis]). Grabar's memoirs were not published until 1937, indicating that this note, which is labeled "1899," was undoubtedly reconstructed at a much later date. It should be borne in mind that Grabar by that time was a committed as well as celebrated Soviet "socialist-realist" painter. Furthermore, a reproduction of a Kandinsky painting, *Alte Stadt*, did appear in *World of Art* (*Mir Iskusstva*) in 1904, issue no. 4.

49. Working from the model bothered him because of the degradation and inhumanity he felt at the sight of so many students, of both sexes and from all nations, crowded around those underpaid "phenomena" who "meant nothing to them" and were often not only "foul smelling," but "nonparticipating, expressionless and usually characterless." In short, the situation repelled him, and he turned to landscape painting in escape. Kandinsky, "Rückblicke," p. xx.

50. The collection at the Städtische Galerie includes some 132 paintings by Kandinsky (including temperas and glass paintings) and many other drawings, watercolors, woodcuts, etchings, wood carvings, etc., as well as Kandinsky's sketchbooks, notebooks, and other memorabilia. The collection was left to the city of Munich in a bequest by Kandinsky's late friend and colleague Gabriele Münter (1877-1962) in 1957. Thanks to the gracious cooperation of Dr. Michael Petzet, former director of the Städtische Galerie, I was able to examine in detail thirty Kandinsky notebooks and sketchbooks, dating from ca. 1898 to ca. 1914, as well as numerous single drawings, sketches, watercolors, prints, and other memorabilia. These are classified by the museum with the code GMS (Gabriele Münter Stiftung) plus a number, and will hereafter be cited in this way, e.g., GMS 344.

51. Kandinsky, "Rückblicke," p. xxi.

52. Kandinsky, "Betrachtungen über die abstrakte Kunst," *Essays über Kunst und Künstler* (Bern: Benteli-Verlag, 1963; 2nd ed.), p. 150 (essay originally published in *Cahiers d'Art*, no. 1 [1931]). Hereafter, this anthology of essays will be cited as *EuKuK* (see also Appendix A).

53. GMS 344, p. 3. This sketchbook, the largest in format, appears to have been in use over a number of years since it also contains much later sketches, as well as anatomical studies on several of the opening pages. Other sketchbooks containing anatomical studies include, for example, GMS 346, p. 1 (a schematic drawing of the eye), and GMS 348, p. 19 (a careful anatomical drawing of the shoulder and upper arm in colored inks). There are also nude studies on loose pages (GMS 438, 440, 439).

54. In fact, the head of the old woman corresponds rather closely to an anonymous painting attributed to the Ažbè school in the *Ažbè* catalog, no. 43.

55. Grabar, *My Life* (Bowlt synopsis).

56. Carl Palme, *Konstens Karyatider* (Halmsted: Raben and Sjögren, 1950), pp. 44-45. Kandinsky's private correspondence abounds in enthusiastic accounts of ambitious bicycle tours, even into the Alps.

57. Grabar, *My Life* (Bowlt synopsis).

58. The drawing measures 138 cm. x 154 cm., signed "Ažbè '86."

59. Unfortunately, the painting has been damaged on the lower left side of the subject's face and poorly restored.

60. Stelè, *Ažbè* catalog, p. 134. Dobuzhinsky recalled that Ažbè's portraits were "striking in their light and color effects— I remember the portrait of one lady as illuminated in red on one side, while on the other side was a green lamp" ("Memoirs," Bowlt synopsis).

61. For example, in his book *Punkt und Linie zu Fläche* (Bern: Benteli-Verlag, 1964; 5th ed.), hereafter cited as *PLF* (see also Appendix A). This work is entirely devoted to an analysis of the formal elements of painting.

62. Other Ažbè students also worked extensively with the palette knife and broad brush as can be observed in many works of Jakopic, Matej Sternen, and Matija Jama in the collection of the National Gallery, Ljubljana.

63. Several sources attest to Ažbè's insistence on individual development among his students, e.g., Stelè, *Ažbè* catalog, pp. 10-14; and Moleva, *Ažbè* catalog, p. 51.

164

CHAPTER II

1. The enormous size of such exhibitions is difficult to imagine today: several thousand pictures were displayed, one hung over the other in rows to high above eye level within the vast halls of the Munich Glaspalast. The fad had been instigated in the 1870s and '80s when two out of a series of eight impressionist exhibitions were combined with large international exhibitions—with phenomenal success. It was then decided to capitalize on the popularity of such exhibits by combining the annual Munich Artists' Society shows with an international exhibition every year. The sheer size and repetitiousness of the exhibitions soon resulted in a drastic decline in overall artistic quality, especially since these shows represented mainly the work of the old guard Munich artists, and less and less any proportionate selection of foreign artistic achievement. A good synopsis of the Secession movements is given in the introduction to the catalog *Secession: Europäische Kunst um die Jahrhundertwende, Haus der Kunst, München, 14. März bis 10 Mai 1964.* A sharp-witted contemporary report on the background of the Munich Secession is Benno Becker's article "Secession," *Pan*, II (1896), pp. 243-47.

2. Excerpts from the memorandum of the Secession, 4 April 1892, are quoted in the Secession catalog cited above, p. 7.

3. Hugo von Hofmannsthal, "Ausstellung der Münchener 'Sezession' und der 'Freien Vereinigung Düsseldorfer Künstler,'" in the *Neue Revue*, 1894, reprinted in *Prosa I, Gesammelte Werke* (Frankfurt am Main: S. Fischer Verlag, 1950), p. 247. See also Ludwig Hevesi, *Acht Jahre Secession* (*März 1897-Juni 1905*) *Kritik—Polemik—Chronik* (Vienna: C. Konegen, 1906), pp. 523ff.

4. *Secession: Europäische Kunst,* pp. 6-17.

5. Ludwig Hevesi, *Acht Jahre Secession* (passage quoted in *Secession: Europäische Kunst,* p. 16) "Das junge Ausland jubelt ihnen seinen Gruss zu. Neu-München, Neu-Berlin stehen wie ein Mann zu Neu-Wien."

6. The Russians included Levitan, Perepletschikov, Serov, and Vasnetsov, according to the *Offizieller Katalog der Internationalen Kunstausstellung des Vereins bildender Künstler Münchens, 'Secession'—1896,* 3rd ed., 1 August 1896. Interestingly enough, Kandinsky later recalled having seen at least one important Russian exhibition around the turn of the century in Munich. The recollection is documented in a letter by Kandinsky of 24.1.1937 to the German art historian Hans Hildebrandt: "Allerdings habe ich vor dem Krieg (etwa um 1900)

einen grossen russ. Saal (oder 2?) im Münchner Glaspalast . . . gesehen. . . ." See H. Hildebrandt, "Drei Briefe von Kandinsky," in *Werk*, XLII (10 October 1955), p. 328.

7. Paul Schultze-Naumburg, "Die Internationale Ausstellung 1896 der Secession in München," in *KfA*, 1 July 1896, p. 293. Schultze-Naumburg (1869–1949), architect and critic, was at that time a persuasive propagandist for the Secession movement and for Munich's real avant-garde of the 1890s—its Jugendstil. Although a prophet of a new art that he himself predicted would be misunderstood, he eventually found himself among the reactionaries, and confused by events he himself had helped to precipitate. His gross indiscretions as a Nazi propagandist have all but obscured his earlier more positive contributions. (See Franz Roh, *"Entartete" Kunst* [Hannover: Fackelträger Verlag, 1962], pp. 68-70.) Yet at the turn of the century, he was one of the more eloquent spokesmen of the then avant-garde arts and crafts movement (which is the concern of the next chapter), and even exhibited in the second exhibition of Kandinsky's Phalanx society. (*Katalog der II. Ausstellung der Münchener Künstler-Vereinigung Phalanx,* January–March 1902, no. 130, Lesetisch [reading table]. The Phalanx exhibitions are discussed in Chapter VI. I am indebted to Erika Hanfstaengl of the Städtische Galerie, Munich, for sending me photo copies of the Phalanx catalogs in the collection of the Gallery.)

8. Schultze-Naumburg, "Die Internationale Ausstellung 1896 . . ." (pt. II), in *KfA*, 15 July 1896, p. 305.

9. See Appendix A, which includes a special note on the translation of *das Geistige.*

10. Kandinsky gave the title *Lyrisches* (Lyrical) to a painting of 1911 and to an important color woodcut which was included in the 1913 album of poems and woodcuts, *Klänge.*

11. *UGK*, p. 110. By "primitive" color combinations, Kandinsky was referring to the combination of red and blue as seen in Italian primitive and German medieval painting, and sometimes in folk art.

12. The "Glasgow School" included Harrington Mann, Francis Newbery, James Patterson, and Thomas Millie Dow, among others.

13. See Chapter IV.

14. Karl Voll (1867-1917) is mentioned as one of the early literary backers of the Secession in *Secession: Europäische Kunst,* p. 8. An art historian, Voll later published scholarly works on Hans Memling and Jan van Eyck. The painter Hans

Purrmann recalled that although Voll often bitterly attacked contemporary art, especially in Munich, he had a soft spot for struggling young artists, and was instrumental in gaining Purrmann's acceptance at the Berlin Secession. See, "Erinnerungen an meine Studienzeit," *Werk*, xxxiv, 11 (November 1947), pp. 370-71.

15. Karl Voll, "Die V. Internationale Kunstausstellung der 'Münchner Secession,'" in *KfA*, 15 June 1898, p. 273. (The apparent confusion over the numbering of these exhibitions results from the fact that the exhibitions held at the Glaspalast in conjunction with the Artists' Society were numbered differently from the Secession exhibitions that were held independently.)

16. Karl Voll, "Die V. Internationale Kunstaustellung der 'Münchener Secession,'" pt. ii, *KfA*, 1 July 1898, pp. 289-90: "Es handelt sich nicht mehr um Naturtreue, sondern vor allem um den Reiz einer höchst persönlichen 'künstlerischen Handschrift.' Der zur Darstellung gewählte Gegenstand als solcher

gilt nicht mehr, nur das, was des Künstlers Laune (jedoch nicht vertiefende Erkenntnis) daraus gemacht hat. Ich leugne Leistikows Gestaltungskraft nicht, aber ich halte diese Richtung doch für sehr bedenklich."

17. Karl Voll, "Die Frühjahr-Ausstellung der Münchener Secession," *KfA*, 15 April 1900, p. 352.

18. Kandinsky, *UGK*, p. 110: "Die Abwendung vom Gegenständlichen und einer der ersten Schritte in das *Reich des Abstrakten* war in zeichnerisch-malerischer Beziehung das *Ausschliessen der dritten Dimension, d.h. das Streben, das 'Bild' als Malerei auf einer Fläche zu behalten.*" In German criticism the term "*Stilkunst*," meaning "style-art" and referring to the highly stylized mode of the period, is sometimes substituted for such terms as Art Nouveau and Jugendstil. *Flächenkunst* is another term commonly used in the literature to refer to that art characterized by the typical flatness or planarity of Art Nouveau, Jugendstil and *Stilkunst*.

CHAPTER III

1. On the new movement as a second "Secession," see Paul Schultze-Naumburg, "Der 'Secessionsstil,'" in *Kunstwart*, 1 January 1902, p. 326. On Munich as the center of the movement, see Schmalenbach, *Jugendstil*, p. 79.

2. On the "modern style," see von Poellnitz, "Betrachtungen über den 'modernen' Stil," in *DKuD*, ii (April-September 1898), p. 300. On the "decorative movement," see *DK*, iii (1899-1900), p. 87, where the author, "C.," of a book review, comments: ". . . today, when we are standing in the midst of the decorative movement."

3. Fritz Schmalenbach, in his dissertation, *Jugendstil*, which has become the standard work on the movement, included a chapter on "'Jugendstil,' Name und Begriff," (pp. 12-22), in which he analyzed the derivation of the term in detail, especially its association (at least popularly) with the periodical *Jugend*. See also Linda Koreska-Hartmann, *Jugendstil—Stil der 'Jugend'* (Munich: Deutscher Taschenbuch Verlag, 1969).

4. Compare Hermann Obrist, "Hat das Publikum ein Interesse das Kunstgewerbe zu heben?" in *Neue Möglichkeiten in der Bildenden Kunst—Aufsätze von 1896-1900* (Leipzig: Diederichs, 1903), pp. 50, 54. See also H. E. von Berlepsch, "Endlich ein Umschwung," in *DKuD*, i (October 1897), especially p. 6.

5. Schmalenbach was among the first to suggest the significance of Jugendstil studies in the understanding of Kandinsky's development and writing (*Jugendstil*, pp. 32, 154).

6. August Endell, *Um die Schönheit, eine Paraphrase über die Münchner Kunstausstellungen—1896* (Munich: Verlag Emil Franke, 1896), p. 13.

7. See the excellent dissertation by Henry Hope on the "Sources of Art Nouveau" (Cambridge: Harvard University, unpublished Ph.D. dissertation, 1942), which convincingly traces the movement from England via Belgium to France and the rest of Europe (stopping short of Germany). Hope successfully based much of his research on the periodical literature and exhibition catalogs of the period. The best source for detailed information on Art Nouveau in Germany is still the dissertation by Fritz Schmalenbach already cited. Schmalenbach traced the explosive development of the movement from Munich to other German cities, with detailed information on very nearly all of the artists involved and analyses of the formal qualities of their work. Friedrich Ahlers-Hestermann's slim volume, *Stilwende, Aufbruch der Jugend um 1900* (Berlin: Verlag Gebr. Mann, 1941), remains a classic personal memoir of Jugendstil. Very useful is the catalog previously cited, *Aufbruch zur modernen Kunst, München, 1869-1958*, edited by Siegfried

Wichmann. A helpful though subjective guide to the literature on Jugendstil is Jost Hermand's *Jugendstil-Ein Forschungsbericht, 1918-1964* (Stuttgart: J. B. Metzlersche Verlagsbuchhandlung, 1965). Perhaps the most useful volume on Jugendstil to date is the anthology previously cited, *Jugendstil, der Weg ins 20. Jahrhundert*, edited by Helmut Seling, which includes essays by experts on various aspects of Jugendstil art (such as painting, furniture, glass, typography, etc.). In the same year appeared the excellent scholarly catalog edited by Peter Selz and Mildred Constantine, *Art Nouveau: Art and Design at the Turn of the Century* (New York: The Museum of Modern Art, 1959), which also analyzed Art Nouveau tendencies in various media, but which included only brief sections on Jugendstil. Hans Hofstätter's *Jugendstilmalerei, Geschichte der europaischen Jugendstilmalerei* (Cologne: Verlag M. DuMont Schauberg, 1963) includes a rather long section on the Germans, but is confined to painting and graphic arts. S. Tschudi Madsen's pioneering work on international Art Nouveau (*Art Nouveau* [London: Weidenfeld and Nicolson, 1967; first published 1957]) touched only briefly on the style's German manifestation. Many works by Jugendstil artists are illustrated in Maurice Rheims, *The Flowering of Art Nouveau* (New York: Harry N. Abrams, Inc., 1966), and in Robert Schmutzler, *Art Nouveau* (New York: Harry N. Abrams, Inc., 1962). Schmutzler's book was one of the first popular works on Art Nouveau to explore its international dimensions, especially its English origins, in some depth, but its all-too-brief section on German Jugendstil contained a number of factual errors.

8. Georg Fuchs (1868-1949), who will concern us later at some length, had come to Munich in 1891 to write for the periodical *Kunstwart*. He was an enthusiastic supporter and publicist of the arts and crafts movement. Already by 1892 he had published an anonymous pamphlet suggesting the creation of an artists' colony with the ultimate goal of achieving a total aesthetic environment ("Was erwarten die Hessen von ihrem Grosshzg. Ernst Ludwig? Von einem ehrlichen, aber nicht blinden Hessen"). (See also Chapter IV [on Obrist and Endell], and especially Chapter IX.)

9. Georg Fuchs, "Hermann Obrist," *Pan*, I, 5 (1896), pp. 318-25. The article was accompanied by an enthusiastic editorial comment by the publisher (and museum director) Wilhelm Bode, pp. 326-28.

10. See the catalog *Hermann Obrist—Wegbereiter der Moderne*, edited by Siegfried Wichmann (Munich: Stuck-Jugendstil Verein, 1968) (no pagination). This catalog gives the date of the exhibit as April 1896, and the number of embroideries as

thirty-five in contrast to Tschudi Madsen, who apparently based his date for this exhibition on erroneous information, giving it as 1894, and the number of embroideries displayed as thirty-nine (in *Art Nouveau* [London: World University Library, 1967], p. 176). The research for the catalog edited by Wichmann, with the assistance of Monika Roth, was based on information in the Obrist Archive which is held by the Staatliche Graphische Sammlung in Munich.

11. *Hermann Obrist, Wegbereiter*, n.p.

12. Obrist, "Hat das Publikum Interesse, das Kunstgewerbe zu heben?" *Neue Möglichkeiten*, p. 54.

13. H. E. von Berlepsch, "Walter Crane," *KfA*, 1 April 1896, pp. 193-98. St. George was to become an important symbol for Kandinsky with much of the same significance. This is discussed more fully in Appendix B. On the crucial role of von Berlepsch in the Munich movement, see Schmalenbach, *Jugendstil*, p. 80, *passim*.

14. *KfA*, 15 June 1896, p. 287. *Die Forderungen der dekorativen Kunst* (Berlin: G. Siemens).

15. H. E. von Berlepsch, "Frühjahr-Ausstellung der Münchner Secession," *KfA*, 1 May 1896, pp. 235ff.

16. Von Berlepsch's suggested comparison indeed came to pass the following December, when another Secession exhibition of posters did include Munich illustrators side by side with internationally known poster artists. Stuck's Secession poster was among the exhibits. The art dealer, Littauer, helped arrange the show, which was characterized by its *Farbenlärm*, according to one reviewer (*KfA*, 15 December, 1896, p. 94). Littauer, who had been the first to show Obrist's work in Munich, was to become one of the first dealers to show the work of Kandinsky (as early as 1904).

17. In fact, Stuck's poster was to provide inspiration to many artists of the new movement, including Kandinsky, as will be seen.

18. *KfA*, January 1897, p. 171 (italics mine).

19. Both Obrist and Behrens were among the first to recognize and encourage Kandinsky, with whom they were soon in personal contact, as will be seen. Behrens was later the teacher of Walter Gropius, Mies van der Rohe, and Le Corbusier. On Obrist, see Chapter IV.

20. For an interesting contemporary discussion of this significant breakthrough, see von Berlepsch, "Endlich ein Umschwung," especially, pp. 3-4.

21. Paul Schultze-Naumburg, "Die Kleinkunst," *KfA*, 1 September 1897, p. 378 (italics mine).

22. *DK*, I, 1 (October 1897), p. 45.

23. Georg Fuchs, "Hermann Obrist," *Pan*, p. 325.

24. The idea of the stained glass window as a valid medium for secular artistic expression was then a novelty. Its luminous coloristic qualities, combined with the possibility of its use in the *Gesamtkunstwerk* of contemporary architecture, fascinated many Jugendstil artists, who soon began to exploit its "abstract" potential. Compare "Farbige Glasfenster," *DK*, I, 4 (January 1898), pp. 160ff.

25. Information compiled from the official catalog and from *DK*, I, 1 (October 1897), pp. 43ff; *KfA*, September 1897, pp. 378ff; and *DKuD*, I (October 1897), pp. 1ff. Many other artists participated (e.g., T. T. Heine, von Heider, Schmuz-Baudiss, Dülfer, Fischer, etc.).

26. Schultze-Naumburg, "Die Kleinkunst," p. 379.

27. Samuel Bing, "Wohin treiben Wir?" *DK*, I, 1 (October 1897), p. 1.

28. "FORMKUNST: Es giebt eine Kunst, von der noch niemand zu wissen scheint: Formkunst, die der Menschen Seelen aufwühlt allein durch Formen, die nichts Bekannten gleichen, die nichts darstellen und nichts symbolisieren, die durch frei gefundene Formen wirkt, wie die Musik durch freie Töne. Aber die Menschen wollen noch nichts davon wissen, sie können nicht geniessen, was ihr Verstand nicht begreift, und so erfanden sie Programmusik, die etwas bedeutet, und Programmdekoration, die an etwas erinnert, um ihre Existenzberechtigung zu erweisen. Und doch kommt die Zeit, da in Parken und auf öffentlichen Plätzen sich Denkmale erheben werden, die weder Menschen noch Tiere darstellen, Phantasieformen, die der Menschen Herz zu rauschender Begeisterung und ungeahntem Entzücken fortreissen werden. A. E." (August Endell, *DK*, I, 6 [March 1898], p. 280).

29. August Endell "Formenschönheit und Dekorative Kunst," *DK*, I, 2 (November 1897), pp. 75-76. On the relationship between the theories of Endell and Kandinsky, see Chapter IV. The development of a theoretical foundation for the concept of an art without objects in the art criticism of the era is discussed in some detail in Chapter X.

30. *DK*, I, 2 (November 1897), pp. 92-93. In fact, the stylized masklike face illustrated in the article is very like Gauguin's work in the same medium, which Lacombe (1868-1916), an associate of the Nabis, probably knew at first hand.

31. "Von dem zornigen Schwane allein die rhythmische Linie zu entlehnen und nicht den Schwan, das ist das Problem für die ornamentale Verwendung" (*ibid.*, pp. 94-95). An interest in the psychology of perception was to be a determining influence in the development of ideas concerning the possibility of an art without objects. This emphasis on the psychology of line, color, and form, abstracted from representation, had a direct influence on Kandinsky's thought, as will be seen. (See especially Chapter IV and Chapter X.)

32. *Ibid.*

33. *DK*, I, 8 (May 1898), p. 70 (italics mine). This observation is especially interesting because Behrens was soon to become a friend of Kandinsky (see Chapter VI, Phalanx II), but particularly in view of Kandinsky's later exploitation of the woodcut medium as a "bridge" to abstraction (see Chapter XII).

34. See the dispersal table of Munich artists, in *DKuD*, IX (1901-02), pp. 247-50.

35. This suggests that indeed Kandinsky probably did know the work of Van de Velde by the time he worked out his designs for *Klänge* (cf. Peter Selz, *German Expressionist Painting*, p. 55). In fact, the vignettes by Van de Velde to which Selz referred (for *Van Nu en Straks*) were reproduced in *DK*, II, 7 (April 1899), p. 1. His rooms for Bing's Art Nouveau shop had already been shown in Dresden in 1897 (where they had caused a sensation) and been thoroughly reviewed in the pages of *DK*, I, 5 (February 1898), pp. 199ff.

36. Tiffany's glass met every time with unbridled enthusiasm. Critics were enchanted by the "fabulous virtuosity" with which the material was handled. "An unexampled facility in calling forth both the intentional and the accidental, a spirited exploitation of chemical and physical laws . . . it is as if opals had been melted and formed into objects by the glassblower's pipe," exulted one reviewer over Tiffany's work at the 1898 Secession (Heinrich Rottenburg, "Das Kunsthandwerk auf den Münchener Ausstellungen 1898," in *Kunst unserer Zeit*, IX, pt. II [1898], pp. 89-98). The same critic praised Obrist for raising embroidery to the level of "pure art."

37. See the official Secession catalog of 1899, also the review by Georg Fuchs, "Angewandte Kunst in der Secession zu München 1899," *DKuD*, V (October 1899), pp. 1-23. (One of the more unusual exhibits must have been the twelve items from Paraguay, apparently mostly lace or linen fabrics.)

38. Literally, *Inspiration* (*Applied Art*), or "art handcraft." Except for its theme, the painting had little to redeem it, representing rather awkwardly a craftsman with a lamp (lighting the way to the future, one might say), "inspired" by a muse brandishing lilies and a snake. It was illustrated in the Secession catalog. It may be noted that Kandinsky was aware of Sauter's work, and mentioned him in a review he wrote for *Mir Iskusstva* in 1902 (see Chapter VII).

CHAPTER IV

1. Hermann Obrist in *Münchener Neueste Nachrichten*, no. 213, 7 May 1901, quoted in the *Aufbruch* catalog, pp. 303-04.

2. The actual relationship between Kandinsky and Obrist is more fully explored in Chapter XI. The present chapter reviews Obrist's achievements and his crucial position within the development of Munich Jugendstil.

3. Not to mention such well-known and successful craftsmen as Bernhard Pankok, Bruno Paul, and Otto Eckmann, all of whom started out in Munich.

4. See Bernard S. Myers, *The German Expressionists, A Generation in Revolt* (New York: Praeger, 1966), pp. 99f; also Donald E. Gordon, *Ernst Ludwig Kirchner* (Munich: Prestel Verlag, 1968), p. 15. Compare also Frank Whitford, *Expressionism* (London: Hamlyn, 1970), p. 39.

5. *Herman Obrist, Wegbereiter*, pt. 1, n.p.

6. Scheffler, "Hermann Obrist," *KuK*, August 1910, pp. 555-59.

7. *Ibid.*, p. 558.

8. *Ibid.*

9. *50 jahre bauhaus, 5. mai-28 juli 1968* [*sic*] (exhibition catalog), Stuttgart, p. 26.

10. Biographical information on Obrist is scanty. See *Obrist, Wegbereiter* for a biographical chronology; also G. Fuchs, "Hermann Obrist," *DK*, III, 5 (February 1900), pp. 196-98; the article in *Pan* previously cited (Fuchs, "Hermann Obrist," *Pan*, pp. 321-25); and Silvie Lampe-von Bennigsen, *Hermann Obrist, Erinnerungen* (Munich: Verlag Herbert Post Presse, 1970 [a 36-page pamphlet]). Obrist was born near Zurich in 1862, son of a Swiss doctor and an aristocratic mother of Scotch-Celtic ancestry. His childhood was spent mostly under the tutelage of his gifted mother. His later deafness was the result of a middle-ear infection at the age of twenty, and has been associated with his drive to communicate abstract ideas in artistic form (see Karl Scheffler, *Die fetten und die mageren Jahre* [Munich/Leipzig: Paul List Verlag, 1948], p. 22). According to *Obrist, Wegbereiter*, he was also susceptible to "visions" which affected his artistic development.

11. *Obrist, Wegbereiter*, n.p.

12. *Ibid.*

13. *Ibid.* His mother had disinherited him, apparently because of his insistence on earning money with his work, but his younger brother shared the estate with him. Photographs of the house and some of its furnishings may be seen in the February 1900 issue of *DK*, accompanying Obrist's article "Wozu über Kunst schreiben?"

14. See Chapter III, pp. 23, 24 and *passim.*

15. Many of these were published in *DK* and other periodicals and newspapers. In 1903, several were published in book form as *Neue Möglichkeiten in der bildenden Kunst—Essays* (Leipzig: E. Diederichs).

16. *Obrist, Wegbereiter*, n.p.

17. Mary Logan, "Hermann Obrist's Embroidered Decorations," *Studio*, IX, 44 (November 1896), pp. 98-105. Also, same issue, p. 148, "Report from Munich."

18. *DK*, I, 10 (July 1898), pp. 138-39.

19. Such uninhibited praise is very rare in criticism generally, but in my survey of *Dekorative Kunst* and *Kunst für Alle*, as well as a more limited survey of *Deutsche Kunst und Dekoration*, I found such warmth of expression only in reference to Obrist.

20. Scheffler, *Die fetten und die mageren Jahre*, p. 23.

21. *Ibid.*, p. 23.

22. Obrist, "Wozu über Kunst schreiben?" *DK*, III, 5 (February 1900), pp. 169-95.

23. *Ibid.*, p. 174.

24. The article outlined a definite program of seminars: three times weekly from October to July, with projection of qualitative comparisons, followed by discussions of specific works, everyone being allowed five minutes speaking time (*ibid.*, p. 185). What he proposed was nothing less than the rule followed today in art schools and art history departments around the world: the projection of slides "and not one after another, but side by side" for the sake of comparison. With a few witty examples, he showed how strikingly the vast gulf between philistine, theatrical works and truly great works of art might be demonstrated, or how a particular motif might require different treatment in different media (*ibid.*, pp. 178ff).

25. Obrist defined art as "intensified life" (*ibid.*, p. 195).

26. *DK*, I, 10 (July 1898), p. 139.

27. Ernst W. Bredt, "Verkünden und Handeln," *DK*, v, 6 (March 1902), p. 222.

28. According to *Obrist, Wegbereiter*, he had created an *ungegenständliche Figur* (a non-objective figure) as early as 1897, which however, was destroyed (see chronology under February 26, 1897).

29. See Hermann Obrist, "Die Zukunft unserer Architektur," *DK*, IV, 9 (June 1901), p. 338.

30. Bredt, "Verkünden und Handeln," p. 220.

31. *Ibid.*

32. *Obrist, Wegbereiter*, notes to no. 60.

33. A manuscript note describing this fountain commented: ". . . irgendwo gesehen—am Berg Rhythmus, der ein lebendig gewordener Brunnen war, Beethoven-Sonaten, Symphonie nur im optischen Raum übersichtlich. Largo. Tod. Das Ganze ein— von Gott geblassener Schwung von Formen" (*ibid.*, n.p.). Obrist's "stream of consciousness" style is nearly untranslatable. The following is an approximation: ". . . somewhere seen—on the mountain, rhythm, that was a fountain come to life, Beethoven Sonatas, Symphony only lucid in optical space. Largo. Death. The whole a God-blown dance of forms."

34. *Ibid.*, no. 59.

35. *Ibid.*, Nachlass Schrift BR4.

36. Obrist, "Die Zukunft," p. 346.

37. Compare Kandinsky, *UGK*, p. 76, where he refers to the artist's *Vorratskammer* of forms, and suggests that to discard the object altogether, to "rob himself of the possibility" of causing a response in the viewer, would be "to diminish the arsenal [*Arsenal*] of his means of expression."

38. These were on view at the Obrist exhibition in the Stuck-Villa, Munich, 1968.

39. As Paul Klee did later.

40. Bredt, "Verkünden und Handeln," p. 224 (italics mine).

41. Probably the "gigantic Something" described by Scheffler in his 1910 article ("Obrist," *KuK*, p. 558). It was illustrated in Obrist's article, "Wozu über Kunst schreiben?" in 1899, and was therefore created before the turn of the century.

42. An interesting comparison is the sculpture created in 1922, over twenty years later, by the Bauhaus student Kurt Schwerdtfeger (Fig. 20). (See *50 jahre bauhaus*, pp. 85-86.) The connection between Obrist's pedagogical ideas and those of Kandinsky and the Bauhaus is discussed in Chapter XI.

43. Fuchs, "Hermann Obrist," p. 320.

44. *Ibid.*, p. 321: "Es erfüllte sich unser Sehnen nach geistiger, reiner, schöpferischer Kunst. . . ."

45. *Ibid.*, p. 323: ". . . zu einem ausdrucksvollen, freien Ornamentmotive umgedacht."

46. "Wie die jähen, gewaltsamen Windungen der Schnur beim knallen eines Peitschenhiebes erscheint uns diese rasende Bewegung. Bald dünkt sie uns ein Abbild der plötzlichen, gewaltsamen Elemente: ein Blitz—bald der trotzige Namenszug eines grossen Mannes, eines Eroberers, eines Geistes, der durch neue Urkunden, neue Gesetze gebietet" (*ibid.*, p. 324).

47. Kandinsky, *UGK*, p. 132: "In a secretive, puzzling, mystical way the true work of art arises 'out of the artist.' Free of him, it receives an independent life; becomes a personality, an independent, spiritually breathing subject, which leads as well a material, real life [and] which is a *Being*." ("Auf eine geheimnisvolle, rätselhafte, mystische Weise entsteht das wahre Kunstwerk 'aus dem Künstler.' Von ihm losgelöst bekommt es ein selbständiges Leben, wird zur Persönlichkeit, zu einem selbständigen, geistig atmenden Subjekt, welches auch ein materiell reales Leben führt, welches ein *Wesen* ist.")

48. The *Whiplash* is preserved in the collection of the Stadtmuseum, Munich. It measures 119.5 x 183.5 cm and was executed in yellow gold silk on greyish (blue green) wool. Another Obrist embroidery of monumental size is the *Blütenbaum*, which measures 321 x 210 cm (Fig. 22). It is done in subtle shades of brown, yellow, and olive green silk on a dark brown silk fabric. (Collection of the Neue Sammlung, Munich.)

49. "O dieser Märchenerzähler, was wir ihm nicht alles glauben müssen!" (Fuchs, "Hermann Obrist," p. 324).

50. Letter 12.4.04. I am indebted to Kenneth C. Lindsay for generously sharing his typescript copy of these early letters from Kandinsky to Münter (hereafter cited as Lindsay K/M letters).

51. E. Roditi, *Dialogues on Art* (London: Secker and Warburg, 1960), pp. 141-42.

52. The close relationship between their theories of the vitality of the artistic media and their approach to the teaching of art is explored in Chapter XI.

53. Kandinsky, "Letter from Munich," *Apollon*, January 1910, p. 29.

54. The funeral oration was presented by Munich's great symbolist poet, Karl Wolfskehl, who was also a friend of Kandinsky. See Bennigsen, *Hermann Obrist, Erinnerungen*, p. 34. (See also Chapter VIII.)

55. A. Endell, "Formenschönheit und dekorative Kunst," *DK*, I, 2 (November 1897), p. 75. Endell documented his apprenticeship to Obrist in the third part of this article which appeared in *DK*, I, 9 (June 1898), p. 121.

56. Endell was born in Berlin in 1871, and died there in 1925. His younger brother, Fritz (1873-1955) had also come to Munich and had come under Obrist's influence by 1895.

57. According to Schmalenbach, Endell studied under Lipps in Munich (*Jugendstil*, pp. 31, 92).

58. Documented in *DK*, I, 1 (October 1897), p. 45, in notes on the Kleinkunst exhibition of 1897.

59. Endell, "Architektonische Erstlinge," *DK*, III, 8 (May 1900), 297.

60. *Ibid.*, p. 297ff.

61. *Ibid.*, p. 298. These changes had been instituted against Endell's wishes but too late for him to withdraw from the commission. His original design, published together with a photograph of the finished building, indicates that indeed the earlier design with its more horizontal emphasis would have presented a more balanced and less overwhelmingly bizarre appearance.

62. The color is described in the *Aufbruch* catalog (p. 178) as "Zyklam-rot und Turkis," and on p. 150 as "cyclamviolett" and turquoise. According to Maurice Rheims (*The Flowering of Art Nouveau*, pp. 35-36), the facade was dismantled on the personal orders of Hitler in 1933; according to the *Aufbruch* catalog, the whole building was destroyed by allied bombing in 1944. In a letter to the author of 30.7.1975, Albert Speer maintained that although the house was to have been torn down because of a street widening project or the like, Hitler ordered that it be preserved as an *erhaltenswertes Unikum*. But Speer could not specify the actual fate of the building, implying that it may have been torn down nevertheless with the intention of moving it to another location.

The most accurate account of the demise of the Elvira Atelier (which was located on Von-der-Tann-Strasse) appears to be that of Gerhard P. Woeckel of the Kunsthistorisches Institut of Munich. According to Woeckel, the Elvira Atelier was classified as "*entartet*" (degenerate) by the Nazi regime, and in 1938 the facade was covered over with gray plaster, a sight he recalls having witnessed himself (in a letter to the author of August 23, 1976). In July of 1944, Woeckel recalls, allied bombs destroyed the building entirely. (See also G. P. Woeckel, "Münchens Kunst im Jugendstil," *Die Weltkunst*, XLII, 15 [August 1973] p. 1204.)

63. K. Scheffler, "Unsere Traditionen," *DK*, VI (1900), pp. 442-43.

64. Compare Kandinsky, *UGK*, Chap. VI, on the language of forms and colors, where he speaks of the artist's use of form intentionally for the purpose of affecting the human soul (e.g., pp. 64, 69, 75).

65. "Kein Ornament ist aus Naturstudien entstanden, selbstverständlich lassen sich Anklänge an Naturgebilde bei dem Formenreichtum der Natur nicht vermeiden; niemals aber war Naturwiedergabe das Ziel, sondern einzig charakteristische Wirkung durch frei erfundene, allein auf diese Wirkung hin ersonnene Formen. . . . Der Zweck ist eben aesthetische Wirkung, nicht Erzählung oder Belehrung über Pflanzen und Tiere." (Endell, "Architectonische Erstlinge," pp. 314-15.)

66. *DK*, II, 4 (January 1899), p. 146.

67. Endell, "Formenschönheit und Dekorative Kunst," part I, "Die Freude an der Form," appeared in *DK*, I, 2 (November 1897), pp. 75ff. Part II, "Die Gerade Linie," and part III, "Geradlinige Gebilde" appeared in *DK*, I, 9 (June 1898), pp. 119ff.

68. Endell, "Freude an der Form," pt. I, p. 76.

69. "Die obigen Ausführungen bewegen sich auf einem so neuen und abstrakten Gebiete, dass wir sie zwar gern aufnehmen, uns aber nicht ohne weiteres mit ihnen identifizieren können" (*DK*, I, 9 [June 1898], p. 125).

70. Kandinsky, *UGK*, pp. 66ff. Kandinsky recalled that he had begun *Punkt und Linie zu Fläche* as early as 1914, although it was not published until 1926 (see "Vorwort," *PLF*, p. 11).

71. Compare Lindsay's discussion of Kandinsky's color theory, in which he demonstrates that it was based on a psychological rather than an optical approach to the problem of color ("An Examination of the Fundamental Theories," pp. 208-26).

72. Endell used the term *aesthetische Schulung* in another essay, "Möglichkeit und Ziele einer neuen Architektur," *DKuD*, I (1897-98), p. 152.

73. It should be recalled that Endell was a student at the lectures of Theodor Lipps in the nineties (see note 57). The influence of Lipps on Endell and indirectly, perhaps even directly, on Kandinsky, can best be observed by comparing this article with Lipps' discussion of the "aesthetic of simple forms," especially the section on horizontal and vertical lines, in *Grundlegung der Aesthetik*, Part I (Hamburg-Leipzig: L. Voss Verlag, 1903), pp. 243ff. The possibility of a direct influence by Lipps on Kandinsky is not to be discounted. Lipps is mentioned at least twice in Marianne von Werefkin's *Briefe an einen Unbekannten*, pp. 30-31. She noted that Lipps was very highly regarded by "my friend," which could mean Kandinsky, Jawlensky, or perhaps even Endell himself. It is certainly apparent that Lipps was discussed in her circle of acquaintances. Furthermore, Lipps published widely in the nineties both in popular and professional journals. Compare also *Raumaesthetik* (Leipzig: Verlag J. A. Barth, 1897), sec. 6, chap. 47 (Schriften der Gesellschaft für Psychologische Forschung, Heft 9/10). The comparisons between Kandinsky's *Punkt und Linie zu*

Fläche and Endell's various writings are so multiple that a thorough analysis of them is much to be desired. Only a few of the most striking comparisons have been included here.

74. Endell, "Formenschönheit," pt. II, p. 120. (This article will be referred to as *FDK* henceforth.)

75. *Ibid.*, p. 119.

76. Kandinsky, *PLF*, p. 106. The original begins: ". . . die Länge ist ein Zeitbegriff." It should be recalled that Kandinsky began work on *Punkt und Linie* as early as the late summer of 1914, according to his own testimony (see note 70). Furthermore, in the foreword to the first edition of *Über das Geistige*, Kandinsky stated that the thoughts developed therein were the result of observations and experiences gathered over the preceding five or six years, and "I wanted to write a larger book on this theme, whereby many experiments in the area of feeling would have had to be made" (*UGK*, p. 17). And in the foreword to the second edition, he stated that this book had been written in 1910 (*ibid.*). These comments together with his talk of a "language of color" in letters to Münter as early as 1904 (letters of 17.4.04 and 25.4.04, Lindsay K/M letters), indicates that his concern with psychological theories of perception was intimately interwoven with his earliest experiences in Munich, and developed continuously over a long period of time.

77. *Ibid.*, p. 96, ". . . wodurch erhöhte Spannung des Aufstieges erreicht wird."

78. *Ibid.*, pp. 103-04.

79. Endell, *FDK*, pt. II, pp. 120-21.

80. *Ibid.*, pt. III, pp. 121-25.

81. Kandinsky used a square divided horizontally and vertically at the median, to demonstrate the *Urbild des linearen Ausdruckes*—the original image of linear expression. He commented that this is a useful demonstration of the reciprocal effect of simple elements on one another in elementary combinations. He also referred to this image as the "Urklang des Geraden" (*PLF*, pp. 68-69).

82. Endell, *FDK*, pt. III, pp. 123-24. It is interesting to note that, at the Bauhaus, Kandinsky began giving his paintings titles such as *Calm Tension* (1924), *Cool Energy* (1926), *Animated Repose* (1923), and the like.

83. Endell, *Um die Schönheit*, p. 11. For original text, see Appendix C.

84. *Ibid.*, p. 27 (italics mine).

85. *Gegenständlich*, literally "objective," by which Kandinsky meant "naturalistic" or "realistic" art.

86. Kandinsky, "Rückblicke," p. VI (italics mine). For comparison of the original text with Endell, see Appendix C.

87. Endell, "Möglichkeit und Ziele," pp. 141-53.

88. Kandinsky, "Über die Formfrage," in *DBR*, p. 143; and *UGK*, p. 76.

89. Endell, "Möglichkeit und Ziele," p. 144.

90. Kandinsky, *PLF*, pp. 40-41.

91. Endell, "Möglichkeit und Ziele," p. 144.

92. It is interesting to note that in 1914, when Kandinsky compiled a list of *kleine Änderungen* (little changes) to be made in a subsequent edition of *UGK*, he added the comment: "Purely abstract paintings are still rare." (This addition was included in the Wittenborn translation of 1947 on p. 68.) Kandinsky also warned against the intervention of the intellect. While a composition may be consciously "constructed," still, what Kandinsky variously calls "feeling," the "inner voice," "inner necessity," has priority over reason. (See *UGK*, p. 142, for example, or "Rückblicke," p. XIX, but especially "Betrachtungen über die abstrakte Kunst," in *EüKuK*, pp. 146-50.) The analogies to music in Kandinsky's works are too numerous to cite, but see, e.g., *UGK*, pp. 55f.

93. "Darauf geht ja all unser Bestreben: der Phantasie freie Bahn, das Ziel klar zeigen und zu gleicher Zeit Beseitigung aller Dogmen, freie Formen ohne jede Tradition, Formen, die aus der Seele des Einzelnen aufsteigen und darum seine Formen, seine Geschöpfe sind" (Endell, "Möglichkeit und Ziele," p. 152).

94. *Ibid.*, p. 153.

95. Endell, "Originalität und Tradition," *DKuD*, IX (October 1901-02), 289ff.

96. G. Fuchs, "Das 'Bunte Theater' von August Endell," *DKuD*, IX (October 1901-02), pp. 275ff; p. 288 specifically. The peculiarly modern "harmony of contradiction and antithesis" was an important theme in Kandinsky's *Über das Geistige*. Compare *UKG*, p. 109, for example.

97. Though perhaps not great poetry, his "Schneetag" published in *Pan*, II, p. 205, set in a design by Walter Leistikow, achieved a certain effectiveness. It is not surprising that we find him the central figure in a photograph taken in the Munich countryside in the spring of 1897 with Rainer Maria Rilke, the flamboyant Lou Andreas-Salomé (the muse by turns of Rilke, Nietzsche, and Freud) and her friend Frieda von Bülow (reproduced in Arens, *Unsterbliches München*, p. 160). The connection between Endell and Lou Salomé is interesting because it was apparently established by Henry von Heiseler, a member

of the Stefan George circle. Heiseler was a Russian-German, as was Salomé—as was Kandinsky. Both Heiseler and Salomé had ties to the St. Petersburg German colony, and to the Munich Russian colony. It would not be surprising then to learn that Kandinsky knew both Heiseler and Lou Salomé, and perhaps through them, Rilke and Endell. Heiseler published in *Blätter für die Kunst* and commissioned furniture by Endell. (The furniture is so identified in photographs reproduced in *DK*, III, 7 [April 1900], pp. 313-14.) For information on the relationship between Endell and Lou Salomé, which continued until his death, see Rudolph Binion, *Frau Lou, Nietzsche's Wayward Disciple* (Princeton: Princeton University Press, 1968).

98. Scheffler, *Die fetten und die mageren Jahre*, pp. 24-25.

99. A. Endell, *Die Schönheit der grossen Stradt* (Stuttgart: Strecker and Schröder, 1908), pp. 44-45.

100. *Ibid.*, p. 42. In his memoir, Kandinsky stated explicitly that the very goal of his books, *Über das Geistige* and *Der Blaue Reiter*, had been to awaken the "capacity for experiencing the *Geistige* in material and abstract things" ("Rückblicke," p. XXVII).

101. Hölzel has been called the "great unknown in the art of the twentieth century" (see Gunther Thiem in *Ausstellungs-Katalog der Pelikan-Kunstsammlung* [Hannover, 1963], pp. 123-24). Indeed, there is as yet no definitive monograph on this seminal figure. Wolfgang Venzmer, of the Mittelrheinisches Landesmuseum in Mainz, Germany, is currently preparing such a monograph, as well as a catalogue raisonné of Hölzel's work. I am indebted to Venzmer for generously sharing his research material with me during a personal interview in June 1972, as well as in numerous conversations and letters since that time. In most cases I have followed Venzmer's dating of Hölzel's works.

102. His work was frequently reproduced and reviewed in the Munich periodicals *Kunst für Alle* and *Dekorative Kunst*, and his exhibitions and lectures announced.

103. W. Venzmer, "Adolf Hölzel—Leben und Werk," *Der Pelikan*, LXV (April 1963), p. 7. Dachau, a few miles northwest of Munich, then a picturesque rural town, had acquired a reputation in the nineteenth century as a kind of German Barbizon, similar to Worpswede in that respect.

104. Venzmer, "Leben und Werk," pp. 4-14. Most of the biographical information in this chapter is from Venzmer's article as well as from catalogues prepared by him, especially *Hölzel und sein Kreis—Der Beitrag Stuttgarts zur Malerei des 20. Jahrhunderts* (Stuttgart: Württembergischer Kunstverein, 1961), and *Adolf Hölzel Ölbilder-Pastelle* (Darmstadt: Kunstverein Darmstadt, 1969).

105. *Ibid.*, p. 4. The comment was made in reference to Hölzel's painting *Home Prayers* (Fig. 31), a work of 1890, purchased as already noted by the Neue Pinakothek in 1893.

106. According to Venzmer, recent research places this trip in 1887 rather than 1882, as it has been previously reported in the literature.

107. Their first group exhibition under that rubric took place in 1898. Although Langhammer died before fulfilling his promise, Dill achieved considerable fame with his moody Jugendstil paintings of the Dachau moor. While he was unable to follow Hölzel stylistically into the twentieth century, he remained a close friend and encouraged Hölzel's continuing experimentation. See W. Venzmer, "Adolf Hölzel und Hannover," *Niederdeutsche Beiträge zur Kunstgeschichte*, V (Munich/Berlin: Deutscher Kunstverlag, 1966), 224, and *passim*.

108. Quotation from a Hölzel letter of 10.1.1904 in Venzmer, "Leben und Werk," p. 5.

109. Now in the collection of the Mittelrheinisches Landesmuseum, Mainz.

110. Venzmer, "Leben und Werk," p. 5.

111. *Ibid.*, p. 9.

112. Kandinsky, *UGK*, p. 66, where he commented on the profound relationship between music and painting, and referred to Goethe's notion of the need for a *Generalbass* in painting. See also his introduction to *PLF*, pp. 14-16, where he suggested the need for theories in painting comparable to those on which architecture and music are based. Already by 1904, Hölzel had written: ". . . as in music there is a counterpoint and a theory of harmony, one must also strive in painting for a certain theory about artistic contrasts of every type and their necessary harmonic balance." See Hölzel in *KfA*, 15 December 1904, p. 132. The article is discussed here in the following pages.

113. A public lecture given by Hölzel in conjunction with an exhibition of his paintings at the Ernst Arnold art gallery in Dresden was reported in *KfA*, 15 May 1901, pp. 390-91. He lectured on "the problem of form in painting," accompanying his talk with projected illustrations.

114. A. Hölzel, Über Formen und Massenverteilung im Bilde," *Ver Sacrum*, IV (1901), pp. 243-54.

115. As noted previously, *PLF* was first published at the Bauhaus in 1926, though work on it commenced in 1914.

173

116. Hölzel, "Über Formen und Massenverteilung," p. 243.
117. *Ibid.*, p. 244. ". . . den geistigen und manuellen Theil unseres Handwerks uns klarzulegen."
118. *Ibid.*, p. 247.
119. *Ibid.*, pp. 248-49. Similar simplified schematic drawings were introduced into a later article by Hölzel, "Über bildliche Kunstwerke im architektonischen Raum," *Der Architekt*, xv (1909), p. 78, and xvi (1910), pp. 10-11, 18-19, 49.
120. Hölzel, "Über Formen und Massenverteilung," p. 250.
121. "Einige auf der Fläche angebrachte Formen können also bestimmend für alle anderen sein, und es erhellt daraus, dass gewisse gegebene oder *erfundene* Grundformen in formaler Beziehung massgebend für die Ausgestaltung und Gesammtaussehen eines Bildes werden können. . . ." (*Ibid.*, pp. 251-52; italics mine.) It should be noted that Hölzel clearly recognized the possibility and significance of "invented forms" at this early date.
122. *Ibid.*, pp. 251, 252.
123. *Ibid.*, p. 253.
124. Kandinsky, *UGK*, illustrations i-v. Kandinsky used a mosaic from San Vitale in Ravenna, a crucifixion by Dünwegge, a Dürer *Pietà*, Raphael's Canigiani *Holy Family*, and Cezanne's *The Bathers* to demonstrate geometrical principles in artistic composition. (According to James H. Marrow, formerly of the department of art, State University of New York [Binghamton], the painting attributed to Dünwegge in *UGK* was identified as *Der Kalvarienberg* by Derick Baegert [1476-1515], in a 1937 exhibition at the Landesmuseum der Provinz Westfalen für Kunst und Kulturgeschichte.)
125. See especially *PLF*, pp. 69-70 and particularly the illustrations on pp. 157, 175, 176.
126. Kandinsky, *UGK*, p. 69.
127. *Ibid.*, p. 71. Also in the essay "Über die Formfrage," *DBR*, p. 143. As was pointed out in the previous section, Endell also spoke of the artist's fantasy "full of forms."
128. Kandinsky, *UGK*, p. 71.
129. Hölzel, "Über künstlerische Ausdrucksmittel und deren Verhältnis zu Natur und Bild," *KfA*, 15 November 1904, pp. 81-88; 1 December 1904, pp. 106-13; 15 December 1904, pp. 121-42. It was based on a lecture Hölzel had given in Frankfurt in November 1903, during an exhibition of his work.
130. *Ibid.*, pp. 86-87.
131. Kandinsky, *DBR*, pp. 164-66, especially on art criticism, which cannot be based on arbitrary rules but only on a genuine understanding of the artistic means and their effects.

132. Hölzel, "Ausdrucksmittel," p. 82.
133. Kandinsky, *UGK*, p. 110.
134. Emil Nolde, who studied under Hölzel in the summer of 1898 (or 1899), recalled that he had drawn an ornament in honor of Hölzel's birthday ". . . in dem Glauben, dass die geistige Verfassung eines Menschen auch in einem Ornament sichtbar sein könne" (*Das Eigene Leben: Die Zeit der Jugend 1872-1902* [Flensburg/Hamburg: Verlagshaus Christian Wolff, 1949; 2nd ed.], p. 222). Two such ornaments are reproduced in the memoir, p. 232. According to Venzmer, Nolde studied under Hölzel at Dachau in 1899.
135. Arthur Roessler, *Neu-Dachau—Ludwig Dill, Adolf Hölzel, Arthur Langhammer*. Knackfuss Künstler Monographien, LXXVIII (Bielefeld/Leipzig: Velhagen and Klasing, 1905), p. 125. One of these ornaments is now in the Günther Wagner collection in Hannover. The other is in a private collection in Stuttgart. Another drawing of this type dated 30.7.98 remains in the estate, and was published in the catalog, *Adolf Hölzel, sein Weg zur Abstraktion* (Dachau: 1972), p. 6. Roessler must have seen these ornaments well before 1905, because he published an article on them as early as 1903 ("Das Abstrakte Ornament mit gleichzeitiger Verwendung simultaner Farbenkontraste," *Wiener Abendpost*, suppl. to no. 228 [6 October 1903], n.p.). In fact, most of the passage on the psychology of perception which appeared in the Neu Dachau monograph (and which is discussed in detail in the following pages) had *already* been published in this 1903 article. Kandinsky was in Vienna on October 12, 1903 (letter of 12.9.03, Lindsay K/M letters).
136. Roessler, *Neu-Dachau*, pp. 115-25 (the passage that, as noted, had already been published in the *Wiener Abendpost* in 1903).
137. *Ibid.*, pp. 123-24; "*seelische und geistige Bewegungen*" might also be translated "psychic and intellectual-spiritual."
138. *Ibid.*, p. 124. It is particularly interesting to note that although Hölzel's "abstract ornaments" were often accompanied by elaborate handwritten texts (loosely related stream-of-consciousness commentaries on art or nature, prose-poems, even short "essays"), Roessler purposely "abstracted" the drawings from their texts and printed them independently. Compare Figure 32b, in which the ornament appears as it was reproduced by Roessler, and 32c, in which the ornament appears as Hölzel apparently originally conceived it, together with a text. Only the central motif of Figure 32a was reproduced by Roessler.

139. *Ibid.*: ". . . inneren Rhythmus der Seele oder des Intellekts."

140. *Ibid.*, p. 125: "Jedenfalls sind es solche Zeichnungen, die das abstrakte Ornament bilden; *abstrakt in der Bedeutung von ungegenständlich*" (italics mine). It is clear from the whole context that Roessler employs the term *ungegenständlich* to mean "having no representational function," or "not depicting any recognizable object." I prefer the translation "nonobjective," although "nonrepresentational" might also be used. The negative function of the German prefix *un-* inverts the term *gegenständlich* (referring to objects or concrete things) into its opposite. The term "nonobjective" seems the simplest and most straightforward translation, despite the ambiguity of the English term "objective," and Washton's somewhat misleading discussion on this point ("Vasily Kandinsky," p. 19).

141. *Ibid.*, p. 123.

142. *Ibid.*, pp. 116-17. He cited the work of Binet and Kräplin [*sic*], among others. In his article of 1904 on the artist's expressive means, Hölzel had written (possibly in reference to Lipps): ". . . the feeling for line in its rich rhythmic fluctuation has been strengthened recently by thorough investigations" ("Über künstlerische Ausdrucksmittel," p. 134). His suggestion in the same context that the strictly formal, abstract attention to simple compositional oppositions (as between vertical and horizontal), characteristic of early Gothic, also might provide a key to the understanding of Hodler's work, presaged a later and similar comment by Worringer on Hodler (see Worringer, *Abstraction and Empathy*, pp. 10, 137 [note 6]). Interestingly enough Roessler made no mention of the work of the Frenchman Charles Henry, close associate of Signac, who had published numerous treatises during the late 1880s on the psychology of colors and forms. These are well documented and discussed in John Rewald's *Post-Impressionism, from Van Gogh to Gauguin* (New York: The Museum of Modern Art, 1962, 2nd ed.), pp. 100, 139 and *passim*. However, it is likely that Roessler (and Hölzel, too) knew of Signac's article on "Neo-impressionismus," which had appeared in *Pan* in 1898, and which touched, although only briefly, on these ideas. The well-known work in this area of the German Theodor Lipps, whose lectures at the University of Munich in the 1890s were heard by many young critics and artists (including August Endell, as has been previously noted) undoubtedly offered a more immediate source.

143. *Ibid.*, p. 115. Karl Scheffler (1869-1951), later to become editor of *Kunst und Künstler*, had already published several articles on the psychological significance of the artistic elements. His essay "Notes on Color" (*DK*, February 1901) was later cited by Kandinsky (*UGK*, p. 66), and is discussed here in Chapter x. Another article by Scheffler, "Ein Vorschlag" (*DK*, July 1904, pp. 378-79), proposed a systematic study of the "physio-psychological aspects of the artistic feeling" based on observations of form-, line-, and color-perception.

144. Roessler, *Neu-Dachau*, p. 117. Kandinsky was later to urge that the observer see the painting solely as a "graphic representation of *mood*" (see Arthur J. Eddy, *Cubists and Post-Impressionists* [Chicago: A. C. McClurg and Co., 1919, originally published in 1914], p. 126).

145. The term *seelische Vorgänge* might also be translated as "inner emotional processes," or "psychic processes." Kandinsky later expressed similar sentiments, particularly in regard to drama, in his essay on stage composition, where he referred to the "vibrations of the soul" that are the goal of every artistic element (Über Bühnenkomposition," *DBR*, p. 191). He also used the term *Seelenvorgang* as the equivalent of "vibrations."

146. Roessler, *Neu-Dachau*, p. 119 (italics mine). Again, this calls to mind Kandinsky's comments on the "purposive moving of the human soul" by the artistic elements (*UGK*, p. 64 and p. 69, for example). Also compare his comment on the effect of sounds such as that of a "fallen board" (*ibid.*, p. 46).

147. Roessler, *Neu-Dachau*, p. 119. ". . . des Geistes oder der Seele."

148. Hölzel had long been familiar with neo-impressionist painting. During his 1887 visit to Paris, he may well have seen works by Seurat, Signac, and others at the exhibition of the Independents, and neo-impressionist works had been shown at the Secession (e.g., in 1900, works by Lucien Pissarro and van Rysselberghe). Hölzel had specifically referred to their work (and to Signac's influential book) in his Frankfurt lecture of 1903. Whether the exhibition of neo-impressionist works by Kandinsky's Phalanx Society in the spring of 1904 exercised a significant influence on Hölzel cannot be determined with certainty (see Chapter vi, Phalanx X). It seems to have influenced Kandinsky himself who, the following summer, produced the only painting in his oeuvre that might possibly be described as "neo-impressionist" (*Beach Baskets in Holland*), although, with its very widely spaced dots of color, it represents a radical departure from Signac and van Rysselberghe (whose work had been shown at the Phalanx). Actually, as Brisch has pointed out, the separate color spot, as an autonomous compositional device, appears in Kandinsky's work as early as 1901

("Kandinsky," pp. 104-06). In fact, both Hölzel and Kandinsky tended to use the brush stroke itself as an independent compositional device rather than as subordinate to a color theory.

149. Venzmer has compared the expressive power of this painting to the work of Edvard Munch ("Leben und Werk," p. 6).

150. *Ibid.*, p. 7. It is not known when the "abstract" title was bestowed. It was also shown at a 1917 exhibition as *Rote Komposition I* (see the catalog *Hölzel und sein Kreis* [1961], p. 114).

151. Venzmer, "Leben und Werk," p. 8; also Kurt Leonhard, *Adolf Hölzel* (Munich: Delp'sche Verlagsbuchhandlung, 1968), n.p.

152. Johannes Itten, "Adolf Hölzel und sein Kreis," *Der Pelikan*, LXV (1963), p. 37. Itten, who worked under Hölzel from 1913 to 1916, recalled specifically that Hölzel discussed Cubism and the *Blaue Reiter* with his students.

153. Under Hölzel's direction Baumeister and Schlemmer helped to decorate a wall at the 1914 Werkbund exhibition in Cologne. Schlemmer and Itten were later to join the staff of the Bauhaus. Itten's introductory course, which was a prerequisite for all entering students, owed much to Hölzel's pedagogical methods (such as formal analyses of the old masters and exercises based on primary elements). See Dietrich Helms, introduction to the catalog, *Adolf Hölzel, Bilder und Texte*, unpublished manuscript provided for me by Walter Buhre of the Gunther Wagner Pelikan Werke, Hannover. See also *50 jahre bauhaus* [sic], exhibition catalog, pp. 35-40.

154. Venzmer, "Leben und Werk," p. 9. It may be noted that Kandinsky, too, frequently chose biblical themes as "expressive vehicles" during the transitional period of his breakthrough to abstraction. The figurative aspects of these paintings have been analyzed in Washton, "Vasily Kandinsky."

155. See Venzmer, "Adolf Hölzel und Hannover" (*Niederdeutsche Beiträge*). In this paper, Venzmer traces the history of Hölzel's stained glass window designs for Bahlsen and later for the Pelikan Company (1932, at the age of 80!) in detail.

156. "Pure art is steeped in the results which, without any program, arise purely out of the means . . . the more colors and chords are used in the execution, the more the work approaches musical creativity, so that we can certainly speak of musical painting, in opposition to literary painting" (Adolf Hölzel, undated aphorism, quoted in Venzmer, "Leben und Werk," p. 12).

157. Venzmer has described this as the "possibility of a reverse-transformation" ("Leben und Werk," p. 12).

158. According to Venzmer, a former student of Hölzel recalled that Kandinsky knew Hölzel quite well and visited him in Stuttgart at least once (in 1921 or 1922); further, that Hölzel's color theory was often discussed in Kandinsky's seminar at the Bauhaus (letter of Vincent Weber to Venzmer, 16 December 1960). Lindsay reported having found Carry van Biema's book, which included a substantial section on Hölzel's color theory, in Kandinsky's personal library (Carry van Biema, *Farben und Formen als lebendige Kräfte* [pt. III, "Eindrücks aus der Hölzelschen Lehre nach mündlichen Mitteilungen dargestellt"] [Jena: Diederichs, 1930]; see Lindsay, "An Examination of the Fundamental Theories," p. 124). While direct contacts between them after World War I are thus quite well documented, the present investigation has suggested that Hölzel's earliest writings (and Roessler's on Hölzel) were influential elements in Kandinsky's Munich experience. Chapter X (below) is devoted to a further discussion of ideas concerning the possibility of an art without objects, based only on the artistic means—ideas similar to those of Hölzel and Roessler, and which were rife in Munich around the turn of the century.

159. Certainly Kandinsky's much publicized *Blaue Reiter* exhibitions encouraged Hölzel's slow progression along a path he had chosen before the turn of the century. He mentioned Kandinsky in his writings after 1914, and, as noted, discussed the *Blaue Reiter* with his students. (Perhaps the earliest concrete example is the Hölzel drawing with text [number 93, in the collection of the Pelikan Werke, dated by Venzmer as ca. 1914], which begins "You are right. Kandinsky is difficult to understand . . . ," but goes on to defend the supranationalistic character of art.) Hölzel's aphorisms, mostly undated, have been collected and published in various documents. Most accessible is the collection published by Walter Hess in the centennial catalog, *Adolf Hoelzel (1853 bis 1934)*, (Stuttgart: Stuttgarter Galerieverein, 1953), with introduction by Hans Hildebrandt. Also see Marie Lemmé, *Von Adolf Hölzels Leben und Werk* (Stuttgart, n.d., ca. 1933). Although the aphorisms contain a wealth of material comparable to Kandinsky's writings (see, e.g., note 156), I have refrained from using very many of them here because of the difficulty in dating, and because such a comparison would require a study beyond the scope of this chapter. On Hölzel's color theory, see W. Hess, "Zu Hölzels Lehre," *Der Pelikan*, LXV (April 1963), pp. 18-34.

160. Now in the collection of Kurt Deschler of Ulm, to whom I am grateful for the opportunity to study this work at first hand.

161. Letter of 3.4.04, Lindsay Collection.

162. *Internationale Kunstausstellung 1901 'Secession'* (catalog), nos. 789-791a. The works by Hölzel included *Winter* and *Winter Landscape*.

163. Unfortunately I have been unable to see the original of the Kandinsky painting, which is now in the collection of L. G. Clayeux, Paris. (I am indebted to Angelica Rudenstine of the Guggenheim Museum for information concerning the present location of this painting.)

164. Hildebrandt, "Drei Briefe von Kandinsky," p. 329.

165. It should be noted that the print, of course, is the reverse of the design on the block, so that in the original drawing, the "tail" of the design turned in the same direction as in the Hölzel drawing. *10 Origin*, portfolio of original graphics (by Arp, Bill, Sonia Delaunay, Doméla, Kandinsky, Leuppi, Lohse, Magnelli, Sophie Taeuber-Arp, and Vantongerloo), published by Max Bill (Zurich: Allianz-Verlag, 1942).

CHAPTER V

1. Kandinsky, "Rückblicke," p. xxii.

2. Gerlach and Schenk (Vienna, 1887). See F. H. Meissner, "Franz Stuck ein modernes Künstlerbildniss," in *Kunst unserer Zeit*, i (1898), p. 8. According to Meissner, there was a time in the eighties when a celebration was scarcely imaginable without invitations, menus, and dance cards designed by Stuck. Meissner gives the date of publication as 1882.

3. H. v. Hofmannsthal, "Franz Stuck," *Neue Revue* (1894), reprinted in *Gesammelte Werke*, p. 198.

4. Meissner, "Franz Stuck," pp. 8, 11.

5. Hans H. Hofstätter, "Das Problem der Jugendstilmalerei," in *Jugendstil*, ed. by H. Seling, p. 139. The section of this essay dealing with Stuck was reprinted as "Zur heutigen Beurteilung von Werk und Wirkung Franz von Stucks" in the catalog published on the occasion of the opening of the Stuck Villa as a museum of the city of Munich in 1968: *Franz von Stuck, Die Stuck-Villa zu ihrer Wiedereröffnung am 9. März 1968*, ed. by J. A. Schmoll gen. Eisenwerth (Munich: Karl M. Lipp, 1968), pp. 60-62. Hereafter, references will be to the excerpt in the catalog, cited as *Stuck Villa* catalog.

6. According to Schmoll, Bruno Piglhein, who had been a teacher at the Munich Academy since 1886, an admirer of Böcklin, was one of Stuck's earliest supporters. And it is interesting to note (in an account by Anton Sailer) that Piglhein was president of the jury at the 1889 exhibition which awarded Stuck the prize. Later, Piglhein was the first president of the Secession, in 1893. See J. A. Schmoll gen. Eisenwerth, "Franz von Stuck, der Deutsch-Römer der Jugendstilära," in *Stuck Villa* catalog, p. 64, and Anton Sailer, *Franz von Stuck, ein Lebensmärchen* (Munich: Bruckmann, 1969), p. 11.

7. According to O. J. Bierbaum, this complaint was raised because one could see where the model's boots pinched his feet! (*Franz Stuck* [Bielefeld/Leipzig: Velhagen and Klasing, 1899], p. 30).

8. Hofstätter, "Zur heutigen Beurteilung" (*Stuck Villa*), pp. 60-61.

9. Hofmannsthal, "Stuck," in *Gesammelte Werke*, pp. 197-98.

10. Meissner, "Franz Stuck," p. 14. See also Heinrich Voss, "Franz Stuck as a Painter," *Apollo*, xciv, 117 (November 1971), pp. 378-83.

11. Julius Meier-Graefe, "Eine kritische zeitgenössische Stimme zu Stuck," excerpted from Meier-Graefe, *Entwicklungsgeschichte der modernen Kunst*, ii, bk. 4 (Munich: Piper, 1927), p. 710, and reprinted in *Stuck Villa* catalog, p. 49.

12. *Stuck Villa* catalog, p. 82.

13. Willi Geiger described her as "accursed and ripe for death" ("Franz von Stuck zum Gedächtnis an seinem 75. Geburtstag—Aus der Festrede gehalten am 23. Feb. 1938 in der Villa Stuck," in *Stuck Villa* catalog, p. 44). The theme of the damned and death-doomed female was a common one in Art Nouveau and Jugendstil. Salomé was also depicted by Stuck and many other artists of the era. Munch's *Madonna* (dated 1895-1902) assumes a pose quite similar to Stuck's *Sin*, and the spermlike figures around the frame, as well as the snakey hair, suggest a possible influence. Indeed, the leitmotif of Thomas Mann's short story "Gladius Dei" (previously cited) was apparently inspired by a combined image of Stuck's *Sin* and Munch's *Madonna*. (Cf. H. Voss, *Franz von Stuck, Werkkatalog . . .*, and see note 14, below.) And Moreau's famous Salomé was admired by the decadent hero of Huysman's novel *À Rebours*.

14. While none of Stuck's paintings touched the philosophical depth or sensitivity of the works of Khnopff, Rops, Redon, Munch (or even Klinger), all of whom treated similar subject matter, they reveal much about the psychology of the era and deserve further study. Hofstätter suggests that Stuck's *Sin* is less an allegory of sin and sensuousness, than an image of the *"feeling* of loss" of the old meaning-relationships ("Zur heutigen Beurteilung," [*Stuck Villa* catalog], p. 61). See also *Stuck Villa* catalog, p. 82. The reader should also be referred to the catalogue raisonné of Stuck's paintings by Heinrich Voss, which unfortunately was not available to me at the time this manuscript was completed (H. Voss, *Franz von Stuck, Werkkatalog der Gemälde.* Munich: Prestel Verlag, 1973). Voss's discussion brings psychological and sociological considerations to bear on his analysis of Stuck's turn-of-the-century sensibility, illuminating especially the erotic content of much of his work.

15. Stuck did not hesitate to combine elements of Byzantine, oriental, and High Renaissance art within the neoclassical frame.

16. Stuck's furniture was awarded a gold medal at the 1900 Paris World Exposition. For detailed information on the Stuck Villa see: J. A. Schmoll gen. Eisenwerth, "Idee und Gestalt der Stuck-Villa," *Stuck Villa* catalog, pp. 7-16; and Helga D. Hofmann, "Das Dekorations—und Raumprogramm der Stuck-Villa," *ibid.*, pp. 17-35. Both of these essays provide insights into Stuck's use of traditional imagery and his freedom with it. See also Helga D. Hofmann, "The Villa Stuck: A Masterpiece of the Bavarian-Attic Style," *Apollo*, XCIV, 117 (November 1971), pp. 384-95.

17. Contemporary German critics were fascinated with Stuck's nonchalant neglect of French impressionist and neo-impressionist techniques. Meissner, for example, boasts that Stuck, like Böcklin and Klinger, has not been "enslaved" by technique (brushwork) like his naturalistic contemporaries, but rather "uses it only as a subordinate means in the formation of . . . new great world ideas (*Weltideen*)." Stuck, wrote Meissner, "did not even, like so many distinguished contemporary comrades-in-arms in the art of fantasy, need to fight his way through a proper naturalistic period of development, because his instinct directed him in recognizing his individuality. . . . He was always a superior artist-poet (*Künstlerpoet*)" ("Franz Stuck," p. 27). It is interesting to note that even in faraway Madrid, Picasso had somehow divined an anarchical tendency in Munich's art, for in 1897, in a letter to a friend, he wrote: ". . . if I had a son who wanted to be a painter, I would not

keep him in Spain a moment, and do not imagine I would send him to Paris (where I would gladly be myself) but to Munik (I do not know if it is spelt like this), as it is a city where painting is studied seriously without regard to fixed ideas of any sort, such as pointillism and all the rest. . . ." Quoted by Xavier de Salas, "Some Notes on a Letter of Picasso," *The Burlington Magazine*, November 1960, p. 483. Schultze-Naumburg had already credited Stuck with rescuing Munich figure painting from worn-out dogmas in "Aus München: Ludwig Dill und die neueren Bestrebungen der Münchener Landschafterschule," *Pan*, III, 3 (1897), p. 175.

18. H. Purrmann, "Erinnerungen an meine Studienzeit," *Werk*, XXXIV, No. 11 (November 1947), p. 366. In 1898, Stuck and his American wife, Mary, appeared at the annual Artists' Festival clad as Greek god (crowned with laurel) and goddess. A double portrait of them in costume is in the collection of the Städtische Galerie in Munich. Numerous accounts recall that Stuck was astonishingly handsome and imposing, very much the *Malerfürst*. It is also well documented that he actually painted in a frock coat, as he portrayed himself in another double portrait with Mary (1902, Fig. 46). It was only gilding the laurel when in 1906 Stuck was officially raised to the nobility and became "von Stuck."

19. F. v. Ostini, "Franz Stuck," *KfA*, 15 October 1903, p. 33. Also Bierbaum, in his 1899 monograph, and Meissner make much of the "healthy" sensual attitude of Stuck.

20. Meissner, "Franz Stuck," p. 19.

21. *Ibid.*, p. 30.

22. *Ibid.*, pp. 1-3.

23. Both Hausenstein and Purrmann were embarrassed by Stuck, as well as by Jugendstil. See Hans Purrmann, "Erinnerungen" (in *Werk*), pp. 366-72 (especially pp. 366-67); also, Wilhelm Hausenstein, *Liebe zu München* (Munich: Prestel, 1958; 4th ed.), Stuck obituary. Further, Geiger noted how strange all Stuck's fabulous creatures seemed next to the isms of the twentieth century ("Franz von Stuck," in *Stuck Villa* catalog, p. 45).

24. A survey of Stuck's students is included in the *Stuck Villa* catalog, pp. 113-20. Haller, who traveled with Klee in 1902, later became a sculptor. Geiger had a distinguished career as a teacher of art and design in Leipzig and in Munich. Both Purrmann and Geiger wrote memoirs of Stuck and student days in Munich. Ernst Stern also exhibited in Kandinsky's Phalanx society (see Chapter VI.).

25. Purrmann, *Stuck Villa* catalog, p. 56. (Quoted from Bar-

bara and Eberhard Göpel, *Leben und Meinungen des Malers Hans Purrman* [Wiesbaden: n.p., 1961], pp. 24f.)

26. Purrmann noted particularly that Kandinsky was much older than the other students, and that he was much impressed by Kadinsky's knowledge and culture ("Wissen und Bildung"), in his "Erinnerungen" (in *Werk*), p. 368. The survey of Stuck students in the *Stuck Villa* catalog indicates that indeed Kandinsky was the oldest student then enrolled, and may well have been the oldest student Stuck ever had. He was only three years younger than Stuck himself. Only one other student may have been born in 1866, and the next oldest were born in 1871, thus five years younger than Kandinsky. Purrmann himself was fourteen years younger than Kandinsky, and Klee, thirteen.

27. Kandinsky, "Rückblicke," p. xxii. Purrmann gives a vivid account of how it felt to present oneself to Stuck. This was the only time a student entered the imposing Stuck Villa. The doorway itself caused Purrmann such alarm that in his memoir he recalled the Medusa-head on the bronze door, which also served as a mailbox. And the strongly patterned parquet floor of Stuck's studio made him feel quite dizzy, especially when the master spread Purrmann's work out upon it in order to make his judgment ("Erinnerungen," p. 367).

28. Brisch noted in regard to Stuck's use of form that it had in common with Jugendstil "the ornamental translation of the seen into a decorative pictorial logic (*Bildlogik*), and as well, the consequent possibility of the conscious use of lines as pure form for the purpose of expression" ("Kandinsky," p. 65).

29. It is interesting to compare the facade scheme of the Stuck Villa with Endell's schematic illustrations and to speculate whether Stuck may not have taken Endell's ideas into consideration in the ordering of a dignified and elegant facade.

30. It is interesting to note that Hofmannsthal, as early as 1894, in his essay on Stuck (*Gesammelte Werke*, p. 199), referred to the *lyrischen Gefühlsinhalt* of his images (their "lyrical feeling-content"). *The Dance* appeared both as a painting on canvas (1894) as in Figure 47, and as a wall decoration in the music salon of the Stuck Villa, 1897-98.

31. The most extreme example of this was, of course, the Villa, itself, a *Gesamtkunstwerk* par excellence. The altar he constructed for *Die Sünde* is another extreme example.

32. "Er sprach überraschend liebevoll von der Kunst, von dem Formenspiel, von dem Ineinanderfliessen der Formen und gewann meine volle Sympathie" (Kandinsky, "Rückblicke," p. xxii).

33. Hofmannsthal, "Franz Stuck," p. 197.

34. *Ibid.*, p. 198 (italics mine).

35. *Ibid.*, p. 197. It is particularly interesting that von Hofmannsthal considered Stuck's talent for, and training in, caricature as of prime importance in this development to an appreciation of form for its own sake. It may be more than just a little significant that many important Munich artists of the period were gifted caricaturists. Those who worked for the Munich periodical *Jugend*, exhibited together as a group under the name of *Die Scholle*. Even more interesting is the fact that Klee, Kubin, and Feininger, all at one time or another closely associated with Kandinsky, were particularly talented caricaturists.

36. Kandinsky, "Rückblicke," p. xxii. In fact, Kandinsky felt that Stuck was not very "sensitive to color," and he recalled, in the same passage, that he was often irked by Stuck's criticisms. But in the long run, he wrote, he was grateful for the year he spent at Stuck's atelier (*ibid.*).

37. It is quite possible, too, that Stuck's advice may have led to his experiments with tempera paint on black cardboard, with which (as has been pointed out by Lindsay in his dissertation) he was able to achieve effects similar to those of woodcuts ("An examination of the Fundamental Theories," pp. 156-59).

38. In his villa, Stuck controlled natural light by day with stained glass or onyx windows (in the studio). By night, rows of electric lamps built into the framework above the windows, which were then closed on the inside with Venetian mirrors, reflected light indirectly and aslant into the rooms. See H. D. Hofmann, "Das Dekorations- und Raumprogram der Stuck-Villa" (*Stuck Villa* catalog), p. 32.

39. *Dancers* appeared both as a painting and as a relief. A *Faun and Nixie* appeared as a painting and as a statuette. The examples are too multiple to enumerate.

40. Geiger, "Franz von Stuck" (*Stuck Villa* catalog), p. 46.

41. Purrmann, "Erinnerungen" (in *Werk*), p. 368.

42. *Ibid.*, p. 372.

43. Geiger, "Franz von Stuck" (*Stuck Villa* catalog), p. 46.

44. Purrmann described a moving experience in which Stuck dismissed him from the class at the end of the first semester as he seemed to be making no progress at all. In despair, the young Purrmann, deciding at least to stay out the last week, gave up the difficult tempera paints he had been using and came to the studio with oils. With a sense of release, he quickly set about to capture the studio and model in order to have at least a souvenir of the class. Unexpectedly, Stuck arrived and,

noticing Purrmann's work, immediately expressed his approval of the young man's new direction, reinstated him in the class and exhibited the painting in a student show, where it won a prize. Thereafter, Stuck continually encouraged Purrmann, who stayed on as a student for some five years. The story is revealing, for there were few Academy professors who would have been so flexible, so ready to admit a mistake, and to rectify it ("Erinnerungen" [in *Werk*], pp. 368-69).

45. *Ibid.*, p. 368.

46. Kandinsky, "Rückblicke," p. XXII.

47. Purrmann, "Erinnerungen" (in *Werk*), p. 369.

48. Letter of 1.7.04 (Lindsay K/M letters).

49. Doris Schmidt in "Franz von Stuck, ein Gefangener der Stilisierung," *Münchener Neueste Nachrichtungen*, no. 59 (March 8, 1968), p. 9.

50. In this respect, the name of Gustav Moreau comes to mind. Stuck has indeed been compared to the great French symbolist (see, e.g., Roditi, *Dialogues on Art*, pp. 140, 145). As has been noted, Moreau often dealt with similar subject matter, though in his own inimitable manner, and had also taught some of the great innovators of twentieth-century art (namely, Matisse and Rouault). But Moreau had consciously pursued the life of a recluse and had never enjoyed the immense popular success Stuck had known for a time. Moreau's taste of oblivion seemed destined, whereas Stuck's seemed one of the crueler vicissitudes of fate, determined partially no doubt by the fact that Jugendstil went out of fashion with such a vengeance, and that his illustrious students were so little appreciated in the Germany of the thirties. It is nonetheless interesting that the Stuck student, Kandinsky, had great admiration for the Moreau student, Matisse (Kandinsky, *UGK*, p. 51); and that Purrmann, who had studied so long with Stuck, was to become so closely associated with Matisse in Paris. (Purrmann was instrumental in helping to organize the Académie Matisse.) Another Stuck student, Albert Weisgerber (who also exhibited in Kandinsky's Phalanx society), was also later associated with Matisse. It was very likely the liberal attitudes of these two older masters in artistic matters that encouraged the development of such students.

CHAPTER VI

1. *KfA*, 15 July 1901, p. 487.

2. Presumably in late 1900 or early 1901. The Stuck catalog lists Kandinsky as having been a student of Stuck in 1900 (*Stuck Villa* catalog, p. 115). Kandinsky recalled: "An dieses Jahr der Arbeit bei ihm . . . denke ich im letzten Schlusse mit Dankbarkeit" ("Rückblicke," p. XXII). Thus indicating that he spent at least two semesters at Stuck's studio, possibly enrolling in early 1900 and remaining until late 1900 or early 1901. By the spring of 1901, as will be seen, he was already busy with other plans.

3. That the group was formed in May or early June of 1901 at the very latest is apparent by the fact that the editorial deadline for *Kunst für Alle* was always one month before the date of the issue, thus the announcement had been submitted by June 15.

4. *Random House Dictionary of the English Language*, 1966.

5. The poster announces the opening on August 15, but an anonymous reviewer in *Kunst für Alle* reported that the show opened on the 17th (*KfA*, 1 October 1901, p. 22).

6. Charles Fourier, 1772-1837. The Fourier "Phalanx" was a community of a predetermined number of individuals living and working together for their common good. Work was to be divided according to individual wish and talent. Social harmony was to be attained by matching individuals of complementary dispositions within the social unit, the Phalanx. The equality of women was considered a crucial factor in social progress. By rational study, Fourier thought, a God-intended world harmony would be attained. The most famous example of an experimental Fourier Phalanx was the Brook Farm community associated with the Emerson transcendentalist group. See Mark Holloway, *Heavens on Earth* (New York: Dover Publications, 1966; 2nd ed. [first published by Turnstile Press, Ltd., 1951]), pp. 134-59. Kandinsky was dedicated to similar goals of social harmony and also to the equalization of rights for women. He admitted women to his school and to the exhibitions he organized. In a review for *Apollon* he expressed revulsion at the rules of the Deutscher Künstlerverband because it did not admit women to membership. During the course of his studies in social economy, it is possible that he had come across information on the Fourier theories, which were known in Germany and Russia. See Kandinsky's "Letter

from Munich," *Apollon*, 1 (October 1909), p. 19. See also Edmund Wilson, *To the Finland Station* (Garden City: Doubleday, first published in 1940), pp. 86-97, p. 143; and D. S. Mirsky, *A History of Russian Literature* (New York: Vintage Books, 1958 [first published in 1926]), pp. 167, 182.

7. See Crane's *Amor vincit Omnia*, in which similar tents are a background motif. Also, the helmets worn by the warriors are the same shape as those on Kandinsky's poster, though without the crest. (Reproduced in *KfA*, 1 December 1897, p. 76.)

8. On the characteristics of Jugendstil lettering, see Roswitha Baurmann, "Schrift," in Seling (ed.), *Jugendstil*, pp. 169-214.

9. Described in *KfA*, 1 October 1901, p. 22.

10. According to Brisch in a building owned by a Frau Prof. Lossem ("Kandinsky," p. 29).

11. *KfA*, 1 September 1902, p. 549.

12. Anonymous review in *KfA*, 1 October 1901, p. 22.

13. *Ibid.*

14. Purrmann, "Erinnerungen" (in *Werk*), p. 369.

15. The significance of Stern, Salzmann, and Jaques-Dalcroze [*sic*] for Kandinsky's interest in the theater is discussed at greater length in Chapter IX.

16. As had been noted by the critic Karl Voll in *KfA*, 15 April 1900, p. 351.

17. *KfA*, 15 March 1900, p. 284.

18. For illustrations of some of these, see Arens, *Unsterbliches München*, pp. 295, 298, 302.

19. Illustrated in the catalog *Europäischer Jugendstil, Ausstellung Kunsthalle, Bremen, 16. Mai-18 Juli 1965* (Bremen: H. M. Hauschild, 1965), p. 181, no. 283.

20. Reinhard Piper (1879-1953) was another associate of the Elf Scharfrichter who was to have direct significance for Kandinsky. Piper later became the publisher of Kandinsky's *Über das Geistige in der Kunst*, *Der Blaue Reiter*, and *Klänge*. See R. Piper, *Vormittag, Erinnerungen eines Verlegers* (Munich: Piper, 1947), pp. 283-86, 433-36. See also Arens, *Unsterbliches München*, pp. 294-302, 310-12.

21. Brisch reported that he found none ("Kandinsky," p. 30). Catalogs are extant of the second, seventh, eighth, ninth and eleventh Phalanx exhibitions. I am indebted to Erika Hanfstaengl of the Städtische Galerie, for sending me photocopies of the catalogs of the second, seventh and eighth exhibitions. Catalogs for the ninth and eleventh exhibitions are listed in Lindsay, "An Examination of the Fundamental Theories," p. 178.

22. Brisch, "Kandinsky," Appendix, p. 17. Reproduced in

Grohmann, *Kandinsky*, p. 349, no. 6. Kandinsky kept a careful record of his works in a series of private catalogs, which he called his "house catalogs," now in the possession of Mme. Nina Kandinsky, Paris. Lindsay, Brisch, and Grohmann have prepared lists and descriptions based on these catalogs. Further, Lindsay has arranged for a microfilm of the house catalogs to be preserved at the library of the Museum of Modern Art in New York.

23. Catalogs of the Internationale Kunstausstellungen Secession 1900, 1901.

24. See reviews in *KfA*, 1 August 1902, pp. 495-96; *KfA*, 15 April 1902, pp. 324, 330.

25. The fundamental significance of the horse-and-rider motif in Kandinsky's oeuvre is analyzed in Chapter XII. Although an earlier *Riding Couple* (ca. 1903) was illustrated in *Kandinsky, 1901-1913* (Berlin: Der Sturm, 1913), it has apparently disappeared and no good photograph is available.

26. Unless otherwise indicated, biographical information on minor artists has been gleaned from: Ulrich Thieme and Felix Becker, *Allgemeines Lexikon der bildenden Künstler* (Leipzig: Seemann, 37 vols., 1908-50); and Hans Vollmer, *Allgemeines Lexikon der bildenden Künstler des XX. Jahrhunderts* (Leipzig: Seemann, 1953-).

27. Announcement of the change was made in *KfA*, 15 November 1901, p. 90. Niczky later went to Berlin where he taught at the Reimann School, an arts and crafts oriented school, and became known as a portraitist, illustrator, and graphic artist. Notes for a meeting of the Phalanx dated 25.2.1904 are found in one of Kandinsky's notebooks at the Städtische Galerie (GMS 340), pp. 9, 11. These indicate that the president at that date was Treumann, and that Kandinsky stayed on as vice-president. That Kandinsky had passed the responsibility on to his friend Treumann is confirmed in a letter by Kandinsky of 4.4.04 (Lindsay K/M letters). For more information on Treumann, see the discussion of Phalanx XI.

28. Gustav Freytag (1876-1961) had arrived in Munich in 1897 in order to study medicine. Portions of a memoir he wrote at the request of Hans K. Röthel, former director of the Städtische Galerie, Munich, have been published in Röthel's book, *Kandinsky—Das graphische Werk* (Cologne: DuMont Schauberg, 1970), pp. 429-36. (Hereafter this work will be cited as Röthel, *KgW*.) Freytag recalled that he met Kandinsky through his childhood friend, the sculptor Waldemar Hecker. Apparently because he was financially independent and because he had an interest in art, Freytag agreed to help the group of

artists in their endeavor to found the Phalanx. He became the secretary of the group, though mainly, he wrote, he took on the duties of treasurer. Freytag also recalled a few other members of the original Phalanx about whom, however, little is known. These, together with the data given in Röthel, *KgW*, were: Eugen Meier, a sculptor; Richard Kellerhals (1878-?), a painter, who lived in Berlin after 1908; and Edmund Blume (1844-?), a portrait and genre painter who regularly exhibited in the Glaspalast. Hermann Schlittgen (1859-1930), another Munich painter, was also an early member of the Phalanx and wrote about it in his own *Erinnerungen* (Munich: Albert Langen, 1926), p. 280.

29. The officers were listed in the *Katalog der II. Ausstellung der Münchener Künstler-Vereinigung Phalanx*, as also noted by Brisch, "Kandinsky," p. 29. However, Brisch apparently did not know about the later transference of the chairmanship to Treumann, and assumed that Kandinsky remained chairman "until the end" (*ibid.*). Grohmann assumed that the group was dissolved in 1904 with the eleventh exhibition (*Kandinsky*, p. 36). Neither apparently knew of the twelfth exhibition of late December 1904 at Darmstadt, reviewed in *KfA*, 1 February 1905, p. 213. Although Kandinsky was not president from the very beginning, Freytag recalled in a letter to Brisch that "Kandinsky was doubtless soon the most influential of the members; with him, I worked out the meetings" (quoted in Brisch, "Kandinsky," p. 30).

30. Compare Brisch, "Kandinsky," p. 33, who also suggested that Kandinsky had close connections to the leading artists of Germany, Russia, and other countries, even at this early date. Brisch, however, did not investigate these connections in detail.

31. Erich Kleinhempel (1874-?) had studied at the Arts and Crafts School in Dresden (1890-93), and had founded a private arts and crafts school there by 1900.

32. Natalia Davidov (1874-?) had studied at the Moscow Art School and then became the chief assistant to Elena Polenova. After Polenova's premature death, Davidov became the leading craftswoman of Russia, with a special interest in the renaissance of native arts and crafts design. See also "Das Russische Dorf auf der Pariser Weltausstellung" in *DK*, VI (September 1900), pp. 480-88, which includes illustrations of Davidov's embroideries.

33. Compare Chapter III.

34. Cf. Freytag's memoir as quoted in Röthel, *KgW*, p. 431. *Kunstwart* was a very influential little magazine devoted to literature and the arts and directed by Ferdinand Avenarius

(1856-1923) of Dresden, whose father had been a founder of the famed Brockhaus and Avenarius publishing firm. The younger Avenarius had dedicated himself to bringing art to the people, which he accomplished with inexpensive reproductions of art works and with his magazine *Kunstwart*. The publishing firm Callwey was responsible for printing *Kunstwart*, and had offices in Dresden and Munich. Avenarius often took up the cause of younger or unknown artists and writers. He was among the first to appreciate the significance of young Alfred Kubin, whose work was also soon to be exhibited by the Phalanx (see A. Kubin, *The Other Side* [New York: Crown Publishers, 1967], p. xli of "Alfred Kubin's Autobiography"). For a discussion of a crucial critical essay by Avenarius which may well have been influenced by his early contact with the Phalanx and its artists, see Chapter X. Louise Schmidt, also listed in the catalog for this second Phalanx exhibition, may have been the Louise Schmidt identified in Röthel, *KgW* as a portraitist (1855-1924).

35. Baurnfeind is particularly interesting because of the fact that the so-called *Biedermeierstil* (of which his grandfather, Schwind, was a leading exponent) was at that time experiencing a real renaissance. Biedermeier style was extolled as exemplary of the kind of excellence in *craftsmanship* Jugendstil artists aimed at. Biedermeier motifs (often ladies dressed in costumes of that period, ca. 1840s) appeared frequently in paintings of the turn of the century, including Kandinsky's. There was even something of a Schwind revival (in *KfA*, 15 January 1904, the lead article is on Schwind). It is also interesting that a period, itself soon to be scorned, restored to respectability an earlier period once scorned. "Biedermeier" was once a derogatory term, as "Jugendstil" was to become.

36. Of the four remaining exhibitors little is known. Leon Kojen was mentioned in the *Kunst für Alle* review as presenting "appealing" and "idyllic" work. Georg O. Artaval, Anna Duensing, Emmy Egidy, and Hedwig Klemm were not mentioned. Egidy was apparently a sculptress, according to *KfA*, 15 June 1903, p. 414.

37. His actual activity as a craftsman is discussed in detail in Chapter XI.

38. *Dusk* (*Dämmerung*) now in the collection of the Städtische Galerie (GMS 99), is discussed further in Chapter XII. The other decorative sketches were: *Summer* (*Sommer*), *Morning* (*Morgen*), and *Fairytale Town* (*Märchenstadt*) (identified in the catalog as a watercolor, whereas the others were tempera). There are at least two sketches of "fairy tale cities"

in the Städtische Galerie collection: GMS 101 which, however, combines crayon and watercolor; and GMS 180, a delicate watercolor (Fig. 55). The other works by Kandinsky listed in the catalog were: *Winter in Schwabing* (tempera), *The Bright Air* (*Die helle Luft*) (tempera), *Autumn Sun* (*Herbstsonne* (tempera), *Autumn Days* (*Herbsttage*) (oil), *Before the Thunderstorm* (*Vor dem Gewitter*) (lacquer), *Old City* (*Alte Stadt*) (oil), *Waterfall* (*Wasserfall*) (oil study), *Evening* (*Abend*) (oil study).

39. *KfA*, 15 March 1902, p. 284.

40. By 1902, Kusnetsov was a resident of Odessa, where Kandinsky's family also lived. It is probable that Kusnetsov was an important link between Kandinsky and exhibition opportunities in Russia. A letter of 29.9.03 refers to "an old friend, famous Russian painter" who had helped him to sell his paintings in Odessa (Lindsay K/M letters).

41. See P. Weiss, "Wassily Kandinsky, the Utopian Focus: Jugendstil, Art Deco, and the Centre Pompidou," *arts magazine*, 51, 8 (April 1977), pp. 102-107. The article includes a review of the major exhibition mounted in Darmstadt (October 1976-January 1977) to commemorate the seventy-fifth anniversary of the Artists' Colony. See also the five-volume catalog of the exhibition, *Ein Dokument Deutscher Kunst 1901-1976*, edited by Marianne Heinz (with Bernd Krimmel, Carl Benno Heller, Gert Reising, Birgit Braun, Annelise Loth, Brigitte Rechberg), Darmstadt: Eduard Roether Verlag, 1976. Peter Behrens was to have a direct personal influence on Kandinsky's career, as will be seen in Chapter XI. For his role in the advancement of ideas leading to the development of the Bauhaus, see Nikolaus Pevsner, *The Sources of Modern Architecture and Design* (New York: Praeger, 1968); N. Pevsner, *Pioneers of Modern Design from William Morris to Walter Gropius* (London: Penguin, 1964 [originally published as *Pioneers of the Modern Movement*, 1936]); Gillian Naylor, *The Bauhaus* (London: Studio Vista Ltd., 1968); and Fritz Hoeber, *Peter Behrens* (Munich: G. Müller and E. Rentsch, 1913). Further, Behrens' ideas on theater reform were to have an influence on Kandinsky, as will be seen in Chapter IX.

42. See Chapter IV.

43. "Was erwarten die Hessen von ihrem Grossherzog Ernst Ludwig?—Von einem ehrlichen, aber nicht blinden Hessen." The pamphlet was published anonymously and created quite a stir. See *Neue Deutsche Biographie*, 1960, "Georg Fuchs," p. 678; also H. Rasp, "Georg Fuchs, 1868-1949," *Vom Geist*

einer Stadt, ein Darmstädter Lesebuch, ed. by Heinz W. Sabais (Darmstadt: E. Roether, 1956), pp. 300-01. See also Gerhard Bott, "Darmstadt und die Mathildenhöhe" in *Deutsche Künstlerkolonien und Künstlerorte*, ed. by Gerhard Wietek (Munich: Verlag Karl Thiemig, 1976), p. 154. There, Alexander Koch, the brilliant publisher of the influential crafts magazine *Deutsche Kunst und Dekoration*, is also given credit for having inspired the Grand Duke's action. The young Duke himself, grandson of Queen Victoria and educated primarily in England, was no stranger to the arts and crafts movement (indeed, as Bott points out, his own mother was acquainted with John Ruskin).

44. Dates of the Darmstadt artists: Behrens (1868-1940), Bosselt (1871-1938), Bürck (1878-1947), Christiansen (1866-1945), Habich (1872-1949), Huber (1878-1902), Olbrich (1867-1908). Thus all were very nearly contemporary with Kandinsky.

45. See *DK*, IV, 8 (May 1901), pp. 289-95.

46. Anonymous article, "Ein fürstliche Idee" (perhaps by Julius Meier-Graefe), *DK*, III, 7 (April 1900), p. 270.

47. Fritz Schumacher, "Die Ausstellung der Darmstädter Künstlerkolonie," *DK*, IV, 11 (August 1901), pp. 417ff.

48. The performance was held outdoors, with music by Willem de Haan, court conductor (and father of Hanna de Haan, wife of Kandinsky's later friend, the symbolist poet Karl Wolfskehl). (See "Eröffnungs-Feier der Darmstädter Kunst-Ausstellung," *DKuD*, VIII [1901], pp. 446-48.) Fuchs and Behrens were obsessed with the idea of creating a new theater. Both published their ideas and worked together toward a renaissance of stylized drama in reaction against the rampant naturalism of nineteenth-century theater. (See Georg Fuchs, *Von der stilistischen Neubelebung der Schaubühne*, with designs by Peter Behrens [Leipzig: Diederichs, 1891]; and Peter Behrens, *Feste des Lebens und der Kunst, eine Betrachtung des Theaters als höchsten Kultur-Symboles*. [Leipzig: Diederichs, 1900].) The significance of these ideas for Kandinsky's interest in the theater is analyzed in Chapter IX.

49. "Von der Darmstädter Künstlerkolonie," *DK*, IV, 8 (May 1901), p. 289. The recent catalog *Ein Dokument Deutscher Kunst 1901-1977* (cited above, note 41), published after completion of the manuscript for this book, contains many photographs of the houses, reproductions of architectural plans, and detailed descriptions of the artists and their projects, as well as scholarly articles on all phases of the Colony (see especially volumes 4 and 5).

50. Photographs of the colony also appeared in *Mir Iskusstva*, no. 10 (1901), pp. 116-20.

51. "eine neugeistige, neuzeitliche Kunst, die unserer Zeit, unserm innern und äussern Leben entspricht und wiederum dieses bildet und formt." *DK*, IV, 11 (August 1901), p. 445.

52. *KfA*, 15 March, 1902, p. 285. Illustrations of the medallion may be seen in the catalog *Kunsthandwerk um 1900, Jugendstil*, ed. by Gerhard Bott (Darmstadt: E. Roether Verlag, 1965), p. 29, no. 8.

53. *KfA*, 15 March 1902, p. 285. At least two of the carpets, *Herbst I* (*Autumn*) and *Verbotene Früchte* (*Forbidden Fruits*) listed in the Phalanx catalog were on view at the seventy-fifth anniversary exhibition in Darmstadt (see note 41, above). They are illustrated in volume 4 of the exhibition catalog (no. 67 and no. 69). Also among the carpets shown were two entitled *Frühlingsreigen*, one of which is illustrated in Seling, *Jugendstil*, no. 335. Christiansen was especially noted for his stained glass window designs. (See Schmalenbach, *Jugendstil*, p. 55 and *passim*.)

54. See Isarius, "Darmstadt, die 'werdende Kunst-Stadt,'" *DKuD*, IX (1901-02), p. 85. One of these six cushions, or one very similar to it, was also exhibited at the seventy-fifth anniversary exhibition. It is illustrated in volume 4 of the exhibition catalog (no. 71). In Figure 56 here, it is the cushion in the upper righthand corner.

55. Several similar items by Huber are illustrated in the catalog, Bott, *Jugendstil*, nos. 53-59. In the same catalog, a number of items designed by Behrens during this period are also illustrated (nos. 1-6).

56. Reviewed in *DKuD*, IX (1901-02), p. 127. Exhibitors included Benois, Vrubel, Maliavin, Somov, Korovin, Serov, and Trubetskoi.

57. Kandinsky, "Rückblicke," p. XIV. "Als ich endlich ins Zimmer trat, fühlte ich mich von allen Seiten umgeben von der Malerei, in die ich also hineingegangen war."

58. *Ibid.*

59. Kurt Breysig, "Kunst und Leben," *DKuD*, IX (1901-02), p. 149.

60. Kandinsky, *UGK*, p. 21 ("Jedes Kunstwerk ist Kind seiner Zeit, oft ist es Mutter unserer Gefühle"). Chapters X and XI analyze in detail the effect of the applied arts movement on Kandinsky's artistic development, and its fundamental significance for his evolution toward abstraction. The reader may be reminded here that Kandinsky was later called to the Bauhaus,

a direct descendent of the Darmstadt experiment. Though the Darmstadt colony did not last long, due to a combination of financial difficulties and governmental control, the ideas that brought it into existence and the ideas engendered by it led directly to the Bauhaus. (See Benno Rüttenauer, "Darmstadt nach dem Fest," *DK*, IX [February 1902], 185ff. Rüttenauer, was overly pessimistic as can be seen by comparing Wilhelm Schäfer, "Die zweite Ausstellung der Darmstädter Künstler-Kolonie," *Die Rheinlande*, VIII [April-December, 1904], p. 454.) Until 1971, as if by poetic justice, the Bauhaus Archive occupied a building on the Mathildenhöhe in Darmstadt, next to the Ernst Ludwig House, in the midst of the Künstlerkolonie. Though many of the houses were damaged or destroyed in the war, many have now been restored, and it is still possible to recover there a sense of community and Jugendstil.

61. Brisch referred to this sudden spurt of activity as a *Tätigkeitsdrang*, or "drive to activity" ("Kandinsky," pp. 28-29).

62. Freytag, quoted in Röthel, *KgW*, p. 436. Carl Palme, who also recorded his memoirs of the Phalanx School, stated that the school was in the Wilhelmsstrasse (*Konstens Karyatider*, p. 40). However, the address on the flyer advertising the school (collection of K. C. Lindsay) is Hohenzollernstrasse 6. While Brisch thought the Wilhelmstrasse address might be an error, the building actually stood near the corner of Hohenzollern- and Wilhelmstrasse. (Compare Brisch, "Kandinsky," pp. 31-32.)

63. Palme, *Konstens Karyatider*, p. 42. See also Brisch, "Kandinsky," p. 31.

64. Kandinsky, "Rückblicke," p. XXII.

65. Freytag, quoted in Röthel, *KgW*, p. 436.

66. Johannes Eichner, who shared Münter's life from 1927 until her death in 1962, documented her career in his book *Kandinsky und Gabriele Münter, von Ursprüngen Moderner Kunst*. The book contains a valuable chronological table based on dated correspondence in the possession of Gabriele Münter, which has been indispensable in the reconstruction of events in Kandinsky's Munich experience.

67. Palme refers to this as a *nouveauté de Paris* (*Konstens Karyatider*, p. 42).

68. Eichner, *Kandinsky*, p. 39.

69. *Ibid.*

70. According to the official school flyer in the Lindsay collection, the hours were actually: 9 to 12 (*Kopfmodell*), 2 to 4

(*Aktmodell*) and 5 to 7 (*Abendakt*). Further, every Saturday evening there was sketching from 7 to 8. Men and women "of any age" were welcome to enroll. It was also possible to enroll for either the whole course, or for only selected sections. The cost for the full course was 30 marks.

71. "Der grosse künstlerische Ernst," wrote Freytag, "das pädagogische Geschick und die menschliche Reife des Mannes zogen immer mehr Kunstbeflissene an, so dass bei ihm immer reges Leben herrschte" (quoted in Röthel, *KgW*, p. 436).

72. Palme, *Konstens Karyatider*, pp. 41, 43.

73. See Eichner, *Kandinsky*, p. 38.

74. Freytag, quoted in Röthel, *KgW*, p. 436.

75. Palme, *Konstens Karyatider*, p. 41.

76. Brisch, "Kandinsky," pp. 32-33.

77. *Ibid.*

78. Letter of 2.10.03, Lindsay K/M letters.

79. This exhibition has been entirely overlooked by Röthel in *Kandinsky, das graphische Werk*, in which the August 1902 exhibition is given as the "third" exhibition, when in reality, the intervening Trübner-Corinth exhibition, in May 1902, must have been the third, and the August exhibition, the fourth (compare Röthel, *KgW*, p. 432). Brisch stated that Freytag recalled that Trübner and Corinth had exhibited at Phalanx, but was unable to document this fact ("Kandinsky," p. 31).

80. *KfA*, 15 June 1902, p. 426: "The 'Phalanx' offers in its third exhibition, organized for the month of May, a collective exhibition of works by Wilhelm Trübner and Louis [*sic*] Corinth, which is finding strong interest. By the former, essentially only minor works are displayed (horses' heads and female nude studies), which are nevertheless significant for the understanding of the newest phase in the development of this artist, which in its totality received an exhaustive treatment in these pages just recently (second May issue). In the fourteen larger and smaller works by Corinth [which are] displayed, one can trace his work back to the year 1893. We prefer to refrain from more detailed comment at this time in consideration of a larger publication we now have in preparation on this artist." ("Die 'Phalanx' bietet in ihrer für die Dauer des Mai veranstalteten dritten Ausstellung Kollektiv-Vorführungen von Werken Wilhelm Trübner's und Louis [*sic*] Corinth's, die starkes Interesse finden. Eigentlich sind's von dem Erstgenannten nur Kleinigkeiten [Pferdeköpfe und weibliche Aktstudien], die vorgeführt werden, aber doch bedeutsam für das Verständnis der neuesten Phase in der Entwicklung dieses Künstlers, die in ihrer Gesamtheit in diesen Blättern erst jüngst [zweites Mai-Heft] eine

erschöpfende Würdigung gefunden hat. An den vierzehn ausgestellten, grösseren und kleineren Werken Corinths kann man dessen Kunst bis ins Jahr 1893 zurückverfolgen. Ein näheres Eingehen darauf möchten wir zur Zeit hintanhalten im Hinblick auf eine bei uns in Vorbereitung befindliche grössere Veröffentlichung über diesen Künstler.")

81. The Trübner works reproduced in *KfA*, 15 May 1902, pp. 382-84, may have been the ones shown at Phalanx.

82. *KfA*, 1 May 1902, p. 359.

83. It is also possible that such connections were made through the Munich art dealer Littauer, who was among the first to handle Kandinsky's work and who was also the Munich distributor for the Russian art journal *Mir Iskusstva* (*KfA*, 15 March 1899, p. 191).

84. Also called Axel Gallen.

85. *KfA*, 1 September 1902, pp. 549-50.

86. *Ibid.*, 15 April 1902, pp. 319-20.

87. Here we find another testimonial to Stuck's qualities as a teacher (compare Chapter v).

88. Purrmann, "Erinnerungen" (in *Werk*), p. 368.

89. *KfA*, 15 February 1902, p. 238.

90. In 1906, Weisgerber was a member of the Café du Dôme group in Paris, with Purrmann (*Stuck Villa* catalog, p. 114).

91. Jean Sibelius (1866-1957) composed tone poems based on the sagas of the *Kalevala* epic (see Joseph Machlis, *Introduction to Contemporary Music* [New York: W. W. Norton and Co., 1961], p. 94).

92. Axel Gallen studied first at the school of the Finnish Art Society in Helsingfors, and then from 1884 in Paris at the Académie Julian and at Cormon's studio. By 1888, one of his early plein-air paintings was shown at the Salon. Acquainted with the Nabis, and strongly influenced by the work of Puvis de Chavannes, he began to develop the decorative monumental style that was to characterize the 1900 murals. (See also the catalog, *Secession, Europäische Kunst*, p. 37.)

93. G. Keyssner, "Russische Bilder," *KfA*, 1 December 1898, pp. 72-73.

94. *KfA*, 1 September 1902, p. 550.

95. Illustrated in *DK*, vi, 4 (January 1903), p. 152.

96. Among these may have been *Winter* (1902) and *Winter Landscape with five Crosses* (*Winterlandschaft mit fünf Kreuzen*) (1902), both illustrated in the catalog *Secession: Europäische Kunst*, nos. 39 and 40. In both, abstract qualities of design override concern with subject matter.

97. "Kalevala," *Encyclopedia Britannica*, xiii (1969), p. 191.

98. After reconstructing the dismembered bits of her son's body, Lemminkainen's mother chanted healing charms calling for the magical honey (an ancient symbol of rebirth) with which to annoint his body and restore him to life (see Elias Lönnrot, *The Kalevala*, prose trans. with foreword and appendices by Francis Peabody Magoun, Jr. [Cambridge: Harvard University Press, 1963], poem 15, pp. 87ff). In the painting under discussion, the magical powers are represented by wavy lines emanating from the heavens. It may be noted that wavy lines symbolic of similar powers are evident in Kandinsky's study for *All Saints* (1911), illustrated in Grohmann, *Kandinsky*, p. 73, no. 13.

99. Purrmann, "Erinnerungen" (in *Werk*), p. 368.

100. Brisch developed the idea of Kandinsky's use of fairy tale as a step toward abstraction in his dissertation, part II of chapter II, "Die Welt als Märchen" ("Kandinsky," pp. 136ff).

101. *Phalanx V and VI*: To my knowledge, neither catalogs nor reviews are extant of the fifth and sixth Phalanx exhibitions of the winter and spring of 1903. Neither Brisch nor Lindsay reported finding either, nor did I discover reviews or announcements in *Kunst für Alle* or *Dekorative Kunst*. However, Brisch reported that, according to Freytag, both Toorop and Zuloaga were represented in Phalanx exhibitions ("Kandinsky," p. 31). Both Jan Toorop (1858-1928), the exotic Dutch symbolist and Art Nouveau painter, and Ignacio Zuloaga (1870-1945), the flamboyant Spanish painter, were extremely popular at the turn of the century. Kandinsky commented especially on Zuloaga in his *Mir Iskusstva* review of 1902 (see Chapter VII).

102. Despite the mistaken and misleading announcement of the demise of the Phalanx in the December 1902 issue of *Kunst und Künstler* (p. 111): "The *Phalanx* has ceased its brief existence; it was not able to make a go of it, although the exhibitions of this artists' society were not without interest." ("Die 'Phalanx' ist nach kurzem Bestehen eingegangen; sie konnte es nicht zu Erfolg bringen, obwohl die Ausstellungen dieser Künstlervereinigung nicht des Interesses entbehrten.") The fact that the lead article in the next issue of *KuK* (January 1903) was by Hermann Schlittgen, who was himself to be involved in the very next Phalanx exhibition (the seventh, of May 1903, which included Monet), makes this announcement, which was included in the report from Munich, more difficult to understand. On the other hand, in his memoirs, Schlittgen claimed (erroneously) that the Phalanx collapsed after the exhibition in which he participated (H. Schlittgen, *Erinnerungen*, p. 280)! In a letter to Münter in May of 1904, Kandinsky recorded

that Schlittgen had written urging him to let Phalanx die, before it " 'kills you' " (letter of 4.5.04, Lindsay K/M letters).

103. *Katalog der VII. Ausstellung der Münchener Künstler-Vereinigung 'Phalanx,'* May-July 1903. Items 1-16: *Vétheuil, Les Iris d'eau, Le Mont Kalsaas, Les Falaises de Pourville, La Tamise à Londres, Prairie à Giverny, La Seine près D'Argenteuil, Une Allée sous-bois, Vétheuil, Jardin à Vétheuil, Le Ruisseau, Vétheuil—Effet gris, Terrasse, Parc de Monceau, Portrait de Mme. M., Le Dejeuner sous-bois*. The painting entitled *Terrasse* may well have been the now famous *Terrace at the Seaside Near Le Havre* (ca. 1867) in the collection of the Metropolitan Museum, New York.

104. The Cassirer exhibition was reported by Hans Rosenhagen in *KfA*, 1 May 1903, pp. 356-57. Brisch suggested that Kandinsky obtained the paintings through an art dealer, and that Kandinsky was at that time in the confidence of the art dealers, but he did not name any specifically ("Kandinsky," p. 30). As has been noted, Kandinsky probably knew Littauer by this time.

105. Kandinsky, "Rückblicke," p. IX. (The date of the Moscow exhibition at which Kandinsky saw this painting is uncertain. However, it is known that Monet's *Haystack—Sunset* was shown at the Munich Secession in 1900 [no. 195 in the catalog, *Internationale Kunstausstellung 1900* "Secession"].)

106. The theoretical acceptance of abstraction in the decorative arts is discussed in Chapter X.

107. Kandinsky, "Rückblicke," p. XV.

108. Letter of 22.11.03, Lindsay K/M letters.

109. Kandinsky and Freytag escorted the Prince through the exhibition (Freytag, quoted in Röthel, *KgW*, p. 433). Although works by Monet had been shown in Munich before (for example, there were two Monets in the 1897, 1899 and 1900 Secession exhibitions, and one in 1901), Freytag may have been correct in stating that this was the "first Monet exhibition in Munich."

110. Items 24-29: *Tryst (Stelldichein), Autumn Study (Herbststudie), Kochel on the Lake (Kochel am See), The Shadow (Der Schatten), Youth (Jüngling), Blue Lady (Blaue Dame)*.

111. Schlittgen was then already well known as an illustrator for the Munich periodical *Fliegende Blätter*. He was also a talented writer and had connections to the Munich symbolist group and to the poet Stefan George, whose portrait he painted.

112. Little is known about Vrieslander. He studied in Düsseldorf from 1897-98, and lived in Munich from 1901 to 1905. In the June 1900 issue of *DKuD*, a carpet designed by him was

illustrated (p. 421, color plate) which was freely abstract, somewhat after the style of Van de Velde. Later, he contributed to the Berlin expressionist periodical *Der Sturm* (in 1911).

113. L. Corinth, "Carl Strathmann," *KuK*, I (1902-03), pp. 255ff.

114. *Katalog der VIII. Ausstellung der Münchener Künstler-Vereinigung 'Phalanx,'* November-December 1903. The curious misspellings of the names of artists included in the portfolio of prints occur in the catalog of this exhibition.

115. G. J. Wolf, *Kunst und Künstler in München* (Munich: Heitz, 1908), pp. 112-14.

116. *Aufbruch* catalog, p. 217.

117. Endell, *Um die Schönheit*, p. 19.

118. Franz Wolters, in a review in *Kunst für Alle*, felt that Strathmann's painting was merely "reminiscent" of applied arts "in the noblest sense," but regretted the wasted effort which might better have been directed in the "right path" (whatever that might be), in *KfA*, 15 September 1904, p. 561. Wolf didn't appreciate Strathmann's significance either. Although he was attracted to Strathmann's work, he called it "half masterpiece, half *Kitsch*," and could not understand why this artist should "make fun" of his public (*KfA*, 1 June 1911, last page, signed G. J. W.).

119. Reported by Corinth in "Carl Strathmann," p. 258.

120. *Ibid.*

121. Reproduced in *KfA*, 1 January 1896, p. 104.

122. Kandinsky also used goldleaf occasionally, as for example, in the color woodcut *Das Goldene Segel* (1903), and in an untitled watercolor in the collection of the Guggenheim Museum (ca. 1910).

123. Kandinsky, *UGK*, p. 44.

124. Kandinsky's second Munich exhibition enterprise (1909-11).

125. Kubin in "Alfred Kubin's Autobiography" (*The Other Side*, New York: Crown Publishers, 1967), pp. xix-xx. Some members of the Sturmfackel were also members of the Elf Scharfrichter.

126. H. R. in *KfA*, 15 February 1902, p. 240. This was probably Hans Rosenhagen, the Berlin-based critic.

127. *Ibid.*

128. *Fünfzehn Faksimiledrücke nach Kunstblättern* (Munich: Hans von Weber Verlag, 1903).

129. Arthur Holitscher (1869-1939) was one of the original editors of *Simplicissimus*, a gifted journalist and friend of many illustrious writers including Frank Wedekind, Knut Hamsun and Thomas Mann. He was an early friend of Kubin. See Arens, *Unsterbliches München*, pp. 453ff, and *passim*.

130. A. Holitscher, "Alfred Kubin," in *KfA*, 1 January 1903, p. 163. It is not without significance that the review immediately followed the lead article by Ludwig Volkmann on "Das Geistreiche im Kunstwerk" (the spiritual-intellectual element in the work of art), an article which is discussed further in Chapter x.

131. *KfA*, 1 March 1904, pp. 268-70.

132. In the introduction to Friedrich Huch, *Neue Träume* (Munich: 1921) cited in Alfred Kubin, *Gedächtnisausstellung* (Munich: Kastner and Callwey, 1964), p. 45.

133. By Ferdinand Avenarius, editor of *Kunstwart*, which, as noted, had editorial offices in the first home of the Phalanx on Finkenstrasse. Kubin recalled that this was in 1903, in his "Autobiography," p. xli.

134. Kandinsky, *UGK*, p. 44.

135. A. Kubin, *Die Andere Seite* (Munich: Nymphenburger Verlagshandlung, 1968 [originally published in 1909], p. 140). The "Autobiography" was published only in the English edition previously cited.

136. *KfA*, 1 March 1904, p. 270.

137. The eleventh, April-May 1904.

138. *Ibid.*, p. 268.

139. *Stuck Villa* catalog, p. 115.

140. Compare Röthel, *KgW*, p. 433, where this artist is identified as the well-known Munich painter Karl Palmié (1863-1911). This would appear to be erroneous, although *KfA* was not typographically immaculate. In the same review, Rudolf Sick [*sic*] is listed as an exhibitor, whereas doubtless Rudolf Sieck (1877-1957) was intended. The remaining exhibitors were Alfred Bachmann (1863-1956) a noted land-and-seascapist, whose favorite motif was sunset; Hermann Pampel (1867-1935); Michael Linder; Eduard Muenke (Muencke? 1875-?) and Hans Schrader.

141. The others were Jules Leon Flandrin (1871-1947), Charles Guerin (1875-1939), Pierre Laprade (1875-1932), Jacqueline Marvel (?-1932) and Louis Sue (1875-1968). It is interesting in view of the crafts orientation of many Phalanx exhibitors (and in view of Kandinsky's later association with the Bauhaus) that Louis Sue was to become renowned as an Art Deco craftsman and designer. The show was announced in *KfA*, 15 May 1904, p. 388. The review appeared in *KfA*, 1 June 1904, p. 408 (signed by "A.H.").

142. The public generally failed to perceive the connections

between neo-impressionism and the more popular movement in arts and crafts.

143. The Munich critic Georg Jakob Wolf also reviewed this exhibition. See his *Kunst und Künstler in München*, pp. 126-31. He reported that, compared to an exhibition of minor French artists at Heinemann's, the Phalanx show was "significantly more valuable," but he, too, had reservations about the neo-impressionists, who he characterized as "romping about" at the Phalanx. "Van Rysselberghe paints, Signac experiments," he wrote, and he worried about Toulouse-Lautrec's morals. A few years later, the same critic was to launch a savage attack on Kandinsky's second art society (the Neue Künstlervereinigung) in a review published in *KfA*, 1 November 1910 (pp. 68-70). While admitting that he had once had great hopes for people like Kandinsky and Kubin, he now compared the *NKV* paintings to the work of *Morphium- oder Haschischtrunkene*. Interestingly enough, he suggested that Kandinsky's *Komposition II* be entitled "Color sketch for a modern carpet."

144. These were: Vereinigung Graphik München; Vereinigung graphischer Künstler; Künstlerinnen-Verein (not strictly graphics but a society for female artists); and Schule für zeichnende Künstler (*KfA*, 1 June 1904, p. 408).

145. *Ibid.*

146. R. Czapek, *Grundprobleme der Malerei* (Leipzig: Verlag Klinkhardt and Biermann, 1908). The significance of Czapek's book for the development of Kandinsky's thought is discussed in Chapter x.

147. There is considerable confusion about Treumann's first name. In this review he was cited as "Georg," but in the review of a later show by Kandinsky and Treumann at the Kunstverein (*KfA*, 1 September 1904, p. 554), he is identified as "Ernst." And in a still later article by Michel on graphic art in Munich, he is "R. Treumann." The latter would appear to be the correct identification as there is a Rudolf M. Treumann listed in *Thieme-Becker*, described as "painter and woodcut maker" (1873-1933). Kandinsky wrote of turning over the Phalanx papers to Treumann (no first name indicated) in a letter to Münter of 4.4.04 (Lindsay K/M letters). Interestingly

enough, Grabar recalled in his memoir that Rudolf Treumann had accompanied him, along with Anton Ažbè, Jawlensky and Werefkin, on a trip to Venice in 1897 (Grabar, *My Life* [Bowlt synopsis]).

148. *KfA*, 15 May 1903, p. 389.

149. *KfA*, 15 April 1902, pp. 324-25.

150. *KfA*, 1 June 1903, p. 407.

151. He had written to Gabriele Münter in some excitement that the Phalanx was to have a "retrospective" exhibition in two rooms of the Kunstverein the following winter, and that he and Treumann had been offered "a whole room for ourselves" immediately, which they had accepted despite the fact that July was the midst of the slow season. He wrote that he was going ahead with it anyway because in the fall Phalanx was to go on tour and other works of his were to be sent to Russia (letters of 19.7.04 and 21.7.04, Lindsay K/M letters). But there may have been another reason. According to Schmalenbach, works by Cézanne, Gauguin, Van Gogh and Matisse were all exhibited at the Kunstverein in Munich in 1904 ("Grundlinien des Frühexpressionismus" in *Kunsthistorische Studien* [Basel: 1941], p. 53). Can this have been the real incentive that brought Kandinsky to the Kunstverein?

152. *KfA*, 1 September 1904, p. 554.

153. *Ibid.* He also used the old saw once again about "drawing the last consequences of impressionism." Apparently Kandinsky's manner of composition by means of color spots or flecks was confused with the pointillist technique of the neo-impressionists.

154. Letter of 9.7.04, Lindsay K/M letters.

155. *KfA*, 1 February 1905, p. 213.

156. This Phalanx show, the twelfth then, and possibly the last, has not been recorded by Grohmann, Brisch, Lindsay or Röthel. In fact, Röthel referred to the eleventh as the "last enterprise of the Phalanx" (*KgW*, p. 435). Furthermore, a comment in one of Kandinsky's notebooks at the Städtische Galerie suggests that a Phalanx exhibition to include the work of "Liebermann, Slevogt, Hoffman [*sic*], Trübner, Corinth, Leistikow," was planned for the fall of 1904 (GMS 340, p. 9).

CHAPTER VII

1. The review appeared in *Mir Iskusstva*, no. 1-6, 1902, pp. 96-97. *Mir Iskusstva* (1899-1904) was backed by the wealthy Russian art patron, Savva Mamontov, and edited by

Sergei P. Diaghilev. It was a lavish publication in the tradition of Art Nouveau book-making. Artists connected with the editorial staff included Alexander Benois, Leon S. Bakst and

188

Valentin Serov. Oleg Maslenikov credited it with having "knit the modernist movement in Russian art into one cohesive force" (*The Frenzied Poets*, pp. 26f). The same issue that carried Kandinsky's review "Correspondence from Munich," also carried an article by Igor Grabar, a fellow student of Kandinsky at Ažbè's school. Possibly it was through Grabar that Kandinsky was given the commission for the review. Or, this might have come through the Munich art dealer, Littauer, who was the Munich representative for *Mir Iskusstva* (noted in *KfA*, 15 March 1899, p. 191), and with whom Kandinsky must have been acquainted by this time. Since completion of the manuscript for this book, an even earlier critical work by Kandinsky has come to light. It will be published in English translation in *Kandinsky The Complete Writings*, edited by Kenneth Lindsay and Peter Vergo (Viking Press, New York, in progress). The article was entitled "Kritika Kritikov," and appeared in *Novosti dnya*, 17 April 1901 (Moscow).

2. I am indebted to Kenneth Lindsay for the use of his personal translation, in typescript, of this review. In the following discussion, all quotations from Kandinsky's *Mir Iskusstva* review are from this typescript translation.

3. Compare *KfA*, 15 July 1901, p. 467, and *KfA*, 15 February 1902, p. 264. The original provocation had been published in *Tag* in April, 1901.

4. *Münchens 'Niedergang als Kunststadt'—eine Rundfrage von Eduard Engels.* (Munich: Bruckmann Verlagsanstalt, 1902), 92 pages. I am indebted to Werner Hofmann of the Hamburg Kunsthalle for providing me with a photocopy of this fascinating document.

5. See Konrad Lange's defense of modern art, "Die Freiheit der Kunst," in *KfA*, 1 February 1902, pp. 193-98.

6. Letter of 31.10.03, Lindsay K/M letters.

7. Herterich submitted two sketches for decorative murals, which were compared favorably by the *KfA* reviewer of the same show to the work of Puvis de Chavannes. See E. N. Pascent, "Die Sommer-Ausstellung der Münchener Secession," *KfA*, 1 August 1902, pp. 483-99.

8. He even referred the reader to a reproduction of the painting in *Mir Iskusstva*, no. 8-9 (1901). (Also reproduced in *KfA*, 1 August 1902, p. 452.)

9. E. N. Pascent, "Die Sommer-Ausstellung der Münchener Secession," *KfA*, 1 August 1902, pp. 488, 491. This review has the distinction of being almost the only humorous review published in *KfA* between 1896 and 1912! *Jenseits von Schön und Hässlich*, is the way the phrase reads in German.

10. Another clue to Zuloaga's appeal is found in Marianne von Werefkin's *Briefe*, p. 33. She wrote that in Zuloaga and Toulouse-Lautrec, "the drawing is only the completion of the color, that the color [in their work] has an inner value without reference to its surroundings. . . ."

11. In fact, Gandara's graphics had been shown in the 1899 Secession graphics exhibition (cf., *KfA*, 15 January 1899, p. 123).

12. Both of these were reproduced in *KfA*, 1 August 1902, pp. 452, 492. Opinions clashed over Gandara anyhow. While a review in *DK* in 1898 compared Gandara to Carrière, another a year later condemned his female portraits as "*Kitsch*" (*DK*, I, [March 1898], p. 266; and *DK*, II, no. 9 [June 1889], p. 94).

13. The persistence of such images or "image-moments" in Kandinsky's memory is discussed in Appendix B. But it may be noted here that this scene, or "image-moment," seems to have turned up three decades later in a 1930 painting called *Flatternd* (*Fluttering*), there reduced to the joyful rig of pennants, a sun symbol, one "flickering candle," and a schematic arch to represent the church (reproduced in Grohmann, *Kandinsky*, p. 378, no. 345).

14. See *KfA*, 1 February 1903, p. 224; and *KuK*, 1902-03, p. 151.

15. Leistikow submitted *From the Grunewald Colony* and *Skären*; von Hofmann, *Midday Magic*, *Myth*, and *Shepherds*.

16. Twelve paintings by von Hofmann were shown at Phalanx II, January-March, 1902.

17. Lichtenberger was also mentioned by Marianne von Werefkin in her *Briefe*, p. 33. She wrote as if she were personally acquainted with the artist. It is therefore possible that Kandinsky knew him as well, and chose this way to give the younger man a boost. Aman-Jean's *Fan* (*Fächer*) Sauter's *Morning Conversation* (*Morgen Unterhaltung*) and a *Study* (*Studie*) by Lichtenberger were reproduced in the official catalog of the *Internationale Kunstausstellung Secession*, Munich, 1902.

18. Pascent, "Sommer-Ausstellung," *KfA*, 1 August 1902, p. 487. ". . . nur gute Stucks," wrote Pascent, suggesting (though not stating) a pun on the German word "Stücke," meaning "pieces" or "works."

19. Erler's *Grauer Tag* (*Gray Day*), mural for a music room, was reproduced in *KfA*, 15 June 1903, p. 419.

20. Kandinsky, *UGK*, p. 136. "Böcklin sagte, dass ein richtiges Kunstwerk wie eine grosse Improvisation sein muss. . . ." It may be recalled that critics often wrote of the *geistige* con-

tent of Böcklin's work (see Chapter II); and that Kandinsky was to title many of his works "Improvisations," specifically describing them as "impressions of 'inner nature'" (*UGK*, p. 142).

21. Kandinsky, *UGK*, p. 135 (italics in original).

22. The painting was entitled *Wer hat dich, du schöner Wald*, a line from a popular song by Felix Mendelsohn-Bartholdy. See Georg Habich, "Die Jahres-Ausstellung im Münchener Glaspalast," *KfA*, 15 August 1902, pp. 509-18.

23. The reader may be reminded here that again and again in *UGK*, Kandinsky defended the right of the artist to use "any form" he found necessary, even the forms of reality (*UGK*, especially pp. 69-76).

24. See Chapters XI, XII, and Appendix B.

25. Purrmann, "Erinnerungen" (in *Werk*), p. 368.

26. These were *Girls on the Shore* (*Mädchen am Ufer*), *Old City* (*Alte Stadt*), *The Bright Air* (*Die helle Luft*), comprising items 119-121 in the official catalog.

27. Rosenhagen, "Die fünfte Ausstellung der Berliner Secession," *KfA*, 1 July 1902, pp. 433-43; and (pt. II) *KfA*, 15 July 1902, pp. 457-60.

28. *Ibid.*, p. 443.

29. Apparently, Anglada was not shown in Munich until 1903, and was not generally well known until after that. Kandinsky mentioned him as one of several colorists in a letter of 1903, more than a year later. Kandinsky wrote the letter from Venice in October of 1903, where he could have seen Anglada's *Evening Party* and *Three Dancing Gypsies*, later reported by Vittorio Pica to have been exhibited in Venice at that time (letter of 9.9.03, Lindsay K/M letters). A major article on Anglada first appeared in the pages of *Kunst für Alle* in 1912 (see Vittorio Pica, "Hermen Anglada Y Camarasa," *KfA*, 1 February 1912, pp. 197-204).

30. *The White Peacock* (*Der weisse Pfau*) and *Evening Party* (*Abendgesellschaft*) were reproduced in *KfA*, 15 July

1905, p. 471 and p. 201. They had been exhibited at Venice that year, and the reviewer referred to Anglada as "*dieser Farbenorgiast*." Kandinsky's *Bright Air* (*Helle Luft*) is reproduced in Grohmann, p. 349.

31. Lindsay also noted Kandinsky's preference for "nostalgic images" at this time, in his article "Graphic Art in Kandinsky's Oeuvre" (*Prints*), p. 244.

32. Anglada's *Spanish Peasants* (*Spanisches Landvolk*) was reproduced in *KfA*, 1 February 1912, but the actual date of the painting is not given there.

33. Shown in the 1903 Munich Secession exhibition along with two other Anglada works, and reproduced in *KfA*, 15 July 1903, p. 478.

34. See *KfA*, 1 February 1903, p. 224.

35. Lindsay, "An Examination of the Fundamental Theories," Appendix B, "List of Exhibitions," pp. 177-98a.

36. "H.," "Die zweite Ausstellung des deutschen Künstlerbunds" in *KuK*, July 1905, p. 411. The author was probably Emil Heilbut, then editor of *KuK*.

37. Michel, "Münchner Graphik: Holzschnitt und Lithographie," *DKuD*, XVI (1905), pp. 435-57.

38. *Ibid.*, pp. 450-51.

39. The print titled *Promenade* was actually the one called *Lady with Fan* (*Dame mit Fächer*) in Röthel, *KgW*, p. 4.

40. Kandinsky had in fact been in correspondence with Michel for some time. His name was mentioned in a list of correspondents in a letter from Kandinsky to Münter in the winter of 1904. (Letter of 20.2.04, Lindsay K/M letters.) Michel's article and the crucial significance of the woodcut for Kandinsky's breakthrough to abstraction are discussed further in Chapter XII.

41. Brisch, "Kandinsky," pp. 28-29.

42. Letter 4.11.02, Lindsay K/M letters.

CHAPTER VIII

1. Portions of this chapter and Chapter IX, much condensed, have appeared in P. Weiss, "Kandinsky: Symbolist Poetics and Theater in Munich," *Pantheon*, XXXV, 3 (July, August, September 1977), pp. 209-218. Until now this facet of Kandinsky's Munich experience has been largely ignored. The influence of French symbolism in painting and poetry on an international scale at the turn of the century has been documented in numerous important studies (for example, in Otto Stelzer's *Die Vorgeschichte der abstrakten Kunst* [Munich: R. Piper and Co., Verlag, 1964], Werner Hofmann's *Von der Nachahmung zur Erfindung der Wirklichkeit* (Cologne: M. DuMont Schauberg, 1970], and in Enid Lowry Duthie's *L'influence du symbolism française dans le renouveau poetique de l'allemagne. Les Blätter für die Kunst de 1892-1900* [Paris: Bibliothèque de la Revue

de la littérature comparée, 1933]). But specifically in Munich it was George, together with Wolfskehl, who was to transmit symbolist ideas and for a number of years to radiate a wide sphere of influence. Yet Grohmann did not mention Stefan George and his group in connection with Kandinsky, nor did he mention the symbolist theater movement in Munich. Brisch mentioned only casually the relationship between Karl Wolfskehl, an intimate friend of George, and Kandinsky. Selz, however, did connect the aesthetics of both George and Wolfskehl to the enthusiasm for "formal structure" amongst Munich's avant-garde, including Kandinsky (*German Expressionist Painting*, p. 180). Washton (Long), although concerned to emphasize symbolist influence on Kandinsky, mentioned the name of Stefan George only in passing, devoting her attention to the French symbolist influence of Maeterlinck and Maurice Denis, translations of whose work were, of course, available in Germany. Recently an unpublished study by Jonathan Fineburg has described in some detail Kandinsky's involvement during the months in Paris (in 1906-07) with the obscure yet curiously avant-garde publication *Les Tendances nouvelles*, with which a number of French symbolist writers were associated (e.g., a statement by the symbolist critic Gustav Geffroy appeared in the first issue in 1904) (see Jonathan Fineburg, "Kandinsky in Paris 1906-7," p. 81 and *passim*). Fineburg's study disputes the influence of George and Wolfskehl, unaccountably ignoring the two important references to George in the *Blaue Reiter* almanach (see below) and the friendship between Kandinsky and Wolfskehl documented not only in their correspondence and in the recollections of Gabriele Münter (see below), but also in correspondence between Wolfskehl and others associated with the *Blaue Reiter* almanach such as Kubin, Marc, and Klee (who records meeting Wolfskehl "at Münter's" in his diary for 1912 [*The Diaries of Paul Klee 1898-1918*, edited with an introduction by Felix Klee. Berkeley and Los Angeles: University of California Press, 1968, p. 272; see also pp. 293, 322]). The influence of Russian symbolism on Kandinsky has yet to be studied in depth, although its influence on his colleague Marianne Werefkin is the subject of a study by Jelena Hahl-Koch (*Marianne Werefkin und der russische Symbolismus, Studien zür Ästhetik und Kunsttheorie, Slavistische Beiträge*, vol. 24. Munich: Verlag Otto Sagner, 1967). None of these authors mentioned the symbolist theater movement which was very important in Munich, culminating in the Munich Artists' Theater in 1908, under the direction of Georg Fuchs (an early associate of George), and which, as will

be seen in Chapter IX, undoubtedly had a formative influence on the development of Kandinsky's ideas on the theater.

2. Kandinsky, *UGK*, p. 143: "neues geistiges Reich" and "Epoche des grossen Geistigen."

3. *Blätter für die Kunst, eine Auslese aus den Jahren 1892-98* (Berlin: G. Bondi, 1899), pp. 10-11: ". . . die GEISTIGE KUNST auf grund der neuen fühlweise und mache . . ." and ". . . eine glänzende wiedergeburt" [*sic*]. Hereafter, this periodical will be referred to as *BfdK*. Selections from it for the years 1898-1904 and 1904-09 were published by the same firm in 1904 and 1909 respectively.

4. Claude David, *Stefan George, sein dichterisches Werk* (Munich: Carl Hanser Verlag, 1967 [originally published in French, Paris, 1952]), p. 138. I am indebted to David's epic work for much of the information on George and his circle in this chapter.

5. Kandinsky, *UGK*, p. 132: "Es lebt, wirkt und ist an der Schöpfung der . . . geistigen Atmosphäre tätig."

6. David, *George*, p. 139, quoting Karl Wolfskehl in *BfdK*, 3. Folge, 1896. This "priest of the spirit" was to proclaim a "new realm" ("neues Reich").

7. Ernst Morwitz, "Stefan George" in *Stefan George Poems in German and English*, rendered into English by Carol North Valhope and Ernst Morwitz (New York: Schocken Books, 1967), p. 14. Not all critics agree with Morwitz, who was a close associate of George. E. K. Bennett ranks George after Hölderlin—still no mean position (*Stefan George* [New Haven: Yale University Press, 1954], p. 10). Hans Siegbert Reiss holds George "chiefly responsible for the revival of German poetry at the close of the nineteenth century" (*Encyclopedia Britannica*, X [1969], p. 218). Morwitz emphasized George's contributions to everyday language particularly. Besides his native tongues of German and French (his family had its roots in Alsace-Lorraine), and the usual Greek and Latin, George mastered Italian, Spanish, English, and Norwegian, producing outstanding translations from all of these languages during the course of his development. His fine ear for language led him to introduce more vowel sounds into the German poetic vocabulary and to intensify the musical qualities of the language to a high degree.

8. Two early representatives of symbolism in Austria and Germany were Hermann Bahr (1863-1934) and Hugo von Hofmannsthal (1874-1929). Bahr's two influential essays "Zur Kritik der Moderne" and "Die Überwindung des Naturalismus," were published in 1890 and 1891 respectively. Hofmannsthal's symbolist poetic drama "Der Tod des Tizian" was published in

191

the first issue of George's *Blätter für die Kunst,* in October 1892.

9. Compare C. David, "Stefan George und der Jugendstil," in *Formkräfte der deutschen Dichtung von Barock bis zur Gegenwart; Vorträge gehalten im Deutschen Haus, Paris 1961-1962* (Göttingen: Vandenhoeck and Ruprecht, 1963), pp. 211-28.

10. Wolfskehl wrote the first article on George to be published in Germany, "Stefan George," *Allgemeine Kunstchronik* (Munich), XVIII, 23 (1894), pp. 672-76. In 1898, he published another major article "Stefan George, zum Erscheinen der Oeffentlichen Ausgabe seiner Werke" in *Pan,* IV, 4 (1898), pp. 231-35. Some idea of Wolfskehl's stature may be obtained from the catalog of the exhibition arranged for the centenary of his birth in 1969: *Karl Wolfskehl 1869-1969 Leben und Werk in Dokumenten* (Darmstadt: Agora Verlag, 1969), hereafter cited as *Wolfskehl* catalog. After meeting George in 1893, Wolfskehl devoted the rest of his life to poetry and criticism. Forced to leave Germany in 1933, he lived out his exile in New Zealand where he produced the superb late poetry such as *Sang aus dem Exil,* which has been compared to the work of Eliot and Auden (*Wolfskehl* catalog, p. 40), and which only in the last twenty-five years has begun to attract attention and appreciation.

11. Arens, *Unsterbliches München,* pp. 397, 402.

12. David, *George,* p. 215.

13. Arens, *Unsterbliches München,* p. 387. See also the *Wolfskehl* catalog, which includes documentary evidence of the truly remarkable range of his acquaintances.

14. Arens, *Unsterbliches München,* pp. 402ff.

15. The letter (dated 6.11.26) appeared at auction in Basel in 1968. I am indebted to Kenneth Lindsay for this information. This was apparently the same letter mentioned and partially quoted by Edgar Salin in his George biography. According to Salin, most of Wolfskehl's letters from his artist friends were lost. Among those that survived, Salin mentioned one from Kandinsky in Dessau to Hanna Wolfskehl, recalling old times in the Römerstrasse (*Um Stefan George* [Munich: Helmut Küpper, 1954], p. 337, n. 204).

16. Kandinsky took the Ainmillerstrasse apartment in September 1908, according to Eichner, *Kandinsky,* p. 208. The Wolfskehls lived first in the Hermann-Schmidt-Strasse, then in the Leopoldstrasse from 1904 to 1909, and then in the Römerstrasse (*Wolfskehl* catalog, p. 158).

17. ". . . Der dunkle Sacharow der helle Alastair, die graulockige Ricarda—dann Kandinsky dessen Gesicht immer so wie so von chinesischer interessanter Schärfe und Feinheit vorkommt, der grosse Wölfflin die kleine Judith . . . Karl sah ganz assyrisch aus!" This letter is dated 20.3.1907 in the *Wolfskehl* catalog (p. 184) and *ca.* 20.3.1907 in *Wolfskehl und Verwey-Die Dokumente ihrer Freundschaft 1897-1946* (ed. Mea Nijland-Verwey [Heidelberg: Verlag Lambert Schneider, 1968]), p. 51 (hereafter cited as *Dokumente*). However, according to letters to the author from Frau Judith Köllhofer-Wolfskehl and Frau Dr. Mea Nijland-Verwey, daughters of the two poets (dated 2.12.75 and 6.9.76 respectively), this letter was originally dated only 3.20 (*without year*). Both women now believe it to belong in the 1913 sequence of letters. If the letter was indeed written during the *Fasching* season of 1907, it would in effect document a hitherto unrecorded return to Munich by Kandinsky who spent the year from May 1906 to June 1907 living in Sèvres near Paris. Other than the possible 1907 letter, the next published document is a letter from Kandinsky to Wolfskehl dated 31.12.1911. This letter clearly indicates a long familiarity (see below). The relationships between the Wolfskehls and Kandinsky, Klee, Kubin, Marc, Georg Fuchs and many others mentioned here have also been confirmed by Judith Köllhofer-Wolfskehl, in the letter to the author previously cited.

Among the personalities mentioned by Hanna Wolfskehl in her letter to the Verweys, the following are of special interest: Alexander Sacharov (1886-1963)—Russian artist, stage designer and dancer, later member of Kandinsky's second Munich exhibition society, the Neue Künstlervereinigung Münchens (the solo dances in Kandinsky's color opera, *Der gelbe Klang,* were probably written for him); Henri Le Fauconnier (1881-1946) —French artist and friend of Gleizes, Delaunay, Léger and Metzinger, also a member of Kandinsky's NKV group and author of the first preface, "Das Kunstwerk," in the catalog of the second exhibition of the NKV in 1910-11; Alastair—pseudonym for Hans Henning von Voigt (1889-1969), noted Jugendstil graphic artist who later became known as a dancing partner of Isadora Duncan (*Wolfskehl* catalog, p. 340); Ricarda Huch (1864-1947)—noted German author and scholar, who was one of Munich's brightest stars at that time and a close friend of the Wolfskehls (though she surprised everyone by turning down an invitation to be presented to the "Master" [George] with the response that if he wished to meet her, he could come to *her*) (see *Wolfskehl* catalog, pp. 272-75); Heinrich Wölfflin (1864-1945)—the noted art historian, who,

though a frequent visitor at the Wolfskehls, was not a permanent resident of Munich until 1912, when he became a professor at the university there. David has pointed out that these Carnival festivals had, for a time, an almost pedantically pedagogic function as demonstrations of the Nietzschean idea of creative inspiration through Bacchic ecstasy (*George*, pp. 225, 459ff). George would appear as Caesar or Dante, while Wolfskehl once dressed as Dionysus. Nearly every reminiscence of Munich at the turn of the century includes descriptions of these festivals, the most famous accounts being those of Franziska Reventlow in her *roman à clef, Herrn Dames Aufzeichnungen,* and Oscar A. H. Schmitz in *Dämon Welt* (compare *Wolfskehl* catalog, pp. 63, 180f, 284).

18. This observation has also been made by the editor of the *Wolfskehl* exhibition catalog and is cited in the catalog, p. 334, where letters from Kandinsky to Wolfskehl of 1911 and 1913 are also quoted.

19. Dauthendey had published his poetry in the *Blätter für die Kunst* as early as 1894. See *Wolfskehl* catalog, p. 327; and Kubin, "Autobiography," p. xxv.

20. Schmied, *Kubin*, p. 12. Subsequently, Kubin married a sister of Oskar Schmitz (in the autumn of 1904).

21. David, *George*, pp. 424, 460; also *Wolfskehl* catalog, p. 334, and *passim*.

22. *Wolfskehl* catalog, p. 131. Behrens worked closely with Hanna Wolfskehl's father, Willem de Haan, preparing the opening ceremonies for the Darmstadt Artists' Colony in 1900-01 (cf. Chapter, VI, n. 48 and Chapter IX, n. 15). George was also personally acquainted with the symbolist painter Ludwig von Hofmann, to whom he dedicated two poems in his *Tapestry of Life* ("Feld vor Rom" [Plane before Rome] and "Südliche Bucht" [Southern Harbor]). Von Hofmann exhibited at the second Phalanx in 1902. Among other artists with whom George was acquainted were the noted Munich Jugendstil artist Thomas Theodor Heine, who designed decorations for *Blätter für die Kunst*, and the Russian-German Henry von Heiseler who was a friend of August Endell, and whose literary efforts were also published in the *Blätter*.

23. It may be recalled that it was in fact Wolfskehl who gave the funeral oration for Obrist in 1927 (see Chapter IV). Judith Köllhofer-Wolfskehl has also confirmed the close relationship between her father and Obrist (and Obrist's friend Wilhelm von Debschitz), noting that it dated from well before 1909 (letter to the author, 2 December 1975).

24. Marie Buchold, "Einige Bücher und Persönlichkeiten,

die für mein Leben wichtig waren," in *Mitteilungen des Bundes der Schülerinnen und Freunde von Schwarzerden*, November 1970, pp. 6-9. I am indebted to Antje Lemke of Syracuse University for bringing this memoir to my attention.

25. Salin, *Um Stefan George*, pp. 204-05. Also confirmed by Judith Köllhofer-Wolfskehl, letter to the author, 2 December 1975.

26. The letter is quoted in *Wolfskehl* catalog, p. 335.

27. "An Kandinsky" in a translation by Wolfskehl was then published in Kandinsky's Sturm catalog, *Kandinsky—1901-1913.* Hanna Wolfskehl's letter of January 1913 to the Verweys conveys some of the excitement engendered by the poem: "Karl translated his part for Kandinsky! He was sweet and proud about it!" (*Dokumente*, p. 110). In the original German, Kandinsky's letter to Verwey reads: ". . . Eine Anerkennung eines Künstlers (d.h. i. künstlerischer Form) ist eine ganz grosse Freude, wie man sie nicht oft erleben kann. Sie ruft eine Geistesverwandtschaft hervor und im Namen *dieser* Verwandtschaft drücke ich herzlich Ihre Hand." (Kandinsky to Verwey, 31.1.1913, in *Dokumente*, p. 111.) The poem is reproduced in *Dokumente*, p. 113 (German) and p. 344 (original Dutch text).

28. For Wolfskehl's translation of the poem, see Appendix D. The letter Kandinsky wrote to Wolfskehl (12.9.1913) requesting permission to use his translation of the poem in the catalog is partially quoted in the *Wolfskehl* catalog, p. 336. It is apparent from the tone of the letter that a friend's permission in such matters is taken for granted, for he admits that it is already being set in type with the translator's signature "K.W." In this, Kandinsky demonstrated his characteristic sensitivity, knowing that Wolfskehl usually preferred that only his initials be used in such cases. Kandinsky also notes that he is working on the "Russian edition of the *Geistige*" [*sic*], which is to appear in Moscow "very soon."

29. Eichner, *Kandinsky*, pp. 55-56.

30. I am indebted to Lindsay for also sharing with me his personal correspondence with Münter.

31. Some of these letters are quoted in *Wolfskehl* catalog, pp. 331-34.

32. Franz Marc, *Briefe aus dem Felde* (Berlin: Rembrandt-Verlag, 1959), especially pp. 17, 112, 129-31, and *passim*.

33. Given the fact that Wolfskehl was almost fanatically devoted to George (to whom he always referred as "*der Meister*"), and the fact that he knew Kandinsky rather well, it is scarcely likely that George's aesthetics were not the subject of

many a discussion between Wolfskehl and Kandinsky, or that Kandinsky did not read at least some of George's works.

34. *Transition*, no. 27, 1938, reprinted in Kandinsky, *Concerning the Spiritual in Art*, p. 91.

35. Kandinsky, *Klänge* (Munich: Piper and Co., 1913).

36. Kandinsky, "Mes gravures sur bois," *XXᵉ Siècle*, xxvii, 27 (December 1966), p. 17 (originally published in *XXᵉ Siècle*, no. 3 [1938]).

37. Letters of 2.9.03 and 12.9.03, Lindsay K/M letters. *White Cloud* is reproduced in Grohmann, p. 403, no. 647.

38. Kandinsky, *Stikhi bez slov* [*Poems without Words*] (Moscow: Stroganoff, ca. 1904). H. K. Röthel assigned 1903 as the date for this album on the basis of Eichner's information that Kandinsky was in Moscow, where it was printed, in September and October of 1903, but not in the fall of 1904 (the date of publication suggested by Grohmann and others). However, according to Eichner, Kandinsky was in Odessa in the fall of 1904. He may well have laid plans for the series during the 1903 visit, and delivered or sent the cuts during the course of the following year. Furthermore, while letters in the summer of 1904 report feverish activity in the making of woodcuts, this activity is scarcely mentioned in the 1903 letters. That he may not have written to Münter from Moscow in 1904 is scarcely to be taken as conclusive proof that the album was not published that year. (Compare Röthel, *KgW*, p. 20.)

39. Furthermore, in 1911, the Russian periodical, *Apollon*, to which Kandinsky had contributed reviews in 1909-10, published poems by Stefan George as well as a major article on him. (*Apollon*, no. 3 [March, 1911], pp. 41, 36; and no. 4 [April 1911] ["Stefan George, His Times and His School" by Joh. von Guenther], p. 48.)

40. "You reached the hearth . . ." from *The Year of the Soul*, in Kandinsky, *DBR*, pp. 240-41. The other compositions in the almanach were "Herzgewächse" by Maurice Maeterlinck, set by Arnold Schönberg; and "Aus dem 'Glühenden'" by Alfred Mombert, in a setting by Alban Berg.

41. Schönberg set the following George songs to music: "Ich darf nicht dankend" from *Das Jahr der Seele* (*Two Songs, Op. 14*, 1907-08); "Litanei" and "Entrückung" from the *Siebente Ring* (*String Quartet No. 2 in F Sharp Minor, Op. 10*, with voice, 1907-08); *15 Poems from the Buch der Hängenden Gärten, Op. 15* (1908-09); and also "Seraphita" by Ernest Dowson, translated by Stefan George (*Four Songs, Op. 22*, for voice and orchestra, 1913-16). See Josef Rufer, *The Works of Arnold Schönberg* (New York: Free Press of Glencoe, 1963).

42. A. Schönberg, "Das Verhältnis zum Text" in Kandinsky, *DBR*, p. 74.

43. The woodcut was apparently based on an earlier tempera painting of the same title which had been exhibited at the Phalanx, according to Grohmann, *Kandinsky*, p. 329. The date of 1903 for the woodcut is given in Röthel, *KgW*, p. 14.

44. See the catalog *Melchior Lechter—Gedächtnisausstellung zur hundersten Wiederkehr seines Geburtstages* (Münster: Westfälischer Kunstverein, 1965). Reproduced in *DKuD*, xiii (1903-04), pp. 2-3.

45. For example, Andre Gide's description, quoted in Morwitz, "Stefan George," *Poems*, pp. 15-16. See also F. Sieburg, "Stefan George," *Die grossen Deutschen* (Berlin: Ullstein, 1957), iv, pp. 277-92. Perhaps the most famous description of George's appearance is in Salin's biography (*Um Stefan George*, pp. 11-12).

46. Karl Bauer (1868-1942) made a career of portraying "geistig bedeutende Persönlichkeiten" (spiritually significant personalities) and had been producing portraits of George (including photographic portraits) since 1893. He also contributed work to *Blätter für die Kunst*. See *Wolfskehl* catalog, p. 129; also the catalog *Stefan George 1868-1968—Der Dichter und sein Kreis*, eine Ausstellung des Deutschen Literarchivs im Schiller-Nationalmuseum Marbach a. N. (Munich: Kösel Verlag, 1968), pp. 60, 80ff.

47. The picture was so described in the review by Georg Habich, "Münchener Frühjahr-Ausstellungen," in *KfA*, 15 April 1902, p. 323. However, no illustration accompanied the review.

48. See Chapter iii and Appendix B.

49. It is also interesting to note that "St." is the German abbreviation for "Stefan," as well as the German (and English) abbreviation for "Saint."

50. Appendix B includes a further discussion of the St. George motif in Kandinsky's oeuvre.

51. By Claude David, "Stefan George und der Jugendstil" (in *Formkräfte*), pp. 211-28. See also Jost Hermand, *Stilkunst um 1900* (Berlin: Akademie-Verlag, 1967), especially pp. 226-36, and *passim*. Hermand prefers the term "Stilkunst" to "Jugendstil" and emphasizes the relationship of neo-impressionism to the general stylistic tendency at the turn of the century (as did Meier-Graefe in his 1904 *Entwicklungsgeschichte der Modernen Kunst*). Nine George poems were included in Hermand's anthology, *Lyrik des Jugendstils* (Stuttgart: Reclam, 1964).

52. See Roswitha Baurmann, "Schrift" (in *Jugendstil*), pp. 202-05. It is interesting that from 1897 to 1907 George en-

trusted the design of his publications to the artist Melchior Lechter (1865-1937) who is credited by Baurmann and others with being the first to introduce the typographical ideas of William Morris and the Kelmscott Press to Germany.

53. Kandinsky, *DBR*, p. 158.

54. The Bauhaus later followed George's lead in publishing its quarterly without capital letters and in a plain, modern type face. See *Bauhaus: zeitschrift für gestaltung*, 1926-29, 1931. Kandinsky was one of the editors in 1931.

55. Hermand has cited as an excellent example of this effect, the poem "Rosenfest" from *Algabal*, in which the short four- and five-syllable lines and recurrent alliteration results in a scintillating effect comparable to that of a neo-impressionist painting (*Stilkunst*, p. 231).

56. David, *George*, p. 124.

57. See Hermand, *Stilkunst*, pp. 231-35; also the excellent essay by David, "Stefan George und Jugendstil" (in *Formkräfte*), in which the parallels between George's poetry and Jugendstil art are analyzed in greater detail.

58. Poetry may, of course, be interpreted on many different levels; primary consideration here is given to the obvious visual images which lend themselves to artistic illustration. Perhaps it should be noted that there were numerous philosophical points on which Kandinsky and George would not have agreed. Kandinsky never shared George's almost fanatic nationalism (which, in the end, the poet must have regretted, dying in voluntary exile in Switzerland in 1933). Nor did Kandinsky share George's apparent antifeminist bias, nor the poet's ultimate rejection of modern music. Each had his own genius. The attempt here has been to suggest some constructive (and, it is to be hoped, instructive) comparisons.

59. The floral imagery of much Jugendstil art is a primary characteristic (see e.g., Schmalenbach, *Jugendstil*, pp. 27, 33, and *passim*).

60. Unfortunately, very few translations of George poems are available. The major work of translation by Marx and Morwitz often departs so radically from the original that it is impossible to use it for the purpose of comparing visual images (see *The Works of Stefan George*, rendered into English by Olga Marx and Ernst Morwitz [Chapel Hill: University of North Carolina, 1949]). Therefore, unless otherwise stated, the translations in the text are my own, in which I have endeavored to render the image primarily, without hope of retaining the music of the original.

Komm in den totgesagten park und schau:
Der schimmer ferner lächelnder gestade ·
Der reinen wolken unverhofftes blau
Erhellt die weiher und die bunten pfade.
Dort nimm das tiefe gelb · das weiche grau
Von birken und von buchs · der wind ist lau ·

Die späten rosen welkten noch nicht ganz ·
Erlese küsse sie und flicht den kranz ·

Vergiss auch diese lezten astern nicht ·
Den purpur um die ranken wilder reben
Und auch was übrig blieb von grünem leben
Verwinde leicht im herbstlichen gesicht.

61. The motif is more clearly to be seen in the color drawing which preceded the woodcut. Reproduced in Röthel, *KgW*, p. 467, no. 6.

62. Assuming for a moment that he did have this poem in mind, the black background of both the color drawing and the print might refer to the autumnal mood of the "park they say is dead." The tension between the black ground and the light outlines of the motif parallels the tension created in the poem by the juxtaposition of motifs of death in nature, and life in memory and art. (Kandinsky did an extensive series of tempera paintings on black cardboard, many of which, as has been previously observed, served as sketches for subsequent woodcuts.)

63. For George, the "rising year" refers to late summer or autumn in which he finds gaiety in sadness, life in death. Compare Robert M. Browning, *German Poetry, A Critical Anthology* (New York: Appleton-Century-Crofts, 1962), p. 298.

Es lacht in dem steigenden jahr dir
Der duft aus dem garten noch leis.
Flicht in dem flatternden haar dir
Eppich und ehrenpreis.

Die wehende saat ist wie gold noch ·
Vielleicht nicht so hoch mehr und reich ·
Rosen begrüssen dich hold noch ·
Ward auch ihr glanz etwas bleich.

Verschweigen wir was uns verwehrt ist ·
Geloben wir glücklich zu sein
Wenn auch nicht mehr uns beschert ist
Als noch ein rundgang zu zwein.

64. Letter of 16.6.03, Lindsay K/M letters.

65. Published with French title in Kandinsky, *Xylographies*, with an introduction by Gérôme-Maësse (Paris: Edition des Tendances Nouvelles, Organe officiel de l'Union Internationale des Beaux-Arts et des Lettres, 1909).

66.

> Mühle lass die arme still
> Da die haide ruhen will.
> Teiche auf den tauwind harren ·
> Ihrer pflegen lichte lanzen
> Und die kleinen bäume starren
> Wie getünchte ginsterpflanzen.
>
> Weisse kinder schleifen leis
> Überm see auf blindem eis
> Nach dem segentag · sie kehren
> Heim zum dorf in stillgebeten ·
> Die beim fernen gott der lehren ·
> Die schon bei dem naherflehten.
>
> Kam ein pfiff am grund entlang?
> Alle lampen flackern bang.
> War es nicht als ob es riefe?
> Es empfingen ihre bräute
> Schwarze knaben aus der tiefe. .
> Glocke läute glocke läute!

67. Eichner, *Kandinsky*, p. 205.

68. Brisch, "Kandinsky," p. 169, and in the Appendix, p. 29. On close inspection, it will be observed that the mill itself is not even delineated, but is only disassociated from the background by means of a clever array of clouds. This may be taken as an artistic equivalent of a verbal pun.

69. Kandinsky's *Sturm Glocke* (reproduced in Grohmann, p. 350, no. 14) might also have been inspired by an allegorical painting by the French painter Albert Maignan (1845-1908). Also entitled *Storm Bell* (ca. 1888), it had been reproduced in *KfA*, 15 January 1902, p. 191. Kandinsky's remarkable visual memory and his often radical transformations of such images are discussed in Appendix B.

70.

> Sie kam allein aus fernen gauen
> Ihr haus umging das volk mit grauen
> Sie sott und buk und sagte wahr
> Sie sang im mond mit offenem haar.

> Am kirchtag trug sie bunten staat
> Damit sie oft zur luke trat. .
> Dann ward ihr lächeln süss und herb
> Gatten und brüdern zum verderb.
>
> Und übers jahr als sie im dunkel
> Einst attich suchte und ranunkel
> Da sah man wie sie sank im torf—
> Und andere schwuren dass vorm dorf
>
> Sie auf dem mitten weg verschwand. .
> Sie liess das knäblein nur als pfand
> So schwarz wie nacht so bleich wie lein
> Das sie gebar im hornungsschein.

71. Literally, "February light," the light of the February moon, the month associated with rites of purgation and the cult of the dead. I am indebted to Gerd Schneider of Syracuse University for discussing the translation and usage of these archaic forms with me.

72. *The Birds* was published in the album *Xylographies* of 1909. The George poem reads:

> Weisse schwalben sah ich fliegen ·
> Schwalben schnee- und silberweiss ·
> Sah sie sich im winde wiegen ·
> In dem winde hell und heiss.
>
> Bunte häher sah ich hüpfen ·
> Papagei und kolibri
> Durch die wunder-bäume schlüpfen
> In dem wald der Tusferi.
>
> Grosse raben sah ich flattern ·
> Dohlen schwarz und dunkelgrau
> Nah am grunde über nattern
> Im verzauberten gehau.
>
> Schwalben seh ich wieder fliegen ·
> Schnee- und silberweisse schar ·
> Wie sie sich im winde wiegen
> In dem winde kalt und klar!

73. C. M. Bowra, *The Heritage of Symbolism* (New York: Schocken, 1961), pp. 103-04.

74. For further indications as to the origin of this motif in Kandinsky's work, see Appendix B.

75. Brisch pointed out the possible relationship between the earlier color drawing *White Cloud* (1902), in which a large

white area dominates and sets the mood of the picture, and the *White Sound* (*Kandinsky*, Appendix, p. 16). The George poem reads:

> Dass ich für sie den weissen traum ersänne. .
> Mir schien im schloss das herbe strahlen tränken
> Und blasse blütenbäume nur umschränken
> Dass er mit zweier kinder frühtag ränne:
>
> Ein jedes einen schlanken strauss umschlänge
> Hell-flitternd wie von leichtgeregter espe
> Daraus als wimpel eine silber-trespe
> Hoch über ihre schwachen stirnen schwänge
>
> Und beide langsam kämen nach dem weiher
> Auf breitem marmelstiege manchmal wankend
> Bis bei dem flügelschlag der nahen reiher
> Der arme sanfte bürde heftig schwankend
>
> Duft-nebel wirbelte von kühlen narden
> Mit denen die Vereinten höherem raume
> Entgegenschwebend immer lichter warden—
> Bald eines mit dem reinen äther-flaume.

76. Brisch, *Kandinsky*, p. 202.

77. The motifs of the rowboat, the Rhine, the medieval lady, and the dragon are all to be found in Kandinsky's *Poems without Words*.

78. David, "George und Jugendstil," p. 223. It is interesting to note that a contemporary critic in attacking Kandinsky's work at the second exhibition of the Neue Künstlervereinigung in 1910, suggested that a more suitable title for Kandinsky's *Composition II* would be "Farbenskizze für einen modernen Teppich" (Color sketch for a modern carpet) ("G.J.W." in *KfA*, 1 November 1910, p. 70)!

79.

> Hier schlingen menschen mit gewächsen tieren
> Sich fremd zum bund umrahmt von seidner franze
> Und blaue sicheln weisse sterne zieren
> Und queren sie in dem erstarrten tanze.
>
> Und kahle linien ziehn in reich-gestickten
> Und teil um teil ist wirr und gegenwendig
> Und keiner ahnt das rätsel der verstrickten. .
> Da eines abends wird das werk lebendig.
>
> Da regen schauernd sich die toten äste
> Die wesen eng von strich und kreis umspannet
> Und treten klar vor die geknüpften quäste
> Die lösung bringend über die ihr sannet!
>
> Sie ist nach willen nicht: ist nicht für jede
> Gewohne stunde: ist kein schatz der gilde.
> Sie wird den vielen nie und nie durch rede
> Sie wird den seltnen selten im gebilde.

80. Letter of 31.1.04, Lindsay K/M letters.

81. Kandinsky, *UGK*, p. 78. Cf. Rose-Carol Washton Long, "Kandinsky and Abstraction: The Role of the Hidden Image," *Artforum*, June 1972, pp. 42-49; also by the same author, "Kandinsky's Abstract Style: the Veiling of Apocalyptic Folk Imagery," *Art Journal*, XXXIV, Spring 1975, pp. 217-28. Washton-Long's studies emphasize the role of French symbolism and theosophy in the development of Kandinsky's concept of "veiling" the image.

82. Kandinsky, *UGK*, p. 123.

83. *Fugue* is reproduced in Röthel, *KgW*, p. 123, while *Archer* is reproduced in the same work, p. 159.

CHAPTER IX

1. Walter Grohmann, *Das Münchner [sic] Künstlertheater in der Bewegung der Szenen und Theaterreformen* (Berlin: Selbstverlag der Gesellschaft für Theatergeschichte, 1935 [dissertation, Ludwig-Maximilians-Universität München]), pp. 124-25. (Walter Grohmann is not to be confused with Will Grohmann, the author of the Kandinsky monograph previously cited.)

2. Kandinsky, *UGK*, pp. 125, 56, 45, n. 1 and *passim*.

3. Kandinsky, "Über Bühnenkomposition," *DBR*, pp. 189-208 (hereafter cited as *BK*), 209-29.

4. The essay on the abstract stage synthesis originally appeared in *Staatliches Bauhaus in Weimar 1919-23* (Weimar-Munich: Bauhaus-Verlag). It was republished in Kandinsky, *EuKuK*, pp. 79-83. In the fragment of *Violett* published in the Bauhaus quarterly, Kandinsky noted that it had been composed in the summer of 1914 (*bauhaus* 3, July 1927, p. 6). *Der gelbe Klang* must have originated prior to 1912, the publication date of the *Blaue Reiter* almanach. According to Will Grohmann, *Schwarz und Weiss* and *Grüner Klang* were written in Russian

in 1909 (Grohmann, *Kandinsky*, p. 413). The notebook GMS 415, at the Städtische Galerie, contains handwritten transcripts (mostly in German) of two plays. One is clearly titled "Bühnenkomposition III, Schwarz und Weiss." The other is entitled only "Bühnenkomposition I," and, in parts, bears a close resemblance to *Der gelbe Klang*.

5. See Troels Andersen, "Some Unpublished Letters by Kandinsky," *Artes*; *Periodical of the Fine Arts*, II (October 1966), pp. 109 n. 9, 110 n. 10. According to Andersen, Kandinsky was also editor of another periodical, *Iskusstvo*, which was originally the organ of the "Theater and Music Department" of Narkompros and subsequently the "Department of Fine Arts" (p. 99). Andersen also quotes from a résumé of a lecture given by Kandinsky in 1920 in which he recalled his own experiments in synthetic art "while abroad" with a "young musician and a dancer" (p. 106, cf. *Vestnik rabotnikov iskusstvo*, no. 4-5, Moscow, 1921, pp. 74-75). Andersen surmises that these were probably the composer, Thomas von Hartmann, and the dancer, A. Sacharov, and that the experiments were related to preparations for the composition of *Der gelbe Klang*. In the lecture, Kandinsky indicated that the Institute of Art Culture was conducting similar experiments in artistic synthesis. It is also interesting to note that in 1921, Kandinsky was named chairman of a subcommittee (of a special committee established by Lunacharsky on "science and art") known as the "physio-psychological section" (p. 108).

6. This was the only one of Kandinsky's dramatic efforts to be performed during his lifetime. (For reproductions of five designs for this production, see *50 jahre bauhaus* catalog, p. 99.) *Der gelbe Klang* was produced for the first time in May 1972, at the Guggenheim Museum by ZONE, Theater of the Visual (associated with the Massachusetts College of Art, Boston). Unfortunately, the production neither adhered to Kandinsky's original instructions (which, as will be seen, were quite explicit), nor revealed any familiarity with the theatrical (or musical) possibilities available to Kandinsky at the time of composition.

7. Kandinsky's possible relationship to the theater reform movement in Munich was touched on fleetingly by Klaus Lankheit in his "Wissenschaftlicher Anhang," *DBR*, pp. 281-83. However, the actual connection with the Munich Artists' Theater was apparently not recognized. Unfortunately the English edition of this work published in 1974 by Viking Press has further obscured the facts (*The Blaue Reiter Almanac Edited by Wassily Kandinsky and Franz Marc*. New documentary edition edited and with an introduction by Klaus Lankheit. The Documents of 20th-Century Art. New York: The Viking Press, 1974, hereafter cited as *DBR*/Viking). In the latter, the word *Künstlertheater*, which had a very specific meaning, as will be shown, was translated loosely as "artistic theater," with lower case letters (cf. *DBR*/Viking, pp. 33-34). Brisch mentioned briefly, in a footnote, an association between Hugo Ball and Kandinsky, in regard to "an artists' theater," also apparently without realizing that *the* Munich Artists' Theater was involved ("Kandinsky," p. 353). Will Grohmann considered Scriabin to have been the primary source for Kandinsky's color-tone compositions (*Kandinsky*, p. 56), while others have emphasized the influence of French symbolist theater, especially that of Maeterlinck. Certainly Maeterlinck, whose work was specifically mentioned by Kandinsky in *UGK* (pp. 44, 46, 137), must have exercised an important influence on him (as rightly pointed out by Washton-Long in "Vasily Kandinsky," pp. 116-26). Maeterlinck indeed was already an international force by the time his *Schatz der Armen* was translated into German and illustrated by Stefan George's good friend Melchior Lechter in 1898, and no doubt his influence was felt by those involved in the Munich Artists' Theater as well. George's friend Wolfskehl owned a copy of *Schatz der Armen*, presented to him by Lechter on the occasion of his marriage in 1898 (cf. Wolfskehl catalog, p. 167). Similarly, Scriabin's work was also known to Kandinsky who in 1911 urged Leonid Sabaniev, a follower of Mussorgsky, to write an essay on Scriabin's *Prometheus* for *Der Blaue Reiter* almanach (cf. Lankheit, *DBR*, p. 267; also *DBR*/Viking, p. 42, where Lankheit's remarks are somewhat expanded). Kandinsky had also mentioned Scriabin several times in *UGK* (pp. 48, 63, 126). Scriabin's ideas on the relationship between colors and tones must have been very important indeed for Kandinsky. However, the intention in the present chapter is to illuminate the theatrical rather than the musical sources that were operative in Kandinsky's Munich environment. The fascinating dimensions of his excursions into the musical theories of Scriabin, Schönberg, and others (such as Kulbin and Sabaniev) must be left for another study.

8. Compare Julius Bab, *Das Theater der Gegenwart* (Leipzig: J. J. Weber, 1928), pp. 115-16. See also Chapter VI (Phalanx I).

9. By 1905 Reinhardt was acknowledged the most talented (and perhaps most controversial) director in Germany. See Heinrich Braulich, *Max Reinhardt—Theater zwischen Traum*

198

und Wirklichkeit (Berlin: Henschelverlag, 1969), pp. 58-62. By 1906, Ernst Stern was working with Reinhardt (see Seling, *Jugendstil*, p. 396).

10. *Stuck* catalog, p. 114.

11. *Ibid.* While Salzmann is reported to have been active in designing light-theater at Hellerau from 1910, the main building containing the large Festsaal (with its 3,000 electric lights!) was apparently not opened officially until June 1912. (See the description by E. Haenel, "Die Schulfeste der Bildungsanstalt Jaques-Dalcroze in Hellerau," in *KfA*, 1 October 1912 [suppl., pp. ii-iii].)

12. Adolphe Appia, *Die Musik und die Inscenierung* (Munich: Bruckmann, 1899). The walls from floor to ceiling, and the ceiling, of the Hellerau theater were draped in plain muslin, behind which were banks of lights which could be adjusted for color and intensity during performance. Julius Bab described a 1913 lighting arrangement by Salzmann at Hellerau as tending toward "wholly unrealistic theater, a pure art of expression" (in Bab, *Theater*, p. 174). Compare also Michael Sadleir [*sic*], *Michael Ernst Sadler 1861-1943: A Memoir by his Son* (London: Constable, 1949), p. 243, where the "luminous" indirect lighting is described. (Sadleir was an eccentric spelling of the family name Sadler, adopted for a time by the son to distinguish himself from his well-known father, the British educator Michael Ernst Sadler.)

13. In fact, the name Jaques-Dalcroze appears in a Kandinsky notebook of about 1908 (GMS 328, p. 86), which is preserved at the Städtische Galerie. The notebook also contains sketches apparently intended for stage settings. In M. Sadleir's account of his visit to Kandinsky at Murnau in 1912, he recalled that he and his father travelled directly from Munich to Dresden to see the Dalcroze school. The implication is inescapable that they did so on Kandinsky's recommendation. (Compare Sadleir, *Memoir*, pp. 240-44.) In fact, both the Sadlers almost immediately contributed essays to a book on the Dalcroze method. In "The Value of Eurhythmics to Art," the younger Sadler compared the Dalcroze system of synthesizing body movements with music to Kandinsky's ideas on art. He also expressed the opinion that Kandinsky's painting "is a realization of the attempt to paint music" (an idea Kandinsky later rejected, in lecture notes of 1914 reported by Eichner, *Kandinsky*, p. 116). He even saw Kandinsky and Dalcroze "advancing side by side . . . leading the way to the truest art, and ultimately to the truest life of all, which is a synthesis of the collective arts and emotions of all nations . . ." (M. T. H. Sadler, "The

Value of Eurhythmics to Art," in *The Eurhythmics of Jaques-Dalcroze*, introduction by Prof. M. E. Sadler [London: Constable and Co., Ltd., 1912], pp. 63f). Of course, Kandinsky was familiar as well with Scriabin's *Prometheus* experiment, which combined colored light and music. *Der Blaue Reiter* contained an article by Leonid Sabaneiev, "Prometheus von Skrjabin" (*DBR*, pp. 107-24). Until now, as noted, Scriabin has been taken as the primary source for Kandinsky's color-tone compositions (see Grohmann, *Kandinsky*, p. 56). However, as this chapter will indicate, the Hellerau light theater and the Munich Artists' Theater provided even more immediate sources of inspiration.

14. See Behrens, *Feste des Lebens und der Kunst—Eine Betrachtung des Theaters als höchsten Kultursymbols* (previously cited). Excerpts from this rare manifesto are available in Seling, *Jugendstil*, pp. 424-26, and in "Ideen zu einer festlichen Schau-Bühne" (probably by G. Fuchs) in *DKuD*, ix (October 1901-March 1902), pp. 108ff.

15. Fuchs wrote the text to the ceremonial masque, "Das Zeichen" (The Sign), while Behrens directed and costumed the processional chorus and speakers. Music for the occasion was composed and directed by Willem de Haan, father of Hanna Wolfskehl. (See Chapter VI [Phalanx II] and Chapter viii; also *Ein Dokument Deutscher Kunst* [Darmstadt: Koch, 1901]; and "Eröffnungs-Feier der Darmstädter Künstler-Kolonie" [previously cited].) They had hoped to construct a theater incorporating their ideas at the Colony, but this plan apparently failed.

16. Besides *Feste des Lebens*, see also Behrens, "Die Dekoration der Bühne," in *DKuD*, vi (April-September 1900), pp. 401-05; and G. Fuchs, "Zur künstlerischen Neugestaltung der Schau-Bühne," in *DKuD*, vii (October 1900-March 1901), pp. 200ff. The article, cited above, "Ideen zu einer festlichen Schau-Bühne," contains other references to articles by Fuchs which appeared in the *Wiener Rundschau* and the *Frankfurter Zeitung* in 1899 and 1900 on theater reform.

17. Fuchs, who had been a high school colleague of Stefan George in Darmstadt and who was an early associate of the *George-Kreis* (his work had been published in *Blätter für die Kunst*, ii, 2), was most certainly aware of the various theatrical strivings of the German symbolist group. In 1899, a "Bühne der Blätter für die Kunst" was announced, with much the same emphasis on a return to stylized antique forms and, of course, a rejection of naturalism (*BfdK*, iv, 5, *Auslese* 1898-1904). The aim of this intimate stage—a kind of "chamber recital"—was

the presentation of the new *klanglichen Gebilde* or "tonal image" (a turn of phrase which would have appealed to Kandinsky). Though at first hopeful of a renaissance in drama (especially under the leadership of Hugo von Hofmannsthal), the George group eventually disassociated itself from the theater reform movement on the grounds that mere external reform (i.e., new forms, new buildings) would be vain without a total literary revival. Wolfskehl's later comment that trying to revive drama by external reforms was like trying to create a renaissance in painting by building a new factory for frames, was probably a jab at the efforts of Fuchs and his associates of the Munich Artists' Theater ("Über das Drama," *BfdK, Auslese,* 1904-09 [Einleitungen und Merksprüche], p. 11). This apparent response of Wolfskehl to Fuchs was not mentioned in the otherwise enlightening article by Ulrich Goldsmith on George and the theater ("Stefan George and the Theater," *PMLA,* 1951, LXVI [March], pp. 85-95). Nevertheless, it is apparent that Wolfskehl thought that if the theater were to experience a revival, it would first of all appear in the form of modern "mystery plays" or "lyrical dialogues." See also Wolfskehl's later essay, also called "Über das Drama" in *BfdK, Auslese,* 1904-09, pp. 66-70, in which he developed an interesting theory about the role of the chorus in drama, which may have influenced Kandinsky's thinking. It should be recalled that Kandinsky knew Wolfskehl and they may well have discussed problems of drama as well as of art.

18. This was, of course, the same Georg Fuchs (1868-1949) who was such a vigorous proponent of the arts and crafts movement and whose efforts in publicizing the work of Hermann Obrist and August Endell have already been cited. His major work on the theater was *Die Revolution des Theaters, Ergebnisse aus dem Münchener Künstlertheater* (Munich/ Leipzig: Georg Muller, 1909). He is often mentioned in the same breath with Adolphe Appia, Edward Gordon Craig, Max Reinhardt, and Stanislavsky as among the great innovators of twentieth-century theatrical production. (Compare H. D. Albright, "Adolphe Appia and 'The Work of Living Art,'" in Appia, *The Work of Living Art* [Coral Gables, Fla.: University of Miami Press, 1960], p. xvii; Tom F. Driver, *Romantic Quest and Modern Query, A History of Modern Theater* [New York: Dell Publishing Co., Inc., 1971], p. 76; Sheldon Cheney, *The Art Theatre* [New York: Alfred A. Knopf, 1970, originally published in 1917], p. 86; and Mordecai Gorelik, *New Theatres for Old* [New York: E. P. Dutton & Co., Inc., 1962, originally published in 1940], pp. 174ff.) Indeed, he is to be credited

with the initiation and coordination of efforts which resulted in the Munich Artists' Theater, of which he was "dramaturgical director" from 1908 to 1914. He was a controversial figure in his own day, and his writings were often polemical, contradictory, and ambiguous. Nevertheless, he brought tremendous energy to the causes he espoused, and was a major figure on the Munich cultural scene from the 1890s to 1914. See also H. Rasp, "Georg Fuchs," (*Vom Geist einer Stadt, ein Darmstädter Lesebuch*), pp. 300-01.

19. Georg Fuchs, "The Munich Artists' Theater," *Apollon,* November 1909, pp. 47ff.

20. *Ibid.,* October 1910, pp. 43ff.

21. Kandinsky himself mentioned the Munich Artists' Theater in passing (in a list of cultural events) in his fourth "Letter from Munich," in the May-June 1910 issue of *Apollon.*

22. Georg Fuchs, *Revoliutsiia teatre* (St. Petersburg: Iakor, 1911). Closer to home, in a geographical sense, were experiments in outdoor theater in which the Munich Artists' Theater engaged at Murnau, the picturesque town south of Munich where Kandinsky worked, and eventually resided, from 1908 on. See Fuchs, *Sturm und Drang in München um die Jahrhundertwende* (Munich: Callwey, 1936), pp. 246-47. Fuchs' memoir does not give the date of this activity but it was probably during the summer of 1909 or 1910, if not earlier.

23. Fuchs' name appears several times in a Kandinsky notebook of about 1908 (GMS 335, pp. 1, 10, 16). The name Fuchs also appears in an even earlier notebook of 1904, apparently in connection with an article on, or review of, a Phalanx exhibition in the "M.N.N." (*Münchener Neueste Nachrichten*) (GMS 340, p. 4). Fuchs also wrote for Kunstchronik and *Jugend.*

24. Since Behrens' ideas on theater were largely incorporated into Fuchs' plans, a detailed comparison of them with those of Kandinsky and Fuchs would be redundant. However, the reader should bear in mind the fact that Behrens and Kandinsky were in close contact during 1902-03; not only was there the Phalanx involvement, but Behrens offered Kandinsky his first professional position as an artist (see Chapter XI). Behrens' concern for the rapport between the dramatic work and the spectator (as participant), and his emphasis on the use of lighting as an expressive (not naturalistic) medium are especially comparable to Kandinsky's ideas on theater (see P. Behrens, "Die Lebensmesse von Richard Dehmel als festliches Spiel, dargelegt von Peter Behrens," *Die Rheinlande,* January 1901, pp. 28-40). His ideas on costuming and stage decor

(also comparable to Kandinsky) anticipated those of Edward Gordon Craig, whose ideas were not widely known in Germany until 1905 (see E. G. Craig, *Die Kunst des Theaters* [Leipzig: H. Seemann, 1905]; and J. Leeper, *Edward Gordon Craig, Designs for the Theater* [London: Penguin Books, 1948], pp. 8-9).

25. G. Fuchs, *Die Schaubühne der Zukunft* (Berlin and Leipzig: Schuster & Leffler, 1905). In discussing his ideas about stage composition in *Über das Geistige*, Kandinsky made reference to a "happy dream of the Future Stage" (Zukunftsbühne), undoubtedly an oblique reference to Fuch's slogan (*UGK*, p. 126). He also used the phrase "Theater der Zukunft" (*ibid.*, p. 45).

26. See Mordecai Gorelik, *New Theatres for Old*, pp. 175-78, 289; also, Cheney, *The Art Theatre*, p. 44.

27. Fuchs, *Die Revolution des Theaters*, pp. 232ff. Fuchs' influential book, written in 1908, is the definitive account of the history and aims of the Munich Artists' Theater. Its appendix includes some forty-eight critical reviews of the first season, which gives an idea of the impact the theater had on its contemporaries. The book has been translated into English as *Revolution in the Theatre* by Constance C. Kuhn (Ithaca: Cornell University Press, 1959; reissued 1972 by Kennikat Press). However, only ten of the reviews were retained in the translation. (The quotations here are from the original, which is cited hereafter as Fuchs, *Rev.*) See also M. Martersteig, "Das Münchener Künstlertheater," in *KuK*, 1907-08, pp. 445-48. The previously cited dissertation by Walter Grohmann, *Das Münchner Künstlertheater in der Bewegung der Szenen- und Theaterreformen*, gives a detailed account of the theater's development and its contributions to scenic reform from beginning to end, from 1908 to 1927.

28. See chronology, Appendix E.

29. Fuchs, *Rev.*, p. 94, and *passim*.

30. The theater had only 642 seats arranged at a gentle slope in modified amphitheater fashion. There were no balconies or gilt encrustations to mar the simplicity of the interior, which was further enhanced by plain wood paneling. The acoustics were excellent. The whole effect of the interior was harmonious, restful, functional, and intimate. See Grohmann, *Künstlertheater*, pp. 16-21.

31. Fuchs, *Rev.*, p. xii.

32. The short-lived Théâtre d'Art of Paul Fort in Paris and its successor, the Théâtre de l'Oeuvre, under Lugné-Poë, had provided a precedent for collaboration between contempo-

rary artists and the theater. The Nabis (including Bonnard, Denis, Ranson, Sérusier, Vallotton and Vuillard) had designed sets and programs for those enterprises during the nineties (see *Bonnard, Vuillard et Les Nabis, 1888-1903* [exhibition catalog, Paris, Musée National d'Art Moderne, 1955], pp. 95-102; also Driver, *Romantic Quest and Modern Query*, p. 74).

33. Erler played a major role in the actual design of the stage, together with the architect Max Littmann, according to Grohmann, *Künstlertheater*, pp. 22, 27, and *passim*.

34. See E. G. Craig, "Munich the Reform Stage," *The Mask*, I, 8 (October 1908), p. 163. On von Brauchitsch, see also Chapter XI.

35. E. G. Craig, "Two Letters to John Semar, 1907," *On the Art of the Theater* (London: Heinemann, 1911, republished 1968), p. 129.

36. Fuchs referred to the conventional theater as the *Guckkasten-theater*, that is, the "peepshow" box, in which perspective is achieved by means of actual distance (*Rev.*, pp. 48f., and *passim*).

37. Behrens, "Lebensmesse," p. 28.

38. Fuchs, Rev., p. 100.

39. *Ibid.*, pp. 101-02. The source for these ideas about the effectiveness of relief was, of course, Adolf von Hildebrand's influential book, *Das Problem der Form in der bildenden Kunst* (Strassburg: Heitz and Mündel, 1893), in which the superiority of relief as the most effective possible sculptural expression was insisted upon, an idea wholly in tune with Jugendstil emphasis on significant surface and line. In fact, von Hildebrand himself was a member of the advisory board of the Munich Artists' Theater Society (see *Münchener Künstler-Theater, Ausstellung München 1908* [München-Leipzig, Georg Müller, 1908], p. 5).

40. The stage was about twenty-six feet deep; according to Gorelik, "the merest shelf" in comparison with the depth of conventional theaters of the time (*New Theatres*, p. 176). See also Grohmann, *Künstlertheater*, p. 12.

41. Grohmann, confused by the apparent contradiction between the "relief stage" and the spatial potential of the lighting, criticized the Artists' Theater for inconsistency. In fact, this very contradiction lay at the core of all turn-of-the-century art; the flat shimmering surface of the neo-impressionist "mosaic" conveyed at the same time a mysterious otherworldly space like the Byzantine mosaics so admired by Kandinsky. The reduction of naturalistic space to symbolic surface was a char-

acteristic phase of Jugendstil, and one described by Kandinsky as the "first step" into the realm of abstraction (*UGK*, p. 110). As Grohmann himself concluded, it seemed as if the "relief stage" had been a necessary historical step toward "exploding" the limitations of the conventional stage (*Künstlertheater*, p. 145).

42. Fuchs, *Rev.*, pp. 110-11.

43. *Ibid.*, p. 111.

44. *Ibid.*, pp. 112, 127.

45. Compare Gorelik, *New Theatres*, p. 176; and Fuchs, *Rev.*, pp. 232ff. The modern *Drehbühne* or revolving stage with its different kind of versatility, which had also been invented in Munich (and first successfully used there in 1896), was considered by advocates of the "relief stage" to be the proper tool of the realistic theater and thus anathema to the symbolists. It had in fact been used to achieve realistic effects by Reinhardt in Berlin.

46. Fuchs, "Ideen zu einer festlichen Schau-Bühne," p. 114.

47. An analysis and interpretation of the symbolism of *Der gelbe Klang* is beyond the limitations of this chapter, but would undoubtedly reveal associations with turn-of-the-century symbolist poetry and drama. Image four, for example, with its bell, child in a white shirt, and "black" man, recalls a similar constellation of images in a George poem ("Mühle lass die arme still," see Chapter VIII). (The possible influence on Kandinsky of Rudolf Steiner's dramatic productions has been pointed out by Washton-Long in "Kandinsky and Abstraction: The Role of the Hidden Image," *Artforum*, June, 1972, p. 47.) The discussion here has been confined to comparison of Kandinsky's stage directions with the practical physical possibilities offered by the Munich Artists' Theater.

48. See the description of the "Prologue in Heaven" in Fuchs, *Rev.*, p. 247 (from a contemporary review).

49. The play, "Wolkenkuckucksheim" was adapted by Josef Ruederer and designed by Adolf Hengeler (see Grohmann, *Künstlertheater*, p. 54). Grohmann also includes illustrations of some of these set designs. The *Birds* adaptation was further distinguished by an extremely simplified stage setting, consisting only of an arrangement of boulders.

50. Kandinsky, *DBR, Der gelbe Klang*, p. 216 (hereafter cited as *GK*).

51. Fuchs, *Rev.*, pp. 169f. Gluck's *May Queen* as well as a modern ballet (*Tanzlegendchen*) were performed during the first season.

52. Compare Grohmann, *Künstlertheater*, pp. 58-59; Fuchs, *Rev.*, p. 112, and the numerous reviews included in the appendix to Fuchs, *ibid.*, pp. 228ff; also Gorelik, *New Theatres*, pp. 175ff.

53. J. Popp in *Kölnische Volkszeitung*, 14 June 1908, quoted in Fuchs, *Rev.*, p. 247.

54. W. Ritter in *Chronique des Arts*, Paris, 20 May 1908, quoted in Fuchs, *ibid.*, p. 244.

55. *Ibid.*, p. 112.

56. Grohmann, *Künstlertheater*, p. 59.

57. Fuchs, *Rev.*, p. 112.

58. Grohmann, *Künstlertheater*, p. 14, and *passim*.

59. *Ibid.*, p. 78.

60. An effect actually employed at the Artists' Theater in 1914 and possibly earlier (*ibid.*, pp. 130-31).

61. Fuchs, *Rev.*, p. 127.

62. Kandinsky, *BK*, p. 192. If taken out of context, this phrase may easily be misinterpreted as "not saying everything until the end." However, it is clear from the context that Kandinsky means that kind of expression which leaves something to the imagination of the spectator, i.e., which does not express everything completely; the not-saying-every-last-thing.

63. Fuchs, *Rev.*, p. 40.

64. Kandinsky, *UGK*, p. 45. The reasons why Kandinsky did not make a specific reference here to the Munich theater are fairly obvious. Fuchs had determined on a renewal of *German* art and culture, and continually agitated for reform in the interests of nationalism. Further, the artists at first employed by the Artists' Theater were from the ranks of the Secession, which had consistently ignored Kandinsky, either because of his "foreignness" or because of his early association with the Berlin Secession (feelings ran incredibly high in this respect, as was noted in Chapter VII).

65. Wolfskehl, "Über das Drama," *BfdK*, *Auslese* 1904-09, pp. 66-70. Compare Goldsmith, "Stefan George and the Theatre," p. 94. Fuchs also wrote a nativity play ("Die Verkündigung bei den Hirten. Ein Schäferspiel," published in *Münchner Almanach*, ed. by Karl Schloss [Munich: R. Piper, 1905]), and a passion play (Kuhn, "Translator's Preface," in Fuchs, *Revolution in the Theater*, pp. xviff), though he specifically rejected the over-mechanized, over-popularized Oberammergau phenomenon. Reinhardt's later productions of Vollmoeller's *Das Mirakel* and *Jedermann* were major manifestations of this tendency.

66. Grohmann, *Kandinsky*, p. 56.

67. Fuchs, *Rev.*, pp. 192-94. Gorelik referred to this as the "first symbolist production" of *Faust* (*New Theatres*, p. 175).

68. Kandinsky, *BK*, p. 206. Compare also *UGK*, pp. 125-26. External unity may even be a limitation, he concluded. In apparent chaos internal unity may best be glimpsed, he argued, if the elements of the art are allowed their "own" free expression. In this argument, however, Kandinsky was taking the symbolist stage a step further than Fuchs imagined.

69. Fuchs, *Rev.*, p. 182. He mentioned among others Frank Wedekind and the former Phalanx artist, Ernst Stern. Reference has been made previously to the Elf Scharfrichter masks included in the first Phalanx exhibition, and to the fact that a number of Kandinsky's early associates were involved with the group.

70. Fuchs, *Rev.*, pp. 68-69, 179-89 (a whole chapter on the cabaret).

71. Kandinsky, "Über die abstrakte Bühnensynthese," (*EuKuK*), p. 79. In the same essay, Kandinsky used an analogy also previously employed by Fuchs. He wrote that the old theatrical forms such as drama, opera, and ballet, had "petrified" into *"museum forms,"* and could only be effective in the sense of museum pieces (*ibid.*). Fuchs had written of former attempts at stage reform as merely resulting in "preserving" the drama for educational purposes as in a *museum* (*Rev.*, p. 27).

72. Reported by T. Andersen in "Some Unpublished Letters" (*Artes*), p. 101. The article, "The Great Utopia" (*O velikoj utopii*) appeared in *Chudožestvennaja žizn'*, no. 3, M. 1919, pp. 2-4.

73. Eichner, *Kandinsky*, p. 208.

74. See *Wolfskehl* catalog, pp. 204-14. The marionette theater also appeared at the exposition, according to Fuchs, as a "conscious parallel" to the Artists' Theater (*Rev.*, p. 39).

75. *BfdK, Auslese 1892-98*, p. 13 ("Einleitungen und Merksprüche" from the year 1899): ". . . ein völliges inhintergrundtreten des schauspielers." Kandinsky's article on stage composition did not concern itself at all with the actor, and in his later production of Mussorgsky's *Pictures at an Exhibition*, figures appeared only twice.

76. Wolfskehl, "Über das Drama," *BfdK, Auslese 1904-1909*, pp. 66-70.

77. Except for the eleven illustrations of glass and mirror painting, this was the most of any one genre in the book. It is tempting to draw a comparison between the activity of painting on glass, and that of making shadow plays. Two masks were also illustrated, one of which was specifically identified as a "dance mask."

78. Fuchs, *Rev.*, pp. 39, 183.

79. Kandinsky, *GK*, pp. 215-16.

80. *Ibid.*, scene five, p. 226.

81. Compare Edward Gordon Craig, "The Actor and the Übermarionette," in *Art of the Theatre*, pp. 54-94.

82. It may be noted that this tendency in theater to eliminate the actor and even to dispense with dialogue finds a parallel in the general inclination of the period to dispense with the object in painting (a subject which will be more fully analyzed in Chapter x). Kandinsky's own progress toward abstraction was undoubtedly affected by these developments in theater, in which he took so great an interest.

83. Reinhardt served as director in residence of the Munich Artists' Theater in the summers of 1909 and 1910. He was also guest director in 1911. There is little doubt that Reinhardt (at that time noted for his "realism") was stimulated by the challenge afforded by the change from the revolving stage of the Berlin Theater, where he had been working, to the planar "relief stage" of the Artists' Theater. Its symbolist elements doubtless helped him toward his later interpretations of Vollmoeller's *The Miracle* and the famous Salzburg productions of *Jedermann*. Grohmann's review of Reinhardt's seasons at the Artists' Theater appears to suffer from an unfortunate (and unjustifiably negative) bias, but is nonetheless enlightening. (See Grohmann, *Künstlertheater*, Chapter III, pp. 64ff. Compare also Heinrich Braulich, *Max Reinhardt*, pp. 115-21.)

84. From the *Münchner Post*, 20 August 1910, quoted in Grohmann, *Künstlertheater*, p. 104.

85. *Ibid.* An innovation from the oriental stage was also introduced in this production: the so-called "flower-path" or ramp from the stage into the amphitheater on which actors made exits and entrances. Fuchs had described this feature of Japanese theater in his book as an example of the desired unity between stage and auditorium, between player and spectator (*Rev.*, p. 63).

86. Kandinsky, *BK*, p. 208.

87. Kandinsky, *BK*, p. 206; also, *UGK*, p. 125.

88. Fuchs, *Rev.*, pp. 118-19. Fuchs was especially enthusiastic about the symbolic use of color in Japanese theater. He described how a simple color change might effectively transform the whole mood of a scene, referring to this use of color

as "rhythmic colorism." In accompaniment to a change of mood in the script, he wrote, the "color-chord" of the setting could be "retuned" instantly by very simple means, such as the sudden dropping of a cloak to reveal a symbolic color. And, in fact, the Artists' Theater did exploit the psychological effectiveness of color in set design and in lighting.

89. Fuchs, *Rev.*, pp. 55-56, 117, 179, and *passim*.

90. Kandinsky, *BK*, p. 206. In *UGK*, these elements are listed as "musical movement," "painterly movement," and "dance-artistic movement" (*tanzkünstlerische*, or art dance) (*UGK*, p. 125). Both Fuchs and Kandinsky mentioned the contribution of Isadora Duncan to the development of modern dance. Fuchs had even written a book on dance, in which the following definition of drama appeared: "The drama, in the genuine sense, is therefore nothing other than the highly spiritualized (*höchstvergeistigte*) and differentiated use of the art of dance" (*Der Tanz* [Stuttgart: Strecker and Schroeder, 1906], p. 13). While Kandinsky credited Duncan with establishing a bond between ancient Greek dance and the "dance of the future," Fuchs criticized her as archaic, though at the same time appreciating her as a harbinger of modern dance. The term *Tanz der Zukunft* (dance of the future), used by both Fuchs (*ibid.*) and Kandinsky (*UGK*, pp. 124-25), was, of course, a reference to Duncan's booklet *Der Tanz der Zukunft, eine Vorlesung* (Leipzig: Diederichs, 1903).

91. Fuchs, *Rev.*, p. 134.

92. *Ibid.*, p. 25.

93. *Ibid.*, p. 94.

94. "Das dramatische Kunstwerk besteht weder auf der Bühne noch gar im Buche, sondern as entsteht in jedem Augenblicke neu, in welchem es als räumlich-zeitlich bedingte Bewegungsform erlebt wird" (*ibid.*, p. 60).

95. Again: "The purpose is the dramatic experience. This does not take place on the stage, but rather in the soul of the spectator under the impression of the rhythmic stimulations which the soul of the viewer receives through the mediation of the senses, the eyes and ears, from the rhythmic happenings on the stage" (*ibid.*, p. 95).

96. "Vibration der Seele" (Kandinsky, *BK*, p. 192).

97. ". . . diese Vibration [wird] der Seele des Empfängers entsprechend auch andere Saiten der Seele in Schwingung bringen. Das ist die Anregung der 'Phantasie' des Empfängers, welcher am Werke 'weiter schafft' " (*ibid.*, p. 192).

98. *Ibid.*, p. 191.

99. *Ibid.*, p. 207.

100. Fuchs, *Rev.*, p. 59 (italics mine).

101. *Ibid.*, p. 99.

102. Kandinsky, *BK*, p. 192. Fuchs also wrote that everything which affects the individual "consciously or unconsciously," as well as the "spiritual disposition" of any given cultural period, are factors in the dramatic experience (*Rev.*, pp. 60-61).

103. Fuchs, *Rev.*, pp. 111-12, 117-21.

104. *Ibid.*, p. 118, "körperliche und sprachliche Bewegung," literally "physical and linguistic movement."

105. Kandinsky, *BK*, p. 208; also Kandinsky, "Über die abstrakte Bühnensynthese" (*EuKuK*), p. 83.

106. Fuchs, *Rev.*, pp. 65-66 (italics mine).

107. The Artists' Theater was actually constructed as an integral part of the great arts and crafts exposition of 1908 (known as "München 1908") on the fairgrounds designed for that purpose adjacent to the Theresienwiese. See *Münchener Künstler-Theater Ausstellung München 1908*, p. 31. There Fuchs expressly stated that the Artists' Theater resulted from that same "cultural transformation" heralded by the applied arts movement. (See also Chapter VI on the Darmstadt Artists' Colony.)

108. See Hugo Ball, "Das Münchener Künstlertheater (Eine prinzipielle Beleuchtung)," *Phoebus*, May 1914, p. 74.

109. Grohmann, *Künstlertheater*, pp. 124-25.

110. Erich Mendelsohn (1887-1953), later the designer of the famous Einstein Tower at Potsdam (1920), had been in Munich since 1910, first as a student and then as an independent architect.

111. All of whom were, or had been, associated in one way or another with Kandinsky. Others who signed included, besides Mendelsohn, Thomas Mann, and Ricarda Huch. See Grohmann, *Künstlertheater*, p. 124.

112. Hugo Ball (1886-1927), later organizer of the Dada Cabaret Voltaire in Zurich (1916), was then a producer at another Munich theater, the Kammerspiele. He was an admirer of Kandinsky and later exhibited his paintings and read his poems at the cabaret. Compare Lankheit, "Anhang," (*DBR*), pp. 281f., 299. See also Hugo Ball, *Die Flucht aus der Zeit* (Lucerne: Verlag Josef Stocker, 1946 [orig. 1927]), pp. 10-11, 12-13.

113. Compare Grohmann, *Künstlertheater*, p. 125 (where the names of Mendelsohn, Salzmann, and Schönberg are

omitted), and Hugo Ball, "Das Müchener Künstlertheater," p. 74.

114. Lankheit, "Anhang," p. 282.

115. *Ibid.*, p. 282 (italics mine). Letter from Ball to his sister, 27 May 1914, quoted by Lankheit (cf. note 7, above).

116. Kandinsky's friend, the musician Thomas von Hartmann, who was to have composed the music for *Der gelbe Klang*, was to write on the "anarchy of music" (*ibid.*, p. 283).

117. After the Reinhardt period, Fuchs tried to "loosen up" the rather dogmatic ideas of some of his associates by introducing musical comedies and experimental plays by local artists to the Artists' Theater. However, many of the works were second rate, and his efforts were apparently misunderstood, so that, despite a successful production of Wedekind's *Lulu* in 1913, he had by 1914 lost the confidence of many of his backers. Unfortunately, Grohmann did not record Fuchs' reaction to the suggestions of the Mendelsohn-Ball committee. But the fact that Fuchs quietly took over a play from the rejected repertoire is significant. Another play in the rejected plan was to have been a "Japanese national drama," and Fuchs did then also incorporate an "oriental" play into his repertoire that season: *The Yellow Jacket* (by two American authors), which was done in the oriental fashion with almost no scenery at all. See Grohmann, *Künstlertheater*, pp. 126-29.

118. Ball, "Das Münchener Künstlertheater," p. 73. Other works proposed by Ball's committee besides *Der gelbe Klang*, *Der Sturm*, and the Japanese piece, *Chiushingura*, included Hofmannsthal's *Elektra* ("but set in Haiti or Catagonia"), and Euripides' *Bacchae* (*ibid.*, p. 74). Grohmann, apparently relying on another source (perhaps the original proposal itself), added Kleist's *Penthesilea* to the list. However, he made no mention of Kandinsky's *Der gelbe Klang* (*Künstlertheater*, p. 125).

119. Ball, "Das Münchener Künstlertheater," p. 73.

120. An interesting confirmation is to be found in a letter from Kandinsky to Hans Hildebrandt in 1937: ". . . did you know that twice a performance [of *Der gelbe Klang*] was offered to me? The first time right before the war—the production was to have taken place in Munich in the late fall. The second time in Berlin (*Volksbühne*) 1922. And this second time the war didn't stand in the way, rather my composer, Th. v. Hartmann, who was then out of touch. So I had to turn it down. I remember suddenly that there was a third time: Schlemmer wanted to produce the piece. But once again it didn't work out. . . . Such things have their own destinies" (see Hildebrandt, "Drei Briefe von Kandinsky" [*Werk*], p. 330).

CHAPTER X

1. Behrens invited him to take over the atelier for decorative painting at the Düsseldorf School of Arts and Crafts in 1903 (see Chapter XI). The crucial relationship between the abstract tendencies of the Jugendstil movement and Kandinsky's development toward abstract painting may best be illuminated by the following survey of the critical literature which reflected those tendencies so clearly, and which was available to the artist in Munich during those formative years. Then, Kandinsky's direct involvement in the arts and crafts movement, which is the subject of the next chapter, can be better understood. Finally, his progress from the early decorative color drawings and woodcuts to abstract painting may be viewed from a new perspective.

2. For a further discussion of this work, see Chapter XII.

3. Kandinsky, "Rückblicke," p. XIII.

4. *Ibid.*

5. Kandinsky, letter of 31.1.04, Lindsay K/M letters.

6. *Ibid.*

7. Kandinsky, letter of 10.2.04, Lindsay K/M letters.

8. Schultze-Naumburg, "Die Komposition in der modernen Malerei," *KfA*, 1 March 1899, pp. 161-66.

9. *Ibid.*, p. 161 (italics mine). "Da Komposition wörtlich eine 'Zusammenstellung' bedeutet, so wird man hier im engeren Sinne darunter eine künstlerische Arbeit verstehen, die nicht ein vorhandenes Stück Natur getreu nachbildet, sondern in der Teile zu einem neuen Ganzen zusammengetragen sind, das in der Natur also Vorbild nicht vorhanden war, so dass man von einem komponierten und einem nicht komponierten Bilde reden könnte."

10. *Ibid.*, p. 162 (italics mine). Again, "seelische" might be translated in this context as "emotional" or even "psychological." ". . . die schmückende Funktion [hat] das Wort; das 'Was' tritt vollkommen in den Hintergrund und gewinnt höchstens symbolische Bedeutung. Bei abstrakten Kunstwerken

werden natürlich dessen rein seelische Werte die Führung übernehmen; nur eben werden diese zum nicht geringen Grade durch die Erscheinungsform ausgedrückt, sind also von der Art der Komposition in Linie und Farbe abhängig."

11. Kandinsky, *UGK*, pp. 73-74.

12. Kandinsky, Letter of 26.4.04, Lindsay K/M letters.

13. Kandinsky, "Rückblicke," p. xiii.

14. *Ibid.*, p. xxv.

15. Kandinsky, *UGK*, pp. 142-43.

16. Kandinsky, "Malerei als reine Kunst," *EuKuK*, p. 68 (originally published in *Der Sturm*, iv, 178/179 [September 1913], pp. 98-99).

17. See Chapters ii through iv.

18. Endell, "Formenschönheit," p. 75.

19. Schultze-Naumburg, "Die Kleinkunst," p. 379. The notion of the decorative arts as a means to salvation for the fine arts was an idea that had also been broached by Van de Velde. In an essay first published in French in 1895, Van de Velde suggested that a thorough renewal of the arts and crafts along the lines laid down by Morris and Walter Crane would result in a "resurrection" of art (see Van de Velde, "Allgemeine Bemerkungen zu einer Synthese der Kunst," *Pan*, v [1899], pp. 261-70, especially p. 269).

20. "Das neue Ornament—die Jungen Holländer," in *DK*, April 1898, pp. 1-18. The article is signed with the astrological sign for Aries, a signature which followed many major articles while Julius Meier-Graefe was associated with *Dekorative Kunst* as editor. Comments by Scheffler in a later article, relating Meier-Graefe to ideas expressed in articles signed with the astrological symbol for "Aries," indicate that this was very likely Meier-Graefe's pseudonym. Following his association with *Pan* and *Dekorative Kunst*, Meier-Graefe moved to Paris, where he founded the periodical *L'Art décoratif* (1898), and his own arts and crafts shop, the Maison Moderne (1899), modeled after Munich's United Workshops for Art in Handcraft.

21. Again, this article was probably by Meier-Graefe, who was Van de Velde's chief propagandist in Germany (see "Henry Van de Velde," *DK*, October 1899, p. 2ff; on the authorship of this article, compare Schmalenbach, *Jugendstil*, p. 59 n. 34).

22. "Georges Lemmen," *DK*, September 1899, p. 209 (italics mine).

23. Aries, "Floral-Linear," *DK*, August 1899, pp. 169-72.

24. In reality it referred to the standing argument between the followers of Otto Eckmann who espoused an organic naturalism as the basis of good design, and those who followed Van de Velde in espousing the free or "abstract" line as the basis of design.

25. Aries, "Floral-Linear," p. 172. It should also be recalled that by the time Arthur Roessler wrote his 1903 article on the Neu Dachau painters, he was able to emphasize that Hölzel's abstract ornaments were "abstract in the sense of nonobjective [*ungegenständlich*]" (see Chapter iv).

26. K. Scheffler, "Meditationen über das Ornament," *DK*, viii (July 1901), p. 401.

27. Kandinsky, *UGK*, p. 66. See K. Scheffler, "Notizen über die Farbe," *DK*, iv, 5 (February 1901), pp. 183-96.

28. See Scheffler's autobiography, *Die fetten und die mageren Jahren*, especially pp. 11-56.

29. Scheffler, "Notizen über die Farbe," p. 186.

30. *Ibid.*, p. 187.

31. "For example, I perceive the vowels in color: a is white to me, e—gray, i—burning red, o—green, u—dark blue, and in this way even the languages of different peoples differentiate themselves for me according to color." ("Ich empfinde z. B. die Vokale farbig: a ist mir weiss, e grau, i brennend rot, o grün, u drunkel-blau, und in dieser Weise unterscheiden sich mir die Sprachen der Völker beinah farbig." *Ibid.*, p. 197.) Scheffler may have been stimulated in his color-vowel associations by symbolist efforts in that direction, e.g., Rimbaud's poem "Voyelles," which, however, suggested a different set of color associations—except for "i" with which they both associated "red."

32. It is interesting that Kandinsky cited this article by Scheffler right at the beginning of his chapter on "Formen- und Farbensprache" (Form- and Color-Language), in relation to color symbolism as suggested by Delacroix. It is especially interesting that Scheffler's private color symbolism was a very literal "color language."

33. *Ibid.*, p. 194. Scheffler cited the well-known color sensitivity of workers in fabric dyeing factories, who learned to distinguish between the finest color nuances, as evidence that color sensitivity could be learned. He urged a naïve and uninhibited study of color in nature as a cure for the jaded contemporary eye.

34. Kandinsky, "Rückblicke," p. xiv.

35. Letters to G. Münter, 14.4.04, 17.4.04, and 25.4.04, Lindsay K/M letters.

36. Letter to Münter, 25.4.04, Lindsay, K/M letters.

37. Another example of the direct influence Scheffler's article exercised on Kandinsky is found in *Über das Geistige* at the

end of Chapter v, "The Effect of Color." "He who has heard about chromotherapy," Kandinsky wrote, "knows that colored light can cause a special effect on the whole body. It has been variously attempted to exploit this power of color and to use it in the treatment of various nervous disorders, whereby it has been observed that red light has an invigorating effect on the heart, and that blue on the other hand can lead to temporary paralysis" (p. 64). Scheffler had written in the article under consideration: "The effect of energetic local colors on the mood [*Gemütsstimmung*] has even led to experiments to influence emotionally disturbed persons by means of color stimulation" ("Notizen," p. 187).

38. In the same issue of *Dekorative Kunst* in which Scheffler's "Notizen" appeared, the lead article was on the eighth exhibition of the Viennese Secession, a show distinguished by a large display of crafts by the Glasgow School (illustrations included the work of Margaret and Frances Macdonald, and Charles Rennie Mackintosh). The article praised these works for using the "decorative element" in an "intensely spiritualized manner," such that the "inner truth of these works . . . has an overwhelming effect." Once again the language sounds like Kandinsky, and ideas on the "spiritual" content of art, and the inherent freedom of the artistic act are also comparable to those of Kandinsky. Since Scheffler's article immediately followed this review (on the same page), it can be suggested that Kandinsky had read it as well.

39. Scheffler, "Meditationen über das Ornament," pp. 401-04. "Die Abstraktion ist also das eigentliche Gebiet des Ornamentikers. Diese merkwürdigen Kunstgebilde sind in Wahrheit tabellarische Linien der ewigen Weltstatik, Paraphrasen über eingeborene Instinkte, Versuche, die grosse Kausalität der Weltarchitektur im Verkleinerungsspiegel aufzufangen, ein fröhlicher Tanz mit der Hand—alles das zugleich. Die Schöpfungswahl des Künstlers ist unendlich; aber in jedem einzelnen Falle steht er unter dem Zwange seiner Vorstellungen, seine Linien sind dann entweder notwendig oder sie taugen nichts. . . . Wer die Konsequenzen ganz zu ziehen weiss, die sich aus den Beziehungen von Graphologie und Ornamentkunst ergeben, wer genau betrachtet, wie Gefühle sich linear entladen, wie das Gesetz sich im Kunstschaffen überall manifestiert und auf einem gewissen Punkt der architektonische mit dem musikalischen, der nachwägende mit dem phantastisch spielenden Instinkt sich trifft und sogar identifiziert, der wird einen grossen Gewinn zu Gunsten einer monistischen Weltanschauung haben. . . . Wir hören noch solche Klänge von alters her, hundert Harmonien schwirren klingend durcheinander; aber eine Fanfare übertönt

sie und ruft hell in die Zukunft. Wer Ohren hat zu hören, der höre!" (Cf. Chapter iv, "Roessler on the Psychology of Line," n. 142, and below, n. 42.) It may be well to note that there were often distinct nationalistic overtones to much propaganda for the arts and crafts movement, but this is not the place to enter into the complexities of that phenomenon.

40. Kandinsky, *UGK*, pp. 81, 84.

41. *Ibid.*, p. 62.

42. Arthur J. Eddy, *Cubists and Post-Impressionists*, p. 126. It may be recalled again that Roessler, in his Neu Dachau monograph (see Chapter iv), also urged the application of the study of graphology to the arts, and described the rhythmic line as an expression of feelings. Indeed, he even referred to Scheffler's writings on the subject (*Neu Dachau*, pp. 115-17, and *passim*). It may also be recalled that in 1904, Scheffler published an article in *Dekorative Kunst* specifically urging the study of "form-, line-, and color-feeling . . . the physio-psychological aspects of aesthetic sensation" ("Ein Vorschlag," pp. 378-79). The article is not likely to have escaped Kandinsky's attention, as he was in Munich at the time. In this context it may also be recalled that the hero of Kubin's novel *Die andere Seite* "attempted to create new form-images directly according to secret rhythms of which I had become conscious; they writhed, coiled and burst upon one another. I went even further. I gave up everything but line and developed . . . a peculiar line system. A fragmentary style, more written than drawn, which expressed, like some sensitive meteorological instrument, the slightest vibration of my life's mood. 'Psychographics' I called it . . ." (Kubin, *Die andere Seite*, p. 140).

43. See Chapter ii.

44. Since Kubin was to exhibit a major show at the Phalanx the following year (see Chapter vi [Phalanx IX]), the suggestion may be made that Kandinsky had read this important article as well as the one by Volkmann. (See also n. 42, above.)

45. L. Volkmann, "Das Geistreiche im Kunstwerk," *KfA*, 1 January 1903, pp. 153-61. On the translation of *geistreich* and *geistig* see Appendix A.

46. Kandinsky recalled that he had begun to collect notes for *Über das Geistige* some ten or twelve years prior to the writing of his memoir, which is dated 1913 (Rückblicke," p. xii).

47. Volkmann, "Das Geistreiche," p. 154.

48. Kandinsky, *UGK*, p. 133.

49. Volkmann, "Das Geistreiche," p. 158 (italics in original).

50. Kandinsky, "Vorwort," *Neue Künstler-Vereinigung München E.V.* Turnus, 1909-10, n.p. (exhibition catalog).

51. Kandinsky, "Rückblicke," p. xxv, note.

52. Volkmann, "Das Wesen der Kunst, Ein Schlusswort," *KfA*, 15 May 1903, pp. 375-81. In somewhat different words Kandinsky also stated the primacy of that which the artist has to say: "The artist must have something to say, because his task is not mastery of form, but rather the adapting of this form to the content" (*UGK*, p. 135).

53. *Ibid.* In a passage in "Rückblicke," Kandinsky also spoke of his recognition of the vast and essential difference between art and nature ("Rückblicke," p. vi). (See also Appendix C.)

54. It should perhaps be recalled that the Munich branch office of *Kunstwart* was located in the same building in which the Phalanx had held its first exhibitions.

55. "A." (Ferdinand Avenarius), "Eine neue Sprache? Zu den Zeichnungen Katharine Schäffners," *Kunstwart*, xxi, 2 (August 1908), pp. 185-93. The same essay (with the exception of the first paragraph) was published in a portfolio of forty-two Schäffner drawings which Avenarius published, probably the same year: *Eine neue Sprache? 42 Zeichnungen von Katharine Schäffner*, mit einer Besprechung von Ferdinand Avenarius (Munich: Georg D. W. Callwey Verlag, n.d.).

56. Avenarius, "Eine neue Sprache?" (*Kunstwart*), p. 188.

57. *Ibid.*

58. *Ibid.*, p. 187 ("Es 'spukt' . . . etwas Neues . . .").

59. *Ibid.*

60. Kandinsky, "Rückblicke," p. xxv. Both Avenarius and Kandinsky pointed out that music, like art, could be imitative of nature. And both noted that art might now approach music in its capacity to create in an "absolute" sense. Both Avenarius and Kandinsky also used Van Gogh as an example of the free use of line as an expressive element. "Van Gogh hat mit besonderer Kraft die Linie als solche gebraucht, ohne damit das Gegenständliche irgendwie markieren zu wollen" (Kandinsky, "Über die Formfrage," p. 161). "In Van Goghs letzten Werken lebt eine leidenschaftliche Seele ihre Verzweiflungskämpfe vor uns mit Linien und Farben, die im Begriffe scheinen, sich zu freiem Kräftespiel von den Dingen abzulösen" (Avenarius, "Eine neue Sprache?" p. 187).

61. *Ibid.*, p. 192.

62. *Ibid.* This is of course, very similar to ideas expressed by Arthur Roessler in his monograph on Adolf Hölzel and the painters of the Neu Dachau group. There Roessler had also discussed the possibility of learning to recognize and understand the hieroglyphics of a new artistic calligraphy (*Neu-Dachau*, p. 123, compare Chapter iv).

63. It is rather astonishing that at this point Avenarius sug-

gested (p. 192) it would be a shame if things were to come to such a pass that an ambition might develop among artists to see who could arrive at the art historical "summit" by the greatest possible limitation of means to insubstantial free lines or light. He seemed to prophesy the subsequent rush of artists for the laurel of "first abstractionist."

64. Caricature and humor are not to be dismissed in the development toward abstraction, as Avenarius pointed out. Compare also Appendix B.

65. W. Worringer, "Rudolf Czapek, Grundprobleme der Malerei," *KuK*, viii, 4 (January 1910), p. 236. See also R. Czapek, *Grundprobleme der Malerei. Ein Buch für Künstler und Lernende* (Leipzig: Klinkhardt and Biermann, 1908).

66. Lindsay, "An Examination of the Fundamental Theories," pp. 213-14. Lindsay reported finding the book in Kandinsky's library.

67. It should be noted that Czapek's wife, Mechthild Buschmann-Czapek, participated in the eleventh Phalanx exhibition in the spring of 1904 (see Chapter vi [Phalanx XI]). Czapek (1871-1935) himself was, for a time, a student of Alexei Jawlensky, but the exact date of this activity is not given in Thieme-Becker.

68. Czapek, *Grundelemente*, p. 40.

69. *Ibid.*, pp. 108-09. In German this difficult passage reads: "Diese langsame Fortentwicklung oder Auswicklung der Malkunst legt die Frage nahe, ob nicht eine glücklich fortschreitende geistige Entwicklung eine Malerei hervorbringen muss, die der ihr immer mehr zu eigen gewordenen Welt der Dinge immer freier gegenübersteht und dem Auge einen für die heutigen Begriffe rein ornamentalen Schmuck von nicht mehr abschätzbarer innerer Bedeutung bietet. Ob aus dem Wege des dekorativen Geistes nicht etwa eine Spirale . . . symbolisch wirkender Ornamentik zu lesen wäre. . . ." Czapek also attempted to develop color and compositional theories based on psychological experience somewhat similar to ideas later advanced by Kandinsky in *Über das Geistige* (in the section on "Farbensprache") and in *Punkt und Linie*. However, a detailed comparison would be beyond the scope of this chapter. The idea of an "ever-progressing spiritual development" parallels Kandinsky's metaphor of the "spiritual triangle" in *UGK*, pp. 29-30.

70. See Kandinsky, *UGK*, p. 78.

71. *Ibid.*, chap. vii, pp. 115-17, but especially, p. 127.

72. *Ibid.*, p. 127.

73. Here Kandinsky indicated in a note that he was thinking of Henri Rousseau whose work he admired (see p. 127). But

he may also have had a more "futuristic" art in mind, such as that exemplified by his own *Cow in Moscow* with its rather surrealistic combination of the "real" and the "fantastic."

74. Something must be said about the retarding effect of Jugendstil. If *Flächenkunst* (surface art), or the exclusion of the third dimension (a primary characteristic of Jugendstil [compare Schmalenbach, *Jugendstil*, pp. 3-11, 24-25]) was "the first step into the realm of the abstract," as Kandinsky wrote in *UGK* (p. 110), and if Kandinsky recognized this so clearly that by 1903 or 1904 he was able to create nearly "abstract" jewelry and embroidery designs (see chapter XI), why then did he hesitate? The answer lies partially in the fact that Jugendstil fell into disrepute almost as soon as it had become popular. Indeed, Kandinsky himself noted that considerations of individuality and *Zeitgeist* (the temper of the times) were retarding elements in the progress of art toward abstraction (*UGK*, pp. 81-82). He distinguished two contradictory drives: the "subjective" will of an epoch to see itself mirrored in its art (which results in stylistic "periods"), and the eternal, "objective" drive of the artist to express the "purely artistic" in art. He saw clearly the difficulties and the necessity of "overcoming" a *Zeitgeist* so vigorously represented in his own time by Jugendstil. Schmalenbach described the inner contradictions of Jugendstil in some detail (*Jugendstil*, pp. 18-22, 59-77): how, despite the fact that artists clung to the ideals of the new movement, their hopes were frequently undermined by commercial interests producing crass copies and even gross caricatures of their earnest efforts for the popular market. Because of this, Jugendstil soon had a "bad name." Many felt that Jugendstil was more of a burden than a blessing, a feeling that burdened the term itself for decades. Yet most artists of the period were stimulated by it to experiment in the decorative arts. Overcoming Jugendstil ornament while retaining its essential elements of good craftsmanship and freedom became the challenge faced by Kandinsky and others of the avant-garde.

75. Kandinsky, *UGK*, p. 115.

76. *Ibid.*, p. 116.

77. *Ibid.*

78. *Ibid.*, p. 116. There is here an implied analogy with painting: although most painting had been based on nature, nevertheless, as in the case of ornament, that was not a necessary determination of its future or possible development.

79. *Ibid.*, p. 117 (italics in original).

80. *Ibid.*, p. 115.

81. *Ibid.*, p. 127 (italics in original).

82. K. Sch. (Scheffler), "Technik als Kunst (neue Seidenstoffe)," *DK*, VI, 8 (May 1903), 318.

83. See Chapter XI.

84. The Behrens carpet, illustrated in *DK*, September 1898, p. 254, had been exhibited in the 1898 Munich International Exhibition in the Glaspalast. The one by Schmithals, illustrated in the June 1906 issue of *DK*, p. 346, was exhibited with works of the Debschitz School in an important crafts exhibition at Nürnberg, in 1906.

85. Evidence that an art historical reevaluation of the relationship between ornament and twentieth-century art is underway may be deduced from the recent publication of several articles and books on the role of decoration in the work of Matisse and other modern artists. See, for example, John H. Neff, "Matisse and Decoration," (*arts magazine*, May 1975, pp. 59-61), and Klaus Hoffmann, *Neue Ornamentik—Die ornamentale Kunst in 20. Jahrhundert* (Cologne: M. DuMont Schauberg, 1970).

CHAPTER XI

1. For example, the passage just discussed at the end of Chapter X, where Kandinsky suggested that if one were to completely destroy the connection between art and nature and aim forcibly at total freedom, the result would be works that would look like "geometric ornament," that would be "like a tie or a carpet" (*UGK*, p. 115).

2. Kandinsky, *UGK*, p. 122.

3. It should be recalled that four of the works Kandinsky exhibited at the second Phalanx were designated in the catalog as "decorative sketches." Furthermore, works he submitted the same year to the Berlin Secession exhibition of graphic arts were also described in the catalog as "decorative sketches," and "sketches for church painting" (*Entwürfe für Kirchenmalerei*). It is tempting to speculate that Kandinsky may have had the decoration of the Russian chapel in Darmstadt in mind when he made his sketches for *Kirchenmalerei* (see Chapter VI on the Darmstadt Artists' Colony). A report in *KfA*, 1 November 1903 (p. 78), noted that the chapel was being decorated by

Russian artists who had been commissioned by the Tsar. (A large mosaic designed by Vasnetsov was also to be installed.)

4. See Chapter VI (Phalanx II).

5. Jugendstil was held in disrepute for so long that Kandinsky scholars suffered some embarrassment in the assessment of his early work. Grohmann's monograph on Kandinsky, for example, contains no reference at all to Kandinsky's activity as a craftsman, except in regard to his woodcuts, and only a few superficial comments on Jugendstil in passing. Schmalenbach's suggestion that the *Flächentheorie,* or "surface theory," of Jugendstil be related to Kandinsky's work was largely disregarded (*Jugendstil,* p. 154). Only Kenneth Lindsay appreciated the fact that the Jugendstil woodcuts might have some bearing on Kandinsky's subsequent breakthrough to abstraction (see Lindsay, "Graphic Art in Kandinsky's Oeuvre," in *Prints,* pp. 237-47). And only recently has there been any public interest in Kandinsky's craftwork, despite the fact that Johannes Eichner specifically listed a number of items crafted by Kandinsky (*Kandinsky,* p. 51). The 1966 exhibitions of Kandinsky's *Hinterglasmalerei* (his painting on glass) was perhaps the first indication of a renewal of interest in his handcraft. More recently, jewelry created after designs by Kandinsky (by a Munich goldsmith) has been exhibited in New York and in Munich (at the Leonard Hutton Galleries, New York, in 1969, and at the Goltz Galerie, Munich, in 1970). Meanwhile, four pieces of furniture decorated by Kandinsky were exhibited for the first time at the Bavarian art and culture exhibition in Munich in the summer of 1972. Two of his wood reliefs were also shown at the same time (see *Bayern—Kunst und Kultur,* Münchner Stadtmuseum, 10 June-15 October 1972).

6. *Société du Salon d'automne; Catalogue des ouvrages de peinture, sculpture, dessin, gravure, architecture et art décoratif exposés au Grand palais des Champs-Élysées* (Paris: 5 October-15 November 1906). Items nos. 850-857 and nos. 838-849 by Kandinsky.

7. *Société du Salon d'automne; Catalogue des ouvrages . . .* (18 October-20 November 1905). Items nos. 816-827 by Kandinsky.

8. Eichner, *Kandinsky,* p. 51.

9. "Da gab es Wikingerschiffe und deutsche Winterlandschaften mit Häschen und Schneemann, für Kinder berechnet, aber auch fast abstrakte Gebilde ornamentaler Art" (*ibid.,* p. 51).

10. *Ibid.,* p. 75. Very likely the one on view at the Städt-

ische Galerie, Munich (Fig. 92). It is a felt appliqué with beaded embroidery.

11. *Ibid.*

12. *Ibid.*

13. "Bilder, dekorative Malereien, Stickereien, ganze Zimmer habe ich plötzlich wieder im Kopf und denke wieder farbig. Ob es lange dauert?" Letter of 13.7.04, Lindsay K/M letters.

14. Kandinsky, letter of 17.8.04, Lindsay K/M letters.

15. *DK,* July 1904, pp. 390ff. The author of this article preferred the use of the term "applied art" (*angewandte Kunst*) to the term "arts and crafts" (*Kunstgewerbe*), and pointed to famous examples of "fine art" that were in reality examples of "applied art" in the "highest sense," such as the doors of the Florentine baptistry or the altar works of the German masters, etc.

16. Letter of 17.8.04, Lindsay K/M letters. The disappointment Kandinsky expressed in one of the letters concerning the Society was undoubtedly related to the conflict between older, more conservative members of the group and younger members, which had brought about the collapse of plans for a large international craft exhibition in Munich in 1904. The ideas for this show were then taken over by the city of Dresden much to the dismay of the Munich artists. Thus the first exhibition of the Society in Munich was postponed until 1905. This postponement may have precluded Kandinsky's actual participation. See E. W. Bredt, "Ausstellung der 'Vereinigung für angewandte Kinst,'" in *DK,* September 1905, pp. 469-70.

17. "Die Kunstgewerbeschule zu Düsseldorf," *DK,* August 1904, pp. 409ff.

18. Karl Scheffler, "Eine Schule für Formkunst," *KuK,* September 1904, p. 508.

19. *Kunstchronik,* 13 May 1904, p. 412. The Phalanx announcement was on p. 413. On the same pages were announcements of openings of exhibitions in Dresden, Düsseldorf, and Berlin, the dates of which Kandinsky recorded in a notebook (GMS 340, Städtische Galerie).

20. Eichner, *Kandinsky,* p. 204. A photograph of Kandinsky and Münter together at the 1904 Düsseldorf "Gartenbau Ausstellung" is included in the Gabriele Münter- und Johannes Eichner-Stiftung at the Städtische Galerie, Munich.

21. Review by Jan Veth, *KuK,* August 1904, pp. 467f.

22. Kandinsky, *PLF,* pp. 111, 113.

23. *Ibid.,* pp. 119, 123. See also the catalog *Linie und Form, Erläuterndes Verzeichnis der Ausstellung formenschöner Erzeugnisse der Natur, Kunst und Technik im Kaiser-Wilhelm-*

Museum zu Krefeld, April und Mai 1904 (Krefeld: Kramer and Baum, 1904). The introduction declared: "The most important expressive means of the plastic arts are color and line." The bibliography included references to articles by August Endell and to the German translation of Walter Crane's book *Line and Form,* of 1900. See also the catalog *Farbenschau im Kaiser-Wilhelm-Museum zu Krefeld* (Krefeld: G. A. Hohns Söhne, 1902), which included texts by Otto Eckmann, Gerhard Munthe, Karl E. Osthaus, and Paul Signac.

24. Letter of 30.8.03, Lindsay K/M letters (my italics). Behrens had been charged with the special task of reorganizing and modernizing the school at Düsseldorf.

25. Letter 5.9.03, Lindsay K/M letters.

26. On the location of the Phalanx School, see Chapter VI (Phalanx School). Later on, the Obrist-Debschitz School moved a block or so up the street, to number 21. (Information from the catalog *Obrist-Wegbereiter,* under "chronology," n.p.)

27. These activities are mentioned in letters by Kandinsky of 6.4.04, 12.4.04, 16.4.04, 19.7.04, and 23.7.04 (Lindsay K/M letters). Gustav Freytag (a colleague of Kandinsky in the Phalanx undertaking) recalled that Obrist used to attend meetings of the Phalanx Society ("Erinnerungen," quoted in Röthel, *KgW,* p. 430.) See also Münter's recollections of meetings between Kandinsky and Obrist in Roditi, *Dialogues on Art,* pp. 141-42.

28. Kandinsky, letter of 12.4.04, Lindsay K/M letters.

29. *Ibid.*

30. Besides the Viking ship embroidery already mentioned, there are apparently other embroideries still extant in the collection of the Gabriele Münter- und Johannes Eichner-Stiftung in Munich, according to a personal letter from Erika Hanfstaengl of the Städtische Galerie. Unfortunately, since the Städtische Galerie does not have jurisdiction over that foundation, she was unable to supply photographs of those other embroideries.

31. Wilhelm von Debschitz, "Eine Methode des Kunstunterrichts," *DK,* March 1904, pp. 209-26. In contrast to academic tradition, individualized instruction was considered of primary importance, as was also the case in Kandinsky's Phalanx classes.

32. See Chapter IV.

33. Kandinsky, *PLF,* pp. 94-96, 147-48. Indeed, the droplet image crops up in late Kandinsky paintings, rising, falling, in general behaving as Debschitz predicted, as for example in *Rayé* (Striped) of 1934, or *Division-Unité* (Division-Unity) of 1943.

34. Debschitz, "Eine Methode," p. 210.

35. *Ibid.,* p. 220 (italics mine).

36. An interesting comparison may be made here between Obrist's students and those Kandinsky later taught at the Bauhaus. One study by Kandinsky's student, Hans Thiemann, was called "eine Hauptspannung . . . darüber ein Netz von Nebenspannungen" (a major [or principle] tension overlaid with a net of secondary tensions), of 1930. Another, by the same student, was titled, "hartnäckig gebogene, dramatische Spannung, mit Schema" (persistently bent, dramatic tension, with diagram), of 1930. Both are reproduced in the catalog of the Bauhaus exhibition of 1968 (*50 jahre bauhaus,* pp. 51-52).

37. Today Obrist's student, Hans Schmithals (1878-1964), is recognized as one of the first artists to work seriously with abstract or nearly abstract forms in the twentieth century. However, very few of his early works survive, and little has been written about him as yet. He later taught in the Obrist-Debschitz School and eventually became more involved in interior design than in painting. One of his early visionary glacier paintings is now in the collection of the Museum of Modern Art, New York, while three others are in collections in Munich. (See *L'Avanguardia Jugendstjil, Hans Schmithals,* exhibition catalog of the Galleria Del Levante, Milan, 1965, with introduction by Siegfried Wichmann; also *Aufbruch* catalog, p. 213.)

38. Obrist, "Die Lehr- and Versuch-Ateliers . . . ," *DK,* March 1904, pp. 228-32. In the prospectus for his "School for Form-art" Endell also compared his approach to a kind of *Harmonielehre der Form,* or theory of harmony for form (note 18, above). As has been noted, Kandinsky was to use a similar expression in *Über das Geistige* when he suggested the possibility of a *Generalbass* for painting like that for music, which would be a kind of "grammar" for painting (compare *UGK,* pp. 66-85).

39. Obrist, "Die Lehr- und Versuch-Ateliers," p. 232.

40. H. Board, "Die Kunstgewerbeschule zu Düsseldorf," *DK,* August 1904, p. 426.

41. Palme, *Konstens Karyatider,* p. 44.

42. *Ibid.*

43. *Ibid.*

44. Eichner, *Kandinsky,* pp. 75-76.

45. A convex vase very similar in form by Hans Christiansen (the Darmstadt artist who had exhibited vases and other objects at the second Phalanx exhibition) was shown at the seventy-fifth anniversary exhibition in Darmstadt in 1976-77. It is

reproduced in the catalog *Ein Dokument Deutscher Kunst 1901-1976*, no. 102 ("Convex Vase with red and green point- and line-decoration," ca. 1901). On the characteristics of Ju- gendstil surface design, see Schmalenbach, *Jugendstil*, chap. I, and especially chap. III, pp. 24-35, on the characteristic wavy line.

46. GMS 986, Städtische Galerie.

47. In the collection of the Landesgewerbemuseum, Stutt- gart. Dated 1902-05 in Rheims, *The Flowering of Art Nouveau*, p. 355, and 1913 in *Aufbruch* catalog, p. 185.

48. The significance of the circle in Kandinsky's oeuvre is discussed in Chapter XII.

49. GMS 986 (which includes the designs for the circles and wavy lines, griffin, the stylized Tunisian village, and the crino- lined lady), is designated on the back of the sheet as "Kandin- sky Entwürfe zu Perlenstickereien" (designs for beaded em- broideries). According to Erika Hanfstaengl, this designation is in Münter's handwriting (in *Wassily Kandinsky—Zeichnungen und Aquarelle im Lenbachhaus München* [München: Prestel Verlag, 1974], no. 71, p. 35). However, Michael Petzet, for- mer director of the Städtische Galerie, attributed the hand- writing to Johannes Eichner (letter to the author of 26 Octo- ber 1972). In any case, the possibility that some of the designs were in fact originally intended as jewelry designs should not be discounted, especially since sketches of rings in one of the notebooks are indisputably intended for jewelry. In 1969, sev- eral of the sketches were selected for actual execution by a Munich goldsmith, and were subsequently displayed at the Leonard Hutton Galleries in New York and by the Galerie Hans Goltz in Munich. See the catalog *Kandinsky, Franz Marc, August Macke—Drawings and Watercolors*, April 16-May 28, 1969, Hutton-Hutschnecker Gallery, Inc., New York, where three of the designs are illustrated (p. 123). See also the cata- log *Goldschmiede-Arbeiten nach Entwürfen von Wassily Kan- dinsky*, 1 December 1970-16 January 1971, Buchhandlung und Galerie Hans Goltz, Munich (execution by Max Pollinger and Cornelia Röthel), in which all the designs are illustrated. In some instances, it is obvious that a considerable departure from the original sketch was undertaken. Furthermore, of course, there was usually no indication of material to be used in the original sketches, and some of these jewelry motifs were even taken from much later paintings.

50. Compare Schmalenbach, *Jugendstil*, p. 24.

51. GMS 340, pp. 23, 27.

52. *Ibid.*, p. 27.

53. GMS 342, pp. 40, 41, 43; GMS 338, p. 34.

54. GMS 342, p. 50. (According to Hanfstaengl, these draw- ings appear on p. 52 of the notebook [Hanfstaengl, *Zeich- nungen und Aquarelle . . .*, p. 162]. The slight variations in pagination are apparently attributable to the fact that the sketchbooks had not been completely cataloged at the time the research for this book was done.

55. See also Chapter IV.

56. GMS 538.

57. Some of the furniture was exhibited at Munich's 1972 "Bayern Kunst und Kultur" exhibition (for descriptions, see the catalog edited by Michael Petzet, *Bayern—Kunst und Kultur*, p. 543). A photograph of the stairway in the Murnau house (with a chair presumably decorated by Kandinsky) is repro- duced in Eichner, no. 54. The wood reliefs, which have been exhibited at the Städtische Galerie, are included in the Gabriele Münter- und Johannes Eichner-Stiftung, the bulk of which has never been made available to the public. The dating of the wood reliefs is uncertain, but they may be related to motifs found in the paintings of the Murnau period. For example, Figure 110a (a sketch for a wood relief, GMS 174) appears to be related to *Composition II* (Fig. 81) of 1910. A woman and child appear in that painting near the right center; opposite them are an old man with a white beard and a hooded figure. In the relief, the two opposing figures are both bearded men. The largest of the three reliefs, which have been exhibited at the Städtische Galerie, is 36.5 x 42.5 x 3.5 cm. All are painted in rich, saturated, matte colors. There is little transition be- tween low and high relief, and the gashing strokes of the chisel have been left in the wood so that the technique contrasts dramatically with the enigmatic subject matter.

58. Grohmann, *Künstler schreiben*, p. 45. In 1976-77, the designs for the 1922 Juryfrei Exhibition (intended for a mu- seum reception room) were reconstructed and installed in the Centre Pompidou in Paris. (See P. Weiss, "Wassily Kandinsky, the Utopian Focus: Jugendstil, Art Deco, and the Centre Pom- pidou," pp. 106-07.) Kandinsky also later designed ceramic murals for the music room at the International Architecture Exhibition in Berlin, 1931. These have also since been recon- structed at the Artcurial centre d'art plastique contemporain, Paris (by Jean and Suzanne Leppien, both former students of Kandinsky at the Bauhaus).

59. Schmalenbach, *Jugendstil*, p. 60. She was the subject of numerous articles in such applied arts periodicals as *Dekorative Kunst* and *Deutsche Kunst und Dekoration*. Indeed, by 1900,

she had already had her own studio school for decorative design for two years (*DK*, v, 7 [April 1902], p. 260). See also Gerhard P. Woeckel, "Bedruckte und bestickte Stoffe um die Jahrhundertwende," *Sammler Journal*, no. 2 (February 1975), pp. 52-53, 57. Two examples of work by von Brauchitsch are illustrated in Woeckel's article (which he brought to my attention after completion of this manuscript).

60. A reviewer in *DK*, October 1904 (p. 24), used the term *Improvisationen* in reference to the immediacy and delight of her works.

61. This was a movement, intimately associated with the social-aesthetic ideals of Jugendstil, to redesign women's clothing for use and comfort as well as beauty. The body was to be allowed to move freely under a loose and comfortable drapery; the corset was banned as unnatural and unhealthy. The movement took Germany by storm in 1902 with a series of fashion design competitions, lectures, and exhibitions, all doubtless inspired by Van de Velde's lead. His lecture of 1900, on the artistic "elevation" of women's fashion (Van de Velde, *Zum neuen Stil*, pp. 77ff) held at Krefeld, was accompanied by an exhibition of dress designs by himself and Germany's leading craftsmen, including von Brauchitsch (see *DK*, IV, 1 [October 1900], p. 41; compare also *DK*, November 1902 and January 1903, both containing numerous references to similar events).

62. C.[?], "Margarethe von Brauchitsch." *DK*, v, 7 (April 1902), p. 258.

63. *Ibid.*, p. 261. The high bodice tie was a feature of reform dresses, to allow the waist to expand to its normal and comfortable proportions, and to permit greater freedom of movement. Von Brauchitsch also designed street dresses that were well off the ground. Photographs of such a dress (actually a "suit") appeared in *DK*, VI, 2 (November 1902), pp. 68-69. The model in this case (also before the Böcklin work) may have been von Brauchitsch herself, who was described as being small and "brave"—an impression conveyed by these photographs. The very fact that a respectable young lady like Gabriele Münter would have agreed to pose for a fashion photograph to be published in a widely read periodical indicates that she must have been a good friend of von Brauchitsch. In fact, both were members of the Munich Künstlerinnenverein (Women Artists' Society). Von Brauchitsch was already a prominent

member of the organization (having held a major exhibition of her works at the Society's house in Schwabing the previous summer) when Münter joined in May 1901 (date according to Röthel, *KgW*, p. 434). Von Brauchitsch's exhibition was probably held in June 1900 (cf., *DK*, III, 9 (June 1900), p. 347).

64. Eichner, *Kandinsky*, p. 33.

65. See the catalog *Hinterglasmalerei by Gabriele Münter*, December-January 1967, Leonard Hutton Galleries, New York, frontispiece: "Gabriele Münter in a dress designed by Kandinsky—photographed by Kandinsky—1906." The date disagrees with the date of 1905 given by Eichner to the same photograph.

66. GMS 392.

67. Letter of 17.8.04, Lindsay K/M letters. Compare Röthel, *KgW*, p. 429.

68. Letter of 10.8.04, Lindsay K/M letters. This letter was also quoted by H. K. Röthel in the catalog *Vasily Kandinsky—Painting on Glass* (Guggenheim Museum, 1966), pp. 7-8, where it is also translated. (As quoted here, the letter appears in my own translation.) Röthel used the quotation as a rationale for the glass paintings, which he described as "in a sense, trifles," despite the fact that in more than one instance they served as sketches for important paintings, and despite the fact that the letter obviously is a serious defense of the artist's essential freedom, which Kandinsky was to defend all his life.

69. The Museum of Modern Art, N. Y., owns one of these rare albums. On the question of dating, see Chapter VIII and Röthel, *KgW*, p. 429. The chronology of Kandinsky's woodcut activity as a whole is still uncertain (cf., Röthel, *KgW*, pp. ix, 425f).

70. See Chapter VIII. Significantly enough, the album was published by a Moscow institution devoted to the development of the applied arts: ". . . the Stroganov Teaching Institute was founded in 1825 by Count Stroganov as a School for Painting, Drawing, and Arts and Crafts. From 1843, it was a government teaching institution for the education of artists and teachers. It encouraged the development of applied arts and sponsored competitions and exhibitions. In 1918, it was reorganized as the Free Government Art-Workshops. In 1945, it was reopened as VCHUTENAS" (Röthel, *KgW*, p. 429, n. 1).

71. A lifetime oeuvre of some 203 graphic works is enumerated in Röthel, *KgW*.

213

CHAPTER XII

1. Kandinsky, letter of 10.8.04, Lindsay K/M letters.

2. Kandinsky enjoyed punning and word play as is evident not only in his published writings but also in his letters to Münter. In this case, it seems likely that he chose the uncommon word for woodcut, "Xylograph," with its Greek prefix "Xylo-" (for wood) because of the latter's more common association with the word "Xylophone"—an instrument on which musical tones are produced by striking wooden bars with a wooden mallet. The idea would have appealed to the artist who thought of his woodcuts in musical terms as *Klänge*. *Xylographies* contained five major prints and two smaller. Three of the large prints suggested musical motifs: church bells, bird song, and musical instruments. Furthermore, a musical motif (as yet unidentified) adorns the first page. It is interesting to note that Kandinsky apparently also planned to publish an album of music and graphics. A design for a title page for such a work is to be found among the drawings at the Städtische Galerie, GMS 178.

3. *Klänge* contained thirty-eight prose-poems, twelve color and forty-four black and white woodcuts. According to a statement by Kandinsky published in *KgW*, the prints range in date all the way back to 1907 (Röthel, *KgW*, p. 445).

4. Kandinsky, "Mes Gravures sur Bois," *EuKuK*, p. 228: "Dans ces bois comme dans le reste—bois et poèmes—on retrouve les traces de mon développement du 'figuratif' à l' 'abstrait' . . ." (originally published in *XXᵉ Siècle*, première série, no. 3, 1938).

5. In a letter of 1932 to Will Grohmann, Kandinsky stated that he had made the woodcuts for the "French portfolio" (i.e., *Xylographies*) in 1906, "when I lived in Sèvres" (in Grohmann, *Künstler schreiben*, p. 60). They are dated 1907 in Röthel, *KgW*. Four of the prints had been previously published in the periodical *Les Tendances nouvelles*, with which Gérôme-Maësse was associated and to which he was a frequent contributor. He was among the first to recognize Kandinsky as a graphic artist, in his essay "Kandinsky, La Gravure sur bois, l'Illustration" (*Tendances nouvelles*, III, 26 [1906]). For further details on this rare publication, and a reprint of this essay, see Röthel, *KgW*, pp. 426-28. In his introductory essay to *Xylographies*, Gérôme-Maësse characterized Kandinsky as an artist of "extreme sensibility, of supreme clairvoyance." A recent unpublished study has shown that the name Gérôme-Maësse was probably a pseudonym for Alexis Mérodack-Jeaneau, founder and editor of this obscure and erratic periodical (cf. Jonathan Fineburg, "Kandinsky in Paris 1906-7," p. 89 and *passim*). Fineburg's study, which was not available until after completion of this manuscript, adds further weight to the argument that the decorative works in woodcut and tempera were crucial to Kandinsky's movement toward abstraction. The Guggenheim Museum, New York, owns a copy of *Xylographies* (the original woodcuts were reproduced as heliogravures for the album).

6. H. K. Röthel, *KgW*, p. 427.

7. Brisch also noticed the development of Kandinsky's brush work, tending toward an ever more abstract usage ("Kandinsky," pp. 132-34, 167-69, 196). Although the dating of *Riding Couple* is not certain, it probably was done in 1906-07, possibly while the artist lived in Sèvres. It is, however, clearly related to a type and method of painting already developed by Kandinsky in Munich and apparent in such other works as *Sunday* of 1904 (GMS 613), *White Cloud* of 1903 (reproduced in Grohmann, p. 403, no. 647), and *Russian Beauty in Landscape* of ca. 1904 (reproduced in Hanfstaengl, pl. IV, GMS 92). Sketches for *Riding Couple* appear in the notebook GMS 336 (pp. 70-71) which also contains sketches in the Jugendstil manner of the earliest work (for example, a study of stylized tree forms on p. 47). According to Gollek, there is an unpublished letter concerning this painting in the collection of the Gabriele Münter- und Johannes Eichner-Stiftung (cf. Gollek, *Der Blaue Reiter im Lenbachhaus*, p. 66).

8. W. Michel, "Münchner Graphik: Holzschnitt und Lithographie" (in *DKuD*), pp. 437-57 (see also Chapter VII, where Michel's observations on Kandinsky's work are quoted).

9. Kandinsky, letter of 20.2.04, Lindsay K/M letters.

10. Michel, "Münchner Graphik," p. 437. To graphic art, Michel opposed the traditional oil painting which, he wrote, belongs to that "classical spiritual peacefulness and objectivity of which the life of our times is such an enemy." Furthermore, the oil painting is "religion and popular metaphysics, because it believes in the fundamental rightness of the world picture as represented to us by our senses." Clearly, Michel saw graphic art as capable of moving beyond the representational world to a more abstract expression of reality. Unfortunately, like many another critic of the period, Michel was unable to keep up with the inexorable movement of the arts toward abstraction. Thus, seven years later when actually confronted with Kandinsky's *Blaue Reiter* exhibitions and almanach, he was moved to ex-

press strong reservations about the total disappearance of the object from painting (see W. Michel, "Die Grenzen des Subjektiven in der Kunst," *KfA*, 1 July 1912, pp. 450-55). Nevertheless, he remained loyal to Kandinsky, at least on a theoretical plane, when in his subsequent review of *Über das Geistige in der Kunst*, he wrote: "Gegen Kandinskys Theorie ist kaum etwas einzuwenden . . ." (To Kandinsky's theory there is scarcely any objection). Yet, he had to admit that Kandinsky's art was beyond him (in *KfA*, 15 September 1912, p. 580).

11. Michel, "Münchner Graphik," p. 440.

12. Lindsay reported that he exhibited woodcuts before 1910 in Munich, Dresden, St. Petersburg, Odessa, Paris, Warsaw, Angers, Rome, Weimar, and Moscow ("Graphic Art in Kandinsky's Oeuvre," p. 237).

13. Lindsay has raised the question of whether or not the early woodcuts affected Kandinsky's *Durchbruch* to abstraction, and suggested that indeed the "natural inclination of the woodcut for the abstract" hastened his development. He also pointed out that the uncertain chronology of the graphic works makes an analysis of this development difficult ("Graphic Art in Kandinsky's Oeuvre," pp. 244, 247). By basing such an analysis on one theme, perhaps the problem can at least be illuminated. (The prophetic essay by Avenarius was discussed in Chapter x.)

14. P. Plaut, *Die Psychologie der produktiven Persönlichkeit* (Stuttgart: Verlag von Ferdinand Enke, 1929), p. 308.

15. Kandinsky, letter of 21.11.25, in Grohmann, *Künstler schreiben*, pp. 49-50.

16. Kandinsky, letter of 12.10.30 to Grohmann, *ibid.*, p. 56.

17. The persistence of the theme of St. George in Kandinsky's oeuvre is discussed in Appendix B.

18. Lindsay has discussed the Russian fairy tale motif of Prince Ivan and the magic steed as a possible source of Kandinsky's horse and rider (carrying the "magic scarf"), in his review of Grohmann's biography ("Will Grohmann, Kandinsky," *Art Bulletin* XLI, 4 [December 1959], p. 349). Lindsay also discussed the relationship between the circle and the horse motif in "Les Thèmes de l'inconscient," *XXᵉ Siècle* (December 1966), pp. 46-52 (English, pp. vi-vii). Kandinsky's reference to the jockey game is to be found in "Rückblicke," p. iv. The relationship of Kandinsky's horse-and-rider motif to apocalyptic imagery has been thoroughly analyzed in Washton (Long), "Vasily Kandinsky," chap. v, and *passim*.

19. In his 1930 letter to Grohmann, Kandinsky specifically wrote: [The circle] "is a connection with the cosmic" (cited in Grohmann, *Künstler schreiben*, p. 56). In the same letter Kandinsky went on to say: "Why does the circle captivate me? It is: 1. the most modest form, yet recklessly self-assertive; 2. precise, yet inexhaustibly variable; 3. stable and unstable simultaneously; 4. soft and loud simultaneously; 5. *one* tension, which carries countless tensions within itself. The circle is a synthesis of the greatest contradictions. It unites the concentric with the excentric in one form in equilibrium . . ." (*ibid.*). It is interesting to note Kandinsky's expansion of this theme beyond the bounds of Jugendstil by comparing a comment by Karl Scheffler on the circle. In his 1901 article on ornament (in which he had identified abstraction as the essential area of the decorative artist), Scheffler had written: "The circle is the eternally beautiful and complete ornament, because within it the most obvious possible equilibrium of two forces—the centrifugal and the centripetal—occurs" ("Meditationen," p. 400).

20. The picture is at the Städtische Galerie, GMS 99.

21. On the question of dating, see Chapter VIII. Kandinsky himself recalled 1903 or 1904 in Grohmann, *Künstler schreiben*, p. 60.

22. These titles are from the list of small woodcuts published in Röthel, *KgW*, p. 425. In *KgW*, the issue has been confused by changing the titles, in some cases completely (and using German forms), where they accompany the reproductions of the prints. I have preferred to use the titles apparently given by Kandinsky.

23. See also the sketches GMS 606 and 609, reproduced in Hanfstaengl, p. 76.

24. See Röthel, *KgW*, p. 186.

25. Grohmann, *Künstler schreiben*, p. 60.

26. See Kandinsky, "Das Bild mit weissem Rand," "Rückblicke," p. xxxix.

27. According to a letter cited in Röthel, *KgW*, p. 196.

28. K. C. Lindsay, "The Genesis and Meaning of the Cover Design for the first Blaue Reiter Exhibition Catalogue," *The Art Bulletin*, XXXV, 1 (March 1953), p. 50. In this article, Lindsay argued convincingly that the drawing was indeed created in 1913, rather than at a later date. See also A. Rudenstine's discussion of the dating of this drawing in *The Guggenheim Museum Collection, Paintings 1880-1945* (The Solomon R. Guggenheim Foundation: New York, 1976), Vol. I, p. 270-271. Rudenstine argues that the drawing may actually have been done in 1924, although dated 1913 by the artist as a device to relate it to the earlier painting of which it is reminiscent.

29. As Lindsay has pointed out, the rider reduced to the double curve appears in such late works as *Green Sound* of 1924 and *Division-Unity* of 1943. In *Green Sound*, the rider is accompanied by his now circular horse. Compare Lindsay, "Les Thèmes," p. vi.

30. In similar fashion, the development of the Jugendstil "whiplash" line into the twisting serpentlike motif which frequently appears in Kandinsky's late paintings might be traced.

31. Kandinsky, *UGK*, p. 135.

32. Kandinsky, letter of 21.11.25, in Grohmann, *Künstler schreiben*, pp. 49-50.

33. Grohmann, *Künstler schreiben*, p. 56 (letter of 1930).

CONCLUSION

1. Kandinsky himself equated inner necessity with honesty, in *UGK*, p. 133.

2. Kandinsky, *UGK*, p. 128. "Neue Prinzipien fallen auch nie vom Himmel, stehen hingegen im kausalen Zusammenhang mit der Vergangenheit und der Zukunft."

3. *Ibid.*, pp. 80-82.

Selected Bibliography

THIS selected bibliography is intended to serve as a guide to the most significant sources consulted in the course of my research on Kandinsky's Munich experience. It is therefore more specific than general, and much material of tangential interest had to be omitted. For example, reviews of exhibitions have been cited only when deemed particularly relevant to the work at hand. The most complete bibliography of Kandinsky's own writings is currently in preparation by Kenneth C. Lindsay for Viking Press, *Kandinsky The Complete Writings* (edited by K. Lindsay and Peter Vergo). For general bibliographies pertaining to Kandinsky studies, see Will Grohmann's standard monograph *Wassily Kandinsky, Life and Work* (Abrams, 1958) and the dissertations on the artist by Lindsay (University of Wisconsin, 1951) and Rose-Carol Washton (Long) (Yale University, 1968). Useful general bibliographies on Art Nouveau and Jugendstil are available in Peter Selz and M. Constantine (editors), *Art Nouveau* (MOMA, 1959), in Robert Schmutzler's *Art Nouveau* (Abrams, 1962), and in Jost Hermand's bibliographic study *Jugendstil—ein Forschungsbericht, 1918-1964* (J. B. Metzlersche Verlagsbuchhandlung, 1965).

Adolf Hölzel 1853-1934: Gemälde, Glasbilder, Pastelle, Zeichnungen. Ausstellung des Kunstvereins Braunschweig, 1963. Introduction by Wolfgang Venzmer.

Adolf Hoelzel (1853-1934). Katalog der Gedächtnis-Ausstellung zum hundertsten Geburtstag. Introduction by Hans Hildebrandt. Stuttgart: Stuttgarter Galerieverein, 1953.

Adolf Hölzel, Ölbilder-Pastelle. Bibliography by Wolfgang Venzmer. Darmstadt: Kunstverein Darmstadt, 1969.

Adolf Hölzel, sein Weg zur Abstraktion. Ausstellung Dachau, 1972. Introduction by Wolfgang Venzmer. "Texte und Bilder" by Dietrich Helms.

Ahlers-Hestermann, Friedrich. *Stilwende: Aufbruch der Jugend um 1900.* Berlin: Verlag Gebr. Mann, 1941.

Albright, H. D. "Adolphe Appia and 'The Work of Living Art.'" *Adolphe Appia's The Work of Living Art & Man is the Measure of all Things, a Theory of the Theatre.* Edited and translated by Albright and Hewitt. Coral Gables, Fla.: University of Miami Press, 1960.

Alexandre, Arsène. "Spanische Kunst—Ignacio Zuloaga." *Pan,* v (1899), pp. 122-24.

Alfred Kubin 1877-1959: Gedächtnisausstellung. Introduction by Peter Halm. Munich: Bayerische Akademie der Schönen Künste und Kunstverein e. V. Munich, 1964.

Andersen, Troels. "Some Unpublished Letters by Kandinsky." *Artes; Periodical of the Fine Arts* II (October 1965), pp. 90-110.

Anonymous. "Atelier-Nachrichten. Hermann Obrist . . ." *Deutsche Kunst und Dekoration* I (October 1897-March 1899), pp. 42-43.

———. "Chronik, Berlin. Der Secessionszwist." *Kunst und Künstler* 1 February 1903, pp. 151-52.

———. "Darmstadt, Stuttgart und München als Heim-Stätten moderner Gewerbe-Kunst." *Deutsche Kunst und Dekoration* IX (October 1901-March 1902), pp. 247-50.

———. "Deutsche und russische Malerei auf der Darmstädter Ausstellung." *Deutsche Kunst und Dekoration* IX (October 1901-March 1902), pp. 124-28.

Anonymous. "Die VIII. Ausstellung der Wiener 'Secession.'" *Dekorative Kunst* IV, 5 (February 1901), pp. 171-83.[1]

————. "Eröffnungs-Feier der Darmstädter Kunst-Ausstellung." *Deutsche Kunst und Dekoration* VIII (1901), pp. 446-48.

[1] From 1900, the publishers of *Die Kunst für Alle* and *Dekorative Kunst* (Bruckmann, Munich) produced bound volumes of these periodicals under the comprehensive title *Die Kunst* (one volume of each for every year). However, because of the very distinct characteristics of each periodical and the specific nature of the citations in this book, it seemed essential to differentiate them in bibliographic references. Therefore, I have elected to refer to them by their specific names, rather than merely referring to volumes of *Die Kunst*, in which case the reader would not know which periodical was meant without actually seeing the magazine itself. Whereas *Die Kunst für Alle* had been in publication since 1886, and was always relatively conservative, *Dekorative Kunst* was born in 1897 as a spokesman for Munich's Jugendstil avant-garde, and continued to express a relatively avant-garde position for several years. The bibliographic record of *Dekorative Kunst* is complicated, however, not only by the fact that it was bound as a "second" volume of *Die Kunst* after 1900, but also by the fact that it was issued in biannual volumes (October to March and April to September) until the year 1902-03, when a volume was issued which included all the issues from October 1902 through September 1903, a practice followed thereafter. The attempt has been made here to consistently number the volumes by whole years (thus October 1897 through September 1898 is cited as volume I, etc.). Nevertheless, the result is that numeration of the volumes is often confusing and may not coincide with numbers published in the separate issues. The reader is thus advised to make use of the references to the exact month and year, which are given in almost every case. In the case of *Die Kunst für Alle*, which, unlike *Dekorative Kunst*, was a bimonthly, the confusing volume numbers have been dispensed with altogether and only the specific dates are referenced (as, for example, 1 July 1902). It is hoped that this system will reduce error and save the scholar interested in pursuing these references both time and aggravation.

————. "Eine neu entdeckte Art photographisch wirksamer Lichtstrahlen" (announcement of Röntgen's discovery of X-rays). *Die Kunst für Alle* 15 February 1896, p. 160.

————. "Henry Van de Velde." *Dekorative Kunst* I (April 1898-September 1898), pp. 2-9.

————. "Hermann Obrist." *Dekorative Kunst* I, 10 (July 1898), pp. 138-39.

————. "Hugo von Tschudi" [obit.]. *Die Kunst für Alle* 1 January 1912, p. 164.

————. "Jan Toorop—im Haag." *Deutsche Kunst und Dekoration* IV (April 1899-September 1899), pp. 541-52.

————. "München" (review of crafts at VIIth International Glaspalast Exhibition). *Dekorative Kunst* I, 1 (October 1897), pp. 43-46.

————. "Neue Arbeiten von Margarete [*sic*] von Brauchitsch." *Dekorative Kunst* X, 3 (December 1906), pp. 118-19.

————. "Neue Bücher—Otto Eckmann, *Neue Formen. . .*" (book review). *Dekorative Kunst* I, 2 (November 1897), pp. 94-95.

————. "Neues aus den vereinigten Werkstätten für Kunst im Handwerk, München." *Dekorative Kunst* II, 4 (January 1899), pp. 145-46.

————. "Röntgens X-Strahlen." *Die Kunst für Alle* 15 March 1896, p. 192.

————. "Vereinigte Werkstätten für Kunst im Handwerk, München." *Dekorative Kunst* I, 10 (July 1898), pp. 137-38.

————. "Von Ausstellungen. Dresden. Galerie Arnold. . . . Katharina [*sic*] Schäffner." *Die Kunst für Alle* 15 March 1910, p. 286.

————. "Von Ausstellungen und Sammlungen. Dresden" (review of lecture by Adolf Hölzel). *Die Kunst für Alle* 15 May 1901, pp. 390-91.

————. "Von Ausstellungen und Sammlungen. Frankfurt a.M." (review of exhibition and lecture by Adolf Hölzel). *Die Kunst für Alle* 1 February 1904, p. 221.

———. "Von Ausstellungen und Sammlungen. Köln. Bei Schulte. . . . Bilder, Skizzen und Entwürfen von W. Kandinsky." *Die Kunst für Alle* 1 December 1905, p. 117.

———. "Von Ausstellungen und Sammlungen. München. Wassily Kandinsky und Ernst Treumann" (review of exhibition at the Munich Kunstverein). *Die Kunst für Alle* 1 September 1904, p. 554.

———. "Von der Darmstädter Künstler-Kolonie." *Dekorative Kunst* IV, 8 (May 1901), pp. 289-95.

———. "Zu den Arbeiten Obrist's." *Dekorative Kunst* III, 5 (February 1900), pp. 196-98.

Anton Ažbè in Njegova Sola. Ljubljana: Narodna Galerija, 1962.

Apollo, XCIV, no. 117 (November 1971). Special issue on Munich.

Appia, Adolphe. *Die Musik und die Inszenierung.* Munich: Bruckmann, 1899.

———. Behrens, Peter; Craig, Edward Gordon; Ernst, Paul; Martersteig, Max; Moore, George; Ricketts, Charles; & Scheffler, Karl. "Bühnenkunst." *Kunst und Künstler* V (1906-07), pp. 217-44.

Arens, Hanns. *Unsterbliches München: Streifzüge durch 200 Jahre literarischen Lebens der Stadt.* Munich: Bechtle Verlag, 1968.

"Aries." [Julius Meier-Graefe?]. "Das neue Ornament—die jungen Holländer." *Dekorative Kunst* I, 7 (April 1898), 1-18.

———. "Eine fürstliche Idee." *Dekorative Kunst* III, 7 (April 1900), p. 270.

———. "Farbige Glasfenster." *Dekorative Kunst* I, 3 (December 1897), pp. 160-173.

———. "Floral-Linear." *Dekorative Kunst* II, 11 (August 1899), pp. 169-72.

———. "Gemälde von Peter Behrens." *Dekorative Kunst* II, 1 (October 1898), p. 46.

———. "George Lemmen." *Dekorative Kunst* II, 12 (September 1899), pp. 209-11.

———. "Peter Behrens." *Dekorative Kunst* I, 8 (May 1898), pp. 70-74.

———. "Peter Behrens." *Dekorative Kunst* III, 1 (October 1899), pp. 2-4.

Aslin, Elizabeth. *The Aesthetic Movement.* New York: Praeger, 1969.

Ausstellungs-Katalog der Pelikan-Kunstsammlung. Introduction by Gunther Thiem. Hannover, 1963.

L'avanguardia Jugendstjil, Hans Schmithals. Introduction by Siegfried Wichmann. Milan: Galleria del Levante, 1965.

"A." [Avenarius, Ferdinand]. "Eine neue Sprache? Zu den Zeichnungen Katharine Schäffners." *Kunstwart* XXI, no. 2 (August 1908), pp. 185-93.

A.V. [?]. "Vermischte Nachrichten. München . . . ['Niedergang Münchens als Kunststadt . . .']." *Die Kunst für Alle* 1 February 1903, p. 224.

Ažbè Archives of the Narodna Galerija, Ljubljana, Yugoslavia. Collection of Dr. Karel Dobida.

Ažbè obituary. *Die Kunst für Alle* 15 September 1905, p. 581.

Ažbè obituary. *Kunstchronik und Kunstmarkt* XV, no. 31 (August 18, 1905), p. 505.

Bab, Julius. *Das Theater der Gegenwart.* Leipzig: J. J. Weber, 1928.

Bahr, Hermann. *Die Überwindung des Naturalismus.* Dresden/Leipzig, 1891.

———. *Expressionismus.* Munich: Delphin Verlag, 1916.

———. *Sezession.* Vienna: Wiener Verlag, 1900.

Ball, Hugo. *Die Flucht aus der Zeit* (originally published 1927). Lucerne: Verlag Josef Stocker, 1946.

———. "Das Münchener Künstlertheater (Eine prinzipielle Beleuchtung)." *Phoebus*, May 1914, pp. 68-74.

Battersby, Martin. *The Decorative Twenties.* New York: Walker & Co., 1969.

———. *The Decorative Thirties.* New York: Walker & Co., 1971.

Battersby, Martin. *The World of Art Nouveau.* London: Arlington Books Ltd., 1968.

Baurmann, Roswitha. "Schrift." *Jugendstil, der Weg ins 20. Jahrhundert.* Edited by Helmut Seling. Heidelberg: Keysersche Verlagsbuchhandlung, 1959.

Bayern—Kunst und Kultur. Exhibition at the Munich Stadtmuseum, 10 June-15 October 1972. Munich: Prestel Verlag, 1972.

Becker, Benno. "Secession." *Pan* II (1896), pp. 243-47.

Behrens, Peter. "Die Dekoration der Bühne." *Deutsche Kunst und Dekoration* VI (1900), pp. 401-05.

———. "Die Lebensmesse von Richard Dehmel als festliches Spiel, dargelegt von Peter Behrens." *Die Rheinlande* IV (January 1901), pp. 28-40.

———. *Feste des Lebens und der Kunst, eine Betrachtung des Theaters als höchsten Kultur-Symboles.* Leipzig: Diederichs, 1900.

Behrens, Peter, ed. *Ein Dokument deutscher Kunst. Ausstellung der Künstlerkolonie in Darmstadt zur Feier der Eröffnung am 15. Mai 1901.* Darmstadt: Koch, 1901.

———. "Über Ausstellungen." *Die Rheinlande* IV (January 1900), pp. 33-34.

Bennett, Edwin K. *Stefan George.* New Haven: Yale University Press, 1954.

Bennigsen, Silvie Lampe-von. *Hermann Obrist, Erinnerungen.* Munich: Verlag Herbert Post Presse, 1970.

Berger, Ernst. "Goethes Farbenlehre und die modernen Theorien." *Die Kunst für Alle* 15 December 1910, pp. 133-41.

Berlepsch, H. E. von. "Endlich ein Umschwung." *Deutsche Kunst und Dekoration* I (October 1897), pp. 1-12.

———. "Frühjahr-Ausstellung der Münchner Secession." *Die Kunst für Alle* 1 May 1896, pp. 235ff.

———. "Walter Crane." *Die Kunst für Alle* 1 April 1896, pp. 193-98.

Berlepsch-Valendas. "Münchener Schmerzen." *Dekorative Kunst* VIII, 9 and 10 (June and August 1905), pp. 373-76, 464-67.

Bezold, Wilhelm von. *Die Farbenlehre im Hinblick auf Kunst und Kunstgewerbe.* Braunschweig: G. Westermann's Verlag, 1874.

Biema, Carry van. *Farben und Formen als lebendige Kräfte.* Jena: Diederichs, 1930.

Bierbaum, O. J. *Franz Stuck.* Bielefeld/Leipzig: Velhagen und Klasing, 1899.

Bill, Max, ed. *Wassily Kandinsky.* With essays by Jean Arp, Charles Estienne, Carola Giedion-Welcker, Will Grohmann, Ludwig Grote, Nina Kandinsky, Alberto Magnelli. Paris: Maeght Editeur, 1951.

Bing, S. "L'Art Nouveau." *Architectural Record* 12, no. 3 (August 1902), pp. 279-85.

Bing, Samuel. "Wohin treiben Wir?" *Dekorative Kunst* I, no. 1 (October 1897), pp. 1-3 (pt. I); no. 2 (November 1897), pp. 68-71 (pt. II); no. 4 (January 1898), pp. 173-77 (pt. III).

Binion, Rudolph. *Frau Lou, Nietzsche's Wayward Disciple.* Princeton: Princeton University Press, 1968.

Der Blaue Reiter. Catalog of the Collection, Städtische Galerie im Lenbachhaus München. 2nd ed. Munich: 1966.

Board, H. "Die Kunstgewerbeschule zu Düsseldorf." *Dekorative Kunst* XII (August 1904), pp. 409-26.

Bode, Wilhelm. "Hermann Obrist. V." *Pan* I, V (1896), pp. 326-28.

Bodelsen, Merete. *Gauguin's Ceramics. A Study in the Development of his Art.* London: Faber & Faber Ltd., 1964.

Bonnard, Vuillard et Les Nabis, 1888-1903. Paris: Musée National d'Art Moderne, 1955.

Bosselt, Rudolf. "Aufgaben und Ziele der Künstler-Kolonie in Darmstadt." *Dekorative Kunst* IV, 11 (August 1901), pp. 432-45.

Bott, Gerhard, ed. *Kunsthandwerk um 1900, Jugendstil.* Darmstadt: E. Roether Verlag, 1965.

Bouillon, Jean-Paul, ed. *Wassily Kandinsky—Regards sur*

le passé et autres textes, 1912-1922. Paris: Collection Savoir, Hermann, 1974.

Bowlt, John E., ed. *Russian Art of the Avant-Garde: Theory and Criticism 1902-1934.* The Documents of 20th-Century Art. New York: Viking Press, 1976.

Bowlt, John E. "The World of Art." *Russian Literature Triquarterly* (Fall 1972), pp. 184-218.

Bowra, C. M. *The Heritage of Symbolism* (originally published in 1943). New York: Schocken, 1961.

Braulich, Heinrich. *Max Reinhardt—Theater zwischen Traum und Wirklichkeit.* Berlin: Henschelverlag, 1969.

Bredt, E. W. "Ausstellung der 'Vereinigung für Angewandte Kunst.'" *Dekorative Kunst* VIII, 12 (September 1905), pp. 469-83; IX, 1 (October 1905), pp. 37-44 (pt. II).

——. "Verkünden und Handeln." *Dekorative Kunst* v, 6 (March 1902), pp. 218-26.

——. "Obrists neues Urnen-Grabmal." *Dekorative Kunst* XI, 3 (December 1907), p. 120.

Breysig, Kurt. "Kunst und Leben." *Deutsche Kunst und Dekoration* IX (1901-02), pp. 135-50.

Brinkmann, Richard. *Expressionismus Forschungs-Probleme 1952-1960.* Stuttgart: J. B. Metzlersche Verlagsbuchhandlung, 1961.

Brion-Guerny, L., ed. *L'Année 1913: les formes esthetiques de l'oeuvre d'art à la veille de la premier guerre mondiale.* Paris: Editions Klincksieck, 1971, 1973.

Brisch, Klaus. "Wassily Kandinsky, Untersuchung zur Entstehung der gegenstandslosen Malerei." Ph.D. dissertation, University of Bonn, 1955.

Browning, Robert M., ed. *German Poetry, a Critical Anthology.* New York: Appleton-Century-Crofts, 1962.

Bruckmann-Cantacuzène, E. "Über die Notwendigkeit einer künstlerischen Reform der Bühne." *Dekorative Kunst* IV, 7 (April 1901), pp. 271-78.

Buchold, Marie. "Einige Bücher und Persönlichkeiten, die für mein Leben wichtig waren." *Mitteilungen des Bundes der Schülerinnen und Freunde von Schwarzerden.* November 1970.

Burger, Fritz. *Cézanne und Hodler: Einführung in die Probleme der Malerei der Gegenwart* (2 vols.), 2nd ed. Munich: Delphin-Verlag, 1918.

——. *Einführung in die moderne Kunst.* Berlin/Neubabelsberg: Akademische Verlagsgesellschaft Athenaion M.B.H., 1917.

Burliuk, Dmitri and Vladimir. Untitled foreword. *Neue Künstlervereinigung München, II. Ausstellung.* Munich: Bruckmann, 1910/11, pp. 5-6.

C. [?]. "Dekorative Stickereien" (review of Margarethe von Brauchitsch). *Dekorative Kunst* III, 8 (May 1900), pp. 347-49.

C. [?]. "Margarethe von Brauchitsch." *Dekorative Kunst* v, 7 (April 1902), pp. 258-61.

Cassou, Jean; Langui, Emil; Pevsner, Nikolaus. *Gateway to the Twentieth Century.* New York: McGraw-Hill Book Co., 1962.

Catalogue of an Exhibition of Contemporary German Art. Introduction by Martin Birnbaum. New York: Berlin Photographic Company, 1912-13.

C.E.G. [?]. "'Mir Iskusstva' (die Kunstwelt). . . ." *Die Kunst für Alle* 15 March 1899, p. 191.

Charles Rennie Mackintosh. The Scottish Art Review (Special Number) XI, no. 4, 1968.

Cheney, Sheldon. *The Art Theatre* (originally published in 1917). New York: Alfred A. Knopf, 1970.

Clark, Robert Judson, ed. *The Arts and Crafts Movement in America, 1876-1916.* Princeton University Art Museum, 1973.

Coellen, Ludwig. *Die Neue Malerei.* Munich: E. W. Bonsels & Co., 1912.

Corinth, Lovis. "Carl Strathmann." *Kunst und Künstler* I (1902-03), pp. 255-63.

——. "Thomas Theodor Heine und Münchens Künstler-Leben am Ende des vorigen Jahrhunderts." *Kunst und Künstler* IV (1905-06), pp. 143-56.

Craig, Edward Gordon. "The Actor and the Übermarion-

ette." *On the Art of the Theater*. London: Heinemann, 1911 (republished 1968).

——. *Die Kunst des Theaters*. Leipzig: H. Seemann, 1905.

——. "Etwas über den Regisseur und die Bühnenausstattung." *Deutsche Kunst und Dekoration* XVI (April-September 1905), pp. 595-605.

——. "Foreign Notes. Munich. A model art theatre. . . ." *The Mask* I, no. 2 (April 1908), pp. 21-22.

——. "Munich the Reform Stage." *The Mask* I, no. 8 (October 1908), p. 163.

——. "Two Letters to John Semar, 1907." *On the Art of the Theater*. London: Heinemann, 1911 (republished, 1968).

Crane, Walter. *The Bases of Design*. London: George Bell and Sons, 1909 (first edition 1898).

——. *The Claims of Decorative Art*. London: Lawrence and Bullen, 1892.

——. *Die Forderungen der dekorativen Kunst* (German translation of *The Claims of Decorative Art*). Berlin: G. Siemens, 1896.

——. *Line & Form*. London: George Bell & Sons, 1904 (first edition 1900).

——. *Linie und Form* (German translation of *Line and Form*). Leipzig: n.p., 1901.

Czapek, Rudolf. *Grundprobleme der Malerei. Ein Buch für Künstler und Lernende*. Leipzig: Klinkhardt & Biermann, 1908.

Das Deutsche Kunstgewerbe 1906. 3. Deutsche Kunstgewerbe Ausstellung, Dresden 1906. Munich: Bruckmann, 1906.

David, Claude. *Stefan George, sein dichterisches Werk* (originally published in Paris, 1952). Munich: Carl Hanser Verlag, 1967.

——. "Stefan George und der Jugendstil." *Formkräfte der deutschen Dichtung von Barock bis zur Gegenwart; Vorträge gehalten im deutschen Haus, Paris 1961-62*. Göttingen: Vandenhoeck & Ruprecht, 1963.

Debrunner, Hugo, ed. *Wir entdecken Kandinsky*. . . . Zurich: Origo [1947].

Debschitz, Wilhelm von. "Eine Methode des Kunstunterrichts." *Dekorative Kunst* VII, 6 (March 1904), pp. 209-26.

De Kay, Charles. "Munich as an Art Centre." *The Cosmopolitan* XIII, no. 6 (October 1892), pp. 643-53.

Dekorative Kunst. I (October 1897)-XVI (1912-13). Munich: Bruckmann.

Denis, Maurice. "Définition du néo-traditionisme." *Art et critique*, 23 and 30 (August 1890). Reprinted in *Théories 1890-1910*. 4th ed. Paris: L. Rouart et J. Watelin, 1920.

——. "Von Gauguin und Van Gogh zum Klassizismus." *Kunst und Künstler* VIII, no. 2 (November 1909), pp. 86-101. (Originally published in French as "De Gauguin et de Van Gogh du classicisme." *L'Occident* XV, no. 90 [May 1909], pp. 187-202.)

——. *Théories, 1890-1910*. 3rd ed. Paris: Bibliothèque de l'Occident, 1913.

Derkatsch, Ingrid. "Wassilly Kandinsky's Theory of the Identity of Realism and Abstraction in his Essay 'Über die Formfrage.'" Master's thesis, University of California at Berkeley, 1967.

De Salas, Xavier. "Some Notes on a Letter of Picasso." *Burlington Magazine* CII (November 1960), pp. 482-84.

Deutsche Kunst und Dekoration. I (October 1897)-XVII (1905-06). Darmstadt: Alexander Koch.

Dobida, Karel. "Biographie Sommaire." *Anton Ažbè in Njegova Sola*. Ljubljana: Narodna Galerija, 1962.

Dobuzhinsky, Matislav. "Iz vospominanii" ("From my Memoirs"). *Novyi zhurnal* (New Journal), no. 52 (1958), pp. 109-39 (unpublished synopsis and translation by John Bowlt).

Donchin, Georgette. *The Influence of French Symbolism on Russian Poetry*. S-Gravenhage (The Hague): Mouton & Co., 1958.

D. R. [Die Redaktion?]. (Editorial rebuttal of Van de Velde's claim that the "renaissance" in German crafts began with his 1897 exhibition in Dresden. Begins chronology with Obrist's 1896 exhibition in Munich.) *Dekorative Kunst* iv, 9 (June 1901), p. 376.

———. "Die Mitglieder der 'Lehr- und Versuch-Ateliers für angewandte und Freie Kunst, Wilhelm von Debschitz, München,' auf der Bayerischen Jubiläums-Landesausstellung Nürnberg 1906." *Dekorative Kunst* ix, 9 (June 1906), pp. 345-64.

———. "Neue Stickereien von Margarete [sic] von Brauchitsch." *Deutsche Kunst und Dekoration* xvi (April-September 1905), pp. 497-98.

Driver, Tom F. *Romantic Quest and Modern Query, A History of Modern Theater.* New York: Dell Publishing Co., Inc., 1971.

Druckkunst des Jugendstils Holzschnitte, Lithographien, Radierungen, Buchillustrationen 12 November-30 December 1966. Zurich: Kunstgewerbemuseum Zurich, 1966.

Dulac, Edmond, illustrator. *Erzählungen aus Tausend und eine Nacht.* Leipzig: Inselverlag, 1907-08.

Duncan, Isadora. *Der Tanz der Zukunft, eine Vorlesung.* Leipzig: Diederichs, 1903.

Duthie, Enid Lowry. *L'influence du symbolism française dans le renouveau poétique de l'allemagne. Les Blätter für die Kunst de 1892-1900.* Paris: Bibliothèque de la Revue de la Literature comparée, 1933.

———. "Some References to the French Symbolist Movement in the Correspondence of Stefan George and Hugo von Hofmannsthal." *Comparative Literature Studies* ix, 1943, pp. 15-18.

"E." [?]. "Neue Stickereien von Margarete [sic] von Brauchitsch." *Dekorative Kunst* viii, 1 (October 1904), pp. 19-24.

Eckardt, A. Simon von. *Web-Muster entworfen von Franz Marc für den Plessmannschen Handwebstuhl.* Munich: Verlag der Münchner Lehrmittelhandlung Wilhelm Plessmann (ca. 1909).

Eckstein, Hans, ed. *die neue sammlung* [sic]. Munich: Die Neue Sammlung Staatliches Museum für angewandte Kunst, n.d.

Ede, H. S. *Savage Messiah—Gaudier-Brzeska.* New York: The Literary Guild, 1931.

Eddy, Arthur Jerome. *Cubists and Post-Impressionists* (originally published 1914). Chicago: A. C. McClurg & Co., 1919.

Eichner, Johannes. *Kandinsky und Gabriele Münter, von Ursprüngen moderner Kunst.* Munich: Verlag Bruckmann, 1957.

Ein Dokument Deutscher Kunst 1901-1976 (exhibition catalog), edited by Marianne Heinz (with Bernd Krimmel, Carl Benno Heller, Gert Reising, Birgit Braun, Annelise Loth, Brigitte Rechberg). Five volumes. Darmstadt: Eduard Roether Verlag, 1976.

Eitner, Lorenz. "Kandinsky in Munich." *The Burlington Magazine* xcix (June 1957), pp. 193-99.

Elias, Julius. "Schwarz-Weiss." *Kunst und Künstler* v, (February 1907), pp. 177-85.

Eliasberg, Alexander. *Russische Kunst. Ein Beitrag zur Charakteristik des Russentums* (2nd ed.). Munich: R. Piper & Co., 1915.

Endell, August. "Architektonische Erstlinge." *Dekorative Kunst* iii, 8 (May 1900), pp. 297-316.

———. "Formenschönheit und dekorative Kunst." pt. i, "Die Freude an der Form." *Dekorative Kunst* i, no. 2 (November 1897), pp. 75-77; pt. ii, "Die gerade Linie." *Dekorative Kunst* i, no. 9 (June 1898), pp. 119-20; pt. iii, "Geradlinige Gebilde." *Dekorative Kunst* i, no. 9 (June 1898), pp. 121-25.

———. "Gedanken. Formkunst." *Dekorative Kunst* i, no. 6 (March 1898), p. 280.

———. "Möglichkeit und Ziele einer neuen Architektur." *Deutsche Kunst und Dekoration* i (1897-98), pp. 141-53.

Endell, August. "Originalität und Tradition." *Deutsche Kunst und Dekoration* IX, no. 6 (1901-02), pp. 289-96.

———. "Schneetag." *Pan* II (1896), p. 205.

———. *Die Schönheit der grossen Stadt.* Stuttgart: Strecker & Schröder, 1908.

———. *Um die Schönheit, eine Paraphrase über die Münchner Kunstausstellungen—1896.* Munich: Verlag Emil Franke, 1896.

Engels, Eduard, ed. *Münchens 'Niedergang als Kunst-stadt'—eine Rundfrage von Eduard Engels.* Munich: Bruckmann Verlagsanstalt, 1902.

Erhardt-Siebold, Erika von. "Harmony of the Senses in English, German, and French Romanticism." *Publication of the Modern Language Association of America* XLVII, 2 (June 1932), pp. 577-92.

Ernst, Paul. [review of] "W. Worringer, *Abstraktion und Einfühlung. Ein Beitrag zur Stilpsychologie.* Neuwied 1907." *Kunst und Künstler* VI (1907-08), p. 529.

Erster Deutscher Herbstsalon. Introduction by Herwarth Walden. Berlin: Der Sturm, 1913.

Esswein, H. T. *T. Th. Heine,* in *Moderne Illustratoren* 1. Munich: Piper, 1904.

Ettinger, P. "Moderne Russische Malerei." *Die Kunst für Alle* 15 March 1907, pp. 273-85.

Ettlinger, L. D. "Kandinsky." *L'Oeil* 114 (June 1964), pp. 10-17, 50.

———. "Kandinsky's 'At Rest'" in *Charlton Lectures on Art at King's College.* London: Oxford University Press, 1961, pp. 3-21.

Europäischer Jugendstil: Druckgraphik, Handzeichnungen und Aquarelle, Plakate, Illustrationen und Buchkunst um 1900. Ausstellung Kunsthalle Bremen, 1965.

Evans, E. P. "Artists and Art Life in Munich." *The Cosmopolitan* IX (May 1890), pp. 3-14.

Evans, Myfanwy. "Kandinsky's Vision." *Axis,* no. 2 (1935), p. 7.

L'Exposition internationale des arts décoratifs modernes à Turin, 1902. Text by G. Fuchs and F. H. Newbery. Darmstadt: A. Koch, 1903.

Farbenschau im Kaiser-Wilhelm-Museum zu Krefeld. Krefeld: G. A. Hohns Söhne, 1902.

Fechter, Paul. *Der Expressionismus.* Munich: R. Piper, 1914.

Feininger, Julia and Lyonel. "Wassily Kandinsky." *Magazine of Art* XXXVIII, no. 5 (May 1945), p. 174.

Fénéon, Félix. *Oeuvres,* Jean Paulhan (ed.). Paris: Gallimard, 1945.

50 jahre bauhaus. Stuttgart: Württembergischer Kunstverein, 1968.

Fineburg, Jonathan D. "Kandinsky in Paris 1906-7." Ph.D. dissertation, Harvard University, 1975.

Fingesten, Peter. "Spirituality, Mysticism and Non-objective Art." *The Art Journal* XXI (Fall 1961), pp. 2-6.

Fischer, Otto. *Das neue Bild.* Veröffentlichung der Neue Künstlervereinigung München. Munich: Delphin Verlag, November 1912.

Floerke, Gustav. "Zur künstlerischen Charakteristik Böcklins." *Die Kunst für Alle* 1 October 1901, pp. 8-17.

Fortlage, Arnold. "Kunst unserer Zeit in Kölner Besitz." *Die Kunst für Alle* 15 December 1911, pp. 146-47.

———. "Die Internationale Ausstellung des Sonderbunds in Köln." *Die Kunst für Alle* 15 November 1912, pp. 84-93.

Frank, Leonhard. *Links wo das Herz ist.* Munich: Nymphenburger Verlagshandlung, 1952.

Franz von Stuck, Die Stuck-Villa zu ihrer Wiedereröffnung am 9. März 1968. Edited by J. A. Schmoll gen. Eisenwerth. Munich: Karl M. Lipp, 1968.

Fred, W. "A Chapter on German Arts and Crafts with Special Reference to the Work of Hermann Obrist." *Artist* V, 31 (1901), pp. 17-26.

Fry, Roger. "An Essay in Aesthetics" in *Vision & Design* (from *New Quarterly,* 1909). Cleveland & New York: Meridian Books, 1963, pp. 16-34 (originally published 1920).

―――. *Vision and Design*. Cleveland & New York: Meridian Books, 1963 (originally published 1920).

Fuchs, Georg. "Angewandte Kunst im Glaspalaste 1898." *Deutsche Kunst und Dekoration* III (October 1898-March 1899), pp. 21-49.

―――. "Angewandte Kunst in der Secession zu München 1899." *Deutsche Kunst und Dekoration* V (October 1899), 1-23.

―――. [G. F.]. "Die Ausstellung der Secession in München 1898." *Deutsche Kunst und Dekoration* II (April-September 1898), pp. 315-19.

―――. "Das 'Bunte Theater' von August Endell." *Deutsche Kunst und Dekoration* IX, no. 6 (1901-02), pp. 275-89.

―――. "Friedrich Nietzsche und die bildende Kunst." *Die Kunst für Alle* 1 and 15 November 1895, pp. 33-38 and 71-73; 15 December 1895, pp. 85-88.

―――. "Hermann Obrist." *Pan* I, no. 5 (1896), pp. 318-25.

―――. "Hugo von Tschudi." *Die Kunst für Alle* 15 April 1908, pp. 329-32.

[―――]. "Ideen zu einer festlichen Schau-Bühne." *Deutsche Kunst und Dekoration* IX (1901-02), pp. 108-23.

―――. "Die Kunst-Hochschule." *Dekorative Kunst* VII, 9 (June 1904), pp. 346-59.

―――. "Melchior Lechter." *Deutsche Kunst und Dekoration* I (October 1897-March 1898), pp. 161-92.

―――. "Das Münchener Künstler-Theater." *Dekorative Kunst* XIV, 3 (December 1910), pp. 138-42.

―――. "The Munich Artists' Theater." *Apollon* November 1909, pp. 47ff.

―――. *Revoliutsiia teatre*. St. Petersburg: Iakor, 1911.

―――. *Die Revolution des Theaters, Ergebnisse aus dem Münchener Künstlertheater*. Munich/Leipzig: Georg Müller, 1909.

―――. *Revolution in the Theatre: Conclusions Concerning the Munich Artists' Theatre*. Translated by Constance Connor Kuhn. Ithaca: Cornell University Press, 1959 (reissued by Kennikat Press, 1972).

―――. *Die Schaubühne der Zukunft*. Berlin: Schuster & Loeffler, 1905.

―――. "Stil, Kultur und Kunstbedarf." *Die Kunst für Alle* 15 July 1904, pp. 470-79.

―――. *Sturm und Drang in München um die Jahrhundertwende*. Munich: Callwey, 1936.

―――. *Der Tanz*. Stuttgart: Strecker & Schroeder, 1906.

―――. *Von der stilistischen Neubelebung der Schaubühne*. With designs by Peter Behrens. Leipzig: Diederichs, 1891.

[―――]. "Zu den Arbeiten Obrist's." *Dekorative Kunst* III, 5 (February 1900), pp. 196-98.

―――. "Zur Kunstgewerbe-Schule der Zukunft." *Deutsche Kunst und Dekoration* XIII (October 1903-March 1904), pp. 259-66.

―――. "Zur künstlerischen Neugestaltung der Schau-Bühne." *Deutsche Kunst und Dekoration* VII (October 1900-March 1901), pp. 200-14.

Furst, Herbert. *The Decorative Art of Frank Brangwyn*. London: John Lane The Bodley Head Ltd., 1924. New York: Dodd, Mead & Co.

Gabriele Münter das druckgraphische Werk. Munich: Städtische Galerie im Lenbachhaus, 1967.

Gabriele Münter, 1877 to 1962: Fifty Years of her Art. Paintings: 1906-1956. (March-April 1966). New York: Leonard Hutton Galleries, 1966.

Galloway, Vincent. *The Oils and Murals of Sir Frank Brangwyn R. A. 1867-1956*. Leigh-on-Sea, England: F. Lewis Publishers, Ltd., 1962.

Gaudier-Brzeska—Drawings and Sculpture (introduction by Mervyn Levy). London: Cory, Adams & Mackay, 1965.

George, Stefan, ed. *Blätter für die Kunst. Eine Auslese aus den Jahren 1892-1898*. Berlin: G. Bondi, 1899.

―――. *Blätter für die Kunst. Eine Auslese aus den Jahren 1898-1904*. Berlin: G. Bondi, 1904.

George, Stefan, ed. *Blätter für die Kunst. Eine Auslese aus den Jahren 1904-1909.* Berlin: G. Bondi, 1909.

————. *Gesamt-Ausgabe der Werke. Endgültige Fassung.* Berlin: G. Bondi, 1927-34.

————. *Stefan George, Poems in German and English.* Translated by Ernst Morwitz and Carol North Valhope. New York: Schocken Books, 1967.

————. *Stefan George Werke—Ausgabe in zwei Bänden.* Düsseldorf and Munich: Verlag Helmut Küpper formerly Georg Bondi, 1968.

————. *The Works of Stefan George.* Translated by Olga Marx and Ernst Morwitz. Chapel Hill: University of North Carolina Press, 1949.

Gérôme-Maësse. "Kandinsky, La Gravure sur bois, l'Illustration." *Tendances nouvelles* III, 26 (1906), pp. 436-38. Reprinted in Röthel, *Kandinsky—Das graphische Werk*, pp. 427-28.

————. "L'Audition colorée." *Les Tendances nouvelles*, 33 (1907), pp. 655-63. (Facsimile in Fineburg, "Kandinsky in Paris 1906-7," appendix.)

Giedion-Welcker, Carola. "Wassily Kandinsky und seine universelle Kunst." *Universitas.* Zeitschrift für Wissenschaft, Kunst und Literatur. Vol. 28, no. 4, (April 1973), pp. 355-62.

Gittleman, Sol. *Frank Wedekind.* New York: Twayne Publications, 1969.

C. G. [Curt Glaser]. "Berliner Ausstellung." *Die Kunst für Alle* 1 May 1912, pp. 361-62.

————. "Frankfurter Ausstellungen." *Die Kunst für Alle* 15 June 1912, pp. 434-35.

The Glasgow Boys. An exhibition of works by the group of artists who flourished in Glasgow 1880-1900 (2 vols.). Edinburgh: The Scottish Arts Council, 1968.

Gmelin, L. "Ausstellung für angewandte Kunst, München 1905." *Kunst und Handwerk* LVI (1905-06), pp. 8-26, 40-56.

Goldin, Amy. "Matisse and Decoration: The Late Cut-Outs." *Art in America* (July-August 1975), pp. 49-59.

Goldschmiede-Arbeiten nach Entwürfen von Wassily Kandinsky 1 December 1970-16 January 1971. Executed by Max Pollinger and Cornelia Röthel. Buchhandlung und Galerie Hans Goltz, Munich.

Goldsmith, Ulrich. "Stefan George and the Theater." *Publications of the Modern Language Association* LXVI (March 1951), pp. 85-95.

Gollek, Rosel, ed. *Der Blaue Reiter im Lenbachhaus München.* Munich: Prestel Verlag, 1974.

Gordon, Donald E. *Ernst Ludwig Kirchner.* Munich: Prestel Verlag, 1968.

————. *Modern Art Exhibitions 1900-1916; Selected Catalogue Documentation,* 2 vols. Munich: Prestel Verlag, 1974.

————. "On the Origin of the Word 'expressionism.'" *Journal of the Warburg and Courtauld Institutes* XXIX (1966), pp. 368-85.

Gorelik, Mordecai. *New Theatres for Old* (originally published 1940). New York: E. P. Dutton & Co., Inc., 1962.

Grabar, Igor. *Moya zhizn* (My Life). Moscow-Leningrad: 1937. (Unpublished synopsis and translation of chap. VI, pp. 119-46, by John Bowlt.)

Grady, James. "A Bibliography of Art Nouveau" in Selz and Constantine *Art Nouveau. Art and Design at the Turn of the Century.* New York, 1959, pp. 152-61.

Gray, Camilla. *The Great Experiment: Russian Art 1863-1922.* New York: Harry N. Abrams, Inc., 1962.

Grieve, Alastair. "The Applied Art of D. G. Rossetti-I. His Picture Frames." *Burlington Magazine* CXV, no. 838, January 1973, pp. 16-24.

Grohmann, Walter. *Das Münchner Künstlertheater in der Bewegung der Szenen und Theaterreformen.* Dissertation, Ludwig-Maximilians-Universität München. Berlin: Selbstverlag der Gesellschaft für Theatergeschichte, 1935.

Grohmann, Will. "Wassily Kandinsky." *Der Cicerone* XVI, no. 19 (1924), pp. 887-98.

————. *Wassily Kandinsky, Life and Work*. New York: Harry N. Abrams, Inc., 1958.

————. "Wassily Kandinsky zum 100. Geburtstag." Festvortrag in der Akademie der Künste am 4. Dezember 1966. Berlin: Akademie der Künste, 1966.

Guenther, Johannes von. "Stefan George, his Times and his School." *Apollon*, no. 4 (April 1911), pp. 48ff.

Habich, Georg. "Die Jahres-Ausstellung im Münchener Glaspalast." *Die Kunst für Alle* 15 August 1902, pp. 509-18.

————. [G. H.-ch.]. "Die Jugendgruppe auf der Jahresausstellung im Münchener Glaspalast." *Die Kunst für Alle* 1 November 1899, pp. 51-54.

————. "Munchener Frühjahr-Ausstellungen." *Die Kunst für Alle* 15 April 1902, pp. 319ff.

————. "Die Sommer-Ausstellung der Münchener Secession." *Die Kunst für Alle* 1 July 1903, pp. 443-50 (pt. i); 15 July 1903, pp. 467-73 (pt. ii).

Haenel, E. "Die Schulfeste der Bildungsanstalt Jaques-Dalcroze in Hellerau." *Die Kunst für Alle* 1 October 1912 (suppl., pp. ii-iii).

Haftmann, Werner. "Musik und moderne Malerei" in *Musica Viva*, ed. by K. H. Ruppel. Munich: Nymphenburger Verlagshandlung, 1969, 175-95.

————. *Painting in the Twentieth Century*. 2nd ed. Translated by Ralph Manheim. New York: Frederick A. Praeger, 1965.

Hahl-Koch, Jelena. *Marianne Werefkin und der russische Symbolismus, Studien zur Ästhetik und Kunsttheorie*, Slavistische Beiträge, vol. 24. Munich: Verlag Otto Sagner, 1967.

Hajek, Edelgard. *Literarischer Jugendstil-Vergleichende Studien zur Dichtung und Malerei um 1900. Literatur in der Gesellschaft*, vol. 6. Düsseldorf: Bertelsmann Universitätsverlag, 1971.

Hamann, Richard. *Geschichte der Kunst von der altchristlichen Zeit bis zur Gegenwart*. Berlin: Verlag von Th. Knaur Nachf., 1933.

Hamilton, George Heard. *Painting and Sculpture in Europe, 1880-1940*. Baltimore: Penguin Books, 1967.

Hanfstaengl, Erika, ed. *Wassily Kandinsky—Zeichnungen und Aquarelle im Lenbachhaus München*. Munich: Prestel Verlag, 1974.

Harms, Ernest. "My Association with Kandinsky." *American Artist* xxvii, no. 6 (June 1963), pp. 36-41, 90f.

Hausenstein, Wilhelm. *Die bildende Kunst der Gegenwart*. Stuttgart/Berlin: Deutsche Verlags-Anstalt, 1914.

————. *Liebe zu München*. 4th ed. Munich: Prestel, 1958.

————. *München—Gestern, Heute, Morgen*. Munich: Verlag Karl Alber, 1947.

"H." [Emil Heilbut]. "Die zweite Ausstellung des deutschen Künstlerbunds." *Kunst und Künstler* iii (July 1905), pp. 399-428.

Helms, Dietrich, ed. "Texte und Bilder" in *Adolf Hölzel, sein Weg zur Abstraktion*, ed. by Wolfgang Venzmer. Dachau: Stadt Dachau, 1972, pp. 21-30.

Henderson, Philip. *William Morris. His Life, Work and Friends*. London: Thames & Hudson, 1967.

Henniger, Gerd. "Die Auflösung des Gegenständlichen und der Funktionswandel der Malerischen Elemente im Werke Kandinskys 1908-1915." *Edwin Redslob zum 70. Geburtstage, eine Festgabe*. Berlin: Erich Blaschker Verlag, 1955.

Herbert, Robert L., ed. *Modern Artists on Art*. Englewood Cliffs, N.J.: Prentice-Hall, Inc., 1964.

Hermand, Jost. *Jugendstil—Ein Forschungsbericht, 1918-1964*. Stuttgart: J. B. Metzlersche Verlagsbuchhandlung, 1965.

————, ed. *Lyrik des Jugendstils*. Stuttgart: Reclam, 1964.

————, and Hamann, Richard. *Stilkunst um 1900. Deutsche Kunst und Kultur von der Gründerzeit bis zum Expressionismus*. vol. iv. Berlin: Akademie-Verlag, 1967.

Hermann Obrist—Wegbereiter der Moderne. Edited by Siegfried Wichmann. Munich: Stuck-Jugendstil Verein, 1968.

Hermann, Curt. "Der Kampf um den Stil." *Kunst und Künstler* IX (1910-11), pp. 102-05.

Hess, Walter. "Zu Hölzels Lehre." *Der Pelikan*, no. 65 (April 1963), pp. 18-34.

Hevesi, Ludwig. *Acht Jahre Secession (März 1897-Juni 1905) Kritik—Polemik—Chronik)*. Vienna: C. Konegen, 1906.

Hildebrand, Adolf von. "Münchener Künstlertheater" in *Gesammelte Aufsätze*. Strassbourg: Heitz, 1909. (Originally published in *Münchener Neueste Nachrichten*, February 1908 and republished in *Münchener Künstler-Theater*, 1908, q. v.)

————. *Das Problem der Form in der bildenden Kunst*. Strassbourg: Heitz & Mündel, 1893.

Hildebrandt, Hans. *Die Kunst des 19. und 20. Jahrhunderts*. Potsdam. Akademische Verlagsgesellschaft Athenaion, 1924.

————. "Drei Briefe von Kandinsky." *Werk* XLII, no. 10 (October 1955), pp. 327-31.

Hilmar, Ernst, ed. *Arnold Schönberg-Gedenkausstellung 1974*. Vienna: Universal Edition, AG., 1974.

"Hinterglasmalerei" (Painting on Glass) by Gabriele Münter. New York: Leonard Hutton Galleries, 1967.

Hirth, Herbert. "Villa Stuck." *Die Kunst für Alle* 1 July 1899, pp. 289-93.

Hoeber, Fritz. *Peter Behrens*. Munich: G. Müller and E. Rentsch, 1913.

Hoelzel, Adolf. "Über Wandmalerei (Vortrag gehalten auf der Versammlung des Verbandes der Kunstfreunde zu Darmstadt)." *Die Rheinlande* VIII (1908), pp. 53-84.

————. "Über bildliche Kunstwerke im architektonischen Raum." *Der Architekt* XV (1909), pp. 73-80, and Neue Folge; XVI (1910), pp. 9-11, 17-20, 41-44, 49-50.

————. "Über Formen und Massenverteilung im Bilde." *Ver Sacrum* IV (1901), pp. 243-54.

————, "Über künstlerische Ausdrucksmittel und deren Verhältnis zu Natur und Bild." *Die Kunst für Alle* 15

November 1904, pp. 18-88; 1 December 1904, pp. 121-42.

Hölzel und sein Kreis—Der Beitrag Stuttgarts zur Malerei des 20. Jahrhunderts. Introduction by Wolfgang Venzmer. Stuttgart: Württembergischer Kunstverein, 1961.

Hoffmann, Klaus. *Neue Ornamentik—Die ornamentale Kunst im 20. Jahrhundert*. Cologne: DuMont Schauberg, 1970.

Hofmann, Helga D. "The Villa Stuck: a Masterpiece of the Bavarian-Attic Style." *Apollo* XCIV, no. 117 (November 1971), pp. 384-95.

Hofmann, Werner. *Grundlagen der modernen Kunst, eine Einführung in ihre symbolischen Formen*. Stuttgart: Alfred Kröner Verlag, 1966.

————. *Von der Nachahmung zur Erfindung der Wirklichkeit: die schöpferische Befreiung der Kunst 1890-1917*. Cologne: Verlag M. DuMont Schauberg, 1970. Translated by Charles Kessler as *Turning Points in Twentieth-Century Art 1890-1917*. New York: Braziller, n.d.

Hofmannsthal, Hugo von. "Ausstellung der Münchener 'Sezession' und der 'Freien Vereinigung Düsseldorfer Künstler.'" *Neue Revue (1894). Prosa I, Gesammelte Werke*. Frankfurt am Main: S. Fischer Verlag, 1950.

————. "Franz Stuck." *Neue Revue (1894). Prosa I, Gesammelte Werke. Frankfurt am Main*: S. Fischer Verlag, 1950.

————. "Gedichte von Stefan George." *Die Zeit (1896). Prosa I, Gesammelte Werke*. Frankfurt am Main: S. Fischer Verlag, 1950.

Hofstätter, Hans. *Geschichte der europäischen Jugendstilmalerei*. 2nd ed. Cologne: DuMont Schauberg, 1965.

————. "Malerei." *Jugendstil, der Weg ins 20. Jahrhundert*. Edited by Helmut Seling. Heidelberg: Keysersche Verlagsbuchhandlung, 1959.

————. *Jugendstil Druckkunst*. Baden-Baden: Holle-Verlag, 1968 (2nd ed. 1973).

————. *Symbolismus und die Kunst der Jahrhundertwende*. Cologne: DuMont Schauberg, 1965.

Holborn, Hajo. *A History of Modern Germany 1840-1945.* New York: Alfred A. Knopf, 1969.

Holitscher, Arthur. "Alfred Kubin." *Die Kunst für Alle* 1 January 1903, p. 163.

Holloway, Mark. *Heavens on Earth.* 2nd ed. New York: Dover Publications, 1966.

Hommage de Paris à Kandinsky. Paris: Musée d'Art Moderne de la Ville de Paris, 1972.

Hoog, Michel and Leopold Reidemeister, eds. *Der französische Fauvismus und der deutsche Frühexpressionismus* (*Le Fauvisme français et les débuts de l'Expressionisme allemand*). (Exhibition Musée National d'Art Moderne Paris, 15 January-6 March 1966, and Haus der Kunst, Munich, 26 March-15 May 1966). Munich: Haus der Kunst, 1966.

Hope, Henry. "Sources of Art Nouveau." Ph.D. dissertation, Harvard University, 1942.

Howarth, Thomas. *Charles Rennie Mackintosh and the Modern Movement.* London: Routledge & Kegan Paul, 1952.

Howe, G. "Die Sonderbund Ausstellung in Düsseldorf." *Die Kunst für Alle* 15 September 1910, pp. 571-72.

"H.R." [Hans Rosenhagen]. "Aus den Berliner Kunstsalons" (review of Claude Monet exhibition at Salon Paul Cassirrer). *Die Kunst für Alle* 1 May 1903, pp. 356-58.

Huch, Ricarda. "Symbolistik vor 100 Jahren." *Ver Sacrum* no. 3 (1898), pp. 7-18.

Huysmans, Joris Karl. *Gegen den Strich.* Translated by M. Capsius (originally published as *À Rebours*, Paris, 1884). Illustrated by Melchior Lechter. Berlin: Schuster und Loeffler, 1897.

Isarius. "Darmstadt, die 'werdende Kunst-Stadt.'" *Deutsche Kunst und Dekoration* IX (1901-02), p. 85.

Itten, Johannes. "Adolf Hölzel und sein Kreis." *Der Pelikan* no. 65 (April 1963), pp. 34-40.

Jakovsky, Anatole. "Wassily Kandinsky." *Axis* no. 2 (1935), pp. 9-12.

Jessen, Jarno. "Moderne Präraffaeliten." *Die Kunst für Alle* 15 November 1903, pp. 83-92.

Jullian, Philippe. *Dreamers of Decadence.* New York: Praeger, 1971. (Originally published as *Esthètes et Magiciens.* Paris: Librairie académique Perrin, 1969.)

————. *The Symbolist Painters.* New York: Praeger, 1973.

Jugendstil Illustration in München. Eine Ausstellung der Stadtbibliothek München in Verbindung mit dem Stuck-Jugendstil-Verein. Munich: Albert Langen-Georg Müller Verlag, 1969.

Kaiser, Hans. "Adolf Hoelzel." *Die Rheinlande* VIII (1908), pp. 33-36.

Kandinsky: Aquarelle und Zeichnungen. Exhibition June-July, 1972. Basel: Galerie Beyeler.

Kandinsky at the Guggenheim Museum. New York: The Solomon R. Guggenheim Museum, 1972.

Kandinsky, Franz Marc, August Macke—Drawings and Watercolors. April 16-May 28, 1969, Hutton-Hutschnecker Gallery, Inc., New York.

Kandinsky (Gabriele Münter Stiftung) und Gabriele Münter: Werke aus fünf Jahrzehnten (19 February-30 April 1957). Munich: Städtische Galerie, 1957.

Kandinsky. Introduction and notes by Herbert Read. London: Faber and Faber Ltd., 1959.

Kandinsky. Introduction by C. Giedion-Welcker. Zurich: Galerie Maeght, 1972.

Kandinsky: Kollektiv-Ausstellung 1902-1912. Introduction (autobiographical sketch) by Kandinsky. Munich: Verlag "Neue Kunst" Hans Goltz, 1912.

Kandinsky: Painting on Glass (Hinterglasmalerei). Anniversary Exhibition. The Solomon R. Guggenheim Museum, New York, 1966.

Kandinsky, Nina. Three personal interviews with the author at Neuilly-sur-Seine: May 1968, June 1972, January 1977.

————. *Kandinsky und ich.* Munich: Kindler, 1976.

"Kandinsky: 'On the Artist.'" Translated by Ellen H. John-

son and Gösta Oldenburg. *Artforum* XI, no. 7 (March 1973), pp. 76-78.

Kandinsky, Wassily. *The Art of Spiritual Harmony.* Translated with an introduction by Michael T. H. Sadler. London: Constable & Co., Ltd., 1914; Boston: Houghton Mifflin, 1914.

———. "Betrachtungen über die abstrakte Kunst." *Kandinsky, Essays über Kunst und Künstler.* Edited by Max Bill. Bern: Benteli Verlag, 1963. (Originally published in *Cahiers d'Art*, no. 1 [1931].)

———. "Das Bild mit weissem Rand." *Kandinsky, 1901-1913.* Berlin: Der Sturm, pp. XXXIX-XXXXI.

———. "Die Bilder Arnold Schönbergs." *Bayerischer Rundfunk* Vol. 11 Series 44, Oct., Nov., Dec., 1960, pp. 34-42. (Originally published in *Arnold Schönberg.* Munich: R. Piper & Co., 1912.)

———. "Der Blaue Reiter (Rückblick)." *Das Kunstblatt* XIV (1930), pp. 57-60.

———. "Komposition 4." *Kandinsky, 1901-1913.* Berlin: Der Sturm, 1913, pp. XXXIII-XXXIV.

———. "Komposition 6." *Kandinsky, 1901-1913.* Berlin: Der Sturm, 1913, pp. XXXV-XXXVIII.

———. "Bühnenkomposition III, Schwarz und Weiss," and "Bühnenkomposition I." Notebook GMS 415 (handwritten transcripts). Archives, Städtische Galerie, Munich.

———. Collection of 30 Notebooks and Sketchbooks (ca. 1898-1914) in the Archives of the Städtische Galerie, Munich.

———. *Concerning the Spiritual in Art.* A version of the 1914 Sadler translation "with considerable re-translation by Francis Golffing, Michael Harrison and Ferdinand Ostertag." New York: George Wittenborn, Inc., 1947.

———. *Kandinsky: Essays über Kunst und Künstler.* Edited, with commentaries, by Max Bill. 2nd ed. Bern: Benteli Verlag, 1963.

———. "Der gelbe Klang." *Der Blaue Reiter.* New documentary edition by Klaus Lankheit. Munich: R. Piper & Co., 1965.

———. *Klänge.* Munich: Piper & Co., 1913.

———. "Korrespondance iz Munchen" (Correspondence from Munich). *Mir Iskusstva* (St. Petersburg), no. 1-6 (1902), pp. 96-98.

———. Letter to Albert Verwey, 31 January 1913. Published in Mea Nijland-Verwey, *Wolfskehl-Verwey. Die Dokumente ihrer Freundschaft*, p. 111, q.v.

———. Letter to Hanna Wolfskehl, 6 November 1926. Copy in collection of Kenneth C. Lindsay. Mentioned also in Edgar Salin, *Um Stefan George.* Munich: Helmut Küpper, 1954, p. 337 n. 204.

———. Letter to Paul Westheim. Published in *Das Kunstblatt* XIV (1930), pp. 57-60.

———. Letters to Gabriele Münter (9.9.1902-25.8.1904), unpublished. Typescript in collection of Kenneth C. Lindsay, Binghamton, N.Y.

———. Letters to Karl Wolfskehl. 31 December 1911; 22 January 1913; 15 August 1913 (postcard); 12 September 1913. Published in *Karl Wolfskehl, 1869-1969. Leben und Werk in Dokumenten.* Darmstadt: Agora Verlag, 1969, pp. 334-37.

———. Letters to Will Grohmann. *"Lieber Freund . . ." Künstler schreiben an Will Grohmann.* Edited by Karl Gutbrod. Cologne: DuMont Schauberg, 1968, pp. 45-71. (Complete series including those unpublished, 1923-43, preserved at the Museum of Modern Art, New York.)

———. "Malerei als reine Kunst." *Der Sturm* IV, no. 178-79 (September 1913), pp. 98-99. (Republished in slightly altered version in *Essays über Kunst und Künstler.*)

———. "Mes gravures sur bois." *XXᵉ Siècle*, no. 27 (December 1966), p. 17. (Originally published in *XXᵉ Siècle*, no. 3, 1938.)

———. Microfilm of five of the six original "house catalogs" in which the artist kept a record of his paintings. Preserved at the library of the Museum of Modern Art,

New York, under arrangements made by Kenneth C. Lindsay. Originals in the collection of Mme. Nina Kandinsky, Paris.

————. *Om Konstnären*. Stockholm: Konsthandels Förlag, 1916 (reprinted in *Kandinsky*. Stockholm: Moderna Museet, 1916).

————. "On the Problem of Form." Translated by Kenneth C. Lindsay from "Über die Formfrage," *Der Blaue Reiter* (Munich: R. Piper & Co., 1912), pp. 74-100. Published in Herschel B. Chipp, *Theories of Modern Art, A Source Book by Artists and Critics*. Berkeley and Los Angeles: University of California Press, 1969, pp. 155-70.

————. *"Pismo iz Munchen"* ("Letters from Munich"). *Apollon* (St. Petersburg), I (October 1909), pp. 17-20; IV (January 1910), pp. 28-30; VII (April 1910), pp. 12-15; VIII (May-June 1910), pp. 4-7; XI (October-November 1910), pp. 13-17.

————. *Point and Line to Plane*. Translated by Howard Dearstyne and Hilla Rebay. New York: The Solomon R. Guggenheim Foundation, 1947.

————. *Punkt und Linie zu Fläche, Beitrag zur Analyse der malerischen Elemente*. (Originally published by Albert Langen, Munich, 1926.) Introduction by Max Bill, ed. Bern: Benteli Verlag, 1964.

————. "Reminiscences." Translated by Mrs. Robert L. Herbert. *Modern Artists on Art, Ten Unabridged Essays*. Edited by R. L. Herbert. Englewood Cliffs, New Jersey: Prentice-Hall, Inc., 1964.

————. "Retrospects by Wassily Kandinsky." *Kandinsky*. Edited by Hilla Rebay. New York: The Solomon R. Guggenheim Foundation, 1945.

————. "Rückblicke." *Kandinsky, 1901-1913*. Berlin: Der Sturm, 1913, pp. III-XXIX.

————. *Stikhi bez slov*. ("Poems without Words.") Moscow: Stroganoff [ca. 1904].

————. "Text Artista." Translated by Boris Berg. *In Memory of Wassily Kandinsky*. The Solomon R. Guggenheim Foundation, Museum of Non-Objective Paintings, New York, 15 March-15 May 1945.

————. "Über die abstrakte Bühnensynthese." *Staatliches Bauhaus in Weimar 1919-23*. Weimar-Munich: Bauhaus Verlag, 1923. Reprinted in *Essays über Kunst und Künstler*.

————. "Über Bühnenkomposition." *Der Blaue Reiter*. New documentary edition by Klaus Lankheit. Munich: R. Piper & Co., 1965, pp. 189-208.

————. "Über die Formfrage." *Der Blaue Reiter*. New documentary edition by Klaus Lankheit. Munich: R. Piper & Co., 1965, pp. 132-82.

————. *Über das Geistige in der Kunst*. 8th ed. [*sic*]. (Originally published by R. Piper & Co., Munich, 1912.) With introduction by Max Bill. Bern: Benteli Verlag, 1965.

————. "Über Kunstverstehen." *Der Sturm* III, no. 129 (October 1912), pp. 157-58.

————. "Violett, romantisches bühnenstück." (Scene VI, beginning, only.) *bauhaus 3* (10 July 1927), p. 6.

————. *Xylographies*. Introduction by Gérôme-Maësse. Paris: Edition des Tendances Nouvelles, Organe officiel de l'Union Internationale des Beaux Arts et des Lettres, 1909.

————. *"Zu unbestimmter Stunde . . ."* (untitled foreword, dated August 1910) in *Neue Künstlervereinigung München, II. Ausstellung*. Munich: Bruckmann, 1910-11.

————, and Marc, Franz, eds. *Der Blaue Reiter*. Dokumentarische Neuausgabe von Klaus Lankheit. ("New documentary edition . . .") (Originally published in 1912.) Munich: R. Piper & Co., 1965. (English edition, New York: Viking Press, 1974 [Documents of 20th-Century Art].)

Kanoldt, Johanna. "Skaski. Russische illustrierte Kinder und Volks-Märchen." *Kind und Kunst* I (November 1904), pp. 55-60.

Karl Wolfskehl 1869-1969 Leben und Werk in Dokumenten. Darmstadt: Agora Verlag, 1969.

Karpfen, Fritz. *Gegenwartskunst: Russland.* Vienna: Verlag Literaria, 1921.

Kellner, Otto. "Rudolph Czapek." *Die Cicerone* XVI, no. 16 (14 August 1924), pp. 739-51.

Keyssner, G. "Russiche Bilder." *Die Kunst für Alle* 1 December 1898, pp. 72-73.

Klee, Paul. *The Diaries of Paul Klee, 1898-1918.* Introduction by Felix Klee, ed. (Originally published by DuMont Schauberg, Cologne, 1957.) Berkeley: University of California Press, 1968.

———. Letter to Karl Wolfskehl. 26 November 1918. In *Karl Wolfskehl, 1869-1969. Leben und Dokumenten.* Darmstadt: Agora Verlag, p. 333.

Klein, Rudolph. "Betrachtungen über Kunst und Dekoration." *Deutsche Kunst und Dekoration* VII (October 1900-March 1901), pp. 131-48.

Klimt, Gustav. *Die Träumende Knaben.* Reprinted 1968 by Verlag Jugend und Volk, Vienna/Munich. 1st ed. 1908 (Wiener Werkstätte).

Koreska-Hartmann, Linda. *Jugendstil—Stil der 'Jugend.'* Munich: Deutscher Taschenbuch Verlag, 1969.

Kramer, Hilton. "Color-Drenched Paintings of Jawlensky." *The New York Times,* Sunday, 2 February 1975, p. 25D.

———. "Theosophy and Abstraction." *The New York Times,* 23 July 1972.

Kubin, Alfred. "Alfred Kubin's Autobiography." *The Other Side.* New York: Crown Publishers, 1967.

———. *Die Andere Seite.* (Originally published 1909.) Munich: Nymphenburger Verlagshandlung, 1968.

———. Letters and postcards to Karl Wolfskehl: 3 January 1905; 6 February 1911. Published in *Karl Wolfskehl, 1869-1969. Leben und Werk in Dokumenten.* Darmstadt: Agora Verlag, 1969, pp. 327-30. In the Wolfskehl Family Archive at Kiechlinsbergen, Germany, are twenty letters from Kubin to Wolfskehl; in the Kubin Archive, Hamburg, fifteen from Wolfskehl to Kubin.

Kühnel, Ernst. "Die Ausstellung Mohammedanischer Kunst München 1910." *Münchener Jahrbuch der bildenden Kunst* II (1910), pp. 209-51.

Kuhn, Charles L. *German Expressionism and Abstract Art.* Cambridge: Harvard University Press, 1957.

Die Kunst des Jahres 1903. Munich: Bruckmann. 1903.

Die Kunst für Alle. From 1896 to 1913. Munich: Bruckmann. (Bound annually after 1900 as *Die Kunst.*)

Kunst in Wien um 1900. Hessisches Landesmuseum, Darmstadt. (Abbreviation of the catalog *Wien um 1900,* q.v.) Darmstadt: Roetherdruck, n.d. (ca. 1965).

Kuspit, Donald B. "Utopian Protest in Early Abstract Art." *Art Journal* XXIX, 4 (Summer 1970), pp. 430-37.

Kuzmany, Karl M. "Die Frühjahr-Ausstellung der Wiener Sezession." *Die Kunst für Alle* 1 June 1906, pp. 385-92ff.

Lange, Konrad. "Die Freiheit der Kunst." *Die Kunst für Alle* 1 February 1902, pp. 193-98.

Lankheit, Klaus. "Bibel-Illustrationen des Blauen Reiters." *Anzeiger des Germanischen National-museums (Ludwig Grote zum 70. Geburtstag).* Nuremberg: 1963.

———. "Die Frühromantik und die Grundlagen der gegenstandslosen Malerei." *Neue Heidelberger Jahrbücher,* Neue Folge, 1957, pp. 55-90.

———. "Wissenschaftlicher Anhang." *Der Blaue Reiter.* Edited by Wassily Kandinsky and Franz Marc (1912). Documentary new edition, ed. by K. Lankheit. Munich: R. Piper & Co., 1965. (English edition, New York: Viking Press, 1974 [The Documents of 20th-Century Art].)

Lassaigne, Jacques. *Kandinsky.* Geneva: Skira, 1964.

Layard, Arthur. "Frank Brangwyn." *Dekorative Kunst* III, 5 (February 1900), pp. 198-202.

Leeper, J. *Edward Gordon Craig, Designs for the Theater.* London: Penguin Books, 1948.

LeFauconnier. "Das Kunstwerk." *Neue Künstlervereinigung Münchens, II. Ausstellung.* Munich: Bruckmann, 1910-11, pp. 3-4.

Lemmé, Marie. *Von Adolf Hölzels Leben und Werk.* Stuttgart: [ca. 1933].

Lichtwark, Alfred. "Aus München." *Pan* II (1896), pp. 253-56.

————. "Die Erziehung des Farbensinns." *Pan* IV (1898), pp. 183-88.

————. *Die Seele und das Kunstwerk.* Berlin: Bruns u. Paul Cassirer, 1899.

Lindsay, Kenneth C. and Vergo, Peter, eds. *Kandinsky The Complete Writings.* The Documents of 20th-Century Art. New York: Viking Press, in progress.

Lindsay, Kenneth C. "An Examination of the Fundamental Theories of Wassily Kandinsky." Ph.D. dissertation, University of Wisconsin, 1951.

————. "The Genesis and Meaning of the Cover Design for the first Blaue Reiter Exhibition Catalogue." *Art Bulletin* XXXV, 1 (March 1953), pp. 47-54.

————. "Graphic Art in Kandinsky's Oeuvre." *Prints.* Edited by Carl Zigrosser. New York: Holt, Rinehart, Winston, 1962.

————. "Kandinsky in 1914 New York: Solving a Riddle." *Art News* LV, 3 (May 1956), pp. 32-33, 58.

————. "Kandinsky in Russia," in *Vasily Kandinsky 1866-1944: A Retrospective Exhibition.* New York: The Solomon R. Guggenheim Foundation, 1962.

————. "Kandinsky's Method and Contemporary Criticism." *Magazine of Art* XLV (December 1952), pp. 355-61

————. "Mr. Pepper's Defense of Non-Objective Art." *Journal of Aesthetics and Art Criticism,* XII (December 1953), pp. 243-47.

————. "Les Thèmes de l'inconscient." *XX^e Siècle,* no. 27 (December 1966), pp. 46-52.

————. "Will Grohmann, Kandinsky." *Art Bulletin* XLI, 4 (December 1959), pp. 348-50.

————. "Will Russia unfreeze her first modern master?" *Art News* LVIII (September 1959), pp. 28-31, 52.

Linie und Form, Erläuterndes Verzeichnis der Ausstellung formenschöner Erzeugnisse der Natur, Kunst und Technik im Kaiser-Wilhelm-Museum zu Krefeld, April und Mai 1904. Krefeld: Kramer & Baum, 1904.

Lipps, Theodor. "Aesthetische Einfühlung." *Zeitschrift für Psychologie und Physiologie der Sinnesorgane* XXII (1900), pp. 415-50.

————. *Aesthetik, Psychologie des Schönen und der Kunst.* I. *Grundlegung der Aesthetik.* Hamburg: Leopold Voss Verlag, 1903. II. *Die ästhetische Betrachtung und die bildende Kunst.* Leipzig/Hamburg: 1906.

————. "Einfühlung und ästhetischer Genuss." *Die Zukunft* January 1906, pp. 100-14.

————. *Raumaesthetik und geometrisch-optische Täuschungen.* Schriften der Gesellschaft für Psychologische Forschung, no. 9-10. Leipzig: J. A. Barth, 1897.

Little, James Stanley. "Frank Brangwyn and his Art." *The Studio* XII, 55 (October 1897), pp. 3-20.

Logan, Mary. "Hermann Obrist's Embroidered Decorations." *Studio* IX, 44 (November 1896), pp. 98-105.

Long, Rose-Carol Washton. "Kandinsky and Abstraction: the Role of the Hidden Image." *Artforum,* June 1972, pp. 42-49.

————. "Kandinsky's Abstract Style: The Veiling of Apocalyptic Folk Imagery." *Art Journal* XXXIV, 3 (Spring 1975), pp. 217-28.

Lönnrot, Elias. *Kalevala.* Illustrations by Akseli Gallen-Kallela. Helsingissä: Otava, 1965.

————. *The Kalevala.* Prose translation with foreword and appendices by Francis Peabody Magoun, Jr. Cambridge: Harvard University Press, 1963.

Lövgren, Sven. *The Genesis of Modernism: Seurat, Gauguin, Van Gogh & French Symbolism in the 1880's.* Stockholm, 1959.

Mach, Ernst. *Die Analyse der Empfindungen,* 3rd ed. (1st ed., 1886). Jena: 1902.

Mackail, J. W. *The Life of William Morris.* New York: Oxford University Press, 1950.

Macke, Wolfgang, ed. *August Macke: Franz Marc Briefwechsel.* Cologne: M. DuMont Schauberg, 1964.

Madsen, S. Tschudi. *Art Nouveau*. London: Weidenfeld and Nicolson, 1967.

Maeterlinck, Maurice. "Das moderne Drama." *Die Insel* II (January-March, 1900), pp. 48-60.

———. *Der Schatz der Armen*, translated by Friedrich von Oppeln-Bronikowski. Illustrated by Melchior Lechter. Florence/Leipzig: Eugen Diederichs, 1898.

Mann, Thomas. "Gladius Dei" (1902). *Die Erzählungen* I. Frankfurt: Fischer Bucherei, 1967.

Marc, Franz. *Briefe aus dem Felde*. Berlin: Rembrandt Verlag, 1959.

———. Letter to Karl Wolfskehl. 5 July 1912. In *Karl Wolfskehl, 1869-1969. Leben und Dogumenten*. Darmstadt: Agora Verlag, 1969, p. 331.

Marsop, Paul. "Die Kunststadt München." *Suddeutsche Monatsheft* I (1904), pp. 41-47.

Martin, David. *The Glasgow School of Painting* (with an introduction by Francis H. Newbery). London: George Bell & Sons, 1897.

Maslenikov, Oleg. *The Frenzied Poets*. New York: Greenwood Press, 1968.

Matisse, Henri. "Notizen eines Malers." *Kunst und Künstler* VII (1908-09), pp. 335-47.

Meier-Graefe, Julius. "Beiträge zu einer modernen Aesthetik. Der Einfluss Millets." *Der Insel* III (1902), pp. 199-223.

———. *Entwicklungsgeschichte der modernen Kunst*. 4th ed. (Originally published 1904.) Munich: Piper & Co., 1927.

———. "Henry Van de Velde." *Dekorative Kunst* III, 1 (October 1899), pp. 2-9.

———. "Peter Behrens—Düsseldorf." *Dekorative Kunst* VIII, 10 (July 1905), pp. 381-89.

———. "Über Impressionismus." *Die Kunst für Alle* 1 January 1910, pp. 145-62.

Meissner, F. H. "Franz Stuck ein modernes Künstlerbildniss." *Kunst unserer Zeit* IX, pt. I (1898), pp. 1-32.

Melchior Lechter—Gedächtnis-Ausstellung zur hundersten

Wiederkehr seines Geburtstages. Münster: Westfälischer Kunstverein, 1965.

Michel, Wilhelm. "Ateliers und Werkstätten für angewandte Kunst." *Dekorative Kunst* XI, 3 (December 1907), pp. 129-36.

———. "Edmund Dulac." *Die Kunst für Alle* 1 December 1912, pp. 97-100.

———. "Ein Frühstücksraum von Margarete [*sic*] von Brauchitsch." *Deutsche Kunst und Dekoration* XVI (October 1905-March 1906), pp. 77-83.

———. "Die Grenzen des Subjektiven in der Kunst." *Die Kunst für Alle* 1 July 1912, pp. 450-55.

———. "Kandinsky, W. Ueber das Geistige in der Kunst." *Die Kunst für Alle* 15 September 1912, p. 580.

———. "Die Kritik der Ausstellung München 1908." *Münchener Jahrbuch der bildenden Kunst* III-IV (1908-09), pp. 69-75.

———. "Materialgemäss." *Deutsche Kunst und Dekoration* XVI (April-September 1905), pp. 628-31.

———. "Münchner Graphik: Holzschnitt und Lithographie." *Deutsche Kunst und Dekoration* XVI (1905), pp. 437-57.

———. "Münchner 'Lehr- und Versuch-Ateliers für angewandte und freie Kunst.'" *Deutsche Kunst und Dekoration* XVII (October 1905-March 1906), pp. 379-98.

Milner, John. *Symbolists and Decadents*. London: Studio Vista Limited (Dutton), 1971.

Mir Iskusstva. Ed. Sergei P. Diaghilev. St. Petersburg, 1899-1905.

Mirsky, D. S. *A History of Russian Literature from its Beginning to 1900*. Edited by F. J. Whitfield. (Originally published 1926.) New York: Vintage Books, 1958.

Moleva, Nina M., and Beljutin, Elij M. "Metoda Antona Ažbèta." *Anton Ažbè in Njegova Sola*. Ljubljana: Narodna Galerija, 1962.

———, and Beljutin, E. M. *Skola Antona Ažbè*. Moscow: Gosvdarstvennoe izdatel'stvo "Iskusstvo," 1958.

Morawe, Chr. F. "Kunstgewerbe im Glaspalast zu Münch-

en 1899." *Deutsche Kunst und Dekoration* v (October 1899-March 1900), pp. 25-33.

Morwitz, Ernst. *Stefan George Poems in German and English*. Rendered into English by Carol North Valhope and Ernst Morwitz. New York: Schocken Books, 1967.

München 1865-1958, Aufbruch zur modernen Kunst. Haus der Kunst. Munich, 1958.

"München—Wassily Kandinsky und Ernst Treumann" (review of exhibition at the Munich Kunstverein). *Die Kunst für Alle* 1 September 1904, p. 554.

Münchener Künstler-Theater, Ausstellung München 1908 (with essays by A. von Hildebrand, Toni Stadler and Georg Fuchs). Munich/Leipzig: Georg Müller, 1908.

Münter, Gabriele. "Bekentnisse und Erinnerungen" in *Gabriele Münter-Menschenbilder im Zeichnungen* (Introduction by G. F. Hartlaub). Berlin: Konrad Lemmer Verlag, 1952, n.p.

Muthesius, Hermann. "Die Bedeutung des Kunstgewerbes." *Dekorative Kunst* x, 5 (February 1907), pp. 177-87.

―――. "Die Glasfenster Oscar Paterson's in Glasgow." *Dekorative Kunst* II (October 1898-March 1899), pp. 150-51, 180-83.

―――. "Neues Ornament und neue Kunst." *Dekorative Kunst* IV, 9 (June 1901), pp. 349-66.

―――. "Der Weg und das Endziel des Kunstgewerbes." *Dekorative Kunst* VIII, 5 and 6 (February and March 1905), pp. 181-90, 230-38.

Myers, Bernard S. *The German Expressionists, a Generation in Revolt*. New York: Praeger, 1966.

Naylor, Gillian. *The Arts and Crafts Movement, a study of its sources, ideals and influence on design theory*. London: Studio Vista, 1971.

―――. *The Bauhaus*. London: Studio Vista Ltd., 1968.

Neff, John Hallmark. "Matisse and Decoration: The Shchukin Panels." *Art in America* (July-August 1975), pp. 39-48.

―――. "Matisse and Decoration: An Introduction." *arts magazine* (May 1975), pp. 59-61. "Matisse and Decoration pt. II." *arts magazine* (June 1975), p. 61.

Neue Künstler-Vereinigung München E. V. Turnus 1909-10. Munich: Moderne Galerie, 1910.

Neue Künstler-Vereinigung München E. V. Turnus 1910. Munich: 1910.

Neue Künstler-Vereinigung München E. V. II. Ausstellung. 1910-11. Introductory statements by Le Fauconnier, Dmitri and Vladimir Burliuk, Kandinsky, and Odilon Redon. Munich: Bruckmann, 1911.

Eine neue Sprache? 42 Zeichnungen von Katharine Schäffner. Introduction by Ferdinand Avenarius. Munich: Georg D. W. Callwey Verlag, n.d. [ca. 1908].

Niemeyer, Wilhelm. *Malerische Impression und koloristischer Rhythmus—Beobachtungen über Malerei der Gegenwart*. Denkschrift des Sonderbundes auf die Ausstellung 1910. Düsseldorf: 1910.

―――. "Peter Behrens und die Raumaesthetik seiner Kunst." *Dekorative Kunst* x, 4 (January 1907), pp. 137-65.

Nietzsche, Friedrich. *Twilight of the Idols and the Anti-Christ*. Translated with an introduction and commentary by R. J. Hollingdale. Harmondsworth, Middlesex, England: Penguin Books Inc., 1968.

Nijland-Verwey, Mea, ed. *Wolfskehl-Verwey. Die Dokumente ihrer Freundschaft 1897-1946*. (Fortieth publication of the Deutscher Akademie für Sprache und Dichtung.) Heidelberg: Lambert Schneider, 1968.

Nishida, Hideho. "Genèse du Cavalier bleu." *XXᵉ Siècle*, no. 27 (December 1966), pp. 18-24.

Nochlin, Linda, ed. *Impressionism and Post-Impressionism, 1874-1904* (Sources and Documents in the History of Art Series, edited by H. W. Janson). Englewood Cliffs, New Jersey: Prentice-Hall, Inc., 1966.

Nolde, Emil. *Das Eigene Leben: Die Zeit der Jugend, 1872-1902*. 2nd ed. Flensburg/Hamburg: Verlagshaus Christian Wolff, 1949.

Obrist, Hermann. "Hat das Publikum ein Interesse das

Kunstgewerbe zu heben?" *Neue Möglichkeiten in der Bildenden Kunst—Aufsätze von 1896-1900.* Leipzig: Diederichs, 1903.

————. "Die Lehr- und Versuch-Ateliers für angewandte und freie Kunst." *Dekorative Kunst* VII, 6 (March 1904), pp. 228-37.

————. *Neue Möglichkeiten in der Bildenden Kunst-Aufsätze von 1896-1900.* Leipzig: Diederichs, 1903.

————. "Wozu über Kunst schreiben?" *Dekorative Kunst* III, 5 (February 1900), pp. 169-95.

————. "Die Zukunft unserer Architektur." *Dekorative Kunst* IV, 9 (June 1901), pp. 329-49.

————. "Der 'Fall Muthesius' und die Künstler." *Dekorative Kunst* XI, 1 (October 1907), pp. 42-44.

"O.M." [?]. "Von Ausstellungen und Sammlungen. München. Winter-Ausstellung der 'Secession.' " *Die Kunst für Alle* 15 January 1902, pp. 190-91.

Osborn, Max. "Die Düsseldorfer Ausstellung." *Kunst und Künstler* II (1903-04), pp. 429-45, 496-504.

————. "Edward Gordon Craig." *Deutsche Kunst und Dekoration* XVI (April 1905-September 1905), pp. 589-95.

————. "La Maison Moderne in Paris." *Deutsche Kunst und Dekoration* VII (October 1900-March 1901), pp. 99-103.

————. "Walter Leistikow." *Deutsche Kunst und Dekoration* V (October 1899-March 1900), pp. 113-36.

Oskar Schlemmer und die abstrakte Bühne (18 July-27 August 1961). Zurich: Kunstgewerbemuseum, 1961.

Ostini, Fritz von. "Die VIII. Internationale Kunstausstellung im Kgl. Glaspalast zu München." *Die Kunst für Alle* 15 August 1901, pp. 513-66.

————. "Adolf Hölzel und Rudolf Schramm-Zittau." *Die Kunst für Alle* 15 May 1907, pp. 369-80.

————. "Franz Stuck." *Die Kunst für Alle* 1 October 1903, pp. 1-40.

————. "Zum Kunststreite Berlin-München." *Deutsch-*

land. Monatsschrift für die gesamte Kultur I (1902-03), pp. 762-68.

Overy, Paul. *Kandinsky The Language of the Eye.* New York: Praeger Publishers, 1969.

Pallat, Ludwig. "Neue Bücher, eine Theorie der Flächenkunst" (review of Denman W. Ross, *A Theory of Pure Design*). *Kunst und Künstler* VIII, (March 1910), pp. 332-34.

Palleske, Siegwalt O. *Maurice Maeterlinck en Allemagne.* (First published Strasburg, 1938.) Paris: Société d'éditions "Les belles lettres," 1939.

Palme, Carl. *Konstens Karyatider.* Halmsted: Raben & Sjögren, 1950.

Pascent, E. N. "Die Sommer-Ausstellung der Münchener Secession." *Die Kunst für Alle* 1 August 1902, pp. 483-99.

————. "Von Russischer Kunst gelegentlich der Pariser Ausstellung." *Die Kunst für Alle* 15 February 1901, pp. 227-30.

Paulsen, Wolfgang. *Expressionismus und Aktivismus.* Bern/Leipzig: Gotthelf, 1935.

Peacock, N. "Das russische Dorf auf der Pariser Weltausstellung." *Dekorative Kunst* III, 12 (September 1900), pp. 480-88.

Petzet, Heinrich Wiegand. *Heinrich Vogeler von Worpswede nach Moskau, Ein Künstler zwischen den Zeiten.* Cologne: DuMont Schauberg, 1972.

————. "Jugendstil und Abstraktion. Adolf Hölzel in Karlsruhe." *Deutsche Zeitung* 16 March 1964, n.p.

Petzet, Michael, ed. *Bayern-Kunst und Kultur.* Munich: Prestel-Verlag, 1972.

Pevsner, Nikolaus. *Pioneers of Modern Design from William Morris to Walter Gropius.* (Originally published as *Pioneers of the Modern Movement*, 1936.) London: Penguin, 1964.

————. *The Sources of Modern Architecture and Design.* New York: Praeger, 1968.

"Phalanx," announcement of formation. ["Vermischtes, München. . . ."] *Die Kunst für Alle* 15 July 1901, p. 487.[2]

————, review of first exhibition. [Von Ausstellungen und Sammlungen. München. . . ." signed "vl."] *Die Kunst für Alle* 1 October 1901, p. 22.

————, announcement of Kandinsky's chairmanship. ["Personal-Nachrichten. München. . . ."] *Die Kunst für Alle* 15 November 1901, p. 90.

————. *Katalog der II. Ausstellung der Münchener Künstler-Vereinigung PHALANX.* January-March 1902. Archive of the Städtische Galerie, Munich.

————, review of the second exhibition. ["Von Ausstellungen und Sammlungen, München. *Die Künstlerverein-igung* 'Phalanx.' . . ."] *Die Kunst für Alle* 15 March 1902, p. 284.

————, review of exhibition in Wiesbaden. ["Vermischte Nachrichten. Wiesbaden . . . ," signed "Off."] *Die Kunst für Alle* 1 May 1902, p. 359.

————, review of the third exhibition. ["Personal- und Atelier-Nachrichten. Die *'Phalanx.'* . . .] *Die Kunst für Alle* 15 June 1902, p. 426.

————, review of fourth exhibition. ["Von Ausstellungen und Sammlungen. München . . . ," signed "G.H." (Georg Howe?)] *Die Kunst für Alle* 1 September 1902, pp. 549-50.

————, incorrect announcement of demise. ["Chronik, München. . . ."] *Kunst und Künstler* I (December 1902), p. 111.

————. *Katalog der VII. Ausstellung der Münchener Künstler-Vereinigung "PHALANX."* Munich: May-July 1903. Archive of the Städtische Galerie, Munich.

————. *Katalog der VIII. Ausstellung der Münchener Künstler-Vereinigung "PHALANX."* Munich: Novem-

ber-December 1903. Archive of the Städtische Galerie, Munich.

————, review of the ninth exhibition. ["Von Ausstellungen und Sammlungen. München. . . ."] *Die Kunst für Alle* 1 March 1904, pp. 268-70.

————, brief announcement of tenth exhibition. ["Von Ausstellungen und Sammlungen. München. Die *'Phalanx.'* . . ."] *Die Kunst für Alle* 1 May 1904, p. 388.

————, announcement of tenth exhibition. ["Ausstellungen. München. . . ."] *Kunstchronik* XV (May 1904), p. 414.

————, review of tenth and eleventh exhibitions. ["Von Ausstellungen und Sammlungen. München. Die *'Phalanx.'* . . ." signed "A.H." (Arthur Holitscher?).] *Die Kunst für Alle* 1 June 1904, p. 408.

————, review of twelfth exhibition. ["Von Ausstellungen und Sammlungen. Darmstadt . . . ," signed "r."] *Die Kunst für Alle* 1 February 1905, p. 213.

Pica, Vittorio, "Hermen Anglada Y Camarasa." *Die Kunst für Alle* 1 February 1912, pp. 197-204.

Piper, Reinhard. *Vormittag, Erinnerungen eines Verlegers.* Munich: Piper & Co., 1947.

Plaut, Paul. *Die Psychologie der produktiven Persönlichkeit.* Stuttgart: Verlag von Ferdinand Enke, 1929.

Poellnitz, von. "Betrachtungen über den 'modernen' Stil." *Deutsche Kunst und Dekoration* II (April-September 1898), pp. 300-08.

Pound, Ezra. *Gaudier-Brzeska: A Memoir.* (Originally published London: John Lane, 1916.) New York: New Directions, 1960.

————. "Vorticism." *Fortnightly Review* XCVI (1 September 1914), pp. 461-71.

Proebst, Hermann, and Ude, Karl, eds. *Denk ich an München.* Munich: Gräfe und Unzer Verlag, 1966.

Purrmann, Hans. "Erinnerungen an meine Studienzeit." *Werk*, XXXIV, 11 (November 1947), pp. 366-72.

Raabe, Paul; Greve, H. L.; and Grüninger, Ingrid, eds. *Expressionismus—Literatur und Kunst 1910-1923* (8

[2] For the convenience of the reader, all Phalanx catalogs, exhibition announcements, and reviews have been listed here together in chronological order.

May-31 October 1960). Marburg A.N.: Schiller-Nationalmuseum im Auftrag der Deutschen Schillergesellschaft, 1960.

Rannit, Aleksis. "M. K. Ciurlionis." *Das Kunstwerk* I (9 September 1947), pp. 46-48.

————. "M. K. Ciurlionis." *Das Kunstwerk* IV (9 September 1950), pp. 34-37.

Rasp, H. "Georg Fuchs, 1868-1949." *Vom Geist einer Stadt, ein Darmstädter Lesebuch.* Edited by Heinz W. Sabais. Darmstadt: E. Roether, 1956.

Raub, Welfhard. *Melchoir Lechter als Buchkünstler. Darstellung-Werkverzeichnis-Bibliographie.* Cologne: Greven Verlag, 1969.

Read, Herbert. *A Concise History of Modern Painting.* (Originally published 1959.) New York: Frederick A. Praeger, 3rd printing 1964.

————. "Introduction." *Kandinsky.* London: Faber and Faber, 1959.

Redon, Odilon. Untitled foreword. *Neue Künstlervereinigung München, II. Ausstellung.* Munich: Bruckmann, 1910-11, pp. 8-9.

Reiss, Hans Siegbert. "Stefan George." *Encyclopaedia Britannica.* X, 1969.

Reventlow, Franziska von. *Herrn Dames Aufzeichnungen.* (1913). *Drei Romane.* Munich: Biederstein Verlag, 1958.

Rewald, John. *Post-Impressionism, from Van Gogh to Gauguin.* New York: The Museum of Modern Art, 1962.

Rheims, Maurice. *The Flowering of Art Nouveau.* New York: Harry N. Abrams, Inc., 1966.

Rihard Jakopic, Retrospektivna Razstava. Introduction by Zoran Kržišnik. Ljubljana: Moderna Galerija, 1970.

Rilke, Rainer Maria. "Heinrich Vogeler—Worpswede." *Deutsche Kunst und Dekoration* X (April 1902-September 1902), pp. 301-30.

————. "Über Kunst." *Ver Sacrum* II, 5, pp. 23-24.

Ringbom, Sixten. "Art in 'the Epoch of the Great Spiritual,' occult elements in the early theory of abstract painting." *Journal of the Warburg and Courtauld Institutes* XXIX (1966), pp. 386-418.

————. *The Sounding Cosmos, A Study in the Spiritualism of Kandinsky and the Genesis of Abstract Painting.* Helsingfors: Abo Akademi, 1970.

Rischbieter, Henning, ed. *Bühne und bildende Kunst im XX. Jahrhundert.* Velber bei Hannover: Friedrich Verlag, 1968.

Robbins, Daniel. "Vasily Kandinsky: Abstraction and Image." *Art Journal* XXII, 3 (Spring 1963), pp. 145-47.

Roditi, Edouard. *Dialogues on Art.* London: Secker & Warburg, 1960.

Roessler, Arthur. "Das Abstrakte Ornament mit gleichzeitiger Verwendung simultaner Farbenkontraste." *Wiener Abendpost,* Suppl. to no. 228 (6 October 1903), n.p.

————. "Meister Anton Ažbè: ein Lehrer der Schönheit" (1902). Reprinted in *Anton Ažbè in Njegova Sola.* Ljubljana: Narodna Galerija, 1962.

————. "Ein Besuch bei den Dachauer Meistermalern." *Wiener Abendpost,* 8 June 1903, n.p.

————. *Neu-Dachau: Ludwig Dill, Adolf Hölzel, Arthur Langhammer.* Knackfuss Künstler Monographien, LXXVIII. Bielefeld-Leipzig: Velhagen & Klasing, 1905.

————. "Die Neu-Dachauer." *Die Gegenwart,* no. 21 (12 May 1904), pp. 329-33.

Roh, Franz. *"Entartete" Kunst.* Hannover: Fackelträger Verlag, 1962.

Rookmaaker, H. R. *Synthetist Art Theories Genesis & Nature of the Ideas on Art of Gauguin & his Circle.* Amsterdam: Swets & Zeitlinger, 1959.

Rosenhagen, Hans. "Die fünfte Ausstellung der Berliner Secession." *Die Kunst für Alle* 1 July 1902, pp. 433-43 (pt. I); 15 July 1902, pp. 457-60 (pt. II).

Ross, Denman W. *A Theory of Pure Design: Harmony, Balance, Rhythm.* Boston: Houghton, Mifflin & Co., 1907.

Rothe, Friedrich. *Frank Wedekinds Dramen: Jugendstil und Lebensphilosophie.* Stuttgart: J. B. Metzler, 1968.

Röthel, Hans K. *Kandinsky—Das graphische Werk.* Cologne: DuMont Schauberg, 1970.

Rottenburg, Heinrich. "Das Kunsthandwerk auf den Münchener Ausstellungen 1898." *Die Kunst unserer Zeit* IX, pt. III (1898), pp. 89-98.

Rovel, Henri. "Les Lois d'harmonie de la peinture et de la musique sont les mêmes." *Les Tendances nouvelles* no. 35 (March 1908), pp. 721-28. (Facsimile in Fineburg, "Kandinsky in Paris, 1906-7," appendix.)

———. "Les Lois d'harmonie." *Les Tendances nouvelles,* no. 36 (May 1908), pp. 753-57. (Facsimile in Fineburg "Kandinsky in Paris 1906-7," appendix.)

Rubin, William. "Shadows, Pantomimes and the Art of the 'Fin de Siècle.'" *Magazine of Art* XLVI, 3 (March 1953), pp. 114-22.

Rüden, Egon von. *Van de Velde-Kandinsky-Hölzel. Typologische Studien zur Enstehung der gegenstandslosen Malerei.* Wuppertal, Ratingen, Kastellaun: A. Henn Verlag, 1971.

Rudenstine, Angelica Zander. *The Guggenheim Museum Collection: Paintings 1880-1945* (2 vols.). New York: The Solomon R. Guggenheim Foundation, 1976.

Rudolff-Hille, Gertrud. "Theaterdekorationen" in *Jugendstil, der Weg ins 20. Jahrhundert.* Edited by Helmut Seling (Heidelberg, 1959), pp. 387-402.

Rufer, Josef. *The Works of Arnold Schönberg.* New York: Free Press of Glencoe, 1963.

Russell, John. "A Manifold Moses: Some Notes on Schoenberg and Kandinsky." *Apollo* LXXXIV, 57 (November 1966), pp. 388-89.

"Das russische Dorf auf der Pariser Weltausstellung." *Dekorative Kunst* VI (September 1900), pp. 480-88.

Rüttenauer, Benno. "Darmstadt nach dem Fest." *Dekorative Kunst* V, 5 (February 1902), pp. 185-90.

———. "Ein Dokument deutscher Kunst." *Die Rheinlande* IV (1901), pp. 5-11.

Sadleir, Michael. *Michael Ernst Sadler 1861-1943: A Memoir by His Son.* London: Constable, 1949.

———. "The Value of Eurhythmics to Art." *The Eurhythmics of Jaques-Dalcroze.* Introduction by M. E. Sadler. London: Constable & Co., Ltd., 1912.

Sailer, Anton. *Franz von Stuck, ein Lebensmärchen.* Munich: Bruckmann, 1969.

Salin, Edgar. *Um Stefan George.* Munich: Helmut Küpper, 1954.

Salomé, Lou Andreas. "Grundformen der Kunst, eine psychologische Studie." *Pan* IV (1898), pp. 177-82.

Samuel, Richard, and Thomas, R. Hinton. *Expressionism in German Life, Literature and the Theater (1910-1924).* Cambridge, England: W. Heffer and Sons, 1939.

Sarre, F.; Martin, F. R. *et al. Die Ausstellung von Meisterwerken mohammedanischer Kunst in München 1910.* Munich: F. Bruckmann, 1912.

Schaefer, Herwin. "Tiffany's Fame in Europe." *Art Bulletin* XLIV, 4 (December 1962), pp. 309-28.

Schäfer, W. "Das Haus Peter Behrens in Darmstadt." *Die Rheinlande* (August 1901), pp. 28-30.

Schaumberg, Georg. "Max Reinhardt und das Münchener Künstlertheater." *Bühne und Welt* XI (April-September 1909), pp. 936-38.

———. "Die Schwabinger Schattenspiele." *Bühne und Welt* X (April 1908), pp. 712-15.

[Karl Scheffler]. "August Endell." *Kunst und Künstler* V (May 1907), pp. 314-24.

Scheffler, Karl. "Eine Bilanz." *Dekorative Kunst* VI, 7 (April 1903), pp. 243-56.

——— ["S."]. "Kunstschulen" (with sections by Peter Behrens, Lothar von Kunowski, Hermann Obrist, Paul Schultze-Naumberg, and August Endell). *Kunst und Künstler* V (February 1907), pp. 206-10.

———. *Die fetten und die mageren Jahre.* Munich: Paul List Verlag, 1948.

———. "Hermann Obrist." *Kunst und Künstler* VIII (August 1910), pp. 555-59.

———. "Die Konventionen der Kunst." *Dekorative Kunst*

VI (October 1902-September 1903), pp. 300-11, 398-400, 438-n.p.

————. "Meditationen über das Ornament." *Dekorative Kunst* IV, 10 (July 1901), pp. 397-414.

————. "Moderne Baukunst." *Kunst und Künstler* I (1902-03), pp. 469-80.

————. "Notizen über die Farbe." *Dekorative Kunst* IV, 5 (February 1901), pp. 183-96.

————. "Peter Behrens." *Dekorative Kunst* V, 1 (October 1901), pp. 3-45.

————. "Eine Schule für Formkunst." *Kunst und Künstler* II (September 1904), p. 508.

———— [Sch., K.]. "Technik als Kunst (neue Seidenstoffe)." *Dekorative Kunst* VI, 8 (May 1903), pp. 318-20.

————. "Unsere Traditionen." *Dekorative Kunst* III, 11 (August 1900), pp. 436-45.

————. "Ein Vorschlag." *Dekorative Kunst* VII, 10 (July 1904) pp. 378-79.

————, and Fürst, Walter. "Dialog über Deutsches Kunstgewerbe." *Kunst und Künstler* VI (1907-08), pp. 509-19.

Scheffler, Wolfgang, ed. *Werke um 1900 Kunstgewerbemuseum Berlin.* Berlin: Kunstgewerbemuseum, 1966.

Schlemmer, Oskar. Letter to Adolf Hölzel, Berlin, 10 May 1933, on the occasion of Hölzel's 80th birthday. Published in *Hölzel und sein Kreis,* Stuttgart, 1961.

Schliepmann, Hans. "Christiansen's Kunst-Verglasungen." *Deutsche Kunst und Dekoration* V (October 1899-March 1900), pp. 205-10.

Schlittgen, Hermann. *Erinnerungen.* Munich: Albert Langen, 1926.

Schloss, Karl, ed. *Münchner Almanach, ein Sammelbuch neuer deutscher Dichtung.* Munich: R. Piper & Co., 1905.

Schmalenbach, Fritz. "Grundlinien des Frühexpressionismus." *Kunsthistorische Studien.* Basel: 1941.

————. *Jugendstil, Ein Beitrag zu Theorie und Geschichte der Flächenkunst.* Wurzburg: Verlag Konrad Triltsch, 1935.

Schmidkunz, Hans. "Das Kunstgewerbe als Ausdruck." *Dekorative Kunst* X, 6 and 7 (March and April 1907), pp. 246-53, 276-80.

Schmidt, Doris. "Franz von Stuck, ein Gefangener der Stilisierung." *Münchener Neueste Nachrichtungen,* no. 59 (March 8, 1968), p. 9.

Schmied, Wieland. *Alfred Kubin.* New York: Praeger, 1969.

Schmitz, Oscar A. H. "Die Abendroete der Kunst." *Pan* III, no. 3 (1897), pp. 185-90.

————. "Ueber Technik, Form und Stil." *Zeitschrift für Innen-Dekoration* June, July 1898, pp. 91-96, *passim.*

Schmutzler, Robert. *Art Nouveau.* New York: Harry N. Abrams, Inc., 1962.

Schoenberner, Franz. *Confessions of a European Intellectual.* (First published 1946.) New York: Collier Books, 1965.

Schönberg, Arnold. "Das Verhältnis zum Text." *Der Blaue Reiter.* New documentary edition by Klaus Lankheit. Munich: R. Piper & Co., 1965, pp. 60-75.

Schreyer, Lothar. *Erinnerungen an Sturm und Bauhaus.* Munich: List Verlag, 1966.

Schröder, Hermann. *Ton und Farbe.* Berlin: Chr. Friedrich Vieweg G.m.b.H., [1906].

Schultze-Naumburg, Paul. "Aus München: Ludwig Dill und die neueren Bestrebungen der Münchener Landschafterschule." *Pan* III, 3 (1897), pp. 174-76.

————. "Franz Stuck." *The Magazine of Art* XX (1896-97), pp. 153-58.

————. "Die Internationale Ausstellung 1896 der Secession in München." *Die Kunst für Alle* 1 July 1896, pp. 289-93 (pt. I); 15 July 1896, pp. 305-09 (pt. II).

————. "Die Kleinkunst." *Die Kunst für Alle* 1 September 1897, pp. 378-79.

————. "Die Komposition in der modernen Malerei." *Die Kunst für Alle* 1 March 1899, pp. 161-66.

———. "Der 'Secessionsstil.'" *Kunstwart* 1 January 1902, pp. 326-30.

———. "Über dekorative Malerei." *Dekorative Kunst* IV, 2 (November 1900), pp. 61-66.

———. "Ziele moderner Kunst." *Die Zukunft* XXVII (1899), pp. 378-83.

Schumacher, Fritz. "Die Ausstellung der Darmstädter Künstlerkolonie." *Dekorative Kunst* IV, 11 (August 1901), pp. 417-32.

Schumann, Paul. "Dresdner Kunstausstellung." *Die Kunst für Alle*, July 1897, pp. 339-44.

———. "Die internationale Kunst-Ausstellung zu Dresden im Jahre 1897." *Deutsche Kunst und Dekoration* I (October 1897), pp. 12-23.

Schur, Ernst. "Bühne und Kunst." *Dekorative Kunst* XIII, 10 (July 1910), pp. 456-69.

———. "August Endell." *Dekorative Kunst* XIV, 8 (May 1911), pp. 375-79.

"Secession." Berlin. *Katalog der . . . Ausstellung der Berliner Secession*. 1900, 1901, 1902, 1903, 1904, 1906, 1907.

Secession: Europäische Kunst um die Jahrhundertwende. Haus der Kunst, Munich, 1964.

"Secession." Munich. *Katalog der Frühjahrs-Ausstellung der Münchener "Secession."* 1905, 1907, 1908, 1910.

———. *Offizieller Katalog der Internationalen Kunstausstellung im königlichen Glaspalaste zu München . . . veranstaltet von der "Münchener Künstlergenossenschaft" im Vereine mit der "Münchener Secession."* 1897, 1901, 1902, 1905, 1909.

———. *Offizieller Katalog der Internationalen Kunstausstellung des Vereins bildender Künstler Münchens: "Secession."* 1896, 1898, 1899, 1900, 1903, 1904, 1906, 1907, 1908, 1910.

Seidl, Ulf. "Feine Brüder." *Wiener Tagblatt*, 4 October 1930.

Selections from the Guggenheim Museum Collection: 1900-1970 (Handbook). New York: The Solomon R. Guggenheim Museum, 1970.

Seling, Helmut, ed. *Jugendstil, der Weg ins 20. Jahrhundert.* Heidelberg: Keysersche Verlagsbuchhandlung, 1959.

Selz, Peter. "The Aesthetic Theories of Wassily Kandinsky and Their Relationship to the Origin of Non-Objective Painting." *Art Bulletin* XXXIX, 2 (June 1957), pp. 127-36.

———, and Constantine, M., eds. *Art Nouveau. Art and Design at the Turn of the Century.* New York: The Museum of Modern Art, 1959.

———. *German Expressionist Painting.* Berkeley and Los Angeles: University of California Press, 1957.

Sieburg, R. "Stefan George." *Die grossen Deutschen*, vol. IV. Berlin: Ullstein, 1957.

Signac, Paul. "Französische Kunst. Neoimpressionismus." *Pan* IV, 1 (1898), pp. 55-62.

Sihare, Laxmi P. "Oriental Influences on Wassily Kandinsky and Piet Mondrian, 1909-1917." Ph.D. dissertation, New York University, The Institute of Fine Arts, 1967.

Société des Artistes Independants. Catalogue des ouvrages . . . 1907, 1908, 1909.

Société du Salon d'automne; Catalogue des ouvrages de peinture, sculpture, dessin, gravure, architecture et art décoratif exposés au Grand palais des Champs-Élysées. Paris, 1904, 1905, 1906, 1907, 1908, 1909.

Spencer, Isobel. *Walter Crane.* London: Studio Vista, 1975.

Spielmann, M. H. "Munich as an Art Centre." *The Magazine of Art* XVIII (1895), pp. 73-75.

Stefan George 1868-1968—Der Dichter und sein Kreis. Eine Ausstellung des Deutschen Literaturarchivs im Schiller-Nationalmuseum Marbach a. N. Munich: Kösel Verlag, 1968.

Steffan, Hans, ed. *Der Deutsche Expressionismus—Formen und Gestalten.* Göttingen: Vandenhoeck & Ruprecht, 1965.

Stelè, France. "Anton Ažbè comme Pedagogue." *Anton Ažbè in Njegova Sola*. Ljubljana: Narodna Galerija, 1962.

————. "Anton Ažbè—Učitelj." *Anton Ažbè in Njegova Sola*. Ljubljana: Narodna Galerija, 1962.

Stelzer, Otto. *Die Vorgeschichte der abstrakten Kunst, Denkmodelle und Vor-Bilder*. Munich: R. Piper & Co., 1964.

Stern, Paul. *Einfühlung und Assoziation in der modernen Aesthetik Beiträge zur Aesthetik*, vol. v. Hamburg: Leopold Voss, 1898.

Storck, W. F. "Die neue Bühnenbildkunst. Zur Ausstellung moderner Theaterkunst in Mannheim." *Dekorative Kunst* xvi, 7 (April 1913), pp. 297-312.

Stuck, Franz. "Die Kunststadt München." *Nord und Sud*, 136 (1911), pp. 261-62.

Tarbutt, Hermann [pseud.?]. "Die Keinerausstellung des Künstlervereins 'Paranoia.'" *Die Kunst für Alle* 1 June 1896, pp. 263-65. (Originally published in the "Fasching number" of the *Münchener Neueste Nachrichten*.)

Taylor, John Russell. *The Art Nouveau Book in Britain*. London: Methuen & Co., Ltd., 1966.

Terenzio, Stephanie. "An Introduction" in *Vasily Kandinsky: an introduction to his work*. Exhibition catalogue. The William Benton Museum of Art, The University of Connecticut, Storrs, Conn., January 14-March 3, 1974.

Teuber, Marianne. "New Aspects of Paul Klee's Bauhaus Style," introduction to the exhibition catalog, *Paul Klee—Paintings and Watercolors from The Bauhaus Years: 1921-1931*. Des Moines Art Center, September 18-October 28, 1973, pp. 6-17.

————. "Paul Klee: Abstract Art and Visual Perception." Paper presented at the College Art Association, New York, January 1973.

————. "Visual Science and Bauhaus Teaching." Paper presented at the College Art Association, Chicago, February 1976.

Thieme, Ulrich, and Becker, Felix. *Allgemeines Lexikon der bildenden Künstler*. Leipzig: Seemann, 1908-50.

Tietze, Hans. "Der Blaue Reiter." *Die Kunst für Alle* 1 September 1912, pp. 543-50.

————. "Cézanne und Hodler." *Die Kunst für Alle* 15 May 1913, pp. 365-70.

————. "Kandinsky, *Klänge* . . ." (review). *Die Graphischen Künste* xxxvii (1914), pp. 15-16.

Trapp, Frank Anderson. "Matisse and the spirit of Art Nouveau." *Yale Literary Magazine* 123, pp. 28-34.

————. "Form and Symbol in the Art of Matisse." *arts magazine* (May 1975), pp. 56-58.

Tschudi, Hugo von. *Gesammelte Schriften zur neueren Kunst*. Edited by E. Schwedeler-Meyer. Munich: Bruckmann, 1912.

————. *Die Kaiserliche Gemäldegalerie der Ermitage in St. Petersburg*. Berlin: Photographische Gesellschaft, n.d.

Uhde-Bernays, Hermann. *Im Lichte der Freiheit Erinnerungen aus den Jahren 1880 bis 1914*. Frankfurt: Insel Verlag, 1947.

Um 1900. Art Nouveau und Jugendstil (exhibition catalog June 28-September 28, 1952). Zurich: Kunstgewerbemuseum, 1952.

Umanskij, Konstantin. *Neue Kunst in Russland, 1914-1919*. Potsdam: Klepenheuer, 1920.

Valentien, F. C. "Max [*sic*] Hölzel und die abstrakte Kunst." *Die Weltkunst* vii (1933), p. 2.

Van de Velde, Henri. "Allgemeine Bemerkungen zu einer Synthese der Kunst." *Pan* v (1899), pp. 261-70.

————. "Die Belebung des Stoffes als Schönheitsprincip." *Kunst und Künstler* i (1902-03), pp. 453-63.

————. "Die Linie," in *Die Zukunft* 6 September 1902, quoted in "Prinzipiellen Erklärungen." *Zum neuen Stil*, ed. Hans Curjel. Munich: R. Piper & Co., 1955, p. 130.

————. *Die Renaissance im modernen Kunstgewerbe*. Berlin: Cassirer, 1903.

————. *Zum neuen Stil*. Aus seinen Schriften ausgewählt

und eingeleitet von Hans Curjel. Munich: R. Piper & Co., 1955.

Van Gogh, Vincent. "Aus der Correspondenz Vincent van Goghs." *Kunst und Künstler* II (1903-04), pp. 364-68, 417-19, 462, 493-95.

Vasily Kandinsky: 1866-1944, a Retrospective Exhibition. New York: The Solomon R. Guggenheim Museum, 1962.

Venzmer, Wolfgang. "Adolf Hölzel und Hannover." *Niederdeutsche Beiträge zur Kunstgeschichte.* V. Munich: Deutscher Kunstverlag, 1966.

————. "Adolf Hölzel—Leben und Werk." *Der Pelikan* no. 65 (April 1963), pp. 4-14.

————, ed. *Adolf Hölzel, sein Weg zur Abstraktion. Ausstellung 1972* (with introduction by Wolfgang Venzmer). Dachau: Stadt Dachau, 1972.

Vergo, Peter. *Art in Vienna 1898-1918; Klimt, Kokoschka, Schiele and their contemporaries.* London: Phaidon, 1975.

————. Review of Paul Overy, *Kandinsky, the Language of the Eye. Burlington Magazine* CXII (October 1970), p. 711.

Verwey, Albert. "An Kandinsky." Translated by Karl Wolfskehl. *Kandinsky, 1901-1913.* Berlin: Der Sturm, 1913.

Veth, Jan. "Linie und Form. Aus Krefeld." *Kunst und Künstler* II (August 1904), pp. 467-68.

Volbehr, Theodor. "Die Kunst-Geschichte und das Verstandniss für die neue deutsche Kunst." *Deutsche Kunst und Dekoration* VII (October 1900-March 1901), pp. 302-06.

Volboudt, Pierre, ed. *Die Zeichnungen Wassily Kandinskys.* Cologne: M. DuMont Schauberg, 1974.

Volkmann, Ludwig. "Das Geistreiche im Kunstwerk." *Die Kunst für Alle* 1 January 1903, pp. 153-61.

————. "Das Wesen der Kunst, Ein Schlusswort." *Die Kunst für Alle* 15 May 1903, pp. 375-81.

Voll, Karl. "Die Frühjahr-Ausstellung der Münchener Secession." *Die Kunst für Alle* 15 April 1900, pp. 351-57.

————. "Die V. Internationale Kunstausstellung der 'Münchner Secession.'" *Die Kunst für Alle* 15 June 1898, pp. 273-76 (pt. I); 1 July 1898, pp. 289-90 (pt. II).

Vollmer, Hans. *Allgemeines Lexikon der bildenden Künstler des XX. Jahrhunderts.* Leipzig: Seemann, 1953–.

Volpi Orlandini, Marisa. *Kandinsky—Dall'Art Nouveau alla psicologia della forma.* Rome: Lerici editore, 1968.

Voss, Heinrich. "Franz Stuck as a Painter." *Apollo* XCIV, 117 (November 1971), pp. 378-83.

————. *Franz von Stuck Werkkatalog der Gemälde.* Munich: Prestel, 1973.

Vukanović, Beta. "Podatki o Ažbetovi Soli." *Anton Ažbè in Njegova Sola.* Ljubljana: Narodna Galerija, 1962.

Wadleigh, H. R. *Munich: History, Monuments, and Art.* London: T. Fisher Unwin, 1910.

Washton (Long), Rose-Carol. "Vasily Kandinsky, 1909-1913: Painting and Theory." Ph.D. dissertation, Yale University, 1968.

Waters, Bill, and Harrison, Martin. *Burne-Jones.* New York: G. P. Putnam's Sons, 1973.

Watkinson, Raymond. *Pre-Raphaelite Art and Design.* Greenwich, Conn.: New York Graphic Society Ltd., 1970.

Webster, J. Carson. "The Technique of Impressionism: A Reappraisal." *College Art Journal*, November 1944, pp. 3-22.

Weiss, Peg. "The Graphic Art of Kandinsky." *Art News* 73, no. 3 (March 1974), pp. 42-44.

————. "Kandinsky and the 'Jugendstil' Arts and Crafts Movement." *The Burlington Magazine* CXVII, 866 (May 1975), 270-79.

————. "Kandinsky and the Munich Academy." Paper presented at the Annual Meeting, College Art Association of America, January 1974 (Detroit, Michigan).

————. "Kandinsky: Symbolist Poetics and Theater in Munich." *Pantheon*, XXXV, 3 (July, August, September 1977), pp. 209-18.

Weiss, Peg. "Wassily Kandinsky, the Utopian Focus: Jugendstil, Art Deco, and the Centre Pompidou." *arts magazine*, vol. 51, no. 8 (April 1977), pp. 102-07.

Werefkin, Marianne. *Briefe an einen Unbekannten, 1901-1905*. Edited by Clemens Weiler. Cologne: Verlag M. DuMont, 1960.

White, Gleason. "Some Glasgow designers and their work." *Studio* XII (1898), p. 48.

Whitford, Frank. *Expressionism*. London: Hamlyn, 1970.

Wick, Peter A., ed. *The Turn of the Century 1885-1910: Art Nouveau-Jugendstil Books*. Cambridge: Department of Printing and Graphic Arts, The Houghton Library, Harvard University, 1970.

"Wie steht es um München?" *Dekorative Kunst* VII, 10 (July 1904), pp. 390ff.

Wien um 1900. 5 June-20 August 1964. Ausstellung veranstaltet vom Kulturamt der Stadt Wien. Vienna: 1964.

Wietek, Gerhard, ed. *Deutsche Künstlerkolonien und Künstlerorte*. Munich: Verlag Karl Thiemig, 1976.

Wilson, Edmund. *To the Finland Station*. (Originally published 1940.) Garden City: Doubleday, n.d.

Woeckel, Gerhard P. "Bedruckte und bestickte Stoffe um die Jahrhundertwende." *Sammler Journal*, no. 2 (February 1975), pp. 52-53, 57.

————. "Münchens Kunst im Jugendstil—Kunsthandwerk um die Jahrhundertwende." *Die Weltkunst* XLIII, 15 (1 August 1973), pp. 1204-06.

————, ed. *Jugendstilsammlung*. Kassel: Staatliche Kunstsammlungen, 1968.

Wöfflin, Heinrich. "Arnold Böcklin, bei Anlass von Schicks Tagebuch." *Die Kunst für Alle* 1 October 1901, pp. 1-8.

Wolf, Georg Jacob. *Kunst und Künstler in München*. Munich: Heitz, 1908.

————. "Die frühjahrsausstellung der Münchner Secession." *Die Kunst für Alle* 1 May 1909, pp. 359-61.

————. "Die Internationale Ausstellung der Münchner Secession 1910." *Die Kunst für Alle* 15 July 1910, pp. 457-541.

————. (Review of *Neue Künstlervereinigung* exhibition.) *Die Kunst für Alle* 1 November 1910, pp. 68-70.

————. ["G.J.W."]. "Von Ausstellungen. München." (Review of Carl Strathmann.) *Die Kunst für Alle* 1 June 1911, p. 408.

————. "Zur Jahrhundertfeier der münchner Akademie der bildende Künste." *Die Kunst für Alle* 1 June 1909, pp. 402-11.

Wolfskehl, Karl. "Stefan George." *Allgemeine Kunstchronik* XVIII, 23 (1894), pp. 672-76.

————. "Stefan George, zum Erscheinen der Oeffentlichen Ausgabe seiner Werke." *Pan* IV, 4 (1898), pp. 231-35.

————. "Über das Drama." *Blätter für die Kunst, Eine Auslese aus den Jahren 1904-09*. Berlin: G. Bondi, 1909.

Worobiow, Nikolai. *M. K. Ciurlionis. Der litauische Maler und Musiker*. Kaunas: 1938, n.p.

Worringer, Wilhelm. *Abstraction and Empathy*. Translated by Michael Bullock. Cleveland: World Publishing Co., 1967.

————. *Abstraktion und Einfühlung*. 3rd ed. (Originally published 1908.) Munich: R. Piper & Co., 1911.

————. *Die altdeutsche Buchillustration*. Munich: R. Piper, 1912.

————. "Frank Wedekind, Ein Essay." *Münchner Almanach, ein Sammelbuch neuer deutscher Dichtung*. Edited by Karl Schloss. Munich: R. Piper & Co., 1905, pp. 55-64.

————. "Rudolf Czapek, Grundprobleme der Malerei." *Kunst und Künstler* VIII, 4 (January 1910), p. 236.

XX^e Siècle. no. 27, December 1966. (Centenary issue devoted to Kandinsky.)

Zehder, Hugo. *Wassily Kandinsky*. Dresden: Kaemmerer, 1920.

Zelnik, Friedrich. "Georg Fuchs, Die Revolution des Theaters. . . ." [Book review.] *Bühne und Welt* XI (April 1909-September 1909), pp. 570-71.

Index

Aubert, Félix, 26
Auden, Wystan Hugh, 191n10
Audiger & Meyer, Krefeld, 117, figs. 90a, 90b
Avenarius, Ferdinand, 158-159n25, 186n133; on abstract form language as vehicle for profound emotion, 113-114, 128; among first to appreciate Kubin, 181n34; biographical, 181n34; compared to Czapek, 114; imagery of, prefigures Kandinsky, 113; and Kandinsky, 207n60; on Katharine Schäffner drawings, 113-114; on ornament as vehicle for intellectual-spiritual, 113; on "super-ornament," 113
Ažbè, Anton, 9, 13-18 passim, 28, 134, 187n147; assessment of, as an artist, 17-18; attitude of, toward study of anatomy, 17; awards for services as teacher, 161n15; caricatures of, 14; character of, 13; circle of artistic and literary acquaintances, 14; color theory of, and neo-impressionist color theory, 15-16; color theory of, as avant-garde, 15; color theory of, compared to that of Cézanne, 16; color theory of, in Grabar's recollection, 15; death of, 13, 161n8; dedication of, 13; description of, by Werefkin, 14; emphasis on line, 16-17; emphasis on pure color, 15; encouraged individuality, 15; enthusiasm of, for bicycle, 17; experimental attitude of, 16; generosity of, 13, 14; independence of, with respect to academic theories, 16; influence on Kandinsky, 18; Kandinsky's recollection of, 13-14; known as Professor Nämlich, 14; method of, 15-16; modesty of, 13; oeuvre extant, 162n20; pedagogical talent of, 14; *principe de la sphère* or *Kugel-system*, 15; rejection of academic compositional rules, 162n40; reputa-

tion of, 13, 15-16; reputation of, in Russia, 13; Russian students of, 13; size of, 161n10, 161n12; students of, 162n19, 160-161n2; training of, 14; use of color recalled by Dobuzhinsky, 163n60; use of palette knife by students of, 163n62; work exhibited at Glaspalast, 14

Ažbè School, date of opening, 14; freedom of, 17; location of, 13; popularity of, 13; popularity of, compared to Munich Academy, 15; reputation of, 160-161n2
oeuvre, Half-nude Woman, 18, fig. 5; *In the Harem*, 18, fig. 7; *Portrait of a Bavarian*, 18; *Portrait of a Man in a Black Tie*, 18; *Portrait of a Negress*, 17-18, fig. 4; *Seated Male Nude*, 17, fig. 3; *Self-Portrait*, 18, fig. 6

Bachmann, Alfred, 186n140
Baegert, Derick, 173n124
Bahr, Hermann, 73, 190n8
Bakst, Leon S., 187n1
Ball, Hugo, admirer of Kandinsky, 203n112; biographical, 203n112; and Munich Artists' Theater, 92, 103; *Das neue Theater*, 103
Banger's Kunstsalon, Wiesbaden, Phalanx at, 65
Baudelaire, Charles, 22, 81
Bauer, Karl, 193n46; portrait of George as Saint George, 85; *Knight before the Battle*, 85, fig. 70
Bauhaus (Weimar), 7, 24, 29, 51, 92, 99-100, 118; color seminar led by Kandinsky, 15; influence of Hölzel at, 175n153; Kandinsky's association with, seen as indicative of pedagogical interest, 64; Kandinsky's interest in craft as precedent to activity at, 124; Kandinsky students' work at, compared to that of Obrist-Debschitz students, 210n36; Kandin-

sky's theatrical activity at, 92; program prefigured in educational ideas of Obrist, 28, 30; relation to Darmstadt Artists' Colony, 183n60; Utopianism of its manifesto, 9
Baum, Paul, 76
Baumeister, Willi, 40, 45, 175n153
Baurnfeind, Moritz, 60, 181n35
Beardsley, Aubrey, 8, 23, 120
Bechteiev, Vladimir von, *Amazonen*, 145n12; and Munich Artists' Theater, 103
Beethoven, Ludwig van, 32
Behrens, Peter, 61, 70, 84, 94, 122, 134, 182n44, 208n84; among first to recognize Kandinsky's talent, 166n19; as craftsman at 1897 Glaspalast exhibition, 24; at Darmstadt Artists' Colony, 61, 62; designed catalog *Document of German Art*, 62; designed own house at Darmstadt Artists' Colony, 62; directed chorus, designed costumes for opening masque *Das Zeichen* at Darmstadt Artists' Colony, 62, 198n15; director, Arts and Crafts School, Düsseldorf, 120, 210n24; and Fuchs, 92; ideas on theater anticipated Craig's, 199-200n24; ideas on theater comparable to Kandinsky's, 199-200n24; influence on, of Obrist, 28; interest in theater, 172n48; and Kandinsky and George circle, 83; and Kandinsky's interest in theater, 93, 199-200n24; member of Munich Secession, 19; and Obrist, 30; offered Kandinsky directorship of decorative painting class at Düsseldorf Arts and Crafts School, 120-121, 204n1; participation in 1905 Society for Applied Art exhibition, 120; at Phalanx II, 60; at Phalanx VIII, 69; significance of, for twentieth-century art, 166n19; on symbolic movement as heart of drama, 95; and symbolist movement

1. ERNST STERN. *Caricature of Anton Ažbè*, ca. 1900.

2. KANDINSKY. *Page from a sketchbook*, ca. 1897-99.

3. ANTON AŽBÈ. *Seated male nude*, 1886.

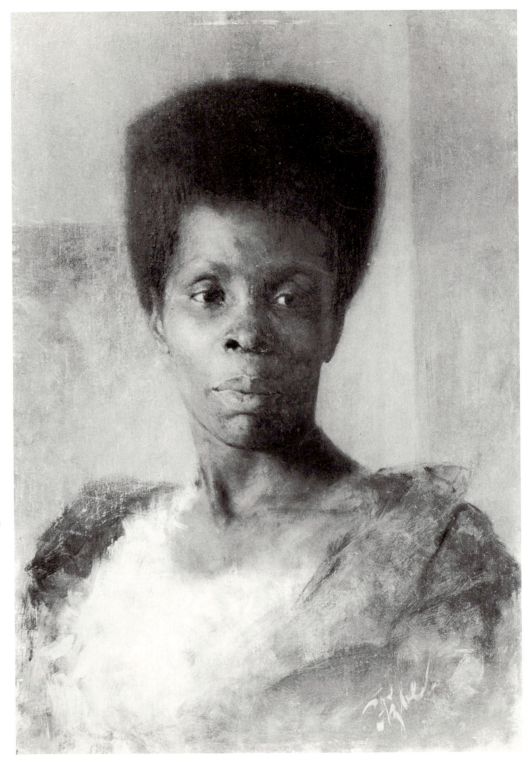

4. Anton Ažbè. *Portrait of a Negress*, 1895.

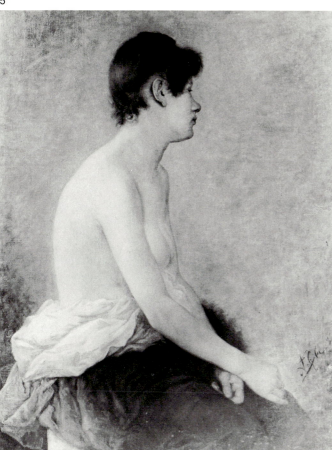

5

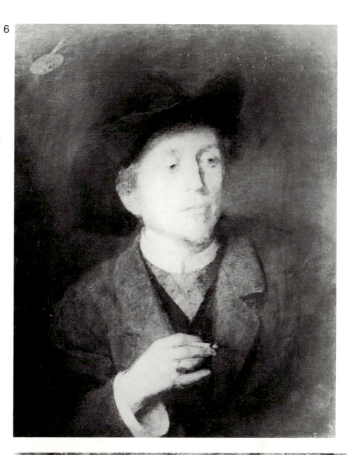

6

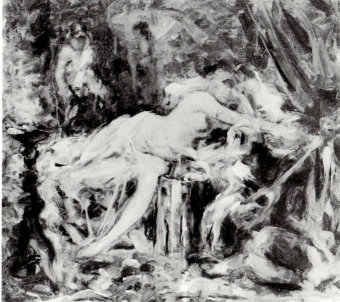

7

5. ANTON AŽBÈ. *Half-nude woman*, 1888.

6. ANTON AŽBÈ. *Self-portrait*, 1889.

7. ANTON AŽBÈ. *In the Harem*, ca. 1905.

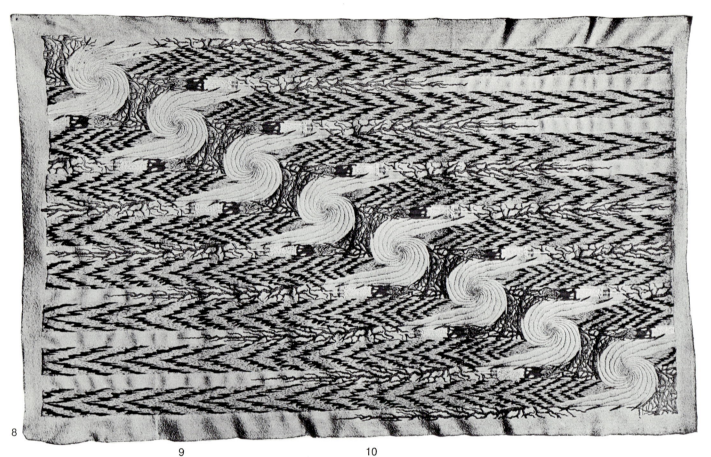

8

9

10

8. HERMANN OBRIST.
*Embroidered rug exhibited
at the Munich Secession,*
1897.

9. AUGUST ENDELL.
Embroidered wall-hanging,
ca. 1897.

10. CARL STRATHMANN.
*Decorative painting with
frame,* ca. 1897.

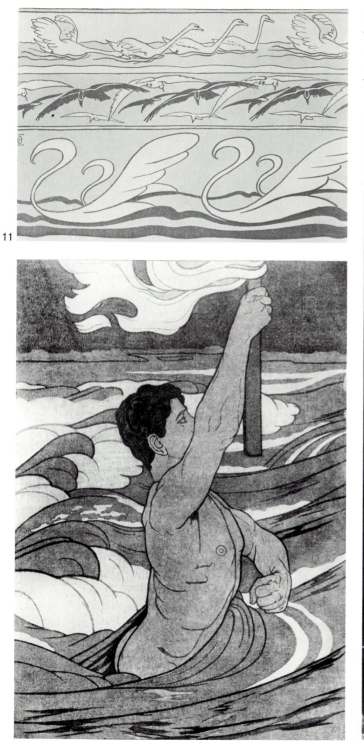

11

12

11. OTTO ECKMANN. *Sketch for decorative design with swan motif*, 1897 (detail).

12. PETER BEHRENS. *Sieg (Triumph)*, 1898.

13. HERMANN OBRIST. *Gewölbepfeiler (Arch pillar)*, before 1900.

13

14. HERMANN OBRIST.
Tomb for the Oertel Family, 1905.

15. ADOLF VON HILDEBRAND.
Wittelsbach Fountain,
Munich, 1895.

16. HERMANN OBRIST. *Brunnenmodell mit grosser flacher Wasserschale (Model for a fountain with large, flat water basin)*, ca. 1901.

17. HERMANN OBRIST. *Brunnenmodell mit drei eiförmigen Becken (Model for a fountain with three egg-shaped bowls)*, ca. 1900.

18. HERMANN OBRIST. *Phantastische Muschel (Fantastic shell)*, ca. 1895.

19

18

19. HERMANN OBRIST. *Steinbrunnen (Stone fountain)*, before 1900.

20. KURT SCHWERDTFEGER. *Bauplastik in Sandstein (Architectural sculpture in sandstone)*, executed at the Bauhaus, 1922.

20

21. Hermann Obrist. *Peitschenhieb (Whiplash)*, ca. 1895.

22. HERMANN OBRIST.
Blütenbaum (*Blossoming
tree*), ca. 1896.

23. August Endell. *Façade of the Hofatelier Elvira*, Munich, 1896-97.

24

26

25

29

24. AUGUST ENDELL. *Stair railing of the Hofatelier Elvira*, Munich.

25. AUGUST ENDELL. *Entrance gate of the Hofatelier Elvira*, Munich.

26. AUGUST ENDELL. *Interior of the Hofatelier Elvira*, Munich.

27. AUGUST ENDELL. *Door handles of the Hofatelier Elvira*, Munich.

28. AUGUST ENDELL. *Window forms*, ca. 1898.

29. AUGUST ENDELL. *View of stage and curtain, Buntes Theater*, Berlin.

30

30. ADOLF HÖLZEL. *Birken im Moos (Birches on the Moor)*, 1900-02.

31. ADOLF HÖLZEL. *Haus Andacht (Home Prayers)*, 1890.

32a. ADOLF HÖLZEL. *Abstract ornament*, before 1900.

32b. ADOLF HÖLZEL. *Abstract ornament*, before 1900.

32c. ADOLF HÖLZEL. *Abstract ornament with text*, before 1900.

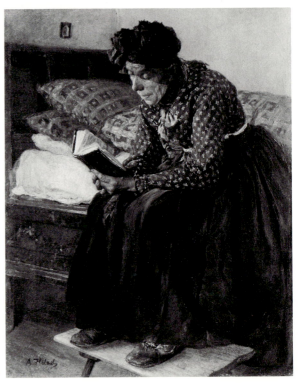

31

32b

32c

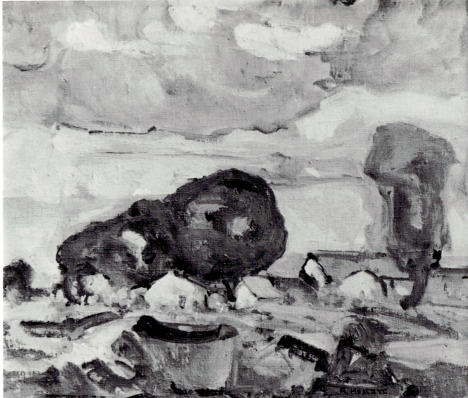

33

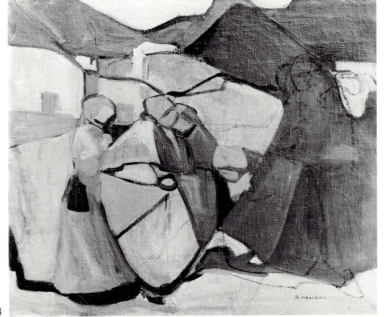

34

35

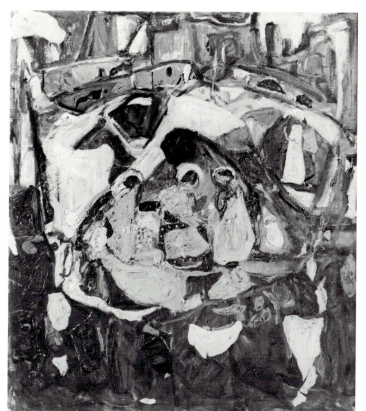

36

33. ADOLF HÖLZEL. *Dachauer Moos IV* (*Dachau Moor IV*), 1905.

34. ADOLF HÖLZEL. *Komposition in Rot I* (*Composition in Red I*), 1905.

35. KANDINSKY. *Improvisation 6* (*Afrikanisches*) (*Improvisation 6* [*African*]), 1909.

36. ADOLF HÖLZEL. *Biblisches Motif* (*Biblical motif*), 1914.

37. ADOLF HÖLZEL. *Detail of stained glass window at the Bahlsen Company*, Hannover, 1916-17.

37

38. KANDINSKY. *Trüber Tag*
(*Cloudy Day*), 1901.

39. ADOLF HÖLZEL. *Winter*
(*Tauschnee*) (*Winter, Thawing
Snow*), 1900.

40. KANDINSKY.
*Woodcut for 10
Origin*, 62/100,
1942.

41

42

43. FRANZ STUCK.
Wächter des Paradieses
(*Guardian of Paradise*), 1889.

42. FRANZ STUCK.
Das böse Gewissen
(*The Guilty Conscience*), 1896.

43. FRANZ STUCK.
Die wilde Jagd
(*The Wild Hunt*),
ca. 1889.

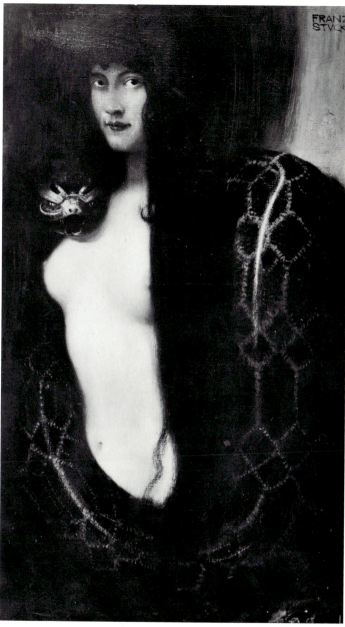

44. FRANZ STUCK. *Secession exhibition poster*, n.d.

45. FRANZ STUCK. *Die Sünde (Sin)*, ca. 1893.

46

46. FRANZ STUCK. *Franz Stuck und Frau im Atelier (Franz Stuck and his Wife in the Studio)*, 1902.

47. FRANZ STUCK. *Der Tanz (The Dance)*, 1894.

48. FRANZ STUCK. *Tänzerinnen (Dancers)*, 1896.

49. FRANZ STUCK. *Tänzerinnen (Dancers)*, 1897-98.

47

48

49

50. KANDINSKY. *Schleuse* (*The Sluice*), 1901.

51. KANDINSKY. *Poster for the first Phalanx exhibition*, 1901.

50

51

52

53

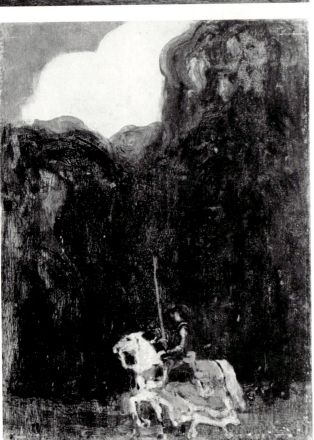

54a

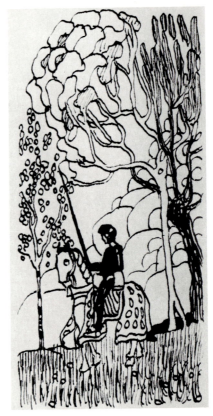

54b

52. CARL PIEPHO.
Am Waldrand
(*At the Edge of
the Wood*), 1903.

53. KANDINSKY. *Der
Blaue Reiter* (*The
Blue Rider*), 1903.

54a. KANDINSKY.
Im Walde (*In the
Wood*), 1903.

54b. KANDINSKY.
*Reiter in
Landschaft* (*Rider
in a Landscape*),
ca. 1903.

55

56

55. KANDINSKY. *Watercolor sketch, fairy tale motif*, ca. 1900.
56. HANS CHRISTIANSEN. *Six embroidered and woven cushions*, ca. 1900.

57

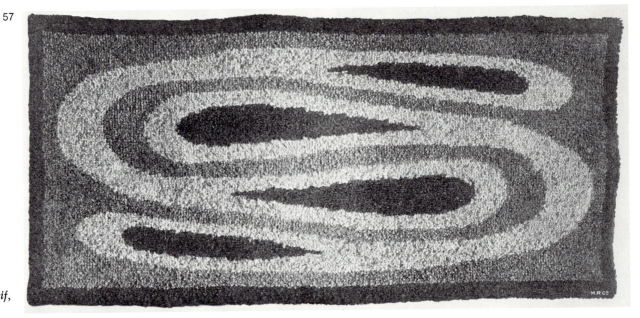

57. PETER
BEHRENS.
*Carpet with
abstract motif*,
ca. 1897.

58

58. PETER BEHRENS. *The artist's home at the
Darmstadt Künstlerkolonie, 1900-01* (with
painted banners designed by the artist).

59. AXEL GALLEN. *The Fight for the Sampo*,
1896.

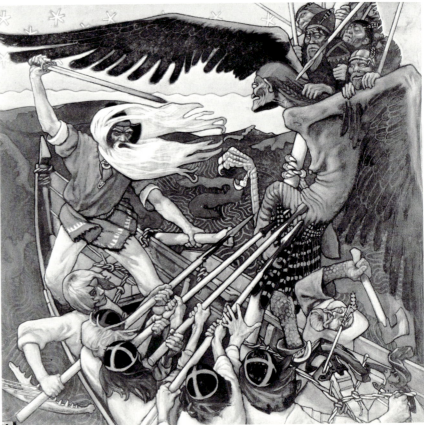

59

60. AXEL GALLEN. *Embroidered table mat, executed by Mary Gallen, 1900.*

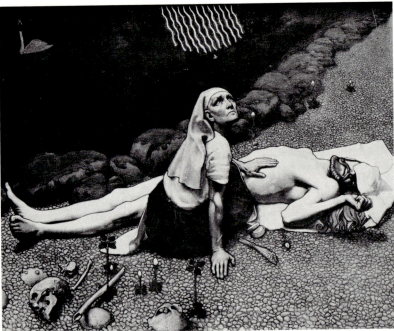

61. Axel Gallen. *Lemminkainen's Mother*, 1897.

63. Carl Strathmann. *Satan*, 1902.

62. KANDINSKY. *Poster for the seventh exhibition of the Phalanx* (detail), 1903.

64. REINHOLD MAX EICHLER.
*"Wer hat dich, du schöner
Wald?"* (*"Who created you,
you beautiful forest?"*),
ca. 1902.

65. HERMEN ANGLADA.
*Spanish Peasants from
Valencia*, n.d.

66. KANDINSKY. *Reitendes
Paar (Riding Couple)*,
ca. 1907.

71

67. KANDINSKY. *Abschied (Farewell)*, 1903.

68. JAN TOOROP. *Portrait of Stefan George*, 1896.

69. J. B. HILSDORF. *Photograph of Stefan George*, ca. 1897, in Munich.

70. KARL BAUER. *Ritter vor dem Kampfe (Knight before the Battle)*, ca. 1902-03, portrait of Stefan George.

71. KANDINSKY. *Im Schlossgarten (In the Palace Garden)*, 1903.

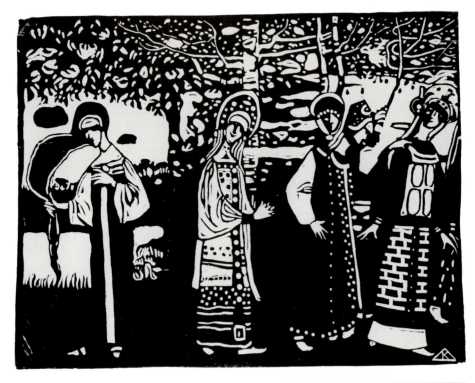

72. KANDINSKY. *Les Femmes au Bois* (*Ladies in the Wood*), ca. 1906-07.

73. KANDINSKY. *Herbst* (*Autumn*), 1904.

74. KANDINSKY. *Mühle (Holland) (Windmill)*, 1904.

75. KANDINSKY. *Die Nacht (The Night)*, ca. 1906-07.

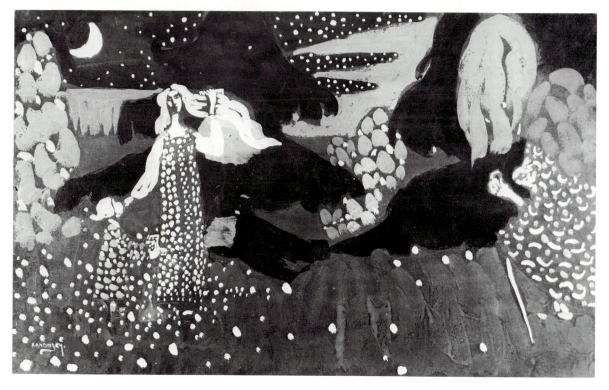

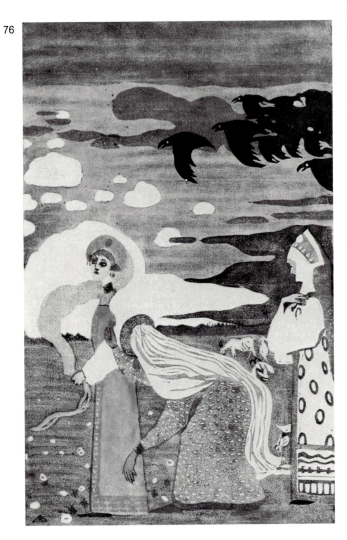

76. KANDINSKY. *Die Raben* (*The Ravens*), ca. 1906-07.

78. KANDINSKY. *Weisser Klang* (*White Sound*), 1908.

79. KANDINSKY. *Weisser Klang* (*White Sound*), 1911.

77. KANDINSKY. *Les Oiseaux* (*The Birds*), ca. 1906-07.

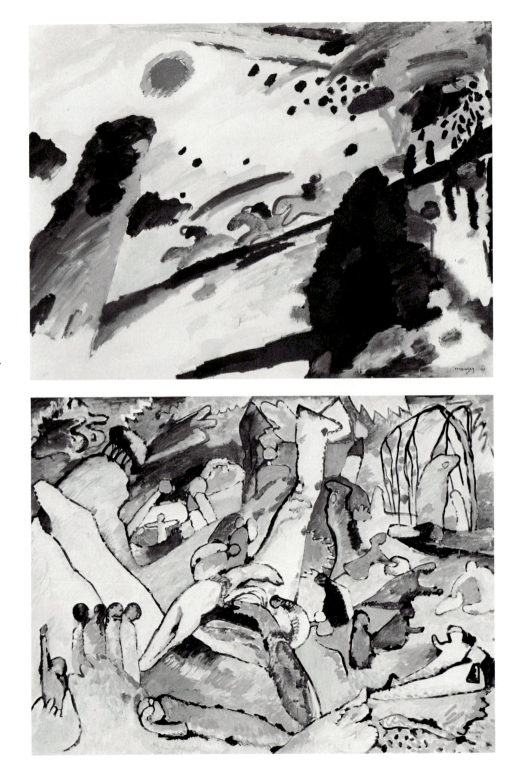

80. KANDINSKY. *Romantische Landschaft (Romantic Landscape)*, 1911.

81. KANDINSKY. *Study for Composition II*, 1910.

82. MAX LITTMANN. *Interior view of the Munich Artists' Theater, 1908.*

83. MAX LITTMANN. *Model of the Munich Artists' Theater.*

84. FRITZ ERLER. *Set design for Hamlet at the Munich Artists' Theater.*

85. ADOLF HENGELER. *Set design for Wolkenkuckucksheim at the Munich Artists' Theater.*

86. HENRI VAN DE VELDE. *Signet for Van nu en Straks*, before 1898.

87. KATHARINE SCHÄFFNER. *Geisterstille (Ghostly Silence)* ca. 1908.

88. KATHARINE SCHÄFFNER. *Schlummer (Slumber)*, ca. 1908.

89

91

89. KATHARINE SCHÄFFNER. *Leidenschaft (Passion)*, ca. 1908.

90a and b. *Tie materials designed by the firm of Audiger & Meyer, Krefeld,* ca. 1902-03.

91. HANS SCHMITHALS. *Carpet, handknotted,* ca. 1905.

90a

90b

92. KANDINSKY. *Decorative scene with Viking ship,* ca. 1904.

93. *Student demonstration drawing of the Obrist-Debschitz School,* Munich, ca. 1904.

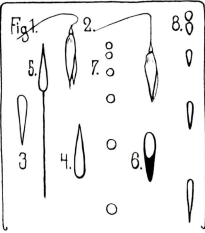

94. B. Tölken.
*Hänge- und
Spannungsstudie
(Hanging and
tension study)*, ca.
1904.

95. HANS SCHMITHALS. *Studie (Study)*, ca. 1904.

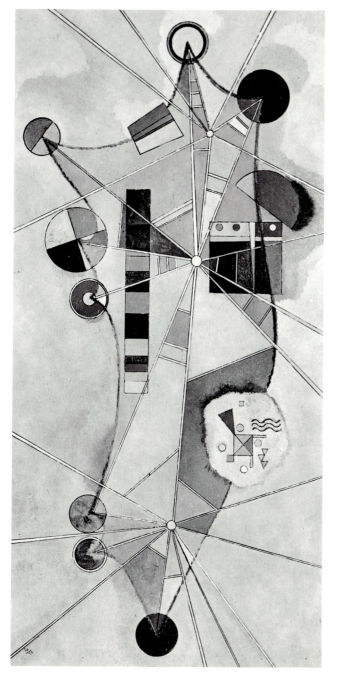

96. KANDINSKY. *Fixierte Spitzen (Fixed Points)*, 1929.

97. KANDINSKY. *Unbenannte Improvisation (Untitled Improvisation)*, 1914.

98

100

99

98. KANDINSKY. *Designs, possibly intended for ceramic or glass medium,* ca. 1902-04.

99. KANDINSKY. *Decorative design with circles and wavy lines,* ca. 1902-04.

100. FERDINAND HAUSER. *Brooch with pendants,* ca. 1902-13.

101

101. KANDINSKY. *Three designs for pendants*, ca. 1902-04.

102. KANDINSKY. *Decorative design, griffen*, ca. 1902-04.

103. KANDINSKY. *Decorative designs*, ca. 1902-04.

102

103

104

105

104. KANDINSKY. *Designs for rings, with fish and flower motifs*, ca. 1904.

105. KANDINSKY. *Design for chair with ship motif*, ca. 1901-03.

106. KANDINSKY.
*Decorative designs for
furniture,* ca. 1900-04.

107

107. KANDINSKY. *Designs for locks and keys*, ca. 1900-04.

108. AUGUST ENDELL. *Designs for locks and keys, probably for the Hofatelier Elvira, 1896-97.*

109. KANDINSKY. *Decorative design, trees and flowers*, ca. 1902-04.

108

109

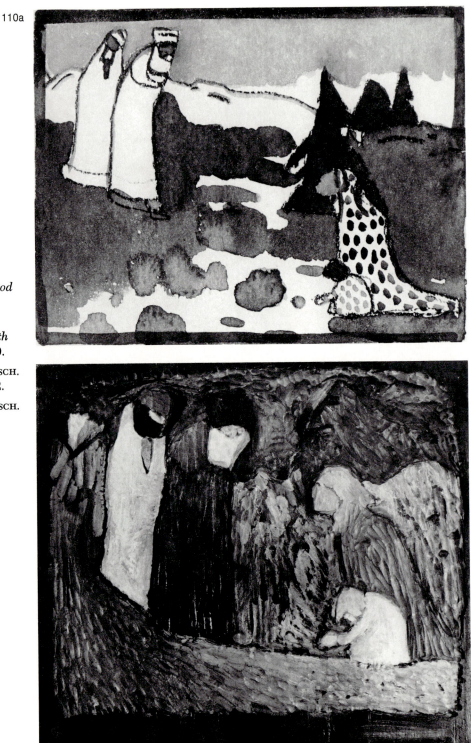

110a

110a. KANDINSKY. *Sketch for a wood relief with figures in a landscape,* ca. 1908-09.

110b. KANDINSKY. *Wood relief with figures in a landscape,* ca. 1908-09.

111. MARGARETHE VON BRAUCHITSCH. *Embroidered cushion,* ca. 1901-02.

112. MARGARETHE VON BRAUCHITSCH. *Embroidered cushions,* ca. 1904.

110b

111

112

113a

b

113a and b. Margarethe von Brauchitsch. *Dress with silk appliqué* (two views). *The model may have been Gabriele Münter*, 1902.

114. Kandinsky. *Photograph of Gabriele Münter in dress designed by Kandinsky*, ca. 1905.

115. Kandinsky. *Photograph of Gabriele Münter in dress designed by Kandinsky*, ca. 1905.

114

115

116a. KANDINSKY. *Dress design, front, side and back view, ca. 1904.*

116b. KANDINSKY. *Dress design, side view and detail, ca. 1904.*

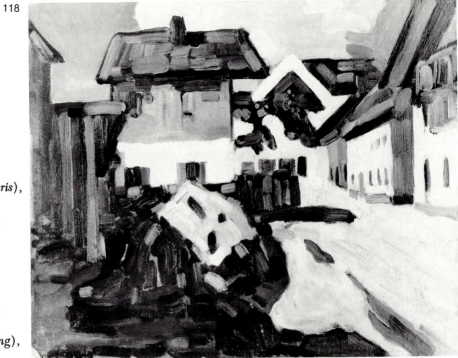

118

117. KANDINSKY. *Bei Paris (Near Paris)*, 1906.

118. KANDINSKY. *Strasse in Murnau (Street in Murnau)*, 1908.

119. KANDINSKY. *Kirche in Murnau (Church in Murnau)*, 1908.

120. KANDINSKY. *Landschaft bei Murnau (Landscape near Murnau)*, 1909.

121. MARTHA CUNZ. *Abend (Evening)*, ca. 1904.

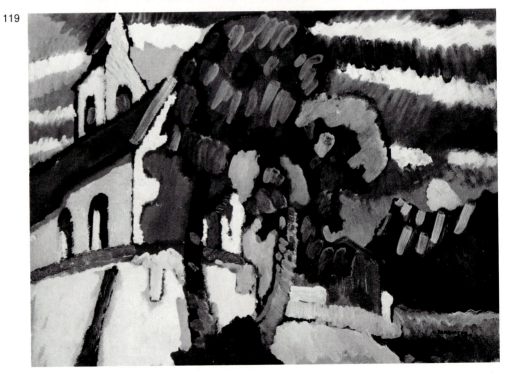

119

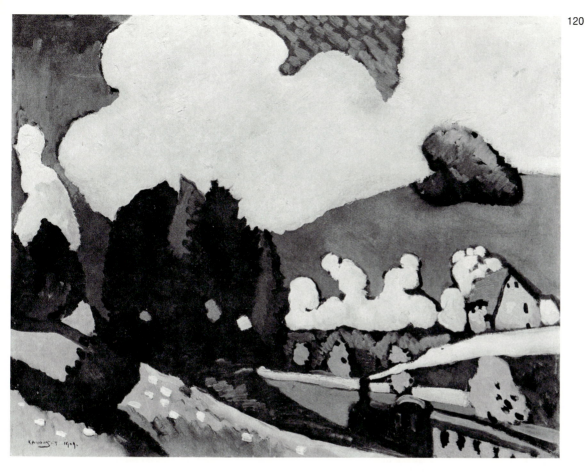

120

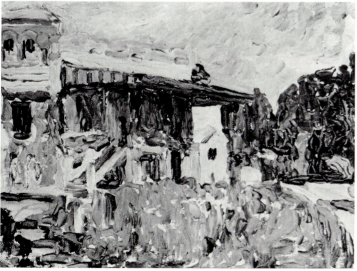

117

121

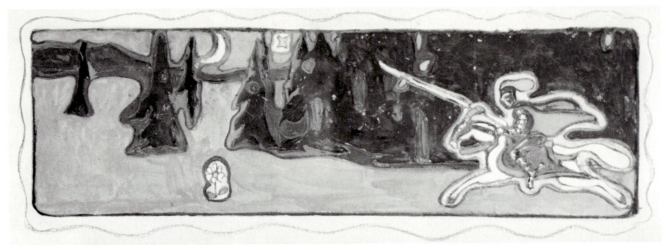

122

123

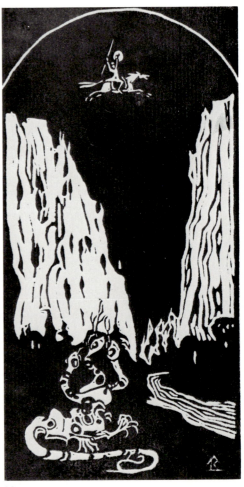

124

122. KANDINSKY. *Dämmerung (Dusk)*, ca. 1901.

123. KANDINSKY. *Title page for Poems without Words*, ca. 1903-04.

124. KANDINSKY. *Le Dragon (The Dragon)*, ca. 1903-04.

125. KANDINSKY. *Chevalier à cheval (Knight on Horseback)*, ca. 1903-04.

126. KANDINSKY. *Chevalier russe (Russian Knight)*, ca. 1904-05.

127. KANDINSKY. *Membership card for the Neue Künstlervereinigung München*, 1908-09.

126

127

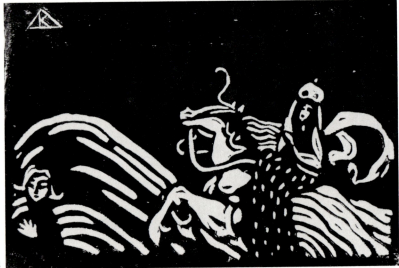

128

128. KANDINSKY. *Vignette published in Tendances nou-velles*, IV, no. 40 (January 1908).

129. KANDINSKY. *Vignette preceding the chapter, "Die Be-wegung" in Über das Geistige in der Kunst*, 1911 (also in *Klänge*, 1913).

130. KANDINSKY. *Sketch for the cover of Der Blaue Reiter*, 1911.

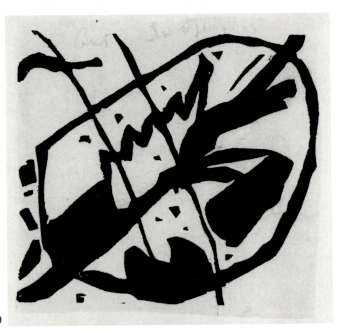

129

131. KANDINSKY. *Cover design for Salon Isdebsky monograph*, 1911.

132. KANDINSKY. *Color woodcut in Klänge (two riders)*, 1913, executed ca. 1908-11.

133. KANDINSKY. *Color woodcut in Klänge (riders, figures, mountain)*, 1913, executed 1908-11.

134. KANDINSKY. *Vignette for the poem "Blätter," in Klänge, 1913.*

135. KANDINSKY. *Color woodcut in Klänge*, 1913 (three riders, red, blue, black).

136. Kandinsky. *Mit drei Reitern (With Three Riders)*, ca. 1911-12.

137. KANDINSKY. *Lyrisches* (*Lyrical*), 1911.

138. KANDINSKY. *Bild mit weissem Rand (Picture with White Edge)*, 1913.

139. KANDINSKY. *Drawing for Bild mit weissem Rand*, ca. 1912.

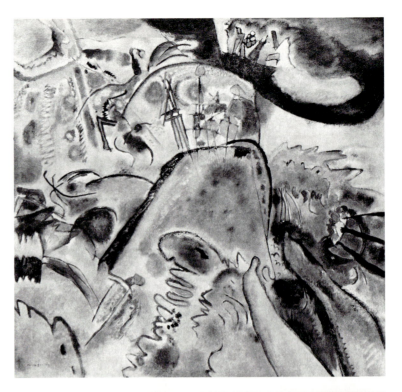

140. KANDINSKY. *Kleine Freuden (Small Pleasures)*, 1913.

141. KANDINSKY. *Kleine Freuden (Small Pleasures)*, ca. 1912.

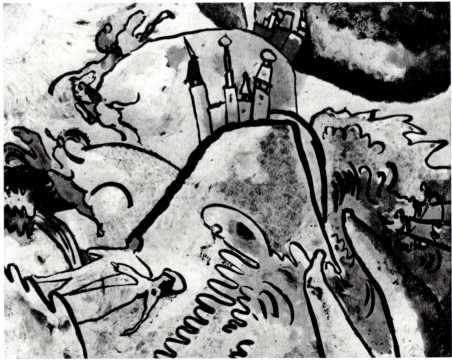

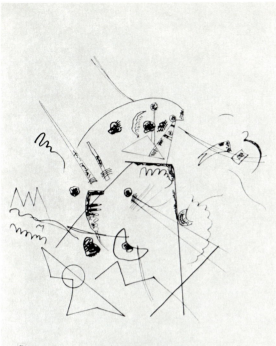

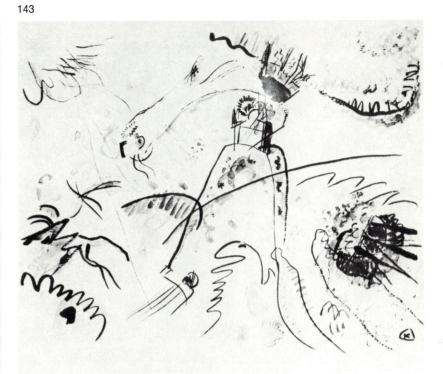

142. KANDINSKY. *Drawing based on Kleine Freuden*, 1913 (1924?).

143. KANDINSKY. *Study for Kleine Freuden*, 1913.

144. KANDINSKY. *Rückblick (Backward Glance)*, 1924.

145. KANDINSKY. *Cover for the periodical Transition,* 1938.

146. FRANCIS H. NEWBERY. *Embroidered wall hanging* (also attributed to Miss Keyden of the Glasgow School), ca. 1901.

147. HARRINGTON MANN. *Hyde Park*, ca. 1901.

148. KANDINSKY. *Im Sommer* (*In Summer*), 1904.

149. KANDINSKY. *Bild mit Reifrockdamen* (*Crinolines*), 1909.

150. ADOLF MÜNZER. *Luxus* (*Luxury*), ca. 1900.

151. KANDINSKY. *Pastorale*, 1911.

152. GUILLAUME ROGER. *Phantasie*, ca. 1898.

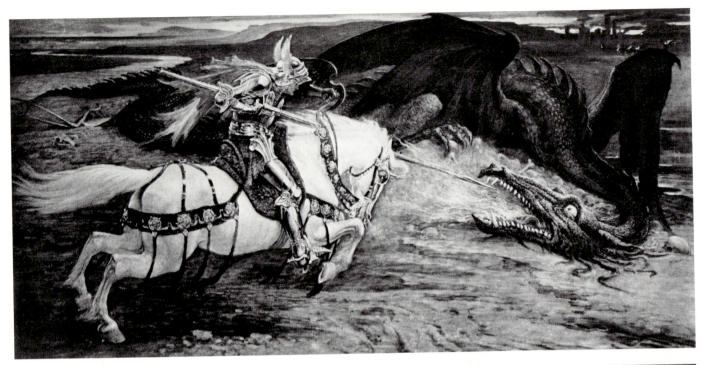

153. WALTER CRANE: *St. George's Battle with the Dragon* (or *England's Emblem*), ca. 1894.

154. HANS VON MAREES. *St. George*, 1880.

155. Kandinsky. *St. George II*, 1911.

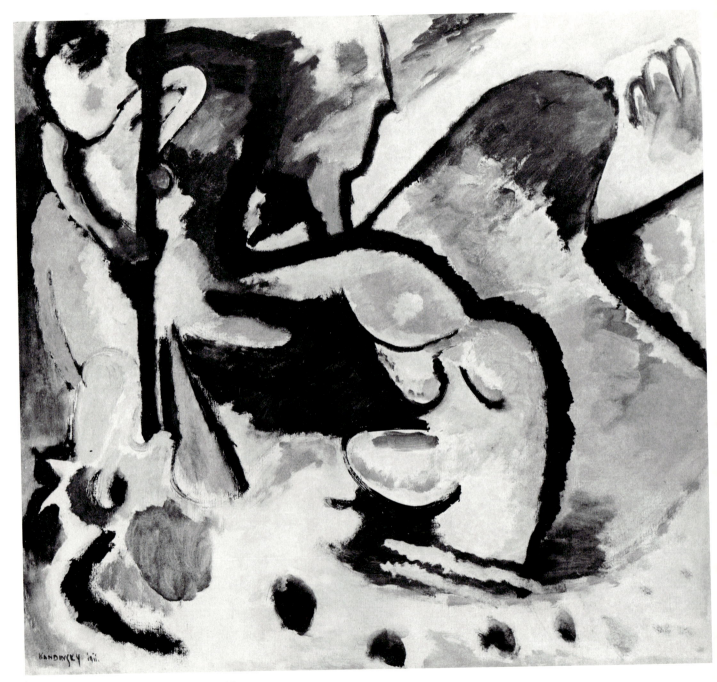

156. KANDINSKY. *St. George III*, 1911.

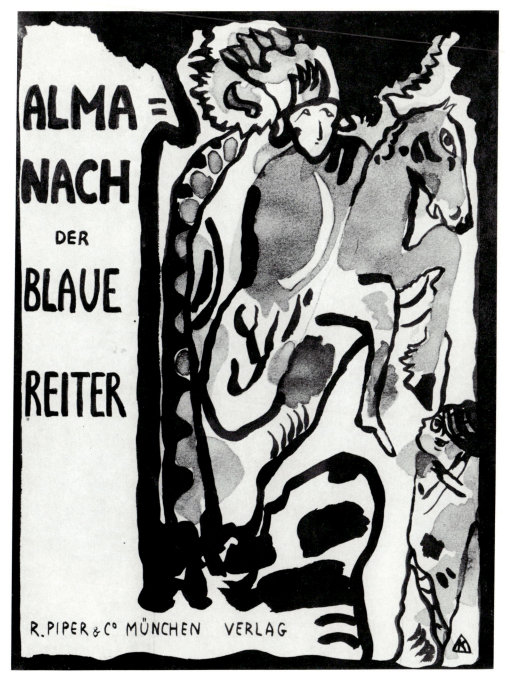

ALMA=
NACH
DER
BLAUE
REITER

R. PIPER & Cᵒ MÜNCHEN VERLAG

157. KANDINSKY. *Final sketch for the cover of the Blaue Reiter almanach,* 1911.

158. THOMAS THEODOR HEINE. *Der Kampf mit dem Drachen (The Battle with the Dragon),* ca. 1902.

159. KANDINSKY. *L'élan brun (Brown Elan)*, 1943.